Pedro
and Ricky
Come Again

Pedro and Ricky Come Again

JONATHAN MEADES

unbound

First published in 2021

Unbound
Level 1, Devonshire House, One Mayfair Place, London w1j 8aj
www.unbound.com

Various pieces in this collection have appeared in the following publications: *Architects'
Journal, Architectural Review, Blueprint, Country Life, The Critic, The Dabbler, Daily Mail, Daily
Telegraph, The Economist, Evening Standard, Guardian, Independent, Literary Review, London Review
of Books, Mail on Sunday, Modern Painters, The Modernist, New Statesman, Observer, The Oldie,
The Quietus, The Spectator, Standpoint, Sunday Correspondent, Sunday Telegraph, Sunday Times,
The Times, Times Literary Supplement, Vice, Vogue, The White Review*.

'On Passing the New Menin Gate' © Siegfried Sassoon
by kind permission of the Estate of George Sassoon

While every effort has been made to trace the owners of copyright material reproduced
herein, the publisher would like to apologise for any omissions and will be pleased to
incorporate missing acknowledgements in any further editions.

Text design by Ellipsis, Glasgow

A CIP record for this book is available from the British Library

ISBN 978-1-78352-950-6 (hardback)
ISBN 978-1-78352-951-3 (ebook)

Printed in Great Britain by CPI Group (UK)

1 3 5 7 9 8 6 4 2

For the enemies of the people

Contents

Introduction 1

Trailer 5

1. Art and Artists 9

2. Buildings 85

3. Cities 123

4. Concrete 141

5. Death 173

6. England 181

7. Faith, Fads and Fashions 226

8. First Person 256

9. France 318

10. Further Abroad 364

11. History 399

12. Language 443

13. London 483

14. Magnetic North 527

15. NSDAP 574

16. Obituaries 612

17. Out of Town 640

18. Pevsner 686

19. Politics 706

20. Pop Culture 746
21. Regeneration 776
22. Richard Rogers 828
23. Sex 836
24. Showbiz 845
25. Sport 860
26. Urbanism 874
27. Writers 918

Acknowledgements 945
A Note on the Author 947
Index 949
Supporters 975

Introduction

The original had a title that meant something. *Peter Knows What Dick Likes* (1988) is a bald boast that men do better hundred-to-eights than women because the giver is likely to be a recipient too. I gallantly proposed that this is not the case, that many women are fully competent. I guess that's evidence of what you might call my feminist side.

Pedro and Ricky Come Again is another sort of title. It's akin to 'Two-Hour Dry Cleaners' where the operative, out of her head on perchloroethylene, tells you that's just the name of the shop and it'll be ready a week Tuesday. It locates this book in the same area as its predecessor. It evidently alludes to a sort of vainglorious masculism, to Derek and Clive – scatological representatives of a very different era before British and, to a lesser degree, French societies were characterised by thin-skinned hypersensitivity, puritanism and a preoccupation with 'respect': essentially a demand that people (tyrants, kiddy fiddlers and politicians are people too) should be taken at their own estimate, their own lies, their own self-delusion, and that to neglect to do so is an aggressive belittlement.

An obviously linked, somewhat paradoxical characteristic of the early twenty-first century is a loud bloc composed of an aggregation of minoritarian special pleaders whose interests may be contradictory, even violently opposed to each other. An axe murderer has rights too – and doesn't he know it, having gained a doctorate in Behavioural

Tropes in Victimology when banged up; that was before he decided to convert to Responsibly Caring Terrorism. An axe murderer's victims' ghosts are equally apprised of their entitlements. While the two groupuscules are philosophically divergent they are bound together by the cacophony they contribute to. They sing the song of their single issue and the song of solidarity with the persecuted of all faiths, tastes and body shapes.

An effect of this atomisation which transforms every person into a one-person minority is that every word written causes offence to someone. Not the words that one intends to cause offence – and god knows they are legion – but those in between, the water carriers: they have an unerring tendency to find targets that were unknown, unnoticed, unsuspected. It's the stray arrow that fells the hind. The pieties of woke and its forebears (right-on-ness and political correctness stretching back to literal iconoclasm) are discouraging. The N-word, the C-word, the J-word, the Q-word, the Ö-word . . . There is no end to these shifty euphemisms which make you want to grab the fastidious by the throat and tell them to be frank.

There is no end either to the inhibitions which we initially scorn but, hardly realising it, torpidly adopt because self-attrition is tiring and no one will, with luck, notice if we mitigate our disquiet at a woke five-star approved cause: a three-breasted, three-penised, mixed-race cyclopean who identifies as a figure of myth, lives on benefits in a Plaistow bedsit and has several thousand followers on Twitter. It's the beginning of our new age. We're only in the foothills of decay.

This is evidently a book which is to be dipped into like, say, the fondant, near-liquid Gorgonzola which is currently fashionable in southern France and which produces gaudy nightmares.

The collection covers thirty years.

My opinions, tastes, preoccupations, enthusiasms remain constant.

My opinions, tastes, etc., are modified by time, age, circumstance.

Introduction

My opinions contradict their precursors and belong to a different writer.

While it would be beguiling to appoint oneself part of that knowing cadre which lacks conviction, I lack the conviction to do so; I am not confident that sitting on the fence till it hurts is the right position to adopt even though it suggests a sanity which is an inoculation against extremism. I am inured to my inconsistency and to my need to check what my position is on countless matters to which I am entirely indifferent, which I simply don't care about. Till I change my mind.

But . . . it's when you witness and pity those who cling to conviction, faith, ideology – the tiny shrill minority capable of belief (in anything) – that you thank yourself that you are fortunate not to be prey to these perverse balms. That you were born without the credulity gene. Conviction is a euphemism for bigotry, intolerance, mono-directional certainty.

Marseille, July 2020

Trailer

He is cold, heartless, perverse, worldly, dandiacal, reactionary. He eschews transcendence in favour of the material. His craft was by his own admission plundered from Raphael, but if you didn't know that you'd think he had conceived of himself as an impious Van der Weyden. (p. 34)

Eight times winner of the Ringburner Masters, six times Victor of Vindaloo. He spoke the universal language of biriani. (p. 198–9)

His first prosecution for pimping was at the age of eighteen. His business colleagues included Tony 'L'Anguille' Cossu (Tony the Eel) and Joseph 'Le Toréador' Lomini. (p. 56)

Christ's body is the most commonly eaten meal in the world. (p. 202)

Salisbury's population is about 40,000. Yet it has two branches of Clintons Cards about 150 metres distant from each other. (p. 209)

Maggie Davies and I translated one of his poems, about the Annunciation. In our version Mary exercises her right to choose and aborts the son of god. If only Muhammad's mother had done the same. (p. 57)

Santa, no doubt a resting actor, breathed his fumous liquid lunch over me, aged three. I cried, and ran from his sordid grotto and began plotting my life's work as the Liberator of Reindeer. (p. 215)

Baron Rogers of Riverside comes on so wood-fired, so extra-virgin, so biodynamic, so ethically sourced and cloudily unfiltered that he might be an obscure Umbrian goatherd's dish served at Lady Rogers' River Café. (p. 830–1)

In the early nineties, Heaven's Pasture advertised its pork sausages with a dancing pig singing outside a cottage:

> It's no small wonder we is cryin',
> We can smell that Mum am fryin'.
> We got reason to be grizzlin',
> Our late Dad's in there a-sizzlin'. (p. 205)

Like Don Quixote or Sherlock Holmes or Jay Gatsby or Humbert Humbert or Leopold Bloom or Mr Pickwick, god is a fictional invention who has transcended the work in which he appears and who has achieved an autonomous, independent existence. God is real, all right. (p. 233)

'A man can have sex with sheep and camels. However he must kill the animal after he has had his orgasm. He must not sell the meat to the people of his village. A neighbouring village is OK though . . . A man can have sexual pleasure with a child as young as a baby. If the man penetrates and damages a child he must then be responsible for her subsistence all her life.' (p. 238–9)

'I think it is beautiful for the poor to accept their lot.' (p. 239)

Trailer

The chef Anthony Bourdain writes of the chef Thomas Keller: 'You haven't seen how he handles fish, gently laying it down on the board and caressing it, approaching it warily, respectfully, as if communicating with an old friend.' The old friend, should we not have noticed, is dead. Are we to suppose that Keller is a medium? Or is he a necrophiliac fish-fiddler, a Jimmy Savile of the deep? (p. 241)

I pity believers. I pity them as I pity those who suffer any disease. But I am also dismayed by their refusal to acknowledge that they are ill. (p. 243)

Christianity becomes delicious when we accept that all its best bits are founded in delirium occasioned by the ingestion of hallucinogenic mushrooms. (p. 331)

On 24 April 1976, the recently appointed UK foreign secretary Anthony Crosland, who died too young, took the American secretary of state Henry Kissinger, who exhibits disturbing intimations of immortality, to Blundell Park to watch a Division Three match between Grimsby Town and Gillingham: the home team won 2–1. (p. 868)

The South Holland and the Deepings MP 'Sir' John 'Pierrepoint' Hayes is eager to do his bit. Dashing in his executioner's hood, this noose fundamentalist will come down from the flatlands once a month with his collection of axes, gibbets and guillotines along with his personal *Einsatzgruppen*. This is true populism. (p. 251–2)

Were the canons composed of works in Good Taste there would be no place for Ballard, Beethoven, Borowczyk, Bron, Buñuel, Burgess, Burra, Burroughs. (p. 253)

Once a week, a bespoke cast of gladiatorial yobgods and wag-roasting Croesus kids descend in tattooed Lamborghinis from their Parnassian blingsteads to run around for ninety minutes of bravura vanity. (p. 306)

He lives alone in a house of grime. All lino and stalactites of cooking grease. Then, she comes into his life. She's a dish – curvy, glamorous, willing. And she loves housework, just loves it. (p. 298)

Magritte was a social realist rather than a surrealist – his work was a representation of quotidian Belgium. (p. 371)

And if the north, like the south, is more than a point of the compass, where is it? Where does it start? Maybe the English north begins where the sense of humour changes. That's to say, on the other side of what might be called the Irony Curtain. (p. 529)

Real slang is base poetry. Nothing glitters like the gutter. The coinages of football terraces, crack dens, stoops, cottages, barracks and bars are vital. (p. 446)

Where is the man from the grassy knoll now that he is really needed? (p. 722)

I

Art and Artists

Light fantastic

Artists' Houses in London 1764–1914 by Giles Walkley

The only thing Giles Walkley appears not to know is the name Rob, the forename of the architect van 't Hoff who designed Augustus John's studio in Mallord Street, an insipidly revivalist piece of work which hardly hints at its author's connection with the expressionistic Amsterdam school of de Klerk, Kramer, etc. John's studio was built in 1914. This was apt. The last studio of the great studio boom was, fittingly, made for the last great bohemian. Of course John did build another studio, at Fryern Court near Fordingbridge, to Kit Nicholson's design, in 1938; and in 1968 Georgie Wolton anticipated the 'heroic' modernist revival of the last few years with a tour de force in Lower Holloway called Cliff Road Studios (Naum Gabo was among the first residents); and in 1986 Piers Gough did a studio for Lincoln Seligman in a west London garden . . .

But these were freakish avatars. Studios belong predominantly to the period 1870–1914, a period which treated living artists with a generosity that is unique in this country. It was, equally, a period when two remarkable generations of British architects were at work. The coincidence of ambitious patrons and consummate

9

artists produced a gamut of buildings that is without peer. It hardly matters that many of those patrons were hack daubers and that the difference in quality between their work and that of the architects they commissioned is chasmic. They did commission them. It might be argued that, say, Luke Fildes' finest work is not *Applicants for Admission to a Casual Ward*, but the house that he had Norman Shaw build for him in Melbury Road. And the same goes for scores of painters more justly forgotten than Fildes. Who *was* Joseph Wilson Forster apart from being the man with the nous to charge the young Charles Voysey with doing a house for him just beyond the ragged red edge of Bedford Park? Who remembers Hal Hurst and E. T. Reed, two of the earlier occupants of the most familiar studios in London, those on the A4/Talgarth Road at Baron's Court? But then who remembers Frederick Wheeler, their architect, the man employed by the developer Major General James Gunter of – Walkley's epithet – 'the renowned catering family'?

The modernistic tenets that a building should express its function and that it should reveal its structure are, generally, mutually exclusive. This incompatibility is frequently obviated in studios whose gargantuan glazing abets, perforce, the revelation of structure. The glazing is a badge of these buildings' purpose and, now, a monument to the redundant technology of natural (north) light. These are instantly recognisable buildings which look back to before the separation of home from workplace that was effected by the Industrial Revolution, and which look forward to the multi-use 'spaces' that are supposed to become the norm when we all work from our electronic cottages. Studios were compromises between the domestic and the feather-light industrial.

They were mostly live-in workshops. Though Alfred Gilbert's in Maida Vale was more akin to a live-in factory, a complex of (pre-) Hollywood-Andalusian ranges round a courtyard on a site now occupied by some yobbish point blocks of the late 1960s. This is

among the very few major losses, and is to be felt not merely on account of its scale or the novelty of Howard Ince's design, but equally on sentimental grounds: Gilbert is one of the rare artists, as opposed to architects, of the first rank to feature in this book. This is a contention that is, obviously, not evidenced by Eros; but look at his sculpture of Victoria in Winchester Castle: the queen is an engorged animal, a bloated Beggarstaff nightmare possessed of a sullen sinister stateliness. Another loss, of greater architectural moment, but artistically picayune, is that of Lululaund at Bushey. This was the only British work by the Bostonian H. H. Richardson, a Ludovician lump of grandeur designed for Herkomer. All that remains of it now is a doorway, which is the doorway to what must be the grandest of all British Legion clubs.

The majority of studios, however, have survived for reasons that are abundantly clear from Walkley's comprehensive gazetteer section. Just get those postcodes. At the very basest level the author has compiled a work of hardcore tecto-porn, a catalogue of highly desirable properties that will whet the appetite of every Humbert in the land – I refer, of course, to estate agents not paedophiles. Kensington, St John's Wood, Hampstead, Chelsea – where the most cossetted of painters built, so merchants and stockbrokers followed. (One of a group of what Walkley calls 'mass produced' studios off England's Lane is currently for sale for £425K.) The studio is perhaps the exemplar of the loose-fit building, one which has been wrought for a specific end, but which is not so comprehensively determined by that end that it cannot be reused, in a different guise.

Cachet no doubt attaches to ownership of a studio-house – tall windows make you arty as well as cold. Walkley's work is catholic enough to suggest something of the society of artists and architects in the formers' hour of abundance: smoking clubs, the Artists' Rifles, a general heartiness . . . It wasn't all charvering models and pansying about. There are all sorts of fascinating oddity here: the enterprise of

three 'maiden' artists in building a terrace in Yeoman's Row, and the contention that the Hon. John Collier's problem paintings were in some measure autobiographical, and the often-told story about the entire Italian families who made a living from posing as ancient Romans. But all that is tangential. What Walkley has really achieved is an invaluable vade mecum, an off-centre slice of architectural history and a covert love letter to central suburban London. (1988)

Of blood and condoms

Modern Nature: The Journals of Derek Jarman

Derek Jarman is protean. There are countless Jarmen: the bricoleur of films, the ad hoc gardener, the autobiographer, the homosexual proselytiser, the airhead, the 'fine writer', the stoic, the trolling queen, the self-consciously English man, the aesthete. And so on.

He reveals himself in these journals as a series of oxymorons. He lurches from camp orthodoxy to imaginative originality, from quasi-adolescent 'rebel' to art-historical panjandrum. One moment he's a coarse poet of KY and penile might, the next he's making Worsthornian jibes about twenty-two-year-old sociologists. Being HIV-positive prompts an appetite for life and a curiosity which not everybody automatically shares. It renders him a stoic of necessity.

The great plague is his milieu's analogue of the flak that might have brought down his bomber-pilot father when the son was still toddling. The father escaped; the son bought it. The father appears to have played out his post-war life one bomb short of a load; at the very least he succumbed to the terrifying intemperance that bristly moustaches and high ranks so often foster.

The son is steadily sane, even in his most outré guises; indeed, these journals, which cover 1989 and most of 1990, are dogged by his very normalcy. The heterophobic ghetto mentality that accompanies it is normal. His films are normal arty avant-garde stuff, in

that they espouse easy outrage and an excess of manner and fail to function independently of their author.

What is not normal is Jarman, and what makes him fascinating is his openness. In his language there is no word for secret. The way he lays himself bare is rash or shameless or brave, according to taste. He exhibits his soul's sores with innocent menace. He has no compunction about showing himself in a disagreeable light; he evidently doesn't care what anyone thinks.

He is a naïf, with a capacity for finding everything in his cosmos interesting. This might be thought delightful, generous and evidence of his (mostly) tolerant mentality. It might also be deprecated as grossly indiscriminate. Obviously, the journal form, if it is to serve any end other than cosmetic self-advertisement, is one that cannot be too tidy. We are probably right to mistrust those who topiarise their lives.

However, Jarman's laundry-list approach to his life is also misleading, albeit unwittingly, because it grants the same weight to the trivial as to the momentous. As a writer, his energy is mitigated by his inability to edit himself; the book's riches are buried beneath bathetic tumuli. When he deigns to write for publication – i.e. when he remembers that he is going to be read – he is lucid and acute, if intermittently inclined to purplish vacuity. His other most frequent mode is that of introspective and inchoate musing; and for someone for whom candour is a duty he is here weirdly uncommunicative, addressing himself and, perhaps, a group of friends who may be expected to understand his reticent allusions. These friends are rarely anything more than mere names: they are Jarman's present. It is the past, the fleeting and the inanimate which he illumines with artistry. Distance and otherness are the conditions that he requires in subjects if he is to invest them with any sort of life.

His accounts of casual sexual acquaintances, his homoerotic reveries, his paeans to work clothes (he is especially keen on leather aprons) are written with a lubricious enthusiasm which is not

currently permitted to heterosexuals; he does not see this. He is the legatee of a tradition of opprobrious persecution by spiteful laws and mean prejudice, and thus can hardly be blamed for tilting at demolished windmills or ascribing his failure to secure mainstream commissions to his homosexuality. That hasn't been an impediment to other film directors – but then they have not, perhaps, shared Jarman's taste for professional gayness.

It seems much more likely that Jarman has remained in the ghetto of his own making because of his uncompromising nature and his peculiarity as an artist – which is dissociable from his sexuality. Jarman's gifts, in prose as in film, are spatial, visual, imagistic. The desire to know *what happens next* is one that he ignores. Paintings, collages of blood and condoms, gardens, descriptions of place, snapshots from childhood – these do not depend on that force. Jarman's flair for topo-graphical evocation and the nuances of the weather is beguiling. He writes excellently about London in the early sixties, and Romney Marsh now. His depictions of his bizarre garden in Dungeness (which, like its maker, survives against the odds) are not perhaps as remarkable as the garden itself, a folly of found objects and hardy plants.

With the exception of his father, his people are sketchy: eccentric aunts, a full *galère* of stereotypical schoolmasters and boys, boys, boys – an entire daisy chain. Tynan's 'love that dare not speak its name and cannot because its mouth is full' is hopelessly out of date. Jarman speaks as he eats. (1991)

The sea, the sea
The Edge of All the Land: Richard Eurich 1903–1992 and its exhibition catalogue with an introduction by Nicholas Usherwood

In the late 1940s Evelyn Waugh bought a pair of (perhaps unwittingly) comical and certainly didactic story paintings by Thomas Musgrave Joy. They are entitled *The Pleasures of Travel, 1750* and *The Pleasures of*

Travel, 1850. The first showed a coach and its passengers being robbed by a stagey highwayman, all tricorn and handkerchief mask. The other, by way of contrast, showed a train compartment full of what British Rail now calls customers sitting safely and smugly and no doubt congratulating themselves on having being born in the steam age. Progress has been made. Waugh commissioned a companion piece to this diptych, *The Pleasures of Travel, 1950*, which represented the tumbling, screaming, mortally fearful human cargo of an airliner that was falling from the sky. The painter was Richard Eurich; and the combination of date, name, hyperbolically detailed style and gruesome humour made me think, when I saw it reproduced in a magazine article at the time of Christopher Sykes's 1974 biography of Waugh, that the painter was most likely a devotee of the Neue Sachlichkeit, an émigré who had perhaps been declared 'decadent': there were evident affinities with Franz Radziwill and Georg Scholz, and with a host of others whose proscription had caused them to be largely forgotten long after the Twelve-Year Reich had been erased.

I was wrong. Richard Eurich was born in 1903 in Bradford, where his father had been brought from Germany by *his* father as a child. I was wrong to search for any mention of him in a revelatory 1972 issue of *L'Oeil* which had opened my eyes to the Neue Sachlichkeit; I should rather have looked in the Southampton telephone directory and read Eurich R., Appletreewick, Dibden Purlieu. I was wrong. And yet . . . Here was a painter who seemed quite forgotten. The 'magic realists' in Germany suffered not only from Nazi persecution but, after the war, from the totalitarian oppression of abstraction's propagandists. Kindred painters in Britain, Holland and Belgium merely suffered the latter. *Kunstführer* in London, Amsterdam and Brussels have taken years to wake up to the hard-edged hallucinatory realism of painters such as Willink, Ket, Hillier, Wadsworth, Frampton and Eurich, painters who are indolently deprecated as 'minor' because they paid no oblations to

the god of splodges and 'marks', painters whose work rarely makes it out of the vaults. These are northern painters, and they are thus disadvantaged in a century which has made a fetish of the south, of the sun, of tomato culture. Sure, simulacra of these fruits are grown, hydroponically, in Holland. But forget that: think, rather, of Norman Douglas and of Cyril Connolly and D. H. Lawrence and of the assumption that the Mediterranean spawn is unquestionably superior to that of Flanders or the Black Country: think of Douglas's topological snobbishness and his coyly couched paganism and his assertion that life only really begins at a latitude south of which apples won't grow but tomatoes and olives will. This is parochialism by another name. It's not of course necessary to be acquainted with Douglas's work to be apprised of its effect: his epigoni have done the work for him – Elizabeth David, Peter Mayle and their like. For every southern writer or painter who has made England his subject there are a hundred who have gone the other way, sheepishly.

Richard Eurich mostly painted the sea: the Channel, the Solent, Spithead, the Portland Roads, Southampton Water. Does this render him 'provincial'? It does not: no one accuses Marquez of provincialism for writing about a small town in Colombia. If, though, you're English and you paint your immediate environs – no matter how guilefully – you're reckoned to be parish pump. Eurich resisted the lure of easy exoticism and created a world in his own back yard. He is never quaint, never a Little Englander. He invented a tradition of his own. He was rarely literal. In his unpublished (and perhaps unpublishable – too literal by half, too much Tonks) autobiography he writes well about what he was later to paint so well, the might and weight of water perceived from Chesil Bank, the nightmarish pebble beach that stretches from Portland to Abbotsbury. Aqueous threat is something he rendered with real power.

In *Robing Figures on a Rainy Beach* eight people in various states of undress – naked, sou'westered, umbrella'd, wrapped around with

pullovers – appear not to see the oil tanker that looms over them, above them, like some sort of floating shark. Nor do they attend to the quoit of fortress on the horizon – this is one of those that the Francophobic Palmerston had built in Spithead in the 1850s. The sea and the sky are shades of slate. There is a witting lack of depth to the painting and, despite the emphatic horizon, a more emphatic verticality pervades, as though the suppression of perspective is just around the corner. Which it was: an ever more distinct flatness informs a painting called *The Gathering of the Waters* of the next year, 1970. Here a male nude is falling over the top of a wave where a female nude rushes to help him; the wave is a fence or wall. The figures are lumpy, clumsy, gauche and quite done down by the sea's potency. Not much later are two works in a vein of tentative surrealism. *Figure and Planes* shows a big-bottomed female nude on a rocky beach staring at two aircraft; it is formal and it evinces the wonder that humankind must first have felt when it saw the sky populated by things other than birds: it makes the (now) quotidian seem miraculous, again. Another painting of 1977, *The Burning Tree*, is of parkland, cattle, deer, broken boughs with antler-like branches and a diseased trunk on fire: it's more Tristan Hillier than it is Magritte, but it's all Eurich.

Dibden Purlieu was, when Eurich moved there, a village between the perambulation (i.e. boundary) of the New Forest and Southampton Water. Since then it has become part of the sylvan quasi-suburbia that has grown up around the power station at Marchwood and the oil refinery at Fawley where freeform pyrotechnics are a norm. Nicholas Usherwood's exemplary catalogue refers to Fawley (which is a great free show). He doesn't point out that the tree stumps in the same painting which resemble almost clasped hands, stumps of hands, very likely derive from the ranked and attrited groynes on the Solent shore near Needs Ore.

Eurich may have been a generation and a half older than me, but we share the same scapes. My earliest memories, extra-pram, are of

silver flying boats at Hythe, a mile or so from Dibden Purlieu. And in so many of the paintings he made there is some item of England's deep south that is so familiar yet so odd that I feel the proper dorsal shiver. Of course, it may be that nostalgia (in its original sense of longing for a lost home) occludes or at least contaminates a purely aesthetic appreciation of Richard Eurich – but, really, what have pure aesthetics got to do with painting, or with any other art. Eurich painted to briefs – from Waugh, as I said, from the War Artists' Advisory Committee, from Edward Montagu. His nocturnes of Southampton and of Portsmouth during the Blitz are certainly paintings of record, but they go way beyond illustration, far beyond, on into the monumental. Eurich painted epic scenes: in *The Great Convoy to North Africa* he achieves what a Neue Sachlichkeit painter might have done in the service of necessary belligerence: there's propaganda and then there's propaganda. (1994)

Excess baggage
Francis Bacon: Anatomy of an Enigma by Michael Peppiatt and *Bacon: Portraits and Self-Portraits* with an essay by France Borel

Michael Peppiatt's is the third biography of Bacon to have been published in the four and a half years since he died in Madrid, an atheist wittingly in the care of nuns. This circumstance hardly amounts to a request for extreme unction but does, nonetheless, suggest a softening of his antagonism towards the delusory system whose creed he scorned but whose paramount image was at the very core of his art. It was also, with farcical aptness, present in his early posthumous existence: Francis Bacon was buried with no ceremony in an off-the-peg coffin with a lid bearing a metal representation of Christ crucified. Peppiatt makes nothing of that; whatever else he has learned from his prodigiously perverse subject, he has quite ignored the compulsion to connect and conflate.

What he has picked up, however, is the elderly Bacon's insouciant tendency to repeat himself over and over. Peppiatt is actually quite astute about the way he turned himself into a one-trick pony, how in the later years his studio was adorned with reproductions of his greatest works, how he cannibalised them as he had once fed on Velázquez and Muybridge and photos of Hitler. The germ of this reductionist programme is there from the start, from the 1933 *Crucifixion* which was followed by a protracted hiatus and eventually by *Three Studies for Figures at the Base of a Crucifixion* in 1944. This was the triptych from hell, which was vulgarly assumed to be 'saying something' about man's inhumanity to man, the horrors of the age and so on, but which increasingly appears in retrospect to say nothing at all; its job is not to talk, but to be.

Bacon loathed illustration, a mode which is dependent on an already defined world, and which obviously has a pre-resolved end in sight: it obviates discovery and chance. He was equally dismissive of abstraction, which he considered unexceptionably to be mere pattern-making. Peppiatt records the life – theft, screwing for money, lurches between the lower depths and high bohemia, lipstick and gambling, search for a father figure – as though there is some deterministic link between it and the painting. He does not heed the epigraph by Harold Rosenberg which he places at the start of an early chapter: 'An artist is a person who has invented an artist.' Bacon's canon is autonomous.

He is not, in this regard, comparable to such contemporary bottom feeders as Genet, Burroughs or Kerouac, whose work is propped up on the dodgy armature of their 'legends' and on an audience's appreciative knowledge of the shooting, the shooting up, the slopping out, the swilling. Bacon's self-exposure was more oblique, more English: he enjoyed secrecy, compartmentalising his life. He was by no means alone in suffering a nostalgia for an era when homosexual congress was against the law. It is, of course, fascinating to read of anyone with such a commitment to excess. It

is no doubt salutary to learn the details of the macerative pro-
gramme he devised for his liver and synapses. But the gift remains
unexplained and so, to an extent, does the man.

Bacon: Portraits and Self-Portraits is mostly pictures with little text:
Milan Kundera's introduction is elegant and tends to take the artist at
his own estimate. France Borel's essay, 'The Face Flayed', is dizzy,
delirious and aspirantly synergetic. It hopes to convey the paintings
and to provide an exegesis of them through rhetoric, hyperbole, tru-
ism, verbless sentences and meditative screams. It is of course an exer-
cise in pure futility, and the writer knows it. The portraits which
precede them are no more susceptible to such frenzied euphemism
than they are to Peppiatt's dogged plod. Freud (Sigmund, whose later
relationship with Bacon is skipped over by Peppiatt) is famously
flawed because he attempted to depict dreams in the rational prose of
diurnal description. Bacon's celebrants and critics are similarly flawed.
What happens on those canvases is extra-verbal. (1996)

Losers
Victorian Fairy Painting at the Royal Academy of Arts

It is no doubt hurtful to say so, but fairies are a bunch of losers. Of all
the myth systems that humankind has invented for itself, faerie is the
most risible, most derided, most incredible. Believe in god and you're
deemed fit to run a country. Believe in fairies and you're deemed fit
for an asylum – a supporter of a team that plays in the Doc Martens
League of credulous irrationality, the Premiership being composed of
Roman Catholicism, Islam, Judaism, etc. (Anglicanism is a sort
of Southampton, locked in a perennial battle against relegation.)
Darwinism's brutal truths are as applicable to spiritual cordials as they
are to animals or humans – and faerie lacks the fitness to survive. God,
in his many guises, is quite different: potent, perpetually reinvented,
miraculously polymorphous, slyly protean. He has occasioned great

architecture, great writing, great art. Fairies have occasioned minor art, genre painting, canvases whose begetters collude in ascribing to fairies pretty much invariable properties – wings, flight, cuteness.

We have favoured god by being fazed by the awesomeness of our invention and by rarely daring to represent it literally. But fairies, poor things, have suffered immeasurably because we know what they look like. Our familiarity with their kit strips them of mystery. It does not, however, mitigate their iffy appeal or indeed the barmy notion that they enjoy an existence independent of human fantasy.

Victorian Britain possessed an apparently bottomless appetite for manifestations of the paranormal: the most powerful industrial and mercantile country in the world sought escape from its brute materialism and its faith in progress through ghosts, ectoplasm, spiritualism and suchlike. The theistic certainties had been undermined by Darwin, but the need for the unknowable remained. After sex, shelter, food and intoxication comes the elemental human instinct for the creation of planned superstition. But of all the dodgy disciplines and earnest enthusiasms which had such a hold on our forebears the only one which occasioned a school of paintings was fairies: there are no phrenological painters, no extra-sensory painters. That is because those pseudo-sciences are impervious, like god, to the illustrative obligations which characterise Victorian painting – they would have required a new art, a new aesthetic. Fairies, on the other hand, were just another subject in an age when subject was paramount.

Even painters usually defined by their routine subject matter would now and then have a stab at exercises in coy pornography with gauzy wings: Sir Edwin Landseer painted *Titania and Bottom* (*c.*1848–51), the latter's head done with the zoological verisimilitude which informs his canvases of 'real' cattle. Then there is John Atkinson Grimshaw, forgeries of whose rainy dockside nocturnes were keenly made during his lifetime: it is improbable that any faker aped his wood-nymph *Iris* (1886). Bereft of his masts and

cobbles glistening in the light thrown by gin halls, he is reduced to a journeyman trespassing on territory that belongs, properly, to a group of specialists of whom the mad patricide Richard Dadd is the best known but by no means the most prolific.

Dadd's peers included Noel Paton, John 'Fairy' Fitzgerald and Richard Doyle, whose son, Arthur Conan Doyle, was famously too eager to believe in the reality of his father's fictions. Much of the work of these painters is studiously saccharine and conventionally escapist; it is perhaps the most extreme manifestation of the Victorian urge to invent an Arcadian past.

But there were exceptions to this rule of retrospective idealisation. While no Victorian painters went so far as to emulate the late-eighteenth-century painter Henry Fuseli (who had eaten raw pork chops to prompt the nightmares that he would subsequently paint), the use of opiates and other psychotropics such as atropine and *Amanita muscaria* was commonplace. Who ingested what is a matter of speculation, but there can be no question that there is a strain of fairy painting which combines the apocalyptic cruelty of Hieronymus Bosch and of Albi cathedral with the trippy internal logic of the psychedelia it anticipated by more than a century. Far from taking the soft option after the *Sensation* exhibition, the Royal Academy seems likely to be in hot water all over again with this paean to the synapse-twisting properties of hallucinogens. I hope that the exhibitions secretary has laid plans for a swift flit into exile. (1997)

North-east

We see the land, the ocean, the elision of land and ocean, the weather moving and morphing ponderously. We hear the nor'easter's minatory screech. We feel its sting on our knuckles and cheeks. We smell the land, the ocean, the sweet airborne effluent. We taste it, too, and the salinity in the air, and the ozone. This landscape, this skyscape, this

buffeting, these septum-grazing spurts, these distant white horses which may be sand whipped up by the wind, all this emptiness which is yet so full, all this featurelessness which is constellated with incident . . .

Our faculties record without mediation, and they impinge on each other's domain so that the totality of this northern coast is a sum received in unequal and indistinct sensory proportions. What is sure is that our senses' primacy is licensed by it all, just as ratiocination is put on hold. This is a place for feeling, not for thinking. A place which, despite everything, still retains a sufficient *tache* of wilderness to invite awed submission, to excite the noble savage within.

And here lies the problem, my problem – though it's not mine alone. The noble savage within, if he were ever there, has shrivelled and died, starved by a sheer bereavement of the stimuli that such a creature thrives on. Sensibilities, as opposed to primal sensory experience, have to be learned: the noble savage, the embodiment of the true romantic sensibility, has to be self-created or educated – literally led out. He doesn't exist by chance. He is a construct, the product of a time, of a place, of northern Europe two centuries ago.

The circumstances congenial to his recreation barely exist on this continent today, and of all the countries of this continent Britain is the least propitious. It offers the fewest opportunities for awe, the fewest experiences that may be infected by sublimity. It is that lack which has quashed the romantic sensibility. We don't possess the equipment to learn it. It is something we may glimpse in ourselves when we are elsewhere: I walked one summer afternoon on Rügen for about four miles through beechwoods so dense that it might have been dusk, a place so primally scary that the knots in branches turned into faces and a childhood terror of fairy tales, cottages in woods, stooped and cackling crones returned. And then, with massive relief, I was at the clifftop where Caspar David Friedrich had painted, and all was light and blinding Baltic refulgence and I realised I had just

traversed an exemplary topography of German romanticism (and of its subsequent perversion). I had passed through it, and it had moved me severally . . .

But this was Germany, this was elsewhere, this was other, this was alien, this was exotic. I was free from the aesthetic programme that Britishness had, unbidden, devised for me. Britishness, in this instance, signifying the lack of domestic opportunity to experience the sublime or, at least, grandeur and the consequent conviction that it is something which belongs, properly, to cultures other than our own – like wine and loden coats and spices and deadly reptiles.

But those we can import, we do import: these islands are the warehouse of a nation-fence long since turned legit. We cannot, however, import midnight sun, Iguazu Falls, desert, icescapes, truly mountainous mountains, moraines, skies as blue as a butcher's apron, skies as red as the blood which stains that apron.

Because we cannot, we have invented a substitute appropriate to our scale-model environs. The picturesque, the predominant British mode for the last quarter of the last millennium (and one which, in its current debasement, shows no sign of abating) is not – despite its bents to twee-ness and fancy and whimsy and ingratiating cuteness and all-too-human scale – a caprice. It is a necessity born of the realisation that we inhabit a topographical Lilliput, a land of close horizons and of such abundant minor mutations that even monotony is seldom available.

It is, incidentally, worth observing that while the picturesque self-evidently derives from the painted fictional landscapes of Salvator Rosa, Claude and so on, the impetus to affect a great leap and create fictional landscapes – model landscapes – out of real earth, real rocks, real trees, real ruins, coincided not merely with British acquaintance with those painters but with the British reali-sation that nature's provisions in these islands fell far short of those of France and Italy. The picturesque was, if you like, the Grand Tourists' ingenious and self-conscious compensation for an

ineradicable inadequacy. It was a defensive response to the omni-presence of the miniature; it was custom-made for the miniature. It fitted just so, like a second skin. It seemed somehow natural. Like folk songs or traditions or the idea of clothes.

We forget that they, too, were made up, that they are the result of a creative impulse (no matter how base). Perhaps it's the case that the baser the impulse the sooner the fact that artifice was in any way involved will be forgotten, the sooner willed invention will be unquestioningly accepted as the inevitable, as that which is taken for granted. So did the picturesque become a British norm: both as a system of design and as a way of looking.

To cast ourselves free from it requires as determined an effort as was required to invent it, as determined an effort as it takes to learn a new language – perhaps more determined, for while we know very well that we speak in English we don't address the fact that we equally see in English.

Not all Britain is susceptible to being seen in English. Not all Britain has been subsumed by the picturesque. The exceptions: Glasgow's quasi-Baltic skyline, Portland, Blaenau Festiniog, the environs of St Austell, the Fens, Wastwater, the north-eastern coast.

There are others, but they are few – and they don't include the rest of the Lakes or the rest of Snowdonia, or the Highlands, whose wilderness and grandeur is never quite wild enough, quite grand enough to discourage the notion that they are, at base, pretty and scenic and unthreatening and the stuff of tourist posters. And such places, once discovered – or invented – by the romantic imagination were tamed by the idiom of humankind's architectural interven-tion: nineteenth-century humankind exhibited in the bargeboarded villas of Windermere or the lavishly baronial auld alliance castles of Pitlochry, the earliest strains of a deference to nature, a deference which was and which remains a paradox in that its refusal to impose upon nature created a bogus unity between structure and landscape.

Landscape was turned into a setting, a backdrop, it was co-opted, forced into an alliance. 'It fits in beautifully . . .' What a depressing construction, and what a familiar one.

That construction, that condition, is the cynosure wherever English is seen. Respect for the inanimate, which is demonstrated, for instance, by building out of local materials, is a form of anthropomorphism, of the pathetic fallacy, of blood and soil. It is sentimental rather than sentient. It is a denial of humankind's primacy. The picturesque affects to acknowledge nature's superiority while tampering with it. It is an artifice which, like literary naturalism, denies its own artifice.

It apparently suits a national temperament which abhors cleverness and reveres modesty, perhaps has much to be modest about, and is self-deludingly capable of finding modesty where none existed: what, precisely, is modest about such exemplars of quotidian normalcy as Shakespeare, Turner, Sterne, Lutyens, Waugh, Wells? Men of the people? Ordinary folk? Bollocks. They might have been born thus – but they reinvented themselves through work and poses.

None was less ordinary than the grossly immodest John Vanbrugh, whose devotion to the north-east bordered on the obsessional. This was a man who knew wilderness when he saw it. Wilderness brought out a quality in him that the comparative gentleness of Yorkshire (Castle Howard), Oxfordshire (Blenheim), Dorset (Eastbury) never did. Sure, his work was becoming ever more brutal, ever more sinister, ever more pared down – but it was this coast, this bleakness, this sky which made Seaton Delaval. I mean, made him make it. I mean, too, made it in the sense that it sits like a malevolent object, like a temple to some forgotten, abominable cult in a malevolent and abominable landscape. The preposterous irony is that it is literally picturesque. If ever there were tectonic proof of Eliot's dictum here it is: this great artist stole – from Claude. Here is a house which duplicates the Enchanted Castle. Yet its picturesque character stops there, with that literality, with its source. It is the very contrary

of pretty. It could be said to be the *fons et origo* of the picturesque movement. In which case its example was betrayed by saccharine.

But what if the picturesque had developed differently, what if it had not been hijacked by ghastly good taste and the demon of easy-looking accessibility? What if it had not become the analogue of lift music, a cliché, wallpaper? What if it were still empowered?

Seaton Delaval is, clearly, as far from a vernacular building as you get, but it strikes me as having had a singular effect on north-eastern building, on, if you like, a parochial sensibility. Drip-down, example from above. Well, something must have occasioned the north-east's architectural micro-culture. As I say, things don't just happen, they have first to be created. Then are they responded to, down the years, serially, severally, over and again. Tradition begins as invention, turns into custom, practice, habit. Then it gets amended, replaced by tradition B, which becomes the tradition, till that too is taken over by tradition C. But none goes away. They exist in a parallel spatial unity which is also temporal mayhem. But one tradition will always own a primacy, an aptness to place. The north-east's tradition is the anti-English one of imposition.

The forms favoured by the picturesque have been employed here: Norman Shaw's Cragside fits in, might have been there for ever – but had William Armstrong not been such a slut to fashion he might have commissioned (from whom at that moment is a question) something merely indicative of his deathly trade, might have been more honest about it. Armstrong is like John Fowler, the designer of the Forth Bridge, an engineer who wanted to be a gent and thus had to live in a gent's house, i.e. a house which entirely denied the principles of his engineering.

From Newcastle down to Middlesbrough, it is all engineering – should be all engineering . . .

In 1989 I conducted a friend who had grown up in Leeds on what he still, to this day, calls an 'industrial safari': the transporter bridge,

the oil refinery, the rust-coloured streams into the sea. For six or more hours we drove and played Blondie and ELO, famously over-produced bands – very obviously creations, very obviously depen-dencies. Now and again, we got out of the car on a forlorn beach, beside a power station, in mid-nowhere – and there's that smell.

I can hazard a guess at why Eric Bainbridge has done what he has done in Hartlepool. He may have understood what should be made without thinking about why it should be made. He may take every-thing I've written as a given. I'd hope that he has no more idea about what he forges than I know what I write. Yes, it can be worked out after the event – but by none of the critical programmes I've suggested. I'd suggest, on the contrary, that because he is north-eastern, he'll always make north-eastern art – a particularity which is exemplified by what he does: that's north-eastern art.

The overwhelming characteristic of Bainbridge's work – on a roundabout, beside a roundabout, up a grassy knoll, underneath a toy-town rail bridge – is that it's a summation of what's fitting in this un-English part of Britain. And what's fitting is, evidently, that which doesn't fit in. Heaven and earth links Vanbrugh with Fylingdales, the fortified church at Edlingham with coal measures, Peterlee with Monck, curtailed terraces in fields with the kilns at Lemington, the Penshaw folly with Newcastle's bridges – it indeed suggests a line of predecessors, it creates a tradition, it provokes the notion of links between these prior sites of a harsh, orthogonal geometry, sites created in contempt of ornament, it enables us to see a particular land anew.

Heaven and earth is disobliging. Unlike the wretched member for Sedgefield, it does not ask to be liked. It does not beg to be pho-tographed – it doesn't grin. It is stern. It is so obviously fabricated. It is so obviously the plastic outcome of deliberation: it didn't just happen, it doesn't pretend to have just happened. There is nothing casual about it, nothing relaxed. There is a tension in the metal which goes further, which prompts a visual tension, a lack of ease,

an acknowledgement of humankind's inability to reach an accommodation with the earth – we either suck up to it (the picturesque) or, better, we dump on it (the north-eastern way). The north-eastern way has truth on its side. It doesn't euphemise. It doesn't partake in that most English of habits, sweeping under the carpet aka self-deception. Bainbridge is entirely out of step with his time.

No work of art has or should have any point other than to be. No artist should work other than to make this or that work, to get it out of himself. Anything beyond that is a sort of excrescence, an add-on, a useless limb from another aeon. Nonetheless, it's impossible to survey this piece of centripetal sculpture-as-engineering and not impute a didactic intent, admittedly a didactic intent which is written into every factory, every chemical plant, every bridge and quay . . . But they are material purpose first, sculptural second. They fulfil functions, they go beyond their shape, they make, they provide jobs.

What Bainbridge's work asks, asks me anyway, is why should the sheer magnificence of this coast and the sheer magnificence of humankind's imposition upon it be endlessly mitigated by cosy complicity with the forces of sweetness? It's not the loss of land that executive estates cause that matters. It is the insipidity, the mediocrity, the curtailment of civic momentum, the aesthetic nullity, the ur-Englishness. Beyond that, Bainbridge reminds us that we owe a duty to ourselves to use our guile in beneficent exploitation of this earth. (2001)

Look, don't touch

Ought Lady Churchill to be exhumed in order to be put on trial for destroying a portrait of her husband which was not her property but Parliament's? And should she be found guilty, how will the length of her sentence be determined? Will the 'sincerity' of her conviction that she was acting to preserve the Greatest Briton's reputation be taken into account?

Judge Bathurst-Norman was, after all, much exercised by the 'sincerity' of Paul Kelleher, who believed that he was making the world a safer place for his son by decapitating a statue of Baroness Thatcher. As a mere barrack-room brief, I'd suggest that sincerity has no place in a court of law. Indeed, it's difficult to know where this property does have a place. 'I sincerely believe' is a hopelessly discredited formulation. Hitler sincerely believed that 'we shall regain our health only by eliminating the Jew'. Himmler sincerely believed that a child conceived on the grave of a German war hero would be infected with the martial qualities of that hero.

Suppose that I go into the National Gallery with my trusty Laguiole hunting knife and slash Titian's *The Virgin and Child*. Will my sincerely held belief that the exposure of the child's genitalia is an incitement to paedophilia be considered in mitigation and per-suade the judge that, like Mr Kelleher, I should get no more than three months? I do hope so.

It's certainly preferable to my term in chokey being gauged according to the Kelleher Tariff, which links length of sentence to the artist's reputation and the work's value. The sculptor Neil Simmons evidently belongs to the Seen You Coming school of figuration: his Lady Thatcher is, supposedly, worth £150,000. So: one month for every £50,000. Given that a major Titian would now fetch circa £10 million, I'll be going down for two centuries. On reflection, I sincerely believe that my knife will stay on my desk.

But what of Lady Churchill? Her advanced age, 118, and her unusual state will prompt special pleading. Those considerations, combined with Graham Sutherland's reputation, should see her out within thirteen weeks if she behaves herself. Graham who?

In my early teens I was taken to visit the newly consecrated Coventry cathedral. For my father and uncle, non-observant Midlanders, this was a secular pilgrimage. And a popular pilgrim-age: there was a queue the length of the building. The place's

magnetism was firstly due to its being the supreme, if tardy, symbol of post-war reconstruction: Jacob Epstein's bronze *St Michael and Lucifer*, suspended from the red sandstone wall beside the entrance, is the most blatant allegory of the triumph of good over evil, of the Allies over the Axis.

Its secondary appeal was that this was an instance of cathedral as art gallery. This is the appeal it retains today: it is an exemplary museum of mid-twentieth-century compromised taste, of modernism with a small, discreetly serifed m. Basil Spence was both architect and curator. He essayed the latter role with notable humility.

He designed a space in which artists could create what were not yet called 'site-specific installations'. The gaudiest, most eye-catching is Graham Sutherland's vast tapestry of Christ which was the third, and biggest, draw. It was woven in Felletin, a ten-minute drive from Aubusson, the tapestry capital of France. Hence the un-Britishness of the background's colour, like fresh moss. This intense green is part of the French chromatic register. But it misrepresents Graham Sutherland. Graham who?

It's no exaggeration to state that he was the most famous painter in Britain in the late fifties and early sixties. This year is the centenary of Sutherland's birth. I did a poll. My eldest daughter, Holly, who was born in 1981, the year after Sutherland died, had never heard of him. I spouted a list of names of artists and writers who were more or less his contemporaries. It became evident that posthumous reputation is in part reliant on parental taste. Thus, she knows the work of obscure painters of the Neue Sachlichkeit, Faulkner, of Hemingway but not Durrell, Edward Burra but not his nearish neighbour John Bratby, Piaf but not Trenet, Le Corbusier but not Mies.

By the same process I was infected by my parents' taste for, say, Britten's folk arrangements and Geoffrey Household. But one's personal pantheon exists in defiance of reputation – which is collective and consensual. It is public not private. Yet it is not, mercifully, in

the gift of the media despite the strenuous efforts of telly and news-papers to apply 'news values' to areas of endeavour which are not really susceptible to such treatment.

Sutherland owned a house at Menton designed by Eileen Gray. She has been loudly 'rediscovered' every decade since the early 1970s, but her shade obstinately refuses to stick around and retreats into obscurity despite the trumpets. The truly effective transmitters of reputation are word of mouth, received ideas and fashion. Beside these immeasurables, the media are doggedly impotent.

In his lifetime Edward Burra, two years younger than Sutherland, was deemed a 'minor' painter. It is not just my daughter who is entirely familiar with his oeuvre. He has been lifted from obscurity into the mainstream. No doubt he was, like Pound's Hugh Selwyn Mauberley, 'out of key with his time', and no doubt his time has come. The past is fluid, it is constantly rewritten. How will 2053 remember us? The only certainty is that it will not be at our own estimate. The 'place in history' that the celebrated and the powerful crave is sumptuously furnished. The one they actually get often turns out to be a slum. (2003)

Germany's loss

The milieu of private galleries and, more especially, public exhibitions is notoriously in thrall to collectors' crazes, the whims of impresarios, curatorial legerdemain. Indeed, the entire trade might have adopted Albert Pierrepoint's motto: 'It's all in the hang.'

Exhibitions have become exercises in mediation. It is no longer the primary works which are of moment but the ostentatious 'interpretations' sutured on to them, whether through apparently random juxtapositions with the disparate creations of another age or through presentations which ignore chronology in favour of desperately conjured themes. It is clear that the janitors have promoted themselves to

speak for their charges as though they mistrust the 'lay' public's ability to read past or present. Maybe that mistrust is well-founded, maybe the public craves such 'accessibility', maybe it wants to be told what to see and think: the rise in admissions to major museums can be taken as justification of this now institutionalised orthodoxy.

This apparatus of 'relevance' might have been borrowed from the classical theatre's attempts to renew itself with cosmetic anachronism: Hamlet in lounge suits, Hamlet in Napoleonic costume, Hamlet in bear skins, Hamlet in woad, etc. These temporal gimmicks are unlikely to alter our perception of Shakespeare, who is, anyway, a poet to be read rather than a dramatist to be witnessed in performance as the object of directorial hubris. Similarly, the collective perception of painters' achievements remains, in the long run, unimpaired by didacticism-lite and efforts to bring them up to date. The history of art may be rewritten from one generation to the next, but it is not rewritten that much.

Popular, if not scholarly, primacy is still granted to the Italian Renaissance, to Impressionism, to the southern experiments of the early twentieth century, to Picasso's countless mutations. Perhaps this resentful yearning for the side of the valley where the grass is parched and where vines grow is the very essence of Britishness. It leads us to undervalue the achievements of this country: witness the defensive triumphalism which has greeted the revelation that this season's *succès d'estime* in Paris has been Constable through Lucian Freud's eyes. Paris! If Parisians love it, that's validation enough. The fact that Paris is a city whose current art is moribund – all exhausted *trompe l'oeil* surrealism or, worse, local colour daubs by the unwitting inheritors of Russell Flint – is overlooked.

We also undervalue or wilfully ignore the broader north: the culture of schnapps and herrings, of Baltic chill and terrifying forests, of crowstep gables and piercing detail. No doubt two world wars have caused us to relegate the greatest modern German art to the status of

'minor' or, at least, to consider it a tributary which was overwhelmed by the mainstreams of the south and, later, of America. But even before then, it had been suppressed by Nazi bombast. The enforced migration of those architects who had flourished during the Weimar Republic famously changed the way the world looked. The painting of those years, on the other hand, led nowhere.

But, as two admirably straightforward exhibitions in Paris show, the fact that Max Beckmann and Christian Schad spawned no notable artistic progeny does not mean that in the eyes of anyone other than art historians their work was not of the highest order: it might have occupied a cul-de-sac, but that was some street, even if it's hardly marked on the map.

Schad has never been granted a retrospective in this country: nothing surprising there, for he is all too easily dismissed as 'a mere illustrator'. He is cold, heartless, perverse, worldly, dandiacal, reactionary. He eschews transcendence in favour of the material. His craft was by his own admission plundered from Raphael, but if you didn't know that you'd think he had conceived of himself as an impious Van der Weyden. His comparatively small mature *oeuvre* constitutes a bejewelled freak show. Whether it represents the supposed decay of the Weimar years is moot, for during much of that time he was outside Germany pursuing his exemplary northernness in climes whose warmth failed to contaminate his sensibility. However, it certainly creates our conception of that decay – which, by the immane standards of what succeeded, was no decay at all. As the result of an extraordinary fluke or a gross oversight, Schad was not proclaimed a Decadent Artist but his career effectively ended with the birth of tyranny.

Beckmann is a safer bet for a major London exhibition. His broad brushstrokes lend him an honorary southernness, even if his most harrowing subjects link him to the tradition of Bosch. And he possesses the selling point of having been officially Decadent, a word which in this context may be taken to mean prescient. With hindsight

— a quality it is fruitless to deny — a potent strain of German art was the creation of a nightmare which it was left to a failed artist to turn into fact. There is something to say for the south after all. (2003)

Hall of mirrors

The coarse irony is that to achieve decadence we have to work. In a state of actual decay, we are incapable of making anything. We rot, rant, slobber, jabber, ignore time, forget place.

Decadence is a posture created by those whose defining quality is vitality.

Martin Fuller isn't rotting. He is far from jabbering. His limpidity of thought is unimpaired, his lucidity — an important word here — remains horribly astute. He stays 20/20. Yet . . . there is a sensibility here in these paintings which depends if not on psychotropic intervention then on dream or the madness of love. A bit of all three, I guess. And a will touched by irreason and contrarily by the conviction that the material quotidian stuff of his life is sensational, but that sensation without reflection, meditation and mediation is sheerly artless. It's easy to make an inventory of the things he doesn't do: answers; explanations; hopes; straightforward coupling; anyone else's take on the world.

He is selfish in the most literal way. He paints himself. But with such tangential deflection that he recalls Alain Robbe-Grillet's declaration that 'I've never written about anything other than myself.' Fuller, no less than that Breton mythologist, takes the self to be a site of mutating memories, distorted pasts and an insistent, slippery present. He raises the question of tense, a question that is seldom raised in painting.

Fuller does not paint in the preterite. There is nothing entirely finite here, the past is not historic — it is forever to be confronted and remade. It is easier to wallow in the sump of abstractionist

futurism, the most facile of escapes. He makes us realise that retro-spection and prospection are lies, that as soon as you make a mark (or write a line) you are creating a fiction. A fiction that Fuller has to rupture. But rupturing something doesn't make it go away. It's still there: the fragments of annihilation remain like the fragments of memory which we've smoothed to our own content.

The present is merely an invitation to the past, a moment when we accede to what was, and what will be. Fuller's self-appointed job is to capture this or that moment of his life. The several tenses collide. Painting is a spatial endeavour. Fuller renders it otherwise, his work is infected with a signal temporality. A drink, say, incites the memory of all previous drinks, a high heel that of every such heel ever swooned over. This is not a matter of representing material archetypes. It is, rather, to recognise that the deliberately straitened gamut of subjects that he eternally returns to are mnemonic catalysts, obsessions echoing obsessions. Every painting he makes has a painting behind it, or the ghosts of many paintings, provisional paintings. The layers add up. We begin to discern a resolution: we glimpse stories without an end, we half-hear songs cut off before their climax, we gape at mirrors that may retain the image of the faces that have preened in them.

Ghosts? Magic looking glasses contaminated by properties that they cannot possess? This is a painter of evanescent inventions who bends the laws of the actual (an always approximate conceit). There is an element of the trickster at play here. And of a man delineating his brainscape, granting himself primacy over the world, making his world, which struggles to defy nature yet, contrarily, hymns the strangeness of the ocular. It is apt that his ears should be full of nineteenth-century opera and the seething luxuriance of grandiose, lush, symphonic romanticism. These forms are only obliquely rep-resentational. They do not tell the truth. They create truths.

Naturalism cannot do this, all it can do is soothe us with the balm of the familiar, show us what we know, invite us to 'identify' with

the comfy world of alienation, flatter us with our heartfelt 'concern' for the downtrodden. Fuller's eschewal of naturalism admits him and, subsequently, the spectator to a multiplicity of milieux which are neither literal nor immediately comprehensible. They do not reveal his own attitude or a moral – let alone a moralistic – take on what he has found sluicing around his backbrain. Fuller is no more didactic than the composers he adores. Yet, unlike music, painting – unless it is mere pattern-making – cannot avoid being about something more than the exhumation of memory and oneiric plunder.

Memories and dreams have subjects. We do not simply dream: we dream of. Fuller digs for the partially occluded through a dogged, convoluted process of line, colour and translucence. He appears determined not to grant himself knowledge of what he is going to find: if a painter has a finished canvas in mind, he is an illustrator. Fuller's work is composed of an aggregate of non-consecutive marks which are generated by each other, which respond to each other. The paintings are created as he goes along. They are made, so to speak, without a blueprint. Yet they are not 'spontaneous'. For their spontaneity is tempered by the rehearsal provided by the practice of his art over most of his life; that is, by the balance of the unconscious with a gamut of formal devices and inescapable preoccupations.

The preoccupations are mostly urban, nocturnal, sensual – and morbid. The pursuit of pleasure is attended by risks. That, however, is no reason to forgo it. At night the decor of *guignol* asserts itself. Pans and satyrs come out to play. Ancient rites are reprised. Spectres grimace in the shadows. Diurnal safety is dissipated. Death gambols. Humans reveal themselves as animals, as elemental participants pushing at the limits of abandon. They see through each other in their orgiastic licence and libidinous candour.

Fuller returns time and again to frames within frames, glass boxes which render their inhabitants exhibits, and to a sort of *baldacchino* which is also a key-light. It is both holy (or blasphemous) and

operatic. The ambiguity may be harrowing but it is coloured by a vaudevillian humour. So, too, is what begins as a draught of wine, mutates into a barium tonic and emerges as menstrual blood.

This is painting of energetic contrariness. It denies admission to any part of the man who makes it save the artist with X-ray eyes, with a taste for display and concealment, with the history of the hothouse contained within him. If there is an approach to straightforward auto-biography here, it is only to be found in a couple of atypical canvases representing domestic abundance in the forms of racked wine and a large oven at work, pleasures of a different kind, which cannot but remind us that the home is a dangerous place. (2006)

Pidgin post

A four-part X-ray of my right knee; Luther by Cranach; the *Princes in the Tower* by Hippolyte Delaroche; Tourcoing's *pompier* hôtel de ville; the Hotel de Mansour, Casablanca by night, 1962; Port-Saint-Louis-du-Rhône's docks at about the same date; a plastic 3D version of Millet's *Angelus*; the same painter's *Spring* – a rainbow, light after a storm, the edge of an orchard; two bronze bulls at Lascaux; containers and pylon by Emma Matthews; the casino at Royan; an eerie Tristram Hillier-esque painting of two 1950s houses on dunes – the designer, and maybe the painter, was Allert Warners; Illinois commuters by Dan Weiner; Gottfried Böhm's Mariendom at Neviges; a group of dwarves in Ruritanian uniform saluting; Saint-Michel, Brussels, illuminated; Saint-Pierre, Caen, illuminated; the singer Barbara; the singer Michel Sardou; Artaud looking moody (what else?); *Vrouwen in de straat* by Pyke Koch; the volcanic prodigy Le Puy-en-Velay; a Wehrmacht observation tower on Guernsey by Peter Mackertich; a street of sub-urban villas in Agrigento; le quai des Belges in Marseille; Mother Russia at Volgograd; self-portrait by Meijer de Haan; self-portrait by Carel Willink; self-portrait by Maxwell Armfield; self-portrait

by Dick Ket; self-portrait by Christian Schad; the *Count St Genois d'Anneaucourt* by Christian Schad; *Agosta the pigeon-chested man and Rasha the black dove* by Christian Schad . . .

These are a few of the subjects of the postcards that hang in my apartment in neat, cleverly designed, flexible, double-sided, transparent kit suspended from the ceilings. Such postcard-holders (wallets?) are cheap. Which is appropriate, for postcards, too, are cheap. I own those and many other Schads, further Willinks, Beckmanns, Nussbaums, van der Weydens, Friedrichs, countless Netherlandish hellfires, a cornucopia of skulls and vanitases, depositions and annunciations.

The reproduction of great paintings is merely one of the uses to which a postcard can be put. But it is an important one. It is not so much populist as popularising; there is a difference. The dissemination of such work in a version approximately 150 mm by 100 mm (6 in. by 4 in.) is supremely democratic. I happily suffer a delusion of ownership without the attendant insurance costs and security concerns. The chief purpose of an original has for several centuries been the provision of images to be copied with increasing degrees of verisimilitude. The ectype's importance has long eclipsed the archetype's. The original, in any medium which is susceptible to reproduction, is an object to be traded by its maker or its maker's dealer, to be coveted by its maker's patrons, public and private. It should not concern us if the avaricious, drawn by the bogus allure of the handmade, lock away what are the analogues of first editions, nor should it concern us if acrylic paintings detrite to the point where they are irrecoverable. They are preserved for ever in reproduction. In monographs, catalogues and, especially, as postcards with which we may construct our personal museums of sumptuous humility.

I have thousands of postcards but seldom send one, seldom receive one either. Few, indeed, have any personal association. Here's one of the newly built Highbury Avenue School in Salisbury where my

mother taught during the war; here's one that she sent me from Lourdes which ends with the words 'pity them' ('them' being the desperate and the gullible, the crippled Catholics sold a pup by their faith). Those are exceptions. Postcards are for collecting and scrutinising and delving into the lives of others. As bearers of greetings, brief messages, thanks and dutiful holiday clichés they are ancient technology: pre-telephone, let alone mobile phone, SMS, anti-social networking, Twitter and so on. Yet they persist in a way that, say, public telephones do not. They began to transcend their function, their supposed function, a century ago: 750 million cards were sent annually during the decade before the First World War. Since then the volume has been constantly diminishing. Nonetheless, over 100 million were posted in the UK last year: Brighton and Scarborough were the most popular postmarks, followed by Bournemouth, Blackpool and Skegness. Those towns make it easy to guess, presumptuously, at both the images and the ritual flurry of exclamation marks verso: doubly hackneyed. But that doesn't matter. They are mute, unselfconscious social-historical documents, bland emblems of the everyday whose value will not be recognised for years hence.

Martin Parr's *Boring Postcards* (that adjective is a porkie the size of an elephant) and David Liaudet's *Architectures de Cartes Postales* gather the work of unknown photographers who recorded the spread of motorways, caravan parks, new towns, hyperbolic paraboloid roofs and churches in the round. They did so artlessly, improbably realising that half a century later they would provide not merely glimpses into the freshly built world of Macmillan, Wilson and *les Trentes Glorieuses* but a powerfully oblique portrait of a long-disappeared age of optimism. *The Postcard Century* is even more ambitious. Postcards have multiple roles and Tom Phillips's wonderful vast book shows the lot. Fine art transformed to kitsch, propaganda, gorblimey bawdy, sentimentality, advertisements, sublimity, technological oddities,

self-mutilation . . . it is rich, chaotic, insensate – like the twentieth century itself. The fragments of messages exacerbate the confusion.

Rather than the disparate work of the cards' artists and photographers, or my raggedly incoherent collection, it was the example of these publications and their concentration which prompted me to consider publishing my own photographs at postcard size in book form. From there it was a short step (or moron's stagger) to resolving to go the whole hog and publish a hundred of them as sendable, stampable, frankable 'real' postcards with a line down the middle, apparently a 'rile' in postcard lex (etymology unknown), and a top right quadrangle showing where to affix the stamp, a 'neeb', after Dieter Neeb the Fulda publisher who invented that device. (Till 1915 the majority of the world's cards, in whatever language, were produced in Germany.)

They are presented – handsomely presented – in a boxette (not quite a neologism). Some of them bear captions which would improbably be found on 'real' postcards. But then they aren't 'real' – they merely pretend to be. They're bogus as a nine-bob note.

The name *Pidgin Snaps* is a programme in itself: it implies, or is intended to imply, a deliberate impurity, a gauged mongrelism, a collision of idioms and styles. It is also inversely snobbish, as though I am defensively dismissive and don't really care. If only! The *fons et origo* of this project was the combination of a new camera and a more than usually grubby motor. I took both into a car wash. The multicoloured roller brushes buffeted and swooshed. Without thinking about it I aimed the camera at the sudsy windscreen. Bingo! Abstract expressionism the easy way, for tyros: no making 'marks', no inhalation of noxious fumes, no splattering clothes. The randomness was thrilling, and liberating. Here was the antithesis of pondering an adjective, of conducting an internal debate about a colon, of searching for a simile for a complexion, of agonising over whether this or that synecdoche comes off, of trying to figure whether a

phrase is one's own invention or is recalled from a distant external source. I suddenly felt myself strangely drawn to car washes. And to nocturnal rainstorms, especially in areas of gaudy neon and plentiful brake lights. Soon I was devising set-ups which although purpose-made left room for aleatory incident. Plastic bags filled with coloured liquids provide the raw material for scenes of apocalyptic mayhem. I submit drawings, scrawls, daubs to what the Polish-French painter Ladislas Kijno called *froissage* – essentially scrunching up the paper or aluminium foil so that it is as wrinkled as Auden's balls. Then there were found objects: rusty doors, nacreous petrol puddles, flint, scrolls of bark, grimy frosted glass. Photograph them, edit them – the eschewal of artifice (saturation, desaturation, tone changes, contrast, brightness) smacks of the very purity I wish to avoid. Admittedly the use of such devices chases out randomness. But practising what I preached to myself would be altogether too perfect. This process, or school of one, is called Liddism. A painting I did of Calvary (a sort of abattoir) was deemed so unpleasant that it was banished to a terrace where it began to oxidise. A friend who almost stepped on it looked at it with a certain distaste and asked: 'Is it the lid of something . . .' She made it clear that whatever that something was she did not want to come into contact with it.

Many of the subjects of the naturalistic snaps – there are infinite degrees of naturalism – are determined by places I have filmed or have recce'd for films and have not shot. I rarely use a photograph as an aide-memoire. It is rather the act of making the photograph that lends a site or scene mnemonic glue. This process is akin to taking notes which once written are seldom referred to. There is, then, a Scottish bias, a French bias, an Essex bias. There is not a person bias. The world of *Pidgin Snaps*, like the world of my films, is largely devoid of people. But people's interventions – shacks, cars, chimneys, roads, pylons, silos, landfill sites – are omnipresent. Nowhere is the poorer for humankind's amendments. Unmitigated nature is

absent: 'beautiful views' and 'unspoiled landscapes' and 'pretty spots' are clichés to feed the aesthetic prejudices of the unthinking.

While it would be ludicrous to claim that these cards have a didactic purpose, they do manifest qualities which are beyond prettiness, perhaps even contrary to it. They celebrate the overlooked – which comes in myriad guises and owes that status to its not having, so to speak, been framed, not having been photographed or painted or otherwise brought to our attention. There is much that we have not been taught to notice.

'Everyone has a book inside them.'

'And that, precisely, is where it should stay.'

The book in question was probably a never-to-be-written novel or memoir. And sure, *Pidgin Snaps* isn't a book. But everyone is now a photographer, sort of. The democratising effects of digitalisation have blurred the line for photographers who are not qualified by 'sort of'. I'm acutely conscious that I am trespassing into other people's territory. I'm equally conscious of the mix of pity and ennui which the writing of people who can't write provokes. (2013)

The curatocracy

Venice may lack Stralsund's skyline, Bavaria's baroque, Edinburgh's drama, Laon's site, but as a purveyor of lairy souvenirs it outdoes even Lourdes. Not merely in *bondieuserie* but in masks whose routine grotesquery renders them affectless, in plastic vaporetti, oo-scale Play-Doh palazzi, glass gewgaws – gondolas, more gondolas, squids, conches, pussy-dolls in ruffs, jabots and fuck-me boots. If we accept Gore Vidal's definition, then this lagoonal kitsch is craft because it is always the same: craft is susceptible to industrial methods.

The scores of shops and booths that peddle it are manned by graduates in hard-sell whose market-barker schtick does not need to include descriptions for their goods are evidently self-explanatory.

They are open the year round. For almost half that time they coexist with a different sort of operation: the galleries, ateliers, showrooms and studios of the Biennale. And with them an ever-burgeoning cadre of soft-sell operatives, who compose the hieratic order of the curatocracy. There is no work of approximate art or workshopped event that cannot be curated, just as there is no foodstuff that cannot be sourced. At a recent 'ideas festival' I was enjoined to participate in a curated walk round a small town. I resisted temptation, sourced a packet of crisps in a vending machine and ate them on a platform at Ipswich station.

When, over a century ago, G. B. Shaw accused them of being 'conspiracies against the laity', the professions were the law, the Church and medicine. Whatever their practitioners claimed, all other endeavours were still trades. Not that it really matters, for once a trade develops its own mores, patois, rites, sartorial code and forms of indenture it pretends to the characteristics of those original learned professions − exclusive, impregnable, self-important, impasted with bogus tradition, in love with its own pinchbeck arcana and gimcrack mysteries. It can safely be said that the curating malarkey has achieved all this and more.

Curators were, till a generation or so ago, urbane historians of the Renaissance or donnish scholars of the Beaker people. The dusty smell of muniments rooms hung about them. Today they are − well, what are they? Achingly hip neophiliacs who have mastered the peculiar illiteracy that comes from having been the willing victims of critical theory, cultural studies and art history, which, as we all know, begins with Duchamp − and ends with him too. Where once museums and galleries were repositories of what already existed, they have mutated into stores of stuff commissioned by their amply funded curators who impose their *pensée unique* upon a public too timid to protest that this is a load of balls/*valseuses*/C.O. Jones. That taste is of course avant-garde, the thoroughly conventionalised, institutionalised art of the establishment.

Curators have moved from the passive to the active. From being receptive to what is actually made to being controlling. From accepting random expressions of individual creativity which belong to no 'school' to proposing taxonomies and ordering up 'site-specific' works: where creation ends and curation begins is moot. The spectre of 'collaboration' looms. And so too does that of the century-old modernism and the anti-establishment posturing which is de rigueur throughout the establishment. This consensual frivolity is of course taken seriously; there can be no more damning proof than the risibly self-important language which the curatocracy employs to explain installations so mute they are meaningless. It is, laughably, called 'art writing': 'on the one hand cultural productions are symptomatic of these relations, while on the other analytic of them – having the potential of intervention and critique, again with a specific placement and angle, or, if you will, method of intervention and mode of address'.

No. Me neither. Curator shall speak unto curator. (2015)

Fake it till you make it

The Art of Forgery: The Minds, Motives and Methods of the Master Forgers by Noah Charney

Louis the Decorator and his chums in the antiques trade use the word airport adjectivally and disparagingly. It signifies industrially produced folkloric objects (prayer mats, knobkerries, masks, *toupins*, necklaces, tribal amulets, djellabas, etc.) which are typically sold by hawkers to departing holidaymakers.

This is the basest level of fakery and is ignored by the otherwise doggedly catholic Noah Charney. Its defining characteristic, however, is tellingly akin to that of the multi-million-dollar scams that fascinate him in *The Art of Forgery*. The duped party is often not all that duped. He is, rather, mutely complicit with the swindler and has faith – that is to say a belief born in witting self-delusion and undemanding of proof

– that the chattel is what it is claimed to be. Those swindlers who happen also to be makers meanwhile harbour a yearning to assert their authorship but can only do so by confessing to it or being detected.

Both parties are thus capable of causing the apparatus to collapse. Both strive to keep it standing. They are conjoined in mutual dependence. The oenologist Serena Sutcliffe believes that most collectors of rare wines 'would rather not know' about fakes, even though there are more bogus bottles from certain estates in certain vintages than there are genuine ones. But then to collectors the prestige of possessing an object trumps appreciation of it. Especially when appreciation may cost £50K per corked glass or carry the risk of pranging, say, a Facel Vega whose price has multiplied fifteenfold since the millennium but whose roadholding hasn't.

The trade in big-name wines and marques of car is straightforward beside that of the foetid can of worms where painting, prints and *objets de vertu* writhe in wrapped accord with the market, with fashion, with fluctuating reputation and with the caprices of the court of provenance, which is composed of vying panjandrums, venal 'experts', committees of backstabbers, committees of placemen, trustees, consultants, museum wallahs and gallery johnnies. A senior London operative in this last trade, idly characterised as a 'superstar', was recently described to me by a sculptor: 'Knows everyone, sees nothing – no eye whatsoever.'

But you do not need an eye when provenance is all; provenance demands no eye. Provenance is obviously not established by looking, but by written evidence, by *catalogues raisonnés*, by dealers' records and so on, all of them as pervious to forgery as the works to which they are attached. And for all their arrogance the investigators of provenance are often hopelessly flat-footed sleuths. One of the faked items supporting the art dealer Gianfranco Becchina's claim that the *kouros* (memorial statue) he was selling to the Getty Museum was genuine was a letter from a Hellenicist written in 1952

from a postcode that did not exist until twenty years later. The purchase went ahead. Again, the same institution's trustees, fearful for its reputation, silenced its curator of Old Master drawings after he drew attention to what he recognised as six forgeries of Raphael by the English virtuoso Eric Hebborn.

In a book which abounds in breathtaking shows of arrogance, some of the more despicable concern the authentication of works by such diverse artists as Leonardo, Basquiat and Warhol. The almighty Joseph Duveen, a man for whom the handle 'compromised' is woefully insufficient, asserted that the version of Leonardo's *La Belle Ferronière* owned by a provincial American soldier, Harry Hahn, was a fake. He was probably correct; but he reached this conclusion on nothing other than the evidence of a monochrome photograph. He had not seen the actual painting.

Charney makes the unexceptionable observation that social class also played a role, that a common soldier ought not to dare to aspire to connoisseurship. It was Duveen and his risibly corrupt tame 'expert' Bernard Berenson who established the squalid mores which, a century on, still pertain throughout the global art bazaar. Conflict of interest remains the tawdry norm rather than the scandalous exception. Multiple hats are routinely worn. And the boast that art is somehow intertwined with charity and philanthropy and the common wealth persists as an unchallenged *idée reçue*.

The questionable pleasure to be had from Charney's energetic trawl through scores of cases is that of seeing the clayfooted guardians of the *kunsthaus* being bettered by the little guy, the selfproclaimed reject. Hebborn, van Meegeren, Elmyr de Hory and Shaun Greenhalgh are only a few of those who bore attritional grudges against the admittedly vacuous and laughably pretentious art establishment and sought an arcane revenge in deception for deception's sake. Pride rather than pecuniary gain seems to be the most common motive. An exception was the novelist Clifford

Irving, who, having written *Fake!*, a biography of Elmyr de Hory, became so enthused by the money that might be gained from forgery that he wrote the 'autobiography' of Howard Hughes, whom he had never met. He was obliged to repay three-quarters of a million dollars to McGraw Hill, was sent down, wrote the confessional *Hoax!* about the affair and, now a fully fledged conman, became a role-supermodel for the young Malcolm McLaren. (2015)

Born yesterday
Artrage by Elizabeth Fullerton

Thames and Hudson is no longer a publisher much associated with writing. You do not expect its books on art and applied art to be wrought with the brio and elegance of Susie Harries or Rosemary Hill, Crook or Summerson. Which is, perhaps, just as well because Elizabeth Fullerton's text is catastrophically clumsy. According to the author note she graduated from Oxford with a degree in modern languages: one must assume that English was not among them. She can just about parse a sentence but beyond that, nothing – save a perennially tin ear, a relentless tide of clichés (sea change, game changer, elitist hierarchy of the fusty art world, national treasure, iconic, hotbed of radicalism, zeitgeisty, alienated modern lives), yesterday's tired neologisms, a hundredweight of received ideas, unwitting mock heroism, ludicrously hyperbolic claims, a willingness to take some really rather stupid people at both their own elevated estimate and at that of the self-congratulatory collective of (once) Young British Artists or 'artists'. These people did everything mob-handed. They were forever 'supporting' each other with cultish zeal. They conned in numbers. They graduated from Goldsmiths, where they seem to have been brainwashed by Michael Craig-Martin and Richard Wentworth.

We are told that Angus Fairhurst was a 'towering intellect', but are

not vouchsafed any example of the heights he is supposed to have attained. Liam Gillick is described as 'the group intellectual', which seems to mean little more than that the poor fellow is fluent in International Art English, the witless jargon which is the staple of such borderline literate magazines as *frieze*, *ARTnews*, *Art Monthly*, etc. Exclusion awaits those in the art world who do not write or converse in this clumsy sociolect (as they would have it) which is as far from slang as can be. Art English lacks all poetry. It is merely a prosy expression of self-importance, self-validation and a means of self-aggrandisement akin to that employed by corporate middle management with its eye on the rung above. One of Gillick's priceless contributions here is that 'We didn't sit around talking about El Greco . . . It's as if we started without any history.' And a 'gallerist' called Sadie Coles claims that before the 1988 *Freeze* exhibition the London art world was 'a very discreet gentleman's club'. The sometime Serpentine Gallery director Julia Peyton-Jones, created a dame for laundering the emperor's new clothes and promoting rampant gimmickry, concurs: 'It was a desert.' Fullerton chips in with 'parochial'.

Where have these people been? They may not have been born but they can surely discover the names of the galleries which flourished in, say, the 1960s: Annely Juda, Kasmin, Redfern, Robert Fraser, Gimpel Fils, Crane Kalman. Or do they suppose that Blake, Caulfield, Jones, Hamilton, Hockney, Hoyland, etc. sold their work from camper vans beside the Bayswater Road railings? Every generation deludes itself to some degree that it is starting from zero, but this one abjured all checks, succumbed to no doubts. It went above and beyond in its ahistoric arrogance and boundless incuriosity. It crassly believed that the 'commodification' of art, to which it would in time of course subscribe, was something new. They might have tried walking around Melbury Road at the western end of Kensington High Street or Tite Street or Hampstead, where their Victorian precursors advertised their wealth in bricks and grand north-facing windows.

It is due to her problems with English that Fullerton writes this sentence: 'Many (YBAs) considered art before 1945 as artefact.' Why 1945? What does 'artefact' mean in this context? I suspect it is Art English, broadly synonymous with redundant or 'irrelevant'. The more boneheaded YBAs' mantra might be 'We don't need no educashun'. This contempt for learning and for the past may or may not have something to do with 'a sense in Britain of the twentieth century as a cultural failure, reflected in the sparse representation of the period in the Tate's national collection'. Who is it that senses this? Is the 'cultural failure' Britain's alone or more widespread? The USSR's perhaps. Or France's. Does culture signify exclusively visual art? The multiple imprecisions are tiresome.

As for the Tate: the problem lies with Nicholas Serota's sure-footed leap on to any passing bandwagon and his curatocracy's sycophantic bias towards mute installation, conceptual vacuity and grovelling shrines to the bogus prophet and teenagers' pin-up Marcel Duchamp. All this folderol is at the expense of rather better artists: Nevinson, Burra, Spencer, Lewis. Surefooted, yes – but also tardy. The juggernaut has almost passed by the time the great museums of state catch on. The recently appointed director of the Tate Modern, one Frances Morris, has the gall to say that 'We don't any longer have a hierarchy where painting is at the top.' Thereby consigning centuries of endeavour to the bin. What daring! How groovy! But consigning it rather late in the day. Such drivel was in the air forty years ago at the time of Carl André's dimwitted *Equivalent VIII* and Mary Kelly's slightly more interesting *Post-Partum Document*.

To those who inhabit Morris's hermetic bubble it's doubtless a welcome statement of the bleeding obvious, an article of faith. To the majority outside the fluidly incestuous carousel of 'gallerists', 'critics' (PRs in all but name), 'artists', collectors, patrons and group-ies, her frivolous pronouncement sounds like clerical treason, a care-less abnegation of responsibility and a philistine boast. *Artrage* comes

plastered with endorsements from members of the art establishment who would, of course, never dream of considering themselves the establishment. These people are evidently *parti pris*. They are blessed with an embarrassingly excitable and near-infantile turn of phrase. The mildest reaction of any sentient person who lacks some sort of stake in the bubble is that of wincing contempt at the anaesthetised juvenilia of the now middle-aged. The two worlds do not overlap.

Just as Art Began in 1988 so, in the next decade, did it become 'more mainstream'. Fullerton's frail evidence for this is the number of provincial galleries built with National Lottery funding: the Baltic beside the Tyne, the New Gallery in Walsall, the Turner in Margate, the Jerwood in Hastings, the Lowry on Salford Quays, First Site at Colchester. They tend to architectural extravagance. There is not even enough third-rate art to fill them – which is just as well since the last thing egomaniacal architects are interested in are displays which might compromise the integrity of their masterpieces. These lumps of tectonic bling are accompanied by unprovable, laughably mendacious claims of art's ability to effect 'regeneration'.

The Lowry actually provides a valuable social service in the way that McDonald's does: it is a well-heated, comfortable drop-in centre for the aged. Essex folklore holds that most of the visitors who pass through First Site's doors do so only to use the toilets. This, too, is a commendable service, but whether it signifies what the author intends by mainstream is moot. She further cites the Frieze Art Fair (homophone, not Freeze) as a manifestation of this chimerical mainstream tendency. But by the time that market began as an annual event in 2003 the YBAs were already a withered force and its star turns were mostly ascetic European installation operatives and earnest American conceptualists.

Three decades on, we are almost as far distant from the original *Freeze* exhibition of 1988 as it was distant from *This Is Tomorrow* at the Whitechapel in 1956 when pop art made its debut and Richard

Hamilton's *Just what is it that makes today's homes so different, so appealing?*, intended as ephemeral (but they all say that), entered the canon overnight. The YBAs' debt to such disparate artists as Hamilton, Bridget Riley, Stuart Brisley and Philip King is immeasurable. Without them they would not have existed. Such is the continuum of influence or theft that much YBA work has increasingly come to look like BritPop Mark 2. A broken continuum – it omits, inter alia, Patrick Caulfield, Duggie Fields and Tony Cragg – all too polished, and Kitaj, Mclean and Blake – all too intense. Intensity and polish do not accord with the deafening detachment (endlessly, wrongly, tiresomely referred to as irony) which was just about the only common characteristic of the stylistically several idioms and media the YBAs worked in. They are for ever condemned by their paucity of reference, and by the Goldsmiths conception of history, which is so straitened that it is damaging. Has any student of that college ever been enjoined to read beyond Guy Debord and the Situationists, Adorno, the Frankfurt School's critical theory and saint Walter Benjamin? These are not useful foundations for making any art other than art about art.

Far from attaining the mainstream, the foot soldiers of the group disappeared into dank rivulets and up winterbournes where the only other people were YBAs. YBA talks to YBA. They conducted lengthy, prolix conversations with each other but had necessarily forgotten them by the morning. The lucky world could have listened in. YBAs controversially lurch about the Dungeness shore. YBAs controversially fall down in the Groucho. YBAs controversially fuck in doorways. YBAs controversially neck bottles of vodka in Whitstable. YBAs ham-fistedly video YBAs controversially throwing up. But the lucky world had moved on.

Meanwhile the officer class, the big names, stayed in view and pursued an utterly conventional career path from ragged rebel starving to death in a bedsit to a civil partnership with Croesus. Some enjoyed a glorious ascension. Damien Hirst, with the assistance of armies of

accountants, tax consultants, studio assistants, fabricators and the sin-
gular taxidermist Emily Mayer, had become the richest artist (or art
impresario) in the world. So he claims, anyway. The 'gallerist' Jay
Jopling is fabulously wealthy. But his fortune is his former client
Hirst's spare change, which must be galling. Tracey Emin is such a
friend of fully accredited major celebrities that she is now a fully
accredited major celebrity in her own right. Mark Wallinger thinks
of himself as the heir to Stubbs even though the astute consider him
the heir to Munnings. Marcus Harvey and the Chapman Brothers are
still box office even if they are losing their power to shock.

But Glenn Brown is having to struggle to distinguish between
'appropriation' and plagiarism. Charles Saatchi's enthusiasm for the
artists he had helped create and whom he had supported has dimin-
ished. As his artists deserted him, Karsten Schubert's gallery went
for a burton, half a million pounds in debt: he became an agent.
And Angus Fairhurst hanged himself near Rannoch Moor. He had
failed in the endeavour most vital to a YBA. His work was neither
the visual assault that Hirst prescribed, nor was it a morally dodgy
jape. He forgot to be controversial. Further, he wasn't much of a
self-publicist. (2016)

The art of relooking

On *Ape Forgets Medication: Treyfs and Artknacks*: an exhibition
by Jonathan Meades

Process, means, method: it was these rather than the results which
initially fascinated me. There was an unmistakable exhilaration in
discovering that I was not merely learning a new language but that I
was creating a language peculiar to myself. Given that it was non-
verbal the word language is inappropriate. In every instance the words,
the capricious titles I have appended to the works (the treyfs and art-
knacks), came after. *Treyf* signifies that which is not kosher. Artknack

is a neologism which suggests arts, a knack or facility, a knickknack or cheap bling, *arnaque* (French for a scam). The titles propose subjects which were not intended, meanings that were not meant.

None of the works are 'about' anything other than themselves and their multiple surfaces. They do not represent anything I have seen, anything I have felt, anything I have imagined. They are not expressive. And yet it is impossible to survey them and not perceive anthropomorphic, zoomorphic, geomorphic forms. The more we seek a void the more we discover multiplicity. 'We': I mean me.

The titles are, as I say, capriciously granted. They are variously cryptic, misleading, allusive. There are homages, jests, puzzles. They are nearly all provisional. The one exception is *Derry Welcomes You*. It is provisional in a different way. It is the only unambiguous piece in the show. A neat idea which I rather chide myself for: too easy, too pat. But there you are, you possess a fondness for your own obloquy. It is a more or less naturalistic image – a selfie wearing a balaclava, against a similarly coloured background, desaturated, touched-up (the lips), re-photographed, reprinted, re-photographed . . .

Babsk 03/09/89: I am sparing in adoration. In the early autumn of 1990, exactly a year later, I was working in Rome on a script (*L'Atlantide*). One evening I was waiting for a taxi with a friend, an Italian cinematographer. I was staring at a wall plastered with layers of torn posters. We were talking football – the 1990 World Cup was only two months back. Who, he asked, is your favourite Italian footballer. Conti, Rossi, Schillaci? All forwards. No, I replied, Gaetano Scirea, the greatest and most nimble of defenders. You know, he said, Scirea is dead. Babsk is the place south-west of Warsaw where he died in a car crash. I still find it hard to look at a palimpsest of posters without recalling this peerless player. The work is the result of multiple collages piled on each other. Typically, I had no idea how it would turn out. Typically, I photographed the first collage, printed it, added further material,

photographed it, printed it again and so on. My methods are primitive. I don't have Photoshop. I fear its predictive interference just as I have long since suppressed spellchecks. Photoshop takes away chance. I crave mistakes, the effects of randomness and of lack of control.

Pignight: The Screenplay: Snoo Wilson was one of the great writers of my generation. He and Dusty Hughes adapted his play *Pignight* as a film. It portrayed or invented a version of rural life which had quite escaped me, which has never left me, which has fed much of my writing. It is the only work by contemporaries whose influence I recognise. Snoo's indignation when the BFI refused to fund it because of its scenes of bestiality was quite something. As he pointed out, carnal relationships with pigs are normal in East Anglia. Every fiction I have written includes a character called Dusty: a sort of fatidic charm. This began, like many pieces, with a painting, gouache on coarse paper. When it looked about right (how that is assessed I have no idea) I placed a further sheet of paper on it and agitated it, then treated the result to a brisk assault with a sponge in the hope of achieving a honeycombed surface of the sort that Max Ernst fetishised. It was subjected to further stramashes. When I looked at it the next day it was Leviathan or some kindred marine monster posing as a particularly minatory combine harvester, a riff on industrialised, non-bucolic countryside.

Cotchford: Final Memory: The writer Phil Griffin tells me that this recalls the toxic Mersey of his youth. It was made with liquids of different densities and properties combining and separating like a vinaigrette, with the sort of polythene sterile syringes are packed in. I doubt that I could replicate the many stages it went through before the aquatic-Gothic thing was done. It was too effete for the Mersey, I thought. Cotchford Farm in Ashdown Forest was once owned by A. A. Milne, who means very little to me. I have no childhood memory of Winnie-the-Pooh and was well into middle age before I learned who Eeyore was. A subsequent owner of the

house was Brian Jones without whom the Stones would have never really been the Stones. He drowned in the pool at the house on 03/07/1969. Who knows what you see when you drown, who knows what it feels like when life leaves you? One of my first essays in television, in 1978, was an attempt to make a film for the tenth anniversary of that death. I met the man who may have murdered the pageboy from hell. He had a well-rehearsed story. I also met a producer whose imagination was so stunted that it might as well have not existed: the first of many such encounters in tellyland.

Adieu, Francis Le Belge: Francis Vanverberghe's surname was unpronounceable by most of the denizens of the Marseille milieu in which he grew up and of which he became a *caïd*. His record was impressive. His first prosecution for pimping was at the age of eighteen. His business colleagues included Tony 'L'Anguille' Cossu (Tony the Eel) and Joseph 'Le Toréador' Lomini. He was a major player in the French Connection. When Marseille became too hot for him, he moved to Paris. He forgot the cardinal role of quarry: vary your tracks. He took to breakfasting every day in L'Artois Club off the Champs-Élysées. Seven bullets, 27/09/2000.

Selbstportrait: The German word is used because the German painter Christian Schad used it for his self-portrait, the greatest self-portrait of the twentieth century. Schad has long obsessed me. I have travelled across Europe to see exhibitions of his work – invariably the same work, for he was far from prolific. If I could paint, I'd paint like him. But I can't, so I am reduced to stealing techniques from a very different but equally beguiling artist, Ladislas Kijno. The technique used here is *froissage*. Take an image on paper, screw it up into a ball, flatten it, photograph it. And repeat till the thing is ready. It's like cooking.

Mary Aborted the Son of God: In my film *Ben Building* on the architecture of the fascist era in Italy, I allude to G. G. Belli, the early-nineteenth-century dialect poet who was the voice of Roman

anti-clericism. Maggie Davies and I translated one of his poems, about the Annunciation. In our version Mary exercises her right to choose and aborts the son of god. If only Muhammad's mother had done the same. (2016)

Loops and circles
Speech given at the Royal Academy of Arts annual dinner

It's a privilege to be invited to give this speech, to stand where the great have stood – not forgetting that the less great have stood here too; and the tiresome, the mendacious, and the frankly preposterous.

A privilege, but also a seductive danger. Sickert warned against the fatuous flatteries of the after-dinner speaker. Poor Hugh Casson, sometime president of this academy, fell so deep into frac-tailed temptation that he found himself being introduced to a New York audience by the superbitch Philip Johnson as 'England's finest after-dinner architect'. Casson's idiolect was constellated by such words as agreeable, congenial, companionable, clubbable, charming, delightful. Qualities that made him a consummate Gentleman Amateur, a Man About the Arts but, equally, not much of an artist: though devotees of the Ismaili Centre opposite the V & A, a building proudly swathed in finest sodalite, may dispute that; so may fans of his terminally whimsical sketchbooks. The gulf between the arts, plural, and art is chasmic, much more than one letter.

The last time I attended this dinner, thirteen years ago, the speaker was the late Robert Hughes, whom I admired, though well this side of idolatry. He was supremely indifferent to whether or not he was liked. And while he might not have gone as far as Régis Jauffret, who said not long ago that he is disgusted by writers who think about their audience, Hughes evidently considered that a writer who is not causing offence is a writer who is not doing his job. The volume of disconsolate muttering that Hughes provoked

in this room might be taken as a sign that he was doing his job. He was not here to make friends. He was physically impaired after his near-fatal car crash and, as if in acknowledgement of that state, he had signed up to the then already *retardataire* fashion for all things slow. A fashion which had begun in Piedmont in the late eighties with slow food. Then came slow living, slow fish, slow science, slow television, slow medicine – which, of course, did not need to be imported; the English already had it. Slowness was a triumph of PR on behalf of root vegetables grown on the moral high ground, of propaganda for wishful Canutism, of slogans validating slow sloth, of imprecations to build pyres of Wonderloaf, Kentucky Fried Chicken and those condoms packed with abattoir slurry called English sausages. These were chemical beacons of the inauthentic.

There was slow parenting. There was slow thought. To discover what slow thought means you have to go to the other end of Italy from Piedmont, hundreds of kilometres south to Syracuse. And there dig up a 2,000-year-old grave. Its disgruntled Sicilian inhabitant will tell you *vaffanculo* – I'm still planning my revenge.

We owe *carpe diem* to Horace. We also owe to him a fuller version of that exhortation. A bucolic Benny is standing on a riverbank, wanting to get to the other side. He decides that he must wait till all the water has gone by before he crosses. Benny was the name given by British troops in 1982 to Falkland Islanders because of their perceived kinship with the very slow character Benny in the telly soap opera *Crossroads*. The wrong sort of slow.

The Falkland Islands should be in our thoughts. They are set to become the monocultural model for the excitingly endogamous, isolationist, crippled, pelting-farm Britain which has detached itself from civilisation and is floating off into the mid-Atlantic in search of a prosthesis. That is one implication of our certainly prevaricating and possibly unreflective prime minister's assertion that 'If you believe you're a citizen of the world you're a citizen of nowhere.' A

second implication is that she sees an immutable geocultural bond between one people and one place, one race and one soil. That is a dogma with unfortunate precedents.

Hughes's proposition was that this never-getting-out-of-first-gear slow mode might be transferred to the making of art and to the contemplation of an art that was somehow timeless. He railed against fast art, immediate art, art which didn't invite protracted rumination. He sought an art which was in defiance of the mass media.

But it has always been the case that the mass media is entirely preoccupied with the atypical, the sensational, the exceptional. Tortoise beats hare: we never hear that it was a long-dead rubber, with the hare having won the nine previous races. The fifth horseman of the apocalypse is overlooked. The guy just didn't feel like coming out that day and stayed home to do some grouting.

Art as superficially attractive as a Big Mac – and as sustaining. That's wrong art, apparently. We should, though, stop to consider the other life of McDonald's. It provides a valuable if noxious social service, it offers temporary shelter to those who have none to, say, veteran British troops, the expendable donkeys who have been dumped on the street by a grateful nation. They're places to while away the days and, with luck, maybe pick up a little mystery. The argument that fast art is meretricious, disposable and ephemeral is untenable. It, too, has an unintended, unofficial life which its makers and first audiences cannot guess at.

It is presumptuous to bet on what will endure. The supposedly ephemeral endures. What is intended to be permanent withers and decays, does not endure. Reading the entrails is often almost as unreliable as the authoritative pronouncements of distinguished economists and leading futurologists. Rock 'n' roll, our teachers told us smugly, was obviously a flash in a Brylcreem'd pan: it'll all be over by next year. Eric Varley and John Moore were both absolute certainties to be prime minister. In 1943, Enoch Powell foresaw

an imminent war between Britain and America. Two years later, as Empire was crumbling, he realised it was his destiny to become viceroy of India. We can all get it wrong.

Fast art is necessary. What other sort of art will respond to the dangerous volatility of the past year – and the next year, and the year after? Engagement is required. Which does not have to mean adoption of the nostrums of the left. Or, for that matter, the right – those polarities are, anyway, worn out and inappropriate today. Engagement means abandoning solipsism, taking active notice of the world outside oneself, and trying to make something of it. The aim of the 52 per cent that decided to shoot itself in the foot was so poor that it also shot the other 48 per cent. This is a subject that is glorious in its squalid hypocrisy. Here, after all, was a supposedly popular revolt, a people's revolt, an anti-establishment insurrection fomented and flamed by little Ingerlandlandland's salt of the earth – that is, by such anti-establishment men of the people as the late billionaire bullyboy Jimmy Goldsmith, the late Nigel Farage, the American of convenience Rupert Murdoch, the end-of-pier Barclay Brothers, Paul Dacre and his loyal valet Stephen Glover, the antino-mian former mayor and back-end of Caligula's horse Boris Johnson, the self-fulfilling prophet of Broken Britain call-me-Dave, Tories on day-release, hedge-fund swine with the finest sties, sincerely committed tax evaders and the sometime pornographer Richard Desmond, who has donated a wing to Moorfields Eye Hospital in repentance for the ocular harm done by his publications.

Perhaps the people now realise that they've been had. Is populism actually popular? Or is it simply bread and circuses, heavily sedative patronisation from which dulled sleepers may awake.

A work triggered by specific circumstances will often outlive the memory of those circumstances, even the very knowledge of them. We do not need to know much if anything about Napoleon's Iberian adventures to appreciate Goya's *Disasters of War* or Potocki's *Manuscript*

Found in Saragossa – though of course they may prompt us to enquire.

The Murder – by Cézanne before he was Cézanne, as Howard Hodgkin put it – hangs in the Walker Gallery. This great elemental painting depicts or invents people reduced to violent animals, human beasts as Cézanne's friend Emile Zola called them. The painting was contemporary with Zola's *Thérèse Raquin* and with the high point of the British sensation novel, which Zola was immersed in. Again, familiarity with this background will neither diminish nor increase our horror and our exuberance at the sheer energy of the work. Stella Gibbons' *Cold Comfort Farm* is celebrated. Mary Webb's *Precious Bane* which it guyed is forgotten. So it goes on.

It is futile to set out to achieve the illusory state of timelessness. Everything, like it or not, is watermarked with its date of creation. James Gillray's *Fashionable Contrasts – or The Duchess's Little Shoes Yielding to the Magnitude of the Duke's Foot* is of 1792. It is now also of January 2017 when the great cartoonist Steve Bell appropriated it. That is, he nicked it. To brilliant effect. The original subjects, only partially shown but evidently conjoined, are the Duchess and Duke of York. In Bell's version the subjects are Trump and Theresa May, again evidently conjoined, but in a different configuration. The president is sodomising the prime minister. It's just Trump's way of showing what the illusory Special Relationship really means and giving her fulsome thanks for inviting him to make an unpreordained and unprecedented state visit.

Bell's cartoon was widely lambasted as vile, disgusting, perverted, inflammatory, seditious, tasteless. You get the picture – the usual accusations, from the usual sources. It would have been strange had it not incited such responses. Bell and Martin Rowson have followed Ralph Steadman and revived a fine and absolutely necessary tradition of caricatural mockery, bile, hatred and vituperation – all seething in a cosmic midden of scatology and eschatology. This is an essentially northern European idiom which treats politicians as scum and more

generally revels in human imperfection: monstrous, Gothic, cold, merciless, pessimistic, misanthropic. Its sympathies, such as they are, lie with the underdog. Its many antagonisms are towards the overdog. The precursors are Hogarth and Dix, Grosz and Rowlandson, Gillray and Schad, Heartfield and Isaac Cruickshank, Georg Scholz and Burra.

This idiom accords with such characteristically northern European and specifically British diversions as public drunkenness, mob violence, immodest behaviour in doorways, bantah, taking the piss, vertically tanned horizontals and barely dressed blue-veined people vomiting in the nocturnal streets of, initially, Newcastle and now everywhere – and with a heartening disrespect for those whom we are instructed are our betters, those whom William Cowper, in *The Task*, called 'peculators of the public gold'. Like the poor, the over-dog peculators are always with us, expecting the underdog to pay, for instance, for their absurd garden bridge or for cleaning their moat: a Scottish grandee remarked that had his moat been as puny as the wretched Douglas Hogg's he'd have mucked it out himself.

Artists like Steadman, Bell and Rowson address the West's self-inflicted catastrophes. Satire has no obligation to be funny, though it often is – after all, the world is grotesquely comic. Satire is not to be confused with parody, which is a mere lark. Satire is didactic. It's a sharp jolt. Very probably unfair. It's often cruel. It's meant to hurt. It's a release. It is, if you like, secular blasphemy. Just about tolerating deluded faith is one thing, respecting it is quite another.

Is satirical cartooning really art? Of course it is. As Duke Ellington said, the question is not whether it's jazz music or classical music, the question is whether it's good music. Jean-François Revel's dictum that 'there are no genres – there are only talents' is pretty much akin. This satirical art is however confined to a ghetto composed of the few mainstream newspapers and magazines not controlled by the men of the people I've mentioned.

Ellington and Revel are both dead and were anyway not part of

the art loop – so what they said is blissfully irrelevant to art's high command, easy to dismiss. Satirical cartooning is below the salt, merely peripheral to the great galleries and to their great panjandrums – no names no pack drill as we used to say at Ladysmith. Cartooning is deprecated as pictorial journalism. Not fine art, whatever that means. It is impure. Why? Because it is about something. The current bias against subject matter, against something, anything, being portrayed or signified or commented on, is total. If a work concerns itself with colour or form or texture or the process of making, well that's just the ticket. Muteness is de rigueur. You get the feeling that many minimalist installations have been sworn to a vow of silence. Apparently there exists some unspecified danger of aesthetic contamination if a work is anything other than self-referential, if it acknowledges anything beyond itself. Content is a dirty word. Incident is an unspeakable word. Housman admonished Swinburne for composing poems about poetry.

What is the point of works which fail, deliberately fail, to engage the eye or to stimulate the intellect or which neglect to be emotionally harrowing, emotionally consoling, which neglect to promote aesthetic bliss, which neglect to speak to the base of the spine, which disdain to address the world outside the art loop?

In the *Heptaméron*, published in 1558, Marguerite of Navarre mentions an epitaph that was to be found in a church at Écouis in Normandy. Similar epitaphs were recorded at Tournai and Valenciennes in Hainaut. It begins *Ci gît le fils* . . .

'Here lies the son, here lies the mother, here lies the daughter, here lies the father, here lies the sister, here lies the brother, here lies the wife, here lies the husband . . . And there are only three bodies in the tomb.'

Presumably this close-knit family had minimal contact with the outside world.

The art loop comprises *soi-disant* artist, collector, curator, critic,

dealer, PR, trustee, philanthropist (again *soi-disant*). Seven distinct callings there. But improbably seven distinct persons. Two or three persons – who augment what in French political life is called their *cumul des mandats* without leaving home. They obviously don't need to get out more. Critic Otto Otto praises artist Dot Tod's swarf work *Albatross Soup* as brave and challenging; curator Dot Tod advises trustee Otto Otto to purchase *Albatross Soup*, whose paracultural radicality has excited critic Dot Tod.

If they did get out more, they might encounter people from beyond the loop who do not subscribe to their cult of puritanical, po-faced, humourless, censorious nothingness, which is, globally, both the grand panjandrum's conventionalised good taste and an object of almost universal derision. Yesterday's avant-garde is today's official art. Gosh, how daring: a five-second video loop of a woman picking up a magnifying glass to inspect an ampersand drawn on a nail head. It's untroubling because it says absolutely nothing. It offends only by its sheer inoffensiveness – and that inoffensiveness, that zealous blandness, is why it is so welcomed by the politically powerful. It is akin to the reason why in the fifties the Congress for Cultural Freedom – that is, the CIA – funded abstract expressionism: quasi-random pattern-making which is neutral, apolitical, harmless. It demonstrated to the equally state-supported social realists on the other side of the curtain that in the West you had the go-ahead to be really messy and play in a free-world sandpit.

Anthony Burgess wrote that 'There can be no art till craft has been mastered. Art must be dangerous. Once it has ceased to be dangerous it is no use.' Burgess was born a century ago, 1917 – the year that Marcel Duchamp changed for ever the face of urinals. It wasn't actually the greatest of pranks even then. The sorts of dross it has spawned are merely the hackneyed imitations of acolytes. They are far from dangerous. And no use. It's mystifying and rather sad that there are still people who, by clinging to it, are unwittingly

admitting that they subscribe to a form of philistine frivolity which they fail to recognise as frivolous.

Oh, but it's so ahead of its time! Can it go on being ahead of its time for ever? It has given irresponsible licence to artists who have no craft at the expense of those who possess great craft but fail to accord with the stipulated fashion – and it is a fashion – for an art that is like water rather than like the bottle and a half of gin a day which Burgess often drank. He was of course bested in bibulousness by such masters as Bacon and Burra and Bellany.

Masters? They are mere easel painters according to the fashion-obsessed Tate. That prefix 'easel' contrives to be a patronising slight, a sly deprecation of one of the world's greatest artistic forms, and a boast of self-perpetuating power – the incumbent tyrant thinker assists in choosing its successor tyrant thinker. You might have expected that anyone who called their application to run a major gallery 'Take the bull by the horns' would be immediately disqualified on the grounds that such a dismally clichéd title was a sign of dismally clichéd thought. But the trustees were, happily, as insensitive to language as the candidate.

That's how a cult or a dogma or a thought system is perpetuated. And that is how art history gets written, through the manipulation of those who are making the history – they are obviously *parti pris*. It is, then, inevitably, victors' history. We are the masters now.

This official art is affectless, impervious to interpretation. That, anyway, is the extraordinary intention. A stapler and a toothbrush are positioned beside each other in a gallery. They are art. This is fatuous – as the Eucharist is to me, yet beguiling to anyone who possesses the credulity gene. With the Eucharist we at least know what it is supposed to signify. Because the stapler and the toothbrush simply are – they do nothing but exist, they are not symbols – we are enjoined to experience them. Well, sure, anything becomes fantastical if you look at it for long enough – which is a useful

means of staving off boredom in a waiting room. But you might as well stay in that waiting room. We don't need to go to a gallery to see either item. A believer believes that the objects are transformed by being in a gallery. Believers see what they believe in. Non-believers believe in what they see. No transubstantiation occurs because there is no such thing as transubstantiation. The dry wafer that sticks to the top of your mouth and the wine-style liquid made from rehydrated powder and ethanol are just that.

And it's here that things shift beyond silliness. It's not a question of experience or interpretation. It is both. No matter how blank, how untouching, how dull, how banal the exhibits – any exhibits – they will incite the germ of curiosity. Which takes us beyond the experience of seeing, touching, smelling. Helpfully, however, we are supplied with a text that tells us what the stapler and the tooth-brush are up to. This text is composed in approximate English or with English-derived words: performative, deconstructability, dialectic, visuality, interrogality, transversal, trope – and of course the ineffable, unavoidable, ubiquitous questioning notions of . . . You have to scream: stop questioning . . . give us some answers.

This massacre of English has ceased to be funny. It derives from the France of fifty years ago via the graceless translations of American academe. Non-anglophone art students and architectural interns, i.e. slaves, believe that this self-important and, needless to say, humourless pidgin is English. Who will correct them? That's a silly question. There's almost certainly a social crime called linguism which prohibits pointing out errors of usage, syntax, pronunciation, grammar and so on. Besides, everyone in the loop, anglophones included, speaks it. There are, god help us, even degree courses in art writing – both art and writing require quotes around them. The novice knows that it's to its advantage to acquire fluency. Unlearning a language as complex and rich as English in order to communicate like primates is clerical treason.

Slang is vital, graphic, it is exuberant low-level verbal invention. The orthodox take is that it excludes or it includes. Dubious. It is, rather, jargon which excludes and includes. Jargon is lifeless, ugly, uninventive, prosy – this is the language of the joiner, the crony, the sycophant, the tyro who imitates its seniors to impress and get a hand up. The jargon of the arts is pervasive because the arts have usurped art. Save in this exceptional academy, which was founded by artists and is to this day run by artists in the interests of artists, the power throughout the art world has been seized by a managerial caste which exercises patronage, which commissions rather than creates, which edits rather than makes, which does deals: empire-building impresarios and entrepreneurs, curators, so-called enablers, operatives who style themselves gallerists – clumsy neologisms are essential to any cult. The arts are parasitical upon art. Operatives in the arts have risen to the top. They call the shots. They can read the spreadsheets.

Just as foreign aid tends to end up in the pockets of tyrannical kleptocrats rather than get to the desperate, so does art aid go to the arts rather than to artists. This is not to suggest that the arts *nomenklatura* peculates with the licence that politicians enjoy, nor that it feeds its critics to crocodiles in the time-honoured manner. What it does suggest is that the fate of artists and of art itself is in the hands of too few persons who share – or are persuaded to share – kindred tastes or beliefs. We are a long way here from the days when poets starved to death of syphilis in a garret for the sake of an adverb and Augustus John could announce: 'We are the people our parents warned us against.' Bohemia has been subjected to cleansing and class clearance.

Cheap space has been swallowed by blingstead apartments. Vocation has been replaced by careerism in the arts, official arts, by people who don't realise that a life spent in meetings is a life wasted. Rise high enough in this milieu and you get to commission a world-class gallery from a world-class architect who specialises in world-class sloping walls on which nothing can be hung – indeed

the entire world-class structure, a three-dimensional logo, a sight-bite, a landmark beacon, an iconically iconic icon, is created in a manner that's inimical to any form of display other than installations. The very buildings conspire against the primacy of painting.

Two decades after the Guggenheim fell into Bilbao like a shot-down airliner, the global arts establishment clings to the faith – and it is a faith, a belief with no empirical evidence to support it – that run-down cities can be somehow healed by cultural regeneration: by building museums, galleries, theatres rather than, say, by building accommodation or studios. This gambit has clearly succeeded in Bilbao, where unemployment and the number of people claiming housing benefit has risen in those twenty years. On the other hand, since the Lowry and Libeskind's Imperial War Museum of the North were dumped on Manchester there has been absolutely no gun crime in that city and the entire membership of the people-trafficking community is retraining as vibrantly diverse modern dance mentors.

Who, then, can dispute the opinion of the former director of the Manchester International Festival: 'You can never have too much culture.' There speaks the authentic voice of the arts, a political endeavour measured by volume and by the cost of glittering venues: which is often less than four times the initial estimate. This particular branch of the regeneration racket is founded in the confident and entirely wrong-headed persuasion that art is a sort of moral balm, a tonic, Sanatogen for the soul, that art is good for us.

We should perhaps recall that after a hard day's exterminating there was nothing an SS officer enjoyed more than returning to his *gemütlich* cottage to sing Schubert lieder and read Goethe to little Heini and Magda.

A. E. Housman rightly declared that the pleasure of the moment is the only possible motive for action. In his case that involved asking his new friend: 'Are you going to shave here, duck, or wait till you get back to barracks?'

Apropos of a more communal sort of pleasure, Sir Peter Blake enquired not long ago: 'What has happened to all the drunken painters?' Let us find out. It is with great pleasure that I invite my fellow guests to rise and join me in a toast – to the Royal Academy of Arts. (2017)

One-man show

In 1917 Kenneth Wood was five and Marcel Duchamp was thirty, going on five. That year Duchamp notoriously signed a urinal 'R. Mutt'. It was a dull jest then and it remains a dull jest, but it has for a century been treated with reverence by morons. And many of those morons, a mass movement of treasonable clerks, have positioned themselves as the *nomenklatura* of Western art, the fashion-obsessed curatocracy which, in its ahistorical ignorance or sheer gormlessness, has trampled on painting, which was for more than half a millennium the supreme means of visual expression, visual representation, visual exteriorisation of sensibility, memory. The director of the Tate demeans painting as 'easel painting' and contemptuously regards it as just another 'genre' alongside installations, video loops, performance art. Placing a line of pebbles across a field is land art. Expectorating a Glasgow oyster is phlegm art. A coat hanger gaffer-taped to a broken chair is sculpture.

What has been effected is not a stylistic shift but a transformation of what constitutes art. Wood's art was founded – as all art, all writing used to be – in craft. Craft must be learned or zealously self-taught. There is a broad, unbridgeable divide between the art of the artist who has absorbed the rulebook then thrown it away, and the artist who has never read it because he or she is too lazy, too complacent, too arrogant to do anything other than shock.

Wood's work is formal, sophisticated, painstaking, knowing. He looked. The past is anything but a burden. It is a springboard. His

work is instantly recognisable. To his aesthetic advantage and his pecuniary disadvantage, he was out of step with his time. He does not belong to any group or movement. No ism can be attached to him. It's futile and insolent to draw comparison with other artists. He had friends who were artists – Rowland Suddaby, Dicky Chopping, Robert Colquhoun and Robert McBride. He referred to the two Roberts as Ben Doon and Phil McCavity.

Wood's paintings in various media and his etchings give nothing away, they do not lend themselves to any kind of taxonomy. Landscapes? Interiors? Figurescapes? Are the recurrent figures with aura around them revenants? They are often insubstantial, near-transparent, escapees from dreamtime. Had the epithet not already been allotted it might be said that Wood's work was metaphysical. He would have dismissed such a characterisation. As well as figures, certain devices recur obsessively. The frieze, the triptych, the stage flat. And certain subjects, Euclidian subjects: the emphatic horizon, the unnervingly straight canal. Above all the concurrence of every element. Thoughts overlap, fight for primacy – so must art reflect that belligerent simultaneity which occurs in our heads unbidden and unavoidable. Figures morph and shape-change, they abandon their aura. There is here no primary reality and secondary reality. It is not a question of the provisional and the permanent. Actuality and dream exist on the same level. And everything comes round again, the motifs recur with nuanced variations. You cannot paint, say, a smothering cushion without the remembrance of other smothering cushions that you have seen or read about or imagined. And the remembered and the imagined may be so potent that they quash the immediate actuality.

There is shock in Wood's work. But it is not sensationalist or meretricious. It is, rather, the comprehension that this is what realism looks like. Nothing to do with naturalism, nothing to do with photography, but an utterly original painted map of memory's ungraspable mercury. A grand project, really – to have tried to limn the mass of synaptical

sensations we suffer, rather than to reproduce that jug while avoiding the window pane and curtain we see from the corner of our eye.

Among Ken Wood's many interests was archaeology. He was, for instance, interested that the archaeologists Stuart Piggott and Stewart Perowne should both have failed to consummate their marriages. Thankfully there was always 'Rick' Wheeler, Sir Mortimer Wheeler, on hand to do some freelance consummating should it be required. Perowne was Ken's boss, a most amiable boss, in Baghdad 1943–5. His *mariage blanc* was to Freya Stark. Ken regarded her as a snobbish Arabist fraud, the appeal of whose writing was and remains almost exclusively to dumb social Alpinists.

One could define Ken by his antipathies, which were many and unpredictable. Alfred Munnings. Committed art. Art with a message. Pop art, which he reckoned to be a form of graphics. Upper-class and aspirantly upper-class writers and their precious prose styles: Patrick Leigh Fermor, James Lees-Milne, the precursors of Bruce Chatwin, people like that. Indeed, the officer class in general was to be treated with contempt. No, contempt is not right. Ridicule is more the ticket.

But . . . back to archaeology. Before there can be analysis, dating, classification and so on, there is cautious digging, the conscientious recording of strata. Much, most, of Wood's work is dependent on a sort of exhumation, of delving into the shifting bog of memory, where one trove leads to another and we are not in control. This, of course, is the very opposite of the archaeological discipline that Ken's friend R. G. Collingwood proposed. But if you are any sort of an artist you don't – or ought not to – know where you're going, you don't know where this mark will lead or the word which will follow that one or what note will come next. Don't think – write! said James Joyce. Louis Aragon found out what he was thinking by reading his writing. I suspect Wood's works are, *mutatis mutandis*, kindred. What

we have in this room is a man's lifetime's colloquium with himself, discovery of himself, an attempt to capture the uncapturable.

Ken Wood came from Sheffield. Ken Wood's art came from – well, that's not so straightforward. When he played the sedulous ape, who was he apeing? Early on there's a hint of Wyndham Lewis, Nevinson, maybe Wadsworth – a *camoufleur* in an earlier war. But he soon arrived at an idiom absolutely peculiar to himself. Some twenty years ago, for want of anywhere else, I stayed with my camera crew in a West Country hotel whose owner had the face of a congenital syphilitic. In the dining room – fine dining, I'm afraid, lemons wearing stocking masks – the walls were hung with Kenneth Wood's work. Instantly, unmistakably recognisable. And marvellously unsuitable. I should point out that it was Kenneth Wood's daughter who both invited me to say something tonight about her father and taught me how to spot a congenital syphilitic, a rare talent, learned from her father. Euphemism, discretion, evasion were not part of Wood's make-up. Mockery and the most exhilarating cynicism were.

When he came to London at the age of twenty-one in 1933, he designed and carved puppets for the London Marionette Theatre. Then founded a puppet theatre of his own. This was not whimsical children's entertainment, but revived folk art and fairly bawdy. The illustrator and historian of design Barbara Jones was involved and would write about it in her post-war book *The Unsophisticated Arts*. Other people involved included Jack Whitehead, who would subsequently carve ships' figureheads, the former suffragette Biddy Lanchester, daughter of the architect H. J. Lanchester, who had once had her sectioned, sister of another architect, H. V. Lanchester, sister, too, of the three founders of the eponymous car company, mother of Waldo Lanchester, mother-in-law of Charles Laughton, mother of Elsa Lanchester, who included puppets in her risqué vaudeville act, part of it written by H. G. Wells.

It's not fanciful to suppose that Wood's preoccupation with flatness, single planes, one-dimensional compositions and surface derived from the several years he worked in this form of theatre. Depth – the *sine qua non* of middlebrow art – held no interest for him.

During the second half of the low dishonest decade, his work was in various group exhibitions. Eddie Marsh – Churchill's secretary and editor and the patron of countless poets – collected his work, as did Kenneth Clark, future lord of Civilisation. His first one-man show – he was still only twenty-six – was at the Wertheim Gallery in 1939. Not, evidently, a propitious moment. But things get worse. Raymond Mortimer wrote in the *New Statesman*: 'Not since the Graham Sutherland show at Rosenberg's have we seen an exhibition by a young British painter so promising as Mr Kenneth Wood's.' Less than a year previously Cyril Connolly had published *Enemies of Promise*. 'Whom the gods wish to destroy they first call promising.'

In 1936 he had married Anne Waterman. They would both have interesting wars. She was a land girl for four years then volunteered to become a fire warden. Someone, unknown to her, wrote VGT on her application: Very Good Type. Within a matter of days, she was seconded to the American army, which had just liberated Paris, where such people as Coco Chanel, Maurice Chevalier, Cocteau, Le Corbusier were swiftly reassigning their affiliations; so, too, were many unknown horizontals whom Ken called officer's groundsheets. The Americans had money. Anne Wood rather took to this society.

War hardly helped Ken's career, though he did have an exhibition in Baghdad in 1944. As I say, he worked in camouflage and was part of that Middle Eastern uniformed bohemia which included Hugh Cott, author of *Adaptive Coloration*, Steven Sykes, whose work can be seen in the Gethsemane Chapel of Coventry cathedral, Olivia Manning and Reggie Smith, Lawrence Durrell and Elizabeth David, Edward Bawden and Dicky Grierson. Ken Branagh's portrayal of Guy Pringle, the fictional analogue of Reggie Smith, in

the TV adaptation of Manning's *The Fortunes of War* might have been based on a pitch-perfect study of Ken Wood.

He continued till the mid-fifties to exhibit at the Leger Gallery and the Redfern, run in those days by the extraordinary Antipodean self-invention Rex Nan Kivell – part conman, part connoisseur, part impresario. Nan Kivell, not his real name, bought himself a knight-hood by donating art works that were not his to give to the National Library of Australia, among them some by Kenneth Wood.

Painting is as susceptible as any other activity to the dictates of fashion. Wood did not follow the route taken by two slightly younger painters from Sheffield, Derrick Greaves and Jack Smith. Smith's progress was straightforward – he moved from the kitchen sink to glossy geometric pattern-making to splodgy abstraction. Greaves' career has been that of a chameleon. Every few years he would find someone new to, let us say, inspire him. There was one point where his work became indistinguishable from Patrick Caulfield's, to Caulfield's amusement. But then Caulfield's work probably amused Valerio Adami. Kenneth Wood was different, he was absolutely aware of fashion but didn't want to join in – he had pride. He was not out to please anyone but himself. *Nil illegitimi carborundum*. And the bastards didn't.

He was a one-man awkward squad. Bloody-minded. He valued the truth more than social ease: he would tell people their cooking was indifferent, actually, *caca* – which he had every right to because his was so good. He was obstinate. Unclubbable – though he did belong to an odd club in Mayfair called the Brevet which had been a favourite of aircrews in the war and by the seventies was always deserted: that, no doubt, was its appeal. He was also rashly gener-ous. He gave me a car, a cute Simca. Were there literality in cutting off a nose to spite a face then he'd have ended up with a fair simula-crum of the congenitally syphilitic face. He was also the far side of self-deprecating. I remember him, Christine and me going into a

newsagent in Maldon. The shopkeeper half-recognised Christine and informed her: 'You're that . . . yes, your dad, he was an artist chap, wasn't he. What's he up to then?' Before Christine could reply, Ken Wood said: 'The bugger died a couple of years ago.'

No doubt the newsagent belonged to the tribe of Boudica – who was in 1971 still Boadicea. According to Ken, these prying Essex natives were called the Iceni because they frequently began conversations with 'I see ye . . . staggering back from the Green Man the other night.' They were also known as pheasant pluckers.

His London acquaintances had included Robert Medley, Tambimuttu, Stephen Sykes, Julian Maclaren-Ross – of whom his unrelated exasperated publisher Alan Ross once said to me, 'better never to have met him'. His Essex acquaintances included a humourless arty – and of course artless – neighbour who always wanted to put me right about Ezra Pound. Mad, fascist, unreadable, and even worse than his fellow traveller of anti-Semitism Eliot, I thought then, and my opinion has not changed. His neighbours had also included the very ancient Arthur Mackmurdo, the Arts and Crafts architect who had introduced Shaw to Wilde and threw away a fortune trying to turn a couple of Essex villages into an artisan yoghurt-weaving community by building bizarre, impractical houses and proposing that human society should take as its model the beehive. Ken had some drawings of his which he offered me. I foolishly declined. When he died they had disappeared. That, thanks to his dutiful daughter and Andrew Stewart, will not be the fate of these works. (2017)

A novel approach

Keeping an Eye Open: Essays on Art by Julian Barnes

The subject of the least characteristic essay in this engrossing collection of meditations on painters, painters' lives, painting and reactions to painting is René Magritte – whose best work David Sylvester

rather rashly claimed induces 'the sort of awe felt in the presence of an eclipse'. Julian Barnes discusses what he calls the artist's doctrine (doctrine?) of 'elective affinities', which proposes the antipodes of Lautréamont's 'chance encounter on a dissecting table of a sewing machine and an umbrella'. Thus, in the painting of that name a bird-cage is filled not with a random safety razor or knuckleduster but with a giant egg. Barnes then introduces an acquaintance who 'can't drive past a field of sheep without muttering Dinner . . . he claims to be merely hungry rather than Magrittean'.

This is a tactful means of pointing to the commonplace meagre-ness of what Barnes calls the painter's 'night-time *aperçu*': he doesn't quite go so far as to say that ideas, conceits and analyses are better left to writers. He seems so bemused and let down by Magritte's conceptual failings that he omits to draw attention to the inade-quacy – a bizarrely Escheresque inadequacy – with which the painter rendered his flattened head and impossibly positioned brush arm in a self-portrait with another (normal-scale) egg and a raptor.

Or maybe he hadn't the heart to put the boot in. This is, after all, a book whose personae, with one exception, are treated with degrees of fondness ranging from dutiful respect to Howardolatry. Barnes does not remind us that Howard Hodgkin – his friend and quondam travelling companion, here known as H.H. – is a kinsman of the artist and critic Roger Fry; a lesser writer whose presence in these pages is only emphasised by his muteness. The overlap of taste, anecdotal style and antipathy to the academy, though, are beyond coincidence.

The same might be said of Nikolaus Pevsner, who, like Barnes, found it difficult to reconcile belief in progress with the places to which progress, or its myriad impostors, leads; especially when those places are morally void markets where '"successful" artists of the 21st century' flog 'their endless versions of the same idea to know-nothing billionaires'.

There is of course nothing peculiarly twenty-first century about

such transactions, though: in 1900 Cézanne was living in a quarry reading Flaubert (as predictably ubiquitous here as the recurring adjective suave is unexpected) when the dealer Ambroise Vollard bought one of his canvases for 300 francs and sold it on for 7,500.

Barnes notes that today one of St Anthony's temptations would be artistic success, for such success is subject to no measure other than pecuniary: how can it be, when there is no standard, no consensus, when 'art' stands for a hangar-sized wardrobe of the emperor's new installations, videos, loops, interactive handshake sheds?

Barnes, nevertheless, confidently asserts that the second half of the twentieth century in Britain will come to be seen as 'a period dominated by painters: Bacon, Freud, Hockney, Hodgkin, Riley (and Caulfield, Auerbach . . .)'. Is this the optimism of a writer whose love of painting trespasses into infatuation? Probably not. Fashion moves quickly and cruelly. Barnes will be proved right; it is the sheer physicality and brute practicality of pigment on a flat surface that will cause painting to endure.

He may, however, have got some of the painters' names wrong. Where is Burra? Where is Weight? Will Freud, a target for Barnes' venomous acuity, really survive? Or will Kenneth Clark's dismay at his change of style from Neue-Neue-Sachlichkeit to impasted daubery come to be time's verdict? Barnes weirdly equates thick brush marks with the truthful rendering of the body. Oblivion has beckoned for many better painters than Freud, some of whom have walk-on roles here. Thomas Couture, for instance, failed to jump on the Impressionist bandwagon which carried his sometime pupil Edouard Manet to glory (and notoriety). Barnes somewhat harshly derides Couture as a 'fashionable *peintre-pompier*' whose posthumous and thus unwitting tort was to be presented at a Musée d'Orsay exhibition four years ago as a precursor of Manet, rather than a teacher whose example the younger man rejected: this misreading was of course a curatorial caprice, an overcute rewriting.

There can be no such rewriting of Manet's death (tertiary syphilis, locomotor ataxia, gangrene, amputation); nor of Courbet's from dropsy. Dr Barnes tells us with quiet glee that 'tapping' (draining the abdomen) produced twenty litres of liquid while steam baths and purges had released a mere eighteen litres from the anus. The cause was alcohol: thirty bocks in an evening, according to another painter granted no more than a cameo, Alfred Stevens, who in his lifetime enjoyed immense fame but is today occluded in the interstices of salon history.

Barnes' writing on art began in the late 1980s, with the chapter in *A History of the World in Ten and a Half Chapters* on *The Raft of the Medusa*. His curiosity about painting, which for him seems usually to mean French painting, began in 1964 at the then neglected Musée Gustave Moreau, the painter's former studio in the quarter of Paris south of Pigalle called la Nouvelle Athènes. Fifty years later, having learned, inter alia, that Moreau was the only contemporary painter whom Flaubert admired, Barnes returns to this quirky shrine. He has, however, also learned what Degas said of it: 'How truly sinister . . . It might be a family vault.' It takes a nifty bit of footwork, a sort of Cruyff turn, to sort this one out. But sort it out he does, triumphantly: 'The Flaubert who admired Gustave Moreau was the Flaubert of Salammbô rather than of Madame Bovary.' So there. (2017)

Beautiful freaks
Edward Burne-Jones at Tate Britain

A certain caste of nineteenth-century aesthete was preoccupied by the lack of an architecture peculiar to the age. Among the most clamorously fretful critics was Thomas 'Victorian' Harris, who owed his sobriquet to having made of the monarch an adjective. He and his kin rued the way in which architecture had been reduced to exterior decoration: a classical cloak about an iron office building, a

Byzantine mantle about an iron railway station. While engineers' structural methods were constantly experimental, constantly evolving, the life of an architect was spent speeding into the past, rummaging in the dressing-up box of the ages.

Initially this produced an archaeologically correct copyism, what William Holman Hunt called 'seeking after dry bones'. He and a group of young painters – who would become the Pre-Raphaelite Brotherhood – felt they were faced with the same problem as architects, whose way out of the cul-de-sac of revivalism in the early 1850s was to mix motifs from different eras, as though chance and indiscriminacy would magically produce an architecture of modernity fit for the age of telephones and steam and sewing machines.

And before those fretful critics' unseeing, unacknowledging eyes, chance and indiscriminacy did just that. The heterogenous styles of the age still excluded engineering as being subservient to architecture, a servant. But they also went far beyond revivalism. This architecture was a composite, a synthesis which revelled in ahistorical collisions and counter-intuitive juxtapositions. The greatest High Victorian architects, the supreme authors of the 'modern Gothic' – Butterfield, Teulon, Pilkington – were mature (and often brutal) poets who stole shamelessly and created, as Eliot would have it, something 'utterly different from that from which it was torn'.

Revenants from the mud and piety of 400 or 500 years before would not have recognised, say, Keble College, Elvetham Hall and the Barclay Bruntsfield church as having anything to do with the few grand buildings they might have seen in their short lives. They are works of bricolage, 'utterly different' and entirely dissociate from the sources of their incongruous components.

The name Pre-Raphaelite Brotherhood was a typically youthful provocation. An incitement to persuade the art world that the leaders of the tyro pack, John Everett Millais, William Holman Hunt and Dante Gabriel Rossetti, were new, fresh and ready to bury Joshua

Reynolds and the stale academy: you know the schtick. The link to the art of the fourteenth and fifteenth centuries was frail. The period of approximate copyism was brief. Again, revenants would have been initially bewildered by the risible pinchbeck medievalism. They would subsequently, in a blind tasting, have been hard-pressed to distinguish between a PRB portrait of a 'stunner' (their word) with big hair, a Pitt-Hopkins mouth and a simulacrum of Simonetta Vespucci's sumptuous clothes, and a portrait of a similar subject painted by a non-joiner, an outsider to the gang whose deviation from its self-imposed rules was predictable.

The break with the past was illusory. So is the clichéd notion, predictably subscribed to by the Tate Britain's curatocracy at the time of the gallery's 2012 exhibition, that the PRB was 'avant-garde' and that the members were 'rebels' when rather, as F. R. Leavis said, *mutatis mutandis*, of the Sitwells: 'they belong to the history of publicity rather than of poetry'. Within a few years of the brotherhood's foundation Pre-Raphaelitism had fused with the mainstream and had come to include novelettish liaisons, snowscapes with sheep, Vikings, mildly erotic nuns, anthropomorphic monkeys, dells and glades full of fairies, geological studies, agrarian (though seldom urban) squalor, stagey historical mawkishness, deliberately modest landscapes. Most of these works are illustrative and moralistic, most of them are achieved with slick precision and heightened naturalism, most of them are infected by the plague of narrative, many of them are contaminated by coy audacity.

Beside his PRB contemporaries, Edward Burne-Jones is a breath of rank air, an orchidaceously foetid zephyr. He was probably truer to the brotherhood's shifting and retrospectively mutating precepts than the three original members. He was certainly the first English painter since Constable and Turner of anything other than parochial stature. While those two were the outdoorsy forebears of J. F. Millet, Corot and the Barbizon school, Burne-Jones's epigoni were

creatures of the hothouse, a fascinating bunch of exotics and poly-morphous perverts – which he himself wasn't. Save for a fling with the excitable Greek sculptress Maria Cassavetti Zambaco he was dutifully uxorious.

There is something of the pathology of the outsider artist about him. The world he created was a world apart, an ostentatious arti-fice. It was a recurring dream or nightmare peculiar to him. What was inside his head had only the most tenuous acquaintance with any sort of external actuality. His work was autonomous, obsessive, zealously self-plagiarising. And because it refers to little but itself it is not emotionally engaging: it doesn't cheer, it doesn't harrow. He indefatigably repainted the same planar compositions whose claus-trophilia is occasionally mitigated by an aperture grudgingly acknowledging an exterior world. More often there's no breathing space. The crowded frame is filled and overwhelming as it would be in Patrice Chéreau's *La Reine Margot*. Perspective is not invariably heeded. The same figures are revisited over and again, figures that are exaggeratedly androgynous wraiths contorted into abnormal postures. They are beautiful freaks, his beautiful freaks. They are far from Rossetti's objects of straightforward lust and carnal slavering.

If Burne-Jones's mannered figures had a natural habitat – and natural is an ill-advised word in these circumstances – it would be the mirrored dungeons within mirrored dungeons in a dark palace of fetishism and unorthodox sexuality. But that of, course, would be to presume a candour in a society which kept its abundant por-nography locked in the library. As Walter Sickert, an improbable admirer, wrote almost thirty years after Burne-Jones's death: 'the exigencies of the reign of Queen Victoria dictated drapery as a nec-essary veil for the figure . . . nine tenths of the people of England knew Burne-Jones through the distorting medium of *Punch*'s stu-pidities'. Small wonder, then, that Victorian painters were so adept at representing self-censoring folds of chiffon, organza and taffeta.

It was also professional necessity to go easy on zoophilia, jezebels in chains, phallic-shaped rocks, leering satyrs, nymphs, latex armour, rapacious mermen and wide-girth snakes and sea worms – 'grotesque, slimed, dumb, indifferent' (Hardy). Painters who worked in less proscriptive societies – Gustave Moreau, Fernand Khnopff, Félicien Rops, Arnold Böcklin – were not obliged to suppress their fantasies of mephitic 'decadence' and masturbatory morbidity to the same degree as Burne-Jones. They showed, while he could only hint.

That constraint was to his advantage. It was his ambition to make paintings that said nothing, which were mute objects, pure pattern, as uncommunicative and ambiguous as the modern Gothic, which by the mid-1870s was going out of fashion to be replaced by yet another bout of revivalism, this time of vernacular buildings with folksy 'roots' in Merry English soil. Burne-Jones's moment endured longer, but although he and his lifelong friend and sometime business partner William Morris were complicit in the foundation of the Arts and Crafts movement, he found himself at odds with English painting of the late nineteenth century, which was a reaction to rigorously formalistic design: looser, unbuttoned, less formulaic, less programmatic than that which had preceded it. And it addresses something outside itself. It looks at the world. 'Decadence', on the other hand, is incurious, ingrown, a decorative verruca. (2018)

Water, mostly

The Fens are against nature. I doubt if that's how I put it to myself at the age of twelve when the black sails of what might have been a Thames barge loomed above a road near Downham Market and shut out the day. It was terrifying. The presence of water higher than land prompts a sensation that is akin to vertigo. The primary purpose of a canal so straight that it disappears over the distant horizon is of course to drain the thousands of acres south and east of the Wash, thousands

of acres which are below sea level. The secondary, unintended, purpose is to frighten, to make hydrophobics of us all.

Denver Sluice provokes awe and horror. It is also addictive. How can we be sure that the banks will hold? In my nightmares they don't. How can we be sure that it is safe to drive across the Ouse washes? The relentlessness is discomfiting: every road looks the same. How can we distinguish the 100-foot drain from the 30-foot drain which might as well be the 50-foot drain? Landscape and waterscape fuse into a unique unforgiving entity that stretches as far as the eye can see: scary, gaunt, austere. This is a geometric open-air factory of meteorological mercilessness.

The Dutch prettify their polders and sweeten their dykes. They make colossal efforts to mitigate the ubiquitous harshness. With rare exceptions, no such niceties are affected in the Fens. To soften them would be to deny their quiddity, would dissemble their provisional essence, would disguise the inevitability of the sea's reclaiming the land, whose horizontal bias apes the sea's. No area of Britain will be more susceptible to the catastrophes that climate change will visit on us.

The sinewy landscape of black earth, the tough metallic waterscape of drains that suck their colour from the sky, the butch pumping stations and uncompromising silos are, whatever their appearance may tell us, fragile, threatened. They exist on borrowed time. Nature – the new nature of the Anthropocene – is going to have its revenge.

Fred Ingrams shares his subject's relentlessness. He paints it to the exclusion of all else. The repetition is fetishistic ritual. So no doubt is the practice of painting *plein-air* when, given how long he has been doing it, he must have the rectilinear maze fixed in his memory. The necessity is psychological rather than practical. He nags at the land and the water in a one-way exchange, squeezing out of them new colours, making them yield fresh forms, rendering himself suggestive to this meld of elements which is in constant mutation – if you keep your eyes open: the clouds and the immense sky,

the murmurations, the purl of water caught by a gust, the shadow of a pike in the reeds, the distant rain moving like a ghost ship.

Drains, delphs, dikes, sluices, catchwaters, gutters, leams: the industrial words attached to the Fens are apt in their bereavement of prettiness. Ingrams' work is a brusque visual analogy of them. He does not confuse the picturesque with prettiness. He offers no relief from an unforgiving repertoire of mudscape and opaque water which is not, however, minimalist. His work does not represent. It is not about the place where he puts down his folding chair and his easel. It is rather about the ideas which that place foments.

Some of those ideas concern colour, though this unclassifiable artist would probably not wish to have such an etiquette as 'colourist' attached to him. Nor would he answer to 'abstractionist', even though he takes prairies and watercourses which are extraordinary in their formal orthogonal cartography – as though Mondrian was working for the OS – and exaggerates them further to the point where the connection between canvas and 'subject' is dissolved. This is the very opposite of a photograph and it makes the point of *plein-air* practice comprehensible. His affection for the Fens is such that he divests them of menace. Familiarity has not bred contempt. He normalises them. In some of the more verisimilar works there are even rivers with bends in them like the Nadder or the Cuckmere, apparent invaders from a more recognisable England of pasture, hedges, sheep and kine.

Ingrams' Fens are devoid of those and, more notably, of human figures, though generations throughout the past 400 years are omnipresent in every drain and drove. It is not fanciful to see in Ingrams' insistent remaking of the same places a meditative monologue with the shades of the Earl of Bedford, Cornelius Vermuyden and the Company of Adventurers, who created the Fens for him, a gift he has repaid handsomely, votively. (2019)

2

Buildings

Super-hackneyed

The Good, the Bad and the Ugly by Rod Hackney

The judge's judgment is unsafe: Lord Scarman starts his foreword with the heart-sinking declaration that 'in a very real sense this book is Rod Hackney's personal testament'. That is to equate 'personal testament' with self-advertisement. Of course, Lord Scarman is not the only *bien pensant* to have been suckered by Dr Hackney's particular brand of no-nonsense northern philistinism – the Greatest and Best of all, HRH the Prince of Wales, has proved to be pervious to the former RIBA president's persuasive auto-hype, which doubtless sounds terrific, but which when committed to page ('with Fay Sweet') is seen to be a right old stew of received ideas and retrospective self-justification.

Dr Hackney's title is, in a very real sense, borrowed and, in a very real sense, crude. It is thus indicative of the book itself; the only original component is the autobiographical one. Dr Hackney was born in Liverpool and brought up in north Wales. The single occasion on which he prompts sympathy is when he admits that he was taught in Welsh. Nothing if not cunning, he imparts that spot of intelligence on his first page in the hope, perhaps, that the reader numbed by his unsupple English prose may forgive him.

So, let us forgive him his fumbling with what is a partially foreign language; after all, we forgive Conrad and Nabokov. And, of course, Dr Hackney doesn't claim to be a writer. No, his claim – made with Tartuffian humility – is that he is Super Hackney, righter of his country's ills, the guy with the prescription that will cure inner-city malaise. Before he reaches the prescription – which is 'community' architecture in massive doses – he treats his readers to a protracted diagnosis. This is an extended and familiar litany of anti-modernist shrieks. His appeal is all too discernible. It relies on his reduction of the comparatively subtle arguments of Bruce Allsop, David Watkin, Nicholas Taylor and even Christopher Booker to simplistic and panacean recipes – the kinds of slogan liable to win favour with those who gull themselves into believing that there is An Answer. He is as much an architectural determinist as any post-war Utopian, and just as ready with a blanket solution.

He doesn't realise – but then he wouldn't – that he is heir to the clean-sweepers with their 'vertical streets' and cities in the sky. His simple, modest wish to go back to the back-to-back is made without apparently investigating why the generation that built in the 1950s and 1960s built as it did. All he can see are the (mostly) sorry results; his antipathy to high-rise slums is precisely akin to that generation's antipathy to terrace slums.

The fact is that high-rise domestic buildings work in most countries, and work here when occupied by the well-to-do. Their failure as 'social' (i.e. working-class) housing was caused as much by this country's lack of a janitocracy as by architectural ineptitude. And the suggestion that vandalism, yobbery, mugging and similar hobbies are fostered by high-rise buildings is to ignore our rich heritage of those pursuits. 'Tradition', the way Dr Hackney uses it, is either invented or selective.

However, the tradition that he himself belongs to is real enough, and doesn't require the qualification of quotation marks. He is the

latest in a long line of retrophiliacs that includes William Morris and Ebenezer Howard. That those writers were vehement opponents of the very buildings Dr Hackney wishes to preserve is neither here nor there – what was new and offensive to them is old and reclaimable to him. The point is this: retrophilia, and a trust in part of the past, is a state of mind, a pretty extreme state of mind. And an understandable one in a youngish man at odds in the early 1970s with, professionally, the architectural decadence of late modernism, and with, personally, the profligate and unimaginative bureaucracy of Macclesfield's planning department.

That Dr Hackney should have become 'politicised' is not surprising; but that he should, almost two decades later, remain victim to his polarised views suggests that he has not put his head up for long enough to appreciate what's going on. While he has been busily undermining the practice of architecture by denying the primacy of the architect, his more gifted coevals (Gough, Dixon, Wickham, Farrell, etc.) have reacted to the architectural bathos of their adolescence, not by throwing in the towel, but by creating buildings that go out of their way to appeal to a popular audience.

The attitudes of Dr Hackney, who seems to believe that houses are no more than shelter, that fitness for purpose is an end and not a beginning, that the past can be repeated, are mercifully irrelevant. (1990)

Let bygones be gone

Ancestor worship is, inescapably, a dominant psycho-cultural force in an old nation which persists in officially sanctioning the primacy of blood and genes, a nation which has deluded itself in the face of momentous social changes that one generation's status quo will do for the next and for the one after too.

The last quarter of this century has witnessed a craven fore-lock-tugging to a gamut of notional pasts – nothing odd here, of course, for even at the apogee of their belief in progress, human improvability and the future, the Victorians were energetically engaged in what Terence Ranger and Hugh Trevor-Roper called the invention of tradition. This is not the oxymoron it first appears to be – all traditions are inventions.

What distinguishes our recent retrophilia from that of the Victorians is its passivity, its respectfulness, its fear, its dubious conviction that we have more of a duty towards our ancestors' artefacts than we do towards our heirs'. It is as though we believe that their posthumous well-being will be jeopardised if we destroy their former habitat.

Our pickling of the past would not have been so debilitating had it been conducted with a less frenzied promiscuity and had it not led to such a meek, milk-and-water architectural mainstream as we have today. I am not, evidently, referring to the work of the stellar few which is so often illustrated in newspapers and magazines that we begin to believe, against the evidence of our everyday experience, that it is somehow typical. It isn't. What are typical are the aesthetically bereft pseudo-vernacular estates of the housing goliaths and the yokelish would-be barns which serve them as supermarkets and which relentlessly cause offence through their nerveless determination not to cause offence.

They are monuments to creative cowardice, to the same cowardice and the same lack of audacity which came close to scuppering Richard Rogers' Millennium Dome. A calendrical fortuity based on a system of belief that no rational person can subscribe to is as good an excuse as any to construct a building whose purpose is to glorify the Christian premier with whom it will be for ever linked: it doesn't matter that it is currently, let us say, pre-functional. It will be bigger and much better than the dome which the slave-driver

Speer intended for Berlin, and it will be complete within three years of Neulabour's *Machtergreifung*.

It is beside the point to dismiss the dome because no one is quite sure what it is for. It is for the sake of making a grand building. It will be its own justification. It is a representative building, a gesture by the state which articulates a faith in the future (even if that future is not wholly independent of the modernist past).

Besides, if this state can pour money into the preservation of buildings which no longer fulfil the functions for which they were intended, why should it not splurge out on one whose future role is obfuscated? This surely represents a greater optimism than customising, say, a theatre or a library. We do not, after all, know what is to become of our children when we bring them into the world.

So the complementary celebratory gesture would be euthanasiac: switch off the life support for buildings which are over the hill, buildings which are burdens. I do not mean old Labour's headquarters in Walworth Road, although the rear extension is a particularly timid example of the desire to salute the undistinguished past by being 'in keeping'. I mean demolition on symbolic rather than utile grounds, in order to lighten the load of history rather than to free space for new buildings – though that would be a peripheral benefit.

There was a time when the old was unassailable because of what might replace it. Today the old is unassailable merely because it is old. Buildings are protected because they have achieved longevity, not because they are any good. Georgian terraces have attained inviolable status no matter how meanly proportioned, no matter how jerrybuilt, no matter how absurd their pretensions to a palatial whole: the very fact of having been put up somewhere between about 1720 and 1830 allows them to bask in the reflected glory of Bath and Edinburgh. The fact that they display none of the energy or imagination of their Victorian successors goes unacknowledged. They set the standard for good taste, which is the enemy of invention.

Islington is one of the most architecturally dreary areas of London. It fails to display London's greatest characteristic, that of perpetual mutation. It affords few surprises other than (obvious) anomalies such as the grotesquely proportioned early-Victorian Milner Square, which might have been wrought merely to tell its neighbours how prim they are, how dismally conformist.

Our 'age concern' for buildings means that to propose the elimination of some repository of Dark Ages mumbo jumbo is a kind of heresy. Well, it's not. The equation of age with worth represents the triumph of archaeological cant over aesthetic consideration. (And it also ignores the uncomfortable commonplace that most medieval churches are merely stone-by-stone copies of themselves.) A little light culling may sound barbarous but it might help to jolt us out of the mindset which has more or less granted old buildings 'rights'.

Had our forebears whom we so value behaved with the same exaggerated courtesy towards the urbanistic and tectonic legacy they got from *their* forebears we would have no sewage, no running water, no metalled roads, no St Paul's, no underground railway networks. I can hear you: what harm has Stonehenge ever done anyone apart from a few dog-on-a-string people and some Wiltshire coppers? And what's wrong with Castle Combe, and Sissinghurst, and Milton Abbas?

You need to have a sweet tooth, sure, but cuteness is no crime. The places themselves are unexceptionable. It is their cloying hold, their douce dulling of the middle-English brain which has to be alleviated if we are not to begin the next big one rushing headlong into yesterday. It is time we considered the dangers of the viruses vectored by our sacred cows in brick and stone, time that we heeded the damage wrought by over-adoration of them. The millenarian delusion will be more sustainable if it accommodates purging as well as making. (1997)

Garden of earthly delights

When they built Heaven-on-Earth in north London, they did it in earnest. They made Hampstead Garden Suburb with unwitting literality. When Shaw referred to Letchworth Garden City as 'the heaven near Hitchin', he did so with what is called Shavian irony (which is no different from anyone else's irony). Sadly, the garden citizens took him at his word and thought that he believed in their arcadia of nude dew-bathing, theosophy, rational dress, folk dance, teetotalism, vegetarianism, communality, socialism and humankind's improvement through such measures.

Letchworth, founded in 1903, and the first garden city, was proselytisation turned into bricks and tiles and hedges. It was a book come true. The book was Ebenezer Howard's *Tomorrow: A Peaceful Path to Real Reform* – the gap between book and the garden city's inception was five years. And the gap between Letchworth and its most potent mimic, Hampstead Garden Suburb – whose buildings last month were listed as 'a national treasure' – was even briefer. We have tended to conceive of the 1890s in terms of that decade's most extreme, most atypical manifestations – the aftermath of Cleveland Street, Wilde's trials, et cetera. It's a rather flawed conception, analogous with the idea that Brian Jones and Brion Gysin typified the 1960s. The current of thought prevalent in the 1890s which has stretched furthest into this century was one of reaction; retrospection pointed the way.

When Spencer Gore and Harold Gilman, Slade contemporaries in the mid-1890s, painted Letchworth, they did little more than record. Their precept might have been 'the more mundane the better'. John Buchan later gave it a going-over in *Mr Standfast*, a First World War adventure story: Buchan's take on the place, which he calls Biggleswick (were you listening, Captain W. E. Johns?), is gleefully antipathetic. He calumnises the sandal-shod peaceniks (as they

were not yet called) as a group of German spies and fellow travellers behind the wicket fence. It's as though Monsignor Paul Johnson of the Church of Christ Paedophile had suddenly cottoned on to the delusion that New Age travellers were all in the pay of Herr Adolf Kohl and M. Hermann Santer.

The garden cities are never, and never were, like that at all. Howard's programme for a means of urban reform, which ignored the very cities that had prompted it, coincided with a generational shift in architectural taste. What was revolutionary – or at least novel – about the men who began to practise in the late 1880s and early 1890s is not that they ignored; they looked backwards as zealously as their immediate precursors, but they looked with a different curiosity. With the exception of the late-Georgian craze for the cottage *orné*, i.e. the tarted-over bothy, the buildings that provided the models for eighteenth- and nineteenth-century architecture were grand buildings.

Domestically, this was translated into the terrace, which pretends, or initially pretended, to be a single building – a palace for the people with, say, an articulated middle and accents at the ends. All detached buildings from 1720 on aspire, one way or another, to be more than they are. The class of 1890 had simply run out of posh archetypes. Either that or it was in thrall to the same vogue which occasioned plain painting and the transcription of folk songs.

All of a sudden, you didn't need to go to Bruges or Siena or Gloucester cathedral. You took your drawing pad to Gloucestershire or down the road to Tenterden or to anywhere whose humbleness was pre-industrial.

This vernacular revival was increasingly characterised by an eschewal of industrial materials. The fakery was no more convincing than that of the High Victorian era but it was softer, sleepier, more mellow. It evoked drowsy summer days. These qualities, evident not only at Letchworth but at Cadbury's Bournville and at Lever's Port Sunlight (also now listed), should have informed

Hampstead Garden Suburb — but that's not quite the way it turned out. Something else got in the mix.

Dame Henrietta Barnett was a philanthropist first and only incidentally a patron of architects. Her family had been instrumental in the foundation of Toynbee Hall in 1883; this was the project which would lead to the Welfare State — both Beveridge and Attlee worked there as young men. The Barnetts also set up the Whitechapel Gallery and land colonies for the unemployed. The Hampstead Garden Suburb Trust was established for other ends. Its purpose was to prevent Hampstead Heath's north-western extension from being swallowed up by promiscuous speculative development. Far better a planned development, a socially engineered development, a development overseen by the great and the good and devised by Barry Parker and Raymond Unwin, who had masterminded Letchworth.

Parker and Unwin belong more to the history of urbanism, or suburbanism, than they do to that of architecture; they were pioneer town-planners whose imperatives were social rather than aesthetic. Their own buildings at Letchworth — the Mrs Howard Memorial Hall, for instance — do not begin to compete with such prodigies as the Cloisters, a residential school of psychology whose students were required to sleep in hammocks on waywardly wrought balconies.

The architect was the little-known William Harrison Cowlishaw, and he was one of many who latched on to the garden city movement as a career opportunity. It was the architectural gravy train of the years up to the First World War. And many of those who had contributed to Letchworth went on to work at what north London rather coyly calls the Suburb.

Despite the tokenism of providing houses for workers — houses which are anything but blue collar today — the Suburb represented a variant on the commonplace pattern of the bourgeoisie following bohemia. It wasn't really socially experimental like Letchworth, it

merely borrowed its mannerisms. The majority of the buildings are in two styles – posh cottage and the acceptable face of neo-Georgianism. The contours of the site and the absence of wide verges give an illusion of high density. There are hedges, closes, white balconies, pseudo-collegiate quads. There are no shops and, as at Letchworth, no pubs. It is a debilitatingly monofunctional place.

Way after garth after close is lined with patently well-made exercises in the muted picturesque. The faux naivety is not overwhelming: here's the hedge, here's the gate, here's the garden, here's the front door and behind the front door is an untroubled family with immemorial pipe tobacco and good plain food on the hob. You don't get this – the delusion, not the food – rammed down your throat. The tweeness stops short of being emetic. The vocabulary of gestures and devices may be limited, but it just about rises above infantilism. The thing that sets the Suburb apart from all other garden cities and suburbs is two sights on its fringes and one at its centre.

A. J. Penty was a Fabian, a devotee of guild-socialism and the author of a textbook on neo-vernacular design. He built only in the artiest, craftiest places such as Ditchling and Haslemere. His masterpieces are both at the Suburb. They are both defences of a sort. At Temple Fortune, the western extremity, he designed two blocks of flats and shops – steep roofs, pitched gables, almost Germanic. To the south he defined the Suburb's boundary with a wall across the Heath extension, a wall which is broken by gazebos. It is a delightful device.

In contrast to Penty, Edwin Lutyens was an opportunist, a genius and a charlatan. Indeed, it has been suggested that his genius was conditional upon his charlatanry. He happily bit the hand that fed, but only *after* it had fed. He described Dame Henrietta Barnett as a philistine and secured the job of designing the Central Square through his client Alfred Lyttelton, who was chairman of the trust.

Lutyens had more or less invented the idioms which every other

architect working at the Suburb was using. He was far too perverse and wayward to follow suit. Instead, he did a version of Heaven-on-Earth which is simply heaven – it works on the senses in such a way that you wonder if you're dead, if you're a revenant visiting an England which has subtly, indefinably, but definitely changed since you moved into another state. It's not quite right, somehow; it's certainly not as you remember it. At dusk, under the leftovers of a mackerel sky, it is the spookiest place. Lutyens had a gift unique in the history of architecture for making buildings which belong to dream or hallucination. They might have been remembered from such a state by their author, and they affect their spectator the same way they amend reality's limits. Marsh Court, Tigbourne Court, the Pleasaunce (get that olde spelling) – these houses are through the looking glass all right, but they're bright and benign.

The Central Square of the Suburb is chilling; one half expects to see Millais' nuns, or a burial, or black-plumed horses. There are two churches. Both have too much roof, both display a volumetric geometry which is counter-intuitive. One has a dome. The other has a weird spire which owns various anthropomorphic, specifically mask-like, features. Between them is a plain with formal lines of trees.

Across the road is the restless bulk of the Institute and the Henrietta Barnett School. These three buildings are at the Suburb's highest point, and from the south, just beyond Penty's gazebo'd wall, they look like the climactic accents of . . . what? It's too easy to say a medieval hill village, and, besides, the elements are also Carolean and baroque. It's more akin to some kingdom of the dead from which we escape on a magic carpet . . . It's more likely Lutyens' joke against utopianism. But it's not hell, certainly not.

The idea of a place where there are no pubs and no shops may seem hellish, but that's different. We have had a century, give or take a few years, to see just how undesirable the single-use suburb

is, and how damaging to society – that's why such places have to have substitutes for social intercourse in the shape of institutes and churches. Cafés, shops, pubs are much more the ticket.

The Suburb has also proved a flawed model for suburbia. Had Nanny Barnett and the Esperantist Howard addressed the problem of cities rather than sweeping it under the carpet . . . But that's looking backwards.

Look eastwards from the first streets of the Suburb and you can follow the degradation of the standards of domestic architecture from that high year when the place was born. By the time you've reached nearby Winnington Road, you're in deep shit and big money; but one day these deluxe mansions will also be listed, as peerless examples of mid-century builder-designed speculation. (1997)

Blind faith

England's 1,000 Best Churches by Simon Jenkins

Big as a dwarf's hassock and heavy enough to stove in an apostate's head, this is one man's monument to his doggedness, deflected patriotism, descriptive acuity and eccentricity.

Simon Jenkins is a supremely urbane man. He doesn't look like a trainspotter. He began with a list of 2,500 churches and whittled it down. He travelled by car with a mobile phone and a copy of *Crockford's Clerical Directory*. If he couldn't gain access to a church within half an hour, he refused to consider it, a method which may account for some of the more startling omissions. (Is, say, the greatest of Greek revival churches, at Great Packington in Warwickshire, not here because the god-botherer in charge wouldn't let our man in? We should have been told.)

He also travels – though he doesn't admit it, he could hardly deny it – with an antiquarian, specifically Gothic, prejudice. His bias is towards buildings of the 400 years before the Reformation

and those of Victoria's reign. The Church was at its most mighty during the former period, and that was one reason why anti-Enlightenment ritualists such as Pugin, who sought to put the mystery and awe back into religious observance, reinvented the architectural and decorative forms of the Middle Ages. Victorian Gothic is probably the most culturally reactionary movement ever to have afflicted this country.

Jenkins likes incense; he enjoys the opulence of such over-decorated temples as Bodley's Hoar Cross in Staffordshire, Pearson's St Augustine in Kilburn and William White's St Michael and All Angels in Lyndhurst. He tells elsewhere that White, a rational dresser and mountaineer, was the great-nephew of Gilbert White. There's a vast amount of such extra-architectural detail: the sort of stuff Pevsner, a dry taxonomist, would not have admitted, but which Jenkins' tutelary precursor, Betjeman, would have delighted in. Edward Jenner, son of the rector of Berkeley, tried out the first vaccines in the parish; among the annual endowments paid to the Hospital of St Cross in Winchester was a fishing village's dolphin. It is these peripheral details which partly validate Jenkins' claim that churches, for so long the focal buildings of communities, are the real museums of England.

Of a former England, one might say, for despite the fuss about the Christian millennium, the Church and its fatuous unreason no longer play an important part in this nation's life: the Church shot itself in the foot when it modernised and deprived its punters of the superstitious solaces they craved. It demonstrated what it was doing by constructing, through the second half of this century, buildings which ruptured the liturgical certainties the Ecclesiologists had so diligently set in stone and polychromatic brickwork, tiles, brass and fruit-gum-coloured glass. Jenkins' abhorrence of slummy worship-sumps is understandable enough: he evidently brackets them with wind farms, power stations and telecom towers. But this doesn't

explain his blindness towards earlier twentieth-century architects such as Edward Maufe and N. F. Cachemaille-Day, pretty much the nearest thing to an expressionist England produced.

He also evinces a marked distaste for classical churches – the century and a quarter between the brief flowering of the English baroque and the triumph of archaeological Gothic is virtually ignored. I suspect that in his view the Georgian practice of building churches as eyecatchers is frivolous and mildly blasphemous. When he does look at a church of that period it is with Daltonist's eyes: St Chad in Shrewsbury is of pinkish-mauve sandstone, not grey. And Pershore is on the Avon, not the Severn. No matter. Jenkins overwhelmingly gets it right. As a vade mecum and a testament to gentlemanly taste, this'll do for a generation or so.

Those who rue the absence in such a book of allusions to the Church's strong suit, paedophilia, are reminded that at Purewell in Dorset, the church of the Immaculate Conception and St Joseph contains a fresco by Frederick Rolfe, aka Baron Corvo, who used unclothed local boys for the photographs which formed the source of the composition. Enjoy. (2000)

From pillars to post

The mildly deprecating acronym nimby – not in my back yard – is, according to Jonathon Green's magisterial *Dictionary of Slang*, an American coinage of the 1970s. Its British usage began in the subsequent decade. These dates are pertinent. Nimbyism was a symptom of a wider, more generalised disaffection with new buildings. Indeed, building sites in those days prompted trepidation: what monstrosity is about to be planted here? The architectural profession was reviled, and knew it, and so lost confidence. It retreated initially into a cowering, self-effacing insipidity, tried to shroud its work in modesty and 'good taste' – qualities which don't come

easily to it. Mannerist late-modernism gave way to a sort of humble neo-vernacular, to buildings which whispered, 'I'm not really here. I'm just fitting in.'

And when confidence was, eventually, partially regained, the buildings that were made expressed a populist desperation to be liked. Postmodernism's infancy was characterised by an eager 'accessibility'. Gravity was out, fun was in. A profession whose product had been the analogue of, say, John Cage or Stockhausen turned within a few years to churning out stuff which possessed all the rigour of a Radio 2 pop tune. We could, so to speak, all hum along.

Architecture is, always has been, allusive, infected by references to its past. The early postmoderns simply wrote their quotes in bold capitals and underlined them for good measure. They dumbed down to suck up. They were humorists – well, aspirant humorists. They attempted to revive the conceit of architectural wit, a strain which, with rare exceptions (Lutyens, Le Corbusier, Lubetkin), had been largely dormant since the turn of the nineteenth century, when Ledoux represented flowing water in stone and the fantasist Lequeu designed a regrettably unbuilt dairy in the shape of a cow.

Apart from Piers Gough and Ricardo Bofill, these postmoderns were seldom particularly funny. Architectural jokes suffer the problem of being for ever there. Most gags wear thin with repetition. I guess that Gough's work, like anything of the immediate past, now seems rather unfashionable. But it persists in delighting this observer with its audacious levity and sheer sprightliness. It's tectonic proof that there's only one school that matters, the school of talent.

The importance of his and his contemporaries raiding the larder of past styles is that it amended the compact between architecture and the public. It created a public appetite for the new. We moved from nimbyism to what might be called pimbyism: please in my back yard. Postmodernism is habitually assumed to be dead,

consigned to the status of period piece along with big shoulders and big hair.

I'm not so sure. I prefer to believe that postmodernism, having ransacked classicism, the Gothic, the baroque and just about every other idiom one can think of, elected to revive early modernism. This tendency had actually begun as long ago as the late sixties and early seventies with the work of Douglas Stephen, Georgie Wolton and the young(ish) Norman Foster.

In 1975 I was going to Portman Road to watch Ipswich play and I vividly recall my first sight of a building which I passed on my way, and can equally recall my bemusement: why did I not know of this sinuous, black glass masterpiece of the 1930s? There was a good reason why. It was, of course, Foster's very recently completed Willis Faber building, which looked back in order to look forward.

The American architect and writer Philip Johnson described Foster as 'the last modern architect'. Johnson was, for once, wrong. Along with Stephen and Wolton, Foster was, on the contrary, one of the first neo-moderns or synthetic moderns. But it wouldn't be till the nineties that the tributary they had created would burgeon into the mainstream.

What we have witnessed these past ten or so years is a sort of user-friendly modernism, a cosmetic modernism stripped of the hermeticism which afflicted so much work of the twentieth century. There no longer exists the pretence that modernism is anything more than a style. The old architectural establishment's boast that it was morally imperative now seems vacuous, a quaint fib spun out of a strangely defensive hubris and out of the British conviction that an aesthetic programme is never its own justification: there has to be an appended reason. It wasn't merely bad buildings that caused architects to be held in contempt, it was also this institutionalised self-righteousness.

Questions have to be asked about the quality and appropriateness of numerous current and prospective schemes in central London. It is as if developers, architects and planners, having rehabilitated themselves in the public's eyes, are once again on the point of forfeiting that goodwill. Not through seeking to build high but by a want of imagination.

Southwark planners who approved the Piano tower are also determined to drive through a proposal to build on the site of Bermondsey antiques market. This will come as no surprise to anyone who has had dealings with this fine cadre. One of their number rejected an architect's application to extend a building in the borough on the ground that his design was not in keeping with the Victorian original. The Victorian original in question was built in 1997. (2002)

Season to taste

After one coincidence, you can be sure the next isn't far behind. I was reading *What's to Become of the Boy*, Heinrich Böll's memoir of his Cologne childhood under the Third Reich, in which he suggests that 'perhaps it is not in school but on our way to school that we learn lessons for life'. En route to one school I attended in Salisbury there was an elegant set of almshouses, a philanthropic gesture of the early eighteenth century in brick with stone quoins. The lesson I learned was that old people smelled so bad that I had to put my hand over my nose. (It wasn't until long after I had left that school that I discovered that the sickly odour I ascribed to elderly folk was in fact that of the 'mash' in the adjacent Gibbs Mew brewery. Preposterously, I cannot to this day inhale a brewery's scent without being assailed by nagging images of senile decomposition.)

This may not be the sort of life lesson that Böll had in mind. It is more likely that he was alluding to the sort of extracurricular

epiphany that the architect Andrew Rabeneck evoked at a recent dinner of the Architecture Club. He described how, while studying at the Regent Street Poly in the 1960s, he would pop round the corner to the Academy cinema on Oxford Street. There, the recent north Italian architecture in Antonioni's films gave him a valuable tutorial, demonstrating that there was a way of doing things 'other than the Smithsons'.

Forty years ago, such an opinion would have been regarded as heretical: the modernist orthodoxy was quasi-totalitarian. Rabeneck was questioning these most sacred of sacred cows: in their day, the Smithsons were surely the very personification of architects' architects, comprehensible only to veterans of the Architectural Association or the Bartlett. And here's the coincidence: only a few weeks previously, I had heard the Smithsons' praises being lavishly sung by a non-architect.

The writer Nick Fox enthused over dinner in Salisbury about the Smithsons' own house from the late 1950s, near Fonthill Abbey on the border of Wiltshire and Dorset. As I discovered the next day, Upper Lawn Pavilion is indeed a delight – not a word I ever expected to apply to their work. How I had missed this elegant caprice is a mystery, as I didn't think there was a lane or road between Salisbury and Shaftesbury I had not cycled or driven along.

Apart from its obvious merit, it is interesting as a rarity: south Wiltshire is architecturally conservative. With the exception of this small house and a demolished paraboloid roof extension to the Royal Carpet Factory at Wilton, there are no modern buildings of any merit. There is, however, plenty of modern dross, much of it inflicted on Salisbury Plain by the Ministry of Defence.

The question we should ask ourselves about buildings is not whether they are cutting edge or hopelessly reactionary but whether they're any good. Unhappily, it appears that we are still

burdened with a Pevsnerian world view that declines to acknowledge merit in architecture that doesn't conform to the tenets of old-fashioned modernism.

Reporting on the prodigal refurbishment of the MoD's Whitehall headquarters, Martin Spring quotes Pevsner's opinion that it is a 'monument of tiredness'. Pevsner also refers to it as 'particularly distressing'. This is to be taken with a pinch of salt. The great taxonomist was also a zealous and predictable propagandist. The MoD is certainly, to use a favourite reproach of Pevsner's, *retardataire*. But then it was designed almost four decades and two world wars before it was built. Half a century on, the fact that it was dated when it was new is an irrelevance. It belongs to an alternative strand of architectural invention, a strand that is as rich as it is unfashionable. It is possible to devise a history of twentieth-century painting that omits abstraction, and an architectural tradition that omits international modernism, but includes revivalism, expressionism, the Torinese baroque of the 1950s, the neo-Gaudí eccentricities of Pancho Guedes and so on. Italian 'rationalist' Aldo Rossi, whose de Chirico-like classicism may – coincidentally – have found its way into Antonioni's films, was famously fascinated by the MoD, and is said to have rather exasperated his English hosts by wishing to visit it rather than architecturally correct monuments to newness. (2004)

Building a library

Architectural writing tends invariably to the propagandist. The battle of the styles was being fought centuries before that epithet was coined. Even the most apparently innocuous and neutral guidebook chastises by omission. And the greatest historians and theorists are linked by their furious bias. So start with Geoffrey Scott's *The Architecture of Humanism* (1914), which reproaches the practices of justifying buildings on grounds other than the aesthetic and of

ascribing to buildings ethical or romantic or progressive qualities. It need hardly be said that Scott's elegant mockery had no effect whatsoever on subsequent writers who continued to advocate whatever pleased their eyes by pleading social necessity or the spirit of the age or moral probity.

The most celebrated, though hardly most culpable, such writer of the recent past was Pevsner, a taxonomically inclined modernist ideologue whose county by county *Buildings of England* (1951–) series initially presented a weirdly partial country largely bereft of neo-Georgian offices, mock-Tudor suburbs, pseudo-Andalusian bungalows and so on. Yet no one can ignore these dry and dogged works which are constantly being revised by more catholic scholars. They are not cheap and recent editions no longer fit in any but the most capacious pocket. Settle first for those to counties you're likely to visit. Many include essays on geology by Alec Clifton-Taylor, author of *The Pattern of English Building* (1962), an unmatchable key to the link between vernacular architectural idioms and locally available materials. He was a man of obstinate prejudices, among them an abhorrence of white-painted woodwork and of the industrially produced brick and encaustic tiles which the High Victorians so relished. He loathed the harsh, fanciful temples to Mammon that J. Mordaunt Crook surveys in *The Rise of the Nouveaux Riches* (1999), an energetic tale of cotton barons, meat extract tycoons, Francophilia, invented genealogies and massive ostentation. It links a particular gamut of buildings to the small section of society that commissioned them: it uses architecture as the oblique illumination of an all-but-forgotten world.

The same may be said of Gavin Stamp's *The Memorial to the Missing of the Somme* (2006), a moving paean to Lutyens' great work, an analysis of its convoluted gestation and equally a sober invective against such generals as the 'repellent' Douglas Haig and the criminal folly of governments which prosecute unnecessary wars.

A kindred melancholy infects Sir John Betjeman's *First and Last Loves* (1952), which is bewilderingly less known than his verse or his telly films. It is a collection of journalism. But what journalism! Born of a relentless curiosity, it is passionate, informed, bolshie and immune to received opinion. There are, as one might expect, essays on Cheltenham (which he preferred to Bath), Cornish churches, municipal vandalism, the Gothic revival, etc. His enthusiasm for the neglected, the decayed and the otherwise unloved is also thrillingly conveyed: the strangely baroque north Wiltshire town of Highworth, Nonconformist chapels, Hayling Island, Weymouth. He notes 'buildings are the only record of civilisation'. That may not be quite so but it is the sentiment which underpins *Nairn's London* (1966), a sort of characterless novel of the capital by the greatest topographical writer of the past half-century. Like Betjeman he looked, gaped, questioned. His sense of place is total. His prose is zingingly fresh. His descriptions are unforcedly original: 'demoniac, an Edgar Allan Poe of a building', 'Earls Court is a hippopotamus in the water hole', 'the Festival Hall: acoustically perfect and spiritually numb'. (2007)

Out of the Dark Ages

In his encomium *La Gloire du Val-du-Grâce*, Molière contrasted Mansart's baroque church with 'the dismal taste for Gothic monuments, hateful monstrosities vomited up in torrents by barbarians throughout the centuries of ignorance'. That, in 1669, was still the received wisdom.

The word gothic was initially a term of propagandist disdain. Though he did not coin it, *gotico*, like *rinascimento* (renaissance), was popularised in the mid-sixteenth century by Giorgio Vasari, urbanist, architect and eloquent champion of the classical aesthetic derived from Greece and Rome. Gothic – in its multiple variations the predominant European architectural idiom between about 1150

and 1500 – was made to stand for everything that Renaissance architecture wasn't. Thus, it was supposedly disordered, accretive, fantastical, superstitious, uncouth, violent and symbolic of the Dark Ages, 'the centuries of ignorance'.

It had only a figurative connection to the Goths, who came from Scandinavia or Pomerania or somewhere else in the benighted north and attacked Rome in the fifth and sixth centuries. But it was a connection that stuck and whose legacy is the art historical bias towards the paramountcy of the south and, particularly, of Italy. A later aesthete also besotted by Roman grandeur and columnar pomp, Adolf Hitler, derided the Gothic as 'Asiatic'. A near miss: the earliest essays in what would in the twelfth century become the quintessential architecture of Christendom are in the ruined city of Ani in Armenia, in Muslim North Africa, Andalusia and Sicily. The last is most significant in the Gothic's development, for the Normans invaded Sicily soon after they had conquered England.

The Normans' attempt to foist their language on their obdurate subjects would eventually result in the mongrelism of Middle English (which results in modern English's glut of synonyms). Similarly, the Gothic architecture synthesised in the Île-de-France (Saint-Denis, etc.) sixty years after the invasion flourished only briefly in England before its 'purity' was contaminated by localised heterodoxy. The rapidity of the Gothic's mutations is testimony to the energy and ingenuity of its makers. The notion of the Dark Ages' barbarism is quashed by the sheer invention and disparity of the great cathedrals: Salisbury's chapter house and spire, Exeter's and Wells' west front, Gloucester's cloisters, the mighty bulks of Ely and Lincoln (which suggest that their builders understood the phenomenon of size constancy). But that notion of barbarism is equally reinforced by these monuments to the vast and corrupt temporal power of the unreformed Church and to abuses made stone, such as chantry chapels.

Buildings

The Gothic may be a gamut of disparate architectural styles and contrasting systems of engineering but what ties it together is its 'sacred' purpose. The majority of Gothic buildings that have survived were built to the glory of god and for his workforce of simonists, pardoners and peddlers of indulgences: the personae of *Piers Plowman*. The homes of the Church's victims, on the other hand, were built of less staunch materials than limestone, flint and brick: they often literally dissolved. Grander dwellings, while better made, were still constructed according to regional precedent: the first great era of unfortified, style-conscious domestic architecture occurred in the wake of the dissolution of the monasteries by when the taste for the Gothic had – perhaps not coincidentally – passed.

Extant Gothic buildings other than churches are rare. And they were nearly all connected to churches: the link between Gothic and god is stubborn. The purpose of (the much altered) Vicar's Close at Wells is self-evident. It was probably unprecedented and is very likely the *fons et origo* of the English terrace. The precincts, closes and liberties of cathedrals abound in detached houses which take their cue from the great house of god in their midst. Hospitals and almshouses – supreme among them St John's Hospital, Lichfield – also borrowed ecclesiastical devices and symbols: thus the pointed arch takes on the role of a favourable conjugation of magpies. The building must be blessed. Even barns must be blessed: especially the tithe barns where crops that the Church excised from farms were stored. The finest of these at Tisbury, Bradford-on-Avon and Great Coxwold may be pared-down, elemental, primitivist Gothic, but they still feel like sacred structures which acknowledge god's provisions of rain and sun. The stench of superstition is almost as worrying as the realisation that people still today quaintly subscribe to what David Hume called 'sick men's dreams'.

Frequent plagues, perpetual wars, short life, painful death . . . Everything was in the hands of god, who existed because humankind

enjoined him to exist, he was ubiquitous in the wishful collective imagination. It was not for nothing that the nineteenth-century religious revival was self-consciously entwined with the Gothic revival (a lot more of the stuff was built that time round, including holy town halls and sacred railway stations). The inescapable link between these great medieval buildings and their purpose, between a visual, plastic idiom and its voided 'spiritual' pedagogy, militates against a ready appreciation. Every exquisite rib vault proclaims a theological deceit, every blind arcade an enslaved mind. Perhaps best to think of it wearily as just another instance of that human perennial, enlightened technology serving an occluded end. (2010)

Failing upwards

The single most celebrated edition of the *Architectural Review* was published fifty-nine years ago. 'Outrage' made Ian Nairn's name. It was a precocious exercise in architectural and topographical agit-prop. It gave the language a fresh coinage, subtopia: even Prince Philip got his laughing tackle round this modish new word. It was widely discussed in the non-specialist press and in the House of Commons. It spawned amenity groups including the Civic Trust, radio broadcasts, TV films, exhibitions. And it was entirely atypical of both the *AR* and of the other architectural magazines of the day. It was such a resounding success because its very subject was failure. Rather, failures.

The failures of planning legislation, of local authorities, of central government, of property developers, of speculative builders and, above all, of the architectural imagination. The failures that were so omnipresent they were taken for granted and had remained largely unwritten about since Clough Williams Ellis's *England and the Octopus* appeared in 1928. Ruralist writers such as H. J. Massingham and Brian Vesey-Fitzgerald might have parenthetically

deplored what the latter called Jerrybethan suburbs and arterial road sprawl, but their paramount interest was the preservation (or revival) of a pre-industrial England, all hurdles and handcraft, a wishfully escapist enterprise that was bound to fail, just as Nairn's faith in a new generation of architects who might heal the damage wrought by their predecessors was destined not to be redeemed. There was an inevitability about this. Nearly all architecture fails in some regard, functionally or aesthetically or technologically or socially. And leaving aside the fact that it is death that is the ultimate failure, architectural lives, like political lives, like, indeed, all lives, end in failure.

Personal failure, professional failure, reputational failure. If you live a long life you will see your works destroyed – if, that is, any of your projects were actually realised; you will be accused of betraying the 'principles' of your (comparative) youth by creating unaffordable housing; you will be accused of having created antisocial housing in your (comparative) youth; you will suffer derision after a lifetime's balmy adulation; worse, you will be ignored and forgotten. The period of neglect which follows your death may be infinitely expanded. It may stretch down the decades. There's every chance that you will be presumed dead when you are merely toddling about the house with that well-thumbed copy of the *1964–65 Daily Mail Book of Bungalow Plans*, which included your breakthrough Sun Trap F-shape House with Double Carport. Fifty years on, of the twenty-five architects whose work is shown in that book, the names of only Michael Manser, Donald Insall and, possibly, the late Peter Falconer would be even vaguely familiar to anyone who was not their contemporary. Fashion's vagaries can be cruel.

Fashion's vagaries can also be kind. Given that 'mid-century modern' is to this decade what art deco was to the 1970s, maybe Kenneth Sargant, Max Lock and Peter Thimbleby will come to enjoy a belated mini-celebrity (or exhumation) as, say, Ronald H.

Franks and Elie Mayorcas did in the decade which taste forgot, and probably overlooked in the first place. The bemused owners of their works will find themselves besieged by the attack dogs of the Twentieth Century Society. Is that a form of belated success? Yes. For we prospectively crave posthumous recognition. However much we may dissemble it, we yearn not to be forgotten. The matter is, of course, largely out of our hands. Literally, for our hands may be turned to crematorium sludge. But death is as unfair as life, and those who have not tasted success in life are unlikely to get it in death.

The manifold varieties of architectural failure are forensically classified in Timothy Brittain-Catlin's *Bleak Houses*. This is an engrossing and thoughtfully perverse meditation on reputation. In it there looms large the shade of Horace Field, the author's 'ultimate loser'. His name may be unfamiliar but his big, blowsy neo-William and Mary railway offices will be known to anyone who has ever disembarked at York Station. (The building is now a hotel.) He was by most conventional criteria reasonably successful, a prolific designer whose timing was unfortunate. His houses of the 1880s in Belsize Park look like works of twenty years later: it never pays to be too original. He committed a crime against posterity by omitting to publicise himself during his lifetime, and no one did it for him. He was of precisely the generation that C. H. Reilly lauded in *Representative Architects of the Present Day*, but was omitted. Thus in death he doesn't make the cut in Alastair Service's *Edwardian Architecture and its Origins* and is cursorily dealt with in that writer's *Edwardian Architecture* and in A. Stuart Gray's *Edwardian Architecture*. He published no manifesto, no theoretical bumf, only a study of domestic architecture of the seventeenth and eighteenth centuries. And unlike Edgar Wood or John Burnet, whose father's pupil he had been, he could not be claimed as a 'pioneer' of modernism. That vital 'progressive' box must remain unticked.

Success is visited upon those who proclaim their success. They are doing their bit for mankind and reading their work for you. That zebra-striped ventilation shaft symbolises man's inhumanity to horse-like animals. That ice sculpture for Dubai is sustainable. That facade in glass bricks is a demonstration of the Groin Corporation's transparency. Zoomorphic forms are the footprints of dreams. And so on. It is nothing short of naive to equate success with the achievement of sublimity or the incitement to delight or even a quality as mundane as fitness for purpose.

James Stirling and the Smithsons were successes. You didn't hear that from me, you heard it from them. Ian Nairn was, it goes without saying, a failure. (2014)

Pomo's greatest hits

In any epoch most of what is built is mediocre, though we may not realise it at the time because our neophilia persuades us of merit where there is none. Equally, we may fail to distinguish the few exceptions – those instances where architects and builders have ascended to a higher standard of mediocrity or have even escaped its dulling clasp. It takes time for public taste to catch up with architects' taste. Today, forty years after brutalism dissipated in an assault of *bien pensant* hostility and oil crises, few weeks pass without a new book or blog hymning its sublimity, energy and gravity. It is, of course, all a bit late. Much of the finest work has already been destroyed.

It will, no doubt, soon be the turn of postmodern buildings to feel the rough buss of the wrecker's ball. Many are, after all, more than thirty years old – that is to say that by current standards they are in their dotage. The Twentieth Century Society has worked tirelessly to protect unsung concrete tours de force. It is now attempting to get its retaliation in first by holding a conference that

will draw attention to the best of postmodernism and to the threat it faces from philistine local councillors, vandal developers, their chums in the demolition community and, of course, architects – for whom a pile of not very old rubble is a site to build on. Best of postmodernism: is that an oxymoron? I think not. Few ages produce nothing of note, and the two decades between the resignation of Harold Wilson and the advent of New Labour are no exception.

Late modernism, of which brutalism was merely the most extreme strain, was far from homogeneous but it was, in all its versions, infected with high seriousness, even earnestness, and it had become the architecture of the establishment: hospitals, the new universities, Vatican II churches. Postmodernism was a brutal reaction: the often conflicting moral and aesthetic orthodoxies that architects had, for half a century, treated as holy writ were cast aside. Demob-happy former modernists who let their hair down and jumped on the postmodern bandwagon (Gaudy! Bright! Loud! Fun!) were condemned as apostates by their more pious peers. Andrew Derbyshire, architect of York University, was calumnised for having abandoned the true faith when he designed Hillingdon Civic Centre, an exercise that shows what happens when a couple of dozen red-brick bungalows clumsily bugger each other. Architectural magazines and newspapers took sides. Heads rolled. Certain writers were declared persona non grata. It was all unwittingly hilarious and delightfully pompous.

The taxonomically inclined critic Charles Jencks was tireless in his promotion of the exciting new idiom's tics and mannerisms: 'quotes' from the dressing-up box of history; allusions to pop art; 'irony' (which had little to do with irony); randomly applied lumps of pediment; upside-down Diocletian windows; cod classical orders; asymmetry wherever possible; multiple and clashing materials; neo-Victorian 'features'. The noisy indiscriminacy was analogous to sentences in which each word belongs not merely to a

different language but to a different writing system: pictogram, alphabet, hieroglyph were piled on top of each other. The lack of constraints, the eagerness to please the visually untutored, the children's entertainer populism might have been devised as the architecturally representative characteristics of Mrs Thatcher's Manchester Liberalism and of Reaganomics.

But perhaps not too much should be made of this: architecture is seldom exclusive to one ideology. François Mitterrand, hardly devoted to the primacy of the market, was probably the single most powerful patron of postmodernism. His commissions amply illustrate both the stylistic and qualitative variety that are gathered under the postmodern handle. They range from the Opéra Bastille's effortfully counter-intuitive asymmetries to the breathtaking gigantism of Ricardo Bofill's classicism in, inter alia, Montparnasse and Cergy-Pontoise. Bofill, no more or less of a megalomaniac than any other globally recognised architect, declared his enthusiasm to work in England on condition that he could design an entire town and replace the National Gallery with a completely new building. England declined this offer, regrettably.

Instead, that gallery, at least a storey too low for its site, got an embarrassingly feeble extension by Robert Venturi, a banal architect, way out of his depth, but an interesting and often eye-opening theorist who more or less defined postmodernism's precursors − a hitherto unfashionable and aptly eclectic *galère*: all sorts of baroque, late Le Corbusier, Armando Brasini, the diner kitsch of American highways, the more extreme end of the shingle style, Las Vegas's neon and Lutyens (who had, according to the ineffable modernists Alison and Peter Smithson, 'perverted the course of modern English architecture'). Venturi militated against the simplifications and minimalism of Miesian modernism. He rehabilitated retrospection, 'historicism', the once wicked practice of pastiche and wall-to-wall impurity.

One's ears began to get mugged by the word ludic. Playfulness was all around. But how playful was it? There's an awful lot of hurt in the nursery. Architectural 'jokes' seldom work. They don't make a gracious exit. They are stuck there, perennially, in stock brick or finest sodalite, repeating themselves over and over, like those gargoyles that must have been a hoot when a Gothic cathedral was being built and carvers of rainheads represented each other as grotesques, but which are pointless once their subjects are forgotten.

The best English work, that which should at all costs be preserved, doesn't do jokes. Instead it possesses a sprightly wit – which is different. The undoubted masters of the idiom were Jeremy Dixon, Terry Farrell and Piers Gough of the partnership CZWG. The MI6 building in Lambeth and Charing Cross station are exuberant or boorish according to taste. They are certainly unmissable. Farrell's aggression is a sort of trademark. London would be poorer without it.

Dixon's houses in St Mark's Road in Notting Dale are as fresh and surprising today as they were forty years ago. Here was a template that combined the nineteenth-century terrace with decoration derived from de Stijl. They have been widely imitated. Indeed they are still widely imitated – Docklands *passim*.

Gough described his work as 'B-movie architecture', which gets it precisely when one recalls that the second feature was frequently superior to the main attraction. He designed England's most famous public lavatory, in Westbourne Grove, as a shrine to Joe Orton. His early masterpiece was in the then hardly 'regenerated' warehouse area of Bermondsey: the Circle comprises apartment blocks strikingly and overwhelmingly tiled in International Klein Blue. In its centre stands a life-size sculpture of a horse by Shirley Pace, which recalls the creature that wanders dreamily through *La Strada*. There is no school of Gough. His work is quirky to the point that it resists imitation.

Sorting the many ectypes from the few prototypes should provide the Twentieth Century Society with hours of pleasurable industry, though the pertinence of such triage is moot given that the strange 'ism' under scrutiny revelled in gleefully announced thefts. Originality was not the point. (2016)

Lord in the round

The Second Vatican Council provides a salutary example of a tiny 'elite' foisting supposedly 'anti-elitist' dogma and practices on the vast 'non-elite' which it (again supposedly) ministers to, and coming a cropper. Vatican II's dates are important. The council was convened in 1962 and concluded in December 1965. These were the high years of the most uncompromising architectural modernism and, just as pertinently, of the craze for theatre-in-the-round, whose champions considered the proscenium arch to be an authoritarian (very possibly 'fascist') instrument inimical to 'participation'.

Rome's neophilia left much of the clerisy bewildered. It was admitting temporal fashions to a spiritual domain. Maynooth's head was spinning. The council's bias was towards the Liturgical Movement's long-hatched plans for modernisation. Hence ecumenicism, the vernacular and often prosy mass, herding the flock close to the host in an access of naïf literalism and turning the matey guitar-strumming priest to face that congregation.

Then there was the matter of iconoclasm, which proved to be a further form of self-harm. Extant churches were 'cleansed', stripped of altars, stained glass, paintings and dubious *bondieuserie*. The result was occasionally akin to the marvellously frigid post-Reformation ecclesiastical interiors of Pieter Saenredam. More often it was doctrinally sanctioned vandalism, with added carpets.

Vatican II, in its eagerness to embrace the spiritual analogues of Harold Wilson's white heat, dispensed with what Clement Attlee

had dismissed as religion's 'mumbo jumbo', the very stuff which appealed to the gullible, which constituted the Church's USP: the dodgy theatricality, the pious ritual, the high formality, the po-faced earnestness, the tonic joylessness, the subjugation by the invocation of a mighty force. The essence of the sacred, the unknown and the unseen was, apparently, to be found in these properties which defined the entire apparatus of mystery.

St Bernadette of Lourdes in squeaky rubber or plastic or steel; 3D Christs with multiple halos; Virgin Mary alarm clocks; toilet roll holders which play 'Ave Maria'; fun-fur Last Suppers; the Stations of the Cross in artisan-tooled low-relief caramel Naugahyde . . . The purveyors of holy tat possess a surer grasp of the faithful's taste than the Bishop of Tarbes and Lourdes, Pierre-Marie Théas, a former *résistant* who commissioned the immense subterranean basilica, and the architect Pierre Vago who designed it for the centenary of Bernadette's apparitions in 1958.

It was one of several churches, going as far back as Dominikus Böhm's work in Cologne and Rudolf Schwarz's near Wurzburg in the late twenties, which anticipated and shaped Vatican II's decrees on architecture.

The most celebrated of these is Le Corbusier's Notre Dame du Haut (1955), in the southernmost Vosges at Ronchamp. That great, ethically dicey, megalomaniacal, atheistic architect's ability to design a 'holy' place was not conditional on faith, unfounded belief, but on the suggestive management of space, the control of light, the invention of forms and the plastic rendering of his paintings' repetitive shapes. The numinous was achieved by stage management. It's not so different from a morally delinquent vegan designing a marvellous abattoir.

Catholics take the road to Santiago de Compostela, a road that had fallen into desuetude until Franco had the wheeze of exploiting piety for tourism's sake. Muslims perform hajj. Architects must go

once in their life to Ronchamp: any visiting Catholic is liable to be muscled out of the way by jargon-spouting acolytes in black clothes and round-framed spectacles.

The Liturgical Movement had encouraged polite amendments to the traditional disposition of nave, transept, chancel, apse, etc. Vatican II went much further. It gave carte blanche to architecture's sculpturally inclined wild men, the brutalist successors to the 'rogues' of a century before. It is getting on impossible to discern from, say, the Mariendom at Neviges, south of Essen, what the brief could have been other than 'enjoy yourself, loudly, *mein Kumpel*!' An exhortation Gottfried Böhm (son of) obeyed with relish in the mid-sixties.

Böhm's hyperbolic expressionism, cinematic rather than architectural, is overwhelming. It alludes to penitents' hoods. Its forms are threateningly zoomorphic and geomorphic. The play of beams dense with particulates and of inky shadow is melodramatic. Whether so restlessly aggressive a building is appropriate to contemplation or to any celebration other than that of human inventiveness is questionable – but the same might be said of the great Gothic cathedrals which are more monuments to man's engineering capabilities than to a wrathful god and carnage at Golgotha.

The Mariendom, Claude Parent and Paul Virilio's bunker-like Sainte-Bernadette du Banlay in Nevers, Walter Forderer's deliriously swooning churches at Hérémence and Chur in Switzerland, the Wotruba Church in Vienna and Richard Gilbert Scott's Our Lady Help of Christians and Church of St Thomas More in eastern Birmingham belong not merely to the age of brutalism but to that of architectural determinism, which held that places and spaces can condition behaviour.

It fails to survive rational scrutiny but that is not to say it was without foundation. The question is how? It would be astonishing had such a radical redefinition of places of worship not touched

worshippers some way or other. It has most evidently touched them by turning them into non-worshippers though there are evidently many further causes of non-observance (court reports *passim*).

I have not voluntarily attended a religious service since the age of seven. My reaction to communicants is to pity them: those wafers! that 'wine'! the twee cannibalism! the sheer credulity! But the fate of those buildings where they submit to and share their folkloric rites and supernatural delusions is important. Brutalism, too, was pretty much a faith. It usurped the faith it was meant to serve. A concrete cuckoo. It was an emphatically physical form of architectural sublimity, an expression of man's imperiousness and of the conviction that technology would enable us to prevail.

Half a century on, such unalloyed optimism seems to embarrass us. And the buildings that signified that optimism are being fought over. The vandals are winning. Here are just a few of their rubble-strewn triumphs: Imperial College's halls of residence, Owen Luder and Rodney Gordon's mighty *oeuvre* in Gateshead and Portsmouth, Claude Parent's Rafale in Rheims, Jean Dumont's Tripode at Nantes. The world must be cleansed before it is renewed, again. Back to zero, again. Consequent result, same again. (2017)

Nowhere in particular

If you keep going west down Foyle Hill from Shaftesbury, you'll come to Stoke Gaylard, Pleck, and King's Stag – marvellous names, the last of which occurs in Thomas Hardy's even more marvellous ballad 'A Trampwoman's Tragedy'. Hardy died almost a century ago. His shade would happily recognise Foyle Hill, which is unchanged and unusual, not merely in that stasis but in the peculiarity of its disposition. It is a narrow unclassified road flanked by verges wider than it is. Verges which are hardly tended, though not

neglected. The Blackmore Vale is sumptuously rich pasture and land values are commensurately high. Yet here is land of manifestly undefined purpose, left uncultivated and ungrazed.

To call land workshy is to submit to the pathetic fallacy, but such an adjective seems apt. There is a lazy ease here, just as there is in the hamlet name Pleck, which signifies not a village, not a hamlet but a 'spot', a place which hasn't been got at, which no one has bothered to improve, which has not been subjected to the least makeover. In France the convention is to call such non-places *un lieu-dit* − e.g. *Lieu-dit Olivier*. Even though the Oliviers are long gone and there isn't even a trace of the house they lived in, the non-place is lent a vestige of identity, is relieved of total anonymity. Nonetheless, named or not (usually not), these places − edgelands or *terrains vagues*, spots − are too readily written off as wasteland, an epithet which suggests a failure to fulfil their destiny, to find a proper role.

They are habitually reckoned to be voids which are waiting, always waiting, to be something else, voids which are essentially worthless as they are. Who makes such a reckoning? The construction industry, of course, in its multitudinous guises − volume builders, architects, municipal vandals, hoddies and their kin, surveyors, developers, regeneration frauds, crane operatives, self-appointed gurus of urbanism, infrastructural freeloaders, estate agents, suppliers of hi-vis waistcoats, demolition wallahs, bankers, concrete technologists. All these people, disparate in their trades and tastes, with their often-conflicting interests, are United.

They are bound together in their dependence on a never-ending supply of land to enable them to ply those disparate trades − all of them, despite the claims of a lavish apparatus of mendacity called PR, are thoroughly unsustainable: there are few endeavours as spendthrift of energy as construction. And few which are so thoughtlessly selfish. The inconvenience caused by building is

inestimable. 'Considerate Constructors' is both an oxymoron and one of the worst jokes of the age. To the United trades a redundant building is a job opportunity. The redundancy is liable, of course, to have been incorporated at birth. The inhabitants of Trollope's Britannula in *The Fixed Period* were euthanised at the age of sixty-seven. Buildings are increasingly being taken to the vet before they're half that span. They are expendable.

Which is why listing is so important, even if there too often is a bias towards buildings that are unlikely to be threatened. But how do you list that which isn't? Spots, bits – you know, over there near the whatsit. It's akin to holding an atheistic service. A shortcut on foot which has worn a marked path between, say, a riverbank and a car park and allows people to avoid the 'official' route on a metalled surface is not readily classified. The same goes for: the cindered alley that runs behind a terrace of Edwardian houses; an unmade, unadopted road which is an ad hoc playground and which ends at a stained chalk cliff which can hardly support the beeches growing out of it – an industrial brick wall designed to retain it bulges ominously; a long outdoor flight of stairs cut into polished and skiddy chalk; a holloway which culminated in a labyrinthine Second World War bunker – these examples are all from within 100 yards of my childhood home. The stairs and the holloway are still extant.

When its architect, Arne Jacobson, revisited St Catherine's College, Oxford some years after it was built, a group of students invited him to an exhibition of their art. Jacobson was petulantly graceless when he saw it: he railed against the canvases and framed prints hung on the walls because they impaired the integrity of his creation. This is not atypical. Architects yearn for tidiness, order, even perfection. The Cité Radieuse in Marseille was intended to be the first of eighteen blocks that would stretch from the suburb of Sainte-Anne to the sea. However, Le Corbusier treated it, as Piers

Gough remarked, 'as an Arts and Crafts building'. As a result it went hopelessly over budget. The remaining seventeen were cancelled.

Architectural photographers also yearn for tidiness and perfection. Few of the tens of thousands of photos of the most important domestic building of the last century show it in its context, which is far from a Corbusian utopia: he was among the very greatest of architects, but he was a duff planner. The thing to ape was the work, not the arid megalomania of his 'vision' (global social housing *passim*). Less deceptive or deceitful photos would show the actuality rather than the ideal. The immediate surrounds include a scrubby length of baked earth where pétanque is played, a decrepit bungalow, a wicket-fenced dog toilet, a splendid bank of cacti, a tennis court, a squash club, a lane whose potholes are not the colloquial *nids de poule* but so large they are *nids de vautoir*, a rat run with ineffective *gendarmes couchés*, a sprawling supermarket buried in signage, three garages with different specialities . . . Nothing, then, of architectural merit. But that's not the point. Humanity cannot live on a diet of masterpieces any more than it can live on shad roe and elvers.

Enter a *hyper-cumulard*, a pushy mayoral hopeful with six official posts at the point where the politics of France's second city, urbanism and blind ambition collide in a car crash of conflicting interests. Madame Laure-Agnes Caradec recently presented a plan to, yes, regenerate the neighbourhood: a thousand homes but no schools, no crèches, no parks, no parking. Sheer genius. She has in the past been labelled a nimby (same word in French) for preventing development close to where she lives. That may or may not be the case. What is certain is that this project, announced without any consultation and which will involve numerous compulsory purchases, has been drawn up by inept architectural students whom one can only advise to find a different career.

The UNESCO listing of Le Corbusier's buildings is a block listing. If the Cité Radieuse is delisted then so will be a dozen and a

half of his other works across the globe. It comes down to Madame Caradec versus World Heritage, the bloated ambition of a political mediocrity up against a commendably effective instrument to protect sites that are vulnerable and, indeed, susceptible to the very threat that this one now faces. This is not what the globalism of the local is meant to mean. (2019)

3

Cities

Birmingham: Livin' things

It is, apparently, aberrant or at least eccentric for anyone who was not born or raised there to express affection, let alone admiration, for England's second city. The orthodoxy is that Birmingham is a sad, grim joke. Like many orthodoxies, this one is founded in ignorance, which is founded in incuriosity, which is, in turn, founded in the orthodoxy. Vicious circle or, as they say in Shard End and Bacon's End, a ring road of misconception.

Seven years ago, I made a film about Brum called *Heart Bypass*: the sheer quantity of brainstorming that went into that title would fill a skip. Here was the very core of England, and it was routinely avoided, merely glimpsed from the motorways that encircle it. They quite properly encircle it, for this had been Motown UK, a city which more than any other celebrated and depended on and was determined by the internal combustion engine. It had made cars, and cars had made it.

Inner-suburban Birmingham has the country's greatest concentration of pre-First World War houses with integral garages, or motor houses as they were then called, before we stole from the French. It also has the nation's first drive-thru balti outfit. Outer-suburban Birmingham possesses the country's most distended

specimens of that 1930s arterial-road temple to drink-driving, the roadhouse (mine hosts: Mitchell and Butler). And down those roads at weekends ventured 'specials', cars bodged in back yards from the components of other cars.

More than anywhere else in Britain, central Birmingham, as reconfigured in the late 1950s and early 1960s after the revocation of building licences, accommodated (rather than tried to correct) humankind's increasing reliance on the car, a reliance which is inevitable in a low-density, widely spread city with pathetically inadequate public transport. In this last regard Birmingham exhibited a candour and pragmatism that are commonplace in the United States but which this country has habitually shied away from, preferring – wrongly as it happens – to delude itself that its cities are constructed on tight-knit European models.

Seven years is a long time in traffic planning. Central Birmingham today has abandoned its love affair with the car, the love whose name this city alone dared speak. It is normalising itself, gingerly coming into line with the rest of the country, obstructing private cars, turning streets over to pedestrians. The city is dispensing with the very characteristic which made it unique. It is disacknowledging its essence. Such an approach speaks of a craven thraldom to vehicular correctness and of a sycophantic municipal populism.

There is no council in the land that has not realised that it can curry favour by amending or destroying the modernism of the 1960s, which it commissioned and promptly consigned to failure by neglecting to maintain. There is no council in the land that has stopped to consider that much design of that decried decade is superior to much design of, say, the 1760s: precisely what is it that is so commendable about Georgian timidity? Thankfully James Roberts' Rotunda has been listed, but his equally scintillating work on Smallbrook Ringway lacks the protection it deserves. So, too, do

the countless contemporary works whose sum constituted the most complete plastic expression of post-war optimism.

The new Birmingham's conformity is manifest in its centrepiece. The 'soft' Selfridges by Future Systems is a shop, self-evidently. And it is also an excitingly different 'landmark' building whose reliance on computer-generated design, disdain for Euclidean geometry, curvaceous bulbousness, and absolute inappropriateness to its site, marks it as just as excitingly different as all the other excitingly different 'landmark' buildings in this continent. They have fallen to earth from a planet where the set square is yet undiscovered. The conformity is further manifest in the way that the spirited rehabilitation of a recidivist canal basin is marred by chain shops, chain cafés, chain restaurants.

There are countless reasons why Brum is the only English city other than London where I could bear to live. The humour (it is this side of the Irony Curtain; people speak against themselves, not 'as they find'), the accent, Junction 6 of the M6, the Saddam Hussein Mosque in Perry Barr, the ELO Heritage Trail . . . For the casual visitor, the greatest attraction is the sheer extent of its prodigious later-Victorian streets and buildings, which no council would, surely, dare now alter. (An optimistic expectation that ignores the sort of people who profess politics at any level.) These streets are unlike anywhere else in Britain.

They are as particular as those built in the 1960s. They owe their singularity to Birmingham's status as the forge of the empire, the workshop of the world: the workshops – this was, despite the munitions factories, predominantly a city of practical crafts practised on a small scale. In consequence it is a place, the only place, where the Arts and Crafts movement of 1885–1910 was not infected with a bucolic whimsy and a *retardataire* fondness for handicrafts. The collusion of machine and imagination here produces something akin to a tough art nouveau – which was essentially urban,

essentially mechanistic. The materials are industrial brick, industrial terracotta. In the Jewellery Quarter there are courtyards which recall Vermeer without any actual allusions to his subjects. This is an exemplar of what might have been without the pernicious influence of William Morris.

Of course, it didn't last, any more than the 1960s would. Nostalgia won the day. It was the emetic chocolate garden village of Bournville, with its waney wood and storybook dormers, that would be the model for suburbs to come. There is only so much urbanism that the English can bear. (2005)

Brighton 1: The man with the peridot teeth

Brighton is, famously, founded on the pleasure principle. It's a sort of protracted *maison de tolérance* where anything goes. That, anyway, is the SP, the *on-dit*, the etiquette that the place has attached to itself with coy daring. It may well be true. There can be no doubt that it is vastly more appealing than this country's other seaside cities, for although it has its share of kiss-me-kwik tack, it isn't defined by such tawdriness. Brighton is not provincial. It is London-super-Mare. Yet its fleshpots, its sybaritism, its hedonism and so on are strangely occluded.

Brighton long ago forgot how to renew itself in a manner befitting its peculiar status. The most public part of the city, the seafront between the two piers – or, rather, between the pier whose lights proclaim 'Brighton Pie' and the marine installation which is what remains of the West Pier – is an insulting anthology of a century's architectural banality. There are two eras that produced buildings appropriate to the seaside: the Long Regency, say 1790 till 1830, and the Interbellum. They are barely represented in this most crucial part of the Regent's playtown.

Instead there are spirited but heavy-handed late-Victorian attempts at gaiety and, far worse, some true shockers of the seventies and eighties, sprawling misbegotten lumps that summon up the *joie de vivre* of Lodz in freezing rain. Brighton does not give itself away, then. You have to go looking for it.

My hunter-gatherer instincts drew me to the Lanes years ago. This is the oldest part of Brighton. Though it predates the formal stuccoed set pieces of Brighton's heyday by only a few decades, the houses and cottages adhere to the street plan of a medieval fishing village. The Lanes are predominantly pedestrianised, wholly labyrinthine, often very narrow. There is a delightful mix of motifs and materials: bow windows and shaped gables, knapped flint and mathematical tiles. A delightful mix, too, of one-off shops, despite the incursion of the usual chain restaurants and coffee shops. The indolent ambler will be well rewarded.

The first thing to go in my imaginary trolley – reg no: C O VET – is a near-obese, verisimilar, life-sized rubber crow from a shop that sells rubber magpies, rubber owls, shotguns, Barbours, cartridge belts, knives: a Swiss Army knife is animated in the window, its blades and marlin spikes and can openers opening and closing in a mechanical ballet of endearing pointlessness. I assume a rubber crow can be relied upon to scare non-rubber pigeons. This shop's presence was oddly reassuring since I had previously believed that all firearms sold in Brighton were illegal. It's reassuring to see someone profiting legitimately.

The man with the rubber crow is, according to the proverb, the man who needs the topaz dentures. So I went to see Mr C. Gull, whose premises stretch back from Ship Street alongside a twitten, the East Sussex dialect word for an exceptionally narrow alley. Chris Gull is a dentist whose establishment won the UK Dental Practice of 2003 award. They picked the right outfit. The surgery is also a gallery which shows anything from Stanley Spencer's

working drawings to local amateurs to Aboriginal artists to – currently – some impressively polished pieces by fashion students.

And then there is the laboratory that is a form of recondite spectacle for those who stray into the twitten. Mike Tiley is a dental technician who served a five-year apprenticeship and a five-year 'improvership'. Until the fifties it was commonplace for dental surgeon and dental technician to work on the same premises. Messrs Gull and Tiley believe that patients requiring dentures have suffered from the lack of a bespoke service occasioned by the denture 'factories' which have become the norm over the past half-century. They reckon turning the clock back is the way forward.

Watching Mr Tiley at work is engrossing. Here is a real craftsman who practises a craft that, I suspect, few of us have witnessed. Casting, injection moulding, vacuum forming, lost wax techniques: a couple on holiday at the superlative Hotel du Vin down the road became so hooked on this singular sideshow that they ended up spending £11K on his'n'hers crowns. The incisorless can select from a dazzling range of colours and materials. In the near future we will have polychromatic teeth. We will wear teeth in the way that we wear clothes or jewels today. Why not? Brighton is already multiply pierced. I shall favour topaz and peridot.

That's the mouth taken care of, then. What of the rest of the body's needs? There was a problem at the erotic boutique a few doors away. A couple were having to return their second faulty vibrator in succession. They'd come to a mature decision not to try a third but to buy underwear instead. The Lanes are almost as well-equipped with such shops as a French town. It is a city that is uninfected by shame, guilt and bodily inhibitions.

There are few places in Britain that are so openly preoccupied with appearance. Among the young or youngish men and women working in the countless jewellers, hairdressers and clothes shops, there are as many exquisites as there were in the sixties. Teased hair,

sharply cut schmutter, chokers, jet cameos – there is artifice in the air. And there is something pleasingly effete about the existence of three artisan chocolate makers within a few hundred metres of each other.

Audrey's is nicely old-fashioned and offers ruched fabric boxes that might have been devised in the forties. Montezuma is a cracking shop selling first-rate produce flavoured with chilli, ginger, cinnamon, citrus, etc.: do not be deterred by the rather infantile packaging that promises much less than you actually get. Choccy-woccydoodah (really) has one window full of delicate, fantastical and enormous *pièces montées* which might have been devised by Carême. And then there's its other window – dark and white chocolate Y-fronts, bras, thongs, together with topiarised poodles fashioned from marshmallows. The end of the pier is not far away. (2004)

Brighton 2: Grandpa takes a trip

This all reminded me of something. Yes, it's just like Haight-Ashbury in 1967. The memories came flooding back. Big Brother and the Holding Company; beautiful people may not be beautiful on the outside – it's their mind that is beautiful; seven-hour-long guitar solos; runaways smeared in body paint; the Filmore Auditorium; roach clips; Buffalo Springfield is a make of lawnmower; the omnipresent reek of grass; sexually predatory, goofily grinning hairies; graffiti'd camper vans; R. Crumb; beads; velvet with mange; halfwitted Eastern religions. False memories, every one of them.

San Francisco held no appeal for me. I never went there. That trite dirge about gentle people with flowers in their hair could hardly have been more off-putting. And yet here I was in the North Laine area of Brighton musing on its kinship to a place and milieu that I happily avoided – and, puzzlingly, I was rather enjoying it.

This probably has something to do with my comparative senescence: I'm not expected to join in. When we go to the zoo, we are not obliged to ape the apes. There's no peer pressure to withstand. There's no expectation that I should have a hairdo the size of a busby or wear a T-shirt bearing a gnomic legend. Having said which, it should be noted that Brighton is very generously provided with middle-aged teenagers, forty- or fifty- or even sixty-year-olds wearing unsuitable and thus entertaining clothes.

Dressing up to promenade is a civic preoccupation. And this grid of narrow streets is where ostentatious ambling gets done. It's quite different from the Lanes, which are prettier, quainter, better known: hence their higher rents and the gradual incursion of retail and restaurant chains. North Laine promotes itself as 'bohemian'. It certainly works hard at its self-conscious eccentricity. Wacky is normal. So when one comes upon a shop that might be found on any high street it seems vaguely aberrational: take O Zone, which sells wedding kit and ensures that you clip-clop through your happiest day in curiously asexual satin shoes. This was perhaps the only shop in the area which had forgotten that it was meant to be a sort of 'character'. The only shop, too, whose merchandise didn't suggest that it might have been designed under the influence of psychotropics. Hence Haight-Ashbury's gatecrashing my brain: needless to say, there are countless small shops selling herbal highs, cigarette papers, hashish pipes and, very likely, banana skins.

The other place that North Laine recalls is the vast flea market at Saint-Ouen in northern Paris. It may not be as extensive, but the seething crush is the same and so is the predictability of the unexpected. In the window of Emma Plus was a sheet of paper: 'Bright enthusiastic person wanted for Saturday work. No experience necessary but an interest in larger-sized women's clothing is essential.' Such an interest is, presumably, frequently encountered in Brighton. It is a city where anything goes, and the North Laine

sedulously strives to maintain that reputation. The problem with anything goes is that a pathological tolerance is developed: tuneless, boring drummers exercise the right to make 'music' in public. Mimes with shiny silver faces perform their mirthless routines before crowds of listless grockles.

Still, there are manifold consolations. Children lie on stretchers to be made up – frighteningly realistically – as accident victims. Why? Well, why not? And everywhere there are shops that are actually enticing. It is frequently difficult to distinguish between street performance operatives and civvies, so theatrical are many of the latter's outfits. It is fitting that this city should remain so obsessed by appearance and surface, for that is how it started. The great set pieces are essentially facades, jerry-built for show. Their interiors are today doubtless the very last word in design-conscious chic.

I surmise that from the sheer number of shops selling elegant modern furniture, novel shelving units, decorative lights and so on. In Caz Systems there are covetable glass bowls and in Start delicious pots by Ian Stallard. North Road Timber has carved baroque sconces and swags. The gardener mugged by fashion can buy 'ironic' gnomes, zoomorphic watering cans, plastic flamingos and galvanised buckets from Bluebell. A plastic merchant that seems to be called Plastic Merchants has sheets of both transparent and opaque materials that can be made into tables and chairs: the enticing colours recall Rowntree's Fruit Gums and Spangles. The adventurous can get bottles of resin and cans of pigment.

There is an unusual amount of craft in North Laine. Some of it is simply too stoned to appeal to the unstoned: a preposterous cup with two vast handles like a coronation mug of the future; novelty this and witty that.

But much of it is delightful and fairly cheap and an encouragement to the tyro to make something, anything. I am going to lovingly fashion a pair of cufflinks. Call me wild. The labour will

keep me off the streets. I went to the Brighton Bead Shop for the jewellery components. The finished items will not be of the standard or size of a pair I found in the tiny premises of a splendid tailor called Gresham Blake whose women's clothes look as natty and sharp as the men's. This is the higher end of craft, and it's proper that it should be undertaken in the service of the quintessential Brightonian trait, vanity.

Yet alongside merchants of the exquisite there exist countless caves devoted to tattooing and body piercing. Cheeringly, they claim to open a fresh needle in front of each customer. I wonder: are these places really in the business of wilful uglification or has the idea of beauty, like behavioural mores, so shifted that what was once reckoned repulsive is now covetable? The sartorial and tonsorial babel of North Laine offers no clues – or, rather, it offers so many that no conclusion may be drawn save that its denizens are both tribal and individualistic, conventional in their nonconformity, dreadlocked and shaven. There are many horribly cratered, bubble-wrap complexions on view. Odd, that: I'd heard heroin was good for the skin. (2004)

Edinburgh: The Scottish play

The Royal Mile is in business to flog a single product which is available in manifold forms: Scottishness, Edinburgh's Scottishness. Given the meretricious crassness and traduced integrity of certain of those forms, it might be thought that Scottishness had very little to do with being Scottish, whatever that means. I wonder. And I wonder as a man whose mother's family was Scottish on both 'sides' back as far no doubt as MacBruce the MacBard – or should that be McBruce/McBard. Who knows? I take no pride in this.

Us Scots and our effing effiquette. The rational world has sloughed this stuff. Yet the two most powerful men in the UK are:

(a) an antinomian victim of Fettes, the nightmare of architectural bogusness: if ever there was a school that Larkined its pupils; (b) a witting kiltwearer from a manse in Fiscaltoun across the firth. What the asterisk is going on?

As I say, I have Scottish roots – but I'd sooner think on the branches and the boughs and the leaves. Since you ask: *Robinia pseudoacacia* – deciduous, like my hair. You don't see many of them in North Britain. I asked the Scottish genius Gove (whose name is not prefixed by Mc or Mac) whether the appellation North Britain was an insult to persons north of Berwick. He clearly reckoned that I was a spleen short of the full haggis to have even wondered.

Celticism was invented so that diasporates could have something to come and search for. Ditto kilts. And tartan. No station of the cross is as fixed as the photo opportunity of the gangster president exhuming his dodgy patrimony in a croft or bothy where his greatgreatgreatgrandpa ewe-abused. Wannabe Scots are fantastically well taken care of on the Royal Mile.

Despite myself I love it. The poet it evokes is not my nominal forebear James Hogg, nor his avatar of dualism Robert Louis Stevenson but, rather, the laureate of London's red-brick labyrinth Robert Browning: 'the tender murderer, the superstitious atheist'. Since you ask, again: it's always Stevenson, the inventor of modern 'English' prose. The litcrit consensus that relegates him – and Swift, and Carroll – to the status of 'children's writer' is dismal. And wrong. Any culture that reveres the mediocre moralist George Orwell, that prefers Lawrence to Nabokov, that fails to put Wells and Flann O'Brien in its pantheon, is to be distrusted. I wish that I could distrust Edinburgh, the Athens of the North, the Elgin of the South, the St Petersburg of the West . . .

Well, to its west there is this city called Glasgow. The film crew – OK: mob – I'm working with is entirely Glaswegian. In twenty years of telly I've never had such a weird time with such dry,

cynical, funny people: the Enlightenment moved to Glasgow. But it didn't take Edinburgh's physical beauty with it. It moved to wherever we might read. Mick Hume – a Woking kid who lives in Walthamstow and travels to Old Trafford – stole his surname from David, stole, too, his 'loony libertarianism' and presumably chose his 'heritage'. Whereas, me – I'm the genuine article. Got mi' own tartan, Jimmie. I hate myself for doing this: but I did walk into the courts where David Hume lived. The wonder of it is that you walk out sentimentally unaffected. This is not inevitably the case: Max Gate prompts the idea that the gloomy writer Thomas Hardy was an even gloomier architect. Hume designed nothing. But even had he designed or built one of Edinburgh's proto-skyscrapers it wouldn't speak. Stones don't. The anthropomorphic fallacy that we can get something out of old structures is just that, a fallacy. Still, we can invest them with whatever we want. Disdain, for instance, or qualified admiration . . .

I guess I should despise the Royal Mile's kitsch. But I love it: OK, bomb Starbucks, bomb Garfunkel's – where are you MacQaeda? The rest: if you need a suit of armour (and four people did, in 2003: shipping is free) you can buy one from heritageofscotland.com, a shop run by Sikhs in kilts who speak with heavy-duty Corstorphine accents. My multicultural heart was lifted.

And then my head got in the way of that tartanturban heart, that plaid sentimentality. There can exist nothing more insulting to reason than the Scottish Parliament. A white elephant with its own shop. The very idea is a nonsense – and the building is a cretinous joke. I have worked on BBC programmes presented by Kirsty Wark: I am thus apprised of the extent of her architectural expertise. Put it this way: she is no Nairn – but then I doubt that she or any other of the visually proficient great'n'good that elected the fifth-division Catalan Miralles to design this stupid, profligate,

hubristic lump of anti-unionist sentimentality knew who Ian Nairn was. And Nairn would never have sat on a committee.

The Scottish Parliament is a national disgrace. I wanted to find, for the film I'm making about Edinburgh, something apt written by a Scot. It is, I'm afraid, the English poet, William Cowper of Olney, who got it right: 'peculators of the public gold'. The building is wretched. The politically correct choice of an architect from another small nation with a big inferiority complex is just about understandable: Catalonia is to Spain what Scotland is to England. A 10 per cent dependency with a massive logo sticking out of its kilt. There are serious architects in Catalonia: Ricardo Bofill, Peter Hodgkinson, Bohigas and Mackay (a Scot, once). The very notion of a shop to celebrate this sty is grotesque. No, I did not buy a pair of Scottish Parliament cufflinks. I bought a direct line to an invention called DOG trading as GOD and asked him to get his boys in MacQaeda to undertake a little light demolition. (2004)

Oxford: University of life

Oxford is, famously, a centre of learning. Here is what I learned there a couple of weeks ago: (a) teddy bears are essential props of Oxfordian life; (b) bratwurst and bockwurst come from Northampton; (c) exquisite buildings do not prompt exquisite behaviour; (d) a spoon chained to a counter will not be stolen save by the very determined but will help build sticky little hillocks of sugar and tea which, as they desiccate, will acquire an attractive brown crust.

Valuable lessons, no doubt, but are they specific to Oxford? Salamanca or Bologna or Heidelberg would certainly have other things to teach us. But Cambridge? Now there's an interesting one. Would the gamut of useless gen conned there be much different? To rue the banal standardisation of English towns and their high streets is a *bien pensant* obligation. We can all recite the litany of

commercial pantomime villains. As a reminder, a train of anti-globalisation protesters helpfully processed along the High Street. They were flanked and followed by a few police officers whose patent boredom was in direct proportion to the protesters' pacific orderliness: no cause for a baton charge here.

One of the protesters left the march. A don, probably. Every bespectacled, sartorially negligent middle-aged man in Oxford is a don – all 50,000 of them. Common knowledge. He exchanged a pleasantry with a policeman and exited my view. A couple of minutes later he reappeared. He was clutching a Starbucks coffee carton. Oh dear: another instance of the triumph of palate (or caffeine dependence) over principle. I went to remonstrate with him about double standards, I gave him a piece of my localisation.

That's a lie. I was at least 50 per cent sympathetic. For, a few minutes earlier, close by, I had bought a double espresso from a sole-owned Gaggia, a slum of stains and – surprising, this – grounds. Surprising, because I got a cupful of hot brown water. Presumably the little drifts of spent coffee were mere *mise en scène*. The liquid was transgressive. Our hearts may sink when we see a branch of Starbucks or Costa or Nero – but our head knows that the coffee from them is more likely to restart our hearts than the drivel from an insanitary café. Standardisation has raised standards.

This is as depressing as it is comprehensible: the challenge of the chains has not been, cannot be, met by small traders to whom economies of scale are so distant a dream that they are forced to stint on the quantity of coffee they put in a machine. Time after time the sentient consumer is forced to choose between conscience and appetite, self-congratulation and reasonable value for money (not good value: chains work in a *faute de mieux*-ish way).

This selective quandary is peculiarly British and results from our governmental horror of *dirigisme*. It is worth noting that the quality of material life and the health of the individual retailer is markedly

higher in countries such as Spain which actively discriminate against chains, by fiscal means and by proscriptive opening hours. Pigs might fly before such measures are introduced here. Indeed, a pig–bustard cross will fly – and still we'll see nothing of those measures for the pigstard will have been the work of everybody's friend, the Sainsbury Foundation for Humane Modification and Transgenic Improvement.

The individual retailer in this country who is going to survive must offer a level of product (schmutter, nosh, snout, whatever) that it is seldom worth a chain essaying: a level of product which attracts a price which only a small fragment of even an increasingly wealthy population is willing to pay. It goes without saying that such individuals are the exception.

Take Oxford's covered market. It is hidden from the High Street by a mid-Georgian facade, the work, as was the original interior, of the bridge specialist John Gwynn. The shops to the street are all chains: Nero, Boots, Whittard, Jessops, Pizza Hut, Whistles. The near inevitability of their presence turns out to be less depressing than the grimness of much within: a war of retail attrition is being waged and lost. Several premises are dark. Others, including a long-established bookshop, bear notices announcing th— ...hey are ...are still a few soon to close. Originally a butchers' mar— ...'ami', Belgian 'pâté', plying this trade. English 'sau— ...industrially reared chicken the aforemention—d 'vegetarian. ...under cellophane bring out my ...about. Avoid. There are a lot of these 'meat' and tra— Indeed, this butcher ...But don't avoid M. Feller Son ...he market. The copiousness and game dealer is the reason to local produce is truly impressive: and quality of the predominantly ingly limited. ...so is the variety, which is reassur-

Otherwise there is, I guess, the Victorian roof to gape at. And the health-food shop which turns out to sell pet food, an easy mistake to make. There are several shops selling bogus German teddy bears – I blame Anthony Andrews. Beyond that there is the means by which you can tell you're not in Cambridge. Oxford's speciality, Oxfodder. Dreaming spires in splodgy watercolour (which is an English disease). An 'impressionistic' photographic print of Christ Church Meadows. A meagre line drawing of the Radcliffe Camera. A sketch of the Botanic Garden's gateway which would have shamed even a Sunday dauber: why is the world so full of amateur artists when it is not full of amateur accountants?

Across the road from the market the prodigal mug can buy a mortar board, or a college scarf of the sort not worn by students since they were still widely known as undergraduates in the days of Jimmy Porter and Jim Dixon, or a sweatshirt: 'Only items bearing the above registered device are part of the official University of Oxford collection.' (2003)

Southampton: Champions league

Football's coming home. Literally, on this occasion. Southampton FC – hu~ ~ically advertised on hoardings as 'the spirit of the city' – is famously with the behaviou~med 'Saints'. This moniker has nothing to do that the club was orig~ ~vers but derives, rather, from the fact beside the Itchen. And it is~ ~ in a district called St Mary's, built.

I shall miss the Dell, which I first ~ ~w stadium has been were then in the Third Division South, the o~ ocean liners and my great-aunt Doll was opening ~ Mackeson to chase another tumbler of Australian 'sh~ ~ints just over twenty miles away in Salisbury which, because it p~

a cathedral and is a diocesan see, styles itself a city. But it is really a market town whose population was then little more than 30,000.

Trips to London were seldom made – less than once a year, I guess. Thus, Southampton, where much of my mother's extended family lived, represented to this child the Big City. I accept that this may seem preposterous – but we learn about places by chance rather than by choice. And our sense of place, too, is determined by a combination of circumstances over which we have little control: at the age when we become topologically sentient, we are still largely dependent on our parents' itineraries. Yet – Southampton!

I can hear your groans. It is an indisputable fact that the etiquette which attaches to it is one of dreariness. It is an equally indisputable fact that that etiquette is wrong. Still, I would say: you can take the man out of Southampton but you can't take Southampton out of the man.

But surely there's something amiss here. It wasn't my home, merely a place I went to most weeks and which was, according to my father, somewhere I was lucky not to have to call home. He had no taste for urbanism: his son acquired his lifelong taste for cities from those frequent outings. I didn't mean to, I didn't set out in some spirit of mild filial rebellion to develop an appetite for the seething, teeming organisms my father did his utmost to avoid – but awe is not a sentiment over which we have control. And the sheer bigness of the place filled me with awe. It seemed never-ending, relentless. Many of the buildings seemed immense. In Salisbury, the cathedral apart, nothing was over three storeys and most were two.

My grandparents' house had four storeys. The boatbuilders' hangars on the Itchen were so vast they frightened me. It was a delicious fright I suffered: they might have been created for a race of giants. Although the city had been heavily bombed, some massive Victorian warehouses and dock buildings were spared. The Royal

Victoria Hospital on the Netley shore was almost a third of a mile long – that's to say, as long as any building in Britain (it is the subject of Philip Hoare's *Spike Island*). The chain ferry across that river, known as the 'floating bridge', was a source of unbounded excitement.

Southampton also struck me – and you'll have to stifle a further guffaw here, too – as exotic: well, everything is, evidently, relative. There were no African or Indian sailors in Salisbury; there were no trams like the ones that hurtled down Bevois Valley, where the pavements were piled high with dead people's clothes and dead people's furniture and the sky was always black. There were no houseboats in my home town. There were no ranks of cranes. I suppose that I should profess to a fascination with Southampton's medieval Bargate and walls, which rival York's, or with the elegant streets of bow-fronted Regency houses – but that was not the case, for they wouldn't have been out of place in Salisbury. They were not ur-Southampton.

What Southampton had most of all was the feel of the future. Because so much of its centre had been destroyed there were – oh marvel! – modern buildings, as modern as those in *Dan Dare*. They are period pieces now, of course, and I am of an age to discriminate between them. The first stages of the reconstruction are indifferent – coarsely timid. But one need only list the names of the designers who worked there in the late 1950s and early 1960s – Eric Bedford; Eric Lyons; Lyons, Israel and Ellis; YRM – for it to become apparent that here's a city of quality. I'm sure you don't believe me.

Next time: Reading, Parnassus-on-Thames. (2001)

4

Concrete

An A–Z of brutalism

Asplund: The term *nybrutalism*, new brutalism, was the jocular coinage of the Swedish architect Hans Asplund (Gunnar Asplund's son). He applied it to a small house in Uppsala, designed in 1949 by his contemporaries Bengt Edman and Lennart Holm and built of industrial bricks. Were it not for that material the house might stand as the very example of the light, ascetic, prim, Nordic modernism which afflicted Britain for some years after the war: the Festival of Britain in 1951 was the Festival of Plagiarising Scandinavian Architecture. Asplund's neologism caught on in Stockholm and was picked up by British architectural pilgrims to that city, among them Oliver Cox, Graeme Shankland and Michael Ventris, the decoder of Linear B. Although the epithet signified nothing, or maybe because it signified nothing, it was taken up as a slogan of defiance or something by arty young British architects, none artier than Alison and Peter Smithson and their representative on earth Reyner Banham, a man whose prose may cause all but the entirely insentient to wince. The first of the Smithsons' few completed projects, Hunstanton School, derives from Mies van der Rohe and has little in common with subsequent buildings that were deemed brutalist.

Béton brut: *Béton* comes from the old French for mortar, *betum*. It was Banham who introduced into the mix *béton brut*, which simply means raw concrete. The common etymology of *brut* and brutal was irresistible. Had, however, it been resisted, the reception of buildings so labelled would have been happier, for their opponents, knowing nothing of *béton brut* and apprised only of the English component, would not have had the ammunition of what seems like a boast of culpable aggression. Or maybe not: France, which gets the dreary pun, has been no more appreciative of its brutalist buildings than has Britain.

Cité Radieuse: Before the war Le Corbusier's architecture was sleek, smooth, orthogonal, rational. Post-war he led the reaction to such architecture. He dumped a technical manual in favour of ecstatic poetry. La Cité Radieuse, aka l'Unité d'Habitation, in Marseille was the first of his exercises in sculptural and plastic moulded concrete which, in spirit if not style, have affinities with the primitivist tendency of the Arts and Crafts. L'Unité provided the word brutalism with a meaning. Poetry trumped technology. Le Corbusier ripped off countless other artists and architects: notably Fernand Léger, Picasso and most importantly Friedrich Tamms. Indeed his later *oeuvre* can be viewed as a synthesis of thefts. But as his compatriot Jean-Luc Godard had it: '*Ce n'est pas d'où tu prends les choses – c'est où tu veux les amener.*' Le Corbusier never applied the word brutalist to his own work.

Dystopia: Brutalism is the stereotypical decor of dystopian cinema, fictions and comics just as the Gothic is of horror. *Alphaville, A Clockwork Orange, Blade Runner, Get Carter, La Haine*, etc. More recently such artists as Neil Montier, Nicolas Moulin and Filip Dujardin have created collages of ideally dystopian, apparently post-apocalyptic cityscapes and *terrains vagues*. Fiction and film have

of course impinged on the way these buildings have been judged down the years and assisted in their condemnation. They have been found wanting beside the hollyhocked cottages and winking dormers that are Blighty's cynosure.

Expressionism: Brutalism, as Pevsner pointed out with some distaste, had its roots in expressionism, the jagged, often counter-intuitive, mostly brick idiom which flourished in Holland, Germany and the Baltic states between about 1910 and 1930. Its greatest exponent was Michel de Klerk, whose social housing projects in Amsterdam retain, a century after they were made, a beguiling freshness. Its kitschiest exponent was Bernhard Hoetger. His Bottchestrasse in Bremen was commissioned by the inventor of decaffeinated coffee, Ludwig Roselius, who dedicated it to Hitler. At the 1936 Nuremberg Rally, Hitler showed his gratitude by declaring it decadent.

Forderer: Vatican II was a godsend to architects. The Roman Catholic Church was a generous and adventurous patron. It invited experiment in the service of renewal. Its buildings were to be advertisements for the Church's newfound modernity. With few functional demands to take into consideration architects enjoyed carte blanche. God can, apparently, live anywhere and in the sixties he shared the common taste for open-plan spaces and theatre in the round. The boundary between architecture and sculpture which Le Corbusier had broached was now comprehensively trampled. The architects who most took advantage of this licence were Walter Forderer in Switzerland and Germany, Gottfried Böhm in and around Cologne, Fritz Wotruba in Vienna. Their work defines brutalism. It is accretive; ostentatious; hyperbolic in its asymmetries and protracted voids; composed of parts which do not connect or are in a fragmentary state; dramatically vertiginous; geometrically farouche; extravagantly cantilevered; discomfiting; aggressive (in so

far as an inanimate object can be aggressive). Its interiors are chiaroscuro in the fashion of *Metropolis*. There is no desire to please with prettiness or even beauty. The reaction demanded is that of awe. The quality that the greatest brutalist buildings manifest is sublimity.

Geology: Brutalist architecture did not seek to represent geological formations. It sought to create buildings which matched such formations, even challenged them. Mankind could take on nature and win, could make its own yardangs, hoodoos, collisions of erratics. Half a century ago mankind lorded it over the earth. The practices of being friendly to vegetables and minerals and of granting rights to animals were far in the future – though they had, of course, been de rigueur in Germany for twelve years from *Machtergreifung* to *Götterdämmerung*.

H: To anyone under the age of fifty brutalism belongs to the age of their non-existence or, at least, pre-sentience. It is something that happened in history. Postmodernism is still with us. Having ransacked all other dressing-up boxes, architects have gradually turned to brutalism as an inspiration. The most prolific of those who have done so is Jurgen Mayer Herman, who trades as J. Mayer H. His border checkpoints and service stations in Georgia would improbably be taken for works of the 1960s but they are uncompromising, assertive, convinced of the artist's right to impose his vision without consultation, without accommodating consensual taste.

Imperial College London: Sheppard Robson's magnificent hall of residence in South Kensington was finished in 1963 and demolished forty-two years later. It is not shown on the practice's website. Nor are its slightly later and happily extant lecture halls at Brunel University. Are the architects who comprise the current practice

embarrassed by their predecessors' work? Uneasy about how poten-
tial clients might react? Imperial College has form in this area. Some
professor of a 'discipline' called Sustainable Energy in Business
defends the destruction of cooling towers thus: 'You have to think:
how much does this enhance the landscape compared to what else
we could do if we weren't having to maintain the towers?' This is
the very epitome of unreflective short-termism and a not particu-
larly convincing justification for sanctioned vandalism.

Jasari: The Tirana School of Advanced Proxenitism, 'the jewel in
Albania's trade college archipelago', was designed by the late
Nexhat Jasari, whose other works included soundproofed contain-
ers, experimental dungeons and the Presidential Bison Run.

Konstantinov: Skopje – in Macedonia, then the southernmost
Federal Republic of Yugoslavia – was largely destroyed by an earth-
quake in July 1963. The masterplan for the rebuilding of the city
was undertaken by Kenzo Tange. Most of the actual buildings were
designed by Yugoslav architects, among them Janko Konstantinov,
whose post office complex presages the wild and delirious idiom of
the *spomenik* (memorials) to the National Liberation War, i.e. the
Second World War. Tito commissioned scores of these futuristic
melds of architecture and sculpture, some of which have been
recorded by the Belgian photographer Jan Kempenaers. Many,
however, were destroyed during the civil wars of the nineties.
Konstantinov's work further presages the weirdly joyous style of
the later years of the Soviet satellites. Much of this has been
recorded by the French photographer Frédéric Chaubin.

Luder: The three finest works of British brutalism were designed
by Rodney Gordon of the Owen Luder Partnership: the Eros
Centre in Catford; the Tricorn in Portsmouth; the Trident in

Gateshead. The first is disfigured, the other two have been destroyed in acts of petty-minded provincial vandalism. One can have nothing but contempt for the scum-of-the-earth councillors, blind planners and toady local journalists who conspired to effect the demolition of such masterpieces. One can only despair at the pusillanimous lack of support from wretched English Heritage. The dependably crass Prince of Wales, the man who sullied Dorset with Pindbrih, described the Tricorn as 'a mildewed lump of elephant droppings', a simile as vulgar as it is visually inept. No doubt his heritage industry toadies removed their tongues in order to chortle a moment's laughter. Ian Nairn was on the money: 'This great belly laugh of forms . . . the only thing that has been squandered is imagination.' Gordon's imagination was indeed fecund, rich, untrammelled. It was haunted by Russian constructivism, Crusader castles, Levantine skylines. But the paramount desire was to make an architecture which had not previously existed. There are as many ideas in a single building as most architects manage in a lifetime's work. The seldom-photographed street-level stuff at the Trident left the observer with the certain sensation that he was in the presence of genius. One thinks of the burning of books.

Monstrosity: It took more than three-quarters of a century before High Victorian architecture even began to be rehabilitated through the efforts of Betjeman, Waugh, Osbert Lancaster, etc. Their pleas on its behalf went unheeded. They were reckoned to be perverse and mischievous. The routine calumny was 'Victorian monstrosity'. Thousands of such 'monstrosities' were destroyed. They are now widely valued and their loss widely mourned. We have learned nothing. Half a century after brutalism's heyday 'concrete monstrosity' tips readily off the tongues of the unseeing, the torpid, the incurious, and Britain is once again being architecturally cleansed in favour of timidity and insipidity.

New: Newness and change were bound to be for the better. Neophilia is today regarded as some sort of infirmity. That was not the case in the post-war years. When Macmillan announced at Bedford in 1957 that 'most of our people have never had it so good' some of our people were still living in caves (in the Severn Valley) and many of our people had no bathrooms and shared outdoor toilets. New flats with those amenities and central heating were welcomed by their occupants. Social housing projects were not yet bins for sociopaths. But they would soon become so: if blocks are unguarded, if there are no janitors, if they are not maintained . . . You don't buy a car and never get it serviced.

Organisation Todt: Pre-war the civil engineering branch of the NSDAP, named after Fritz Todt, built *autobahnen* and ordered their surrounds in order to achieve minimal damage to the landscape: these animal lovers were nothing if not green. From the outbreak of war its work was almost entirely martial. After Todt's death in 1942 the OT was directed by Albert Speer. Its architects included Werner March, author of the 1936 Olimpiastadion, and the startlingly prolific Friedrich Tamms, who created the designs for sixty different types of gun emplacement, bunkers, shelters, flak towers, U-boat pens, etc. Tamms was, arguably, the first brutalist. He revived the expressionism that the NSDAP had proscribed. The forms he used were seldom functional. Rather, they employ the imagery of might – visors, chainmail fists, anthropomorphism and zoomorphism. They were terrifyingly graphic warnings to the populace of occupied countries. Le Corbusier, who spent two years attempting to treat with the Vichy government, cannot have failed to be aware of Tamms' work. He didn't advertise this familiarity.

Parent: The church of Sainte-Bernadette in Nevers was consecrated in 1966. It is the work of the architect Claude Parent and the

theorist Paul Virilio, author of *Bunker archéologie*, who for some years had been studying and photographing the many thousands of structures which comprise the Atlantic Wall, built, by slave labour, 1940–44. The congruence between the structures and brutalist architecture had been brushed under the carpet. In their church Parent and Virilio make the link explicit. Parent's contemporary Maison de l'Iran at the Cité Universitaire in Paris is a tour de force in different materials.

Quebec: Canada's campuses are constellated by brutalist libraries: the Robarts in Toronto, the Weldon in London, Ontario, the Kilham in Halifax, Nova Scotia. The two most extreme essays are in Quebec City – Dimitri Dimakopoulos's boorish Concorde Hotel, and Quebec Province – Moshe Safdie's thrilling Habitat 67 at Montreal, a collision of 150 residential units that appear to teeter perilously. The effect is both fragmented and monolithic, a labyrinth constructed by orthogonally inclined termites.

Robbins: The Committee on Higher Education chaired by the economist Lionel Robbins sat 1961–63. Its report recommended the massive expansion of tertiary education. New universities were to be built. Old universities and former university colleges and former colleges of technology were to be extended. One sort of reaction was Kingsley Amis's observation that 'more will mean worse'. Another sort of reaction was delight on the part of architects who saw an incomparably rich gravy train approaching. Denys Lasdun's UEA is perhaps the finest of the lot. Chamberlin, Powell and Bon's Roger Stevens building at Leeds is agreeably weird. Sussex, which preceded Robbins, the expanded Southampton – both by Basil Spence – York and Essex are anthologies of well-maintained brutalism. One minor nail, a drawing pin, in brutalism's coffin was its rapid espousal by the Wilsonian establishment, which

caused half-witted Spartist protest-kids to identify it with repressive authority.

Soreq: Those protest-kids have no doubt directed many howls of self-righteous anger at the Israeli Nuclear Research Plant at Soreq. The architect was Philip Johnson, who in his long life – he lived to the age of ninety-nine and never retired – had jumped on many bandwagons and had even started a few. One of this creepy social-ite's many enthusiasms was Adolf Hitler – which makes an Israeli commission a matter of wonder. While his brutalist buildings in the United States are as unconvincing as most of his *oeuvre*, the temple to radiation on the dunes a few miles south of Tel Aviv is impressive. Brutalism was the architectural mode of the Cold War, on both sides of the Iron Curtain – Mutually Assured Construction.

Tange: The viscerally exhilarating Yamanashi conference centre in Kofu is a vast machine which seems to be missing vital parts. Kuwait's embassy in Tokyo might have been assembled from several vaguely similar extant buildings. The Shizuoka press centre is all cages attached to a stout pole. Then there is Kenzo Tange in a more sculptural mood, hanging cantilevers at oblique angles and creating buildings which look as if they are in the process of collapsing.

Utzon: The Danish architect Jorn Utzon is celebrated for the Sydney Opera. His essays in brutalism were failures, tentative and timid. Indeed this was an idiom for which Scandinavians seemed to have had no stomach. A tragic lack of insensitivity and an excess of rationality no doubt militated against its adoption.

Vanbrugh: Luder, Gordon and Sheppard are in good company. The proto-brutalist John Vanbrugh's buildings were widely lam-basted while he was still alive – Blenheim was described as a

'quarry'. When he died the Reverend Abel Evans – incumbent of Great Staughton, a living that was in the gift of Vanbrugh's nemesis, the Duchess of Marlborough, and only a few miles from Vanbrugh's Kimbolton – famously wrote, 'Lay heavy on him earth / For he laid many a heavy load on thee.' (Is this where the Prince of Wales gets his cloacal inspiration?)

World's End: This estate of seven towers between King's Road and the Embankment was designed by Jim Cadbury-Brown and Eric Lyons. More than any other London scheme it demonstrates brutalism's debt to expressionism, explicitly the expressionism of Hamburg and Bremen. It is restless, angular, red-brick, complicated. Cadbury-Brown's earlier work included the Royal College of Art, which owns an equally commanding presence.

X: Team X was a loose grouping of youngish architects, manifesto folk, who in 1953 broke with CIAM (Congrès Internationaux d'Architecture Moderne) to pursue a less rational architecture – in other words, they had understood the prevailing change of mood. They included Le Corbusier's collaborators Shadrach Woods and George Candelis, who had been instrumental in changing that mood, Jaap Bakema, Aldo van Eyck, the Smithsons. In Rachel Cooke's *Her Brilliant Career* there is a photograph of the teenage Alison Smithson – at first glance it appears to be Kevin Rowland in Dexys' ragamuffin period. This is worrying.

Yale: Paul Rudolph began his career in Florida, designing light and airy houses, mostly of modular construction. He moved from these chamber pieces to full-blown and very noisy symphonies, massive lumbering sullen campus buildings which manifest a spectacular indifference to what anyone thinks of them. This is sod-youism at its most stubborn. One is obviously led to think of clumsy robots

in a scrum. Rudolph was Dean of Yale's Architecture school and author of that faculty's building which is now named after him. Among his pupils were Richard Rogers and Norman Foster. Photoshop Rogers' Lloyd's Building and render it as though it were built in concrete.

Zapotec: During the 1920s there was a Californian craze for neo-Mayan architecture or, more precisely, exterior decoration. The pre-Columbian modes that attracted attention in the 1960s were the Zapotec and the Inca – massive, bold, cyclopean and devoted to 45-degree slopes. Where building ends and natural formations begin is often moot. (2014)

Public transports
Soviet Bus Stops by Christopher Herwig

If we are to judge by the architectural archaeology of its final years, the very name Soviet Union seems to have been more an expression of hope than a reflection of the actuality. The buildings of those last two decades, from a few years after the deposal of Khrushchev until the whole edifice crumbled, increasingly shout about an absolute lack of unity or consensus or order. Rigid aesthetic control is supposed to be a totalitarian staple, a condition of tyrannies. It is notable by its absence. If it was exercised, then it was with marked laxity. The diversity of styles is staggering. There is a glorious lack of restraint and a marked antipathy to the austerity which characterised both Khrushchev's time and the beginning of Brezhnev's long term. It seems probable that it was the stagnation of the later Brezhnev era that allowed the cult of individuality to flourish. It is increasingly clear that freedom of expression became rather stronger in the Evil Empire than it was in the Free World – which, of course, counters the propaganda of both Cold Warriors.

The past decade has witnessed a burgeoning fascination with this largely unknown architecture of the late Brezhnev era. Frédéric Chaubin has photographed an amazing range of offices, laboratories, theatres, transmitter masts, etc. Jan Kempenaers has recorded Yugoslavia's monuments to the battles and fallen of the Second World War. These investigations are evidently linked to a more general reassessment of late modernism and of brutalism in particular. But they have been restricted to structures which, however bizarrely extravagant, are unmistakably works of official architecture and sculpture. And they, like such works in any style, are prone to pomposity and smugness.

Christopher Herwig's obsessional project also posthumously illumines the Soviet empire's taste for the utterly fantastical. It restricts itself to one building type, the bus stop or shelter, which tends in western Europe to be meanly utilitarian. There is a certain amount of that here. But it is atypical. The norm is wild going on savage. Just as follies were, in the eighteenth century, often try-outs for new architectural styles, so may some of these wayward roadside punctuation marks have been structural or aesthetic experiments; they certainly don't lack grandeur and audacity. Indeed the disparity between their banal use and the confidence they display might seem puzzling.

It puzzled me when ten years ago I first travelled through the Baltics from Druskininkai in southernmost Lithuania, where I had stayed in a hotel apparently designed by Gaudí, the Cosmonaut. After the shock of countless totem poles in forest clearings, a humble bus shelter might have been just the thing to bring me down to earth. That was not the case. Every few miles on the road to Vilnius there were cubistic concrete tents. Deserted and neglected, they were like components of some unimaginably vast pyritic bauble. There were no buses.

Furthermore, these curious sites were cut off. They were not close to villages or even hamlets. It was not till a couple of days later that I

got the hang of them. Somewhere between Kaunas and Siaulai I watched a man trudge out of deep forest clutching a plastic bag. He walked along the road to a bus shelter which, while it was orthogonally shaped, had been charmingly and painstakingly painted with sheep and fecund fruit trees. He was greeted by a man sitting on a bench. They opened cans of beer and put the world to rights. This was a scene I saw time and again en route to Tallinn. When did these shelters turn into drop-in centres? Does it matter? It gives them a use. And it gives people who live in remote, pub-less, village hall-less isolation a place to hang out. They provide an ad hoc social service. Further, they grant, or have granted, aspirant sculptors, builders, architects and assorted makers opportunities to flex their creative muscles. Not least they have given a fine photographer that most precious and elusive of quarries – a truly distinctive subject, one which he celebrates with an almost tangible warmth and with a fondness for the anonymous men and women who created them. (2014)

Late to the party

Brutal Bloc Postcards: Soviet Era Postcards from the Eastern Bloc
by Damon Murray

The chronology of Soviet architecture, like certain Cyrillic letters, is to Western eyes the wrong way round, or at least out of step and, maybe, even anticipatory: the Evil Empire – home of chugging pollutant Zils, Ladas, Chaikas and Volgas – was, in that regard, stylistically ahead of the Free World. Austere orthogonal modernism was proscribed in favour of historicist bling four decades before a kindred quaintly regressive shift to populism occurred in the fiefdoms of Thatcher and Reagan, elective absolutists possessed of a proud philistinism which they believed to be shared by their subjects.

They may not have been wrong. The former's Victorian values had evidently something in common with Stalin's. He was a

hands-on patron, a living god who guided 'his' architects Iofan, Shchusev, Rudnev et al. to build palaces for the favoured people. Legible, readily comprehensible, grandiose barracks which impressed their often undereducated and overcrowded inhabitants through their approximation to the (reviled) bourgeois dwellings of the nineteenth century: the *nomenklatura* was artistically conservative.

At the Twentieth Party Congress in February 1956, Khrushchev famously delivered what was effectively a four-hour-long charge sheet listing his predecessor's crimes. Just over a year previously, he had denounced the excesses of Stalin's architecture. This has habitually been interpreted as a proxy denunciation of the man. And so it was. But it was also to be taken at face value. Khrushchev's populism was far from bread and circuses, it went beyond surfaces and tawdry glitter.

His aims were humanistic, his means technocratic. One aim was to achieve a functional architecture which would provide the many with decent accommodation: something, anyway, better than tents, stairwells and *bidonvilles*. The workers would get offices and factories on the Western model. And for a while, design throughout the Soviet bloc was in concert with that of the West. A further aim was to defeat capitalism in space: plucky progressive canines, future heroes and heroines of the Soviet Union, queued to sacrifice themselves.

Tomorrow was already here; by the time the often gung-ho and Western-fixated loner Khrushchev was deposed in 1964, tomorrow was yesterday. The infection of popular culture and goods by space imagery and space themes was waning. A decade of rapid change and, with it, the appearance everywhere of the ubiquitous *khrushchyovka* apartment block (cheap, system-built, prone to multiple flaws, but at least a roof) would cede to two decades of stasis-going-on-sclerosis, environmental torpor, continued centralism – and improbably, counter to that, an architectural diversity which

thrived despite the renewed repression of Brezhnev's cautious and reactionary gerontocracy. A gamut of restrictions on civil society and artistic endeavour was reinstituted to quash the effects of Khrushchev's 'thaw'.

Writers were less fortunate than architects, who did their masters' bidding as servants of the state. The Politburo's relinquishment of aesthetic control over architecture was bizarrely out of character. It was, perhaps, due as much to governmental indolence as to the perception that the unimaginative homogeneity which had become the empire's norm might be Soviet but was not Russian or Georgian, Uzbeki or Romanian. The bloc's historic taste for different forms of deafening bling is as marked as the 'traditional' English taste for the genteelly picturesque. Stalin had been wise to this; his abrogation of constructivism and abstraction had not proved unpopular.

The postcards assembled here show many building types from, predominantly, the last two decades of the Soviet Union. Lurking here and there are straightforward, if tardy, thefts of Le Corbusier's totalitarian Plan Voisin, a number of deadening quasi-Miesian blocks which might be French or Scottish, and gigantic hotels which would not be out of place in Spain's earliest industrialised resorts. The gulf between East and West is reduced by such physical manifestations. The other ceases to be the other when its quotidian environment is so similar. The kinship of human animals is emphasised by the similarity of the hutches they inhabit.

But more often the genealogies of late-Soviet projects are peculiar to that empire, that epoch. There is even a strain of socialist realism that endured well into the 1980s. Where it comes from is clear enough, it belongs to the appetite for the early years of the Revolution, an appetite that comes and goes. Under Brezhnev there was no shame in admitting to that appetite and, by implication, to a longing for the good old days of shortages, starvation and genocide.

The 1970s statues of Aurora at Krasnodar and that of Lenin in Jurmala, a pretty art nouveau resort outside Riga, differ only from works of forty years earlier in their anti-naturalism and tendency towards expressionism; the 'heroic' posture is as corny and risible as ever. And almost surely as unaffecting: propaganda tools which may have succeeded in impressing a hardly educated, illiterate public during the thirties and forties would appear crude to more educated generations, particularly to those living under the colonial yoke. An evident paradox of mass education in a totalitarian regime is that it equips the recipients of that education with the discrimination to perceive the regime's flaws and criminality. While monuments and memorials such as those at Jurmala (which lasted only twelve years before it was demolished in 1990), Novorossiysk and, famously, Buzludzha may have become bereft of their original meaning with the dissipation of communism, their frequently counter-intuitive forms were picked up by the designers of more obviously utile buildings which have endured. They incited a move away from rectilinear repetition towards a more wayward geometry, towards structures which are fragmented, counter-intuitive and sculptural.

There are evident parallels with Western brutalism, parallels that are stylistic rather than chronal. Soviet brutalism flourished late, by which time the idiom had all but evaporated in the West, buried by a wave of cultural conservatism, widespread opposition to neophilia, the oil crises of the early seventies and, in France, *la circulaire Guichard*, which formally prohibited the construction of further *grands ensembles*.

So, as the Free World expressed its freedom by restricting architecture to the infantilism of postmodernism and neo-vernacular timidity, the expiring Evil Empire created an architecture which looked forward to today's Russia: Land of Opportunity and Egalitarianism. Well, of course it didn't: there is no intimation in these photographs of last days, of impending collapse, of the greatest socio-political shift in half a century.

Architectural photography tends to mendacity. It glorifies buildings just as monuments glorify the Great Patriotic War, reduce sacrifice to an abstraction and omit the enormities committed by all sides. It is victors' photography, a sort of PR achieved with perspective correction and cropping which turns buildings into stand-alone works of jewelled art with no context. This collection is rather the obverse of architectural photography. It is artless and unwittingly truthful, despite the chromatic delinquency of film stocks such as Svema Isopanchrom, which was polarising: brilliantly hued 'props' (cars, buses, clothes, flower beds) would bleed while neutral colours were etiolated, so diminishing the composition's prime subject in a hazy occlusion and absence of (figurative) focus. When a camera – a Zenit-E, very likely – is concentrated on a building it may, in order to achieve an ideal angle or range, be forced to include the building's surrounds. It is here, in these interstices, that clues are to be found to the life led in the Soviet Union almost half a century ago, when Photoshopping was something that happened only to the unfortunate of the Politburo.

The maker of postcards lacked the means to dispatch inconvenient sights that had crept into frame: certain of those sights might exceed in size the subject. They might be roads, streets, squares, pavements, *terrains vagues*. While apartment blocks, hotels and offices may register as familiar to the Westerner, these spaces don't. This is where the alien and the strange are to be found. The spaces are often deserted. Are they public? Are there warnings not to venture into them? If they were for show, who were they attempting to impress? The Soviet notion of collectivity is belied by absences which imply a preference for privacy, for a domestic life.

Of course there may be practical reasons. Vast stepped and staggered hotels, far beyond the pocket of the many, would be empty for the majority of the year, when no numbing conference was under way. Shopping malls whose shops are short of goods are not

liable to attract customers. Rhomboids and parabolas, 'organic' forms and extravagant cantilevers, may create eye-catching places but they do not invest those places with life and vitality. That would come with *glasnost* – and its attendant confusion, tribal atavism and world-class business practices. (2018)

Grey matters
Speech given at the Southbank Centre in London

The baroque was described by Benedetto Croce as an artistic perversion, artistic ugliness. The word he used was *bruttezza*.

As a playwright John Vanbrugh – whose characters included Sir John Brute – prompted delight and outrage and the wrath of censors. His architecture prompted merely outrage – both among his contemporaries and for years to come. From baroque beginnings at Castle Howard it ascended to heights of uncompromising primitivism. And was predictably calumnised: ugly . . . clumsy . . . disgusting . . . impure . . . odious . . . barbaric . . . Friends such as Swift and Pope mocked him. Blenheim was described as a quarry of stone. Voltaire reckoned it had neither charm nor taste.

Addressing the architecture of the sixties in an editorial, one trade newspaper wrote: 'It is the first time in the history of art that crudity has been directly and laboriously sought out.' This was hardly atypical: aberrational, coarse, absurd, grotesque, uncouth, violent, excessive, degraded, the supreme manifestation of the cult of ugliness – these became standard issue.

This was the 1860s. And the architecture in question was what was called modern Gothic – certainly modern but only approximately Gothic. The most ur-Victorian of Victorian idioms.

Had Margaret Thatcher exhorted Britain to embrace Victorian values a few years before she actually did so in 1983 she would have

prompted incredulity. For most of the twentieth century the very word Victorian prompted rancour, despisal and, above all, ridicule. On the one hand it evoked moral and social squalor, the workhouse, the exploitation of children like little Tom the chimney sweep, rookeries. On the other hand . . . well, another bunch of clichés: preposterous sentimentality, ostentatious piety, finely tuned hypocrisy, adherence to what Orwell snobbishly decried as 'the money grubbing Smilesian line'.

Mrs Thatcher, in that line of descent from Samuel Smiles and Manchester Liberalism, was only able to get away with exhortations to emulate the Victorians because by 1983 a shift of taste had occurred. The vigour, energy, seriousness and inventiveness of the nineteenth century were at last widely recognised. Those qualities were most tangible in the buildings that it had bequeathed us. The layers of lazy prejudice were being removed.

The buildings' harsh weirdness was coming to be appreciated as something quite extraordinary by people who did *not* belong to the Victorian Society, who did not go on rood-screen field trips, who did not attend polychromatic tessellation workshops. The public was belatedly, very belatedly, catching on to the imaginative invention of long-dead artists, long-dismissed artists. This particular shift of taste was contingent on several circumstances.

First. There was by now a century's gap between the buildings and their growing band of new admirers.

Second. A generation had come of age witnessing all around it the routine destruction of nineteenth-century buildings which, while they stood, were overlooked or taken for granted.

Third. A taste for Victorian architecture and for the era's devalued painting was disseminated by such aesthetes as Barbara Pym, Barbara Jones, John Betjeman, Harry Goodhart-Rendel, Osbert Lancaster, Evelyn Waugh.

Most important, and importantly, there was a new enemy, a new bogey, a new word to prefix 'monstrosity'. Concrete.

The modernism which emerged in the late 1950s and early 1960s – modern modernism if you like – was a reaction to the smooth, sleek, elegant work which had preceded it. It shunned prettiness, sweet-natured niceness and emetic unction. It did not set out to soothe. It would soon become the object of *bien pensant* loathing.

For the first time since the 1860s there was an architecture with guts, with attack, with vigour and urgency, with what the Victorians called Go! We don't expect films or novels, sculptures or paintings to be pretty – so why should buildings be? Nightmares are more captivating than dreams. More memorable, too. They hang around longer. Georges Braque said that art's job is to trouble us, while science's is to reassure. There are too many artists who want to be scientists.

The architecture of both the 1960s and the 1860s has incited irrational opposition and baffled incomprehension disguised as moral censure. Even the densest scum-of-the-earth, eager-to-ingratiate-itself politician knows that it will be applauded at the mere utterance of the words concrete monstrosity. While the concrete architecture of the third quarter of the twentieth century emulates the *mood* of the 1860s, it steals the *forms and shapes* of the defences built for an atrocious regime by slave labour and glorified by Ernst Junger as holy: but then Junger did have a quasi-mystical attachment to the apparatus of war.

The French writer Paul Virilio likened bunkers, observation posts, U-boat pens, flak towers, anti-aircraft posts to barrows, tumuli, funerary sites (which of course they inadvertently sometimes became). The Organisation Todt built thousands of fortifications to approximately sixty designs, most of them by the architect and engineer Friedrich Tamms. He described them as 'Cathedrals of artillery. To shelter is to pray. They are true monuments to god and

to the eternity of the German people . . .' They are, certainly, hard to get rid of.

The majority of Germany's less trusting artists had emigrated while they could. As one of them, Billy Wilder, had it: 'The optimists died in the gas chambers, the pessimists have pools in Beverly Hills.' Those who remained were subjected – willingly or not – to censorious compliance which was as small-minded as it was sinister. Conditions for creation were hardly propitious. Art and architecture were propagandist instruments: folksy glorifications of idealised peasants, populist glorifications of genitally impoverished athletes, kitschy essays in emulation of imperial Rome. Though they had drawn on and exaggerated various strains of 1930s European art, they were, after the war, regarded as works which had occurred in toxic isolation and which were so contaminated that they were now in eternal quarantine.

The fortifications are the exception. They were the most original and most influential works of art made during the twelve and a half years of the National Socialist imperium. This was not perhaps the architectural gift that Hitler and Albert Speer wished to bequeath to the post-war world. Under the nose of the tyrant and his toady, Tamms had unwittingly laid down the blueprint for the greatest architecture of post-war. His own practical source lay in the engineering structures that he himself had designed in the first six years after the glorious seizure of power – autobahnen, their bridges, their viaducts and landscaping. It was the greenest of regimes. Tamms expressed his theoretical basis thus: 'The monumental should have no practical use. Practical use stands in the way of appreciation of pure form.' This must have been cheering for those who sheltered in his bunkers.

Ernst Junger called Tamms' structures not just holy, which can mean anything, but also Cyclopean – which strictly signifies a drystone Mycenaean architectural idiom of 3,500 years ago. It is

composed of large, uncut boulders many times larger than those that are typically used for upland walls in Britain and Spain. Structures are held up by gravitational force. By the sheer weight of stone upon stone. More broadly, Cyclopean has come to mean elemental, massive, crude – maybe that should be *apparently* crude.

In the early years of the twentieth century there was a fashion among occidental painters and sculptors to draw on Meso-American, Polynesian, Maghrebian and sub-Saharan African sources: masks, sculptures, totems, hieroglyphs, ideograms, pictographs, *moai* – Picasso, evidently, and his countless imitators; and Matisse, Modigliani, etc. Simone de Beauvoir said the Algerian city of Ghardaïa was like a magnificently realised cubist painting. It should be the other way round.

The early-modern movement in painting, music and sculpture was a dependence of the colonialism which it reviled and of the imperialists it scorned. It was escapist. The early-modern movement in architecture took a different path. Different path*s*. But all led towards a fundamentalist trust in progress, a trust so strong that it was a faith. The strain of modernism that became known as the international style held that the future would be determined by technocrats. Architects did not consider themselves as builders or as artists but as social engineers. Reason didn't sleep. Far from it. It suffered such insomnia that it created its own monsters, monsters so hyper-rational that they were instruments of managerial madness.

Regimentation, pathological neatness, centralisation, strict order, planning, efficiency, grids: these were the intrinsic properties of the new society, a society that was, of course, a sort of machine under the control of its authoritarian managers. Authoritarian dieticians and eugenicists in pristine clinics planned the human and human hybrids fit for the socialist future, the National Socialist future.

There was nothing scientific about international modernism's programmes. Social science is not science. It is a kind of scientism

– it mimics science, pilfers its procedures, wears its clothes. Progress, the progress the programmes were claimed to represent, was also a pretence. Progress explicitly connotes movement, change, perpetual experiment. Equally explicitly it precludes stasis. By the mid- to late thirties rectilinear white modernism had ground to a halt.

It was not until mid-century that architecture caught up and sought to emulate the variety and energy which abound in modern painting, sculpture, literature. A shift of self-image occurred. Architects began to cotton on to the idea that, rather than remain sterile technicians of a neverland that had never come to be, they might create the neverland that never would be in the guise of artists.

If the architectural modernism of the long sixties had as one source the grubby secret of Nazi fortifications, it could also claim less compromised ancestors: the expressionism of the 1910s, 1920s and early 1930s. Like the contemporary but hardly expressionist German painting of Schad, Dix, Nussbaum, Scholz – the Neue Sachlichkeit – it was for many years unmediated or forgotten or if not forgotten then treated as an obscure backwater. The expressionist instinct was entirely contrary to that of international modernism. It's undisguisedly individualistic. The artist is omnipresent, pulling the strings, performing, asserting him- or herself – in the case of architecture it is almost certainly a him.

It is not the moral squalor of part of its provenance that causes sculpted concrete to be called brutalism and the prolific, influential, religiose, unrepentant National Socialist Friedrich Tamms to be considered the first brutalist. Though that would be reason enough. The term *nybrutalism,* new brutalism, seems to have been the jocular coinage of the Swedish architect Hans Asplund. It referred to a small house in Uppsala designed in 1949 by his contemporaries Bengt Edman and Lennart Holm. In comparison with the work which would subsequently be labelled brutalist the house is meekness itself.

The word brutalism caught on. A group of English architects were on a then-routine pilgrimage to Scandinavian shrines when they met Asplund. His coinage became popular in London's architectural society. But what did it mean? It was a signifier in search of an object. This was taxonomy back to front. The title preceded the book, so to speak. It appears to have been initially used in a mildly derogatory sense. It was adopted by the architects Alison and Peter Smithson almost as a badge of defiance. It was further disseminated by their sometime acolyte and interpreter Reyner Banham. While it still had absolutely nothing material to describe – other than a vacuum – the word became laden with further associations.

Just as the generation before his had drawn on African and Polynesian artefacts, so did Jean Dubuffet draw on the untutored, often disturbed, often disturbing work of psychiatric patients and the mentally fraught, patronisingly revered as idiots savants when they're possibly just idiots. He called it *l'art brut* – brut here meaning rough, crude, expressive of demons and backbrain horrors. It's also an extra-cultural phenomenon. That's to say the work of, say, a sometime taxi driver in Mumbai will resemble that of a former gardener in Castile: the work is created without reference to the cultural norms of the society which its makers inhabit. There is, then, an unwitting internationalism to it.

Brutalism also had appended to it a link to *béton brut*. Raw concrete. The stuff of bunkers. A material that would evidently be reckoned harsh and unaccommodating by a public that apparently craved the solaces of bogus beams, wicket gates, winking dormers and prettiness. Not even beauty, just prettiness. Most pertinently, brutalism suggested Sauchiehall Street after an Old Firm derby. Stramashes. Bottlings.

With minor variations the word brutal recurs in countless languages. To people across the world brutalism suggested merely

brutality: they were not apprised of the French words for raw concrete. They knew nothing of Dubuffet. Here was a further instance of unwitting internationalism.

When Friedrich Tamms began designing bunkers there was nothing new about concrete. It was indeed a very old material, used with great mastery by the Romans – the Pantheon, the Pont du Gard, etc. What *was* new was Friedrich Tamms' appreciation of reinforced concrete's plastic capacity, its pliability, its potential as a sculptural medium. This might seem an irrelevance in a martial structure. But Nazi Germany was, evidently, a tyranny which controlled by every means including aesthetic ones. Dress, ceremonial, film, painting, architecture. Tamms created forms, *quasi-figurative forms*, that recalled fortresses, dungeons, megaliths, helmets, animals preparing to pounce. Part of the Atlantic Wall at Lacanau in the Medoc, manned late in the war by a battalion of the Indische Legion, Indian members of the SS, and now demolished, had the shape of a hideous reptile. The point of this threatening imagery was to send unequivocal messages of German might to both the population of occupied countries and to the German people – who came themselves to feel that they were victims of occupation.

How does an idiom made for war adapt to peace? Readily. What changes need to be effected? Few.

It was the very bombast and bellicosity which attracted architects who were browned off with the restraints of good manners, monochromatic smoothness, lightness of touch. And no architect was more browned off with those cardinal properties of modernism, so-called heroic modernism, than Le Corbusier – who was its unquestioned master.

Le Corbusier was the twentieth century's greatest architect. He had no doubt of it. Nor did his numberless idolaters who refer to him as *Corb*, an intimation of familiarity as embarrassing as that of people who call Miles Davis *Miles* or Buckminster Fuller *Bucky*. No

less embarrassing though than Le Corbusier's own habit of referring to himself in the third person: a habit today associable with brainectomised footballers and backward celebrities. One might take a cue from André Gide. When asked who was the greatest French writer, he replied Victor Hugo, alas.

Le Corbusier, alas . . . He had all the usual qualities of a big-time architect – paranoia, vanity, startling selfishness, egotism, resentment, sycophancy, moral nullity: like Talleyrand and the vicar of Bray he had the ability to switch sides with impunity. After two years anilingual treating with Pétain's Vichy government – he even went to live in that benighted spa – he attached himself to de Gaulle's minister of reconstruction within days of the liberation of Paris.

As a theorist he was a harmful eccentric, rashly provocative and dangerously influential on those same idolaters who took his megalomaniac projects seriously. But he was as fine a painter and sculptor as he was an architect. And at some point, Le Corbusier-painter-and-sculptor began to coalesce with Le Corbusier-architect. They begat a new architect, the architect that he would be in the last third of his life.

The pre-war master of orthogonal villas for the rich and arty mutated into a primitivist, a pseudo-primitivist, working – supposedly – for the people. A stylistic Talleyrand too, then. His architecture took on the farouche colours, irrationalism, emotional heat and dreamlike exaggerations which he displayed in the other disciplines. His sculpture became architecture. His architecture became sculpture, functioning sculpture, sculpture with a social purpose. It was an extraordinary mutation. He had, so to speak, abandoned the prose of a technical manual in favour of the poetry of the sublime.

L'Unité d'Habitation in Marseille was not the first building that Le Corbusier designed in reaction to his earlier idiom: he had made tentative forays – left-handed, ham-fisted – as early as the early thirties. But l'Unité's size, its ambition, its fecund invention, its

effrontery and its sheer originality caused it to capture the imagination of the world's architects. In contrast to the reaction – the much-bruited reaction – of Marseille's inhabitants.

They are *said* to have referred to it as *la maison du fada*. Fada means madman. It's not spoken with fondness. Who actually coined this epithet is not recorded. It was most likely the work of the Society for French Aesthetics. This obscure group also brought a bizarre lawsuit against Le Corbusier demanding damages of 20 million francs for aesthetic crimes. It lost. It appears to have been typical of those clamorous factions – among them taxi drivers who write for newspapers – which claim, presumptuously, to speak for what they call *ordinary people*, which invent slogans for *the common man*, which encourage *hard-working families* and a legion of further demographic fictions to militate against the unfamiliar *just because* it is unfamiliar.

Muslims make the hajj to Mecca, credulous invalids visit Lourdes, Hindis immerse themselves in the septic, shit-thickened Ganges, architects get their grail at l'Unité d'Habitation, for sixty years an invitation to plagiarism or homage – which are the same thing.

Prefabricated, factory-produced building systems of the same era – Clasp, Reema and so on – evidently produced standardisation. They succeeded in achieving a worldwide monotony. Brutalist buildings, forged on site from poured concrete, had a capacity for uniqueness or at least for difference from each other – they were not reliant on ready-made components. Some of the pilgrims who congregated at l'Unité randomly pilfered tics and mannerisms of the sculptural vocabulary, the plastic font that Le Corbusier had invented.

Mounting a building on pylons, or pilotis, wasn't new: Le Corbusier had been at it since the twenties, his nameless predecessors had been at it for approximately 6,000 years. Mounting a building on such hefty legs was, however, unprecedented. They are the legs of a pachyderm. What kind of pachyderm has thirty-four legs?

More than a rugby scrum. So — it must be an insect . . . but even an insect with elephantiasis doesn't have legs that thick. Further, these pilotis create a nave, or a nave's ancestor — a sacred grove.

It is all exhilaratingly impure. It's an oxymoron, a mongrel, centrifugal, simultaneously pulling in several directions — it's what Max Ernst said of his own work: a hallucinatory series of contradictory images. When Jean Cocteau first saw Nijinsky he said: 'What grace . . . what brutality.' And indeed, as well as possessing a singular delicacy of movement and an exceptional gamut of expression Nijinsky had the shoulders of a prop forward and the face of a manly woman. 'What grace . . . what brutality' is the most fitting reaction to l'Unité. It wasn't till l'Unité began to attract idolaters, of a sort, that anyone took notice of Friedrich Tamms' bunkers as architecture rather than the defences of a vanquished regime.

Now: imagine a form of IVF that creates babies which are giants. Their pituitary gland is programmed to gradually shrink a 12-feet-tall, 20-stone newborn throughout childhood and adolescence until it arrives at adult size. The brutalist mindset was enthused by such impossibilities: *apparent* impossibilities . . . the lure of counter-intuition, of going against nature — but, then, nature goes against nature. Nature overturns what is carelessly called the natural order. Inverted pyramids, reckless cantilevers, toppling ziggurats, vertiginous theatre and the apparent defiance of gravity — which is invariably the sign of a demi-god at work . . . The architectural imagination was flying. Which was alarming to the timid aesthetic arbiters of a country which was zealously divesting itself of the relics of the last time that architects went on a collective bender. England was being architecturally cleansed of High Victorian works. Modern Gothic buildings of great presence and greater brutality were demolished at the rate of a dozen a week throughout the 1950s. They were, of course, monstrosities.

Brutalism changed the way architecture drew upon nature. Applied decorative representations had disappeared with international modernism. They didn't return. But brutalism did not shun representation. Anything but. Instead, however, of just incorporating natural forms, its ambition was to create buildings which were themselves natural forms. Such a remaking of the planet was not a modest undertaking. It didn't copy what was already there. It *invented* natural forms, *new* natural forms — that's what art does, it makes what was not there before, it creates what was lacking. These new natural forms possessed manifold textures and surfaces.

Bunkers were often given dense, irregular impasted surfaces of random incisions and accretions to break up the shape of a building seen from the air. Texture was more important than colour, for all reconnaissance photography was still monochrome. Brutalists created the most haptic civilian architecture ever: board-marked concrete grazed skin, furrowed concrete tore cloth, bush-hammered concrete hurt.

Untrammelled by the inhibiting rules and manifestos that international modernism had wrapped itself in at countless conferences, Brutalists did what architecture had always done. They looked to the past, to pasts. But to pasts further distant than those with which the Renaissance, neoclassicism and the Gothic revival had nourished themselves. To a far past. To prehistory, to proto-history.

It was the elemental qualities of ancient architecture that the brutalists immersed themselves in, as if learning how to build from the beginning. They were finding their way back to rudiments. There was no question of mimicry, of reproducing decorative surfaces. Here was an aesthetic programme which sought to rediscover the very essence of architecture, which aspired to start from scratch . . .

It has to be emphasised that the denigration of brutalism is mostly retrospective. The world of over half a century ago, the world that brutalism was built for, was far from hostile to it. It was keenly receptive, excited by newness, eager for change, maybe

naively eager – but change was presumed to mean better. The years after the war were years of privation, of a country bankrupted by America, the victor which had got the spoils. In real terms, people were much poorer than they were to become. But comparative indigence did not mean that the fifties were a period of tedium. This is yet another retrospectively imposed notion – probably a result of the world, on this side of the Atlantic, still being represented in monochrome – it's a wrong notion, with, on the side, a dash of decadism.

Architectural change was inhibited by the rationing of materials such as steel and by building licences, which were not removed till late 1954. Even after that date there were still shortages of materials. There could be no greater incongruity than that of brutalism's complexity, earnest, sternness, danger and menace and early pop music's fluffy immediacy and eagerness to please. They belonged to different eras which happened to exist at the same time; they inhabited parallel worlds. The music of brutalism is *musique concrète*, Schoenberg, Berg, Eric Dolphy, serialists and Stockhausen. Even though pop music grew up in the middle 1960s there was still an absence of affiliation with the architecture. There was still a generation gap: brutalism was Dad's architecture. Furthermore, it became the architecture of the establishment, of Harold Wilson's great administrations, of the new universities, of municipal libraries, the state's theatres and galleries, of cultural welfarism and hospitals.

Save for a vague correspondence between the blues craze of 1961–64 and the architectural fascination with the primitive, governmentally sanctioned brutalism had only the frailest cultural links to popular music, clothes and so on. What it did share was an insatiable appetite for turning over the old order, for novelty, maybe novelty for its own sake. Why not? Novelty did not then carry a pejorative implication. The forces of novelty pulled in countless conflicting directions. Nouvelle vague. Nouvelle cuisine. Nouveau

roman. New left. New psychiatry — the therapeutic state is controlling you: bin your medication. New universities busily invented new disciplines. Vatican II decreed that new churches should be churches in the round like theatres in the round.

During the high point of brutalism I was in my teens and early twenties — I shall never forget my excitement when walking across Hyde Park I saw the Royal College of Art for the first time; I shall never forget my amazement at the sheer virtuosity of the almost finished not yet inhabited Tricorn in Portsmouth: concrete from outer space. That was long ago. You get to realise that you have lived through what to subsequent generations is *history* — second-hand, lied about, generalised, mediated. And only obliquely related to one's own experience of a far-off epoch whose mores and hopes and moods actually promised a better world. Though we knew the promise was preposterous.

The simians of the demolition community must salivate at the very thought of brutalism. Such juicy pickings. England's two finest brutalist schemes, designed by Rodney Gordon of the Owen Luder Partnership — the Tricorn and the Trident at Gateshead — have both been destroyed. Pimlico School, gone. Basil Spence's Hutchesontown flats in Glasgow, gone. Sheppard Robson's hall of residence at Imperial College, gone. The cooling towers at Richborough near Ramsgate, at Sheffield, at Retford, at Didcot — all gone.

The intrinsic value of a structure has nothing to do with how old it is. A menhir whose age is measured in millennia is not necessarily superior to plant whose age is measured in decades. There is, incidentally, nothing remotely sustainable about destroying the evidence of the recent industrial past: unless that is, sustainable means merely a devotion to the bottom line. The appropriation by every exciting start-up of the prefix sustainable would be comical were it not so obviously mendacious.

Sustainable street furniture, sustainable nail extensions, sustainable liposuction, sustainable logistics – deliveries! – sustainable root-canals, sustainable bestiality, sustainable strategies, sustainable offal shampoo, sustainable masturbation.

Open, transparent, sustainable – the three great lies of the age. Life itself is not sustainable. I am going to die. *You* are going to die. Get over it. (2013)

5

Death

Stuffed

When my father died, he willed that his ashes be deposited in the river that flowed past the end of my parents' garden. My mother, my mother's sister and I watched as the undertaker pulled a handle on top of the urn, thus occasioning an aperture in its bottom from which the sticky, sludgy ashes fell to the surface of the swollen river and spun round in a whirlpool shining like petrol in a puddle, like mud infected with mother-of-pearl. I shall never forget the horror on my mother's face.

When she died, her sister and I watched as the same undertaker, equipped with a kindred vessel, released her ashes and unerringly found the same whirlpool. The flammable agent was less evident thirteen years on – crematorium technologies had doubtless come along a bit, they had grown greener – but there was no mistaking the greasy, flaky, faintly granular meal: that was familiar enough, that was family.

When I die, I want to be mounted, stuffed, subjected to benevolent and verisimilar taxidermy, displayed in a glass cabinet. I am entirely confident the sculptor and taxidermist Emily Mayer will do me posthumously proud. But if I die tomorrow, she will not be allowed to.

Instead of providing material for a consummate artist, I shall be obliged to suffer the indignity that my parents chose for themselves, or I'll be buried, swept under the carpet of earth and turf. The dead are denied choice. The dead are other, they have no rights. They are obliged to submit in this culture to one of two means of disposal, and to do so quickly lest they embarrass the still living.

It is not the momentous physical change from one state to another that is homogenising, but the severely straitened gamut of posthumous possibilities. It is not death that is the leveller but the unimaginative conformity the living bring to its immediate aftermath in the delusion, no doubt, that shock is a sickness requiring cosseting rather than a state of exhilarating bemusement and concentration.

It is the living who are the problem in their relations with the dead. We seek to protect ourselves from the dead and their invariable unwelcome message to us, just as we try to protect ourselves from those who would enact the primal scene before us.

It is interesting and perhaps pertinent that Anthony-Noel Kelly should be, as well as a quondam abattoir operative and a bit of a nob, a Roman Catholic.

There is no doubt that formerly Catholic cultures are both sexually and mortally better adjusted than those that are contaminated by the hangover of Protestantism and Puritanism. It is an English imperative to keep sex and death apart from life, to pretend they don't really happen. We are happy to put up with the most rigorous censorship in Europe. We are proud to be children who require protection. We are proud of our disability to confront the elemental. We revel in our squeamishness and cosy fastidiousness.

We do not object to policemen, typically people of limited learning and intelligence, imposing their dismally commonsensical aesthetic code upon us: 'It was frankly unbelievable . . . It was sickening. Just because you've got royal connections it doesn't mean you can mess with real human beings.' Thank you, Cunstable. It is

easy to sicken policemen, even those 'used to working with some horrific cases' – they are sensitive souls, these barometers of middle England, easily riled and thus the ideal audience for stunt art.

The tradition that includes Mary Kelly's *Post-Partum Document* (used sanitary towels), Ralph Ortiz's performances (biting the head off a live chicken), Otto Muehl's performances (sewing himself inside a cow's carcass, fucking a goose) and the more recent work of Damien Hirst, Genesis P. Orridge and Gilbert and George is one fuelled by bourgeois animus and fulminatory ranting. Its success is not to be measured by the fawning adulation of conspiratorial critics but in the outrage it provokes.

Unhappily, Anthony-Noel Kelly doesn't belong to this tradition, even though his assistance with police enquiries may ease his passage into it. His appropriation of redundant bodies, soft machines with no further use and bereft of the autonomy that made them alive, is different from Damien Hirst's use of sheep and kine. This is not simply a question of species. Hirst's beasts are amended and preserved ready-mades. The sheep is not represented, but shown: Hirst's process is omissive; it eschews painting the sheep like Holman Hunt, or making a fibreglass model like Nicholas Munro. With Hirst there is no perspectival craft or marks on canvas, there is no quasi-industrial process of moulding that results in something standing for a sheep. What Hirst has done is to make signifier and referent one: it is this aesthetic stratagem as much as the actual subject that infuriates art-loving rozzers.

Kelly uses his rustled bodies merely as tools. He makes casts of them to achieve work that might easily have been executed a century or more ago; it may not be deliberately retrospective, but it is certainly not modern in any sense other than that it is recently made. Kelly cannot at least be accused of perpetrating a hoax.

His means may be questionable, but even the *Daily Mail* seems to reckon he's aesthetically kosher. He is, after all, connected to that

fount of reaction, the Prince of Wales's Institute of Architecture, and is only doing what Leonardo, Michelangelo and their contemporaries did as a matter of course. That, though, was before a barrier was drawn up between art and science, when that dichotomy was yet uninvented.

What the fuss over Kelly's enterprises reveals is the extent to which science is held in awe and art is not: this is statutorily sanctioned – a body may be willed to scientists but not to artists. Art, like sex and death – and especially art that treats of sex and death – is another thing middle Britain is uncomfortable with, while medical science, because it is utile and because it ultimately extends our life by a few slobbering, incontinent months, is a wonderful thing.

Kelly has not murdered to secure his materials – the Burke and Hare analogies are red herrings – and he has not used them as trophies like Kurtz's heads or Himmler's furniture made from bones. Although he may have offended the DoH's Inspectorate of Anatomy, his only real tort has been to produce such unpromising work.

It is instructive to compare it with Gaudí's sensational, tireless Sagrada Familia, the expiatory temple that dominates Barcelona, and whose portals are encrusted with organic forms, including those of babies' bodies. The greatest European religious building of the century displays work that was based on casts made in a children's mortuary. Foreigners. (1997)

Beyond the grave
The Forbidden Zone by Michael Lesy

Death invites more slang words and more euphemisms than almost everything apart from sex and drunkenness. This is remarkable for something which is supposed to be taboo. True, euphemisms like

'pass away' are evasions, but they're also solaces of a sort, literally happy modes of speech that mitigate our shock at someone else's death. The slang words are, characteristically, curt and hostile – expressions like 'own goal' (boy-in-blue for suicide) or 'snuff it' or 'Roman candle' (squaddie for parachute failure) are not the ones we use when bereavement touches us but they are very likely as evasive as the more patent euphemisms, forming a barrier between death and our contemplation of it. The conventionalised representations of (mostly violent) death on television have the same effect: they fool us into believing that we are bravely familiar with death, that we can face it.

The American writer Michael Lesy's harrowing and unflagging book is a measure of the extent of our delusion and of our smug conviction that the death taboo has been broken. It is shocking in many ways, not least because it emphasises the meretricious cheapness of the minds that turn death into an entertainment; Mr Lesy, by contrast, faces death head on, with wonder, sobriety and speculative curiosity.

His nine chapters are devoted to homicide policemen, pathologists, counsellors of Aids sufferers, undertakers, a homicidal 'warrior'. He visits the scene of a murder, hangs out on Death Row. For a relief from human mortality he goes to a slaughterhouse, where he is instructed by a rabbi who is a *shochet*, a ritual slaughterer. Lesy's method is part-reportage, part-autobiography. He never stands back but records, with a sometimes ingenuous candour, how this fearful progress is touching him.

Mostly it touches him the way you'd expect: badly. It's not just that he sees too much of death – that can be said of all his subjects, too – but that, unlike them, he has no capacity for acceptance: custom has removed the abnormality of their jobs for those who actually work with the dead and the soon-to-be-dead (when you've been removing people's spleens for long enough, it gets to be a job

like any other). But *his* job is to question everything, which prevents him from being able to acquiesce; the very quality that enables his subjects to live with themselves is the one he can't allow himself. Many of the people he talks to are unselfconscious and comic, others are repositories of cracker-barrel saws, others have got DIY philosophies and loopy mystic programmes. Each, in his way, is contaminated by the very defences he has constructed to keep the actual at bay.

The technicalities of evisceration, of the operation of electric chairs, of shooting a steer, of taking off a man's head with a *khukuri*, are graphically written up. It's through his relentless concentration on surfaces, on the physical, on tics and minute detail, that Lesy builds so concrete a picture of the face of the unknowable. The milieux he recreates are eerily mundane and prone to nurture superstition. While Lesy tries to keep himself stuck in the material universe his collocutors are forever clocking creatures from other planets, telling ghost stories (that they believe in), witnessing weirdness. Maybe this is what the omnipresence of death does; or maybe it's just that such fruitcakes gravitate towards the dead and the dying.

Either way, those in the death industry tend to prolixity, and the author's deftness in suggesting this (and what he had to put up with) while not inflicting it on his audience is admirable. The result is something that is tight, dense, composed with harsh grace and revelatory of every question save the big one – it's actually a wonder that Lesy, who is nothing if not persistent, failed to find one of those fortunates who has suffered a post-mortal experience and has a tale to tell. (1998)

Life in death

The day after tomorrow I shall be in Barcelona. There was a time between the late seventies and the mid-eighties when I visited the

city regularly, drawn initially, like hundreds of thousands of others, by Gaudí and then by the sheer vitality and aesthetic bravura of the place. It's now sixteen years since I saw the expiatory temple of the Sagrada Familia, the cornucopian decoration of whose portals includes representations of an arkful of animals (often chloroformed before they were cast), of live adults and of dead babies.

It was Gaudí's practice to haunt hospitals asking if anyone had recently died, and to hang about at mortuaries for the body. The figures of children slaughtered by Herod were cast from stillbirths. This is well known. But what is not apparently known is how Gaudí got away with what is close to grave robbing, whose consent he was obliged to obtain, or whether no one was too bothered.

This is a matter to which neither César Martinell's hefty and ill-Englished study, nor Gijs van Hensbergen's polished recent biography pay much attention. The latter does, however, note Gaudí's implicit belief that 'we are all God's puppets'. Bear in mind that Gaudí was not merely Barcelona's supreme artist, he was a religious artist who may have considered he had some celestial licence to babysnatch in his pursuit of his monumental act of devotion. If so, he was gently deluding himself.

Van Hensbergen quotes Santiago Calatrava, the Valencian architect of Lyon airport and a rare apostle of Gaudí: 'The God, or rather, the Goddess that Gaudí venerated was architecture herself.' Well, of course: in this regard he was no different from any other artist who camouflages an aesthetic strategy with a moral or philosophical programme, who justifies the work by something outside the work, by a sort of add-on.

For all his imaginative inventiveness and sublime originality Gaudí was – sculpturally at least – at the end of a tradition in which the Gothic and the baroque are mixed. The mainstream of twentieth-century practice relegated the naturalistically realised human form to the sidelines. It possessed a horror of copyism. It emphasised the

primacy of mutation, it revelled in the body's pliability. If ornament was 'crime', likenesses were a bad joke. Picasso, more active than any artist in quashing the hegemony of the European Renaissance tradition, was contemptuous of Gaudí.

If I wasn't going to Barcelona I'd have gone to Leeds, where some examples of a fascinating backwater of that older tradition are from today being exhibited in *Second Skin*, at the Henry Moore Institute. What Moore would have thought about nineteenth-century anatomical life-casts we can only guess at. When a more comprehensive version of this exhibition was mounted at the Musée d'Orsay, Julian Barnes wrote an essay about the way in which objects intended for anthropological, phrenological and medical purposes are transformed by the passing of time and the passing of their utility into works of art, although they were never thus intended. Every contemporary curator is a bit of a Duchamp. But then Duchamp's conceit of the found object was itself an expression of the curatorial impulse.

Gaudí's contemporary Santiago Rusiñol bequeathed to the seaside town of Sitges his house, and with it a collection that includes Catalan sacred medieval ironwork of notable horror and undeniable art – undeniable, that is, if you're living now. Its forgers no doubt thought differently.

And so, I imagine, did the nameless technicians who cast faces chancred with syphilitic sores, heads which sought to demonstrate the physiognomic characteristics of different races, limbs suffering rheumatoid arthritis. These objects seem to us now precursive of the work of such artists as Marc Quinn (some of which is included in *Second Skin*) who have, thankfully, returned the body to a central place in art. (2002)

6

England

Cottage industry
Arts and Crafts Architecture by Peter Davey

Arts and Crafts architecture is elementally nostalgic, it is a longing given plastic form in stone and brick and clunch and tiles (hand-made tiles, that is). There is a kinship with such contemporary works as Kenneth Grahame's *Dream Days* and H. G. Wells' *The History of Mr Polly* – it has a drowsy, hallucinatory quality. It is like stuff that was conceived in dreams. Few eras have been as architecturally fecund as that between, roughly, 1885 and 1905; certainly, no subsequent era in this country has produced so many buildings of such disparate invention. It was the last golden age. Yet it is not one which can be unqualifiedly celebrated. The loveliness and the cleverness and the cuteness are liable to promote unease, even embarrassment – not because their aggregate is kitsch, the way the decadent works of post-Arts and Crafts architects such as Ernest Troubridge and Blunden Shadbolt were, but because this most quintessentially English architecture is entirely the spawn of the injurious English disease, retrophilia.

Arts and Crafts belongs to arcadian recovery, the summoning of merry England, high-minded Luddism, anti-urbanism and bogus bucolism. The buildings may be beautiful; much of the

anti-intellectualism behind them is tawdry, reactionary, gormlessly utopian. But then one might argue that such a gulf between programme and product is inevitable – the way of the world.

There is a sort of libertarian tendency in architectural history which insists on the independence of buildings from the society or systems that generated them. In a literal sense, the probity of this approach is unimpeachable – buildings are vessels which can be filled with multitudinous meanings as they change their use; buildings cannot be held morally responsible for the regimes that construct them or for what happens in them – to ascribe moral (or immoral) characteristics to a building is to fall prey to the pathetic fallacy. And in a pure world that would be that. But the idea that buildings exist in a vacuum, that they are innocent of associative potency and that they work only on our aesthetic sensibilities, seems dangerously unworldly. It also diminishes the power of architecture. And when applied to architecture which is self-proclaimingly didactic, it is irresponsible to ignore what it's intended to say.

Peter Davey is acutely alert to the paradoxes and ironies inherent in the wholemeal-and-sandals side of the Arts and Crafts movement. But when he addresses the troubling matter of Nazism's debt to Arts and Crafts, he is, I think, careless: 'Völkisch architecture can scarcely be added to the catalogue of crimes perpetrated by the Nazi state.' One might as well absolve *Der Stürmer*. The analogy is not facetious; the vernacular revival in the Third Reich was nothing if not propagandist, xenophobic – an instrument linking the smallholder or settler to the mythical German past, a past which might be regained through toil and racial hygiene.

No such programme informed the work of Lutyens, Prior, Mackmurdo, etc. Nonetheless, the shared assumption that High Victorian capitalism, industrialisation and machine worship might be vanquished by guilds, maypole mysticism and handicraft was

debilitating, and was to have the gravest consequences for England in this century. Had these architects been less gifted, had they failed to capture the popular imagination, then the prodigal waste of land which the arterial road suburbs typified in the thirties, just as Barratt estates do now, would have been avoided. But Lutyens was a spellbinder. He created the archetype of what is still reckoned, a century on, to be domestically desirable – asymmetrical, 'old', low, quaintish. The castle which the Englishman covets – and domestically the English are thoroughly conservative – is a dilute avatar of the Lutyens particular; it is this pathetically cosmetic bungle which swallows land and replaces country with ersatz country. It is not roads and retail parks which are the villains, but these dinky expressions of little England's inalienable right to spray-on beams and leaded lights.

Most of the work shown here (both photography and design are unexceptionable) was made for high bourgeois clients. The populist ambitions of Morris, Lethaby and Ashbee was only fulfilled a quarter of a century after the end of this great flowering – and thanks to the sort of machinery these men despised. Davey negotiates this area with deftness, and his take on the formulaic legacy of his subjects is not snobbish. But equally there are chapters of whimsy he is too indulgent of.

Take, for instance, the case of George Devey, an Arts and Crafts architect *avant la lettre*; his buildings, mostly in Kent, are characterised by the ambition to make them look as though they have grown 'organically' over the centuries – a Tudor porch, mullioned windows in stone, sash windows in brick, ragged edges to suggest parts which have fallen down. This elaborate fakery should remind us that much Arts and Crafts work was different from High Victorian revivalism only in the care which was taken over it, and in the eschewal of industrial materials in favour of what was to be found locally. So the massive technological leaps of mid-century were

ignored, and the clock turned back to before the railways and canals which had obviated a locality's dependence on this stone, that clay.

For reasons that have everything to do with the marketing of expensive anglophone art books and nothing to do with the insular Arts and Crafts movement, four chapters are tagged on to the end of the book: two about America, two about Europe. These skim across the surface of Muthesius's propagation of English ideas, and across the sci-fi expressionism of the Amsterdam school; nowhere near so fascinating as Davey's paean to Edward Prior, or his catalogue of the forgotten, the provincial, the underrated: Alfred Noble Prentice, C. E. Mallows, Arnold Mitchell, H. Thackeray Turner . . . These are names to excite the devotee of this most extraordinary, and retrospectively unfortunate, episode in the history of English building and taste. (1995)

Country pancakes

I arrived in Boston, Lincs, after a day in the land of superdykes, i.e. the Fens. I checked into a hotel and went to the bar, left ten seconds later and went instead down the road to a wine bar where five Neanderthals were clutching beer bottles by the neck as though they were hoping to strangle them. I knew it was a wine bar because it said 'Wine Bar' on the fascia. Wine Bar was its name. I asked a sixth Neanderthal, who lurked behind the bar looking menacing but who wasn't strangling anything, if I could see the wine list. He looked at me incredulously. The other Neanderthals looked at me incredulously. He replied: 'Red or white?' Which are, according to Kingsley Amis, the three most depressing words in the English language.

In Ryde, Isle of Wight, I stayed in a hotel named after a small town in Algeria, though the owner was Manuel, from *Fawlty Towers* – that's what happened to him, he got his own hotel on what

yachties call the Island. The first morning I was there, I sat down at breakfast and decided to augment my usual pint of Typhoo, with teabag in, with some bacon. When the bacon arrived, it was raw. You could tell it was raw because (a) it was stone cold and (b) it had not even begun to seep white pus all over the plate the way British bacon does. So I called over Manuel and said: 'Teensy problem we've got here. The bacon is raw. Could it go back to the kitchen and be introduced to flame?' To which Manuel riposted: 'Oh, fussy eater, eh?' That night, the hotel kitchen caught fire and we were evacuated from our rooms at 2 a.m. to watch Manuel get excited about firemen. Two mornings later, my alarm call didn't come and eventually the TV producer I was working with rang me. I hurried downstairs and was just telling him that I hadn't had a chance to even shower, when Manuel came up behind me and said: 'Shower you 'aven't 'ad a shower in six weeks.' I gave him what is called an old-fashioned look and went out to the car, with him scurrying along behind me pulling at my jacket, saying: 'Only a joke, only a joke.'

Now, I am not so rash as to draw any grand conclusions from these incidents in run-down establishments in run-down towns 200 miles from each other. But I would say that they belong, unmistakably, to that provincial England which we are enjoined on an almost daily basis to believe has caught up – whatever that means – with London. It only takes Harvey Nichols to open in Leeds for some hype merchant to assure us that that city is as elegant as Rome in the fifties, as vital as London in the sixties. This, of course, is cojones. Plymouth gets a particularly beautiful newspaper office, a warehouse is converted into lofts in Bristol, someone in Smethwick buys a Philippe Starck chair . . . we suffer serial national diseases and this tendency to discern a summer when there's been just one swallow is among them.

There is a cultural and social chasm between London and the rest of England which is far deeper, far wider than that between, say,

Paris and the rest of France. The fact is that London has achieved a de facto secession from the rest of the country. It is a cosmopolitan city-state. It has declared UDI without anyone quite noticing. Now, this affects us in different ways according to what we do and, of course, where we do it. If you're a writer – rather, if you're this writer – it is a boon to have the exotic on your doorstep. I don't have to travel up the Congo or across the Andes to find a seam of incredibly rich material, which is also incredibly foreign. I don't need inoculations and a passport for I have only to go outside the M25 to find myself in a far-off country. I assure you, incidentally, that this is not intended as a metrocentric boast. I come from Salisbury. I often go back. I'm not particularly proud to feel so alien there, but since I do I might as well exploit it: that's what writers do.

I no doubt exploit my disaffection with the industries of my native patch – the Church and the Army, those twin towers of hierarchical humility and brusque boneheadedness. It has been advantageous to me that my mother should have taught in a school where children were sent in winter wrapped by their parents in newspapers and rabbit furs; thus, life imitates Baby Bunting. At the same school, she once instructed her class to do a drawing of a flower seller. The entire class duly delivered crayoned pictures of happy, smiling women standing at stalls laden with tulips and daffs and gladis. The entire class apart from one pupil, that is – a little girl whose father was a baker drew a cellar, a subterranean room, full of sacks of flour with rats crawling over them.

It's advantageous to me, too, to have, for instance, a friend who was in the habit of chaining his very flash motorbike to the railings in front of his house in a supposedly delightful north Wiltshire town. He was in the pub only three doors away one night when a fellow approached him and said: 'That Norton Commando, that's yours, isn't it, mate? Want to sell it?' Steve said no. The fellow

became importunate, and then almost threatening: 'I got my heart set on it.' So Steve left the pub to go home and the fellow followed him. He pulled out a wad of notes from his top pocket and started to count out £2,000 on the bonnet of a car. 'Cash,' he said, 'and I'll take it now. I'll put it in my van.' With which he pointed across the road to a furniture removals van parked on the other side. Steve asked: 'Do you always drive around in that?' The fellow said: 'No, don't be soft, I'm just off up to the Cotswolds to shoot some sheep.' And to prove he wasn't kidding, he led Steve over to his cab and showed him an arsenal of automatic shotguns.

All this gear – and dog-on-a-string people, and abattoir owners up on charges of stealing combine harvesters and being in receipt of stolen grain, a guy who runs over a fox, eats it, then describes its taste by suggesting that no, it's not really much like dog – all this is evidence, anecdotal evidence, admittedly, that there is, as I've said, a chasm between country and capital, but that it's not perhaps the chasm we tend to think of.

For we suffer the delusion that the country is some sort of idyll. We idealise it. We associate it with a *douceur de vivre*, outdoorsiness, the good times and their ancient relatives, the good old days. We do not associate it with breeze-block piggeries, pollutant agrichemicals, cruelty to animals, rural squalor, ignorance, incest and the various low-life incidents I've just mentioned. But if you actually open your eyes to the country, you may note that it isn't all Castle Combe or Broadway or Lavenham or the Lake District, that it isn't all fully accredited, five-star beauty spots and heritage sites.

We are conditioned by those bits into believing it's all like that, for those are the bits which are represented on calendars and postcards and travel programmes, those are the bits we go to see, those are the bits which are destination countryside, whose purpose is to delight our eye and which succeed in doing so, not merely because they are beautiful or, more likely, pretty, but also because they are

atypical. But we convince ourselves that the atypical is, in fact, typical, just as surely as during the eighties, we – with Chancellor Lawson's help – convinced ourselves that debt was credit. The colour-blind believe blue is green. You get the picture.

The reality of the country is properly appreciated by such artists as Claude Chabrol – it's nasty and brutal and best seen from a locked car. Our worship of it derives, of course, from our removal from it. This is the grass-is-greener syndrome at work. The history of bucolic supremacy includes the daft, sentimental cult of the noble savage – which was not peculiar to England. What, of course, was peculiar to England was the scale of urban industrialisation and the coincident enclosure of land, the officially sanctioned theft of common land which gave smallholders no choice but to job-seek at the doors of satanic mills. And, of course, the job provider, the mill owner, wished to ape the yeoman and the noble because he had no other model. And so there grew up this massive nostalgia for the country. Now you need only read Mayhew or Engels or, more pleasurably, Dickens to appreciate the wretchedness of the life led by a sizeable proportion of the population of the great Victorian cities. It is more difficult to appreciate that the solutions and remedies applied a century ago have blighted English architecture ever since. The solution was not merely to look to the country for a way to proceed, but to look to a bogus country of the past.

It is this rurally inclined retrophilia which has stunted England, which continues to stunt England. So long as politicians drool about warm beer and cricket on the village green, we should know we're in trouble. We are onussed, as Ron Atkinson would say, by the combined weight of an invented past and a manifestly sham bucolicism. We are proud of *rus in urbe* when we should be trying to achieve *urbs in urbe*. Our perpetual response to cities is to try and pretend they aren't cities: hence the phenomenon of otherwise sentient people convincing themselves that London is composed of

villages. Have they ever seen a village? London is composed of elid-
ing suburbs like a predominantly Victorian Los Angeles. Those
suburbs pretend to rurality – look at the names: Wood Green,
Wood End, Forest Hill, Primrose Hill, Chalk Farm, Shepherd's
Bush, Honor Oak, Gospel Oak – there are 480 streets in greater
London called 'oak' something or other, there are almost 250 which
honour beech trees, there are 182 orchards, 90 chestnuts . . .

Do we believe in tree spirits or what? There's something almost
pagan here. It certainly defies reason. And so do the domestic build-
ings which line those streets after a while – spray-on beams are no
longer funny, joke oak ceases to be a joke and seems merely pathetic.
I grew up in an era when the cultural climate was such that we looked
back on the spec buildings of the teens, twenties and thirties of this
century with a sort of superior amusement. That cosmetic merry
Englishness was gone for ever, we thought. It was the prospective
rather than the retrospective which preoccupied us, but for all too
short a while. The very idea of progress died with not so much as a
whimper twenty-five or more years ago, and with it, for the most
part, the making of those architectural artefacts which expressed some
kind of faith in the future, which said this is what it's going to be like.

There's a bizarre inversion here: we live in a society which is
apparently happy to patronise modern design and modern con-
struction for garages and superstores but insists on unconvincing
fantasies for domestic habitation, fantasies which show just how
profound the English commitment to the country is by sprawling
over greenfield sites. We are in thrall to a terrible vicious circle. So
long as our social, cultural, domestic aspirations are towards the
cosmetically bucolic – i.e. to the pretend country of the suburbs –
that is where most of the money will move to, leaving the cities to
fend for themselves.

So long as those aspirations are in place, the epithet 'inner
city' will be shorthand for dereliction and hopelessness. It is

extraordinary how readily we accept that that is what inner city means. It is not inevitable that it should do so. It doesn't mean that in the rest of Europe. It's beginning not to mean that in London. But, as I say, London is an exception. What is so special about us English is that we have to live horizontally, have to swallow up what remains of the country by planting a bogus country on it: the process is analogous to that of tourists destroying the very site they have come to admire. But it's not so much the disappearance of nature that should concern us – nature is not only seldom natural, it is also overrated. And green fields are merely adventure playgrounds for cattle rustlers.

What should concern us is that we do not persist in applying the irrelevant remedies of a century ago to post-industrial towns which are actually clean places. I don't, of course, know what the remedy actually is that will halt this conformist and horribly unambitious diaspora from them. What I am certain of is that it is pretty much beyond the powers or the will of politicians to achieve.

There is a bright cloud, a single one . . . It's a truism that the dis-integration of towns began when the home was separated from the workplace. It is equally a truism that the reunification of home and workplace is one of the greatest shifts in two centuries. Our fate is to work at screens in what has been called the electronic cottage. Virtual work, virtual meetings, virtual coffee breaks, virtual having-I'm-afraid-to-let-you-go. But what about virtual eyeball contact over the photocopier? And virtual piss-ups after work? And virtual three-hour lunches?

Work is society as well as graft. Indeed, it is or was, probably, *the* social activity, the dating agency, the gang. Those functions cannot be replicated in some electronic cottage in the back of beyond and hardly in an electronic cottage in a suburb. But the electronic ter-race house, the electronic flat, the electronic mews, the electronic loft – now we're talking.

The future of towns, cities, dense concentrations of humans, lies in those humans' need for other humans, in the need for playmates of both the Arthur Askey and the Hugh Hefner sort, in the need for the society of the works canteen. It is not education that will change middle England's taste, but necessity and fear of isolation. There is a possibility that the twenty-first century will be the first since the eighteenth when the English take a leaf out of the Scottish and French books and understand that the city is something to celebrate and to nurture. Citizens and civility are qualities which derive from cities. Civilisation depends on cities. (1996)

Hot property

Country Life, 1897–1997: The English Arcadia by Roy Strong

It is difficult to imagine Sir Roy Strong ejaculating over the centre spread of *Whitehouse*. Indeed, it is very likely that this rare exquisite has never even seen such a dubious publication. Which is not a disqualification for writing a history of *Country Life*, merely a disadvantage – for *Country Life* is a sort of porn mag. It may substitute Belvoir for beaver and its readers' wives may be horses with Alice bands rather than lardy odalisques in unsensible shoes, but its appeal and its longevity are ascribable to its weekly provision of architectural porn to the needy. Here they'll find thirty pages – it used to be more – of fantasy houses: Gothic caprices, tile-hung yeoman farms, limestone vicarages, stucco boxes shaded by cedars, cutesy cottages, palaces in post-and-railed parkland, and so on.

Now, just as top-shelf magazine fortunes are founded on saddo punters dreaming of giving Sheree there a right seeing-to but knowing they won't because they're not footballers or roadies, so has *Country Life* (the 'o' in the diphthong is there for decency) thrived on saddo punters dreaming of bucolic ownership, of getting

a stake in immemorial midmost England, of connecting with the ancient patrimonial sod.

These punters, aspirant gentlemen (an epithet of such lavish bogusness that it is now used only by PRs), are catered to by *Country Life*'s lifeblood, its advertisers. But, save for an unamplified assertion that its position as 'the prime agent for the sale of superior country property' militated against editorial change and for a reproduction of an advertising page of 1920, Strong ignores the magazine's raison d'être. He tactfully disacknowledges the fact that, with the exception of *Exchange and Mart*, it is the only nationally distributed magazine bought almost exclusively for its advertisements. This is not to demean the editorial pages which, under the current editor and his immediate predecessor (the only woman to have occupied that chair), are sprightly and conscious of the magazine's base in a townee fantasy of the country. It was dreamed up on a Surrey golf course, and in its first two decades was closely identified with Lutyens (the architectural Elgar rather than the classicist of Empire).

Lutyens designed the magazine's offices in Covent Garden and carried out three private commissions for its founder, Edward Hudson, and numerous others for his friends. Lutyens' early work was all hallucinatory *douceur* and perpetual summer, a dream of an older and better and more rustic world. *Country Life* was sentimentally analogous: it proselytised for Merrye Englande in all but name. It exemplified the debilitating anti-urbanism, anti-intellectualism and anti-modernism which have contaminated Britain throughout most of this century. In outlook and taste, it has often resembled an averagely stupid army officer.

For years, it was almost wittingly dull and proudly immutable, fearful of the new and rucksacked by tradition. In style it was plain, blunt, untouched by irony or (deliberate) humour. Peter Anderson Graham, who edited the magazine for the first twenty-five years of

the century, was described as 'a leisurely man of letters rather than a working journalist', and Strong notes that *Country Life* was 'viewed as somehow not tarred with the squalid brush of journalism'. What it was tarred with was a literary amateurishness – I mean that in both senses; although, like everything else to do with the magazine, the amateurishness was slightly cosmetic. The policy was to employ a buff, a preferably non-academic expert, rather than a writer. Thus the readers of the mutually compatible departments might always sense that they were being addressed by a peer. The exceptions have been the architectural-historical writers. Forget the eternally tiresome debate about hunting, the reports of rackets tournaments, the pesticide controversies and the parish-pump arguments about coppicing techniques – what *Country Life* has done consistently well, sometimes supremely well, is to write in detail about buildings and to photograph them.

Unlike Pevsner (the historian rather than the propagandist), *Country Life*'s bias has been to the secular and the domestic; unlike Pevsner, too, it has eschewed quasi-scientific taxonomy. It may have lacked any writer of the quality of Ian Nairn (very red-brick, very non-U), but it had Mark Girouard and a succession of bright young reactionaries who gave great forelock to the past and put the boot into the present, unless the present looked like the past. No wonder it is so keenly monarchist – Prince Charles is its most ploddingly dogged pupil. His cretinous opinions are distilled from the magazine's retrophiliac scholarship. Its, and his, partiality has not lately produced winners – the classical revival of the eighties is now on life support if not dead, a fate which has little to do with classicism per se and everything to do with its recent practitioners' inability to create rather than to mimic. Which doesn't mean to say that the classical survival will not persist as it did even in *Country Life*'s darkest architectural days, the post-war epoch of the modernist hegemony.

Strong's grasp of modernism is shaky: he seems to think that its earliest patrons in Britain were public authorities rather than the (currently unthinkable) progressive bourgeoisie. And in a more generalised way, he writes about it as though he knows nothing more about it than what he's swotted from the thirty-five-year run of copies which he cringe-makingly vouchsafes he married into. More usually he's astute, coyly heretical (this is, after all, an authorised, sanctioned, official 'biography') and easy to read: he's not going to tax the retired brigadier from the 11/17 Queen's Own Philistines, nor is he going to displease effetes like me, the ones who no sooner see a lodge than we go trespassing up the drive. Strong, of course, gets invited up the drive: he is a fascinating example of the upwardly mobile, of those who have connected well, who don't get on by aping apes in tweed but through cleverness and not dissimilar camp charm.

There is, though, a pull between the aesthete and the arse-licker. No one but the latter would laud as 'memorable' this description by James Lees-Milne, the world-class name-dropper with the horrible prose style: 'Dressed in clothes subfusc she favoured large hats with rampageous feathers.' Rampageous is bad enough but the inversion of subfusc and clothes is truly nasty, quaint and arch.

In his post-curatorial career as a writer, Strong possesses the vast advantage of a lower-middle-class background; he should not deny it. (1996)

Lies of the land

Look! There's Great Yews and the gallops, I think. That's surely Homington, which, as a tiny child, I called Somming – so my mother never ceased to tell me. And that *tache*, no larger than this fleck of ash, could that be the house beside the Ebble she once longed to buy? Perhaps. Which is Ogdens? Where is Abbots Well?

I'll bet if we go this way, we can find the Larmer Tree Gardens. This thing I'm gaping at is called *England: The Photographic Atlas*. It comprises some 750 pages of photographs taken from just over a mile high and reproduced in a variety of scales. It is a bewilderingly ambitious endeavour, a technical triumph, and very heavy indeed.

There was never a time when I didn't pore over maps. My earliest ambition was to be a cartographer, to work for the Ordnance Survey in Southampton. Because I know the country south of Salisbury better than any other part of rural Britain, it is to there that I first turn. The symbols go to work as recollective triggers. I relish the formulaic abstractions, the chiaroscuro of the hachures, the zebra-print of the steep coombes' contour lines, the shorthand for deciduous and indeciduous, for reed beds and bogs (of which the New Forest possesses an abundance).

Over the years the Ordnance Survey's symbols have become simpler and less arcane. Nonetheless, this user friendliness doesn't detract from the fact a map is both hermetic reality and reductive code. A map exists as an object in its own right and as a useful instrument. This photographic atlas isn't a map. This project blacks out Wales and Scotland so that Shropshire and Northumberland seem to perch on the edge of the world. It is hardly a country of extremes. Most other country's foothills are our mountains. Many other country's ponds are our lakes. Wilderness is practically non-existent. England is various, but within a straitened gamut of scapes. The *Photographic Atlas* has the effect of further narrowing that gamut and of homogenising the country. The same spectrum, the same field systems are apparently to be found everywhere.

Hills are flattened. Places elide with each other. Entire counties are indistinguishable without the aid of a map. This is doubtless due to our being familiar with a bird's-eye view only through the mediation of maps. And that mediation is an artifice, an act of

cartographic anti-naturalism whose tendency is hyperbolic: the OS's England is a more exciting place than an aerial camera's. Besides which, the OS's patterns mean something, while the *Photographic Atlas*'s are those of an overliteral cosmic patchworker trying to break into the camouflage business. Neither camera nor computer-generated cartography sets out to create a fiction, but both inevitably do, and the latter, with the incomparable advantage of greater human intervention, thus creates the more beguiling.

The Photographic Atlas is land-art. Land, on the cover of *This England*, 'Britain's Loveliest Magazine', is duly prefixed 'green and pleasant'. It 'guards the nation's values and traditions' which include the freedom to be a beefeater, to make walking sticks as a hobby, designate Metric Martyrs, put the pride back into your British Passport, to display a Patriot's Pack of anti-Euro stickers in your Triumph Toledo (dodgy name, that) and – presumably – to wear head-to-toe beige with a polyester tie bearing your county's coat of arms and to read prose which might grace a National Trust tea towel. This is evidently the Little Englander's house journal. The edition I was sent the other day included forty-five representations of either the Union flag or the flag of St George in its eighty-two picturesque, xenophobic pages.

Harmless? Probably: the blood and soil sentiments that are expressed are parenthetical, dilute. Artless? Surely: and that is what makes it so true to Little England. The bravura, invention and rigour which inform both the OS and the *Photographic Atlas* are quite missing. The magazine is unmistakably the voice of its readers, and those readers feel disenfranchised. They hang on to the illusion of an England which if ever it existed was in the work of Arthur Mee, artless and – to use a neat phrase of Kenneth Rexroth's on the work of Woody Guthrie – 'the organised social lie'. And that, I guarantee you, is the only time you'll find Woody Guthrie anywhere near *This England*. (2002)

An A–Z of English food

The three films which comprise *Meades Eats* set out to scrutinise Britain's problematic relationship with what it eats. They are also intended as antidotes, or ripostes, to telly food programmes. Food on telly is evidently part of the problem, both symptom and cause. It has turned cooking into a sort of light entertainment which attempts to dignify and defend itself by pretending to be instructive. The best light entertainers seek only to entertain: Benny Hill wasn't pretending to instruct his audience how to chase girls round a suburban park. The best telly teachers seek only to teach: A. J. P. Taylor and Alec Clifton-Taylor were not music-hall turns – Betjeman was an exception. It is tempting to say of chefs that those who can, cook; those who can't, get a gig on the box.

Tempting but wrong-headed, for there are a few telly chefs who can cook, though the medium's invariable formats make it impossible to distinguish them from the majority of characterful also-rans. There is nothing on television that matches Radio 4's *The Food Programme*: Sheila Dillon and Simon Parkes have learned from the incomparable Derek Cooper that intelligence, scepticism and judicious enthusiasm are not incompatible with engrossing broadcasting. This is obviously a lesson that I have not learned.

Hence the presence in my shows of wide-boy farmers, Black Country curry-eating champions, foul-mouthed old women, certifiable academics, dwarf cheese-makers, blind prejudice posing as incontrovertible fact, burgers of a two-metre circumference, Austrian accordion artistes, self-immolating barbecue operatives, bucolic road-kill myths, the nosology of Sunday-lunch syndrome, dyed poodles, pastiche advertisements, rigged vox pops, etc. Within me, and not far beneath the surface, there apparently lurks an aspirant Max Miller blocking my passage towards untempered earnestness. Which one of us composed the following A–Z of British gastronomy is unclear.

Angulas: Not, evidently, an English word, but the word used to describe 90 per cent of eel fry taken in this country's rivers when they are eventually served at table. If Britain really has suffered a gastronomic revolution, why do the elvers netted on the Severn and traded at the Elver Station in Gloucester overwhelmingly go to Spain, Argentina and France (where they become *pibales*)? Why is Britain similarly spendthrift with its shellfish and game? Tight-fistedness plays a part, but not so large a part as ignorance. This country overlooks many of its comparatively few indigenous resources although they might form the basis of a sustainable cooking. It is, rather, indiscriminately reliant on cheap air-freighted imports which are necessarily unfresh or unripe: we measure freshness in days, not in hours.

Boiling: The national dread of boiling is ascribable to its being taken too literally by inept institutional cooks – small wonder, for cooking in Britain was a bottom-rung trade, undertaken by people who couldn't do anything else: that, at least, has changed for the better. Boiled meat should not be boiled but simmered, boiled cabbage should first be blanched – and so on. Boiled beef and car-rots is, rather was, a glorious dish. But does anyone today cook it, professionally or domestically? The British abroad are delighted to eat *pot au feu, bollito misto, cocido* – but those names don't include the very word boiled save when there's a translated menu to deter the traveller. In Dorothy Hartley's *Food in England*, written fifty years ago, boiling is still the predominant cooking method. And deep-frying is treated with contempt.

Clent, Wayne: A living legend, internationally famous from Upper Gornal to Brierley Hill. Variously bass player with Dudley prog-rock band Handsome Albino, Radio Black Country disc jockey and curry-eating champion – eight times winner of the

Ringburner Masters, six times Victor of Vindaloo. He spoke the universal language of biriani. A natural: he owned a cast-iron colon and an asbestos duodenum. In his last competition, the '99 Finals at the Taj Excelsior, Wolverhampton, he consumed a record 6.2 kilos of phal, 3.8 kilos of rice, 29 parathas, 21 nans (8 of them stuffed), 23 litres of lager. After he exploded, he spoke without regret of 'man's inhumanity to man's stomach'. Buried at Sedgley in a coffin modelled on a foil takeaway container. The address was made by his friend and rival Len Dredge, who appears in the third of my programmes. He talks movingly of the effect on him of both Clent's death and having to have his own stomach pumped at Harborne General. He has now, as he says, 'slipped seamlessly into management, rather like Trevor Francis'. The Ringburner Masters has now been renamed the Wayne Clent Cup. Come to think of it: a dead legend.

Design: From custard-powder packets to treacle tins to bevelled glass pubs to sleek modern restaurants. Perhaps the British have always consumed with their eyes.

Ethnic: We are all ethnic yet some are more ethnic than others. There is a two-tier system at work here. Certain cuisines, forms of dress and music, and art and artefact, are habitually referred to by the name of the country they derive from. The rest are bundled together under the label ethnic, which has become a euphemism for 'not like us'. It is at best lazily incurious, at worst an expression of unwitting racism, a form of prejudice which is predicated on the half-witted assumption that all people of a certain group share the same attitudes, aspirations, ideals, etc.

Full English: Maugham's dictum that if you want to eat well in England you have to eat breakfast three times a day was no doubt an

epigram for an epigram's sake. But it contained a still pertinent truth. Full English, a hotelier's coinage, is all too English in one regard: bacon with mushroom, with choice of eggs, with black pudding, with sausage, with kidneys, with fried bread, with toma- toes . . . With, with, with. 'With' is the preferred conjunction of this country's professional chefs. They may regard Full English as old hat but a majority of them unwittingly take it as the model for their multipartite creations: seared tuna osso bucco, with chorizo lanyards, with fudge-flavoured couscous, with a gruyère filo samo- sette of okra and spearmint cracklings, with a line-caught sea urchin napping. Like I say: babel. Full English is also a specialised form of flagellation.

Gastronomic writing: Several hundred books every year, millions of words in newspapers and magazines, countless hours of telly – all devoted to food and drink. So we must have suffered a gastronomic revolution. No question. Or is the bruited revolution merely a self-congratulatory boast of these books and articles and pro- grammes, a boast which justifies their existence as they strenuously attempt to fulfil their own prophecy. If the revolution we con- stantly read about is more than a chimera, then it probably affects the diet of no more than the 10 or so per cent of the population which reads broadsheets. The number of words expended on the true revolution – the commercial triumph of fast foods and conve- nience foods – is in inverse proportion to its popularity: tellingly, where those words are to be found is in health or medical or science columns. Which is apt, for the fast-food industry is a branch of the chemical industry.

Healthpolice: There is no country in Europe where artisan food producers have a harder time than in Britain. This doesn't mean that the several agencies that can be lumped together as Healthpolice are

effective as well as officious. The number of cases of herpes contracted from frankfurter abuse rises every year; in the West Country pasty-related dementia is epidemic; lager contains particulates which cause tinnitus. Nothing is done about it because one government after another allows its food policy to be influenced by the interests of bulk producers and supermarkets: witness Milords Sainsbury and Haskins. So the Healthpolice pick on small producers with a zeal unknown elsewhere in the EU, where disadvantageous regulations are seldom enforced. Why? Because in those countries the people who are meant to implement such regulations are the people who will eventually consume artisanal produce. Comes down to class, again, and to gastronomic consensus and to the conviction that real food is more important than mere petty laws.

Indian restaurants: There are 8,500 'Indian' restaurants in the UK. That is, one restaurant for every 117 Britons of subcontinental origin. This is an extraordinary figure. There are 5,000 Chinese restaurants: one for every 30 Britons of Chinese origin. This is an even more extraordinary figure. Were that ratio of restaurants to head repeated with application to other ethnic groups, then the UK would have 11,000 Jewish restaurants instead of about 30, 17,000 Caribbean restaurants, 26,000 Irish restaurants and 1.75 million white Anglo-Saxon restaurants. So the idea that restaurants reflect the intricate complexion of this country's mongrelism and ethnicity is a non-starter. What they do demonstrate is the existence of ethnically determined catering castes using restauration as the first step up the economic ladder.

Innovation: Britain, having abjured its own cooking, considers, rightly, that it is uninhibited by tradition. It consequently considers, wrongly, that cooking is a matter of creativity and innovation.

It isn't. Cooking is a craft. The difference between a craft and an art is that art ought never to repeat itself while craft ought always to repeat itself. Paul Bocuse believes that a chef is unlikely to invent more than one new dish in a lifetime: his job is to refine what's already there. CAKE, the Campaign Against Kitchen Experimentation, honours this precept.

Jesus: Christ's body is the most commonly eaten meal in the world. Yet its purpose is neither sustenance nor pleasure. Its purpose is the collective remembrance of someone whom no living person knew, a remembrance prompted by the Middle Eastern staples of 2,000 years ago. The Eucharist's brilliance lies in its recognition of food as both communal bond and mnemonic. It is also an unquestionably cannibalistic rite, which is what accounts for Jesus's failure to return. He knows that were he to do so and to announce himself he would be eaten by his more fervent devotees. So, if he has come back, he's living anonymously, in a suburb of Kettering, say.

K, Special: The actor who advertised the Kellogg's breakfast cereal Special K, John Slater, died from bowel cancer.

Labskaus: A meat and potato hash which originated in either East Friesland or Schleswig Holstein: it is to be found on nearly all restaurant menus in both provinces and is also commonplace in southern Denmark. It is usually served with a fried egg and *schmalz* herring. Do not be put off, it is delicious. But you'll have to go to somewhere like Lübeck or Emden to find out for yourself. For although it was imported by sailors to Liverpool and, modified with ship's biscuits, became that city's peculiar dish – to the extent that its inhabitants were named for it – it is today considered unworthy of consideration by Scouser chefs. But then it is a northern, cold-climate dish. Even when the temperature is sub-zero, Britain

mysteriously wants to eat food appropriate to hot climates. Get yourself a Thai or Hindi mail-order bride to enslave in a kitchen and you'll clean up. Get a Russian or a Balt and you're looking at Carey Street.

Ludlow: This Shropshire hill town's streets swarm with journalists and telly crews reporting on Britain's gastronomic revolution. Why? Why do they travel so far from London? Because there is nowhere else that fits the bill. It is the exception that proves the rule of the provinces' gastronomic backwardness. The concentration of real butchers, fine cheesemongers, good restaurants: yes, it is special – by British standards. Anywhere else in Europe it would seem normal.

McDonald's: The first branch in this country opened in Woolwich, a grim barracks town which has been subsumed by south-east London's sprawl but which feels anything but metropolitan. That was in 1976. The quality of our life has subsequently improved immeasurably. We have learned such expressions as 'a few fries short of a Happy Meal'; we have somewhere to go when we are homeless or want to pick up a squaddie or watch naval problem families swearing at each other (a Sunday lunchtime speciality of the Gosport branch).

National dish: Roast beef is not peculiarly British. The notion that sirloin got its name from a joint of beef having been 'knighted' by Henry VIII or James I or Charles II – the admiring monarch varies according to the teller of the tall story – is balls. The etymology derives from the Old French *surlogne*. Its attribution to royalty is symptomatic of that same forelock-tugging cravenness which insists that Shakespeare's work 'must have' been written by an aristocrat. Nor is fish and chips peculiarly English. It is a Sephardic dish

introduced as recently as the mid-nineteenth century. It was for years beset by the problems of this country's indigenous frying agents, animal fats which saturate both batter and potatoes. Deep-frying is a cooking method that was occasioned by the plentiful availability of a suitable frying agent, i.e. olive oil. It is not for nothing that Cadiz is the deep-frying capital of the world.

Organicising: Common practice undertaken by industrial farmers, criminally inclined wholesalers, bent retailers, etc.

Pike: Another wasted resource. The finest flavoured river fish, but reckoned blue-collar because fish in this country are classified according to their potential as 'sport', which has nothing to do with their worth as a foodstuff. Salmon and trout are posh, the rest aren't.

Queens: Once upon a time, a British restaurant meant a place owned by two screamers with an extravagant colour sense, an interesting poodle, a developed capacity for nannying, a fluency in Polari, a friend who was a friend of Joe and Ken, a load of antiques (for sale), a few recipes from Elizabeth David. They were amateurs in the original sense. Today, British restaurants are professional. And amateurism is routinely considered to be inimical to professionalism, rather than its foundation.

Regionalism: The literal foundation of the figurative expression 'as different as chalk from cheese' is vouchsafed to any sentient child of Dorset, Wiltshire, Hampshire, West Sussex. The chalk downs were for sheep, thence for wool, for sheep meat. The valleys were for cattle, dairy, cheese. Britain's micro-topographies once determined its produce, if not its diet. This is evidently an absurd reduction of regionalism. It demonstrates the former importance of

place, an importance which has now disappeared. Britain's gastronomy is today regionally homogenised: the diet of a labourer in Southampton will not signally differ from that of a labourer in Newcastle. At the same time Britain's gastronomy is differentiated along lines of class and income: a CEO in Southampton will eat more or less the same repertoire as a CEO in Newcastle – neither will eat the same as the labourers they employ. Such regionalism as exists is self-conscious, a tokenistic add-on.

Sausage: Only a country with a collectively defective palate could refer to an industrially produced aberration as 'the great British banger'. For most sausages, the first three ingredients are cheap: a condom; a load of abattoir slurry; a cocktail of flavour enhancers, colorants, stabilisers, emulsifiers, preservatives, hydrogenators. The fourth and most important, most expensive ingredient is packaging/ marketing/branding/advertising. In the early nineties, Heaven's Pasture advertised its pork sausages with a dancing pig singing outside a cottage:

> It's no small wonder we is cryin',
> We can smell that Mum am fryin'.
> We got reason to be grizzlin',
> Our late Dad's in there a-sizzlin'.
> We's still pigs but they am pork –
> A meaty treat for knife and fork.

The explicit link between dead animal and sausage caused sales to plummet.

Source: In Foodworld, ingredients are never bought or picked. They are sourced. If the ingredient happens to be olive oil it is never poured. It is drizzled. If the oil is used for cooking rather

than dressing, it is for a method called pan-frying – so called in order, presumably, to distinguish it from bonnet-frying or coathanger-frying. These usages are ugly, precious, twee. And they suggest that 'real' food belongs to a hermetic caste with an exclusive vocabulary. They suggest correctly.

Table manners: It may be argued that Britain's elaborate table manners – the saying of grace, the formal laying of place settings, the prohibition of discussing what was being eaten, the invariable structure of meals – was a compensation for the quality of the food served during those meals. Adherence to the rules, rather than gastronomic enjoyment, was the point of a meal. Note for younger readers: a 'table' is an inanimate quadruped where people ate in the olden days. It has been replaced by street, couch, car (when not picking nose).

Tripe: *Tripes, trippa, callos, flaki*. None of these words carries the pejorative connotation that 'tripe' does in English: but then none of them belongs to the language of a country which prides itself on squeamishness the way Britain does. But Britain's squeamishness is qualified, selective. We prefer not to exploit horse, say, as a foodstuff. Our sentimentality about species is as inconsistent as our fastidiousness about the parts of the animal that we are willing to eat, knowingly. We don't knowingly eat horse or duodenum, donkey or spleen. Yet we do eat fast food.

Udder: Nature's answer to Spam. Used to be sold in the north of England as 'elder'.

Vigo–Bream, Dr F.-X.: The Milhench Professor of Neurobehavioural Ecologies at Thamesdown University claims in *The Roots of Recidivism* that all exercises in social and architectural determinism

are doomed to fail because they are 'crude psychological carrots which may well go unrecognised by the person who should, so to speak, be eating them'. The dietary determinism Bream favours is, on the other hand, a 'physiological stick – but a somewhat soft stick'. He explicitly links junk-food diets to low self-esteem, nail-biting, antisocial behaviour, learning difficulties, premature ejaculation, jaywalking, daltonism, hormonal imbalances, wheezing, criminality and reoffending. A series of experiments conducted with fourteen- to sixteen-year-old 'habitual' joyriders in Swindon and Didcot demonstrated that when they were subjected to a diet of fresh fruit, unprocessed meat, green vegetables and goat yoghurt, the interiors of the cars they wrecked and abandoned were found to be free of Burger King wrappings, crisp packets, crushed fries, chocolate stains and ruptured ketchup sachets.

Wendy Burgers: See above.

Xenophilia: Britain always imported a proportion of the dishes it ate. Imported them and traduced them. Until the seventies most of them were, however, prepared with indigenous, sustainable ingredients. There was a recognisable national kitchen, a gastro-cultural consensus, a recognisable gamut of dishes which added up to something called British cooking. Which was nowhere near as bad as its retrospective reputation claims. A segment of the population may perhaps eat better than its forebears did. Nonetheless, what it eats is a culinary collision. Britain is unique in Europe in having no cooking of its own. Instead of repairing or reinventing its own cooking it has crazes: French, Thai, Swedish, Cantonese . . . There is no kitchen in the world that is safe from the clumsy depredations of the British cook exhibiting both a denial of confidence in national identity and the dumb conviction that the gastronomic grass is always greener.

York ham: York ham, Yorkshire pudding, Aylesbury duckling, Cheddar cheese, Cornish pasties, Bakewell tart, Eccles cakes, Cumberland sausage, Lincolnshire chine, Sussex pond pudding . . . and all the other British foodstuffs with place names attached come from an industrial estate in Corby. Names are not protected. Which is a sign of the importance we grant to the integrity of produce.

Ziegler, Zog: Morgan-driving omnivore who, having run over a fox, ate it. What did it taste like? It tasted, he says, like dog. So there you have it. (2003)

Say it with bears

Henry Cole was a civil servant, cultural entrepreneur, industrial designer and educationalist. He was one of the chief forces behind the Great Exhibition of 1851, and thus of the Crystal Palace. He was a founder of the South Kensington Schools, from which would emerge such institutions as the Royal College of Art and the Victoria and Albert Museum, where he is commemorated in a wing named after him. He is, however, more routinely, if anonymously, commemorated as the 'inventor' of the modern Christmas card.

The practice of sending friends an ornamented and calligraphically scrupulous verse or a sort of family newsletter was well established by the 1840s, when Cole hit on the idea of saving time and nibs by sending out a printed card which he got the painter J. C. Horsley to design. One can hardly blame Cole for all that has followed. And it is surely unfair that of all his achievements this should be the one which has enjoyed the broadest and most enduring effects. It is as if Terence Conran were to be remembered a century hence for a soft toy designed in his youth and expunged from his CV. But there is, as they say, no legislating for posterity –

and no legislating for soft toys, either. Anyone who's allergic to these cutesy things should stop reading now.

Christmas cards appear to remain the most popular of all cards. They outsell birthday cards. We may not know the date of our friends' and colleagues' birthdays but we all know when Christ's falls – at least we all know when Christmas occurs, which is not quite the same thing. And we send cards. Out of habit, guilt, duty, seasonally affected sentimentality. The custom of sending cards grew in proportion to the embourgeoisement of the Victorian populace: they were tokens of arrival on a particular rung of the social ladder in the way that the acquisition of white goods would be a century later. By the 1870s they were commonplace. With the custom there grew an industry attuned to the provision of jolly propriety tempered by novelty: so, pop-ups and cut-outs and sliding panels were devised to the point where cards were very nearly machines. Cards became an end in themselves.

A century and a half after Cole, the assiduous devotee of cards – the cardy? the cardifan? – has an excuse to send a couple each week. Traditions have been energetically invented to legitimise the habit and to excite the appetite. Cards are, it seems, drugs. Mother's Day, Father's Day, Brother's Day, Sister's Day, Pet's Day. Every dog has its day in Cardworld: 'No, Prince can't acshally read as such not words an' tha' – but, like, he unerstans!'

Salisbury's population is about 40,000. Yet it has two branches of Clintons Cards about 150 metres distant from each other. Please don't worry if you live elsewhere. You are never going to be far from a branch – there are another 700 spread across the country. Till just the other day I had not entered any of them, though I had, of course, clocked their omnipresence.

Their ubiquity baffled me. It shouldn't have done. High streets once provided the old staples plus the odd treat. Now they provide neither. They have become sites of debased recreation. Pedestrianised,

tarted up with heritage-serif signs and pointless bollards, lined with chain cafés flogging NewBrits a chimerically 'continental lifestyle'. Oh, the daring!

Clintons Cards trades in two of the basics that nourish NewBrits. Larkiness and sentimentality. It has abundant products to suit both moods. There are few occasions that cannot be turned into a real laugh!!! Taking exams, passing exams, failing exams, say. The specificity of the stock is such that there is the precise card not merely for each eventuality but to accommodate the 'profile' of the recipient. So, if you have a ginger-haired, buck-toothed niece who is a people person with an interest in J-Lo and Leo, who works alternate Saturdays shelf-stacking, who drinks Baileys with Red Bull, who bears a cupid tattoo, who has passed three GCSEs despite multiple learning difficulties and a raft of special needs . . . Clintons Cards has the richly amusing card to send her.

It will very likely feature an animal – a cartoonish cat or a cuddlesome pooch with oh such lovely eyes – and a dumb pun. As well as richly amusing, it will be comically comforting, cosy as carpet slippers. When, in a few years, she gets married she can be sent a pair of hilarious, fun-fur handcuffs – naughty but not that naughty!!! If, on the other hand, she doesn't marry the father and becomes a pramface with a double buggy and a white-flour complexion, don't worry: there's a custom-made card for her.

Now, a neighbour dies. For £4 you can buy a card fashioned from handmade paper *tached* with turquoise ink and a panel which admits 'I Am So Sorry For Your Loss'. Within is a homily composed by one Debbie Peddle: 'A loved one is a treasure of the heart and losing a loved one is like losing a piece of yourself. But the love that this person brought you did not leave, for the essence of the soul lingers!' And so on. It's as though NewBrits, scornful of the old stiff upper lip, reticence and sweeping it under the carpet, feel an obligation towards 'openness' but have to hire a surrogate to be

emotionally incontinent because they lack the means to write for themselves.

The gross inarticulacy of this nation – occasioned by, inter alia, Shirley Williams, Margaret Thatcher, accessibility, most broadcasting, all tabloids – suggests a lack of will to be educated. But no wonder: it's great to speak less fluent English than, say, a Dutch footballer. To 'read' the *Sun* and the *Mirror*. To watch television turn into a medium run by morons. To boast that you've never read a book. The combined readership of Britain's broadsheet newspapers adds up to, perhaps, 10 per cent of Britain's population. We inhabit the most formidably stupid society on this continent. Clintons Cards is a symptom and a beneficiary.

Here's a fake-fur bear to lay on the roadside where your boy died in his tragic motorcycle accident. (2003)

The birth of tomorrow

We are relentlessly assailed by anniversaries. The birth of the once famous, the death of the formerly infamous, battles in countries which no longer exist, inventions which are ingenious in their optimistic primitivism. It is easy to decry our apparent obsession with calendrical fortuities. But they do possess an unquestionable value for they serve as mnemonic triggers, they incite curiosity, they bring to our attention that which is buried beneath the weight of the years. They are a counter to the straitened, ahistorical tendency of 'presentism', a tendency which in its passive form foments mere ignorance and in its active form promotes a petulant dismantling of tradition. Where once we blithely destroyed ancient buildings, today we destroy ancient institutions and practices: it seems that there must always be some manifestation of the past deserving of obliteration. The very word anachronism is never spoken save pejoratively. Its neutral connotation is extinct.

Precisely a hundred years ago, on 9 October 1903, there occurred an event which would have momentous consequences for England throughout the twentieth century and whose tremors we still feel today: the first garden city of Letchworth was inaugurated (though it had of course been some years in the planning). Now, to prefix 'city' or 'village' with 'garden' was not unprecedented. Nor were the notions of starting from zero, of creating what no one – other than George Bernard Shaw – dared mention in the same breath as heaven, of anti-urbanism. Nonetheless, in its drawing together of these characteristics and in the extent of its social and architectural ambitions Letchworth was – and remains – remarkable. It is a fusion of conflicting traditions.

To talk of particular sorts of landscape or building as peculiarly English is to invite dissent, for to do so implies the existence of physical typicality. And this is a property which is thankfully in short supply: what we have in its lieu is manifold typicalities. The endurance of local, even parochial, variety in the face of homogenisation's bulldozer is a gift which we must never take for granted. Last weekend I was surrounded by blindingly garish ironstone like petrified gingerbread. Next weekend will be all half-timbering and red-brick pyramidal oasts.

We create for ourselves a topographical pantheon. Perhaps it's more apt to say that we discover it, almost despite ourselves, that it is revealed to us. It is determined to a degree by conscious aesthetic preference and by associational sentiment, but much more by the bottom of the spine and sheerly irrational fascinations founded in heaven-knows-what buried experience. The point is, we do not select the places which move us and to which we long to return.

It is a pathetic fallacy, I know, but places choose us: we have no more control than we do in matters of love. There must have been a primal moment, so to speak, when, at a tender age, a demonstratively planned place first exerted its pull on me. Hindon?

That south-west-Wiltshire village of near-uniform stone cottages and neat pollards has a quality which sets it apart from its neighbours, a quality so obvious that even the untutored (and the young) might descry it. It is ordered, it has an unusually straight main street, a street which has patently been imposed. All buildings are artificial. In England we dissemble it more than elsewhere. It is the commonplace English ideal to pursue the curious fiction that buildings are somehow 'natural', that they grow out of the soil, that they are the product of geological accident, that they 'just happened', that they develop 'organically'. The paradox of the picturesque is that the more it strives to achieve a semblance of naturalness the more it reveals its douce fakery. Our pretence of our own lack of involvement in its creation is, it goes without saying, the greatest artifice of all.

Such self-effacement renders us particularly susceptible to the country's rare instances of formal planning, to those places which far from seeming to grow out of the earth revel in having been plonked down upon it. Bath is a sort of cynosure not merely because it possesses a stately beauty and a peerless site but because it is *sui generis*, exotic and, dare I say it, un-English in its formality. But, such is its reputation, it is not a place that we can any longer discover for ourselves.

There is, though, a gamut of 'made' places which are habitually overlooked and which constitute a recurring if minor strain. One reason, no doubt, that they are off the map is that they are seldom conventionally enticing. Further, 'industrial village' is not the most appealing epithet, and the same might be said of 'land colony'. In the popular hierarchy 'fishing village' comes much higher, even though such places were also occasioned by an industry. The property that most distinguishes industrial villages and land colonies of the nineteenth century is a dislocated urbanism.

Take two sites in Gloucestershire on either side of the Severn: the remnants of the Chartists' Snig's End and the estuarial port

Sharpness. At neither does the architecture make any allowance towards its rural setting. We expect villages to look like, well, villages. We demand that they should be 'villagey'. Snig's End and Sharpness do not oblige. They break the rules. The effect is profoundly odd. I write, admittedly, as a southerner who, in middle age, is still surprised by Northamptonshire's shoemaking villages and Nottinghamshire's mining villages. We are used to urban buildings which flaunt their bucolicism; we close our eyes when the process is reversed. The reasons that the terraces, occasional detached houses, pubs and churches – more likely chapels – in such places are of an urban mien were financial. They belong to that long half-century between the end of vernacular building as an optionless necessity and the revival of vernacular building as a popular (and cheap) stylistic choice.

Had Letchworth been built a decade earlier, its anti-urbanism would have been manifest only in its isolated muddy site near Hitchin. Its buildings would probably not have been cottages. They would have lacked the whimsy and prettiness which render so many of them beguiling. As it was, its timing could not have been happier: it is a made place constructed at the very apogee of English domestic architectural design. There is a whiff of the maypole about the town. It does not take much of an imaginative leap to conjure up a cast of naked dew bathers, toga'd theosophists, vegetarians, rational dressers and teetotallers (no licence to sell alcohol was applied for till the 1960s – and that after a referendum).

There is no indication in his polemical blueprint that the garden city's founder, Ebenezer Howard, had the least interest in architectural style or the picturesque or that he harboured any concern about what it would actually look like. My preoccupation with Letchworth, its disparate precursors and its various successors is doubtless frivolous because it is based in the appearance of the place. It is, after all, with our eyes that we register buildings. Here we find the

democratisation and mass production of the picturesque, which had thitherto been confined to estate villages and such small-scale exercises in *bourgeois oblige* as Port Sunlight and Bournville.

The Letchworth that spawned its many successors was not however the tangible Letchworth of Arts and Crafts cottages but Letchworth the theoretical ideal, the social experiment. An experiment which was flawed by the town's predictable failure to become autonomous and self-sufficient: it is, and always was, within commuting distance of London. The speculative 'garden villages' that came in its wake neglected, with rare exceptions, to acknowledge that Letchworth's essence is architectural and that its success is dependent on the high quality of its ersatz bucolicism rather than on its low density and land-hungry planning. It is these latter traits which persist in blighting Britain. Letchworth's good intentions have paved the way to an exurbia which is still, a century on, in thrall to the wrong bits of the template.

Still, one cannot blame the father for the sins of the sons. Cannot one? Two and a half cheers. (2003)

Selfie store

Gamages. Gone – like sandwiches and Burslem brown ale at No. 10. Gorringes. Gone – like moustaches killing grice on moors with Purdeys and ermine-covered flasks. And Whiteleys, and Swan and Edgar, and Marshall and Snelgrove, and Style and Gerrish (where Santa, no doubt a resting actor, breathed his fumous liquid lunch over me, aged three. I cried, and ran from his sordid grotto and began plotting my life's work as the Liberator of Reindeer – but not till I had found my mother who had apparently deserted me. For an apparent eternity I chased through towering forests of shirts, minatory naves of coats). I don't know the fate of Beales and Bobby's and Brights in Bournemouth, but I fear the worst.

This country is so prone to deluding itself that it is crippled by tradition that it regularly commits corporate, institutional and statist self-harming in the name of modernity. New Labour's very name is testimony to this tendency. We congratulate ourselves on not having suffered A Revolution while occluding the constant, malignant minor revolutions that happen by stealth. The truth of the matter is that Britain is preposterously and pointlessly neophiliac, restlessly obsessed by the implementation of change. Doing nothing is an option. But it is one we are increasingly reluctant to choose.

One of the perennial delights of the great European cities – among which I include New York and Buenos Aires – is a palpable sense that the question is not past or present but both/and. This country tends to preserve with the desperate archaeological detail that it brings to costume drama, or to destroy: there is apparently no middle way between formalin and explosives, between aspic and destruction. This is a country, probably the only country, whose demolition industry is so proud of itself that it has annual awards, complete with ceremony, speeches, piss-up, optional paid sex. Hence the disappearance of so many department stores – which were, too, as much victims of supermarkets as small grocery shops were.

Harrods is, of course, no ordinary department store. It is a world away from Grace Brothers or Arding and Hobbs. That was always the case. The building is an advertisement for itself. In the patois of American architectural history, it is 'representational'. Yet it is also an advertisement for Doulton's patent terracotta. Doulton's own premises on Lambeth High Street were an even louder advertisement, thrillingly harsh and wild. But, as I say, this is a country which destroys – only a fragment of them remains. Doulton was also responsible for Harrods' food halls which do, mercifully, remain intact. It is one of London's more extravagant interiors.

London is not much blessed (or infected) with art nouveau. This is one of the better examples. I'd suggest that it's a place for looking at rather than buying from. Years ago, I heard a tetchy old bird scream at a hapless assistant: 'Your cheese is never ripe and your butter's always rancid.'

That is not the case today. The cheeses certainly look in peak condition (I didn't taste). But with the exception of various artisan Goudas they are all available elsewhere in central London at less imaginative prices. Mr Al-Fayed did not get where he is today by offering bargains. At one of the numerous eat-in opportunities (pizza, sushi, fish and chips for £15, oyster bar, salt beef, etc.) I stopped for a glass of 'fresh' orange juice. I guess it depends on what you mean by fresh. This came out of a carton, and cost £3.75 for a glass of approximately 25 ml. No matter, the point of Harrods is not, never was, value for money. It is a kind of show, a circus – although the animals and reptiles have, alas, moved on. When there was a pet department somewhere in the heights, I heard a boa constrictor roar. An easily made mistake: the noise was that of a cage door scraping against its jamb.

Harrods' only major competitor, Selfridges, is a generation younger and currently more fashionable. Bourgeois Londoners patronise it. Peter York says it's OK to shop there. He knows about such matters. If Selfridges is cool, then Harrods is hot, going on scalding. I couldn't swear to it but it wouldn't astonish me if less than 10 per cent of the people milling about Harrods one afternoon last week were inhabitants of this city.

Like the Tower, the London Dungeon, open-top buses, Madame Tussauds, the pedestrian crossing on Abbey Road, Parliament Square, the Mall and so on, Harrods belongs to a parallel, touristic London of the sartorially inept with their callipygian bum bags and crutch purses and incredibly naff hats and multipocketed shorts and fascinating dermal conditions. They heave and seethe and lurch like

cattle at Welshpool market. When they relieve themselves it is in Luxury Toilets. They throw coins into the apparently celebrated shrine to the Princess of Wales and Mr Dodi Al Fayed. I had not previously seen it (this was my first visit to Harrods in a decade or more). It is at the bottom of an escalator well which is fulsomely over-decorated in the Egyptian style. Of course it's the grossest kitsch. But it rather makes the case for kitsch. It seems appropriate in the way that a more restrained shrine would not. Cheap decor is as potent as cheap music – and can be just as expensive to produce. It is an admirably touching monument to the consequences of employing a chauffeur with a drink and tranquilliser problem.

The product Harrods sells most of is itself. Souvenirs of That Very Special Visit to Harrods come in a multitude of predictable forms: soft toys, biscuits, gewgaws, own-brand teas and wines and soaps and lifestyle fragrances. I bought nothing and sprayed myself liberally – the place is replete with testers. I momentarily coveted a beautiful moss-green velvet jacket, a ringer for one in a painting I own by the English surrealist Peter Lucas. And I admired the un-pestering staff. They appear to be chosen for their looks: good hair, good teeth, good clothes, good eye contact. I didn't check availability. (2004)

Bull in a bear market

The initial reaction to the coy, mock-audacious, aggrandising euphemism 'retail therapy' is to wince. It was, possibly, the coinage of a rag-trade thinker. More likely, it was that of a fashion 'writer'; that is, a member of the band of enthusiastically brown-nosed illit-erates who lauded last season's *sans-culottes* futurism ('daringly zeit-geisty'), who laud this season's apocalyptic serf look ('famine is so thrillingly now'), who will laud next season's fresh-out-of-Dachau silhouette ('courageous neo-waifism').

Retail therapy is, lest we forget, shopping. And shopping is acquisition. And untrammelled acquisition is the only civil liberty that most Britons have truly valued since Margaret Thatcher's cultural revolution a quarter of a century ago sanctioned greed, and her chancellor, Nigel Lawson, performed that extraordinary act of conceptual legerdemain which turned debt (a bad thing) into credit (a good thing). Maybe it's more than a civil liberty. Maybe it's a secular creed. Maybe buying is therapeutic, more than therapeutic: one still, nonetheless, winces at the epithet.

But to believe in the regenerative capacity of gaining material ownership or even of covetousness (hereafter known as 'aspiration') is rather less absurd than to believe in one or another of the ancient Middle Eastern myth systems which dog the modern world with their hoary antagonisms and supernatural clichés: at least white goods are useful; at least Eau Lente and Castrol X smell delicious; at least Manolos and sweetbreads are sensually satisfying.

In any event, all creeds wane, and shop attendance is down, again. We are losing the habit of buying our way to serenity or, indeed, of buying Serenity with its interactive links to Bliss and full set of hand-crafted Happinesses. A CBI survey of the retail sector is constellated with minus signs, with cries of the utmost despair – 'People are holding off from replacing their washing machines!' – with boldly proposed panaceas – 'Staff at Comet are being trained to improve the quality of conversations.'

There exists a syndrome that one might as well call the Professional Fallacy, whereby members of a profession or caste ascribe to civilians their specialist attributes and knowledge. Thus, economists have difficulty in realising that the rest of us don't behave according to the 'laws' of economics, and so blithely assert that our reluctance to go shopping derives from a widespread financial insecurity prompted by uncertainty that the inflation of property prices will increase for ever and ever, despite full employment and increasing

earnings. As John Coleman, chief executive of the House of Fraser, corroborates: 'Consumers have got money. But they are using it to pay debt. Something has spooked them.'

That 'something' could be the tardy dawning on them of the long-term ramifications of Lawson's sleight of hand. It could be the culmination of the gradual realisation on the part of many property owners that their ownership is indeed provisional, yet that their property is their pension.

What economists and retailers such as Coleman neglect to address is that consumerism has an autonomous motor, whose power is not directly linked to exterior economic circumstance. It is entirely conceivable that we are bored with shopping, with the same shops everywhere, and that we'll find a new solace to render temporarily sacred. The British high street is a site of homogenised mediocrity because the corporate guarantee of a poorer quality of material life is unchecked by the sort of *dirigisme* that exists throughout the rest of western Europe, largely in reaction to the flawed Anglo-Saxon model, and which positively discriminates in favour of small retailers by circumscribing the opening hours of chain stores, and by operating a sliding rating and fiscal system. The Howard de Walden estate which owns much of Marylebone, a stone's throw and a world away from Oxford Street in central London, has, exceptionally, made a sterling effort to attract one-off shops – the Ginger Pig (butcher/charcuterie), Daunt Books, La Fromagerie, John Rushton Shoes – on the commercially hard-headed grounds that such a measure will increase the value of the area's domestic properties. These enterprises have succeeded in realising that cynosure of a thousand wishful estate agents: they have helped to create something close to a village; one of only two or three in the urban (as opposed to suburban) quarters of the capital.

Needless to say, the wretched Tesco, uninvited to the party, has gate-crashed by setting up two stores within sight of each other in

premises whose leases were not controlled by the estate. Nonetheless, Marylebone High Street and its surrounds have become an exemplar of what is possible given the will of enlightened commercial despotism. It goes without saying that every Parisian arrondissement has several such streets. But then Paris is the world's capital of *flânerie* (of which shopping and window shopping are subdivisions), while London is the world capital of breakneck scurrying hither and thither for a purpose. Even London's narrow pavements militate against their being used as anything other than byways. They're not for loitering on.

I am just back from Angoulême (population 110,000 and with a central food market way beyond anything that London, seventy times its size, can muster). Waiting for me was an email from a friend with a tremendous piece of journalism attached, an interview with an astonishing creature called Scott Pack, the head buyer for Waterstone's and a most dogged servant of bottom-line populism, who has informed his fellow alumni of the Philistia Academy that 'my life is better than yours'. It made my friend's flesh creep, and mine. But then it occurred to me that the loud-mouthed booby was merely a picayune symptom of the malaise of gigantism: structures topple when they outgrow their strength. It does not need Poujade, the voice of small shopkeepers, or the little English nostrums of guild socialism to effect such a change. It just needs time. Oh, and an infrastructural makeover would be a boon.

It can be argued that a country's retail pattern is a reflection of its manufacturing system – or former such system. The countries where shopping remains a pleasure rather than a utilitarian chore are countries that support small businesses and small-scale, climatically and geologically appropriate agricultural enterprises. Countries that are partially deaf to the anglophone exhortation to think global, countries that value quality over choice and where the middleman does not need to be cut out because he didn't exist in the first place.

The heartening conclusion to be drawn from the CBI survey is that consumers are not behaving as the high street and supermarket juggernauts would wish them to. The evidence for this is that the only retail area to show increased profits is that of specialised food shops: the emphasis should be on specialised. The British consumer is at last coming into line with the European consumer. This bodes ill for Goliath's future health. (2005)

County of contrasts
Excellent Essex by Gillian Darley

Gillian Darley embraces several disciplines. She is variously historian, anthropologist, topographer, geographer – but on no account psycho-geographer: she is courteously dismissive of edgelands expressionism, perhaps too hastily dismissive given the sympathetic hearing she gives to cults and their often-dotty nostrums.

What those unfamiliar with the many versions of Essex Darley scrutinises but who are up to speed on popular misrepresentations of the county will make of this energetic, dense, quasi-omniscient piece of work is anybody's guess. It may come as a sort of revelation. Darley's Essex is multi-layered and constantly counter-intuitive. Much of its character is due to the scarcity of big estates and the consequent non-feudal nature of its old settlements.

Newer settlements or tied villages such as Silver End (Crittall windows) and Bata (shoes, plus jackboots for fascist Italy) established their own forms of non-feudalism which involved organised leisure, communal activities, the horrors of folk dance, sports days and anything else the heavy hand of philanthropy could foist on workers – a small price to pay for steady employment and a house with an inside toilet. These exercises in living flowered in a county whose denominational nonconformity was (maybe still is) so ubiquitous it was actually conformity, the norm. However,

Brentwood cathedral, the major sacred building of the last century is, perversely, Catholic (and timid). It is sutured onto an off-the-peg High Victorian church. Such juxtapositions are the very stuff of Darley's Essex.

In huddled proximity there come, for instance: House for Essex – an earnestly kitsch extravaganza by Alain de Botton, Grayson Perry and Charles Holland; Hamford Water, a wonderful fluid expanse of marsh and saltings which Darley associates with Arthur Ransome's *Swallows and Amazons* rather than with some important artists of an earlier generation, Eduardo Paolozzi and Nigel Henderson, who lived there and whom she ignores; Harwich, where a group of boys from a Kindertransport discovered 'a red light district'. Harwich? Really? Well, it is a port: Harwich for the continent, Frinton for the incontinent as they used to say in Clacton, and probably still do. Darley is, improbably, a failed Redcoat. Whether she rues not having enjoyed a 'stellar career' like Ted Rogers and Des O'Connor is unclear: the first rung on a Redcoat's ladder to stardom was emptying chemical toilets in Skegness.

To move up to macro level, that north-eastern chunk of the county, bordered by the tidal Colne and the tidal Stour and shaped like a hand of pork, is a few miles and many eons distant from the jungly green hinterland which included Dedham Vale. This was the author's childhood route into the county – she grew up in Sudbury which is just in Suffolk. The hand of pork is often desolate. I remember early one summer evening being at a crossroads south of Manningtree from where you could see for miles in every direction. No building. No vehicle. No person. No noise. Nothing – that greatest of modern luxuries, granted to us by agribiz. A marked contrast to the clamour of a packed land and coast: much of Essex is, after all, London seeping ever eastwards. That seepage and its staunching is what Essex apparently has over more monocultural counties – but do such counties really exist? There are other unsung

and diverse counties which would be susceptible to the same approach: Worcestershire, Staffordshire, Lincolnshire.

But she special-pleads on Essex's behalf as though Britain is otherwise composed of administrative accidents which are implicitly homogeneous or, at least, coherent. Essex's incoherence gives Darley her structure. It is thematic, often indifferent to chronology, reliant on association and formidable energy. She reproduces a sketch by Edward Bawden of his fellow artist John Aldridge in the Bell, Great Bardfield. Darley might be Aldridge, four empty-sleevers in front of him, holding forth unstoppably to the local thatcher, imparting knowledge and folklore that even that horny-handed son of reed was unfamiliar with.

The index is a signal of the book's vitality and range. Close by each other as they surely never were in life are James Lees-Milne, the world-class name-dropper with the horrible prose style, and Norman Lewis, the very great travel writer, novelist and memoirist, whom Darley represents as an obstinate curmudgeon, a portrait which does not accord with the sprightly and curious charmer who well into his late seventies used to turn up at London parties, have a glass or four and enjoy the adulation of his juniors. His outer North London accent, specifically Enfield, has largely disappeared, though Lord Tebbit retains it. Similarly, the old Essex alloy of cockney and bucolic twang is today rarely heard. Accents die with generations. And they are as prone to fashion as ideologies, hairdos and perceptions of England.

Mid-twentieth-century Essex-based artists such as Edward Bawden and Edwin Smith made Essex stand for England, an England that was not entirely a fiction but which you had to point the camera/easel in the right direction to capture before an ethical developer considerately constructed it into oblivion.

Darley, less prone to fabrication, gives us the garden villages (notably Gidea Park), the banal post-war new towns and the

plotlands, idealised now they are gone, insanitary when they had yet to be bulldozed.

There are a few errors. Eindhoven is a creation of Philips rather than Bata. She describes a writer who once buttonholed me and sneered 'You don't really believe in that gas chambers stuff do you?' as 'contrarian', which is, I suppose, one way of putting it. The ghastly Alfred Munnings lambasted Picasso at a Royal Academy of Arts dinner, not at the Royal College of Art. Rod Stewart was born and brought up in the part of Scotland called Upper Holloway, N19.

No matter. This is a generally stellar performance which Ted and Des would have been hard-pressed to match. (2019)

7

Faith, Fads and Fashions

Tinker, tailor, Tennant

Serious Pleasures: The Life of Stephen Tennant by Philip Hoare

Here they come again. The usual fragrants and exquisites and paper-skinned lavenders. The same old titled fag-hags whose dogs have such witty names. The sinister, petulant arse-bandits whom Waugh stitched up (but they didn't see it thus). The climbers who are now so familiar they are almost family (thank God they're not). They're back, team-handed, for another season. Just get those glittering one-liners: 'common people smell so rank'; 'mauve is so defiant, too brave'. Just watch them rehearse the pranks they've performed a hundred times before.

They are the Biog Mob. In life they strove to be in *Vogue*. In death their carcasses are annually wheeled out to attend the posthumous party of one or other of the sodality. They are: Brian Howard, Diana Cooper, Cecil Beaton, Rex Whistler, a Mitford or two, the Sitwells. They constitute the officer class of the Arty Army, the top drawer of the buggerocracy. They are the major Minors. And this year's party is thrown for a chum who, even by their taxing standards, enjoyed a life of more than usually sumptuous fatuity.

Had Stephen Tennant been born a girl he might have married well and ended up a duchess; as it was he was fated to remain forever a

queen. Had he been born to a less financially cossetting family, he might have made a living, a meagre living, as an illustrator; again, he might not: he might have been forced to get the bit between the teeth and become a tart, hawking his brawn on the 'Dilly. Had he been born fifty years later he might have turned into Boy George.

His gifts were for dressing *en femme*, for the application of slap, for bitchery and bad-mouthing. His greatest gift was for being Stephen Tennant, for being true to the child who proclaimed his ambition – 'I want to be a Great Beauty, Sir'. Sir was his father, the first Lord Glenconner whose fifth child he was.

The gifts he yearned to possess were, predictably enough, for writing and painting. But he was a tenth-rate Firbank, and an eighth-rate Burra. He was 'artistic', certainly, but no artist – it's often the way, indeed it's the norm among the Biog Mob: how many times have we been told that Diana Cooper *could have* been a great actress? The point is: she wasn't. Stephen Tennant's art was artless. He chose rotten models, of course. Firbank has been death to his aspirant avatars save Waugh and Orton (who wondered, tellingly, about this guff about writers being 'sensitive'). We all know about Waugh; and Burra, too, was *tough*. Tennant confused attitude with action, was endlessly prey to distractions – in times of trouble he created his own – and he was preoccupied by 'style', not in Buffon's meaning (*le style est l'homme même*) but in the contrary sense of an applied manner.

The type is, *pace* Philip Hoare, commonplace. What distinguished Stephen Tennant was, banally, money. Nothing else. Take that away and he's just another valetudinarian, another precious berk without the wit to realise that knowledge is the springboard of imagination, that limits are the precondition of art. It was money – legacies and unearned income – that obviated the possibility of his achieving concentration, discipline. It was money that allowed him to Be Himself. *Her*self was out of the question in the days before vaginoplasty was perfected, though it might have been the answer.

Stephen Tennant was born in 1906. Aunt: Margot Asquith. Stepfather: Lord Grey –'The lamps are going out all over Europe'. That's Lord Grey, Foreign Secretary, who got the next bit wrong. Stephen did his best to light up Europe. After his non-education he partied, he groupied, he travelled – to Germany, for instance. 'Stephen's first impression was of a "queer place, everything so German! German! German!"' Quite. He had an affair with Siegfried Sassoon. He became well known for being in gossip columns. He inherited the Arts and Crafts house called Wilsford Manor (architect, Detmar Blow) and trashed its interior with the aid of Syrie Maugham.

He wore clothes. He connected well. He wasted Mrs Woolf's time. He spanieled round Strachey and Forster and Ackerley. He planned and wrote and never finished a novel called *Lascar* – all matelots and Marseille. (Prison might have been a boon here, as it was for Genet. It concentrates the mind.) But he was never busted, he was the victim of total freedom. He spent much of the war at Bournemouth whose three big department stores began with B. Beale's and Bobby's didn't figure, but he did go for Bright's! The fabrics, the fragrances!

When he returned to Wilsford, forty miles up the Avon by Amesbury and requisitioned for the duration, he undid Mrs Maugham's work and littered it with fabric samples. He spent a decade or so in bed. There was a breakdown, there was baldness (never let *that* get in the way of henna), there was toothlessness. Sometime in the sixties, which weren't the twenties – forty years too late – but which had affinities (flat chests, fastness, 'serious pleasure'), he was taken up by some senior beautiful people who must have seen in this sexagenarian Bright Young Thing not just the picture of their future selves but a secular and sybaritic analogue of the religiose charlatans that junior beautiful people genuflected to. Tennant could spout vapid apothegms quite as finely as any fakir. And – always a problem area, this, with seers from Hyderabad – he had, as I say, *style*. Tinker, tailor, style guru.

We've skipped a generation, to my generation's leading geronto-phile, Hugo Vickers — a man whose hand must be withering from all the letters of condolence that it has written, a man who would cross Europe for a memorial service. Vickers, famous among people who organise sales that pretend to be garden parties, is the man who got Philip Hoare on the case.

It's Mr Hoare who wheels out the carcasses to this year's party. He possesses a singlemindedness of a kind that Stephen Tennant had only heard about. It would flatter Tennant to suggest that he'd see this biog-raphy as a massive joke — no one so frivolous, no one so lacking in bottom (*fond* not *cul*) fails to take himself seriously: it is, generally, the serious who don't take themselves seriously. Mr Tennant's carcass must adore Hoare.

Boy — and Mick Channon was born only three miles from Wilsford, in a different world, mind — done brilliant. He done brilliant in his research and in his purposeful groupiedom (from the nation's favourite charlady, the Queen Mother, to Gore Vidal: it's odd that neither Simon Blow nor Nigel Burwood is credited with an assist).

Hoare's method is Holroydian without the tics, i.e. without the occasional aperçus that break the path trodden by the feet of fact. It's a method that derives from somewhere like Ann Arbor or Madison, Wisconsin. It's a method that works when the subject is already known, when the exegesis is of the familiar, the already con-sumed. It presumes a curiosity whetted by an opus, by achievement, by fame *tout court*. It's not apt here. And to lumber Tennant of all people with such quasi-academic baggage is only to diminish him.

Not that he needed much more of that. He was a preposterous figure, of course. But to treat him with biographical tact and chronal discretion is to get him wrong. There are para-fictive devices that might fix him: there is a way of recounting lives that does not depend upon their being written by keen boys with a name to make.

The only time I met Stephen Tennant I was eight, and I was never so scared by a pantomime dame. Never so terrified by a bloated chorus boy. He may even have been a lesson to this pre-pubescent: here was Fotherington-Tomas gone bad. (1990)

Make mine a Babycham

In the spirit of research ... This habitually signals hefty, jocular irony. But I'm afraid I mean it literally. It was in the spirit of research that, at different times, I tasted Blue Nun, Hirondelle, Mateus Rosé, Piat d'Or, Jacob's Creek and Black Tower. I did not expect to much enjoy them and, sure enough, didn't. But it's important to have sampled them, to have sated curiosity. One cannot in good faith excoriate or, for that matter, defend a product of which one has no direct experience. Better, then, to listen to one's palate than to heed the reputation or to be gulled by the protestations of brand managers for whom units shifted are their own justification. You know the smugly desperate line: so many people can't be wrong. Oh no?

Again, just as it is necessary to taste a great wine in order to recognise a good one, so it is necessary to taste a bad wine in order to recognise a mediocre one. Further, these wines – I use the word in an access of benevolence – are useful indicators of British popular taste, which, evidently, veers towards the quasi-chemical, the cloyingly saccharine, the insipidly emetic. They are the vinous analogues of a Harvester meal, of Celine Dion's records, of the products in a branch of the mysteriously ubiquitous Clintons Cards – perpetually naff, perpetually outside (rather than out of) fashion, perpetually bought in vast quantities by people who are indifferent to such considerations, who are susceptible to advertising or who know no better.

It was announced last week that Black Tower is to be rebranded, despite its claim to be among the top twenty best-selling wines in this country. This could be taken as a sign that the constituency of

people who know no better may be shrinking. Or it could simply mean that the yeomen of the Black Tower are tardily jumping on what has proved to be the bandwagon of the past five years, that they are subscribing to the still potent if hardly untarnished nostrum that there is no product whose performance cannot be improved by a cosmetic makeover. They may of course be correct: it never does to underestimate the New British appetite for change for its own sake. If such changes to, say, industrial foodstuffs and mass-market perfumes are efficacious, why not volume wine?

Black Tower has been around for almost thirty-five years, for a generation and a half. It is a contemporary of wine in boxes, of rehydrated grape powder, of Spanish 'burgundy', of dodgy blends, of evasively labelled generics, of two-litre bottles of filth 'brewed from banana skins in the cellars of Ipswich'. The plethora of such products was an opportunistic response to a shift in British drinking habits prompted by mass tourism to vinous countries. These products preyed on a collective oenological ignorance and enthusiastic indiscriminacy. They were marketed in the certainty that in such circumstances the British would buy anything. This was, remember, before Augustus Barnett and Oddbins, let alone specialist supermarket departments: the only (limited) high street chain then was Peter Dominic. Otherwise the complexion of the wine trade was as gentlemanly ruddy as it had been in the immediately post-war years, when the majority of table wines, non-fortified wines, came from two sources, France and Germany: hock, Piesporter, Bernkasteler . . . the names seem as quaintly dated as Armstrong Siddeley, Lanchester, Allard. Which for younger readers – those of you, that is, who have improbably tasted those German wines – are marques of English car which disappeared in the fifties.

Today the English own German cars and German electrical goods. If anti-German sentiments are still harboured, they are certainly not expressed through our pockets. But envisage a past

when millions of Trabants – Robin Reliants with an extra wheel – were imported from the east, and imagine what that would have done for the reputation of pan-German automotive engineering: would our roads be so packed with BMWs, Mercs, Audis? Of course not. However solidly constructed, they would be tarred with the same rusty brush that has thwarted the sales of upmarket Japanese cars. Serious German wines have suffered because they come from the country of Black Tower and its kin. They are guilty by association.

London is the wine warehouse of the world. There is no city which is as vinously cosmopolitan, as wide open. Germany is the only country missing from the feast. That is an unhappy situation which is unlikely to be changed by Black Tower's rebranding. Indeed, it will be exacerbated by that process, whose aim is to introduce the stuff to the generation that's innocent of German wine. The problem is that this generation is more clued-up, more exposed to quality, more familiar with numerous varietals, more inclined to turn up its nose in distaste than its starved-for-choice predecessors were. All that it's going to discover is that Black Tower is, well, Black Tower – which isn't going to do German wine any favours.

What next? Wincarnis: the new Red Bull. (2002)

The lord is my pigherd
Address to the Durham Students' Union

It would, in this chamber, in the present company, be impertinent to deny that god exists. Not only impertinent, it would also be quite wrong. God does exist. He – She? It? – has existed since humankind first asked the elemental questions: What are we doing here? How come we are here? Who put this all together?

And because the natural world is astonishing, and something which we wonder at, which we properly regard with awe, which is

full of marvels, our forebears, in their fearful ignorance, for want of any other answer, were able only to conceive of a maker, a sort of empyrean mechanic, a celestial grease monkey. They invented for themselves a supernatural explanation. Rather – they invented supernatural explanations. Plural.

Tribe A believes that god lives on the moon. Tribe B across the river believes there is a team of gods which lives in the clouds. Tribe C in the next valley – where they are queer folk and really foreign – worships a god who lives in trees and makes their boughs seethe when he is angry and demands sacrifices of children born with different-coloured eyes. And so on.

And in this severalty of crudely theistic and pantheistic imaginings is the root of what has proved to be, to put it mildly, the first problem: the playground problem of My Tribe's god is better than your god, My Tribe's god is the true god, Your Tribe's god is an impostor. Your creation myth is just a creation myth. It is not the One and Only Truth.

This is a problem that would come to afflict us eternally. It afflicts us because god continues – as I say – to exist. They exist in the mind of those who believe in them, who elect to believe or who feel they are helpless to make a choice. God is the most successful, most enduring, most pervasive and most banal of all fictional creations. Like Don Quixote or Sherlock Holmes or Jay Gatsby or Humbert Humbert or Leopold Bloom or Mr Pickwick, god is a fictional invention who has transcended the work in which he appears and who has achieved an autonomous, independent existence. God is real, all right.

It requires faith to believe in god: faith is not susceptible to proof; proof is an irrelevance in the matter of faith. Faith is my telling you and you believing me that I am a dog [barks to prove it]. Faith is my telling you and you believing me that this is made of porphyry. Faith is frivolously indiscriminate. Why should we respect it?

Religion is a problem here because it demands for itself a right it won't grant to lay thought. The Crusaders were faithful Christians murdering Muslims. The Muslims were faithful in their desire to wipe out the Infidel. Hitler had faith in his nostrums. He was sincere – another worthwhile quality apparently – he was sincere about wanting to annihilate a race, and believed he was doing the Lord's work: it's not for nothing that the swastika is called in German the *Hakenkreuz*, the hooked cross. It was the symbol of a theocracy. National Socialism was an evangelical religious movement: what were the Nuremberg rallies but black masses?

Similarly, the Bolsheviks had faith in Lenin and Stalin. The dead mummified god and the living god whose speciality was death. But then all religions are death cults. They promise heaven – a kitschy utopia of willing virgins and abundant sweetmeats – in return for obedience and indulgences on this earth: a transaction which in any other circumstances would seem horribly fraudulent. The Koran says: 'Who so desireth any religion other than Islam in the next world shall be among the lost.'

Christianity is a death cult in another way. Its paramount icon is that of a legalised murder foretold and willingly submitted to. Calvary was an abattoir. Literally an abattoir, because what communicant Christians do with Christ is eat him; Christians are cannibals. Butchered on Calvary and still being eaten all around the world 2,000 years later . . . That terrible wine from Crediton in Devon and those horrible wafers are not symbols – they do not stand for the body and blood, they *are* the body and blood. This is a problem. It is especially a problem for Christ. No wonder he doesn't return to earth. He knows very well that were he to do so he would be ripped limb from limb and eaten.

Faith demands the suspension of disbelief – like any drama, any fiction. But we are usually capable of distinguishing the fictional from that which exists in primary reality. And it is here that the

faithful seem compromised, sick, disturbed. In their capacity to allow one sort of reality to become contaminated by another. To grant primacy to that which is imagined is part of the compact made between audience and play, between reader and writer. But we know where to stop, where to draw the line. The faithful don't. And while this may not be the business of anyone else, it surely affects us all when the faithful are in a position to affect our lives.

We no longer – unless we are a half-witted, intolerant Saudi imam – believe that the world is flat, so why do we believe in a construct such as god which belongs to the same mindset, to the same apparatus of ignorance?

Religion is paradoxically – and not by its own admission – a question of the survival of the fittest. A religion is one person's belief, one person's fiction, which that person propagates till it is taken up by a group. If it survives that far it becomes a collective belief system. If it survives further, and that survival depends on its successful propagation, it becomes a cult. And a religion is an institutionalised cult: it is a codification of an allegedly spiritual irrationalism just as surrealism is a codification of aesthetic irrationalism. Religious denominations evidently fear and denigrate cults because they are rivals – business rivals, you might say.

God has outlived his rivals because he is global, the best-branded product on earth. Which ubiquity has everything to do with the power of proselytisation and with the Church's commercial acumen and moral stranglehold, with what sort of supernatural mumbo jumbo is deemed acceptable and what is not: god has succeeded where the fairies at the bottom of the garden have failed. As I've written elsewhere, if you believe in those fairies you are reckoned to be in need of psychiatric help. If you believe in such tall stories as the transubstantiation, the virgin birth, the ascension, the miracles, the rising from the dead and all the rest of what

H. L. Mencken called the pile of garbage – well, then, you are reckoned fit to govern the country. This is a problem.

Even the most zealously irreligious are obliged to admit that in this country the self-proclaimed believers seldom seem sick. But that is because its dominant faith throughout much of the time that I was growing up was increasingly self-secularising. The news that someone or other is a worshipper generally comes as a surprise. For Christianity seemed rarely to affect the believer's mores: it was a kind of add-on, an optional extra, like being a moderate smoker, a social drinker, an occasional gambler. It did not go to the core. And the Church of England was, during the period I'm talking about, for many years from the publication of *Honest to God* to the former Bishop of Durham's observation that the resurrection was a conjuring trick with bones . . . it was characterised by a clergy which was sceptical and humane. Which demonstrated that there is a gulf between belief and ethics, between credulousness and decent behaviour.

I am afraid that that period is now in the past. There is a new intolerance abroad. A willingness to challenge the right to free speech. The dominant faith has been infected and emboldened by the stridency – the regrettably effective stridency – of faiths such as Islam which have not contributed to the dominant culture: that is, a post-Protestant culture of laissez-faire humanism. The Church of England is regrettably waking from its slumber of the last half-century to become once again the Church Militant of the second quarter of the nineteenth century. How dare its rank and file send the BBC identically worded messages denigrating an entertainment they have not seen? Worse, how dare its senior officers support Sikh militants violently forcing a play to close down? Why do they enthusiastically condone such criminality? Because it is in the interest of one form of theism to bury its differences and to support another form when the opposition is atheistic. This is a problem.

For why should religious denominations be statutorily protected

when lay thinking is not? Such protection grants superstitions a status that reason is denied. Let us say that I believe the dicta of a character of mine in a novel I wrote a decade ago. Ray Butt is a sometime comedian who suffers a vision on Portsdown Hill above Portsmouth. He looks at Spithead and the English Channel and the harbours on a rainy, windy day, and notices that the puckered sea is like a plucked chicken's skin. He is told – as such visionaries are – that the world is a chicken. He founds something called the Church of the Best Ever Redemption. He realises that a denomination requires a dietary law. So he proscribes all that doesn't fly or at least have wings. This is a problem. Because he misses bacon. So he and his sons take a pig to the top of a tower block and bung it over the edge to show that it can fly. It fails to do so and writes off a car. Butt is however unabashed; he claims that the pig was simply shirking, could have flown had it wished – and he continues to eat bacon.

I made this up. Just as someone or other made up god and equally preposterous dietary laws – Leviticus would be comic were it not taken so seriously. If everything we make up is claimed to be an expression of a religious impulse, then everything will be protected, nothing can be mocked, and all discourse will come to an end as it did in those holiest of states where there was only one law: Soviet Russia and Nazi Germany. It is humans who invent faiths, idols, liturgies, saints, who determine to genitally mutilate their children. It is humans who deem what is sacred.

When we criticise religions, we are criticising the *amour propre* and the sanctimonious pride of low-level inventors whose confidence in their inventions is so frail that they demand external protection. Perhaps we should not even dignify them as low-level inventors, for they are merely carrying a baton handed down through the ages from a time when the clergy at least had some excuse to believe, though no excuse to crusade and to instigate pogroms. Of course, after a religion has become institutionalised, after it has wielded

sacred power, it will aspire to wield temporal, secular power. This is a problem when religion starts getting holy – as it has in this country in the last decade.

Atheism is not a problem because it is not asking for anything, save to correct the excesses of those institutions that seek to impose their warped worldview and to capture the minds of the three most vulnerable sections of the planet's populace: children, the psychologically damaged and the uneducated. Nor does atheism lead, as its opponents quaintly claim, to Marxism or utopianism. It is more modest. It has no creed. It might lead anywhere. It does not seek human perfection. That, surely, is the Christian Pelagians' apostatical quest. We think for ourselves: that is what freethinking means. I am, for instance, perfectly sanguine about acknowledging that humankind has as great a capacity for evil as it has for good. That view is merely realistic, based in observation and experience, rather than a dogma dressed in the dodgy raiments of original sin.

If they were to strip away the age-old myths, religions might possibly achieve an ethical compact with the secular world whose ethical values they mostly share. But if they do strip away those myths, religions abandon the very cause of their existence. They have nothing to perpetuate. And all religions possess a sort of reproductive instinct. Why else, when attendances are falling and it possesses many buildings which are shut and disused, does, for instance, the Church of England persist in building new churches. They are functionally redundant. They are merely tokens of the Church's spurious engagement with the future.

Let me conclude with some gear from the mouth of various horses.

Here's the Ayatollah Khomeini: 'A man can have sex with sheep and camels. However he must kill the animal after he has had his orgasm. He must not sell the meat to the people of his village. A neighbouring village is OK though . . . A man can have sexual

pleasure with a child as young as a baby. If the man penetrates and damages a child he must then be responsible for her subsistence all her life.'

So – that's all right then.

Here's the multimillionairess Albanian witch Mother Teresa: 'I think it is beautiful for the poor to accept their lot.'

The cultural relativism which demands that we should respect such gems is as much a problem as religion itself – and it is of course fomented by religion, it is a facet of its self-pitying, bullying special pleading. (2005)

Fine dining for vegetables

You Aren't What You Eat: Fed Up With Gastroculture by Steven Poole

This is a bloody, brutal and necessary sacred-cow hunt. Heston, Jamie, Gordon and the entire gruesome *galère* of mononomial food-ists are mocked, derided, exposed and forced to endure the echo of their vacuous 'philosophies' and inane dicta. They are allowed so much rope that they suffer multiple deaths. Steven Poole shows about as much mercy as an abattoir shootist. Unlike such an operative, however, he is brilliantly and consistently and winningly funny: his is a great comic performance, and evidently hurtful. Or, rather, it would be hurtful were his multiple targets to possess his acuity and be able to understand what he writes. It's all too probable that they simply won't get it, they won't realise that they've been well and truly rumbled. And even if they dimly perceive that this man is taking multiple pots at them, he can be discounted because he is not part of the guzzling 'community' which listens only to its own because it is cultishly ingrown.

It is difficult, for instance, to imagine that such titans of contemporary thought as Prince Charles and Mr Sting will be dissuaded of their support for the Soil Association because its founder, Jorion

Jenks, was a member of the English Mistery and British Union of Fascists: astonishingly, he continued to correspond after the Second World War with the then imprisoned Richard Walther Darré, the Reich minister of agriculture, the ideologue of blood and soil and 'theorist' of Lebensraum. To point to Jenks' sources, beliefs and penpals is not an ad hominem criticism, for those beliefs remain at the very heart of this cranky, Luddite and – as Poole makes clear – misanthropic organisation, which values mineral earth over human-kind. Darré must be beaming with pride in whatever circle of wholemeal hell he inhabits. Poole correctly discerns a strong element of misanthropy and first world exclusivity throughout the entire bio and organic racket, which, like any dumb religion (and is there any other kind?), puts reason to sleep in favour of dodgy nostrums with no bases other than those of 'faith'.

A hapless fellow called Craig Sams is quoted. He believes that meals become 'imprinted on our DNA', that they become 'part of your heredity'. The book is littered with such professions of pseudo-science. But hold on: maybe Sams has a point, for it turns out that he is some sort of fair-trade, holistic, ethical, carbon-sequestering, cacao-growing, allotment-digging, tomato-avoiding macrobiotic entrepreneur. Could it be that his diet has so scrambled his brain that he has come to actually believe such guff? Or is Poole closer to the mark, and more forgiving, when he suggests that Sams' theory is a 'marvellously subtle form of moral blackmail', for what you eat will affect not just you but 'your as-yet-unborn children, who will inherit your disgustingly screwed-up beefy genome'.

The personae whose wings Poole gleefully picks off belong to many and different gastronomic subcultures. They are nonetheless bound together by their extremism and their hyperbole. There is no place in these milieus for balance, for doubt, for self-questioning – let alone for the self-knowledge that might provide a bulwark against loopy mendacity ('if you cook these recipes, you will be

rewarded with good times, brilliant weekends and big smiles all around the table'), against childish chemistry experiments, a wearily hackneyed lexicon ('drizzle', 'source', 'forage', 'artisanal', 'heritage', 'proper', 'real'), preposterous claims of provenance, grossly sentimental ancestor worship and the delusion that cooking is an art. It's not. It's at best a craft.

Attempts by persons of little learning to elevate it are risible. The sheer bollocks that chefs spout is startling. This is a caste drained of all irony, all wit. The chef Anthony Bourdain writes of the chef Thomas Keller: 'You haven't seen how he handles fish, gently laying it down on the board and caressing it, approaching it warily, respectfully, as if communicating with an old friend.' The old friend, should we not have noticed, is dead. Are we to suppose that Keller is a medium? Or is he a necrophiliac fish-fiddler, a Jimmy Savile of the deep? Rather bizarrely, Poole, succumbing momentarily to an injurious relativism, claims that Bourdain is 'a serious, and seriously good, writer'. Had 'writer' been suffixed 'for a chef' that contention would have been apter.

Still, it's a forgivable lapse given the sheer bathos which he is obliged to wade through. Virtually every page yields some startling sample of the food world's self-congratulation, its pompousness, its pretension, its sheer wrong-headedness. Franc Roddam, who invented *MasterChef* in 1990, claims ludicrously that 'at that point good food was only for rich people. It was like, "No hang on a second. Let's democratise this."' So that's what he was up to, putting food on the poor's table by telecommunication. That 'It was like' is, incidentally, a sexagenarian's priceless essay in the very 'democratisation' he is claiming for his debased telly format. Still, it cannot be denied that *MasterChef* has given us some glorious moments such as this voiceover: 'This is fine dining now, so Steve must remove the outer skin from each individual pea.'

Any sentient adult will wince at the construction 'fine dining'.

Poole is not afraid to quote stuff that will cause us to cringe. Us. For every us there is a them. Nor, it appears, is he afraid to court accusations of snobbery. Here is an intelligent, well-read, highly educated man with a heightened sensitivity to language having a whale of a time poking fun at a brigade of toque'd unfortunates who are less intellectually favoured than he is, mostly subliterate people who talk with their frying pans rather as footballers talk with their feet, people who are largely incapable of realising how absurd they appear to those who are not fellow believers.

Two hundred years ago Steven Poole would have been an assiduous guide to the horrors of Bedlam. We should be thankful that in a more humane age the patients have been released and are now available to be gaped at in restaurants, magazines and on telly. All the time. (2012)

If I ruled the world

The degradation and moral putrefaction which eventually attend the rulers of mere states are nothing beside the reeking tide of corruption that no holder of this post is immune to.

The time will come when I commission elephantine neoclassical blingsteads from Speer's heirs and triumphal stadia from Lord Foster, appoint Berlusconi as Pimp Imperial and DSK (aka Big Mac) as Procurer Extraordinary, prosecute war against Mars, exterminate Venusians and oblige every capital city in the world, my world, to construct several 1,000-metre-tall heroic statues of myself.

But before megalomania's grip is entire, before I succumb to omnipotence's caprices, I shall institute a programme of measures to make this planet a marginally better place for those billions of little people whose misfortune it is not to be Ruler.

The need to expunge all religions as torpid folk-myths born out of ignorance, climatic extremities and psychotropics is strong. The

lesson of countless attempts to do so is that a proscription of public worship incurs resentment, foments antagonisms, provokes wars, pogroms and so on. And, anyway, delusionists are stubborn: their silly creeds endure, underground. A Ruler who, for all his superstitious atheism, is a beneficiary of a Judaeo-Christian ethos, or post-Judaeo-Christian ethos, suffers the peculiar disadvantage of not knowing what it is to believe, to abase oneself towards a figment of an ancient collective imagination. I pity believers. I pity them as I pity those who suffer any disease. But I am also dismayed by their refusal to acknowledge that they are ill and am angered by their special pleading.

Though not so angered as I am by the appeasement of such pleading, by its inevitable success in a world where murderous absurdity is granted the same value as sane probity lest the advocates of murderous absurdity be offended. Why on earth should the defences that he is a man of faith or she is devoutly observant or they attend mosque twelve times a day be taken as anything other than boasts of credulous nullity? We have no duty of respect towards other people's preposterous fantasies.

Faith merely means acceptance without proof. So: no protection or privileges for vulture worshippers or fools who immerse themselves in the shit-thickened Ganges or the deceived who Zimmer from coach to cave at Lourdes. Further: automatic disqualification from public posts of those who subscribe to supernatural baloney and believe they are answerable to their god rather than their fellow humans.

French anti-communitarianism is of course imperfect but it at least pretends to effect equality, and it implicitly acknowledges that the Bible contains such germs of the Christian Church's self-secularisation as 'Render unto Caesar the things that be Caesar's and unto God the things that be God's' and the Song of Solomon. The French model is morally if not pragmatically superior to the sectarianism or voluntary apartheid which Britain promoted throughout

its empire in a spirit of laissez-faire and which, now it has brought it home, it dignifies as celebrating 'diversity'. The inevitable prefix 'vibrant' is one of the age's greater lies. 'Resented' is more the ticket. This Ruler will encourage, by means yet to be revealed, the celebration of commonality, of the kinship between peoples – a feat more readily achieved if the peoples are not weighed down with the baggage of exclusivity and tribal pride.

We can, nonetheless, learn from sacred texts and sources. Rather, we can cherry-pick those dicta we approve of while discarding the rest of the wrath. Leviticus 19.28: 'Ye shall not make any cuttings in your flesh for the dead, nor print any marks upon you.' A world without tattoos might not be a better place but it would look cleaner. This Ruler, never anything if not inconsistent, has nothing against vertical tanning, Botox and monkey glands.

Nor against following below-stairs Vatican policy on population control. This is what politicians might call a 'challenge' were they prepared – and they're not – to address the unhappy truth that our planet is finite and that people are going to fall off the edge, so to speak. But people are not going to stop rubbing offal. After shelter and food, sex comes next in the hierarchy of basic human needs. Given its quaint ideas about contraception, the Holy See might not be the most obvious site from which to seek counsel on stemming the global birth rate. But let us look at its No Nephews Initiative, a radical policy created to keep nuns and nuncios out of trouble and free of paternity suits by promoting classic fellatio and heritage cunnilingus as these lusty clerics' exclusive sexual practices. And what is good enough for the shepherd is good enough for the flock. This Ruler wants you to know it makes sense. Nine out of ten cardinals agree.

Meanwhile, I need to scrutinise Santiago Calatrava's plans for a transmodular negroni fountain and take some me-time to planify my personal happiness and serenity sectors. So I've convened a

synod of taxi drivers and rickshaw wallahs to advise on parochial matters such as reversing the Anthropocene and burying the condemned. (2013)

Cooking with E numbers

Bad Food Britain by Joanna Blythman

Monoglot incuriosity and dumb insularity certainly have their benefits. They allow those who suffer them to enjoy the smug boast that the way things are done in their village, their nation, their faith, is the right way, the proper way. We heal sores with powdered stiv bark; our votive pieces are hewn from tufa. They – the ignorant people across the sound – they make poultices of osk-eel skin!

Things are not so different today. We may affect cosmopolitanism and multiculturalism. We may inhabit countries that are not those of our parents' parents' birth yet partially adhere to their mores. We may travel promiscuously and even meet waiters who speak English. But we all too evidently live in atomised capsules that are prophylactics against understanding and empathy.

It is improbable that Joanna Blythman wittingly set out in the manner that Peter Nichols did in *The National Health* or Lindsay Anderson in *Britannia Hospital*. She has nonetheless created in *Bad Food Britain* a potent metaphor for a pecuniarily divided, culturally impoverished, proudly philistine, socially dysfunctional, self-deluding country whose greatest collective gifts are for packaging, spin, PR, merchandising, rebranding, euphemism and, of course, the keen gullibility that such forms of mendacity initially create and subsequently depend upon.

Blythman is depressing and exhilarating. Depressing because the topics she addresses coalesce into a gruesome portrait of national degradation. Exhilarating because she composes this portrait with

precision, contempt and a truthfulness that is reckless, unselfserving. She will be blacklisted by the foodporn magazines that supermarkets publish to claim green cred and gastro correctness. She will be an embarrassment to the vast battalion of Francophobic consumer journalists whose anilingual chumminess with the food industry that bottom-feeds them renders them producer journalists, de facto PRs. Blythman belongs to an honourable school.

So, too, no doubt does Rod Liddle – but that doesn't stop him proffering this moronic gem: 'I would argue that in London you will find better Thai, Indian, Chinese, Italian and French cooking than you would in the indigenous countries.' Such Little English expressions of laughably deluded complacency constellate the text. Here is one David Gregory protesting that a shepherd's pie composed of no fewer than fifty-nine ingredients – most of them stabilisers, glutens and colorants – is based on home cooking: 'I recently got out an old university cookbook and the list of ingredients hasn't changed a great deal.' Mr Gregory is Marks & Spencer's head of food technology, so we can guess at the nature of that cookbook.

Most of the food that Britain consumes is prepared in factories to formulae devised by Gregorian chemists: it is dishonestly linked to actual cooking by the photographic presence on the packaging of an all-effin' all-blindin' telly chef. An endless *galère* of these irony-free freaks is industrially produced by the independent producer Optomen, which makes a small yet sterling contribution to Britain's soaring rates of obesity and cardiovascular disease. Blythman thus links the rarefied milieu of Michelin-starred crazes – the current one is 'molecular gastronomy' – across class and income to the debased grot which has caused the average female waist measurement to have increased by six inches in the past half-century.

The grot trade, like the tobacco industry it so resembles, possesses a multiplicity of professional lobbyists and academic apologists with so many letters after their name they form an anagram of

trahison des clercs. One will tell you that 'there are bad diets but there are no bad foods'. A second that 'we make treats, a reward at the end of a long day, a pleasure to enjoy in moderation' – the reward in question is biscuits: and the berk who thus pronounced is disingenuous if he believes that the British are capable of doing anything in moderation. 'Just doing 30 minutes of physical activity a day can keep you fit and burn off calories,' says the crisp salesman Gary Lineker, who also counsels moderation.

To 'burn off' a Big Mac, Medium Fries and Small Vanilla Milkshake you'd have to walk from Marble Arch to Hemel Hempstead. The Savoury Snacks Information Bureau (honestly!) plays the heritage card: 'Snacks are indisputably an integral part of the British culture.' But so was hunting with dogs: that pursuit, however, was perceived as wickedly elitist by the anti-elitist elite whose cross-party populism obliges it to feed filth burgers to its kiddiz, to brandish tea mugs, to drink beer from the bottle, to proclaim its man-of-the-people appetite for fish and chips – the 'national dish' that we're no better at cooking than we are at playing the 'national game'. Egon Ronay describes it as our 'most distinctive contribution to world cuisine'. He is wrong. It is Sephardic: the first fish and chip shop opened in the East End in the mid-1850s. A century later Dorothy Hartley, in her exhaustive *Food in England*, mentions the dish once, and is dismissive of deep-frying. That book shows what we have lost.

This one begins to show why we lost it; why Britain, uniquely in the world, abandoned its own cooking. Certain of the causes that Blythman advances are audacious, apostatical. She claims that the feminist movement of the seventies characterised cooking as a demeaning chore because, quaintly, it was done to please men. She's probably right: feminism was, after all, a middle-class fashion, and here was a generation of middle-class women rueing the lack of cheap skivs their parents had employed.

She's certainly right to rue the seductive, ultimately baleful

influence of the Mediterranean. The problem is that in Britain southern cooking is climatically inapt, sustainable only by imports, culturally deracinated. And it is acceptable only in a, so to speak, eviscerated or bowdlerised form. The urban and suburban British are pathetically squeamish: they will eat anything if it is disguised, preferably as colourful, orthogonal shapes, but they live in fear of unbattered fish, offal and geometrically delinquent vegetables.

Thus the majority of the population happily conspires with successive governments, believing that natural foods are likely to be dangerous – a notion enthusiastically propagated by health and safety agencies whose operatives, likely as not, live on Wotsits and Big Macs. And this majority is equally passive in accepting governmental sycophancy to supermarkets, equally supine about demanding the *dirigisme* which might positively discriminate in favour of small shops and small producers. It is hardly surprising that such thinkers as Tessa Jowell and Richard Caborn quite fail to see the grotesque comedy of junk food producers and corporatist confectioners acting as sports sponsors and exercising their inalienable right to flog their chemicals in schools.

Britain values cheapness over quality. It spends a smaller proportion of its income on food than the inhabitants of any other western European country. It prefers to spend on clothes and cars and gadgets and drink. I'm not sure that a football reporter's unastonishing observation that Wayne Rooney's girlfriend patronises Kwiksave is quite the evidence needed here. And Blythman also lowers her guard when she approves Raymond Blanc's observation that 'In all Latin countries, we drink with food: we hardly ever drink without food. That is an English invention.' Blanc's native town of Besançon is hardly Latin. Only a man who has lived all his adult life in Oxfordshire can sentimentally subscribe to the *bien pensant* idea of the sober south.

Joanna Blythman does not quote Edgar Morin's dictum that 'the

kernel of every culture is gastronomic'. It is, however, peculiarly appropriate to Britain today. Though hardly in the way that Morin intended. (2014)

Right to offend

In a telly film David Bailey made about him in 1971, Cecil Beaton is shown on a train out of Waterloo. As it approaches Woking, he's anxiously on the qui vive for a site that is evidently important to him. It is an Edwardian house converted into a studio and shop by the photographer Sidney Francis. It was against Francis and his parish-pump business that Beaton measured his worth and celebrity. 'There, but for the grace of god, go I,' he sighs, with a faint grin that is not entirely smug. There is, too, an element of nervous relief at never having had to broach the worlds of wedding photography, aldermanic portraiture and local journalism, worlds of standardisation and convention, worlds which occupied the most menial position on his ultra-sensitive register of Taste.

'Taste breaks out all of the rules . . . it must always renew itself,' he wrote a year later. He was, of course, a Taste freak *avant la lettre*. Taste's slippery vagaries preoccupied him. His own Taste was inclined to collage rather than consistency. Steal from Louis-le-Rococo, copy von Klenze at the same moment, and throw in a bit of, say, Mallet-Stevens: that is the way to achieve something strange and satisfyingly worrying. Waspish observations on Taste – mostly other people's, mostly found wanting – fill his diaries. The 'crass Bad Taste' of Elizabeth Taylor ('vulgar') and Richard Burton ('butch and coarse') was an aesthetic offence. But then so was what John Betjeman called 'ghastly Good Taste'.

Yet neither was as distressing as – oh, be prepared to blench – No Taste. No Taste was far beyond offensive. No Taste was a sort of disability that afflicts the majority, the multitudinous flocks of the

misled and easily led. And to avoid it, Beaton's life, self-creation and very core were larded with devices designed to make him stand out from the *vulgo*, to shout that he had Taste. Wittingly or not, he followed Nietzsche: 'Blessed are those who have Taste – even if it is Bad Taste.'

Polonius's sartorial advice to Laertes, 'not expressed in fancy; rich not gaudy', could not have fallen on deafer ears. Evelyn Waugh routinely anointed him with the faintest praise. Noël Coward reproached him for his 'conspicuously exaggerated' clothes and his countless affectations. His friend and neighbour Lady Juliet Duff was precise. He was 'like a very successful Parisian madame who had decided to give it all up, moved to the English countryside, and took all her bordello belongings with her.'

He was exquisite and epicene but not really a dandy. Dandyism is subtler, quieter, essentially narcissistic. Its audience is the one in the mirror. It is manifest in understatement: it has to be sought out. Beaton lived near Salisbury, that's where the train through Woking was taking him. He obstinately neglected to conform to the dull sartorial strictures of that architecturally prodigious but wearyingly churchy and dourly military city.

Beaton was an ambulatory advertisement for himself, for big straw hats, crêpe de Chine shirts, turquoise jabots and rope-soled shoes which fleetingly turned the cathedral close into a chimera of Ibiza. He invited ostracism. Above all he was the incarnation of what the majority of his fellow citizens regarded as Queer Taste, Outsider Taste, Bad Taste. These supposedly aberrant appetites can only exist if there is a strong *doxa* to diverge from, and to oppose. Life-enhancing exhibitionism depends on the drear norms of the day being consensual life-negation, collective moroseness, narrow horizons, risk aversion and puritanical chiding; the day, in Britain, which seems never quite to end.

De gustibus non est disputandum is not a universal prescription. It is

only applicable in a tolerant, non-coercive society. It is not appropriate to a milieu which confuses Taste and morality, morality and moralism, and adheres to the dictates of the Guild of Fishwives, the Guild of Cab Drivers and the Guild of Tabloid 'Writers'. The mob has muscle. Fashions in thought and skirt length, in colour and catchphrase, gadgets and fonts move as mysteriously and as determinedly as starlings' murmurations. The mob doesn't invent them. But once they are established, deviation from them incites the mob's wrath. Practices which are illicit in one decade are deemed admirable in its successor, and vice versa. What was commonplace 150 years ago is now regarded with distaste. Rather, it is meant to be regarded with distaste. But covertly, the people's desires are faultlessly atavistic.

Take Salisbury (again). Following the visits of Putin's architecturally inclined murderers and the demolition of Sergei Skripal's house, the city is getting a £500K makeover from a rebranding agency called Heavenly, which is fluent in management drivel and motivational slogans: it is hardly astonishing that the BBC is among its clients.

This agency should forget about a vibrant new platform of artisanal foam hassocks, digital chapter-house samplers and Trollope goblets. Think instead of Judge Jeffreys. Turn Salisbury into a Bloody Assizes theme park. Reality TV is watched by millions because it is licensed humiliation in the tradition of visiting Bedlam to mock and prod the hapless inmates. The time is apt to go a step further, to allow the baying people to reprise the past, to really take back control. Imagine the city's great market square as a potential arena. Let them have public executions in that vast space. That's the way to put Salisbury back on the map.

The South Holland and the Deepings MP 'Sir' John 'Pierrepoint' Hayes is eager to do his bit. Dashing in his executioner's hood, this noose fundamentalist will come down from the flatlands once a

month with his collection of axes, gibbets and guillotines along with his personal *Einsatzgruppen*. This is true populism. It acknowledges the profundity of human imperfection and the thrill of virtuous delight in witnessing miscreant sheep rustlers and combine-harvester thieves being taught the ultimate lesson.

Now, that recipe should no doubt be calumnised as being in the Worst Possible Taste. But as Beaton offended by his apparel and physical demeanour, so is it for the writer to offend with words. Those improbable bedfellows Kingsley Amis and Joe Orton were united in the conviction that a writer who is not giving offence is a writer not doing his job. Orton wondered too: 'What's all this about writers being sensitive?'

One effect of Western social, sexual and moral Balkanisation is that there exists an ever-growing *galère* of thin-skinned communitarian sensibilities not to be given the immunity they believe they are entitled to, not to be taken at their own estimate, not to be treated with sympathy and sensitivity. Christian denominations appear broad-shouldered enough to accept scorn and jibes. Islam doesn't. It resorts to special pleading, to bullying claims of exceptionalism. It seeks protection not granted to other religionists, hobbyists, delusionists: ought not flat-earthers and jigsaw-puzzlers to get bespoke treatment? They are special, too.

Islam paranoiacally casts itself as a victim suffering persecution by such means as Israel's occupation of Palestine, blithely deemed to be more murderous than Nazi Germany's occupation of France. The more it equates itself with Europe's Jews of the 1930s and 1940s, the more it renders its routine cry of 'Islamophobia' both self-pitying and self-aggrandising. Yet at the same time it denies its responsibility for the resurrection of anti-Semitism throughout the continent.

It may be in Bad Taste to draw attention to its stratagems. However, Good Taste would concede that lapidation, FGM, brainwashing

and clothes as propagandist badges are merely quaint manifestations of a different culture and should be ignored: they do things differently. Sweeping it all under the carpet, pretending it has gone away (whatever 'it' is), convincing oneself that it may not happen while it is happening all around. Good Taste is the Taste of the sand you have buried your head in, certain that you are making yourself invisible.

Writing or making any art in Good Taste is evasive if not entirely dishonest. Good manners may be socially desirable but are otherwise redundant. Were the canons composed of works in Good Taste there would be no place for Ballard, Beethoven, Borowczyk, Bron, Buñuel, Burgess, Burra, Burroughs.

Or for Burges and Butterfield, two architects who were near contemporaries. They were stylistically divergent and mutually unsympathetic. Nonetheless, it is largely due to them and to such farouche artists as S. S. Teulon and F. T. Pilkington that High Victorian architecture – the modern Gothic of approximately 1855–75 – was, until the last quarter of the last century, invariably suffixed with 'monstrosity'. Harsh, hard, mannered, boorish, ugly, distorted, overbearing, contrapuntal, exaggerated, aggressive, perverse, hallucinatory, grotesque . . . The charge list was long and it was already being drawn up even as the Barclay Bruntsfield church, Elvetham Hall and Keble College were being built.

There was no accommodation with the picturesque, with the consolations of prettiness, with terminal Englishness, with Good Taste, which is the repetitious expression of the familiar. Hence the inflated reputation of instantly recognisable classicism and the numbing idealisation of Georgian jerry-building. The presumption that columns, pilasters, rustication and pediments are the *ne plus ultra* of tectonic achievement can only be held by obstinate clots who don't look, who are so fixed in their ways that they might spontaneously petrify. And who fear any lack of decorum.

Squeamishness and mimsy restraint are the enemies of imagination. No art, architecture included, should reassure us. The government's notion that Roger Scruton stirring up 'better design and style . . . knowledge and tradition . . . greater community consent' will beautify Britain is of course a vague promise of bread and circuses for the cowed, bread and circuses in the precise form of Poundbury, a dull prince's dislocated fantasy of facadism and the very apogee of feeble Good Taste.

As an exemplar of Beautiful Britain, it is dismally predictable, as predictable as Scruton's antipathy to 'modernism' – which he seems to believe is a single hegemonic idiom rather than countless strands of invention. This illusory hegemonic idiom has of course crushed the 'vernacular' and the 'traditional'. Which vernacular would that be? The vernacular of thatch and cob or the next valley's stone and pantiles? There are numberless vernaculars. There are numberless traditions: one might facetiously recall some which are ripe for revival: the great tradition of rickets, the traditions of child labour and prostitution, the tradition of transportation, the tradition of back-street abortions, etc.

But let us forget those. What tradition evidently signifies in this quest for Beauty is the Terminal Englishness of, say, Kate Greenaway, beneficent squires, lusty yeomen and the age-old buildings they live in. A fantasy matched, as it happens, by the opposing vision of Lord Rogers of Riverside, whose urbanism belongs to a different past, the recent past. It is softly bossy, idealistic, car-free, mostly practical, perhaps overfunctional, dotted with virtuously non-smoking coffee drinkers at outside tables no matter what the weather, lots of glass and steel. It is otherwise inhabited by people dressed in black with heavy spectacles who look as though they have studied at the Architectural Association. It is more of the same, but far less ludicrous than Scruton's warmed-over Duchy Originals.

Being right-on is an inhibition, no matter how great an architect you might be.

Neither possesses vitality in its countless forms. They both exhibit differing forms of Good Taste that leave a pedagogic after-taste.

They are both inimical to the sheer exhilarating zip and Go! of Bad Taste: Cecil Beaton, of course, zoot suits, Dr Sir Leslie Colin Patterson, Googie drive-ins, the entire *oeuvre* of Martin Rowson and Steve Bell, public readings from Rabelais with enactments, Dick Emery, heavy drinking and knee-tremblers (the two generally exclusive of each other), the Tiger Balm Gardens, 1950s Cadillacs, hobble skirts, bad company, dodgy clubs, dodgy clubs in the afternoon, lions on gateposts, Derek and Clive, funfairs, Marty Feldman, footballers' hairdos, Black Country accents, J. Mayer H., more dodgy clubs, the Rubettes, neon, two-tone anything, floating gin palaces, Springtime for Hitler, Mr Freedom, Chris Morris, Biggins, another coked-up politician nailed down in an S & M dungeon, Yamoussoukro's basilica, Roy Wood, candy floss, Thom Mayne, zoomorphic topiary, royal weddings, leaving the bottom button of a waistcoat fawningly undone, misspelled tattoos, Ernest Trobridge's houses in Kingsbury, hot lunches, Le Jardin des Supplices, Nicky Haslam . . .

There is nothing cool about Bad Taste. If Good Taste occupies the taupe corner then Bad Taste occupies the fluorescent lime green and magenta spotted corner. It wants to be noticed. (2019)

8

First Person

Be Tsar

Jonathan Meades interviews himself about *tvSSFBM EHKL*,
or *suRREAL FILM*

JM: Why get so unnecessarily worked up about the use of 'surreal'
as a synonym of weird?

JM: You don't hear anyone describing behavioural tics or incidents
as symbolist/cubist/vorticist/fauve/expressionist/cobra. Do you?
Surreal is just a vogue word, lazy fancyspeak, current journal-
ese.

JM: Perhaps – but it's no better or worse than rum or odd. Surely
its very popularity and commonness reinforce the point you
endlessly bang on about – that surrealism was more than an art
movement. You can't have it both ways.

JM: Why not? Of course you can. Besides, it's not both ways.
The surrealists and their wretched manifestos frivolously
hijacked the irrational tradition, gave it a name thought up by
Apollinaire, and the adjective from that name has now been
frivolously hijacked by – well, just about everyone who's too
slothful to avoid linguistic degradation. What I'm talking
about is the process of creating clichés.

JM: Linguistic degradation! Are you becoming proscriptive about usage?

JM: Next question!

JM: You can't really believe that the surrealists created nothing but clichés?

JM: Not to start with, no. But it's indisputable that the painters became one-trick ponies, self-parodists who fed almost exclusively on their own work. They each devised a formula and stuck to it. They turned out product. There's that line in *Pnin*: 'Salvador Dalí is Norman Rockwell's twin brother who was kidnapped by Gypsies as a child.' Dalí's every bit as predictable as Rockwell. That's why they're so popular. Compare that to Goya or Picasso who constantly—

JM: Goya? What sort of surrealist was he?

JM: A surrealist *avant la lettre*. That sort. Along with whoever it was that invented Medusa, the Minotaur, the Valkyries, the Annunciation, Christ's miracles, heaven and hell, whoever painted the inside of Albi cathedral. Et cetera. Oh, and Swift, Carroll, Poe, Lequeu, le Facteur Cheval, l'Abbé Fouré, Huysmans, Jules Verne!

JM: Sounds a pretty familiar list. A clichéd list, you might say: the officially sanctioned forebears. It's no doubt because of your keenness to avoid clichés that *tvSSFBM* includes nuns masturbating, I suppose?

JM: What else do you expect nuns to do? It's a very specific allusion: to the nuns with vast wimples in Franju's *Le Sang des Bêtes* and *Judex*.

JM: I thought you said when we were talking before they referred to Diderot?

JM: Ah, yeah. Sure. Him too. *La Religieuse*. Bernini, maybe. And, for that matter, to Borowczyk's *Behind Convent Walls*, oh, and to Lequeu's bare-breasted nuns.

JM: Yours aren't bare-breasted!

JM: Regrettably not. But then one of the subtitles is *Provided It's Valid within the Context of the Script and Done in the Best Possible Taste.*

JM: Pull the other one. You've got balaclava'd terrorists doing a disco invitation to sign up to the INLA; you describe Bobby Sands as a heroic surrealist; Ian Paisley is transformed into a papist; that chalkwork by Martin Rowson is pornographic; there's Christopher Biggins as a quizmaster dressed in SS uniform; there's a man in suspenders with an orange in his mouth. Best possible taste?

JM: In any other medium such things go unnoticed. Even television, throughout the rest of Europe, is perfectly at ease with such stuff. This isn't a matter you can treat by resorting to the British stratagem of sweeping everything under the carpet. That was the problem with surrealism in this country: it was cosmetic, it pulled its punches, it was nothing more than a decorative idiom. Anyway, we did decide not to shoot a scene of two blind men giving each other a hand job. That's the trouble with British telly, it incites self-censorship.

JM: Isn't it old hat, all this *épater les bourgeois* stuff?

JM: Very likely. But it's all too evident from the pronouncements of such eminences as Beverley Hughes and Tessa Jowell that there is still a proportion of the populace whose appetite for moralistic offence is to be whetted. Someone's got to do it. I mean, my appetite for aesthetic offence is daily whetted by just about everything else on television. There's no reason that so supple and versatile a medium has to be 90 per cent moronic.

JM: You're no more Catholic than I am so why this preoccupation with Catholicism or at least faith? It's not just in this film, either.

JM: To be a sentient atheist you've got to have at least toyed with Catholicism. It's the most potent – the Capstan Full Strength of Christianity.

JM: You smoke Marlboro Lights.

JM: For my health! Religion is bunk, I resist it for my health, but the study of religion is scholarship. You don't need to believe a word of it to find it endlessly fascinating: you don't have to suffer delusion in order to scrutinise delusion. Just as the Society of Jesus's hierarchy provided the template for the SS – Hitler called Himmler 'my little Loyola' – so did the Catholic imperative of rendering the figurative concrete and plastic provide a template for the fantastical. Rome has for ever led the way in exteriorising what is interior, in turning private thought into public imagery. Protestantism has failed because it has tried for going on half a millennium to propagate the irrational by rational means. OK?

JM: But it says here that your director, producer and executive producer are all Catholic.

JM: Precisely. That's the magic of it all. There are two of them yet they form a trinity. Then there's me, which makes us quadriplegic. Put what I said another way: you cannot blaspheme unless you fear that you may one day, your last day, be drawn into it. Until then I'll go on inventing my own mysteries rather than borrowing ready-mades. That's why I despise naturalism: it pretends to address what is, rather than what isn't. It abhors speculation.

JM: The valley of the shadow of death is nothing if not a ready-made.

JM: Even though it's Lord Head's property, my valley of the shadow of death belongs to me alone – unless the psalmist knew that particular coomb. Perpignan rail station wasn't Dalí's property, but it belonged to him. Piazza Vittorio Veneto

in Turin belonged to de Chirico. Belongs, rather – present, not preterite.

JM: You could have just said past. What's your favourite bit of the film?

JM: Dunno. Michael Fenton Stevens and Moist Groin? Chloe Billington answering a question on *Valhalla or Bust*? What they put in Scunthorpe? The two Alices, maybe? The corned beef? Buñuel's grin? What was yours?

JM: The end. (2001)

Strippers of joy

Here are two names to conjure with. Laurence Stone and Claire de Clermont-Tonnerre. They are unlikely to be known to more than a few readers of this newspaper. They are surely unknown to each other. One works in London, the other in Paris. But they both exercise power in a manner which would be laughable were it not so pettily censorious. They should, duly, be twinned like towns, so that they can go on fact-finding freebies to each other, to learn from each other, to observe what mores are considered worthy of prohibition in their respective worlds. Isn't that the idea behind town-twinning?

The burghers of Salisbury can pick up hints on the sweet quality of life enjoyed in Saintes, while that sleepy town's worthies can discover how to 'market' a great cathedral: the paramount rule is to suppress any mention of Victorian restoration and to pretend that the West Front is medieval. Chagny, the architectural low spot of Burgundy, can infect the formerly dry garden city of Letchworth with its bacchanalian and gastronomic spirit and receive in return a useful masterclass in the informal planning and cottagey neo-vernacular of a century ago.

My lap-dancing days are over. I'm through with it. Enough is enough. In this country, anyway. I have hung up my thong. I

understand the distress that this will cause to many loyally spend-thrift gentlemen. But every artiste has to move on to new challenges. Then there is the question of the damage I may be doing to the said gentlemen, who are in danger of developing a costly 'compulsive sex addiction'. The result of which is that they'll have to hand over good money previously destined for my sequined gar-ter to psychiatric clinics offering recovery programmes which claim to wean them off me. Where would such clinics be without the delusion that the human appetites for illicit sex, excessive drink and dangerous narcotics are remediable? Silly question.

The foremost cause of my retirement, however, is the emergence of a caste of punter who merely poses as a gentleman. He enjoys the refined luxury and generous hospitality of our workplace. He benefits from our friendship even though he may not seek what we call full friendship. He is the local-authority licensing inspector. He is luckier than his Bog Squad colleagues, who have to endure the rafters, stench and spyholes of antiquated cottages. But does he show any gratitude? No: he is on a mission to grass.

Laurence Stone is employed by Westminster Council. He pro-vided the evidence which has prompted the prosecution of the club owner Peter Stringfellow, a sexagenarian (of course). It is, alas, too late for Marty Feldman to play Mr Stone in the Stringfellow biopic *Bubbly 'n' Bouffant*. There is no living actor who could do compar-able justice to Mr Stone's lines: 'Twice she squatted between my legs. Each time her buttocks rubbed my thighs. She was groaning in a sexual manner.'

When Mr Stone is twinned with Mme de Clermont-Tonnerre he will learn that Paris adopts a different attitude towards private peccadilloes. It takes the view that sexual morality, like any other morality, is private and consensual, and that while attempts to reg-ulate it may excite the sympathy of fishwives (and fishhusbands, for that matter) they are doomed to failure because they are impractical

as well as impertinent. This is not to say that Paris's officials and elected members want for issues which can be subjected to a scrutiny so small-minded it is almost microscopic.

Mme de Clermont-Tonnerre is a councillor in Paris's 15th arrondissement. She belongs to the UMP, the centre-right party whose boss is the former prime minister, aspirant president and current mayor of Bordeaux, Alain Juppé. That makes her a Jupette, a by no means flattering epithet which takes happy advantage of the proximity of his name to the word for skirt. Juppé's mayoral term will be judged by a very public project, the restoration of Bordeaux's magnificent eighteenth-century waterfront: sure, there is presently traffic chaos, but unlike London's, it is merely temporary.

Mme de Clermont-Tonnerre has, meanwhile, an exciting project of her own. She has observed that a rash of 'false' plaques is being attached to buildings all over Paris. They are, at first glance, indistinguishable from official commemorative plaques – incised marble rather than the blue vitreous enamel used in London. But when you read them, they bear legends such as: 'On 17 April 1967, nothing happened here.' Or 'This plaque was put up on 19 December 1953.' Others commemorate the birth or inhabitancy of non-existent people. They add up to a serial work of circumspect surrealism. It is their quietness and subtlety which are so delightful.

This is not spray-can graffiti, but something cunning. It recalls the rumour that Marcel Duchamp forged works by the eighteenth-century architectural draughtsman and pornographer Jean-Jacques Lequeu, smuggled them into the Bibliothèque Nationale and placed them in the Lequeu collection, leaving only the most ambiguous of clues to the possible fakery. Mme de Clermont-Tonnerre all too evidently comes from a different tradition. 'This is detrimental to genuine commemorative plaques. It belittles those who've truly made their mark on history.'

I wish I'd never suggested that twinning. Its exchange of spoil-sport ideas is bound to mean that no sooner have I put up my plaque than it will be torn down. 'Jonathan Meades lap-danced his last here, 2002' is something you will never read. (2002)

Pleasure principles

Over the past few weeks I've spent many hours in parts of London whose existence I've long been apprised of and fascinated by, but over whose threshold I had never previously had the temerity or excuse to pass. It has been an entirely pleasurable, heartening and salutary experience, this venture into the heart of the de facto ghettos of Turkish London and Kurdish London – the parallel Londons of often monoglot immigrants who, far from resenting my curiosity, have been endlessly welcoming to me, to my fixers, to my production team, to my camera crew. Arriving mob-handed, invading other people's semi-private space, blinding them with lights, asking them to keep quiet while I drool on . . . middle England has seldom, if ever, reacted with such patient grace.

Nor with such hospitality. I don't believe that the generosity we enjoyed has anything to do with us being the people from the telly who'll put them on the screen for a few seconds: there is no thought of a quid for a quo. There is merely an astonished bemusement that their hermetic, expatriate, linguistically exclusive milieu should warrant such intrusion – and a culturally etched obligation to make self-invited guests wholly welcome. This attractive trait will be familiar to anyone who has hung out in the Maghreb and near-Middle East. But it may seem surprising to anyone who has observed Stoke Newington and Green Lanes from the outside, or who knows of these places through the mediation of national newspapers and telly – which by definition report the exceptional and

the aberrant (Bernard Levin once observed that if you want to know what life in Britain is like you should read only local newspapers).

Sure, there have been battles between tribally based drug gangs tooled up with light arms. Yes, there are shops which offer, along with wedding services, the provision of circumcision, a cruel ritual maiming inflicted on boy children for no reason other than that of institutionalised superstition. Admittedly, there is a colonial architecture of minarets and decorative tiles peopled by women who are forbidden to show their faces to the world – a further superstition. And Finsbury Park mosque with its diet of intolerance for the susceptible is not far away.

But the heartening quality about the people I met is that, although they might claim to be Muslim and might unthinkingly write thus on a census form, they are behaviourally occidentalised even if their grasp of the host language and its figurative constructions is frail – for example, 'a tap on the shoulder' for 'a pat on the back'. Their observance of their supposed faith's dumb proscriptions is far from wholehearted. All these men, and more women than one might expect or hope for, who pass their days playing ten-card rummy, backgammon and pool in rooms with a telly that is forever showing highlights of Galatasaray versus Besiktas, eat during Ramadan's daylight hours and drink alcohol with abandon. They do not adhere to ancient myths forged in the desert. They are city people who are secularised by cities' trade and by cities' self-evident gift to the world, civility. A civility which, nonetheless, has its limits: witness, for instance, the Beiruti despisal of Gulf Arabs as bumpkins who've won the lottery.

It is round about this time of year that religion, inevitably and tiresomely, raises its pin-brained head. Quite why the vicious balms of a millennium ago should retain any appeal after all the crimes committed in their name, and after the Renaissance and after the Enlightenment, is a banal mystery, easily solved. Quite why this or

any other newspaper should report on its front page the cultist 'thoughts' of Archbishop Freakybeard rather than those of, say, the Pope of Atheism, Keith Porteous Wood, or Harold Pinter, is another soluble mystery. Who should we go to for an answer: why not George 'Lord' Robertson, the quondam minister of defence and current secretary general of Nato, who had the impudence to suggest that Pinter should 'stick to writing plays'. What does this mediocrity think plays are about?

One of Blair's many declarations of his crassness was his boast that he had nothing to learn from Martin Amis. The point is that the acknowledged legislators of mankind despise the unacknowledged because the latter are the ones who live on: we all know *A Handful of Dust*, but no one gives a toss about the prime minister of the moment (Baldwin?). Official Britain, the people with posts, can't get the hang of the fact that what makes this (and most other) countries what they are is the non-official, non-governmental. It is the everyday life of material secularism.

I used to be unwillingly taken to Christmas carols in Salisbury cathedral. It always was cold in that shrine to austerity. The Anglican chants are drear: there is no joy in the ecclesiastical attempt at doo-wop. There was once an occasion, age fifteen, when one of my French exchange *mecs* made eye contact across the dismal nave with a girl he had picked up the previous summer and who stood rammed between her Protestant parents. I would never dream of taking my children to such a place.

We'll do what we always do. I will have obtained, during the autumn, several hallucinogenic heads of the mushroom *Amanita muscaria*. I have dried them and powdered them. We make cocktails of them. We get out of our heads. We acknowledge that Christmas is happily coincidental with Solstice, that it's Christianity's theft of the longest night. And that's about it.

Apart, that is, from former glam rocker Roy Wood: he comes round every year, Brum's pagan love-Santa, the pantomimic beast who just does for baby Jesus. (2002)

Loitering with Mr Blobby

For part of every year since the mid-1980s I have desk-swapped. I get the worst of the deal. My desk — its top is sealed, rusted steel, its legs are reinforcing rods — is an 8 ft x 3 ft brute wrought long ago by the metalworker Tim Sherward. It is, of course, a slum. But it's my slum. These are the shades of my coffee cups, my wine glasses, my cigarettes. That ream of perpetually pending papers is my ream. The desiccated fibre-tips are my desiccated fibre-tips.

I swap my desk for an ad hoc office-cum-green room on the back seat of a hire car or, if luck is with me, in a coach or Transit. Luck, in this context, is evidently relative. The sort of telly I make might have been conceived to convince licence-payers that their money is not being misspent: you know, treats the audience as sentient humans, demands a certain concentration, that sort of thing. What it convinces the crew and participants of is the BBC's screwed-up sense of financial priorities: millions ploughed into channels no one can receive and into 'presentation'; millions dispensed on the salaries of 'cost-cutting' apparatchiks; thousands wasted on parties, each embossed leather invitation to a nightmarish melee in a car showroom last winter cost £20.

But its parsimony towards its menials — i.e. anyone who makes programmes — is not without its advantages for these unfortunates, at least for this unfortunate. To use its own all-too-imitable jargon: the BBC factors in a substantive silver-lining option. The spirit of the bivouac, enforced subsistence and obligatory discomfort do, however, prompt a certain camaraderie that might be dissipated by the provision of location catering, Winnebago trailers and

acceptable accommodation. On the other hand, it might not. We shall never know. Such luxuries might also discourage me from street corners, and that would never do. As it is, I grow weary of reading the papers, gaping vacuously at bridge problems, button-punching the radio. The sheer ennui of filming is worsened by the physical circumstances in which one is forced to kill time while the lights are rigged, the track is laid and the sun disappears. One might as well simply loiter.

Loitering doesn't have much of a reputation in this country. It unquestionably connotes idleness. It is practised by shirkers. Worse, it is so often suffixed by 'with intent' that it might be reckoned an explicitly criminal activity. I contend that no self-respecting loiterer possesses any intent whatsoever: loitering's very essence resides in its passivity. A similar pejorative etiquette attaches in this country to *le flâneur*, which merely means an ambler, a stroller: it does not originally suggest loucheness. But to walk slowly and to stand around are profoundly un-British qualities. Our cities are full of people hurrying. Their narrow pavements are not made for promenades at snail's pace: they are for getting from A to B rather than civic recreation. Walking for its own sake may be further discouraged by the climate and, equally, by the work 'ethic'.

This week I put in several hours' sterling loitering interspersed with energy-saving bouts of *farniente* supinity. Observant sloth is its own reward. Just hanging around and seeing what happens. Ambling for any distance is, regrettably, out of the question: there are lines to be recited, and time taken searching for the absent writer is money. But an ambit of even fifty metres offers such richness to a desk jockey out on day release, demob happy and going one-to-one with the Real People who inhabit the foreign country called Middle England.

I guess there is a smug satisfaction to be had in observing that RP sometimes behave as predictably as one wishes them to. In the

streets around Arsenal's stadium on a non-match day, countless club shirts were being worn. Why? I wondered, out loud. Because, came the reply, there would be trouble if they wore Spurs shirts. Is there not a third way: no football shirt at all? We had hired actors to do little but munch burgers in the street to demonstrate the unastonishing observation that that is where the British eat. We need not, perhaps, have bothered. In Margate every other RP eats in the street. Loiter outside Dreamland and you are assailed by the stench of fast food and the gleam of masticating teeth, by distended cheeks and taut mauve tongues fellating ice creams. Indeed, my initial response to Margate (though in fairness, which has no place here, it could have been any Kiss Me Kwik resort) was to speculate how many calls per day the town's Samaritans receive in high season.

Time, in the form of a few minutes spent lounging about doing nothing in particular, is, however, a healer. The confounding of expectations is tonic. Here came a sprightly twelve-year-old with his mates, all eating chips of course, throwing them at each other. One landed on him. Quick as you can say Jack Robinson, he brushed it from himself with the spontaneous delight of someone seizing the punning moment and cried: I had a chip on my shoulder. He looked about for approbation and received it from a loitering man. Just moments later two octogenarian dames sped past racing each other in their electric buggies, grinning for all the world as they retreated into the lowering sun and second childhood. To witness their innocent fun was, well, restorative. So was a child beside the roller coaster inside Dreamland who asked me – I was wearing a dark suit – if I was 'the' security guard. This was a marked improvement on the question a near contemporary of hers asked me, loitering on Sheppey five years ago: 'Are you that Mr Blobby?' I am even able to overlook this mite's persuasion that, in her straitened world, suit equals bouncer. (2002)

Speak, memory

On *The Fowler Family Business*

I am not a superstitious person: god, how rational I am. My right hand is Diderot's. My left is Crowley's. Twenty-one years ago this March we were doing up a house. On 17 March 1981, we had done about ten days without respite. We got in the Fiat 124 I had in those days and drove to the country. Round along 13.30 we parked up off a C road beside Outwood Common. There's the post mill. Turn your head, my dear. No! You look. Look, at those people. I looked. Those people scared me as people had rarely scared me before. They were a man and a woman, lardy-faced the both, black goggles, black helmets, stiff clothes carved from tarpaulin, an old motorbike and a sidecar, teeth. They stared. No: they gaped right through me. It wasn't exactly creepy. I looked into the man's eyes, so far as I could beyond the goggles. I suspect the matt-black hair which seeped from beneath both their helmets was dyed. They reminded me of a Rip Kirby comic I had bought at Salisbury bus station in 1959, the one with a character called Mrs Malarkey.

We decided to go to Grain. At about 14.00 I had to stop at a roundabout outside Sevenoaks. Something gripped my right thigh, clasped it tight. It was different from cramp. It felt like a machine. It felt like something I had never felt before.

On Grain there are cranes. There are silos heading vertically out of the marshes. There are hulks in the silt. I could gape at this sludgescape all my life, and I do. It has never left me. It's stuck there for ever because when we got home the phone rang and Sally came down the three steps to the kitchen crying and told me my father was dead, had suffered two heart attacks late lunchtime.

I can't count the years it took me to accept the inevitability of his eternal absence. For an unconscionable while my mother's first words on the phone, 'He's gone away,' seemed not a consolatory

euphemism, the first of her many essays in self-solace, but a truth to be taken literally. A month later in the garden that was now hers, not theirs, I stared at a high hedge grown ragged at the top and found myself telling myself that when Daddy comes back he'll get it in trim again.

One drowsy afternoon in the late summer of '84 I saw him on Lewes railway station, standing alone at the end of the platform where the track enters the tunnel. I ran along the platform towards him. And I must have blinked: I lost him in a systole. He was no longer there. He hated travelling by train. In my dreams he is often alone, a widower revisiting his former house; he is reluctant to tell me where exactly he lives now.

The almost thirteen years of my mother's widowhood was undoubtedly the worst time of her life. She threw in the towel the day he died. Having always seemed a decade younger than she was, she aged overnight. It was as though she had determined to become old in order to hasten her death. When I finished writing my novel *Pompey* in the summer of '92 I had already begun a book about a mother and a son, about the former's antipathy to life and her enthusiasm for euthanasia, about the difficulty of fulfilling the obligation (or habit) of filial love when the object of that love does not want to be loved.

In the November of that year the representative of a residential home phoned me to say that my mother was in its care. Astonishingly, she had been admitted earlier in the day after a minor fall. A care home rather than a hospital? Yes. This was on the instruction of her GP, who had, evidently, not consulted me. My mother was certainly in a state of some confusion. Her short-term memory which had been gradually failing for some months had, in the three weeks since I had last seen her, all but vanished. I went to see the GP, to try to get a diagnosis and to remonstrate about his high-handed behaviour which was tantamount to sectioning her. He was

one of those tweedy, desiccated, superior types who thrive in the provinces where 'the professions' are still looked up to. No, he couldn't discuss my mother's condition because I was not the patient. I spoke to my mother's solicitor, whom I rather liked. But he too, of course, belonged to a 'profession' and he closed ranks, telling me that Dr J—— was a sterling chap, a keen huntsman. I hoped that Dr J—— might be thrown from his mount.

I abandoned that all-too-autobiographical book. Which might be taken as an act of cowardice – or of compassion towards myself, that is, for I knew that my senescently insentient mother would never read it. I knew that this was going to be her last illness. And that I was going to bear weekly witness to it.

The gap between her asking the same question grew ever briefer. 'Did you come by train, darling?' 'No, I drove.' 'There was a wonderful mackerel sky! Did you come by train?' I watched her disintegrate. I understood the literality of seeing the life go out of her. A royal flush of aphasias afflicted her: mackerel sky would soon be beyond her, she'd ever more frequently lose her battle for the right word, for her grandchildren's names. Yet in some form of compensation, as though that void was abhorred, the distant past returned, the preterite mutated into a continuous present, the years were concertina'd, the Southampton of the teens and twenties of the twentieth century was brought back to vivid and fluent life.

In one of the last conversations I had with her – no, that she had with herself – she was attempting to settle, as though her life depended on it, the make of car in which my grandfather would drive them to Emery Down in the New Forest where there were penny buns as far as you could see.

After a period in the residential home – now, there is a licence to print money if you have a cold heart – I had moved her back to her house with round-the-clock carers who would regale me with stories she had told them, stories that this inveterate talker had never

told me. Who was Stuart: was he the man with a lounge moustache who was an aspirant Bechet in south-coast jazz bands? Who was it that had taken her to Tetouan in 1934, to Stockholm a year later?

Writing and performing back-to-back telly shows doesn't leave much time for long-haul projects. Or it's a way of putting them off. When I took the book up again, she had been dead for more than four years and I confirmed to myself that her death – or my loss – had killed that novel: its internal motor's fuel source had run dry. The compulsion to write it had evaporated. I had no appetite for merely going through the motions, of trying to replicate the me who had still had a parent.

An old friend had meanwhile told me a story about the singular arrangement reached between two couples he knew; one had children, the other yearned for a child. Here, so to speak, was a ready-made. On a plate. All – all! – I had to do was to write it. I was, however, not long into it when I sensed that the echoes of that abandoned book and, with them, the ghost of my mother, were infecting it. Now, the notion that characters take over, that they enjoy a life of their own, strikes me as at best an absurd canard, at worst an admission of faux-naïf artlessness. But, equally, it is unde-niable that there are qualities of tone, rhythm, voice, momentum, construction, which naggingly present themselves, which become unbidden preoccupations. One can run with those preoccupations or one can fight them. I elected to fight on the grounds that there was no place within the armature of the book to accommodate the intruders. If I won the fight it was on points.

There is no element of autobiography in the book's incidents, in its topographies, in its protagonist's preoccupation with his trade, and yet there but for the grace of god go I, as Henry Fowler, and there goes my mother, and my father, too, as his parents. Had I not suffered an overwhelming need in my teens to create myself in my own image and to tear myself away in a brutal manner, had my

parents habitually submitted to straitlaced traits, which they suppressed save when faced by my worst excesses, had we entered a compact of familial accord, each knowing his/her place, well, then maybe. That's a lot of ifs, of course.

Fiction is an alternative life. It's what didn't happen, what could have happened, what can be made to happen out of wishfulness, out of, in this instance, fear of what might have been. My titular Fowlers comprise a heavily close family, as numbingly dystopian as it is nuclear. Its horizons are limited, its ambitions are straitened, the London it inhabits is effectively provincial, confined to a few south-east postcodes in which, I convince myself, life is immutable, much the same one generation to the next.

Rather, I convince myself thus for the purpose of this narrative. It is important to believe the elaborate lie you are weaving. I would sooner listen to my imagination and plumb the sump of my back-brain rather than undertake research. Which is not to say that I didn't make an occasional field trip to Honor Oak, Forest Hill and Sydenham. But they were not made in a spirit of observational curiosity; rather, I wished to confirm that those suburbs adhered to the models of them that I had long ago invented, when I took a sort of possession of them.

In a similar way, I wished the tale of Henry Fowler to conform to some tale already told, to chime with something that is in every son's mind in the guise of an elemental fear, with something that is in every father's mind, where it resides as a potential humiliation. There is no more pleasurable act of creative mutation than to establish an apparently impregnable integrity then to gleefully destroy it, piece by piece. Such inversion, such delight in the suffering of one's characters, is surely a symptom of sadistic degeneracy, the adult analogue of picking the wings off insects? I'll go along with that: but I should make it clear that they're my characters, and they do

what I tell them – save when they heed the persuasive whisper of the dead voices within me. (2002)

An education

My mother taught in primary schools for over forty years. It was not her first choice of career. That had been architecture. Which she gave up after two years. It is not disloyal to her shade to say that teaching's gain was not architecture's loss. Her interest in architecture was that of a passionate spectator rather than a maker. It's a trait I share.

Teaching was her vocation. It was something that she really couldn't help but do. It was a necessity. Thus, I was taught – with some degree of formality – long before I went to school. There was no division between the place where I lived and played and the place where I struggled to identify letters, to commit to memory the conjunction of symbol and sound, to understand the marvel of putting together these one-dimensional shapes with their mandatory loops and dots that magically mutated into things one could see: rug, door, chair, cup, sky, bun. Literally familiar things.

Had I been receiving this instruction in a school's classroom I should no doubt have been apprised of a different gamut of objects. It is impossible to gauge the effects of being introduced to pedagogic instruction as opposed to more casual learning in what the rest of the time was the tiny dining room of the tiny cottage my parents rented. I have nothing to measure it against. It obviously seemed normal to learn in this way: I didn't compare notes with my contemporaries in the sandpit or on the swings or at Riverside Walk where the nuns smiled their terrifying thin-lipped smiles.

At that age the cottage, too, seemed normal. It was anything but. It was one of four in a terrace: a thatched terrace. This is a far from normal building type. There may be precedents, there may be

avatars. I have not seen them. Even the self-consciously distended cottage *orné* is a rarity. The vernacular kin of where I lived seem not to exist. Even though there existed thatched walls built of the pounded chalk called pugg in Wiltshire and cob in Dorset and Devon, and there were thatched bus shelters and thatched garages and thatched vans – well, there were two thatched vans.

There is a sound reason for the rarity of the thatched terrace. My mother was accident prone. She drove carelessly rather than recklessly. And then there was her sideline: she was an enthusiastic chip-pan incendiarist. When dry thatch catches fire it burns at an alarming speed. It spreads from the roof of one terraced cottage to the next, leaping and vaulting with blithe abandon, then dodging beneath the surface only to re-emerge some way off like a diver coming up for air.

Watching the flames, I realised that it's a really duff idea to put on a pan of dripping at full heat then go to the pub, even though the pub is only a minute's walk away. And I realised why thatch should only be used for stand-alone structures. I'll go further: I came to loathe thatch. What began as a visceral night demon, the mortal fear that I might be burned in my bed, transformed itself, as I grew increasingly sentient and increasingly preoccupied by buildings, into an aesthetic distaste for this sort of roofing.

We are all used, I believe, to inventing moral reasons to dignify what are merely our quirks of taste: this is an inversion of that process. Thatch is ragged when old, it's damp, decayed – and just about excusable. But when new it's like the sculpted coiffure of a 1970s light entertainer. It is the material of choice of the populist, debased end of the picturesque, a movement which in many guises has had the most deleterious effects on Britain's appearance. Think of the bogusness, of the primacy of the falsely bucolic: I shall return to this.

So – as well as having learned in that cottage I learned from it. Mute lessons certainly, oblique lessons – which we seldom acknowledge

when we suffer them. We don't know that a seed has been planted. Equally, we do know that certain of the seeds we wish to be planted will never flower. But there are consolations.

The serendipitous dogs us if only we will allow it to, if we make ourselves open to chance encounters, if we keep our senses sharpened, if we are susceptible to the unexpected. It is vital to our appropriation of place – by which I mean that heightened appreciation of place which is a sort of possession of place. We do not need deeds and leases to own cities – they are museums without roofs, theatres without walls. This is more easily understood in cities which encourage *flânerie* – idling, dawdling, ambling, staring. Such encouragement is as much physical as cultural. Or, rather, it is physical expression of a culture. British cities tend towards the utilitarian. They are made for a purpose. The creation of wealth. The manufacture of a commodity. The sale of livestock. The exploitation of a particular geology. The propagation of knowledge. The glorification of god.

They are about something other than civil recreation. There is no tradition of *la passeggiata*, no one suggests *allons faire un tour*. For that one needs boulevards, wide pavements, expansive public space, the conviction that the streets are a shared property of the people, and one needs a slower pace than that which is this country's norm. It's at such a pace that we allow ourselves the opportunity to witness the small things, the inexorable oddities, the felicitous elisions and the clumsy disjunctions which, multiplied time and again, form the urban fabric.

Of course this can occur in London, in Manchester – but chance is, so to speak, not given so much of a chance in places which value privacy, efficiency and getting the job done over *la dolce vita* or *la douceur de vivre*: there is, tellingly, no English epithet which is apt. Oh, and if we dawdle to gape, we're liable to be pushed into the street.

The serendipitous is equally vital to the makers of buildings. Those who attempt to recreate the serendipitous are setting about planning the unplannable, they're trying to ape the gods of chance, to deliberately make what only flukery can make. They are trying to achieve by design the illusion of a town or burgh or village or landscape which has grown, to use the cant word, organically over different generations, which is the result of accretion and accident. This has been the cynosure of certain architects – British architects – on and off for several centuries. It is a utopian aspiration which denies that it is utopian. It is a form of vanity which tries to dissemble its vanity. Every few years a British architect discovers Tuscan hill towns – the fact that they don't discover Calabrian or Sicilian hill towns points to conventionalised itineraries. Anyway, they discover them, and resolve to remake Barnsley in their image. Cumbernauld is astonishingly derived from a Tuscan hill town.

The poet David Constantine has these lines: 'What is achieved in Nature, effortlessly and with superabundance, still wants doing by us.' Our self-consciousness inhibits perfection. Instead of 'Nature' he might equally have written our ancestors. 'What is achieved by our forebears, effortlessly and superabundantly, still wants doing by us.' However, merely because it's vanity and is bound to failure, does not mean that we should not try to emulate that accretion of several ages in one go. It's still worth doing. Indeed, I would suggest that the current architectural mainstream essays little other than retrospection. The modernism which we see all around us, the smiling good taste of the Blair Years, is synthetic modernism, modernism-lite – a sort of amalgam of the cosmetic, easy-on-the-eye, less recondite elements of the many and varied schools of European modernism of the earlier twentieth century. But such exercises in retrospection cannot but create environments peculiar to their own epoch: we can turn back the clock all we like, but doing so doesn't enable us to time-travel. And it won't be till these

new places have in turn been amended by the passage of years that they will be capable of inciting the sort of frisson I'm referring to. A frisson which is the product of mood and memory and of a physical actuality defined by what must be called acquired imperfection. Architects make buildings. It is time and happenstance that makes buildings into places.

My earliest education outside the home was at a jerry-built bungalow of, I'd guess, the years immediately after the First World War: it was like those self-built on plotlands by returning soldiers who received grants for smallholdings and market gardens. It was damp and dismal, barely lit, wreathed by river mist. Around it were barren, lichen-poxed plum trees, the rotting remains of an orchard. The window frames were rotting, too. The texture of the flaked paint repulsed me. There was always condensation obfuscating the panes. The biscuit-colour pebbledash render had crumbled in patches to expose bricks and friable mortar the way a dog's diseased pelt shows patches of sore skin. An archery club practised across the road: I was convinced I would be shot like William Rufus who had been killed a few miles away at a picnic site some time before. In the unkempt garden among the plum trees was a pond clogged with leaves. In the pond my fellow pupils found an adder and prodded it with a sodden broom. I drank a jar of murky water in which we had rinsed our watercolour brushes. I was told I was going to die. I was brought home to die in a lavishly half-timbered shooting brake under a green tartan travel rug. It seemed like great luxury in comparison with my father's tiny Morris Eight. This evidently was what happened when you died. I lived.

I moved to another school in a tall, austere late-Georgian house faced in the grimmest stucco. I was incessantly pinched by the girl who sat next to me. I drew countless pictures of arrow victims. The house's semi-basement alarmed me because it hinted at premature burial. I gazed distractedly at the north front of Salisbury cathedral,

which was beyond the cedar of Lebanon beyond the sash window. I feared sash windows: something to do with guillotines. One morning I watched entranced as a helicopter hovered over the spire taking photographs and was told I was a disgrace to my school, my parents and myself for being so shamefully late. Another morning I threw up over my classmates. My tipple of choice had turned from watercolour water to half a pound of melted butter for breakfast.

It was time for another school at which to malinger. This one was in Salisbury's medieval grid. It was a Tudor house. The interior had long ago been coarsely partitioned with wood that was either splintering or slippery. It was a dog's dinner. The exterior was terrific: heftily timber framed, jettied, ebulliently carved, doggedly asymmetrical with patterned brickwork and bereft of right angles. Shockingly, it was demolished in the early seventies when in an act of the greatest corporate vandalism a dual-carriageway was driven through that grid.

My next school occupied what had for 700 years been the bishop's palace. It was again in the shadow of the cathedral. It was a fabulous conglomerate of idioms whose successive begetters had considered need not be in keeping with each other. Our forebears were more confident than we are about adding to and amending old buildings, they were less reverent to the past. Especially when they were bishops. Christopher Wren's Oxford friend and fellow astronomer Seth Ward installed a grandiose staircase. A magnificent Georgian room, a double cube with symmetrically positioned Venetian windows, sat on top of a vaulted thirteenth-century undercroft – a space of such unadornment it might have been the creation of the primitive end of the Arts and Crafts; two eras of late-medieval fortified facade gave way to a third which was Gothick with a terminal k. The grounds were landscaped. A stream had been dammed in the late eighteenth century to form a serpentine lake. It is to the school's – or the dean and chapter's – eternal discredit that it has since drained the lake to provide, of all worthless things, extra playing fields.

Now, the masters at this school behaved in those days according to the time-honoured precepts of Evelyn Waugh. Sometimes an entire term passed when not a single one of them was sacked for attempting – as it was protectively euphemised – to kiss a chorister. I was resentful that none wanted to kiss me. They comprised a fine *galère* – exhibiting war wounds, offering nips from their hipflasks, wearing flashy threadbare jackets. They were the lesson. Their teaching was, let us say, variable: it lurched from the gently inspired to the physically violent, but it must be clear by now I'm of the opinion that such considerations hardly impinge upon education, that education is something that happens fortuitously – nonetheless there are good fortuities and bad fortuities, which is a matter to attend to.

This, like all its predecessors, was a school which had not been built as a school. They had all been sort of squatters in premises commissioned for other purposes and obviously possessing differing architectural qualities and measures of suitability for their subsequent purpose. They were improvised.

The school where my mother taught, whose witch of a headmistress had forbidden me from attending, was built as a school. It was a work of the diocesan architect of the mid-nineteenth century, T. H. Wyatt, who hardly diverged from a model design published a couple of years earlier by William Butterfield, who had established an archetype. It hardly ranks alongside Wyatt's great Romanesque extravagance at Wilton a few miles away: that is a building of national importance. This wasn't. It was a Gothic shed, stone and flint, with steep pitched roofs and pointed arches. It possessed a quality that my schools thus far hadn't: it was, unmistakably, a school – anyone would distinguish it as a school. Just as the church next to it was unmistakably a church: porch, spirelet, exterior expression of liturgical demands and so on. This may not be fitness for purpose – but it is a proclamation of purpose.

At the age of thirteen I found myself in a boarding school that, too, had been built expressly in the 1860s. I would spend four years there. Nothing about the tiny establishment where my mother taught or those that I had attended remotely prepared me for this monstrous mass of red sandstone and sanctity. It retained the ethos of the era of its construction. Chapel every day and twice on Sundays. Obligatory CCF, obligatory games. It was a boot camp for Christian boy soldiers, intended to turn the sons of Somerset *garagistes* and Devon farmers into pious gentlemen, the better to perform on the forecourt, the better to apply for subsidies to rip up hedges. I suffered the rudest shock. It was not merely the punishing schedule of pointless pursuits and the permanently irate masters and the preachiness that I found it so difficult to come to terms with. There was the matter of the building itself.

It was the work of an ecclesiastical hack called C. E. Giles, who was many leagues beneath T. H. Wyatt. This was by far the largest commission he would ever undertake and he was going to make the most of the opportunity. He duly gave his clerical patrons a building that was a programme of deafening indoctrination. Every unlovely corridor was a cloister. Every unlovely room was adorned with an ill-modelled plaster saint. There were friezes of scriptural text. The reek of incense from the chapel – one can, I know, not blame Giles for this – suffused great tracts of the school. The material used in the most formal parts of the interior resembled highly polished brawn. This was the Gothic revival at its most harshly evangelical and most hideously unimaginative.

Of course, once imagination is exhibited in a design, that design may be invested with aesthetic worth or at least with some interest that's not merely propagandist: so it will be susceptible to a reading other than that which is desired. This is apparent in the architectural forms adopted by the twentieth century's tyrannies: they are impervious to interpretation, they abhor ambiguity, they contain

only one meaning. Consider, too, the Mariolatrous kitsch and saintly gewgaws flogged in Catholic shops. Or plastic mosques and Kaabas. Devotion to the laughably named great faiths – that is, the most subscribed to of dangerous superstitions – demands that artless crassness be overlooked. The more oppressive a regime or religion, the more it will incline to gormlessness. The same goes for any seat of learning which fears education and substitutes for it pedagogic brainwashing.

There was a junior education minister on the radio the other day. This chump believed, shockingly, that 'to success' is a transitive verb: a synonym of 'to enable'. She also justified the creation of faith schools on the grounds that we have a long tradition of these aberrations – which is akin to sanctioning bestiality with domestic pets on the grounds that we have been at it for hundreds of years.

It was the justification that was offensive. She was right about the long tradition. The architectural history of schools, colleges, universities is equally a history of disinterested education's capitulation to dogma of one sort or another. The dogma may be denominational – hence, say, the La Salle foundations – it may be theosophical, it may be freethinking like University College London, it may be militaristic or sporty, it may emphasise the primacy of woodcraft or speaking from the diaphragm, it may be vegetarian or pantheistic or survivalist, it may discourage learning for the sake of the fuller being. Perhaps all educational theories aspire to emulate Jesuit practice.

Even if they don't, there is here an unmistakable sectarianism, an exclusivity that will attempt, if it has the means, to express itself architecturally: one again thinks of the Jesuits and Vignola's template for the society's churches across the world. This is what is today called branding. But only the name is new. Steiner schools, also, are logos of themselves.

There isn't an architectural style to attach to every mode of education. But there are quite enough styles to show that, irrespective

of their doctrinal disparities, educators are united by their subscription to architectural determinism. That is, by the conviction that a particular form of environment can determine a particular form of behaviour. It need hardly be said that the effects of architectural determinism are immeasurable. It is a faith rather than the science it has sometimes pretended to be. It may be quite true that bricks can afflict the brain in a programmed fashion – but it's impossible to prove. And, as we know, imperviousness to proof is faith's strength.

Did the early- and High-Victorian application of neo-medieval ecclesiastical forms to educational buildings promote godliness and piety, a capacity for sacrifice and so on? We shouldn't doubt that at the time certain of those who passed through such buildings may have been so enthused – but was that because of the stained glass and tracery? Or was it because of the pressure of the epoch, of what Matthew Arnold called 'the culture', in which inanimate buildings play only a minor role in the ethos? Arnold's father was headmaster of Rugby school: his precepts were 'firstly religious principles; secondly gentlemanly conduct; thirdly intellectual ability'. Dream on: Rugby is world famous as the setting of Thomas Hughes' epic of bullying, abuse and man's inhumanity to children, *Tom Brown's Schooldays*. Still, all that'll have stopped when William Butterfield rebuilt it and gave industrial Warwickshire the chunk of Burgundian monasticism it so needed. Like much of Butterfield's work it is dissonant, tense, awkward, chromatically wild and somehow suggestive of suppressed violence – and this oddness is thrilling. But whether Rugby, or for that matter Butterfield's Keble, actually shaped young minds in the prescribed manner . . . every time you look at Keble Chapel you should remember that this house of god was, like Tyntesfield, paid for by the profits from guano.

The Victorian preoccupation with universal improvement occasioned an educational building boom from the late 1840s till the early 1870s. The architects whose work dominated the earlier

nineteenth century had seldom designed schools because there was rarely call for them to do so. And it was a building type to which little prestige attached. But from the time of the Tractarians, the place of schools et cetera in the hierarchy of building types ascended rapidly. The sheer number of establishments that were founded, expanded or rebuilt is witnessed by any Pevsner. It became a gravy train for architects. Though not necessarily for architects of the first rank. Butterfield was something of an exception. The list of those who did not undertake such commissions, or who undertook only minor ones is telling. In order of date of birth: Lamb, Teulon, Brodrick, Burges, Pilkington.

What a different country this might be had its youth been sub-jected to the tectonic perversities of these artists, who even in their lifetime were reckoned beyond the pale. On the other hand, this country might be just the same. Like I say, the effects cannot be measured. But it's significant that the reforming clerics and philan-thropic grandees who patronised the boom were not willing to take a chance on such gamey eccentrics. For work that is as exciting as they might have made, one has to look to one-offs by lesser-known architects. For instance:

First: W. H. Crossland's Royal Holloway College at Egham, one of the earliest women's university colleges, vast, fantastical, derived from Chambord, Loches, Azay-le-Rideau and countless other Loire châteaux – it belongs to no movement, no school, or rather to the only school that matters, the school of excellence.

Second: Henry Woodyer's St Michael's College near Tenbury Wells. The Gothic revival was at its most engaging, or according to taste, most certifiable in the late 1850s and early 1860s. The acute angles here are sadistically tightened, the oblique angles are soft-ened. Spaces are exaggerated: proportion is awry. And it's all done with gleeful panache.

Third: Stanley Halls School in the south-east London suburb of

South Norwood, designed by the non-architect W. F. Stanley, inventor of the soccer fan's tool of choice, the Stanley knife. It was based on a German *Gewerbeschule* – i.e. a trade school which taught practical skills.

Whether these buildings were or were not successful is quite irrelevant to their weird glamour as buildings: architecture and function tend to get confused – not least by architects and by those who actually use buildings.

The roll call of big-name Victorians who did do this sort of work is impressive, but with the exception of Pugin tiresomely predictable: Street, Scott, Waterhouse – hardly worth the detours. But, nonetheless, it's indisputable that the bigger the names of the architects it employs, and the larger the number of projects it commissions, the healthier, more thriving is an endeavour or industry or trade or preoccupation. And it shows where the money is.

The Victorian boom lasted for less than thirty years. Yet the buildings it produced remain emblematic of scholastic architecture today. Victorian churches are kindred. We have grudgingly to admit it. Why do these buildings hijack our imagination? Why do they define the type? Ubiquity – maybe. Conviction – without doubt. We suffer the illusion that certain types of building belong to a particular era, are at their peak in that era. Cinemas are of the 1930s, cooling towers of the 1950s and 1960s. We are consequently liable to overlook buildings of the same sort which preceded or succeeded them: allotment huts which didn't belong to the golden age of allotment huts, that sort of thing. This taxonomical idleness is evident in middle England's favourite architectural guide, *England's Thousand Best Churches*. It includes only one church designed since the First World War.

I guess that a companion guide – England's Thousand Best Schools, Colleges and Detention Centres – would be similarly omissive. Similarly prejudiced. Similarly wrong-headed. The 1960s, the decade of the greatest volume of educational building in

three-quarters of a century, would be ignored – at best. The architecture of that decade now occupies the same place in the collective psyche that the architecture of the 1860s once did. The most obvious of Aunt Sallies. It used to be Victorian monstrosity. Which did not refer to the late-Georgian hangover of the early part of her reign, nor to the old English and vernacular revivals of the later years. Monstrosities were exclusively High Victorian. Today, any sycophantic politician or pandering columnist can incur favour by uttering the words 1960s monstrosity. The two decades have much else in common. Technophilia, gigantism, brawny toughness, high energy, high seriousness. An impatience with the picturesque, with the pseudo-bucolic, with easy lyricism, with elegance. This was architecture for grown-ups in a country which has preferred architecture made for children: every now and then there has been a brief hiatus, Vanbrugh, for instance. Owen Luder, whose practice – that is to say, Rodney Gordon – built the now-demolished Tricorn Centre in Portsmouth and the endangered Trident Centre in Gateshead, described it with typical coarseness as saying Sod you; that is, Sod you to populism. This was the high point of modernism, the architectural analogue of, say, Alain Robbe-Grillet's fiction.

The idea of accessibility is blissfully absent: all that accessibility means is that everything must be pitched at a level comprehensible to the stupid and the intellectually torpid. Accessibility means that art must follow rather than lead. That it must take familiar consoling routes. This is a sort of betrayal by the clerisy. It's worth noting that the 1960s of lazy retrospective conception – short skirts and sybaritism, pop art and psychedelia – was, broadly, the reaction of one generation against the earnestness of the generation which made the architecture, a generation that had been through the war, which subscribed to the post-war consensus whereby *noblesse oblige* was nationalised, and which cannot have dreamed that its academic

buildings would provide a stage for exhibitions of frivolous mysticism and crass irrationality – the flaws they had fought to rid the world of. One wonders if this was the last generation to believe in the ideals of the Enlightenment.

The new school and university architecture was far from homogeneous. The Smithsons' school at Hunstanton – which was, tellingly, attacked by the *Architectural Review* for being self-referential, architecture about architecture – is a world away from Jim Cadbury-Brown's Royal College of Art. Lasdun's UEA is a work of great originality, Basil Spence's Sussex is so derivative of Le Corbusier that the Switzer could have demanded a cut of the swag. The same people, RMJM, designed York and five years later Stirling: they took note of Picasso's dictum, also apparently Basil Spence's, copy anyone – but never copy yourself.

Nonetheless what was constant – hardly the word in the circumstances – about this endeavour was the belief that architecture must be explorational, experimental, enquiring. It must ask questions about itself and about our relationship to it – rather than provide the same old answers, the same cosy comforts. Its covert programme was then congruent with the most basic, most essential, most etymologically founded definition of the word educate – i.e. to lead forth. To destination unknown. (2005)

XXXXXXXXXL

Fat Land: How Americans Became the Fattest People in the World
by Greg Critser

I have four daughters. Nonetheless, my sperm count is low. I know this from reading the desecratory bulletins which have turned cigarette packets into oblong propaganda. I know, too, that my skin is ageing and that smoke contains benzene, nitrosamines and hydrogen cyanide. I know, further, that . . . Oh, why bother? Why should I do their

work for them? What I want to know is why adults who buy cigarettes are thus instructed, while children who buy burgers are not.

There are certain triggers which cause me to put my instinctive libertarianism on hold. One is Amsterdam, which is a gross-out: pornotopia is an unhappy hell – why can't flying fists just stay at home with the web? A second is junk food, which is to real food what pornography is to sex. I wish José Bové had gone further than merely dump manure outside McDonald's in Millau. I wish that the Great Lewis-Smith had not already (twice) published my recipe for the aberrational turd called 'The Great British Banger': still, here it is again – go to a pub bog, buy a condom (textured to taste), fill it with abattoir slurry, fry in hydrogenated veg oil, enjoy. And enjoy it they do, *les angliches*. I say they, not we, because I belong to that 15 per cent of the population which doesn't buy sliced white bread, never touches fast food, abjures ready meals – blah, snobbishly, blah. My discrimination didn't stop me getting fat, though. Very fat.

After fourteen years of writing about restaurants for *The Times* I had ascended from 13½ stone to 19½ stone. I did in my right knee walking about Buenos Aires: Johnny Argentine cooks a mean steak but can't lay a level pavement. The doctor at the Wellington scrutinised me and said: 'Mr Meades – you are, evidently, not a professional footballer, but you have a professional footballer's injury.' Cruciate ligament. He then did a truly decent thing and admitted that keyhole surgery might well not work. Far better to do physiotherapy and shed weight. Enter Dr Jeffrey Fine, an extraordinary and subtle man who may have changed (and extended) my life, certainly changed my shape: I lost seven stone in a year.

Maybe every former fat bloke has a Jeffrey Fine lurking. Greg Critser has James O. Hill. He is described as 'a vigorous, intellectually engaged fellow with an agile debating style . . .' He has prompted Critser to achieve something that is messianic, very important and technically engaging. *Fat Land* works as a combination of polemic

and reportage. He is a better reporter than he is an essayist – he slips into a kind of preachy chumminess in that later mode. But when he gets on to, say, the advertising stratagems of the 'food' chains or the skin diseases fostered by shit diet (*Acanthosis nigricans*, for instance) he is genially brutal. He is good at facts. There is a description of the obese body which makes one wince: been there, done that.

How pertinent is *Fat Land* to the UK? The lardy dystopia that Critser has identified is knocking at our door. The more that we are in thrall to the USA the more we shall be pervious to its dietetic murderousness. There are all sorts of things that still come out of that country – DeLillo, indie movies, Allen Edmonds shoes – which are engagingly European. And the food in New York (though not in New England) is fairly good. But despite what Manhattan supremacists tell you, it's not as good as London's, let alone Paris's.

The reason for this is the collective palate. Fast food, with its chemical additives and flavour enhancers, has coarsened the tongue of even the very best chefs. They exaggerate flavours because they, and their punters, have been brought up on industrial grot. So there is, too, an aesthetic/gastronomic objection to the USA's colonisation and to its spread of the empire of obesity. It's not just a question of corporeal hygiene but one of taste.

Critser doesn't see it that way. He is preoccupied by Middle America, which eats to live (and kill itself). How much kinder to ourselves it is to be an Old European who lives to eat. (2008)

Au contraire
On Jonathan Meades on France, parts 1–3

Pippa Tregaskis: Would you agree that France is a bit obvious – as a subject. Compared with Cowdenbeath or Hanseatic ports or many of the things you've done before?

JM: It depends how it's done. It depends on which France is shown. Equally what's left out . . . Erm, what I've done is very partial.

PT: In a way you're having your cake and eating it. Don't you think? You're saying: like this is unfamiliar, you won't know about such and such, you've never heard of da-di-da, just how obscure is this . . . The demographic for BBC4 do know, they have heard of. Even the more sort of off-the-map aspects of France are more familiar than the Baltic states. You're just flattering them. Telling them how clever they are, that they are part of the elite that knows . . .

JM: It hadn't occurred . . . I mean the last thing I set out to do is flatter. Or for that matter . . . I don't pitch my stuff according to an imagined audience. An imagined audience's capacity. In any way. If you start taking into account an audience's . . . supposed taste, supposed level of . . . It's not the way I go about it. That focus group, erm, that focus group approach is . . .

PT: Lowest common denominator? That what you were going to say? Tad obvious? No?

JM: It may be obvious. I'd suggest it's true though.

PT: You say. Let's get on to the section at the beginning of each programme where you say what you're not going to deign to include.

JM: Deign?!

PT: Boules, Piaf, check tablecloths, the Dordogne, street markets. Don't you think it's thoroughly condescending not to even devote a moment to what is, for many of us, the essence of France?

JM: No.

PT: Thoroughly contrarian then?

JM (laughs): No, again. The point, in so far as there is a point, is to

show a country that we think we know in a different light. Or rather illumine what is obscured. Nothing particularly condescending or contrarian about that.

PT: Isn't revisionism on the subject of Algerian independence contrarian?

JM: Revisionism! Look, I'm merely declining to follow what the French call *la pensée unique* . . . the consensual wisdom – though quite how consensual . . . the Algerian decolonisation was a catastrophe. It still, erm, resounds . . . half a century later. De Gaulle's behaviour was grotesque. He abandoned over a million French citizens.

PT: Who took the law into their own hands.

JM: Peh! A few. Sure.

PT: You appear to sympathise with them.

JM (shrugs): To a degree, yes. With their plight, certainly. The general indifference to it was . . . the hostility they faced. Imagine the outcry if a million Muslims were told to leave their homes in a European country and get out on pain of death. *La valise ou le cercueil.* Pack your suitcase or end up in a coffin. More likely a mass grave, actually. The *pieds noirs* are like Northern Irish Protestants or Serbs or white Rhodesians . . . victims of liberal bigotry. Routinely portrayed as quasi-fascist. Targets of what Pascal Bruckner calls the racism of the anti-racists. Easy meat for half-witted comedians.

PT: That's not what I was getting at. You appear to sympathise with the OAS. A murderous right-wing terrorist organisation. Whose leaders were executed.

JM: Victors' justice. The methods were reprehensible. Sure. But their position was unexceptionable. They were hardly right wing. More a coalition of nationalists of various political colours. They did have a point – look at Algeria's subsequent history . . .

PT: They had a point! Really? Why drag this up all these years on?

JM: It's not a question of dragging it up. It's never sunk, so to speak.

PT: Does it impact on France today? I think not. You're furtively nostalgic for colonialism.

JM: It's nothing to do with nostalgia. Algeria could have remained a French department. The majority of its citizens, they wanted it to. But de Gaulle treated with the FLN – a minority of extremists. As soon as they came to power, they exacted a terrible revenge on those who hadn't supported them. Unspoken genocide.

PT: That long section about dictators' properties in Paris. It's all played for a laugh, isn't it? Ah ha. It's like you're saying if there were still colonies these greedy black tyrants wouldn't exist.

JM (rolls eyes): They wouldn't. Self-evidently wouldn't. Anyway, what I hope I show is that they were created by France to a large extent. They're France's monsters. They shame France – and its covert colonialism. Which is fertile ground . . . it's an invitation to corruption.

PT: You find corruption everywhere.

JM: Well, not everywhere. What's interesting . . . There's probably no more or less corruption than in England. But the way it's viewed. And what comes out . . . The French see it as an everyday . . . erm, not phenomenon because it's so common, more an everyday occurrence. It's regarded as inevitable. Part of the pattern. Something you live with. Whereas in England, people are constantly taken aback, they're surprised. Even though it goes on all the time. It's . . . there's an expectation of . . . of probity which doesn't exist in France.

PT: So you're saying that the British are idealistic and the French are cynical?

JM: Not cynical. Realistic. Realistic in their expectations. Maybe it's that England is post-Protestant, and France is post-Catholic. Don't know. There are all sort of causes of cultural differences. Despite everything, there is still optimism in England. Rather . . . huge optimism in comparison with France. The entire populace is on anti-depressants. The real, erm . . . the practical difference is that regulation is much tighter in France. There's less leeway. So what in France is adjudged as corrupt is merely free-market business practice in England. The buccaneering spirit and all that. Buccaneers were waterborne thieves.

PT: Your films give no indication why you live in France.

JM: I don't think any of the stuff I've done on England ever gave much indication of why I lived there. (2012)

Desert island objects

Painting: Christian Schad's self-portrait is spellbinding. It is no doubt an unhealthy spell it casts. He was famously (and somewhat damagingly for his later reputation) not reckoned 'degenerate' by the Nazis. Which suggests – no surprise – that whatever *kunst* operative was calling the shots had a risibly literal take on degeneracy. Schad was the greatest painter of the Weimar years, an era of exhilarating mongrelism and inspired impurity, which Peter Cook called 'the heyday of satire . . . look how it stopped Hitler'. Of course, in the footling hierarchy of twentieth-century painting, artists such as Schad, Dix, Grosz, Willink, Koch – northern artists – are also-rans beside the supposedly big beasts of the south, with their splodgy formalism and endless movements and art about art. This bias is absurd. Schad should be acknowledged as one of the supreme masters of his century. His eroticism is icy and perverse. The diaphanous green blouse is among the most disturbing garments

in Western art. The painting is thrillingly passionless. The sex it promises is fetishistic, maybe commercial and makes both parties long for more when the man's body is up to it: these people are linked by genital and oral friction, nothing more. Any connection with the state called love is fortuitous. The woman is a chattel, a thing. Her left cheek is scarred with a *freggio*. It's a sort of brand, to demonstrate that she is a man's property. A pimp's? A painter's? It is claimed (by the Tate, for instance) that this was a Neapolitan fashion, though there is otherwise sparse evidence of it. Schad was a deadpan creator, paintings are fictions, the *freggio* is in all probability his invention. We're on surer ground with the narcissus, which presumably has something to do with self-adoration, though that is hardly a property manifest in the painter's depiction of himself.

Sculpture: The roof of l'Unité d'Habitation is a summation of thousands of years of Mediterranean culture. As someone once said, it's like having Odysseus at your shoulder. As Piers Gough once said, it's an Arts and Crafts building – tweeness excised, of course. As Jim Cadbury-Brown once said, it is hand-made – like a Bristol motor car. Le Corbusier was a virtuoso sculptor with a rough touch which mutates into suavity. Now he is butch, now he is delicate. I first visited l'Unité in the 1980s. A quarter of a century later I moved here. This sublime space, which feels as though it is contiguous with the surrounding mountains, is my concrete garden. I only wish that it was not periodically squatted by banal and boorish installations whose creators fail to respect the place's sinuous majesty.

Photograph: The disjunction between title and subject is huge and comic. *A Day in the Country, Poland* promises – what? Hiking in the Silesian foothills, drinking at a forest tavern built of logs and shingles, a vast outdoors lunch (*pierogi*, *flaki*, beer), strip field

systems, fifty-year-old tractors, horse carts. Ah, horses! Joel-Peter Witkin's extraordinary photograph is zoophiliac, specifically hippophiliac. It shows a masked naked woman holding the erect penis of a white stallion which is supported above her by a scaffold of canvas straps, wires, chains and pulleys. Its rear legs touch the ground, its forelegs are high above her head. In Witkin's world what is habitually and unthinkingly denigrated as degenerate or disgusting is treated with a tenderness that is dreamy rather than nightmarish. He infects bestiality with a farmyard sweetness, with love even. He is on the side of the transgressive, the outcasts, the freaks far beyond the pale. He shows that what the majority might consider abnormal is, to those so touched, the everyday normality which they are trapped in, often willingly trapped in.

Furniture: For the past twenty years I have lived with a sofa and dining chairs by Antonio Citterio (whom I revere), a glass and powder-coated dining table by Alex Goacher, Le Corbusier's Petits Conforts, G-plan chairs by Leslie Dandy, a vast desk made of reused steel and reinforcing rods, outrageously overpriced industrial shelving. The only exceptions to modernist orthodoxy are a limed oak table, a limed oak roll-top desk and a further desk from Rinck, even more outrageously overpriced as befits Louis the Decorator's finest craftsmanship. Time for a change. Time to get, say, folksy. I detest folk art, folk music, folk dance – all telling the same institutionalised, self-pitying lie about oppression, all gormlessly utopian, all sentimentally humanistic. But then there are always exceptions. There is the work of Ilmari Tapiovaara. His Pirkka table – an evident precursor of Citterio's Spoon table – is, along with its matching benches, chairs and stools a work of near-cyclopean primitivism, the primitivism of the sophisticated and artful master with the lightest of touches. The best examples are stained chocolate and black. They are not contaminated by colours which belong to the grim spectrum

marked 'natural'. There can be no better table at which to eat *gravad* salmon or cured salmon or kippered salmon – staples of what Jacques Chirac ignorantly called the worst kitchen in Europe.

Engineering structure: There can be no better table at which to eat motorway service station food than one of those at Michel Bras' Aire du Viaduc. The viaduct in question is across the Tarn gorge west of Millau. It links the Causse du Larzac to the Causse Noir. The engineer was Michel Virlogeux, the architects were Foster Associates, whose supreme achievement it is – apart from their several other supreme achievements. The sheer elegance of the great bridge is breathtaking. It is not merely a consummate feat of problem solving and of extent. Highest, yes. Longest, yes. What distinguishes it is its capacity to move, to speak to that combination of brain and spine which only the greatest structures achieve. The frigid technophiles from Battersea touch on sublimity. And Bras' team deliver the best motorway snacks in the world.

Ceramics: The writer and journalist Rachel Cooke looked at my modest collection of Vallauris nightlights with shocked incredulity: 'What are they? They are hideous.' They are kitsch. Specifically, they belong to the highest – maybe that should be lowest – stratum of marine kitsch. Fishes, amphorae, conches reworked by a fairground surrealist with a taste for the briney. I justify my delight in them with the old saw that there is nothing wrong with bad taste; it is no taste – beige insipidity and mimsy coyness – which is reprehensible. (2014)

The old man's comforts and how he gained them
Address at the Assembly Rooms in Edinburgh

The most recent film I made was on the sculptural neo-expressionistic architecture of the late fifties, sixties and early seventies,

known as brutalism. This film has had bizarre and unintended consequences.

Forty years ago, two fine comic actors, both now dead, John Fortune and John Wells, collaborated on a novel called *A Melon for Ecstasy*. The title comes from a Turkish proverb: 'A woman for duty, a boy for pleasure, a melon for ecstasy.' The protagonist of this squib was a dendrophile: dendrophilia is the condition of being sexually aroused by trees. This party, who happily lives in the New Forest, seeks a consummation that is several steps beyond tree hugging. It raises questions today which it didn't when the book was published: Can trees consent? Does an oak have rights? And if so, do they match a wellingtonia's?

Now, in the last few months, a research team at Cold Spring Harbour Laboratory on Long Island – the base during the 1920s and 1930s of the Eugenics Record Office – has identified a strange pathology which is akin to dendrophilia. It has been named brutophilia. Sufferers are sexually attracted to concrete. Not just the material but the very word. They are also keen to count me among their number. Since the film was transmitted, groups of brutophiles – entirely indistinguishable from people who are devotees of, say, steam trains or chocolate or rubber – have come to every talk and lecture that I've given. So can I ask you all to be on the qui vive and pay attention to your neighbours. Should you notice that he or she is sporting lacerations occasioned by brutophiliac acts or becomes uncontrollably excited at the mention of concrete – concrete! – please let the front-of-house staff know and they will provide the sufferer with man-size tissues and treble-strength wipes. There is an ample supply of them.

It was proposed that this event should be billed as 'intimate': 'An intimate encounter with . . .' That sort of thing. I knocked it on the head; intimacy in such a context is a lie. I don't do cosy. It recalled two instances of false intimacy.

The first was a telly advertisement of the seventies which was reprised in the nineties. A small-town Sacha Distel (who thinks he's a small-town Alain Delon) attempts to seduce an archly smiling English slapper by repeating 'Cointreau, Cointreau' (which I had thitherto reckoned to be an excellent flavouring for soufflés). This was someone's idea of sophistication. You could wince, you could cringe, you could watch it through your fingers shielding your eyes.

The second instance was this. He is lonely, old, pasty, grey. He has lost his looks and doesn't know where to find them. He lives alone in a house of grime. All lino and stalactites of cooking grease. Then, she comes into his life. She's a dish – curvy, glamorous, willing. And she loves housework, just loves it. The moving tale of their romance was recorded in a *BMJ* article by Dr N. D. Citron called 'Penile Injuries from Vacuum Cleaners'.

That piece was gleefully brought to my attention by the late Jeffrey Bernard, possibly the only man in Britain to have made a living out of being perpetually pissed. Jeff attempted to turn every day into a party. His fiftieth was remarkable. There was little to drink save cases of neat vodka. One's elders and betters were misbehaving. Jo Grimond slid down a wall; Elizabeth Smart was passed out on the floor. Graham Mason fell over and was kicked in the head by Jeff, who announced that 'I . . . I don't want drunks at my party.' Enoch Powell arrived, took one look and scampered off.

Among Jeff's dicta were these. Never more than three hours early for a party. Never more than three months late with copy.

I like to think that Jeff's shade is smiling approvingly and that he's running his tongue round the inside of his mouth hoping to find some loose change like someone frisking a sofa between the cushions. He would delight in my tardiness. I was more than three months late with delivering *An Encyclopaedia of Myself*. Much more. More than three years. I was actually seventeen years late, as my

long-suffering publisher Nicholas Pearson frequently likes to remind me.

When he commissioned the book, I was middle-aged. I began writing it; I made my usual list. In this case of people, places, things, pets, recollections, antagonisms, friendships, bogus majors, drunken majors, psychopathic majors, spinsters and horizontals, numerous incidents, prepubescent sexual experiences and one post-pubertal experience – and pretty soon abandoned it. It took me some while to figure why I couldn't write it or, rather, why I couldn't write what I wanted to read. You are, after all, your first reader. But at the same time, you write to an extent to find out what you're thinking, not the other way round. I mean, you don't think, work it out, plan it then write as if filling in the colours in a writing-by-numbers way. It is essential to surprise oneself. You do not – or ought not – to know where you're going, and if you do know you should at least not know how you're going to get there.

When you are young the world is an open labyrinth, a labyrinth without walls, and there's no Ariadne with a clew. You don't even realise that it's a labyrinth, as you negotiate it in a state of almost perpetual bemusement. You don't even know the word labyrinth and not knowing what the word was for this or that thing was the cause of galling frustration – to me, and to the adults whom I nagged wanting to be told and who dissembled their ignorance by telling me not to be so bothersome. But until I knew the word I could not make sense of the thing the word signified. Things remained mute. This lexical pathology was probably proto-literary, it certainly belonged to that cast of mind. It marked me as someone who would never have the essential gift of three-dimensional intuition required by an architect or a sculptor: a gift that has nothing to do with literary intelligence – which is no doubt why the more outstanding the architect, the greater the catastrophe that will occur

when he or she attempts to write. Judging by the house he designed for himself, Thomas Hardy made the correct career decision.

I further antagonised my seniors by demanding explanations of, well, everything. Not just the words for whatever I saw. The words might come first:

Rye House. When was Rye House?

Elsan. So that's what an 'Elsan' is. Why doesn't Uncle Wangle's caravan have its own Elsan?

Bolters. Who is a 'bolter'? Is Henry dead because Honor is a bolter?

Alice. How can she be in Wonderland if she's buried in a New Forest churchyard?

Princes in the Tower. Who murdered them?

Why don't flying boats sink when they land. Jonathan: they don't land.

Uncle Eric dimmed another cig. Are Kensitas better than Players?

Why are there only men and women, boys and girls? What about Gypsies?

Why isn't Auntie Kittie married?

Where are the rheostats? Where are the transformers?

What are tart shoes?

How is a double declutch?

Does Aunt Doll drink anything apart from Mackeson stout?

I learned the answer to that at a tender age. Yes, she also drank Marsala, port and British cream sherry. 'Oh go on. Fill it just to the brim would you, Jonathan, my tresshure. I like to see a hearty meniscus on moine.'

Is it the bears or Boney that get you if you step on the cracks between the paving stones? Or both?

How can the Wild West be in America if America is where Chevrolet cars with fins and square Hamilton watches and hooded-nib Sheaffer pens come from?

What's the difference between a nice piece of homework and a popsy?

Why do long engagements play havoc with the urethral tract?

Are trees pollarded as a punishment – like robbers whose hands are cut off?

Why do the ladies in the dry-cleaner shop giggle so much?

Do women go on heat like dogs?

Did Jesus have a navel?

If Jesus could rise from the dead he could have taken revenge – on Pilate, Judas's family, the mockers, the bullying soldiers. Why didn't he?

This sort of question made adults wince: 'The little know-all is at it again.' But of course I wasn't a know-all – yet. I wanted to be one, which is why I was incessantly interrogative. As an adult I can answer my former self with this explanation: that Jesus was like the Sicilian who, when exhumed after 2,000 years, said, 'Why did you wake me – I'm still planning my revenge.'

Why is god such a nasty old man?

This was rather better put by the immunologist and Nobel laureate Peter Medawar, who managed to endure an English public school and Oxford education without ever having read the Bible. In his late twenties he found himself in an American hotel without a book. He sent a postcard to his wife. 'Am reading the Old Testament . . . My dear, the people!'

Did god forgot to take his medication the week he made the world?

Why do churches smell of old women?

Is suicide wicked?

Where is Huntingtower?

Why is Milady de Winter so evil?

The capability of distinguishing between the factual and fictional, let alone the multitude of layers between those states, escaped me.

Why do hotels misspell menus in a French so illiterate that even a schoolboy can detect its deficiencies?

What had the wan girls who lived as near prisoners in the grim St Michael's Home School done that earned them the epithet 'bad'?

And so on – a long litany of what, why, how, when. Now, in middle age, the age, as I say, that I was when I signed to do some sort of memoir or autobiography – not yet called an encyclopaedia – at that age you suffer the delusion that you are on top of things. You know the words for many things. You reckon that you've more or less got it taped. You belong to the generation that has the power, even if it exercises it crassly, the generation that determines the cultural complexion of the state, whose mores are the norm, whose beliefs, beliefs once reckoned outré or wishful, become statutorily enforceable. All the deeply cherished notions and practices of your pushiest coevals become governmental policy: the reckless invasion of distant countries whose rulers we demonise, the banning of fox hunting, the pursuit of relativism, the mandatory use of jargon and euphemism, the elite's pretence that it is not the elite and is anti-elitist, the ascent of priggish authoritarianism, the fascism of anti-fascists, the rise and rise of mendacious PR, the false familiarity of addressing everyone by their given name, risk aversion, the employment of slaves called interns, the timid appeasement of hostile minorities. If all that sounds like an evasive description of smugness: bang on, that's what it is. You are, without realising it, of the establishment whether you like it or not.

Middle age is, further, a state that is inimical to empathy, to recapturing the uncertainties and bewilderment and confusion of childhood and, above all, trying to sense through the brain and eyes (and nose and tongue) of the child you once were. In middle age I was not good casting as the former me. I wasn't right for the part. The book I wanted to write – the book I wanted to read – demanded a degree of ventriloquy. And at that juncture I could

only conjure my former self from the outside: the first person of the book would have been an invention and invention was a mode that I had resolved to shun. Which left me sort of stranded. I couldn't find the key that would unlock the gate to the precocious burden I once had been. Maybe it was more a question that I was unwilling to find that key.

The problem was: I did give a damn. I did care what people thought. I worried about what the living would think. I worried about what the friends and families of the dead would think. I worried about what my daughters would think even though they were perfectly acquainted with my fictional work and the self-revelation and obsessions it contained: I once said to Holly the eldest, when we were talking about sexual proclivities, that I could understand most things but the impulse to commit incest was quite beyond my comprehension. She replied: 'Well, that's just as well, isn't it, Dad.' She and her sisters have my measure.

But this book was not going to be fiction. Fiction is one sort of lie. Supposedly the lie that tells the truth, though that pat generalisation fails to mark the gulf between the fiction of say E. L. James and Henry James – who was seldom to be found chained in a dungeon wearing head-to-toe latex. The lies in the book I was not going to write were of a different sort, a different tenor; they would not be witting. But, rather, the unavoidable accidents of memory, some slight, some of them multiple pile-ups.

I worked hard to discover countless ways of disqualifying myself for this particular task. My capacities as a shirker were, I realised, boundless. And so it went on for more than a decade. Then, well, you can no doubt guess where I'm going. Then I started to receive intimations that I was no longer quite so middle-aged as I reckoned myself to be. Hair was being removed from the top of my head and rehomed in my ears and nostrils. These intimations were about as welcome as brown envelopes – which, incidentally, was what Jeff

Bernard always thought of to stop himself coming too quickly. My solution used to be to picture Princess Anne but I've moved on – I find Nicola Sturgeon does the job nicely.

The realisation that I was closing in on death was hardly a surprise. There have been few days throughout my life where I have not thought about death: it was a preoccupation from childhood. What fascinated me, what I endlessly demanded to know, was what happens when we die. It was the shift in physical states that was so scarily gripping.

This had nothing to do with the frivolous sideshow of religion which, despite going to a cathedral choir school, did not then touch me – save as a source of killing boredom. (My extended family had multiple faults but none of them ever set foot in a church.) The four last things are balls. The annunciation – god's projectile ejaculation – is balls. OK, an emptied scrotum. The ascension, the feeding of the 5,000, the book of Genesis, the apple in the garden, that wretched snake, the freakish supernaturalism, the cannibalism of the Eucharist, the parting of the sea, the fifth horseman of the apocalypse, the one who developed osteo-inertia and couldn't be bothered to keep up so got written out of the preposterous tale – it's all balls. But then a religion without mumbo jumbo is like a dominatrix without a whip. The practice of worshipping a hackneyed fantasy which has no existence save in the minds of people of faith (those who require no proof) is degrading, it diminishes humankind, it diminishes our achievements in science, in philosophy, in art – to understand and explain the world. Religion, all religions are so lazy: they think – hardly the word – for you. Imams, nuns (the candle-loving brides of Christ), priests (also the brides of Christ but with a Vatican-sanctioned kiddy-fiddling app), ayatollahs, mullahs, scholars – scholars! – these are people who lack the paramount ability of our race, the ability to self-invent. That is what the marauders at the gates – in Calais and beneath the Channel and no doubt tunnelling

into this very building as I speak — are striving for: the chance to renew themselves, even if that means working for a gangmaster in a potato field in Lincolnshire. Though of course they may have no greater ambition than to join a minoritarian tribe that loathes the host country.

I believe in what I see. The doctrinaire see what they believe in. The hardening of my antipathy to religion, my anger at its special pleading, the insolent presumption that those who have faith are morally superior to those who are not so diseased — this animus was forceful; it was an exaggeration of my previously passive derision. It was, I realised, a symptom of being old. And cussed. One symptom.

I clearly wasn't taking the mellow route — how I hate that word — all soft rock, and goofy dopers with bad hair and Fry boots. Far from it: I felt the brakes were off. It occurred to me that I didn't give a toss what anyone thought. I could become a monster of severity, abrasion, mordant laughter and mocking asperity.

It further occurred to me — were I a person of faith I'd say it was revealed to me — that the jabbering, slobbering, ranting face of Pampers that I had become could empathise with the child I once was. This empathy was conditional on my constant astonishment at the world around me. Without my noticing, everything had changed. Just as in infancy the world had to be learned, now it had to be relearned. I'm not talking just about digitalisation, anti-social media, sit on my Facebook and so on. Rather, about fundamental changes in mores, in behavioural patterns, social attitudes, which are only seldom occasioned by the ubiquity of the virtual. And the more I looked around me at what I had hardly bothered to notice, what I had torpidly taken for granted, the stranger it seemed and my childhood seemed even further distant. Yet, this polarity, this startling contrast with the present, brought the past into focus with an acuity I could not have dreamed of. Scales had been lifted.

Having put off the composition of the book for fifteen years I sat down and wrote it in as many months.

On New Year's Eve a few years ago, I went to get a haircut in what may have been Lyndhurst's premier salon. The hairdresser, a young woman, was going to a party at a Southampton nightclub. Not that she really wanted to but that was what her two best friends were doing. They would all take a bus to the Hythe Ferry and then go across the estuary to the big city. The problem was getting back. The ferry stops at 11 p.m. A taxi from Southampton to Lyndhurst on New Year's Eve would cost £100. More than £30 each. She was so preoccupied by this dilemma, not wanting to let her friends down and so on that she failed to notice the damage she was inflicting to my hair: an acquaintance would remark a couple of days later that I looked as though I was just out of chokey. Nonetheless, I gave her a generous tip and wished her a happy new year. As I put on my coat she said wistfully: 'It must be great being so old that you don't have to go to clubs.'

The club she was going to was Celebration Plaza, formerly owned by Matt Le Tissier, who, when called on as a witness to an assault in the club, prefaced his testimony with the words: 'Your honour – you must realise that I had drunk at least thirteen Malibus . . .' He belonged to the last generation of footballers I understood.

Now, once a week, a bespoke cast of gladiatorial yobgods and wag-roasting Croesus kids descend in tattooed Lamborghinis from their Parnassian blingsteads to run around for ninety minutes of bravura vanity. When they score, they no longer cuddle but commit 'celebrations', massively orchestrated displays of appreciative self-love and pathetic braggadocio – which are of course euphemistic. Why don't they just masturbate? And when they walk onto the pitch – 'the park' – they are hand-in-hand with small children. Why? And have any of these children ever been seen again? If so, where?

How did we arrive at this state of affairs? At least when I was a

child I had a plentiful supply of adults to bother with my questions. To whom ought I to address my enquiries?

Given that every adult, myself apart, has been abused as a child and has duly turned into an abuser, it is surely risky to subject children to this faintly sinister ritual? Isn't it?

And how can I find out why every football manager has a philosophy? And every chef, too, and reality TV thinker, and all comedians – who we know are hilarious because they laugh so relentlessly at their gags before they tell them. And where do they get their philosophy from? Can you order a philosophy online?

The former midfield legend Wayne Clent, back now as ambassador for Tamworth City after suffering a perforated duodenum in the semi-final of the West Midlands Vindaloo Trophy Challenge, said that his recuperation was aided by having a 'philosophy'.

Dr Johnson instructs us that we should give to beggars because if we don't give to them they will not have the means to continue in their profession – which is begging. I was at the fancier end of Westbourne Grove when I saw a youngish man who was not so much etiolated as ghostly slumped in a shop doorway in rags smoking a roll-up with his styrofoam begging cup beside him. I dutifully lobbed a pound coin in the cup and was about to walk on fortified by an aura of self-satisfaction. I had hardly gone a pace when the young man yelled, 'What the fuck do you think you're doing?'

In that instant I saw that what I had done was to ruin his skinny latte, and not just his skinny latte but his mid-morning chill-out. I had failed to read the sartorial signals: pre-shredded, pre-masticated, pre-digested Gucci jeans (£875), retro Converse All Stars with integral vintage tinea pedis (£250), hair by trained rodent at Nicky Clarke (£300). Grunge? Neo-grunge? Neo-neo-grunge? Urban crusty?

Having had B-all interest in youth tribes when I was a youth I have signally failed to keep up with the tribes that my juniors form.

And just about everyone is my junior. And living in France – or rather Marseille, which is to France what Liverpool is to England – I can rejoice in my indifference towards not merely British popular culture and its denizens but towards France's, too. I feel doubly blessed in my deep-bed ignorance: it's closer to clunch than to chalk.

The geriatric's bemusement at the world differs from the child's. The child seeks the answers, as a matter of urgency. The geriatric has no problem about reconciling himself to his incuriosity. I'm resigned to being likely never to visit a petting zoo or, though it promises to be more outré, a heavy-petting zoo. I wasn't particularly put out let alone embarrassed to discover recently that a video game I had never seen – I haven't played a video game in my life – was actually a telly series I have never seen called *Game of Thrones* and, not as I had thitherto believed, *Game of Thorns*.

The very state of not knowing this and much else triggered a capacity to at least partially inhabit or maybe mimic the creature whom I have referred to elsewhere as a midget autodidact. Not knowing did not prove to be an impediment. Rather the opposite. I could delve into the past as though I was there.

The structure of *An Encyclopaedia* was designed to simulate the processes of memory. Well, of my memory. And when I say *designed*, I am claiming a degree of control which was I hope absent. The shapes and shifts of my memory or memories determined the structure: I write before I think, I write to find out what I'm thinking. I have a very capacious memory. It is equally a very promiscuous memory. It doesn't differentiate between what is deemed important and the allegedly trivial. Indeed, it makes such classifications seem as footling as they are.

Further, it is partial, as prone to head into a cul-de-sac as to trigger an associative chain. The abundance of these dead ends is the result of resolving not to create one of these things called a

narrative: one of these ubiquitous things. Narrative is a means of tidying actuality – which is resistant to being tidied – unless of course it is contorted, trimmed, squeezed, cut, tucked, and now and again bulked out in order to fit into the sausage skin of narrative. A narrative is a hackneyed device which the modernists rightly derided and despised, but which their romper-suited successors have exhumed. A narrative is a lie. Well, nothing wrong with that but it is a banal lie; it is the lie that is so pervasive it has become an *ideé fixe*.

Narrative makes life easy for the consumer/the reader/the spectator, makes the life it purports to depict easy. It is a false representation – of everything. We do not live linear lives. A novel is meant to be novel – the very name. It seldom is. My intention was, as I say, to write a book, a novel if you like, in which nothing is invented – no person, no incident, no place, no smell, no taste, no conversation. There is hardly any reported speech. As I say in the epigraph, 'Nothing wilfully invented. Memory invents unbidden.' And doesn't she just. She. Mnemosyne is female.

The movement of memory is akin to that of dream. It doesn't so much defy the linearity of narrative as simply not know about it. What happens, happens without explanation, without cause. In dreams we often see places we sense are familiar but which we struggle to recognise. This is probably because the brain does not process the internal images. Which are consequently like flipped images, printed the wrong way round, so the characterful breast-pocket handkerchief is on the right-hand side of the jacket. Think of primitive cameras.

Think, too, of an absence of scale. Scale as we have learned to see it due to the triumph in the west of pictorial perspective – which is as conventionalised as narrative, little more than half a millennium old and pretty much peculiar to Western, Christian and post-Christian societies. Perhaps the greatest achievement of modernist painting was to make us see afresh, to show us that our visual

perception can shake off the dictates of perspective and the ethos associated with it. So when we recall, say, a street from childhood, we do not see it hurrying away to a vanishing point. We are more liable to have scrambled its components, to have failed to correctly position them in relation to each other. Some elements are absent. Others seem improbably large or ridiculously small. Memory creates ellipses and collisions. It tricks us, it endows people with properties they didn't possess. It is liable to attach the features of one place to another unrelated place.

I wrote of my father's lifelong friend Osmund Edwards: Uncle Os lived far away beyond the Severn; he owned a pub surrounded by orchards and hop yards. I have a very strong memory from the age of about three and a half of that place, of a bright day, of a line of trees – limes maybe – beside a dusty dappled road. That was, I believed, the first time I registered dapple.

My memory was indeed very strong – and entirely incorrect. Forty years later I returned to that pub between Tenbury Wells and the worryingly Gothic St Michael's College. No orchards, no hop yards, and the surrounding fields were devoted to cereal crops. Lime trees? According to an old postcard I subsequently found, there never had been trees. I had no compunction about allowing reality, my mnemonic truth, to obliterate this boorish array of inconvenient facts. Memory's strength prevailed. I was not writing a report. Robert Lowell said that I have every right to change spring to fall – it's my poem. Alain Robbe-Grillet, having observed seagulls on the Breton coast, decided that they didn't fly how he wanted them to: he duly described seagulls flying his way. That is poetry, that is fiction.

Not a report. Not a narrative. Not a confession – I am far too tricksy and sly for that. Not really an autobiography – the me of the book is, as one reviewer correctly pointed out, 'a bugging device in boy form', a pair of eyes and ears: I was and remain more

interested in the people around me and the minute details of their lives than in myself. Not, then, a psychological investigation of a child that shared my name. Not — most certainly not — a misery memoir, a genre I deplore, not least because it is that very thing: a genre, generic, thus standardised.

What it is, is an exercise in memorious recreation, in retrieval, in description. My preoccupations are literary rather than sociological. As I say, the personae and the places are not invented. The form or structure is invented. The intention again was to mimic memory, but not the process of memory but what is actually remembered — which may bewilder us by its randomness and will often exist in isolation with no precursors and no consequences. It is also in a state of perpetual mutation. Every time we remember, say, the feline shape of a shadow cast by a shrub or the expression of surprise on the face of a Ghanaian seeing snow for the first time, we remember them differently, adding features or diminishing them or amending the angle from which we witness this inner cinema — the peripheral may occupy centre stage. Borges's character Funes could remember every time he had remembered remembering a face or a tea cup or a harrow. His memory is like a recessive machine. He obviously suffers a particular pathology: he has been thrown by a horse, suffered brain damage. Nonetheless his memory is different from the norm only by degree.

Collage is the antithesis of narrative. Pictorial collage, photomontage, is evidently experienced in a different and more immediate way from literary collage, which is necessarily sequential. The invariable message in the work of John Heartfield, Georg Grosz, Hannah Hoch, Georg Scholz — that Herr Hitler is not quite such a nice guy as he appears — doesn't much interest me. Even in the best causes, didacticism palls quickly. But the techniques that these great artists used and the effects they realised are beguiling and have literary analogues: distortion, perspectival chaos, a refusal to

acknowledge size constancy, anomalies of scale, astonishing juxtapositions.

This is thrilling stuff. And so is the energy. And so is the way that the workings are shown. The artifice is not occluded. Insofar as there is any flow, it is constantly broken up: even in the comparatively suave work of the late Tom Lubbock's work you can see under the bonnet, so to speak. Collage promises surprise. It delights in non sequiturs and avoiding the programmatic. I hoped to surprise myself and the reader. When you start writing a book you may know how it will end but you ought not to know how you're going to get there. Hence alphabetic chapter headings which often bear little relation to what the chapter itself will turn out to contain and which scramble chronology. Hence, on a micro-scale, the practice of beginning a sentence with no idea of where it is going to lead. Hence persistent changes of focus as though switching from a fish eye to a long lens.

I hope what I have said makes nothing clear. (2015)

Magpie recipes

JM: *The Plagiarist in the Kitchen* . . . couldn't that title be applied to countless cookbooks?

JM: It could. But it isn't. The majority of authors of such books decline to admit their thefts and borrowings. I guess that they reckon they can get away with them, though they are sheerly obvious. You'd think that the public would see through it.

JM: So by fessing up to multiple thefts, a lifetime's thefts, you're dismissing your colleagues and smugly presenting yourself as a figure of culinary probity. The prig in the kitchen.

JM: That's the first time I've been called a prig: I don't like it. The French for a knuckleduster is *une poignée americaine*. Remember that. I'm not embarking on a career as a cookery writer. I'm

not a pro. This is the only such book I shall write. Colleagues? I know very few people who have written cookbooks. And I hardly regard them as colleagues. I admire some more than others. I tend to admire those who can write rather than those who provide mere blueprints for dishes. But I feel little commonality with them . . . I am no more likely now to become a member of the Guild of Food Writers or any other chapter than I was during the decade and a half when I wrote about restaurants. I'm not a joiner.

JM: Very few of the recipes you include derive from that decade and a half – when you wrote mainly about London. There's a bias towards Europe . . .

JM: Approximately half the restaurants I wrote about during that period were in London, a quarter in the rest of Britain, a quarter in western Europe, America and Argentina. The influence of London is greater than might be immediately apparent. London looks outwards – and will continue to do so despite Ingerlandland's wanton self-harm. It is unconstrained by culinary tradition. It is, collectively, a magpie nicking from everywhere, mostly from Europe, evidently. So I am, I suppose, in that regard a typical Londoner, even though I haven't lived there for ten years.

JM: There's little indication in the recipes that you live in Marseille.

JM: Marseille's repertoire goes far beyond bouillabaisse and *pieds et paquets*. The former is a restaurant con, the latter (lamb's tripe and trotters) is not to be attempted at home. Rather, not in my home, much as I like them. An Italian influence is everywhere apparent. The pizza, often close to a *tarte fine*, is generally better than Naples's. Again, it is not a dish for the home. The same goes for couscous. It wasn't my intention to link dishes to places. As I make clear, the best cassoulet I've had was not

in the south-west but in Paris. Dishes are necessarily interna-
tional – like people, they migrate.

JM: Isn't that just a bit boorish? Only to be expected, though:
there are numerous instances throughout the book of
bloody-mindedness, contrarian swagger, provocative dicta and
so on, which are designed to draw attention to yourself and
infuriate your readers should you be so lucky to have any.

JM: Some may be infuriated, others not. And who else should I be
drawing attention to? I am not out to make friends. I don't
have the light entertainer's or politician's creepy yearning to be
liked. The dishes are ones that please me. The only criterion
for inclusion was that I have at some time or other cooked
them. Nothing new, then. It meant I had, for instance, to
relearn soufflés which I hadn't done for years. The short
digressions on plagiarism, influence, appropriation and the
various layers between them are, again, squibs and jests that
please me. The subject is fascinating but not so fascinating that
I'd want to undertake a detailed study of it. (2017)

On my bike

My health in general up until 2016 had been good. I do have dodgy
knees from playing squash back in an era when Nike trainers and
the like had yet to be invented. The most reliable shock absorbers
you could get then were Converse All Stars. The cartilage in one
knee got so worn down that I ended up having an operation in
2004. In late January 2016 I had an agonisingly sharp intercostal pain
which I self-diagnosed as pleurisy, having had the same thing in
1988 when a nervous locum doctor had mistakenly diagnosed a
heart attack and I spent three days in UCL. The next bed was occu-
pied by a perpetually fulminating man in a once-plush dressing
gown who resembled a haggard Terry-Thomas. He had all of his

possessions – mostly books – around him which when read caused him to yell at them.

The 2016 attack was over within twenty-four hours which I spent in La Timone hospital in Marseille. After a course of drugs, I was given the all-clear. The *generaliste* – GP – I go to said I ought to have a scan, but I put it off because I was travelling back and forth to London preparing an exhibition. When I did get round to it the hospital receptionist said I might as well not hang around and that I could collect the results after the weekend. But as I was leaving a doctor emerged from a door, ordered me to follow him and said, 'You could die at any moment . . . but if you do exactly what I say you won't.' He was grinning. I had a blood clot which could readily have led to deep vein thrombosis.

A heart specialist prescribed more medication, this time to thin my blood – to correct its density from a thick *jus* to a mere *bouillon*. (I should point out that medicine in France is rigorously demarcated. The person who does the diagnosis is not the person who will operate and so on.)

But I continued to go back and forth to London, where I was having problems with a publisher.

In September of that year I more or less collapsed. I could hardly walk, was gasping for breath and so on. The specialist booked me into Clairval Clinic in Marseille for investigations because my heart was arrhythmic. One valve was blocked and another was leaking, so a date was set for an operation: 13 October. It was a five-hour epic. When I came round from the anaesthetic I told a nurse that I didn't want to go through with it because the catheter was painful. 'Too bad,' he replied. 'It's all done. You've had the op.'

My recovery was quick – I was out after two days, which I spend rereading *Libra*. The level of care I received was beyond all expectation.

I was told to exercise for thirty minutes every day on a bike, *un vélo d'appartement*. Which I do without fail. I have absolute confidence in the heart specialist I see. And, indeed, in French doctors in general. Many have worked in the UK – they have the measure of the NHS's failings. What Macron Bonaparte will bring to health-care in France is something that worries the medical establishment.

I probably work slightly slower now than I did, but the difference is marginal. I have always written in fits and starts. The only film I have done since – *Jargon: Matrix Hubbing Performative Pain Badgers* – was done in a studio, which is both less exhausting than being on the road and a better use of time given the insultingly low budgets we get.

Did I think I was going to die? I have always thought that I might die at any moment. Since I was a child I have pondered death on a daily basis. It is always with me. How . . . where . . . when . . . These questions have been a lifetime's preoccupation and, I guess, they form part of my very being. You try to grasp the only inevitable mystery and it always slips away.

Then, a little more than a year after my operation, I had a minor heart attack at the very end of November 2017. This was quite independent of my previous problem. Plumbing as opposed to electricity is the way it was put to me. The jolly nursing staff welcomed me back to Clairval: 'Coming here on holiday again . . . you know how to give yourself a treat . . .' This time the operation was swift, just forty-five minutes, and I now have a metal stent which prevents an artery from closing up. Which reminds me, I once met the Brummie comedian Malcolm Stent . . .

The exercise bike I use every day is in a corner of my office in our apartment in Le Corbusier's Cité Radieuse. It looks out onto a balcony which is proof that I am no gardener. Cacti do OK because they require little care. Beyond – a couple of blocks of flats which do not mar the view of the Marseilleveyre, the high limestone hills

above the Calanques. Under them are the half-dozen towers of a 1970s development called Roi d'Espagne. They are a human intervention which enhances rather than degrades nature.

Cycling allows me to concentrate on music in a way that I have rarely done. I have no taste for symphonic music. I find the bombast tiresome. In the summer of 1976, I sat through every Beethoven symphony at the Albert Hall. I clearly missed the point. Nor, absurdly, do I have a taste for wind and brass. I like strings and, now and again, piano. My diet comprises nothing but the very great. Of course my idea of the very great is somewhat straitened. Mozart, Haydn and Bach don't figure.

But these do: Beethoven, obviously, and equally obviously, opp. 127, 130, 131, 132. Schubert's *Death and the Maiden*, *Rosamunde* string quartet and quartet D94. Brahms' piano quartets 1, 2 and 3; sextets opp. 18 and 36; string quartets 1 and 2; quintet 2. Mendelssohn's *Octet for Strings*; quartets 1, 2, 3, 4; quintet 2. Now and again Dvořák, Tchaikovsky, Schumann and Smetana. And that's it. (2018)

9

France

A segment in a poke

Cricket is played in France. I, who would do anything to avoid watching this most tiresome of games, have inadvertently glimpsed two matches: one at Talence, a suburb of Anglophile Bordeaux in 1969 and another, ten years later, in the de facto British dominion whose blazered, boorish *colons* believe is called the Doordoink. France has forty cricket clubs, more than a thousand regular players and an international team − the captain is, disappointingly, called Simon Hewitt − which recently defeated mighty Switzerland. Does France then consider itself a major cricket power? Does it look across the water and smugly inform *les angliches* that we're sorted, we're taking over? I suspect not − despite the fact that at the top end English cricket is going through a bad patch . . . but what other kind of patch does it ever go through?

Cooking is done in Britain (so, for that matter, is wine made). But food remains as culturally peripheral here as cricket in France. Nonetheless, in an access of collective self-delusion the British have convinced themselves that they are the new culinary masters: London, we are told (by the tirelessly hyperbolic Terence Conran, by armies of PRs, by torpid hacks who swallow the line), is something called 'the restaurant capital of the world'.

And this delusion, far from being smothered like a prince in the Tower, is actually abetted by a vociferous pig of the French culinary establishment: I use 'pig' here in the late-Georgian sense, as a synonym of 'segment'. The vociferous pig in question is M. Alain Ducasse, who was reported the day before yesterday bemoaning French cooking's stagnation, its over-formality and its decreasing global influence. As evidence he pointed to the failure of French restaurants in cities around the world.

This report prompts a number of observations. The first has nothing to do with gastronomy but quite a bit to do with what might be called the segment-ignorance of the reporter, who was hardly reporting but merely repeating what Ducasse had said in a magazine interview. I thought we all knew by now that the medium, the messenger, is rarely neutral. But no, it seems not to have occurred to him that interviewee and interviewer might be in cahoots, that the magazine in question – *Gault Millau* – has its own interests to prosecute and that they coincide with Ducasse's. Then there is the unquestioning acceptance of Ducasse as some sort of spokesman for French cooking. Ducasse is, in virtually every way one can think of, atypical.

He is a businessman with a chef's toque, a neophiliac who pollutes his native cooking with witless lifts from around the world. He appeals to the people who compile guidebooks, people who are gulled by dull luxury and ostentatious novelty, people like the late Henri Gault and Christian Millau whose baleful influence on French cooking over the past thirty years is now mercifully waning. They praised and damned according to whether or not a kitchen was pursuing the aberrational gimmickry which as naked emperors they prescribed. Their influence was such that the red Michelin was forced to ape their taste, rendering it equally useless. But over the past six or so years things have changed. French professional cooking has

gone backwards – which is forever the way forward: I give you the Renaissance, the classical revival, the Gothic revival, etc.

Gault Millau has been left behind. And so have 'innovative' chefs like Ducasse. When he talks of the failure of French cooking, he is exhibiting a hubristic sore, he is howling because he has been found out. What has failed is Ducassien cooking: his temerity in conflating himself with French cooking is risible and insolent. His efforts in London have been pitiful: a hideously expensive, gastronomically indifferent restaurant in a Knightsbridge club whose kitchens have now been taken over by Jamie Oliver, a hideously expensive, gastronomically indifferent restaurant in the Sanderson hotel. It goes without saying that the cooking in both had little to do with France. Ducasse's dated modernism is rootless. This last-ditch nouvelle cuisine is the same all over the world, like airports.

France today is as good a place to eat as it was in the fifties and sixties: I'm sure that village cricket is thriving, and not in the pastel Day-Glo that our monosyllabic professionals wear. And everyday wine is much better. Now, there is a case of commercial failure, 10 million cases indeed. Bordeaux, Burgundy and to some extent the Rhône have greedily priced themselves out of the running, while the startling value that is to be found in Languedoc-Roussillon and the furthest south-west is not reflected in sales: a ten-quid bottle of Collioure or Faugères or Saint-Chinian is of equivalent quality to a fifteen-quid bottle from the Barossa Valley or Napa. The problem for France is that Australia and America are anglophone. When wine in Britain was the preserve of a smallish aspirantly francophone proportion of the bourgeoisie, a certain etiquette attached to the stuff coming from France. Now that the British are even more proudly monoglot than they were, yet have become a nation of wine drinkers, it's hardly astonishing that they should prefer bottles with facetious names they can remember to ones they can't pronounce.

The only solution is for French winemakers to give their produce English names. That's very generous of you: mine's a '47 White Horse, chiss. (2001)

Going hyper

From the far distance – and it is visible from some 20 km away – Rodez looks Spanish. The bulky silhouette of its cathedral suggests that the town you are about to reach is in Old Castile. Drive on, though, into its interminable outer suburbs and there can be absolutely no doubt that you are in France, because everything seems American. The sprawl of big-shed retail businesses is linear, uncontrolled, ugly, chaotic. It would be shocking were it not so familiar, had one not seen it repeated over and again, everywhere from the Somme to the Tarn, from the Rance to the Doubs. Actually, such exposure renders it no less shocking. What has taken over France's burbs in the past two decades is entrepreneurial anarchy. Whatever happened to *dirigisme*?

The only directives here are signs that guide you from afar to clamorous hangars still touting for business with massive logos when you reach their car park. This is a land of hard sell and simple-minded nomenclature: Brico-Jardi-Deco. Bricopro. Monsieur Meuble. Intermarché. La Halle! Casino. L'Hyper aux Chaussures. Décorial. Cité de la Déco. Hyper U. Soberia (computers) and Big Mat (building materials) are perhaps less obvious. Then there are the biggest of the big: Mammouth. Carrefour. Auchan. Leclerc. Géant.

The golden memories come flooding back. Is it really eleven years since I missed a Dover ferry because a friend went into overload mode at Mammouth in Saint-Omer and failed to control his three trolleys? Like I say, golden.

In Rodez, it had to be Géant that, after eight months' work, has just been relaunched as Nouveau Géant. Then I noticed that

Leclerc, about a dozen roundabout-clusters distant, had knocked 20 per cent off its prices; it claimed that this retaliation was a celebration of its twenty years' trading. Unfooled, I stuck with Géant. Not that my loyalty was rewarded with a loyalty card. Never having owned one of these things I thought this might be the moment. Inadequate identification. The man looked at me pitilessly, thinking: you English, come over here, claiming to love our traditional pastis/poison-pen/incest lifestyle, when what you're really here for is loyalty card scams . . .

I wandered, as is non-people's wont, beneath cliffs of aubergine brassières and along long aisles of things that I'll never own. I counted 127 television sets. Among the gourmet cat foods: Sheba, Friskies, Ophèe, Pickit, Felix, Whiskas, Kitécat, Les Océanes, Les Félines, Ronron, Déficat (really). There are twenty-four different dog shampoos, and doggy cotton buds the size of aniseed balls: French dogs are so pretty they deserve whatever they get. They possess a chic that their provincial owners seldom share.

Géant is where those owners can select from fifty patterns of carpet slipper, a dozen rat killers, thirty-five padlocks. Madame can sport interestingly cut clothes fashioned from fifties curtain material. And one can buy hypoallergenic socks. You really can. I did. Don't ask. I also bought some mothballs. What do they do with the rest of the moth? What I didn't buy was handkerchiefs. They are not sold here. Nor, for that matter, at Monoprix. '*Ou sont les morves d'antan?*' Has French mucus disappeared: is that what the common currency has done to the common cold?

Beside a British hypermarket, Géant is . . . Well, it's bigger. But this is an inappropriate comparison; this is not like versus like. Géant has no aspirations to elegance. It does not employ architects like Grimshaw or Foster. It is a retail warehouse, practical going on basic. Its aim is not that the punter should 'Experience Shopping Totality With All Six Senses' or something kindred: PR is no more

part of the equation than design. Its aim is old-fashioned; it is to flog gear at low prices. The bewildering difference, however, between Géant and, say, Waitrose is not that the former also sells motorised hoes, wall safes and telescopes, but that France's town and city centres have not felt the sledgehammer effect of exurban shopping in the way that Britain's have. This is due to: (a) the French custom of living in the centre of towns (though that is changing and the Anglo-Saxon suburban/commuting model is being increasingly aped) and of patronising neighbouring shops; (b) a developed or, if you prefer, primitive sense of regional identity which is manifest as much in local tastes as in departmental autonomy; (c) the notion that the freshness of foodstuffs should be judged in hours rather than weeks.

You might reckon that hypermarkets would not bother to concern themselves with the latter two. They are earnestly acknowledged by Géant. Thus, its Rodez branch offers a different gamut of goods to that in, say, Troyes. This goes way beyond tokenism. Géant knows that a show of localism is vital for its survival. It is not France's communications that militate against central buying and consequent standardisation, but its very culture. Thus, as well as gastronomic and agrarian products there are shelves of parish-pump books, including a number of 'regional' novels published by Terre de Poche (which is a national imprint, devoted to folksiness wherever it comes from). They sit alongside Grisham and Ludlum just as *tripous* and *aligot* sit alongside Campbell's soups and Kellogg's cereals.

I went to think about the globe and the village over lunch. The waitress's expression said that she knew a sad case all right. The man who still read the Géant catalogue even though he was refused a loyalty card. Raw ham, bloody Aubrac beef, red Marcillac wine – all from within 40 km. Delicious.

The flavours of the terroir, the essence of the red earth, Le Rouergue: what could be more French? The dining room was

attached to a bowling alley called, of course, Le Bowling and apparently airlifted from a suburb of Des Moines. Like I say: what could be more French? (2003)

Beyond the milky way

Peppers, potatoes, tomatoes, turkeys, white (cassoulet) beans, chocolate.

These are, famously, post-Columbian foodstuffs. They were introduced by returning conquistadors to Iberia whence they spread across 'the continent' (like the British, the Spanish use that epithet to describe the rest of Europe). They certainly didn't spread with alacrity. Peppers, or capsicums, for instance, have only been a feature of the British diet for the past thirty or so years – and we still don't know how to eat them: the practice of serving them raw is gastronomically and peptically indefensible. But this is only to be expected. These islands own a uniquely uncanny capacity for the perversion of produce. One need cite only hydroponically grown tomatoes, industrially raised turkeys, canned baked beans. And British 'chocolate'.

The quotes are mandatory if the word is prefixed by British because the stuff isn't really chocolate. It is, rather, a comestible that has been traduced as a moral weapon. Quakerism possesses admirable qualities: ecumenical tolerance, proto-welfarism, pragmatic utopianism – Bournville and New Earswick are both the creations of 'chocolate' manufacturers. But the propagation of sensual pleasure is not among this ascetic sect's attributes: the Society of Friends Cookbook is a wafer-slim volume.

Just think of Quaker Oats. Just think of Dairy Milk, Five Boys, Black Magic. Just think of the coy application of such words as 'wicked' and 'sinful' to 'chocolate': they imply guilt. But a lesser guilt than that which the consumption of alcohol encourages. It

was chocolate's potential as a force for temperance and teetotalism that initially attracted Quakers. Thankfully, in the rest of Europe chocolate was made by religionists who failed to discern its proscriptive use.

Marranos – Sephardim forced in Spain and Portugal to convert to Christianity and humiliated by having to eat non-kosher *treyf* – settled just across the French border in Bayonne in the early seventeenth century. Though spared the Inquisition's persecution, they were not allowed to practise Judaism till 1723. By which time Bayonne's Jews had turned their small town into France's chocolate capital. They had brought with them chillies and the Aztec drink *xocoatl* (*xoco* is an onomatopoeic representation of the sound of boiling, *atl* is water). Their success resided in their having devised a method of solidifying chocolate, initially with egg yolk. The prestige attached to this novelty was such that when Vauban completed the magnificent fortifications of the town in 1680, he was ceremonially presented with Bayonne chocolate rather than with Bayonne ham (or, for that matter, with a bayonet). Astonishingly, Bayonne is still France's chocolate capital; even more astonishingly it still manufactures artisanal chocolate that a revenant Vauban or his patron Louis XIV would probably recognise: the king was a keen devotee and granted the first licence to sell the stuff to a chocolatier in nearby Ciboure.

While chocolate became a vogue throughout France, chilli never caught on outside the Basque country, whose culinary repertoire is characterised by its use in the local form of *piment d'Espelette* – the folksy village 25 km from Bayonne where it is cultivated. It is not as coarse as the Spanish assault weapon called *pimentón picante*, but it is nonetheless too spicy for the French palate in general: the spices used in the vernacular cooking of such 'spice-ports' as La Rochelle and Saint-Malo are mild in comparison. Bayonne's ancient recipes still combine chocolate with chilli. Forget Vauban and Louis XIV,

this is a flavour if not a texture that Moctezuma would recognise: the Aztecs invariably drank it thus spiked.

At the foot of the pedestrianised old town there are three chocolate shops within a few metres of each other on the rue Port Neuf. Two of them, Daranatz and Cazenave, are beneath a long arcade. It also provides shelter for many of the town's 'illegals' who are ostentatiously ignored by the forgetful descendants of former immigrants. Its disadvantage as a mendicant site is that alms may be provided in the form of chocolate. But what chocolate! The shops themselves, it must be said, are not particularly visually enticing. Their displays are lacklustre. They have the feel of fusty tea rooms. Perhaps they don't need to bother. The product is all: ganaches; nougats; mints; gingerbreads; slabs flavoured with honey, cinnamon, cloves, nutmeg, teas; slabs that incorporate candied peel and nuts. The expertise is such that even the aberration called milk chocolate tastes good. The priestesses, the middle-aged and elderly women who serve, wear hygienists' overalls and expressions of fulfilled content. Even though some of the packaging is luminously gaudy there is no fussy gift-wrapping, no teasing of ribbon with scissors. That, again, would be an irrelevant add-on.

Climb the hill towards the (strangely northern) cathedral and Puyodebat's window can hardly fail to catch your eye. Its centrepiece is a chocolate fountain in the form of a potter's wheel with a chocolate vessel constantly inundated with chocolate slip. The sculptural potential of chocolate is not otherwise manifest in Bayonne. There is, however, always the Musée du Chocolat nearby in Biarritz, Bayonne's brasher, Basquer neighbour.

One of its displays is of chocolate representations of dogs, dolphins, motorbikes and so on. These are made bespoke by the museum and incite the visitor to break off a handlebar or fin or tail. Beyond them is an extraordinarily compendious collection of moulds, from *c.*1830 onwards.

Crowns, ships, violas, axes, spanners, pipes, scissors, anchors, rifles, clerics, keys, visors, taps, pince-nez, plumes of feathers and, of course, bayonets. Plus the means to create an entire brown bestiary of elephants, lions, chickens, butterflies, giraffes, oxen, horses! Sure, much of it – most of it – is kitsch. But equally it is craft in the service of innocent gaiety. (2003)

Within these walls

In a spirit of respectful humility or sentimental fatuity I sought out the house where Joe Bousquet spent most of his necessarily straitened life in a shuttered room. In May 1918, at the age of twenty-one, he had been rendered paraplegic by a German bullet. His condition determined the sort of writer he would become.

'My wound preceded me: I was born in order to become its incarnation . . .'

'I was wounded. I turned into my wound . . .'

'A wound isn't something you possess. A wound possesses you.'

'My shadow turns around me. You turn around your shadow.'

He exhibited quietist fortitude. His imaginative energy was potent, no doubt compensatory. His analytical evocations of immobility illumine the quotidian marvel of mobility. His stoic meditations on want are tacit admonitions that we should not take plenty for granted.

Bousquet lived and died in the 'new' Carcassonne, the rigid grid of streets between the left bank of the Aude and the Canal du Midi. It was mostly built during the eighteenth century when the town was rich from wool, like a sunnier Stroud. Its speciality was a sort of cloth, named because it mimicked a London fabric: *londrin*, aka *nain londrin*, which has nothing to do with dwarfism but is an abbreviation of the Urdu *nainsook*. In London it was woven by Protestant refugees from France, the upper storeys of whose houses in such areas as

Spitalfields and Borough were glazed to admit maximum light and thus prolong working hours, working life. Blindness is not a disability that a weaver can advantageously overcome the way a writer can.

It is the 'old' Carcassonne, to the south, which is celebrated, which is designated a World Heritage Site, which attracts 2 million visitors each year, which prompts me to thank the unknown child at a Southampton panto from whom I caught measles and so (probably) grew up a myope.

Physical and sensory disabilities in creators are well documented. In *The World Through Blunted Sight*, the ophthalmologist Patrick Trevor-Roper proposed that much painting was subject to a form of ocular determinism. Thus focus, colour, structure, shapes, etc. are manifests of myopia, astigmatism, daltonism, cataracts, macular degeneration. Turner, Degas, Pissarro, Monet and Cézanne suffered a rich gamut of defects. This is a delightful conceit, although it underestimates mankind's free will to be enslaved by fashion: it is hardly probable that, say, Boccioni and Balla, Nevinson and Wyndham Lewis shared the same retinal defect.

What did Viollet-le-Duc suffer from? Was the nineteenth-century 'restorer' of Carcassonne's citadel as laughably short-sighted as I am? Or did he merely count on those who would come to observe his stupendous folly being thus handicapped? The walls and crenellations and *tourelles* and gates and barbicans are convincingly medieval only to the uncorrected eye at a distance of at least half a mile. From anywhere nearer – or through spectacles – they are as winningly bogus as the plastic suits of armour which the scores of intra-mural tat shops specialise in.

The difference, of course, is that no one pretends the armour is 'real' or 'authentic'. Whereas Carcassonne is predictably mute about the licence that the architect granted himself. Just as Bousquet was trapped – to his creative benefit – in a place, so was Viollet-le-Duc trapped in a time, willingly one may assume.

Both artists are characterised by the primacy of their imagination. They made rather than replicated, they invented rather than represented. Viollet-le-Duc's work at Carcassonne belongs to an aesthetic system entirely at odds with that of Pugin, less than two years his senior. And it is symptomatic of a more general gulf which still exists between French and English attitudes to the past and to art.

The Gothic revival in England was, initially, a Christian propagandist idiom; it was Pugin's built epistle of sacred earnest; it possessed a non-tectonic high seriousness; it was touchingly Gatsby-ish for it believed that the past — specifically, the Middle Ages — might be repeated; it abhorred the playful, archaeologically incorrect Gothick that had begun with the profane Vanbrugh and ended with the profaner Nash.

Viollet-le-Duc, on the other hand, saw himself as part of a continuum, as belonging to the same enlightened world as the Encyclopaediasts: rational, secular, contemptuous of institutionalised superstition. No less crazy than Pugin, he divested the Gothic of religious associations, reduced it to a structural system whose precepts might be adapted and improved upon, might be made modern.

And how! The stones of Carcassonne are cut by machine. They might be the blueprints of breeze blocks. They are mechanically hammered in crude mime of chiselling. Save that they are 40 cm thick, they are as insubstantial as stage flats: mimetic accuracy is not a means of illusion. I walked and walked around the astonishingly deserted dry moats which turn to sand. Often there was no one in sight. Did I feel I was temporally transported? Yes. But not to the Middle Ages when everyone looked like the divine Marty Feldman and sported an award-winning bubo. Nor to 1850, the moment when Viollet-le-Duc was creating the future.

It all felt like the past of a 1960s epic. Vaguely affecting, in a sluttish, corny, sentimental, body-fascistic way: a lovely backdrop for

the gun-fancying Charlton Heston in his loincloth days. But – sadly – it is nowhere near so affecting as those concentrated, compacted architectural items infected by ulterior purpose, by religious intensity, by the add-on of agenda. No matter how intently we may wish it not to, the associative potency of buildings is more than that of mere walls. (2004)

Saints alive

Another of the mysterious ways in which He works is to ensure that He remains acknowledged as an excuse for shutdowns in a state which has for a century been officially secular. France's calendar is littered with days for shirking in Christianity's name. To continue to celebrate the majority former superstition while prohibiting Islam's quaint sartorial tics might seem tactless, but it does send out two powerful, incontrovertible messages: it owns up to European secularism's antithetical dependency on Christian culture; and it suggests that assimilation is the only choice, an obligation. When in Rome is a maxim that has been forgotten and that needs to be relearned.

This, anyway, is what I found myself thinking when I gaped at closed café after closed shop after closed bar in Le Puy-en-Velay one recent Thursday.

I was thinking that when I wasn't thinking how browned off I was that Christ should have chosen to ascend on this very day, and couldn't he have just waited till a day later, upon whose anniversary I would already have properly cased the interiors of rue Pannessac. Its exteriors are splendid. The Logis des Frères Michel Sculpteurs 1620 is a marvel of what John Summerson called 'artisan mannerism' – an advertisement of the brothers' craft carved in black volcanic stone: lozenges, swags, escutcheons, putti, pilasters. That happy notion of infinite mercy. How can one put it? It needs look-

ing into. So, indeed, does the entirely beautiful, entirely primitive ascension. Flying to heaven! This omnipotent folk myth, like all the others, is psychedelic.

Christianity becomes delicious when we accept John Allegro's and R. Gordon Wasson's kindred proposals that all its best bits are founded in delirium occasioned by the ingestion of hallucinogenic mushrooms. Of course, by the time a mountainous site of former volcanoes became Le Puy – and yet another stop on the road to Santiago and the House of the Scallop King – the cult of *Amanita muscaria* had been long forgotten and the Church was institutionalised. Its connections to trance and trips were occluded.

Still, the notion that the C of E, New Labour at Prayer, should be even distantly derived from desert hallucinations, stramonium visions, synaptical short circuits and synaesthesiac tingling is one to delight in.

Le Puy's descent from such stimuli is less dissembled. It is a town that pronounces its (former) faith in a manner that is awesome and *buffo*, reverent and jokey. We are used to laugh-a-minute, carnival icons in Catholic shops: light-up saints, flashing haloes, toilet-paper dispensers which hum 'Ave Maria', 3D Last Suppers, plastic fishes and plaster loaves, crown-of-thorns-style party tiaras, hologrammatic Calvaries. There are plenty such gewgaws to be found here.

But when it actually builds for perpetuity, Rome, even at the height of the Counter-Reformation, usually attempted to exercise a sort of restraint. Not in size, of course, but in matters of taste. Kitsch that is acceptable on a microscale is not to be countenanced when wrought in stone. This observation must seem slightly flawed if your knowledge of Catholic architecture is derived from Le Puy.

If the outside world knows Le Puy at all it is as a name on verbena products. Verveine is a Chartreuse clone. The major distiller is Pagès. Richard Clayderman's natal name is Philippe Pagès. Whenever I drink the stuff, about once every three years, do I hear a

winsome ingratiating floppy bottle-blond glissando? This is a private matter. I'm not obliged to say anything.

The outside world knows it, too, for its lentils: *les lentilles du Puy*.

Religiously inclined, Clayderman-listening, verveine-swigging myopes often arrive in Le Puy hoping to correct their sight. You can clock them staggering from one branch of Alain Afflelou to another, then making do with lentil bread, lentil soup and lentil lentils when they realise their mistake: these *lentilles* are not contact lenses. They continue to gape just as I gape when I remove my glasses.

For us, the world is out of focus. Think of a long-lens snap in which just the foreground subject is sharp and everything beyond is a blur for want of depth of field – that's myopia. Corrected by the plastic carmine-tinted prosthesis wrapped around my head, I can see the bizarre magnificence of Le Puy, a magnificence that belongs to fairytale – dreamed by Edmund Dulac or Willy Pogany – or to topo-surrealism. Representations of it look faked, made up.

The Romanesque cathedral's coarse west front of ironstone and tufa obligingly looms as a stage flat. This is a quality of English west fronts – Wells, Salisbury: the screen which hides yet advertises the worship hangar. But it is rare in France. The cathedral is, however, the least of Le Puy's bewildering sites. Above on a sheer volcanic chimney there is Mariolatry made metal, a statue of the virgin and waving child forged from cannons captured at Sebastopol. It is as high as a six-storey house and orange from oxidisation. Then there is the great, spired chapel of Saint-Michel d'Aiguilhe perched on a needle, which rises 250 ft from the valley floor.

And there Le Puy might have rested. However, fifty years after the virgin was erected, an even more outlandish construction was built. On yet another rock which rises high above the river Borne, there arose a monastery dedicated to St Joseph. If the dotty, inaccurately medievalist architecture has a precedent, it is Ludwig II's

Neuschwanstein: all turrets and machicolation and crenellations. On top of it is a figure of the bearded St Joseph holding a child who is waving across the valley to the infant Jesus. He is also waving across the top of the houses clustered around the bottom of the rock. The pair appear fleetingly – lurching beyond tiled roofs, between satellite dishes, half obscured by gables, above a lean-to where there's a domestic boiling up nicely to screaming pitch. The saint looks, disturbingly, as though he's on the point of abducting the boy – he's taking him to fly to neverland over chimney tops. (2004)

Sun King for a day

To the château of Versailles, for the first time since my teens – when, to my embarrassment and to the quizzically chauvinistic chagrin of my Parisian hosts, I was unmoved and insufficiently impressed. And so was I again, to my own chagrin this time: surely my taste ought to have changed, to have improved? Isn't that what happens to taste – as a result of education, knowledge, sensibility, discrimination? Isn't that why we slough our adolescent enthusiasms and antipathies?

My constancy worried me. But at least the knowledge, sensibility and all that gear which has just about stuck down the years enables me to identify why Versailles is so compositionally unsatisfying. It is too small.

I'm not being cute. It is small in thought. It is too small in scale for its extent. It is too small, vertically, for its site. Its uninflected details are bereft of the gigantism that such size demands. Its central bays are a storey short of the full tale, they are simply not tall enough and big enough to command the protruding wings of the Marble Court on the town side: the resultant concavity is anticlimactic. On the west, the slope of the gardens is such that the lowest storey is occluded save from close by, so that the facade is diminished, timid

and preposterously horizontal: the dislocation between topography and architecture is chasmic. It is a misfortune that it should have been built at the very moment when the farouche, hallucinatory roofscapes which had characterised French architecture since the late Middle Ages had just been eliminated from the repertoire. Kingsley Amis's depreciation of *Brideshead Revisited* as 'lush and arid' fits the bill precisely. Versailles is grandiloquent with nothing to say: it is thus an all too apt representation of the regime that created it.

I am by no means immune to the allure of French monarchical and imperial monuments. Marie Antoinette's bogusly bucolic hamlet in Versailles' park would be a hoot were it not the precursor of dressing-down: it's the sub-architectural equivalent of the aristocracy and the bourgeoisie affecting jeans and work clothes. Napoleon III's mausoleum – at Farnborough in Hampshire – is touching. The royal chapel at Dreux is engagingly dotty. Chambord and Arc-et-Senans are works of genius that speak to the head, to the heart and to the base of your spine. The château of Versailles speaks only to closet absolutists, wannabe monarchs and aspirant tyrants.

You think such freaks constitute a rare breed? Think again. This outer Parisian suburb teems with them. Coach upon coach disgorges punters fantasising about ruling the world or, anyway, a medium-size country of *primates capitulards*, because rulers of such countries get to inhabit far from medium-size palaces, decorate them with gold and gilt and porphyry and onyx, people them with herms and putti, terms and sphinxes. The construction of a palace where mythical beings are one's familiars is a self-fulfilling prophecy: the creator is aggrandising his divinity with the carving of every relief. It is all to his glory. Just as god in heaven has cathedrals that are treasure houses, so does the living god who is a king proclaim his unique stature through richness, lustre, the accumulation of stuff: more stuff displayed with more ostentation than anyone else. Monarchy is a very primitive notion.

Versailles obliges the aspirant by allowing Louis le Paume from Meudon and Lewis the Saddo from Merthyr every opportunity to buy into the dream. What was once the knocking shop of the Western world – Louis XIV had sixteen 'official' byblows – is now just another shop. And outside the 'official' shops within the palace there is a hierarchy of retail desperation whose lowest ranks number dozens of importunate Africans freighted with blankets, concertina'd postcards and wire circles, like Delon's key ring in *Le Samouraï*, from which are suspended Eiffel Towers.

A rung above them are the stalls flogging the same tat that is available inside the palace, but without – what should we call it? – the blessing imparted by Sunkinged Inclusivity. Those so blessed are not fussed about which particular form of dictatorship or delusion, concubine or concupiscence they are peddling. It's all heritage, isn't it? The old patrimonial legacy lark. And it really is old. M. Paume and Mr Saddo and their thousands of fellows are avatars of the poor dupes who bought relics: this splinter of the True Cross, that thread of Christ's shroud. The difference here is that the manifold objects for sale do not pretend to 'authenticity'. But that hardly mitigates their efficacy as something more than a mere souvenir, a remembrance of an afternoon that begins with a stinking hot dog and ends with the eternal return to quotidian banality of familial bickering, screaming, oaths. Those parentheses are, of course, not part of the mnemonic package.

They enclose the hours when we are all kings, and these are the hours we commemorate with a piece of Versailles, a palace whose *objets de vertu* and works of art replicate themselves as surely as skin does. A plastic musketeer; an extensive range of miniature rococo and Directoire clocks; a miniature slipper for a courtesan of restricted growth; a cheeky little plaster putto whose smile, like a clown's, masks the personal torment of a gender identity crisis; a Madame Du Barry bust; a Marie Antoinette T-shirt; a Marie Antoinette jewel box.

Then there is the Napoleon range. He was wrong about one thing. It is France that is the nation of shopkeepers. And memorialists: Napoleon jigsaws; Napoleon colognes ('the only olfactory recollection we have from the Emperor'); Napoleon silhouettes by Caran d'Ache; Napoleon medallions. These are the transportable props of a vain dream. Which is a dream about a dream: for all its brute physicality, Versailles is as insubstantial as a dream, for it represents a conceit of extraordinary frailty – about which Louis XIV famously had no illusions. I guess M. Paume and Mr Saddo have to decide what sort of monarch they wish to be. A silk-swathed robber baron grown fat on fattened geese who'll make potential regicides of all his subjects, or a drab missus with a Tupperware habit who no one would dream of topping. Me, I'd risk my head. (2004)

Living on a knife-edge

The Aubrac is the southernmost part of the Massif Central, the northernmost part of the Aveyron. It comprises hyper-verdant highlands and precipitous bosky valleys whose autumnal palate (flame, ochre, tan, tea, etc.) is a match for anything New England has to offer. There are no coach parties of leaf-peepers, though. And no moose either. But in compensation for the latter there are Aubrac cattle. They are among the most beautiful of kine. The bulls possess a leonine air. Their meat is superlative. The Centre for the Promotion of the Aubrac Breed occupies a determinedly non-rustic high-tech group of buildings, which might seem improbable were it not for the fact that the other predominant local industries are similarly housed. The message is clear: this might be the back of beyond, but it's not backwards.

So far as I know the only British Aubrac herd is that raised by Sir John Eliot Gardiner on the Dorset–Wiltshire border near Shaftesbury. There is a project to breed them in the very different

climes of Algeria: I eavesdropped on a group of agronomists from that country during their protracted fact-finding lunch in the Aubrac's capital, Laguiole (the g is silent). Most of the other guests at l'Hôtel de l'Aubrac were from coach parties – of cutlery tourists.

Laguiole is not merely the breed's home town, it also gives its name to a cheese and to a knife. If this seems an unusually excessive ambition in a 'town' (a village, really) of 1,500 inhabitants, that is only apt. For it is a most unusual place. Its industries – and there is a fourth, gastronomy – are interrelated and hermetic in a way that is today rare even in isolated places. This, of course, has not come about by chance, but through the self-conscious renewal of local artisan tradition by applying modern technology where apt, while adhering to straitened disciplines.

Within 300 metres of each other, there are to be found: La Maison de Laguiole, which is no relation to Le Couteau de Laguiole, which is not to be confused with La Coutellerie de Laguiole. There are, further, the Coutelleries de l'Aubrac, de Coeur de l'Aubrac, du Barry, de Benoît l'Artisan, de H. Cros, du Foirail, de Glandières, de Lacaze & Rambaud. There is l'Artisan en Coutellerie d'Art. And there is, controversially, La Forge de Laguiole.

The first Laguiole knife is attributed to Pierre-Jean Calmels and was forged in 1824 or 1829. That original was, for sure, a refinement of a commonplace Auvergnat pocket knife. It was, for sure, based on a Catalan dagger. The Auvergne is close. But the Rouergue (the modern Aveyron), to which the Aubrac belongs, traded with Catalonia and had the *langue d'oc* in common. Either way – and the best hunch is both – throughout the nineteenth century the Calmels family (which is still manufacturing in Rodez, 50 km south) developed its combination of functional jewel and decorative tool to the point where it established a template.

Early on, the handles were exclusively horn, of which there was evidently a plentiful supply, or of box wood. Later in the

nineteenth century, ivory was used. The first technical innovation was the introduction of a folding knife, which became more or less exclusively the property of men. Then came the knife which incorporated a corkscrew, made at the behest of the Aveyronais and Auvergnats who owned three-quarters of Paris's cafés, still do. The classic shape of a Laguiole knife, arrived at by the turn of the century, is streamlined, bereft of right angles, sensuous, as elegant and vicious as a pike. At its hilt there is a stylised bee, presumably out of deference to the late Emperor Napoleon. Even in its most utile guises the knife is vaguely effeminate. Surely the cutlers and artisans didn't shop on both sides of the street?

Today they'd have a job to do so, for the main street has shops and workshops on only one side. Opposite, on the west, there is a market place which doubles as a car park for tourists. It is dominated by a life-sized bronze of an Aubrac bull. During the sixties and seventies, beef, cheese and knives alike were threatened with extinction. Thirty years ago there was only one cutler, a Calmels descendant, left in Laguiole. A combination of self-help groups, local governmental and departmental interventions has subsequently and triumphantly turned round the place's eponymous industries. But while the cheese can only be made from local milk and the cattle cannot be crossed with other, alien breeds, the cutlers enjoy no such protection. They crave an *appellation contrôlée*. There is a particular animus towards the much larger cutlery town of Thiers in the Puy-de-Dome which, along with factories in Pakistan and China, continues to industrially produce 'Laguioles'. There is also a less than cordial relationship between the two biggest players in Laguiole itself, La Coutellerie de Laguiole and La Forge de Laguiole.

Their high-tech factories are next to each other on a mini-industrial estate on the village's edge. And that's all they have in common. La Forge's sleek, serpentine premises were designed by

the ubiquitous Philippe Starck, who has also 'reworked' the knife – other celeb cutlers commissioned by La Forge include Sonia Rykiel and the *ye-ye* singer Eddy Mitchell, France's second-oldest rocker who once led Les Chaussettes Noires. La Forge has thus attracted a deal of attention. But are these flashy riffs the real thing? Starck's are predictably attractive but they carry the wrong name, they recall such 'witty' gimmicks as fish cassoulets and satin duffel coats.

That, anyway, is the opinion of this Laguiole fan, who eats at home with nothing else. The appeal of the true Laguiole knife is that it sets its designer strict limits. Constraints are a trigger of imaginative ingenuity, and that's the quality that characterises La Coutellerie's work, and indeed that of the majority of local artisans. Attempting to apply art to craft objects blights them. The joy of Laguiole knives is in their tiny deviations: they remind me of army officers, no two of whom dress identically, yet they're still recognisably in uniform. (2004)

Small worlds

On a prominent hillside three kilometres from where I live, there stands a half-built house: roof, unrendered breeze-block walls, apertures for windows. And that's as far as it got. Nonetheless it's evident that it is not yet another pseudo-vernacular 'pavilion' of the sort that pocks France like an unstemmable rash. It is well-proportioned, austere, architecturally meritorious. The lintel above the front door is incised 1998. I asked various neighbours about it. What is its story? Why was it abandoned? This prompted bemusement. No one appeared to have even noticed it. But, I insisted, you must have seen it, above Les Ouches, just the other side of Boresse. Aah, Boresse – that's a different commune. Eight kilometres beyond Boresse is a nationally, perhaps internationally, celebrated outsider art site, a house and its environs littered with the possibly psychotic

works of Lucien Favreau (1912–90), a disciple of Le Facteur Cheval. Our gardener, who has lived here all her life, thought she might possibly have heard of it but wasn't really sure . . .

These instances of incuriosity and hyper-parochialism are replayed in countless guises. They are indicative of the extreme atomisation which characterises France, a country (maybe not quite the word) of uneliding cuisines, dislocated cultures, mutually incomprehensible accents, parallel lexicons, micro-fiefdoms, secessionist longings, separate developments. A country whose authorised version proclaims a republican homogeneity and the unity of the hexagon. According to this official lie – which the press, irrespective of political affiliation, connives with – there is the individual and there is the state, and that's that.

The actuality, however, is as factional as Britain, with a kindredly thriving special-pleading industry. It is, of course, claimed that minoritarian bullies don't exist, indeed cannot exist because this is indivisible France. But France has insouciantly succumbed to the Anglo-Saxon and northern European models it professes to despise, those of multicultural diversity (vibrant! edgy!), gender politics, positive discrimination, self-censorship. Earlier this year at La Villette, after La Comédie-Française the most heavily funded arts venue in the country, there was a vast and exciting mixed exhibition called Kréyol Factory. My friend Sokari Douglas-Camp – born in Yoruba-speaking Nigeria, educated in England, studio in south London – had one of her inimitably potent sculptures in it. I wondered what her work had to do with that of, say, Kinshasa-born, French-speaking, Belgian-based photographers or Antillais painters practising in Marseille, or . . . Got it! Skin colour. This in a country that boasts of its 'colour blindness'.

The interior minister Brice Hortefeux may trot out his wishful mantra that there is no place for *communautarisme* in France, but, regrettably, there is, whether he likes it or not. And the executive of which he is part is, in the instance of this exhibition, fomenting it.

It is, besides, profoundly ahistorical to ignore the degree to which tribalism shaped modern France. The legacy of that tribalism thrives in a country which is more wedded to tradition than neo-philiac England, and it has been exacerbated by post-colonial immigration which is not, incidentally, code for Muslims whose annual festival of car burning may be dismal, but is still a world away from the genocidal dreams of their British bruvs: the country's socio-political complexion was as much changed by the pied-noir exodus from Algeria in 1961–62. Almost half a century on, the children and grandchildren of the deracinated *colons* still consider themselves the victims of the state's injurious betrayal, and thus members of a particular caste which receives about as much sympathy as Serbs or the Orange Order.

The tendency to identify oneself through a group is all too human. Clumsily monolithic republican utopianism, far from extinguishing it, has had the opposite effect. The group may be based in political allegiance or religious belief, in place, profession, race and skin colour (which are, evidently, not coterminous), club, sexual proclivity, entitlement grudge, language. Thus you define yourself as, say, (a) bisexual and *échangiste*, (b) Leninist, (c) wind-surfer, (d) award-winning pet relooker, (e) creative director of Roucas Blanc's prestigious Gentleman Dog, (e) not Marseillais because you were born 30 km away in Cassis to parents from Colomb-Béchar, (f) *verlan* speaking. After that inventory of characteristics do you have the time or the will to be French, let alone European? Whatever European means.

With the exception of the gleefully contrarian weekly review *Marianne*, which puts in the boot irrespective of party or faith, the press doggedly refuses to acknowledge the majority's degree of Euroscepticism (or indifference) manifest in the 2005 referendum, which revealed, embarrassingly, that the sole consistently Europhil-iac region is aspirantly secessionist Brittany. And the best-known

politicians to challenge the abuses of the Brussels dictatorship – Philippe de Villiers, Laurent Fabius and the dotard Jean-Marie Le Pen – are today peripheral figures.

The mainstream political consensus is out of step with the populace, just as it is in England. Even French agriculture has turned Europhobic as Brussels has developed the unhappy habit of decreeing that many French governmental subsidies to fruit and veg producers are illegal. 'Europe' was a fecund teat. When it becomes a desiccated dug it is less enticing. Its adoption of English as its official language has further alienated the French who, when they do look beyond their commune or special interest group, see *la grande Francophonie*, the linguistically determined association of west African gangster states, the Maghreb, Indian ocean islands, Quebec, Vietnam, etc. This is, perhaps, more than France's commonwealth. It is its de facto colonial empire. (2009)

Time doesn't heal

Fifty years ago, on Sunday 8 April 1962, France voted in a referendum on the Evian Accords, agreed three weeks previously by representatives of Charles de Gaulle's government and representatives of Algeria's government-in-waiting. The referendum enthusiastically ratified the treaty, a foregone conclusion. Three months later Algeria would become independent. The gruesome war of liberation – fomented by the suppression of nationalist manifestations in May 1945 and unabated since 1954 – was at last over.

That, anyway, is the official version, the happily received idea which, in the way of such things, omits a multitude of uncomfortable truths. The people who would be most affected by France's withdrawal were disenfranchised. They had no say in their future: such was de Gaulle's arrogant will.

This vainglorious ingrate despised not only the British. He was also contemptuous of a swathe of his compatriots, the little people, the unimportant people, the cosmopolitan *pieds noirs*: over a million Alsaciens and Sicilians, Bretons and Catalans whose families had been in Algeria for a mere five generations, since the beginning of French colonial rule in 1830; Jews whose families had fled there when banished from the Iberian peninsula in 1492; Jews whose families had been there for a millennium, before the Islamic invasion.

And beyond these, the harkis, Muslims loyal to France who had opposed the murderous terrorists of the FLN (National Liberation Front). The murderous terrorists were now of course gloriously victorious freedom fighters: the difference between the massacre of the village of Melouza by the FLN and the massacres of Oradour-sur-Glane and Lidice by the SS is that the SS were on the losing side.

It was not to the Algerian people that independence was granted, but to a cadre of sanguinary gangsters who had eliminated all internal opposition. They were backed by a singular combination of Parisian fellow travellers, French-based Algerian extortionists, Nasser's secret service (which had actually given an exciting new start in life to numerous members of the SS), pan-Arab anti-Semites, British spooks and arms dealers, Islamophiliac Swiss bankers and the Soviet Union.

And to that list must be added the ignominious French state, whose shift of position was polar. Through the summer of 1962 it entered into an occluded alliance with the FLN. It ordered its troops not to intervene while harkis and *pieds noirs* were massacred as they tried to escape to a grotesquely inhospitable mainland France, which had been fed massive doses of misinformation and so believed the refugees to be racist pariahs, wealthy slave-drivers rather than dirt farmers and small-time functionaries: they were a

minority all right, but the wrong kind of minority in *bien pensant* eyes.

Further, the French state cold-bloodedly executed members of the OAS (Secret Army Organisation) which had, with the frail support of the CIA, attempted to fight the politically, if not militarily, lost cause of colonisation. At the same time the French state was granting amnesties to FLN bombers who had indiscriminately targeted civilians, and it was compounding its treachery by refusing asylum to thousands of harkis, thus condemning them to certain death at the hands of the FLN, which had by now purged itself of its moderate wing.

The moral inversions of those years were disgusting. Little has changed. Fifty years is not long enough for a suppurating wound to heal. The war is not over.

This unhappy anniversary has spawned an industry. As though obeying some statute, every newspaper and magazine in France has produced a special edition or a supplement dedicated to decapitations, slit throats, burning buildings. Every television channel has done the same: monochrome footage of guerrillas training in the mountains, instruments of torture, piles of bodies, rookies barely old enough to shave frisking djellabas, ambushes, the desperate attempt to lead a normal life at the beach, at clubs dancing the Madison. And then there are the hours and hours of talking heads, sparring excitably but refusing to say the unsayable.

The problem is that France's Delta squadrons of philosophers, free-range intellectuals and polemical historians are, with a few exceptions, wary and self-censoring. Although they would never admit it, they are crippled by political correctness, an affliction they ascribe to Anglo-Saxons. This may be due to their wishing to hang on to their university posts.

This tendency was particularly evident at a three-day colloquium at the National Theatre of Marseille organised by *Marianne*, a

weekly magazine which lurches from investigative rigour to infantile leftism, from smug spite to passionate defences of the indefensible. It is, perhaps too calculatedly, a leader of the awkward squad. But among the impressive *galère* of speakers it had assembled there were few who were genuinely awkward, who deviated from *la pensée unique*, the standard-issue take, the received orthodoxy. There was little sign of anyone who failed to subscribe to what in the UK would be termed the Guardian World View™. Had the right of centre refused to show up? Or had it not been invited? The absence of such voices – which would of course have been lambasted as '*facho*' – resulted in the usual Festival of Liberal Guilt.

Thus:

a) the crimes of the European colonist are necessarily graver than those of the North African; there is positive discrimination in favour of the Muslim torturer because he is inflicting electric shocks in the cause of freedom;

b) there exists a generalised Whiggish, historicist assertion of decolonisation's inevitability.

Bernard-Henry Lévy actually challenged the first of these. He was on stage with Zohra Drif, whom the mediator, *Marianne*'s editorial director, introduced as an Algerian senator, a witness to the revolution and to the birth of a new nation, etc. He omitted the most salient point about this smirking old hag. An elderly man in the audience was less reticent. He stood up and yelled: 'You are a war criminal. You murdered children.' Liberals can't get along without bouncers; half a dozen thicknecks pounced on this person, this little person, this unimportant person.

Fifty years on, such voices still don't count, the politico-journalistic establishment is not interested in them. Zohra Drif is a murderer. On 30 September 1956 she planted a bomb in a café called the Milk Bar in central Algiers. Several people died, dozens were injured and maimed. Lévy seemed increasingly disgusted to be in the presence

of this woman. In an echo of Albert Camus's *Les Justes* (The Righteous) he allowed, questionably, that the cause she espoused was unexceptionable but that her means were barbarous. Unfazed, untouched, unfeeling, she replied that she was at war. One of her victims was in the audience: Danielle Michel-Chich, who was five at the time, lost a leg. Her grandmother was killed. She wrote a book called *Letter to Zohra D.* This was the first time they had been in a room together in fifty-six years. Madame Michel-Chich was dignity herself.

Unlike, say, William Calley, who has repented for My Lai, Drif chillingly and wickedly told her victim that she should be addressing herself to the French state, which was ultimately responsible for her terrible injuries. A moral coward, then, as well as a physical coward. As though she were an automaton lacking free will, Drif abjured all responsibility for her actions. It was France's fault. Here was Algeria's conviction of its victimhood and its manifold failures played out at a subhuman level. All the country's woes are due to its having been a colony fifty years ago: in its proud self-determination it searches for a scapegoat and settles on the obvious one.

The Algerian novelist Boualem Sansal has bravely written that his country resembles Nazi Germany: 'militarisation, brain-washing, falsified history, racial supremacy, a Manichean vision of the world, a predisposition to victimisation, persistent allegations of a plot against the nation (Israel, America and France are each in turn evoked by the state when it's in a tight spot – and sometimes Morocco), xenophobia, racism and anti-Semitism dignified as dogmas, the cult of the heroes and martyrs, the cult of the glorious leader, ubiquitous police and informers, soaring speeches, mass movements, mass rallies, religious aggression, incessant propaganda, thought destroyed by cant, megalomaniac projects as expressions of power . . .'

That is what Drif killed for.

The unsayable must be said. The FLN had been defeated. Granting independence was a political act unforced by military exigency. Algeria could have remained French in the way that New Caledonia and Réunion have. A sensible French government would have granted the Arab/Berber population the same rights as the rest of its citizens. Its young people might then not have wanted to leave in droves. A non-future in the *banlieues* of French cities is adjudged preferable to a non-future at home.

But this is, as I say, unsayable. A couple of hours after Drif had uttered her squalid denial of responsibility in Marseille Jean-Pax Méfret took to the stage at Olympia, the most celebrated of Paris's variety theatres. Méfret is a writer, journalist and singer. He was also the youngest member of the OAS to be imprisoned. He has become the poet of the French Algerian diaspora: wistful rather than angry, regretful but far from hateful.

It goes without saying that no radio station, no magazine, no newspaper (not even *Le Figaro* whose magazine he wrote for and edited) mentioned this concert. Méfret is beyond the pale. Free speech is one thing – but it has limits, it is subject to consensual accords. Mustn't upset the applecart. (2012)

So mot juste

The Marseille politician Eugène Caselli is deservedly nicknamed 'Brushing'. This is not a moniker that is intended to flatter. *Un brushing* is a blow-dry. It's an everyday French word whose meaning is liable to puzzle the anglophone. There are countless instances of such borrowings or thefts. It's a commonplace that languages infect each other. It's not peculiar to French. What is peculiar to France is the size of its appetite for English words. What is further peculiar is the dogged Canutism of a certain stratum of French society which quite fails to acknowledge that languages are mongrel organisms

347

and that the idea of purity is as unachievable as it is undesirable. Deporting Roma is a piece of cake compared with deporting buzz-words and ginchy phrases.

The most recent voice raised against verbal immigration is that of the media-friendly philosopher and all-purpose octogenarian sage Michel Serres, who in an interview with LaDépêche.fr has helpfully noted that 'There are more English words on Toulouse's walls than there were German ones during the occupation. So: who are the collaborators?' This is a question worth asking. France in 1944 was a nation of 40 million people of whom 45 million had been *résistants*. Today it is a nation of 65 million people, none of whom will own up to linguistic torts. Serres' position seems particularly dicey since he is a sort of digital Candide, convinced that the technological revolution of the past couple of decades will fundamentally alter humankind and alter it for the better. Quite how this accords with lexical cleansing of the Western world's lingua franca he does not vouchsafe. And when he proposes that France should go on strike and boycott manufacturers who use English in their advertisements he is pissing in the wind.

No matter: there are few greater crowd pleasers in France than vilifications of English's insidious march. Yet the pleased crowd is happy to watch as the march continues. The preposterous 'royal expert' Stéphane Bern insists on calling the Duchess of Cambridge 'Catherine-Kate'. Legions of journalists and copywriters create such formulae as 'inspirations design' and 'shopping trendy' and 'le fast-food'. 'So' is used ubiquitously – so arty, so frenchy, so London, so grunge. The latest edition of *Le Figaro Magazine* has on its cover 'Jean Rochefort Gentleman Français'; presumably no one at the paper knows that the only people in London who would write the word gentleman are Jermyn Street PRs. The English are routinely referred to as *les fuck-offs*: slang has a spirited wit which the cataract of feeble bilingual puns lacks.

As a *fuck-off* I should doubtless react to Serres' silly wishfulness with gloating smugness. After all, English – OK, American – has triumphed, hasn't it? I wonder. As soon as a French person realises that you are English, they will attempt to speak English, or rather to speak the five or so words of English they know. When you reply in some of the 5,000 words of French you know, they will be furiously attentive, waiting to catch you out and correct your usage, pronunciation, the gender of a noun *und so weiter*.

What kind of triumph is it for English to be massacred, day in day out, by a nation whose touchiness about its own language is near-pathological? The French attitude towards English is pretty much akin to its attitude towards anything that comes from elsewhere. That is to say, it may be jolly good but it would be better if it were French. This applies to cultural artefacts, to cooking and, above all, to people. Provided the immigrant to France dresses, behaves, speaks, thinks like the French (whatever that means), he or she is welcome no matter what race or colour or religion. This, again, is silly wishfulness, but it is the silly wishfulness upon which the values of the republic are founded. Serres' dotty proposal is, then, merely an expression of national mythology. (2013)

The judgement of Paris

The French for French-bashing is *le French bashing*. This verbally costive nation is at it once again, torpidly borrowing an approximately English expression rather than coining its own. Such bashing is not an exclusively Anglo-Saxon practice. There is indigenous bashing. At least there is Éric Zemmour, whose salutary *Le Suicide français* was published a couple of months ago. Its very first sentence declares that France is the sick man of Europe – which prompted Manuel Valls, little Hollande's prime minister this week and a man who is not growing into that poisoned office, to take the bait,

exhibit a preposterously thin skin and denounce the book twice in a few days.

This is not to suggest that Zemmour – a tireless stirrer, an exhilarating hater, a man for whom giving offence is a duty – is necessarily on the money about everything. His exhaustive trawl through France's maladies and imaginary maladies is more notable for its provenance than for its originality. What distinguishes it is that it comes from within the Hexagon. It is Made in France. Elsewhere – in America, Germany, England, even Italy – such a gleefully gloomy discourse is *la pensée unique* (consensual non-think – the French do have an expression for this).

Like some pamphleteering guerrilla, Zemmour prosecutes *ad hominem* attacks on the chest-waxer-supreme Bernard-Henri Lévy, the sinister Mitterrand, the comical stage villain Jean-Noël Guérini, the folksy green agitator José Bové ('a useful idiot'). He cites popular singers as gauges of mores – a disputable strategy at best. He castigates what George Walden has characterised as the elitism of the anti-elites. The anti-racist, anti-homophobe, anti-Islamophobe, anti-fascist establishment may be a sitting duck, but that doesn't deter Zemmour from giving it both barrels. He is scornfully contemptuous of the many fellow travellers who (still) seek to mitigate the exterminatory crimes of the left.

Can a great country really have descended to the level that a cosmopolitan band of bashers and Zemmour insistently claim it has? He rues Paris's status as – sloppy but useful epithet – a 'world city' and the consequent chasm between it and the rest of France. However, the political and social life of the de facto secessionist capital seems to be all that he knows. And, like France's critics from without, he insouciantly makes it stand for the entire country.

Zemmour's work apart, Paris's most shrilly mediated cultural events this autumn ('prestigious', 'landmark', 'world-class') were the reopening, after five years, of the Musée Picasso in the Marais and,

eclipsing it, the launch of the Fondation Louis Vuitton in the Bois de Boulogne. This latter is yet another of Frank Gehry's exercises in outsize origami. Post-industrial rustbucket cities on autopilot call for architects such as Gehry, Foster, Koolhaas, Calatrava to design them out of trouble.

But Paris is not a post-industrial rustbucket. By stooping to apply an unproven remedy deemed appropriate to Metz, Walsall, Salford and Liège, it demeans itself. Far from being some sort of solution to Paris's malaise – can there be any city in the world that less needs another gallery or museum? – it is a symptom of the city's nervy lack of confidence.

The building is in flagrant breach of the strict planning prescriptions formerly applied in the area. But then Bernard Arnault, its instigator, is the richest man in France – a 'philanthropist', a friend of presidents, a witness at Sarkozy's second marriage. Little Hollande got the tone spot on when he described this masterwork as 'a cloud of culture in the Parisian sky'. The contorted piles of vitrous bling rise high above the trees. The very myopic may just about discern a vague correspondence with Charles Letrosne's similarly incongruous Grand Rocher at Vincennes zoo on the other side of Paris. Just about . . .

It is a vanity project, so is evidently obliged to be ostentatious. Its connection to Paris, which is mostly characterised by architectural reticence and courteous homogeneity, is tenuous. It might be in any city where a member of the Croesus community could get away with it and invite the titans Anna Wintour and Karl Lagerfeld to the opening. No one has even bothered to attach to it the routinely mendacious claim that this fabulously spendthrift toy will incite that most elusive of elixirs, 'regeneration'. It won't. A transsexual hooker working the avenues of the Bois de Boulogne will still have to blow 140 johns per week for 500 years to earn the €130 million that this clumsy boast cost. It is rash to judge an entire country by

the comings, goings and hothouse gossip of *le microcosme*, by tax dodgers and rich men's follies, by *ze people* (slebs) such as the rancorous former First Bimbo and, on the other hand, across the ring road, the tooled-up rabble battalions of Seine-St-Denis.

Forty years ago the young Michel Sardou sang of metropolitan snobbery towards *la brousse*: '*il y a Paris / mais la France est aussi un pays / Où il y a quand même pas cinquante millions d'abrutis* [morons]'. Today that snobbery has been replaced by defensive anxiety. (2014)

Man of *les people*

Revolution Française: Emmanuel Macron and the Quest to Reinvent a Nation by Sophie Pedder

In 2011 Emmanuel Macron, no stranger to statements of the obvious, wrote in *Esprit*: 'Everything ought not to be expected of one man. The 2012 presidential election will no more deliver us a demiurge, a mechanic of the universe, than any previous election has . . . The reconstruction of responsible politics cannot be effected by personal charisma, by a compact between an absolutist and his people.'

It is, of course, difficult to imagine anyone less like a demiurge than François Hollande, the excitingly pudding-like small-town lothario who got the socialist nomination in a *faute de mieux*-ish way because Dominique Strauss-Kahn (bizarrely endowed by Sophie Pedder with 'rock star appeal') went just a tiny bit too far in a New York hotel room. Hollande, then, won because his opponent was the incumbent Nicolas Sarkozy. Luck was with Hollande, just as it would be with the keen young Macron, who had thrown in his lot with Hollande after being courted by both Sarkozy and DSK. Macron rose and rose before shafting his patron when the latter's popularity rating had free-fallen to 4 per cent.

In cafés, in friends' apartments and in his own apartment (bought with a 'loan' from one of his many 'mentors', the late businessman

Henry Hermand) he conspired to form a party, En Marche (now LREM), a mix of campaign machine and self-advertisement. He convinced thousands of teenagers and young adults to doorstep on his behalf. This smartphoned volunteer force of Macron Jugend went in the face of conventional French wisdom that such a form of targeted canvassing was intrusive and ineffective; but conventional French wisdom had been founded long ago in the Dark Ages, before the demographic uses of social media were apparent. France was a latecomer to the digital party, handicapped by its reluctance to abandon Minitel, a system every bit as successful as Betamax.

Macron had further convinced his followers – clearly a dangerously credulous bunch – that he was a *métèque*, a pejorative, racist word by which he probably intended something like 'mongrel'. He was, supposedly, an outsider to the farcically corrupt and properly despised *classe politico-médiatique*: is there any politician anywhere that does not present itself as an outsider, an anti-elitist, an opponent of the establishment? This has been standard-issue political mendacity since the advent of Bomber Blair: if we are to take the word of these power-hungry prefects, there are no insiders left. It's akin to *The Man Who Was Thursday*.

Nonetheless, it was quite a feat of legerdemain for Macron, who is an *énarque*, a sometime inspector of finances, a Rothschilds banker and deal maker, a greedy accumulator of offices, a ministerial adviser (or, according to his many enemies, 'an intern') promoted to minister and evidently an adept of *pantouflage*, a negotiator of revolving doors who obtained the bulk of his party's funding from businesses and corporations which he publicly lambasted but with whose higher echelons he had connected very well indeed and whose interests he looks after. He also has a promiscuous fondness for *les people* (airhead showbiz celebrities).

It might be said, as it always is, that he made his own luck. But he can have had no control over the minister for economic recovery,

Arnaud Montebourg, who broke ranks to publicly criticise Hollande's splendidly humourless prime minister Manual Valls – nor, for that matter, can Montebourg have had much control since he was probably drunk at the time. Macron was the beneficiary of Montebourg's dismissal. Appointed in his stead, he became known for the first time to the public.

A far greater stroke of luck was the fall of François Fillon, the favourite to win the 2017 presidential, a rightish Catholic placeman whose main achievement as Sarkozy's prime minister had been to keep his head down and not appear too complicit in that president's caprices. His decades-long peculation of public money, paying his alarming sinecurist wife and school-age children as 'aides', was exposed when he was ahead in the polls and appeared likely to win the presidency. His nemesis was *Le Canard Enchaîné*. The paper grassed him up. Was this Macron's lucky break? Or was it down to opportunistic cunning? Where did the paper get its information? The timing would suggest that Macron and his accomplices were behind the detailed revelations which can only have come from somewhere near the heart of government. The hyper-Tartuffe Fillon's exposure cleared the way for him, for victory and for one of those things that comes round twice every decade called 'a new beginning'.

A year on, a 'popular tide' is mobilising. It is partly whipped up by the unions, partly by the leftist bully boy Jean-Luc Mélenchon (yet another self-proclaimed outsider), partly by Macron himself. He makes tactless gaffes, preposterously suggesting, for instance, that the French should not complain about cuts in housing allowances when they could act like the heroic Colonel Arnaud Beltrame who exchanged himself for a hostage in a terrorist attack near Carcassonne and paid with his life. He lacks empathy with all but the wealthy and has no grasp of the struggles faced by the majority of his *concitoyens*, whom he patronises as his subjects. Effigies of him are being burned in the streets, placards showing him dressed in SS

uniform (with, predictably, an unordained Israeli armband) are held high in demonstrations all over the country and the polls show his popularity declining – but that goes with the job; he is actually marginally more popular than Sarkozy and Hollande were at the same stage of their presidency. Both, note, enjoyed but a single *quinquennat*. And it seems likely that Macron will suffer the same fate.

According to Martin Rowson: 'It's his face: the grinning mad-eyed look of the teenage nutcase who's going to fuck the teacher and get ahead.' Sophie Pedder's Macron is, unastonishingly, a rather different creature – or creatures, a complicated gamut of contradictions whose obsessions include being taken for a statesman, spending 9,000 euros a month on his make-up consultant and gauging the meaning of his every heavy-handed gesture. The day he announced his candidature he went to the Basilica of Saint-Denis where kings and queens are buried. The symbols of office, French history and myth, a Barrès-lite mysticism, the ties of national indivisibility, grandiloquent shows of duty, international prestige – these seem to preoccupy him in a way that quotidian matters don't. They are beneath him. It's as though his solipsism enables him to inhabit some higher plane, a place of exceptionality, in signal contrast to his immediate predecessor. How this goes down in the grim *corons* of the Pas de Calais and the HLMs of Bobigny is not hard to guess.

Pedder has been *The Economist*'s bureau chief in Paris since Chirac presided. Leave aside her gift for pitch-perfect journalese and novelettish description; she is formidably knowledgeable, can find her way through the labyrinth of ministries and functionaries, is fluent in Macronese, is perhaps somewhat in awe of the man and certainly shares his enthusiasm for digital start-ups, which may not be quite the panacea France needs. She has interviewed him several times and obviously writes with sufficient lack of animus to get herself invited back.

This is not to say that she is a journalistic *beni-oui-oui*, a yes-woman. Macron tends to surround himself with such people. He

might have taken to heart George Harrison's observation: 'It's better to have yes-men than no-men.' There is, then, little brake on Macron's impetuosity. Pedder possesses a marked discretion that he lacks: 'Macron's haste and ambition lead him to push too hard in ways that are divisive.' Too right. His ability to alienate, for instance, white bluecollars and boondocks smallholders marks him as either clumsy or negligent. His duplicity when, as a representative of Rothschilds, he was negotiating the sale of the near-bankrupt newspaper *Le Monde* suggests a moral infirmity. A current gag goes like this: Macron has two kinds of supporters. The rich and the idiotic. Which kind are you? Check your bank balance to find out. He is routinely derided as Napoleon III and as Badinguet, a name with a variety of folk etymologies which was given to the future emperor when he escaped from prison and which was extended to Eugénie, Badinguette.

The one person he listens to is his ever-smiling wife on whose behalf he self-importantly militated in order that she might be officially pronounced *Première Dame*. Nothing doing. Pascal Bruckner, the no longer *nouveau philosophe*, calls her, with unusual lack of originality, '*l'éminence grise*'. In this guise she was probably responsible for her husband's cravenly bathetic performance at Johnny Hallyday's funeral, several minutes of high-octane drivel which caused the insentient to weep and the sentient to wince. Pedder amiably describes it as 'both romantic and deeply calculating'. The same might be said of any number of populist, lush, intellectually void spectacles which offer no more than temporary relief, temporary communion. They are mere diversions. They are his forte. Chislehurst awaits. (2018)

The LVMH prayer

The predictably gruesome sideshow provided by 'luxury' goods billionaires, brand-name bling-mongers and friends of Emmanuel Macron in competition with one another to throw money at Notre

Dame's restoration will continue even when they have all boasted that they will big-heartedly abjure the tax breaks available for 'cultural' donations under a 2003 law. This law informally bears the name of Jean-Jacques Aillagon, aka the Man in the Revolving Door. A culture minister under Chirac, he is now employed by the Pinault family to administer its fashion-led art collection.

It is inconceivable that the Pinaults, the Arnaults, the Bettencourts and the rest of the Maecenas mob (*Christie's Magazine passim*) will not demand some say in how their money is spent. It is equally inconceivable that they will ever admit that their gifts come with strings attached. They are going to want at least a chantry each.

Aillagon has retracted his knee-jerk demand to the government to increase tax breaks to 90 per cent. This is a time when there is weekly civil disobedience by gilets jaunes, ultra jaunes, black blocs and rent-a-mob international. They do not share in the supposed National Outpouring. Why would they? The urgency of the governmental reaction to the fire has been a further incitement to riot. Aillagon's lack of empathy and cloth ear for the collective mood briefly outdid even Macron's.

Aillagon's precipitous interference is an indication of how the ashes of the cathedral are going to become the site of a proxy struggle between some of the greatest fortunes on the planet including, presumably, the Catholic church, whose war chest for the defence of priests could pay for the repairs. Why the government of a secular state should pay for a cult's building is yet to be explained. Besides, Notre Dame is only important from a Shakespeare's-birthplace point of view. Architecturally it is a nullity beside the cathedrals of Beauvais and Laon, Albi and Marseille, Rouen and Clermont Ferrand (a sinister marvel of black tufa).

The struggle will begin with the architectural competition announced by the widely loathed Macron and the so far less loathed PM Édouard Philippe. How will the competition be conducted?

Who will select the committee that will select the committee that selects the architect or engineer whose name will get attached to the building, like Viollet-le-Duc, who restored it in the mid-nineteenth century with all the nous of a medieval surveyor enjoying the good fortune to live under the July monarchy.

William Burges, an architect of genius, described Viollet as 'a great scholar, an average architect and a disastrous restorationist' – a verdict which ought to be recalled by that constituency which demands Notre Dame should be rebuilt just as it was. Just as it was when? With the exceptions of Salisbury and Amiens, the great cathedrals have been built over many centuries in many styles: they are accretive collages. It should, however, also be recalled that Viollet, unlike both his Tractarian British contemporaries and the aesthete Burges, was a rationalist: restoration was precisely *not* copying what had once been there and was now destroyed. It was the 're-establishment of a structure as it had never been before': in other words, just as it wasn't.

He was a technocrat *avant la lettre* who considered the Gothic to be a programmatic system of building rather than a sacred duty. An evidently inanimate system of minerals to which feeling, memory, national outpouring, godliness, beneficence, etc. cannot possibly be ascribed – save by those who do so. From a practical point of view, the obstruction to an imitative restoration is that France, like any modern country, currently suffers a shortage of highly trained medieval construction workers.

So Philippe and Macron spoke of the restoration taking into account 'today's techniques and knowledge' and being achieved 'within five years': where will they be then? They happily admitted that France is no longer a land of wandering masons from la Creuse. There are indeed hardly enough craftsmen to maintain historic structures in normal circumstances, structures which are in perpetual mutation and, in many instances, fakes of themselves, so

comprehensively have they been worked on. All this hints at a bias towards an architecture that looks gingerly forward.

The Gothic does not have to be wrought of limestone, wood, alabaster and *lauzes*. Viollet militated for iron as a building material, though he didn't use it as successfully as Victor Baltard, whose Halles were destroyed in the seventies but whose splendidly gross Saint-Augustin remains.

Artisan drought aside, the major hurdle to 'just as it was' will be the nationwide, perhaps worldwide scream of accusatory architects: 'Pastiche!' The architectural doxa decrees that pastiche is a Very Bad Thing Indeed. The collective convention forgets the history of architecture is the history of pastiche and theft: von Klenze's Walhalla above the Danube is based on the Parthenon; G. G. Scott's St Pancras borrows from Flemish cloth halls; Arras's great squares are imitations of themselves. It forgets, too, that after a few decades the bogus ape becomes indistinguishable from the authentic ape, which of course may not be all that authentic: how far back do you have to go before you strike the very kernel of authenticity?

The cultural objection to pastiche is that through the century and a quarter of modernism's paramountcy, architects, a flocking species, have seldom dared to diverge, egregiously, from the mainstream, which is nothing more than the old avant-garde without the built-in shocks. Those who have excepted themselves and have broken rank tend to be stubbornly eccentric or unconcerned about making a living, even though they are perhaps more in touch with the tastes of the happily unreflective creatures patronised as 'ordinary people' who enjoy fantasies, follies, Mariolatrous kitsch and Poundbury.

Macron's overworked catchphrase '*en même temps*' translates architecturally into the 'both . . . and . . .' of postmodernism's harbinger Robert Venturi and the 'unity by inclusion' of the Scottish ecclesiastical architect Ninian Comper. It can be read as a recipe for polite

compromise or for an exuberant maximalism. The fire is extinguished but the fire goes on. It has legs. It is a god-given PR opportunity for a wobbling yet obdurate president – if he can work out how to seize it. Given that he only raises his head from the sand to demonstrate how out of touch he is, it's likely he won't. His latest dumb wheeze, the proposed dissolution of the Ecole Nationale d'Administration, of which he is himself an alumnus, has met in the polls with 80 per cent hostility. It has been rumbled as a crudely tokenistic gesture of anti-elitism by the elite of elites.

The rebuilding cannot risk such dodgy populism. It's meant to last. Between the stylistic (and political) poles of copyist fidelity to the structure as it was till the early evening of 15 April and, say, the titanium scrapyards of Frank Gehry (Arnault's man), there are countless options of idiom and strategy, and there'll be countless interests promoting them. One option that will not be explored despite its romantic appeal is that of leaving it ruinous so that nature can assert itself – but with nature in cities there come crack pipes and used needles.

It appears that no bookie is yet offering prices on the potential contenders for this prize. Here are a couple of punts:

Long odds: the New Yorker Mark Foster Gage is a farouche outsider, the most decoratively radical architect at work today; he has revived the lavish tradition of Burges, Gaudí and Coppede.

Odds on: the exemplary model for how to proceed is 500 miles due south of Paris. The Millau Viaduct is the greatest Gothic structure of the past century: the clusters of cables form diaphanous spires. It's an anthology of superlatives: highest, best, most startlingly beautiful. It took a mere three years to build. The combined ages of its creators, the engineer Michel Virlogeux and the architect Milord Foster of Thames Bank, is a mere 155 years. They're kids. Let them get on with it. (2019)

All the president's man

Among the traditional duties that fall to French ministers is the denial that the government is running a clandestine paramilitary force. Here, for instance, is Roger Frey addressing l'Assemblée Nationale in 1966, a few months after he was implicated (if only through dereliction) in the disappearance of Ben Barka: 'I solemnly swear, once and for all, that there is not a parallel police force in France. These odious calumnies must cease, these tales of *barbouzes* . . .'

Ah! The *barbouzes*. The original *barbouzes* were the unaccountable mercenaries, including former French employees of the Gestapo, sent with Charles de Gaulle's connivance into Algiers and Oran in the winter of 1961–62 to extinguish the OAS (whose members included former *résistants*). They swiftly failed and crept back to the mainland licking their wounds. Frey himself dissolved them as early as February 1962. They had never existed.

Over the past several months there has been talk of neo-*barbouzes* lurking in the Elysée's corridors. The star exhibit has of course been Emmanuel Macron's buddy and sometime bodyguard Alexandre Benalla, né Maroine Benalla: under the law of 25 October 1972 his mother had every right to frenchify his name. Online foot soldiers of the Rassemblement National (formerly FN) like to believe, wrongly, that his natal name was Lahcène Benahlia: they appear not to notice that they themselves are using pseudonyms. This nomenclatural racism is a tiresome diversion from the many plots and freelance delinquencies to which Benalla is supposedly connected.

France hasn't enjoyed such a festival of bodyguard conspiracies since Alain Delon's former hard man and gofer Stevan Marković was found in a state of decomposition on a municipal dump in the Yvelines over half a century ago. Marković was fingered, on flimsy evidence, as a spy for Tito and, more convincingly, as a blackmailer

in possession of sexually explicit photos, claimed to be of the president's wife Claude Pompidou. Predictably enough, Benalla has been accused of being in the pay of the Moroccan secret service. Both his parents came from that country so, as night follows day, he is bound to be a spook run by Rabat.

These extravagances occlude rather graver matters: how the Elysée is managed; the derogation of protocols dictating the way appointments are made; the three-way struggle to be the agency that protects the president; the president's inviolability; diplomacy on the black; the dangerous scent of absolutism; the separation of the man from the office he holds; immunity or at least protection for favourites and members of the kitchen cabinet. And Benalla is closer to the epicentre of power than a gangster like Marković could ever have hoped to be: Delon may be a (former) god but he was never president of the republic.

Benalla has a boysy, flirty if somewhat rebarbative relationship with Macron, telling him when he needs a haircut, skiing and sledging with him. It was no problem, then, to obtain a diplomatic passport – which, after his arrest for impersonating a police officer and assaulting a protest kid, he was meant to have handed in along with his firearms (he has those too). But when you connect as well as Benalla, such matters are paltry. As his latest patron, the Israeli businessman and operator Philippe Hababou Solomon says: 'When you arrive in a country where you're going to be with the rulers, the etiquette is that you're met at the airport and all the formalities are taken care of . . . Visa, no visa . . . it makes no difference. Me, I travel on a Guinée-Bissau diplomatic passport.'

Last autumn Solomon and Benalla opened doors in Turkey and Israel for an Indonesian delegation wanting to invest in cybersecurity. In late November they were in Congo and then Chad, displaying their versatility by obtaining contracts for the supply of military uniforms. Whatever Benalla's real mission was, it is inescapable that

Macron was there a month later. It is also the case that, according to Solomon, Benalla was warned off conducting himself as though he were 'M'sieu Afrique from l'Elysée'.

Solomon declined to say who issued this warning, but there is every probability that it comes from the office of Franck Paris, Macron's adviser on African affairs. This is an important post. France has never really ceded its African interests. It still possesses a de facto colonial empire. Paris's distant predecessor Jacques Foccart advised four presidents from de Gaulle on, masterminded several coups, was widely regarded as one of the most powerful men in France, and 'invented' Françafrique, the model of dependent independence which Macron wishes to diminish. It is hardly surprising that the cautious Paris fears Benalla's clumsy interference. His heavy hands are everywhere, stirring with gung-ho recklessness. Even while awaiting to hear whether he is to be charged with perjury he has been in close contact with Macron, though with new friends in the oligarchy he is less beholden to the president than he was and evinces an increasing disrespect, scorning his reliance on technocrats, rather than on those creatures called 'real people', i.e. people like him.

To the fury of three already warring acronymic security agencies (GSPR, SDLP, GIGN), Benalla told the president that the man to succeed him as personal bodyguard was one Christian Guédon. Note this name, Macron did, and duly appointed him.

Ten years ago, Guédon dropped out of the GIGN. He paid no heed to that corps' motto, *s'engager pour la vie*. He went into private security in the Central African Republic, Mali and Gabon before setting up a sniper unit in Saudi Arabia and devising anti-piracy strategies in the Indian Ocean. His CV boasts, extraordinarily, of his skill at 'discreetly opening the locks of buildings and vehicles in pursuit of justice'. The lock picker and the president, the cowboy and the *énarque*, bond in the Elysée's basement gym, where they have regular boxing matches. (2019)

IO

Further Abroad

Belgium 1: Nouveau riches

I should have gone to Belgium when I was fourteen. I would have gone had my father not been so blithely contemptuous of the OAS's ability to detonate its *plastiques* that he refused to follow the example of my coevals' parents and cancel my pre-O-level exchange to France and send me to francophone Belgium instead – that was where my schoolfriends ended up. Me, I went to war: I mean, a bomb *did* go off in Lyon while I was there. Pitiful harassed, bewildered, homeless refugees were everywhere. It was the sight of them in their hundreds, maybe thousands, that made me *Algérie Francaise*. Even in the drab town of Belfort, where I spent part of that month, every wall was inscribed with nationalistic slogans, threats to de Gaulle, minatory warnings to those who would abandon Oran and Bizerte to *les bougnous*.

It wasn't much but it was enough: I returned to school and spun tales of explosions, roadblocks, martial manoeuvres; I'd witnessed fights in bars; I'd seen men jump from a black DS and haul a loiterer inside. All my schoolfriends could counter with was the habitual adolescent litany of beer, cigarettes, girls: fictions, I reckoned – and I didn't give Belgium another thought for more than ten years.

A different secret army was involved this time. One summer in the early seventies, the BBC transmitted a four-part film entitled *The Red Orchestra* about NKVD agents working in Germany and those countries occupied by the Reich before Hitler broke his pact with Stalin. The film was standard-issue Buchanery, all treachery and trench coats. It would have slipped the memory along with all the rest had it not been for its Bruxellois locations – streets of immensely variegated and inventive facades, terraces in which every house is different. I sat glued to the thing, ignoring the labyrinthine turns of the plot, seduced by the tireless architectural energy of the setting, overwhelmed by a serial tectonic epiphany.

You don't have to be in a building's presence to go ape for it. Von Klenze's Walhalla near Regensburg has haunted my dreams since I first clocked it on a tourist poster when I was sixteen. I've still never been there. But photographed buildings *are* qualified lies. The context (i.e. all but the immediate neighbours) is necessarily neglected. And it is invariably the atypical that is photographed: the firsts, the freaks, the famous – and the doctrinairely correct. Pevsnerian partiality tries to persuade us that there was a deterministic progress towards the modern movement; Watkinian propaganda tells us that classicism never died; tourist organisations mug with heritage. I torpidly assumed that *The Red Orchestra*'s designer and location finder must have scoured Brussels to discover settings of such unparalleled richness. Wrong. I've just returned from Belgium where I have been making a (sort of) documentary about, inter alia, suburban architecture: the only problems were the plethora of choice and the matter of indicating that what looks to English eyes rare, special and bizarre is the norm. It is as though all subsequent architects in London had paid heed to Nash, as though Barcelona was shaped exclusively by Gaudí's epigoni, as though Turin was entirely neo-Juvarra.

In Brussels you can just about shove down a camera on any corner, track along any street, find a visually fecund location with a pin

and a map. Brussels is the one city in Europe where the stuff that is familiar from books is actually characteristic of the whole. In the other great cities of art nouveau – Nancy, Genoa, Barcelona – the work on this idiom is still thin enough on the ground to be constantly surprising; in Brussels it is everywhere. The most outré of post-baroque styles (and the only one that derives from the baroque) is so prevalent that you might almost cease to wonder at it. Well, you might after decades of exposure to it – although I never cease to be enchanted by Nash, and I gaze on that peculative cuckold's stately opera, oh, two or three times each week. And Nash, in the set pieces I'm thinking of, tends to sameness.

Horta and Strauven and Van de Velde (the ones who make all the history books) and their countless contemporaries (who don't) were apparently competitive in their desire to be different – from each other, from their selves of the previous month, from the pan-global architectural bent towards copyism. Volitional egregiousness is what they strove for and what they passed down to future generations of their compatriot architects. If you thought England was insular . . . Belgian architecture has, for a century, fed off Belgian architecture.

Art nouveau had just about run its course by the outbreak of the First World War (brave little Belgium), but it was still there in the reaction to it. The primacy of originality went unchallenged even though the vocabulary changed and the gamut of decorative devices was drawn from a different hat. The men who wrought that reaction, Antoine Pompe and Fernand Bodson (no more known outside Belgium than Edgar Wood and Edward Prior are outside England), created, sometimes in partnership, a beguiling modern domestic architecture that was independent of both (a) the international modern movement and (b) the retro-cum-rustic gear of our own dear Arts and Crafts.

Their example was, in the inevitable Belgian way, duly followed: think anew every time, forget formulas, abjure style (in the imposed

rather than the Buffon sense). Of course there were 'imports': Pompe himself toyed with an amended Arts and Crafts mode; the expressionistic Amsterdam school had a marginal influence; De Stijl was evidently studied; here and there one comes across essays in art deco that look more American than European; there are cottagey garden suburbs that resemble, say, the Old Oak estate in East Acton. But the mainstream is peculiarly Belgian and, as I say, peculiarly unlike anywhere else.

This epithet can be extended to apply to the entire country, a country which Ian Nairn described as 'the most exotic in Europe'. He was in earnest, and he may very well have been correct. The sheer quality of the everyday strangeness is astonishing. Level crossings, trams, post boxes, Tintin – these lend the tiny nation a sort of toytown feel. Which is at odds with the boastful gigantism of its public buildings and the boorish eastern Europeanism of much of the short coast: Ostend has Baltic aspirations, although Bredene, beside it, has a prominently exposed fifteen-foot bronze statue of a naked, big-bottomed hippie chick with a Kevin Keegan hairdo.

Le Pays Noir, the industrial heart of Wallonia, really is black, as black as Dudley and Tipton and West Brom were twenty or thirty years ago, pre post-industrialism: Charleroi is a nightmarish forge of flames, smoke cumuli, swarf mountains, swart canals, slag heaps (*les terrils* – increase your word power). It recalls Wright of Derby's Coalbrookdale; it is primitive, elemental, spooky. The hydraulic boat-lifts on one of its canals would recall a very different artist, Heath Robinson, were they not so sensorily terrifying. In order to obviate a flight of, say, forty locks, boats enter metal basins which lift them the height of a house to the next stage of the toxic canal. Vertigo and hydrophobia meet in a cocktail of pure fear.

In the shadow of a steel mill I saw a new Fiat that had just been dredged from a canal basin; it looked drowned, it was smothered in oily mud the way Magritte's water victims are in constricting

sheets. The desolate morbidity of le Pays Noir may be frightening, but it is also exhilarating in its relentlessness; it is an apt backdrop for Belgian hearses bearing emphysematous bodies to harsh grave-yards. These hearses are magnificent, celebratory, and derive from plumed horses: they are bumper-size American station wagons, customised crow-black, fitted with gaudy roof lights in the shape of crowns and with, of course, plumes. They might belong to a deathly fairground. They would be unimaginable in England for they don't push mortality under the carpet; they might even be reckoned impious – is this a matter of mere style or of Protestant inhibition?

Belgian memorials to the dead of the First World War prompt the same question. In lieu of the sobriety and gravity of the War Graves Commission (e.g. Blomfield's Menin Gate at Ypres) you get an architecture that is flashy, futuristic, ostentatious and cinema-like – and which must induce a different sense of responses towards the muddy enormity, the spendthrift generals, the wanton waste.

I guess the most extreme example of this idiom is at Cointe above Liège. The blocky, stepped tower dominates much of that city. Immediately in front of it (and thus invisible from the valley of the Meuse below) is the caretaker's caravan. Behind it is a domed, vaguely Steineresque basilica, whose architect sued the architect of a similar church in the riverine city for plagiarism. Maybe this is why all Belgian buildings strive to be different from each other. Maybe the fear of litigation is the mother of Belgian invention.

Liège is the very obverse of the Belgium of the popular imagina-tion. That Belgium is all lace and crowstep gables and flatness; it is nederlandophone, stolid, thrifty; it is often emetically cute – Bruges is Bourton-on-the-Water run out of control. Liège is not flat; it is the steepest post-medieval city I have ever set eyes on. It is francophone and believes itself French – 14 July is celebrated widely; it is republican. It has the largest population of Italians of

any non-Italian city in Europe. It is famously bent, municipal corruption is a way of life – which may or may not be the reason why the greatest square in the city has been a building site for almost a decade. Its centre is like Soho-en-Meuse. It never sleeps. It has a bit of edge – which is sorely needed, for even the most entrenched bourgeois needs a place to bunk off to, to go wild in. A diet of inventive buildings and good cooking is never enough.

Good cooking in Belgium means, mostly, meat. The caricature of a nation that lives on mussels, chips and mayonnaise is just that – a caricature. And vegetarianism is so rare as to be aberrant, a dietary perversion. This is a country where fur coats are proudly worn, where Proddy squeamishness is unknown, where consumption is guiltless, where everything that moves is eaten. Although it's a pity they don't eat more of their canines – Brussels' pavements are thick with dog shit. Still, the news on the cat front is good – the meat of cats is sold as *lapin sans tête*. I didn't find any, but I did find some nice horse. I cooked it myself in the kitchen of Le Bierodrome in Ixelles.

Horses are not slaughtered at the Anderlecht abattoir. Everything else is. Joris Tiebout, one of the directors and a proselytiser for Belgian beef (provided it is from francophone kine), led us through his carnal empire, where the smell of blood is pervasive, where quadrupeds are abstracted and transformed, where muscles shiver posthumously and living things fulfil their no-choice fate as product. There are high-pressure hoses, screams, pelts discarded carelessly like eager lovers' clothes, offal garlands, pigs' hearts hanging like chandeliers, decorative duodenums, flags of mesentery, tripe drapes, pink bagpipes. I'm afraid I didn't suffer the normal human response – although it may be that the normal human response (an avowal of vegetarianism) is far from normal and the prerogative of those who habitually disassociate veal from calf, daube from ox, brain from lamb.

Opposite the abattoir and cattle market – an immense and soaring steel and glass structure of *c.*1890 – are a number of doggedly carnal restaurants to which one can retire for a spot of nosebag after seeing your lunch make its ultimate sacrifice. These places are far from fancy, but they are equally far from the saturated-grease tips that surround Smithfield. They cook simply, copiously, well.

At this everyday level I'd suggest that Belgium has the edge over every country in Europe, France included. 'French finesse, German portions' was the way a grip characterised it. And the latter half of that neat formula stands up – but rarely in Belgium outside grand restaurants will you find fiddly, overworked, ponced-about cooking that has become a dismal commonplace all over France. Belgian chefs seem happy to be sound artisans rather than try to be *soi-disant* artists. Belgium is now, appropriately, the home of bourgeois cooking, of the time-tested standards which France has so rashly abandoned, of the French cooking that the English crave.

This is the only beer country with a first-division cuisine. That may sound like an oxymoron; but remember, this is also a fervidly Catholic country which is also a brumous, northern one. Cuisine *à la bière* is not so common as it was – not least because, I surmise, Belgium is very, very fond of French wine, and food cooked in beer is not invariably wine-compatible.

The beer is the best in the world, and the most varied; this may be why Nairn, the only alcoholic I've ever met who stuck to beer, reckoned Belgium so exotic. (One dimly remembered lunchtime the great architectural critic drank fourteen pints.) Just as Belgium will put anything that moves in a pot, so will it use the most improbable ingredients to flavour beer or, for that matter, eau de vie. In Namur I bought a bottle of brain damage posing as *alcool blanc de céleri* – it certainly smelled of celeriac, although its taste was pure tractor fuel.

The great thing is that there is an endless resourcefulness with domestic produce; this trait is usually associable with rural indigence

and subsequently gets lost. Why it didn't get lost in Belgium is any-one's guess. Holland has lost it to the point where it makes England seem like a gastronomic utopia. Maybe it's something to do with colonial legacy. The ersatz cooking of former colonies takes its dyspeptic revenge by way of vindaloo (England) and nasi goreng (Holland). But then France had colonies – worth, apparently, bomb-ing for; and so did Belgium, although *les affreux* did their work in what is now Zaire rather than at home.

Still, there is no Congolese influence on Belgian cooking. Indeed, it always went the other way: *les trois quarts*, the 75,000 Belgians who inhabited Léopoldville, lived a de-luxe ghetto life. They lived Belgian; and, latterly, in the fifties, ate fresh Belgian – L'Union Mineral de Haut Katanga which, de facto, ran that colony and which funded Tshombe's secession, saw to it that there were oysters every day, airlifted along with all the other things one needs: foie gras, mussels, Belgian beer.

Like every other European country, including the risibly titled United Kingdom, Belgium is divided, and the aspiration to Flemish separatism fomented by the Vlaams Blok party is strong. There does not seem to be any correspondent gastronomic disparity – perhaps the country is simply too small for that. The culinary repertoire in the gin-soaked city of Antwerp is pretty much akin to that of the formerly French town of Namur. (1993)

Belgium 2: Joys of an impure spirit

Belgium is the title of a TV film I made in 1992. It was only very approximately about the country of that name. It was, rather, an exploration of an idea, of an aesthetic and, specifically, of my contention that René Magritte was a social realist rather than a sur-realist and that his work was a representation of quotidian Belgium.

A contention which, for all its caprice, is easy enough to sustain, for it's a lie that tells the truth, or a truth.

After numerous drafts, several recces, a long shoot, many fact-finding dinners and six weeks in the cutting room (there were budgets in those days), we had a piece that we were pleased with. But we had no title save the working title of my script. After inventing and rejecting dozens of ginchy handles it dawned on us that we should stick with *Belgium* – not merely *faute de mieux* (as they don't say in Antwerp) but because all of us working on the project had suffered the experience of being gaped at with a mix of pity and incredulity: '*Belgium*!? You must be joking.'

Nothing has changed. So far as Johnny Bulldog is concerned, Belgium remains a specialised and apparently perverse taste in a way that no other western European country does. The millions of morons who voted for the freedom of indigence and the sovereignty of chaos evidently associate it with their abhorred EU and, in their proudly born ignorance, fuck all else. They know nothing of its multiple identities, its sublime painters, its eccentric writers, its formidable gastronomy, its thrilling urbanism, its magnificent suburbanism – a domestic suburbanism which has no peer.

It's a country without a label, without an identifying cliché. Such labels, such clichés are grossly caricatural and founded in what might be called social xenophobia, but they are useful mnemonics which hint vaguely at what might be expected of a place. Lacking those props, Belgium beyond art nouveau, beer and Berlaymont – the devil's throne, source of all evil according to the tiresomely unfunny psychopath Johnson in the *Telegraph* – is regarded as a sort of negative entity. How wrong, and in how many ways, the mob can be. And not just the mob.

The Northern Renaissance was misnamed; it was no such thing for there was a seamless continuum of thought and expression running on from the 'Middle Ages' which invalidates the use of

taxonomies deemed retrospectively appropriate to Italian city-states. Nonetheless it was, and is still, used: the prefix Northern proclaims that it is second tier. It was not the Renaissance, *tout court*. So it never attracted the admiration of the grandest Grand Tourists and subsequently, Ruskin, Roger Fry, Lawrence – the taste makers of their epochs whose example and biases have seeped down.

Who, for heaven's sake, would visit Ghent when they might go to Florence? Me. I would. Flemish or netherlandophone Belgium and Walloon or francophone Belgium are self-evidently linguistically rent. But is there a cultural divide? A denominational divide? Whatever the gulf between the 'communities', it is not architecturally expressed. Brussels speaks both languages. Only a seer or a fraud would dare to scrutinise buildings in that city and proclaim that this is the work of a Fleming and that of a Walloon. Speak French in Antwerp/Anvers and you will be cold-shouldered. Yet a house there of, say, 1925 might be the ringer of a contemporary one in franco-monoglot Liège. Architecture or, at least, architectural fashion overcomes linguistic divides, just as it overcomes schisms of communion, denomination and politics. Belgian architecture and domestic suburbanism are pan-Belgian. Further, they seldom seep beyond the country's borders. They are exclusive. They exhibit a blithe indifference to what was happening in neighbouring countries.

A recurrent device of both visual and literary surrealism is incongruity, apparent incongruity. A garlanded lion prowling through a parterre. A crucified baby grinning. Skeletons with squeegees at a traffic light. Tree surgeons amputating their own limbs. All of these are within possibility's bounds.

So too, astonishingly, is a mile-long street in which every house adheres to the building line and no two houses are identical even if they share a broad gamut of gestures and devices and are more or less contemporary. This street, again astonishingly, was created and

repeated time after time in Belgium between the late nineteenth and mid-twentieth centuries.

An art nouveau terrace is something to behold. But art nouveau was not peculiar to Belgium. It flourished in places where the baroque had flourished, in new countries (Belgium was a creation of 1831) and in aspirantly secessionist regions. They rather unluckily proclaimed their difference by the same architectural means. The high decades of Belgium's suburbanism came in the wake of art nouveau. Such architects as Fernand Bodson and Antoine Pompe fused two conflicting strains – art nouveau, which affected to be machine-made, and the Arts and Crafts, which was hand-made, or pretended to be.

One of the eternal unknowables of twentieth-century art is what route modernism might have followed had the Dutch genius Michel de Klerk not died so young. The answer is to be found in Brussels and Antwerp, where the expressionist spirit survived – not that the world was watching, so taken was it with white immaculacy and the moral dogma of the orthogonal. And Belgium was, then as now, a mere backwater, hardly meriting a footnote in twentieth-century architecture's orthodox, blinkered histories.

The stylistic amalgam which constellates suburban Belgium is satisfying because it is defiantly impure: garden cities which look to the future rather than to one of those delusions called a golden age – when radical preachers were hanged, stillbirths were the norm and streets were sewers. Impurity is achieved by the inventive mixing of opposites to create what has not previously existed, rather than by riffing on what is already there to come up with the old familiar tune. (2018)

Italy: Oh Gino

The construction 'the falsification of history' is pleonastic. It is the very condition of history that it be false; I'm not referring merely

to the palpable drivel wrought by the delusional and consumed by the credulous (e.g. the Koran, the Bible, the Bhagavad Gita). And if not false then at least biased, propagandist. It is as *parti pris* as victors' justice. The future may be fixed; the past isn't. It is end-lessly mutable, susceptible to the whims of the present, to conform-ing with our mores and our fashions. It is shaped to our taste. We want the past to be the present in fancy dress, in our own fancy dress: thus the ancient Rome of 2015 is very different from the ancient Rome of 1915. This falsification is not necessarily witting. The pressure of the received idea and the common consensus is as potent as it is unnoticed: we subscribe to it insouciantly. We should beware of doing so.

Architectural history is no exception, though it can seldom exculpate itself by pleading insouciance. For the past three-quarters of a century such history has predominantly been the endeavour of modernism's true believers and fellow travellers.

Like the doctrinaire in any field they see what they believe in, while the unprogrammed agnostic believe in what they see. They bruited the triumph of modernism even when it was a minority fad, when all evidence pointed to its failure to appeal to a public untutored in abstraction and not apprised that ornament was crime. They made history a form of proselytisation through repetition. Say something loud enough and long enough and it will come to pass. A bogus past is means to creating a real future. It is more than wishful, it is predictive.

The same buildings recur over and again to support the claim of modernism's not yet existent hegemony. The works of such optimistic vanguards of tomorrow as Pevsner, Gideon, Bertram, Furneaux Jordan, Fry, Boumphrey, etc. is testimony to the meagre supply of examples. There were simply not enough modernist buildings to sustain the myth without constant reuse. But the writ-ers fooled themselves and gradually fooled their followers.

In so fundamentally dishonest an ethos there was bound to be collateral. It came in many guises – neo-medieval, neoclassical, neo-baroque, neo-vernacular, sub-Arts-and-Crafts, Queen Anne, Anglo-Normand, belle époque, romantic nationalism . . . All copyist styles which, in modernist eyes, had had their day. They were adjudged *ein alter hut*. *Vieux jeu*. Old hat. It was clear as day to any self-respecting neophiliac that they were 'irrelevant to the needs of modern society'. They were not 'expressive of the twentieth century'. And they had a weak spot: they hopelessly lacked, as the non-extremist centre always will, a cadre of rational champions. There was no inevitability about modernism taking over the world. Its adherents worked to make it happen while the disciples of revivalist severalty were fragmented, too worldly to form movements, too urbane to compose manifestos, too satisfied in their work and their world to observe that they were being written out of history. The few who actively opposed modernism hardly served their cause by presenting themselves as peevish, choleric ranters. And no one ranted quite like Reginald Blomfield, a boorish journeyman for whom, according to Geoffrey Boumphrey, 'modernism is anything approximately contemporary of which he disapproves'. Blomfield, who must have counted it a gross misfortune to find himself Edward Burra's uncle by marriage, typically disguised his aesthetic distaste as moral obloquy. A kindred dissemblance is practised today by the Prince of Wales and his anilingual court. A regrettable consequence of shrill demagoguery on behalf of the architectural status quo was that little distinction was made between works of inspired invention and those of meretricious hackery: so long as they were 'traditional' they were lumped together as a cause, no matter what their worth.

The same applied to essays in modernism. Again, it was aspiration that was the mistaken criterion rather than achievement. Both sides had in common a blindness to the essence of a particular work

and a reluctance to see beyond style. Cultural belligerents are unlikely to heed the disinterested wisdom of Jean-Francois Revel's observation that 'there are no genres only talents'.

Till just over a generation ago the routine opinion of Edwin Lutyens among modernists was that expressed by the ineffable Alison and Peter Smithson. The clowns of the avant-garde half-wittedly denounced this extraordinary artist who 'had perverted the course of English architecture'. A sentiment echoed by their confused beardy chum Reyner Banham who, because he disapproved of Lutyens' clients (landlords, plutocrats, bankers), found it necessary to disapprove of his architecture too.

What would he have had to say of Lutyens' contemporary who built for the immeasurably rich ship owners and export magnates and underwriters of Genoa, Gino Coppedè?

Gino who? His name was once a byword on the Ligurian riviera for untrammelled extravagance and fabulous opulence but victors' history has unsurprisingly overlooked him: Italy was, after all, the epicentre of that modernist variant called rationalism. Rationalism aspires to minimalism. Coppedè moves in quite the other direction. This man was a maximalist. *The* maximalist. The maximalist's maximalist. His extravagance was peerless. Yet, google Lutyens: 400,000 pages. Google Coppedè: 18,000. Now google Antoni Gaudí: 3,000,000. Gino Coppedè died in 1927 so he is past caring about such inequity. But his devotees aren't, not for the moment. And we number, well – we're into double figures. The disparity with Gaudí should prompt incredulity. But Gaudí, especially late Gaudí, somehow appeals to the modernist sensibility. He is thus to be found in all the histories. His appeal seems likely to derive from his being a bridegroom of Christ, an ascetic, and still, probably, like J. L. Borges, a virgin when run over at the age of seventy-three by the tram on Gran Via in Barcelona. In other words he was an 'outsider', and there's nothing the moderns liked more than an outsider,

wrapped in cuddly mantles of alienation, otherness and autistic genius. Much of Gaudí's work, especially his interiors, prompts questions about his sanity. It is closer in expressive psychosis to that of *idiots savants* such as Le Facteur Cheval and Raymond Morales than it is to the mainstream of Catalan *modernisme* – which, tiresomely, does not signify modernism but, rather, art nouveau, known in Italy as *stile Liberty*, which derives from the London shop whose vessels, fabrics and jewellery – actually more Arts and Crafts than art nouveau – enjoyed a wide vogue in Italy. Given its name it was odd that it should be seriously mooted as the 'Italian national style'. But Anglophilia was in the air, always had been; Lampedusa's prince, the Leopard, wears Atkinson's eau de cologne. Traffic was two-way: there was a sizeable anglophone colony in Florence and smaller ones in Genoa, Alassio and Rapallo. Livorno even had its own English name, Leghorn.

Coppedè's first important client was Evan Mackenzie, a half-Scottish, half-Serbian, kimono-clad insurance tycoon whose voracious appetites and eclectic tastes were in tune with his architect's. Both men had been born in Florence, both were to make the boom town of Genoa their home. The Castello Mackenzie, designed in the mid-1890s, established the template of Coppedè's most recognisable idiom. Genoa is an exceptionally hilly city of buildings recklessly piled on top of each other. The castello, the first of several such buildings that Coppedè was to design in the city, exploits the precipitous topography. The immensely tall perforated tower looks frighteningly precarious, as though it may teeter and fall. The building is a mass of apertures and incrustations. There are abundant loopholes and machicolations, Guelph crenellations (rectangular parallelepipeds), Ghibelline crenellations (rectangular parallelepipeds incised with a V). It appears to include fragments of other buildings and gives the impression of having been constructed in different stages, in different eras, in different styles. Like all great

artists Coppedè steals and transforms. He seldom bothers to cover his tracks. The Palazzo Vecchio in Florence is just a starting point. He uses it like an armature on which to hang further thefts – from such wildly disparate sources as Byzantium, *Liberty*, sure enough, Venetian Gothic, Mughal and Moorish buildings that never existed, an invented Orient, a skewed Renaissance.

His fabrications are sheerly marvellous. They evince a palpable joy in their maker's fecundity. Just when you think there cannot be any more, he pulls another trick out of his hat, a novel form of rustication, say. This is architecture as entertainment, art without angst, with happiness: yes, there does exist such a thing. He tended to copy himself, much of his prolific *oeuvre* comprises variations on the castello. Several architects, mostly younger contemporaries, imitated him: Giulio Arata, Also Andreani and most sycophantically Ernesto Verrucci, whose Palazzo di Montezza at Alessandria borders on forgery though he never matches Coppedè's most deafening trademark – the restless energy which is the very antithesis of the unities, of rules, of preordained formulae, of the classical orders . . .

Yet here I am in an animated street market in Genoa, September 1982. It's all flashing eyes, grins and barkers' catchphrases. That summer's hit 'Come On Eileen' blasts ebulliently out of every stall's speaker. My eye is drawn to some plates. Plastic, representations of animals – so far so banal – but with inbuilt craquelure. They have been 'aged'. The corniness is epic, and hilarious. I buy half a dozen then turn round to a sight that first astonishes me then sends some freezing pulse to the base of my spine.

I am in the presence of a building which is wholly sinister. It might be half remembered from a nightmare. It might be a set for that worryingly creepy Italianate novel, J. Meade Falkner's *The Lost Stradivarius*, possibly the greatest ghost story written by an arms dealer. Here – not that I knew it at the time – was Coppedè in his other mode, the self-appointed heir to Serlio and du Cerceau,

decadents *avant la lettre*. Never have Piranesi's minatory fantasies been brought to such morbid life. And just round the corner there was more. Once again classical symmetry, once again high-relief rustication, once again seething stone. Facades are encrusted with distended motifs and frozen menageries of malevolent animals which belong to no known bestiary. The aggression of these buildings is quite at odds with the picturesque felicities of the castello and its offspring.

It was to that idiom that Coppedè returned for his most famous project, far from Genoa, in the northern centre of Rome. The streets that radiate from Piazza Mincio possess the hallucinatory crispness and brain-twisting logic of M. C. Escher. The concentration of buildings is, as though it were needed, proof that more is more. The welter of detail is alluring rather than aggressive. The development, which includes palazzi, villas, apartment blocks and a decorative bridge, properly bears the name of its architect, who died in 1927 soon after it was completed. The Quartiere Coppedè was of course hopelessly out of fashion by then. But so what? Fashions come and go. Almost ninety years on it ought to be a matter of supreme indifference to us that it was not at the forefront of architectural design: quality and anachronism are entirely compatible. We do not dismiss von Klenze's Walhalla because it was built 2,000 years after the Parthenon.

And there we might leave it, save that in Knutsford, a small town in the Cheshire footballer belt, stands one of the most remarkable groups of buildings in England. They are the work, in the first decade of the twentieth century, of a wealthy, much travelled amateur architect, Richard Harding Watt, and every one of them proclaims the benign influence of Gino Coppedè. (2015)

Russia: Old father time

The Paris Exposition Internationale des Arts et Techniques was staged on the right bank opposite the Eiffel Tower in 1937 as 'a

celebration of peace and progress': some hope. All that remains of it today is the Palais de Chaillot, which at the time attracted less attention than the now defunct Soviet and Nazi pavilions that famously faced each other close by the river. The architects Boris Iofan and Albert Speer competed in size, bombast and boorishness. They were both awarded gold medals. Speer's was a vertical essay in his invariable pared-down classicism, funereal and gigantic, an appropriate enough symbol for a death cult.

The other, the work of a defter architect than Speer (not difficult) was jazzier, louder, odder: it contained a map of the USSR dotted with rubies and topazes. On top of it strode two triumphal figures, bulkily muscled optimists of Soviet nurture. These XXXL lumps of mega-kitsch in unwittingly caricatural human form were the work of Vera Mukhina: *Worker and Woman from a Collective Farm*. He clasps a hammer, she grasps a sickle. As they did. The frou-frou at the summit of the Nazi *pièce montée* was merely a swastika and an eagle. Lower down there of course lurked unwittingly homoerotic statues of Aryan manhood hawking their brawn.

Because these two buildings represented dictatorships, they were reckoned to resemble each other. But there was little stylistic kinship between the pair, save that they were *retardataire*.

In 1938, Osbert Lancaster made two drawings for his squib *Pillar to Post*, which show the same building, very slightly inflected with marginally different columns and statues, as both Nazi and Soviet. The notion was born that there existed such a thing as Dictator's Architecture, that the twentieth century's tyrannies employed common forms to common ends. This is a misapprehension: its wrongness is even more evident when Nazi and Soviet idioms are compared with those favoured by Mussolini. The only point of architectural agreement between Hitler and Stalin was an antipathy to modernism. The equation of totalitarian regimes with modernism – peddled by such thinkers as Prince Charles and Simon Jenkins

– is risibly ignorant and historically inaccurate. Even Mussolini, who was initially sympathetic to the cult of the machine, soon wearied of it.

During the earliest Soviet period, there was little exercise of aesthetic control by the state. Fellow travellers and useful idiots have, down the years, pointed to constructivism – the Soviet varietal of European modernism – as proof of an equation between political revolution and artistic revolution, as testimony to the Soviet Union's progressive bias.

Had, so this apologia goes, Lenin lived, then the great social experiment would have advanced alongside the great architectural experiment. As it was, few constructivist works were actually built: the country was broke and, besides, this was only one of several styles then practised. And by the time the USSR was back on its economic feet, a cultural revolution had occurred.

It may have been instigated by Stalin, but the overwhelming majority of architects needed little persuasion to abandon abstraction and abjure the avant-garde. At the First Congress of Soviet Architects, a couple of months before the opening of the Soviet pavilion at the Paris Exhibition, Nikolai Bulganin, then chairman of the Moscow Soviet, spoke tardily against 'uniformity' – i.e. modernism – and was rapturously applauded by his audience, which had long ago buried it, thriving in the climate of paranoid isolationism that Stalin decreed. Journeys abroad could only be undertaken if 'essential'. The state's borders were locked. The guards who made them impregnable were such heroes of the people whom they imprisoned that they and their dogs were honoured in grandiose statues at Ploshchad Revolutia metro. Such isolationism demanded appropriate aesthetic expressions which made no reference to the world beyond the incarceratory walls, the world which had ceased to exist. Soviet architects opportunistically remembered that they were Russian architects, too, and that they had centuries of Russian architecture to serve as a model.

But what was Russian architecture? And which bits might safely be exhumed in the service of the Soviets? Stalin exercised far greater power than the later, liberal tsars. He had, after all, reintroduced serfdom, which they had abolished half a century before. He had a secret police vastly more effective than that which had neglected to assassinate him when he was still Djugashvili. Yet the monuments that were to glorify him and the people – a one and indivisible construction: he was the people – had to differentiate themselves from those of the tsars. Then again, the notion that his years as a seminarist in Tbilisi had caused him to reject theism is torpid and frail. He had countless churches demolished. Stalin was the living god. He had murdered god and had assumed his place, a usurper on a cosmic scale.

So long as he himself could be god he was profoundly religious. He was, until his victory in the Great Patriotic War, the son. Dead Lenin was the father, exiled Trotsky was Judas – these two were constantly cited exculpatory devices. Like god, Stalin diverted rivers, created seas, held the power of life and death and altered the climate – though not as often or as much as he might have wished. Cheap (and rather delicious) ice cream was made available to Muscovites to delude them that the weather was hotter than it actually was.

The architecture of state was invested with temporal swagger and sacred pomp. But, again, it had to avoid allusion to the many idioms of the churches that were being reduced to rubble. There was much for the keen party hack to beware of. Russia's architectural past was richly boobytrapped. Moscow is an Eastern city in Western clothes. Or is it a European city whose fragile carapace the inchoate Orient is trying to break through?

Since the early eighteenth century, fashionable Russian architecture had become increasingly European. St Petersburg is Paris on Neva, Turin in the Gulf of Finland; it's a formal anthology of idioms from the late baroque onwards. Moscow, in comparison, was

unplanned: because it was developed piecemeal, it changes at every corner, like London.

Much of it was architecturally hick – a combination of vernacular and coarse, second-hand imitations of St Petersburg. Its appeal to the Soviet nationalist sensibility lay in its great monuments belonging to eras before the advent of rococo icing, Italian caprices and Scottish neoclassicism – when Russian architecture had seemed inviolate and had come from the steppe, the Urals, Siberia, that direction. Russian architects might rediscover the Russianness of Russia by once again looking inwards.

Much of what was built during Stalin's quarter-century of dictatorship derives from that willingness to look inwards combined with an imperfect capacity to act on what was thus seen: until the mid-thirties, most architectural education had been conducted in the Western, beaux-arts tradition, and Russians had routinely studied in Paris and Rome. They were foreigners to the architecture of their own country: similarly, the Russian intelligentsia had, till the Revolution, spoken as much French as it did Russian. That class was of course obliterated by the Soviets.

Architects, as always biddable, were required to address their single patron: the people. They were, then, required to design buildings that were, in the cant of today, accessible – which is a euphemism for comprehensible by the stupid and the hardly educated. In the mid-thirties more than 30 per cent of Soviet subjects were illiterate. The more primitive a society, the more it demands deafening colour and crude ornament, the more it is affronted by undecorated planes and monochrome surfaces, by lack. Soviet society was astonishingly primitive, its architecture was astonishingly maximalist – like that of a fairground. A fairground where both attendance and enjoyment were mandatory.

Ernst May was the former city architect of Frankfurt who had worked as a young man at Hampstead Garden Suburb. At the

belching steel town of Magnitogorsk in the southern Urals, he designed orthodox, featureless white modernist blocks. In the technophiliac years of Lenin and electrification, they might have been lauded. But in the early thirties they were wrong. They were denounced as hutches, as machines for subsisting in that were typical of exploitational capitalism which treats its workers like robots. May reckoned he was lucky to get out of the USSR alive.

Soviet people didn't understand or appreciate socialist housing: it's improbable that the people anywhere did. What the people crave are palaces. And, increasingly, in the USSR, they got them. At least some of them did. For those who didn't there was always promise. Now there is none.

Communism peddled a delusion of a better future. The Russian Federation of Putin is incapable of that great institutionalised lie, the lie that was a solace, a lifetime's comforter. Nonetheless, it is apparent that there is a longing today for the dodgy certainties of Stalinism: the cranes that dominate the Moscow skyline are not there to knock up chunks of the synthetic modernism that is the norm in Manchester, Lyon, Zaragoza – the all-purpose (and often no-purpose) gestural engineering of the dickhead process called regeneration.

Moscow's new wealth yearns for what it never got enough of first time round. These very congenial people – she looks like a vertically tanned pornstar, he looks like a vertically tanned pimp – buy you drinks and complain about the past half-century. The half-century that began in December 1954. In a speech that month that went unacknowledged in the West, Khrushchev railed against ornamentalism. This was a coded attack on his predecessor, a means of preparing the way for his subsequent denunciation of Stalin and his crimes (not that Khrushchev's hands were clean). It is a measure of the extent to which dictators are knowingly defined by the architecture they decree.

The commonplace that Stalin's Russia looked grim is wrong-headed: it may, in this country, even derive from the mystifying filmic convention of using Dundee as a location to represent mid-twentieth-century Moscow. Now, Dundee really is grim. Whoever first reckoned it to be an appropriate stand-in had probably never seen Russia.

Stalin was infuriated when Roosevelt jocularly informed him that in the West he was nicknamed Uncle Joe. Uncle! By the time of Yalta, he was the Father. Father of his empire. In a self-created creation myth, he 'fructified the earth'. As he embraced an early dotage, he yearned increasingly to recreate the sumptuous architecture of his childhood.

Tbilisi had enjoyed a boom when he was a smooth-haired boy. Its rich merchants had built art nouveau villas. Its workers had incorporated art nouveau devices in their shacks and shanties. There are parts of Moscow which, given this knowledge, seem like bites of memory-cake made stone. It's as though a dictator's infantilism can turn back the clock: only a climate changer and a calendrical meddler can make this happen.

I was walking early one morning along Kutuzovsky Prospekt in western Moscow looking for a coffee, gaping lazily at the nineteenth-century tenements on the south side of the boulevard. Then I read the year incised above a keystone: 1951. So much for my uncanny ability to date any building . . . But then that dating gene is specific to western Europe. This was the moment when the sheer occlusion of Stalin's Russia actually hit me. Had such a building existed in Britain, it would have been designed in the laudanum mania of the late 1850s or 1860s, when the farouche genius of Cuthbert Brodrick and Frederick Pilkington was untrammelled, and the whimsical *douceur* of the domestic revival and the Arts and Crafts was far in the future.

I'd hope that Stalin's architects enjoyed the psychotropics available to Pilkington and Brodrick, William Burges and William

Desdemaines-Hugon — but so far as I know it was, dismally, just distillated grain spirit and of course fear that drove them to ever-more extravagant feats of second-guessing the ogre in the Kremlin. So structure became a mere device for the display of representational ornament. And that ornament has itself to be embellished by further ornament. There is a pathology at work here, one quite as disturbing as that of Stalin's contemporary, the barking Viennese proto-Modernist Adolf Loos, who declared that 'ornament is crime'.

Stalin's architecture is unquestionably retrospective. But it also presages what happened in the West in the seventies and eighties. A dictator could, by *ukase*, overnight stipulate what it took the free market many decades to achieve — an undemanding tabloid architecture made for the people rather than for other architects. There we have it: Joseph Stalin, mass murderer, Father of the Nation — and father of postmodernism. (2006)

Soviet bloc: Travelling hopefully
Landscapes of Communism by Owen Hatherley

Here, once again, is everything his fans have come to expect from Owen Hatherley: curiosity, precision, disputatious rigour, a contempt for received ideas tempered by agnostic humility, the keenest eye, an openness to the unexpected, a phenomenal knowledge, an indifference to the paltry virtue of consistency.

And here, for the first time, is a new ingredient: a woman. In these tireless reports of wandering through the cities of what was once the (notably heterogeneous) Soviet bloc, this *flâneur* is accompanied by Agata Pyzik, whose *Poor But Sexy*, composed in English, both puts monoglots to shame and prompts a reappraisal of what the populace of those cities expected after 1989. Certain of the itineraries are determined by her and, I suspect, followed by him with

an initial reluctance. We are vouchsafed glimpses of their endlessly peripatetic life together and their diet of milk-bar *piroshki* and architectural taxonomy.

A more frivolous writer might have developed this into *It's Grim Up North Silesia* – but both Hatherley and Pyzik are pretty much strangers to any contemplative attitude other than that of high seriousness. As though to prove it, the only lost opportunity in a book which is dizzyingly comprehensive occurs when they take a break in the north-eastern outskirts of Tallinn where the city elides with the beach resort of Pirita. A holiday mood overcomes them – as well it might when presented with the sight of the Pirita Top Spa Hotell, to which the only reaction can be incredulous laughter. They are distracted by an Eesti grunge band (don't ask) at an impromptu festival. They lower their guard. They somehow fail to spot, above Pirita, the 300-metre-tall TV tower with its complement of skydivers and bungee jumpers. Nor do they see Lasnamäe beyond it.

This is a bloated high-rise satellite, or 'microrayon', of 125,000 people (predominantly ethnically Russian), immigrants during the last fifteen years of the Soviet empire. They comprise almost a quarter of Tallinn's population and are subjected to a sort of revanchist apartheid which has prompted the Russian Federation's cyberattacks on Estonia. This is, or ought to have been, classic Hatherley territory. He has a gift for unravelling layer upon layer of demographic complexity, topographical paradoxes, tribal knots and neo-liberal sharp practice – which come in many guises. Much of the former Soviet bloc has 'caught up' with the West in its abject neglect of publicly owned modernist housing. It has emulated London and Manchester in its class clearances. Super-capitalist Moscow has gleefully dumped the orthogonal modernism which Khrushchev revived in the mid-fifties and its later ever-wilder variants which continued up to 1989.

Yuri Luzhkov, mayor of Moscow 1992–2010, was a Stalin idolater. He unastonishingly promoted sugar-coated neo-Stalinist bling, much of it built by his oligarch wife, who of course lives in London to be close to her lawyers. For the umpteenth time it is necessary to point out that 'Stalinist' as a synonym for repetitive grimness could not be more wrong-headed. The idiom the Cockroach Moustache decreed was infantile, loudly precursive of postmodernism, crazily decorative. This is evident in 'gifts' such as the Palace of Culture and Science in Warsaw, the Academy of Sciences in Riga, Casa Scanteii in Bucharest and most obviously in the Moscow metro and that city's skyscrapers – among them the Hotel Ukrainia where neo-liberalism has triumphed to such a degree that an entire floor is given over to screeching prostitutes getting bilked by their no-browed punters. Given the sheer volume of Stalin's 'baroque' (whose self-parody emphasises that style's debt to the Gothic), its early date and the manner in which war-damaged Gdansk and Warsaw were reconstructed as replicas of divergent verisimilitudes, Hatherley is surely correct to dispute the notion that postmodernism was exclusive to capitalism.

Indeed a strong case might be made for its being as much a peculiarly Soviet creation as dogs in space, the statue of *Mother Russia* in Volgograd, the Zil 4104 and gerontocrats embalmed while still alive. There is corroboration in, of all places, Bournemouth. In that town's eastern suburb of Boscombe stands a lumbering XXXL apartment block called San Remo Towers. It has always been described as an exercise in the Spanish Mission style. Its architect Hector Hamilton was born and educated in England and subsequently practised in London and New York. In 1932 he won joint first prize in the competition for the (never to be built) Palace of the Soviets. Once you know that, it all falls into place. It becomes blindingly obvious that his inspiration was not California but Moscow. It is probably Britain's most genuinely Stalinist building,

with a gaudy abundance of decorative faience made by Carter's Poole Pottery.

Stalin's proto-postmodernism wasn't parthenogenetic. Hatherley wonders whether Lenin's temporary mausoleum by Alexey Shchusev – the most Talleyrandesque of architects in a field where competition is stiff – marked the end of the avant-garde which Stalin would soon proscribe or the beginnings of his Potemkin baroque. Other sources are mooted: most interestingly the fantasies of Hugh Ferriss – the American Piranesi or maybe the American Nevinson – who is, for all his current obscurity, a much more influential artist than Sant' Elia. Without Ferriss's example Tony Furst's Gotham City would never have existed. Nor, maybe, would Moscow as we know it. Hatherley is also on the money with his frequent allusions to East–West exchanges and plagiarisms. He exposes the myth of total isolationism and mutually assured disregard.

Khrushchev's denunciation of Stalin's crimes in 1956 was preceded by his denunciation of 'the excesses' of Stalin's Potemkin facadism and palaces for the people. That, then, was the end of Soviet proto-postmodernism and of socialist-realist sculpture, bulgy muscled heroes of the foundry and the lathe yet to subscribe to the right penis enlargement course.

The weirdest, most rewarding and least-known period of architecture in the Soviet bloc, certainly in the satellite states, begins in the mid-seventies at the time of economic stagnation. To go by what was being built, this would be when Lenny Brezhnev, crooning in Vegas in a bemedalled glitter jumpsuit and neglecting his duties at home, neglected to curtail some exceptional architectonic imaginations which were flourishing in the boondocks. The extravagant buildings of this period show that the aesthetic control exercised in most western European countries was unknown in the evil empire's decadence. Designers enjoyed a licence their Free World counterparts could only dream of. Stylistic chronology was scrambled. As the West lapsed

into postmodernism, the architecture slow learners prefer, some of the most exciting buildings of the twentieth century were being made in Georgia (constructivism), Lithuania (son of Gaudí), Ukraine (zoomorphic brutalism). Much of this work, now in desuetude, has been photographically recorded by Frederic Chaubin and Roman Bezjak. Hatherley unexceptionably describes the Moscow Academy of Sciences as 'the project of a cracked scientist'.

No matter what the era of the streets, estates, mausolea, libraries and apparently purposeless set pieces he scrutinises, Hatherley does what the best travellers do – he finds himself drawn to the places whose existence should be provisional but which endure regime upon regime: rows of tin garages; paths to nowhere; unsanctioned urban farms; allotments; shacks. Unordered spaces and structures which are all but lost in countries where land equals money and every plot has a price. Places whose value is not pecuniary.

In his previous books this excellent writer has evinced a nostalgia for a world he is too young to have known, the welfarist utopia which he suspects existed in the Britain of his parents' childhood. Here his reactions to the real thing, the tainted utopia, are marked more by a protracted bemusement than by longing. It's impossible to read this book and not rue the universal human capacity for screwing up. (2015)

Spain: La Concha on fire

I first saw San Sebastián in the aftermath of a ferocious electric storm that turned day to dusk. This was climatic theatre of the most melodramatic coarseness. Lightning had repeatedly illumined a clifftop south of Biarritz. The road had turned into a torrent. The old Panhard I was a passenger in had slewed about the skidpan surface. It began to leak. Its wipers groaned. Visibility was stunted. The driver – who would subsequently die of a massive overdose –

quite lacked an elemental instinct for self-preservation and raced on heedless of his passengers' jabbering imprecations. By the time the bolts were exhausted and the tympanic mayhem had abated, we had crossed the border, whose guards had been atypically lax, preferring to risk the security of El Caudillo's fascist bastion rather than get soaked.

San Sebastián was deserted under a sullen sky. The streets were shiny. The bay of La Concha was spellbinding. Here was nature aping Cocteau, a doucely fantastical stage set of bosky headlands with a magic island between them and sea mists swirling on cue with the aplomb of choreographed dry ice.

Now, I have been back to San Sebastián many times, but custom has never staled it. The illusion that it is an epic artifice, a creation, remains curiously intact. It feels as man-made as the park of Buttes-Chaumont in north-east Paris, where cliffs and caves are constructed in concrete. It might be a life-size model rather than a happenstantial collision of ocean, rock and flora.

The purpose of driving 250 km from Bordeaux was not of course to admire this decor. It was to hang out in a listless teenage way. To bar-crawl. And to eat. France's culinary chauvinism was not, even then, so stubborn that it failed to appreciate its neighbours' cooking – in certain instances. One of those instances was San Sebastián, which was ungrudgingly considered in Bordeaux to be a gastronomic mecca, an exception to the Spanish norms: part of the point being that San Sebastián's cooking (inventive, whimsical, ever-mutating) has little in common with that of its adjacent Spanish provinces.

But nor, strangely, does it own much affinity to that of Biarritz, Bayonne and Saint-Jean-de-Luz. The Spanish Basque country and French Basque country are notably different. Their cooking is merely one indication of that gulf. There is no serious separatist aspiration on the French side of the border. The only bombers are fugitives from Spain gone to the mattresses in Béarnais villages.

During San Sebastián's extravagant *Semana Grande*, secessionist malcontents – persons who look as though they wouldn't know a good time were it to sit on their grim faces – take the opportunity to parade with banners and drums and chants in front of the vast crowds gathered in pursuit of their various pleasures. Which do not include enthusiastic appreciation of political, linguistic and cultural warriors. Again, the Basque separatist urge to ban bullfighting because it may be taken as a symbol of Castillian colonialism or unwelcome unification, is regarded as an irritation rather than as a serious threat to humankind's inalienable right to torture animals. To be a bullfighter is still quite something. The dark-blue Mercedes-Benz Sprinter vans which comprise El Juli's circus attract envious attention and are stroked for good luck. Meanwhile, the toreador himself is being interviewed for local radio – in Castillian, of course. The dangers of the trade are made graphic by the hasty alterations to programmes: neither Enrique Ponce nor Javier Conde would be appearing because of recently sustained injuries. It is a pusillanimous fear of seeing humans gored rather than of bulls humiliatingly stabbed that keeps me away.

Untangling what is Basque and what is pan-Hispanic is, to borrow a Basque simile, like trying to put the fish back together after the soup has been made. It is well known (and inaccurate) that the only word the Basque language has given to the world is yacht. Were it so, it would be fitting for the sheer outdoorsy sportiness of the Basque people is a genuine characteristic. Every village is dominated by a church and a *fronton*, a court which is adapted to the several varieties of *jai alai*, *chistera* and *pelota* – games that recall fives, rackets and squash. They are played at every level, demand formidable fitness, agility and eye–hand coordination. They are, however, positively girlie in comparison to rowing in eights across rough seas, chopping tree trunks, forming human pyramids, hefting barrels of concrete, throwing dwarfs (subject to availability: kiddies provide

an adequate substitute). These are not the pursuits of a slothful southern culture: indeed, there are correspondences with Highland games.

The Basque country is hostage to its weather. Cool – hence the flight in summer from the furnace of Madrid to San Sebastián – and wet, very wet. The time before last that I was here, it rained hard for four days and four nights. This was as potentially maddening as the mistral. The climate alone cannot of course account for the wonderful mayhem of late nights during the *Semana Grande*.

Throughout the day the city is calm and, while hardly deserted, it is no more animated than Bournemouth. There are, nonetheless, buildings to delight: Rafael Moneo's recent Kursaal is a far more satisfying creation than Gehry's Guggenheim in Bilbao; the baroque facade of the cathedral is almost Sicilian in its farouche exuberance; there is a spectacular belle époque bridge in the same spirit – art nouveau was the great-great-grandchild of the baroque. It is a pleasurable place to walk in. Bourgeois families amble along the front. Oldsters potter in contemplation of something or other. Teenage boys race each other on makeshift rafts fashioned from oil drums, tyres, polythene demijohns, planks. Middle-aged boys fly remote-control aircraft, the screeching models swoop parlously low above sunbathers like seagulls with a grudge. The beaches are all surf and flesh. But flesh that is judiciously uncovered, with propriety and decorum: this is not a city for the card-carrying body fascist or the mammarial exhibitionist.

It is not till some time after dusk that the cloak of respectability is doffed. Eating, talking, drinking, walking. The early nocturnal rhythms are soon established. Groups move from bar to bar. Soon they'll be lurching from bar to bar. Our self-scourging myth that public inebriation is never found outside Britain is exposed here. At half past ten the crowd's nature changes. It is as though the disparate groups are suddenly subject to a centripetal force. The tide of

breath and expectation moves inexorably in one direction, towards the eastern end of La Concha. Where night after night pyrotechnic 'teams' – from all across Iberia, from Italy, France, Britain, etc. – scribble graffiti on the sky, lighting it with evanescent displays of cork-screwing spacecraft, endowing the heavens with new constellations, leaving cliffs and valleys of smoke that recall Europe after the Rain. Now there are carmine diaereses and cobalt cedillas and golden ampersands. Verdant raiments and taffeta skirts in richest amber disappear – to where? Bright white sperms rush to their goal. The noise is colossal. The city quakes. It is as though the ultimate pyrotechnic aim is to change climate. To challenge nature with chemistry. To ape an electric storm of long ago.

Then the cosmic gives way to the comic. Through the crowds rush boys dressed in bull costumes, with headdresses of fire. There are screams. Prayers to the virgin. But this is the work of Pan. The night is mad, pagan, dense with smoke and sweat and scent. Most of all, the night is ancient. (2005)

What lies beneath

Underland: A Deep Time Journey by Robert Macfarlane

If I was a shrink I'd worry about Robert Macfarlane, his dicing with eschatology, his claustrophilia, his recklessness, some of the company he keeps: sewer punks, cavist ultras, grotto mystics. But I'm not: I'm merely a repeatedly delighted fan of a true original, a poet with the instincts of a thriller writer, an autodidact of botany, mycology, geology and palaeontology, an ambulatory encyclopaedia – save that much of the time (a dodgy word in this context) he does not ambulate but hauls himself feet first through tunnels the circumference of a child's bicycle wheel in absolute darkness where day, night, maps and GPS do not exist. That's when he is not being driven at absurdly high speed through potash mines beneath the

North Sea's shipping lanes by a gung-ho security specialist or lifting a rust-flaked manhole cover to gain admittance to Nether World or trespassing in any government's subterranean chambers. When this orphic mole comes up for air, he relaxes by climbing the transporter bridge high across the Usk at Newport.

His obsessive pursuits and explorations are all potential killers. That evidently is a part of their appeal. Risk is like a drug. Maybe 'like' is redundant. He does not delude himself. He lists cavers and divers who have died. Some have disappeared only to be found years later, some get trapped in places from which neither they nor, subsequently, their body can be removed: premature burial in slow motion. He writes: 'I could only understand these pursuits . . . as fierce versions of the death drive . . . But over time I saw that there was another aspect to the Thanatos at work. Divers and cave drivers often describe their experiences in terms of ecstasy and transcendence.'

That polarisation or separation is not, however, apparent in his own subterranean jags, which are described like adventures, unusually scholarly adventures, which grip the reader. The sense of mortality is more potent than that of wonder or sublimity. How will he get out of this fix? We know that he does get out, just as we know that, say, Richard Hannay and Allan Quartermain will survive whatever scrapes they have got themselves into.

That knowledge does not preclude the primitive, powerful urge to want to discover what happens next even as Macfarlane is listing examples of the lexicon of extreme caving: 'terminal sump', 'chokes', 'dead out', 'the dead zone'. These pitiless epithets could equally describe terranean loci: he quotes Anselm Kiefer: 'There is no innocent landscape, that doesn't exist . . .' Well, if you're Anselm Kiefer it obviously doesn't, because that great artist creates his own landscapes with an emphatic bias towards the horrors he was born into. Macfarlane, a great artist in an unclassifiable synthesis of

disciplines, is a generation younger and, to put it baldly, has to go looking for trouble. It's not an all-enveloping mantle of guilt and shame and having to face up to the abominable. Nonetheless, it's there all right, in forms as lethal as nuclear waste (potentially deadly for 100,000 years) being buried in southern Finland, as magnetically enchanting as a labyrinth which pulls you on into its depths while whispering sweet promises of death, as banal as an abandoned Welsh slate mine that is now a de facto wrecker's yard of old smokers: he spots a blue Cortina estate and a moss-green Triumph Herald.

It's this sort of site that prompts Macfarlane to counter Philip Larkin's overquoted 'What will survive of us is love.' 'Wrong. What will survive of us is plastic, swine bones, and lead-207'. In other words, a souvenir gift pack of the Anthropocene – which will survive along with what is already down there, mutating very slowly indeed.

The places of the book are various. But in all of them darkness, discomfort and danger provide a relentless decor. They are its norms. Such is the intensity of Macfarlane's prose that the negative becomes the positive, the subterranean turns into the quotidian, the creatures of the blackness just go about their routines, the exceptional is the rule.

The result is that when Macfarlane writes about his fellow explorers in their homes on the exposed surface of the horizontal earth, they are infected with a peculiar exoticism. Drinking tea with Sean and Jane Borodale in their Mendips cottage takes on the status of a bizarre rite. A retired Norwegian fisherman talking about how he built a stucco mini-palace for his Indonesian girl-friend's nail-parlour business belongs to some kind of arcane mythology. These terrestrial diversions adhere to a different time scale from Nether World, where the rules of chronometry no longer apply and are exposed as a Swiss con job.

The imaginative young scientist Merlin Sheldrake, a famous name, a scholar of flowerless plants, talks about mutualisms, the

subterranean non-parasitical symbiosis of mycorrhizal fungi and certain trees. This is initially familiar stuff but he then refers to a 'wood wide web', a mycelial network in which plants communicate with each other, notably by sending immune-signally compounds to each other. His qualified animism connects with evidence-based Western scientific orthodoxy. Sheldrake has an attractive second string: he makes mead, cider and a coca drink. He also has friends who bring guitars, harmonicas, drums and bones to Epping Forest where he and Macfarlane are sleeping under the stars. All this campfire excitement, like some moot of the Order of Woodcraft Chivalry, pushes Macfarlane, 'despite a learned weariness', towards anthropomorphism. But by the next chapter he appears cured.

On occasions he writes in a campaigning spirit, for instance against the drilling for oil around the Lofoten Islands 600 miles north of Oslo. The dilemma is all too familiar: powerful industrial interests against an alliance of fishermen, environmentalists and undeveloped tourism interests. What lifts Macfarlane's account far above the routine is a remarkable fisherman called Bjornar Nicolaisen: 'We face death every morning . . . to bring food to those idiots . . . politician idiots.'

He is contemptuous, as any sentient person should be, of the 'consultation' process – the usual PR mendacity. In this instance the Norwegian Petroleum Directorate gave itself permission to carry out seismic mapping. But Nicolaisen was an inspired organiser who eventually not only prevented oil extraction but helped to turn the national mood, the collective attitude to assaulting the planet.

Macfarlane shares Nicolaisen's passion and probity. *Underland* is a moral hymn to the strangeness of existence and a sharp warning not to take anything for granted. (2019)

II

History

Off track

Myths, Emblems, Clues by Carlo Ginzburg, translated
by John and Anne C. Tedeschi

Carlo Ginzburg suggests that 'the oldest act in the intellectual his-
tory of the human race [may be] the hunter squatting on the
ground, studying the tracks of his quarry'. Ginzburg himself is in
direct line of descent from that rudely clothed archetype. He may
lack the squatting hunter's urgency, but he possesses a massive
capacity for conjectural interpretation, for divination, for reading
the signs. He possesses, too, a truly awesome sensitivity to nuance
and graduation – he discerns particulates, he can spot a spectrum
where others might see a monochromatic blob. He is thus contemp-
tuous of polarisations and drawn to subjects demanding a delicate
acuity for illumination. This is a micro-surgeon, not an axeman.

All of which is fine, save that untampered fastidiousness fosters a
hermetic self-regard: one longs – too often, no doubt, and shame-
fully – for an axeman-historian who fells trees in order to illumine
the wood. Ginzburg is, very likely, what someone calls a historian's
historian. Like, say, Robert Darnton (*The Great Cat Massacre*), but
unlike Richard Cobb or Simon Schama, he does not feel it incum-
bent upon himself to transform history into literature. He is too

ingenuous or too arrogant or simply unwilling to put a spot of spin on his stuff. I think such a bereavement is philistine, a symptom of academic verrucadom. He will probably consider me philistine for having even alluded to the matter of readability.

He is not disdainful of the notion of the story. Venatically obsessed, he ascribes the origins of narrative to hunting society, to 'relating the experience of deciphering tracks'. (Is there nothing that cannot be provenanced by the tale of man and quarry?) Yet his actual grasp of how to tell a tale is weak. His subjects are fascinating; his treatment of them is characterised by diversions that spawn further diversions, by qualifications that demand their own qualifications.

Myths, Emblems, Clues comprises eight essays with recurring pre-occupations and themes: the subjects include Hitler's various uses of pagan Germanic mythologies, Freud and lycanthropy, Freud and Sherlock Holmes, an early-sixteenth-century inquisitorial trial of a witch at Modena (the store of such trials that have not been scrutinised by recent historians must be running low). Ginzburg claims in his introduction that he is 'guided by chance and curiosity, not by a conscious strategy'.

Nonetheless, he persistently concerns himself with critical analyses of past historiographical methods, and with investigations of the manner in which irreason (religious delusion, folk credence, magic, ancestral myth) contaminates the everyday.

It would be impertinent to suggest that Ginzburg has anything so generalised as a 'lesson' to teach, but in his endlessly obfuscatory way he does demonstrate the hideous thread that links the Inquisition, the Third Reich, and the Iran of Khomeini – at least, I think he demonstrates it – his fondness for scoring points off his little enemies who have previously laboured in the same poisoned garden militates against an unequivocal statement.

While Ginzburg may not, as I say, attempt to create literature, he does subscribe to the now rather aged literary vogue for

self-consciousness and integral self-criticism. His kind of scholarship lends itself to fruitful parody; when conducted in earnest, it is prone to self-parody – which is different, for the player is unaware of the game he is playing; the gulf we call irony is missing. More than a quarter of the book is made up of footnotes and the text itself is dense with parentheses, words in quotes, cornucopias of hanging clauses and – when it suits the author – imprecisions of the sort he elsewhere rails against ('Gombrich's ties to the Vienna school, and in general to Viennese cultural circles, were very close'). This is the visible surface. However, were we to go to work on Ginzburg the way he does on others we might eventually conclude that he is not so po-faced.

Behind the energetically embroidered arras of his essays lurks a saga of really quite venomous spats at oral history colloquia, of library annexes disturbed by eureka hand-rubbing at the prospect of colleague assassination, of triumphs in the letters columns of journals whose circulation sometimes reaches three figures, of treacherous shifts from the camp that believed in the primacy of rite to that which believes in the primacy of myth, of misattributions gloatingly exposed and misinterpretations pithily disposed of in epigrams that are only 5,000 words long. (1990)

Blood and limestone

The Fall and Rise of the Stately Home by Peter Mandler

Blood and soil was a potently pernicious doctrine that failed to gain a mass of adherents in this country, even though it held great appeal to the Germans and the French. Why should the English have been so indifferent to the notion of a link between ethnicity and place, however risible, however scientifically indefensible? It is not as though this country possessed an endemic antipathy towards the mystically nationalistic, nor that it evinced a paucity of religious

gullibility – after all, until recently it believed that the monarch was holy, blue-blooded and didn't pee.

The nagging implication of Peter Mandler's intermittently lucid study is that we didn't need blood and limestone. Mandler doesn't go so far as to articulate it thus, but the foundation of his enterprise is that grand country houses are more than the demesnes of a redundant aristocracy, that they are symbolic chalices of English-ness, repositories of national identity, cultural artefacts that belong – but obviously not in deed – to us all. He pulls out all the stops to plead their centrality, their importance and their ever-mutating hold on the public: tastes change from generation to generation, as do the fiscal fortunes of country house owners and the expressions of *noblesse oblige*.

He admits in his introduction that 'the country house has not always hung over us', but even in his surveys of those periods when lack of tourism and proprietorial diffidence combined to wipe them from the public consciousness, he never lets them out of his sights – with the result that he promotes the illusion of their perpetual paramountcy. His case looks more convincing today than it would have done twenty years ago, when the *Barry Lyndon* syndrome was still in its infancy. (I mean the nerveless adaptation of a 'classic' that is more costume than drama and which is watched as much for its heritage decor and National Trust sets as for its story, characters and mood.)

There is no doubt that middle Britain loves olden times, but we know that already. What fascinates Mandler is the protean nature of retrophilia. He seems to take as a given the English appetite for looking backwards, and he is not out to deprecate or correct it. He shows how various this appetite is, how fashions come and go, along with different causes of retrospection and conflicting pro-grammes of authenticity. The house in aspic, decorated and fur-nished as it would have been when built, is a creation of the last two

decades. We were not always so archaeologically fastidious, nor so eager that country houses should provide quasi-educational experiences (as well as the souvenir shops staffed by septuagenarian forelocks peddling their loathsome 'good taste').

In the eighteenth century, a form of internal Grand Tour was conducted: the noble and persons of sensibility and aspirant sensibility trawled each other's parks and houses with reciprocal covetousness, envious curiosity and a keen eye for coming fashions. Throughout much of the nineteenth century, after the construction of the railways, which were hardly slower than they are today (the journey from Charing Cross to Quex Park at Birchington is a mere six minutes shorter than it was a hundred years ago), both the old landed families and newly elevated mercantile castellans fulfilled an obligation to urban workers by opening their parks, if not their houses. Some, such as General Sir Augustus Pitt-Rivers, who constructed the Larmer Tree Grounds on Cranborne Chase, went so far as to provide gardens specifically for the recreation of the masses, a precursor of the urban municipal park. Pitt-Rivers actually lived a couple of miles distant, thus retaining his privacy, and he did have a covert motive, which was to offer a Sunday alternative to church.

Nevertheless, there did exist, all over the country, populous evidence of a response to a genuinely liberal aristocratic enlightenment. Mandler contends, with a certain academic point-scoring, that this period came to an end in the 1880s with the exponential growth of communications telegraphy and photography, and evidences José Harris's useful phrase, 'the unique dominance of the present time'. But that present time was when Edward Bellamy published *Looking Backward* (which Mandler doesn't know or overlooks), was when Axel Haig, the 'Piranesi of the Gothic revival', published his finest work (ditto), was when the garden city movement and land colonies were born, and when the incipient Arts and Crafts burgeoned into the mainstream. Retrospection had taken a

new turn, one that was nostalgic for the quotidian, the humble, the yeoman, rather than the lord, who was increasingly viewed as a distant swell tarnished by piratically acquired money and 'continental' taste (if in doubt, blame France).

The grandees of late-Victorian and Edwardian England were growing too close to their eighteenth-century forebears for comfort. And they showed it in their antipathy to such agencies as the Commons Preservation Society, which opposed enclosures, and the Society for the Protection of Ancient Buildings and the National Trust (consider the meaning rather than the too familiar name), whose purpose, *tout court*, was to challenge the very notion of ownership with that of stewardship, which is the norm in those kindredly ancient countries that have mercifully enjoyed purging by revolution. Mandler quotes the Duke of Rutland, a Ruritanian title if ever there was one; he railed against 'the artistic element in the country who are concerned in preserving for themselves places, pictures and articles . . . at the expense of the owners thereof'. It's all rather like fox hunting on the duke's Belvoir estate; which polarised faction is the worse – the philistine incumbent or the aesthete sab?

The result of power having devolved to non-landed PMs such as Asquith and Lloyd George was that of aristocratic defensiveness. Houses that had been open for half a century were closed, and the appetite for them was assuaged in England's cosmetically rustic interbellum suburbs and by a strain of country-house literature. Mandler is sound enough on Waugh and the tendency of satirists to covet and eventually acquire a chunk of what they had once guyed, but Henry Green is omitted and Wells is misread. Mandler's contention that 'the servants were wreaking their revenge' – Wells' parents were in service – may be supported by *Tono-Bungay*, a hymn to the self-made. But it is contradicted by *The Passionate Friends*, an analogue of Uppark, where his mother was a maid, as delightful

playground. The place is celebrated, but not on its own terms, not in the way that its owners would necessarily recognise.

These houses, works of utile art (sometimes) and vessels for art, will for ever be taken psychic possession of by people who have no material stake in them. They are susceptible to manifold interpretations, and as we advance into further invented pasts, those interpretations grow ever more detached from the bricks, moats and machicolations that occasioned them; an Englishman's castle is a day-tripper's text. (1997)

Ptarmigan tattle

The Rise of the Nouveaux Riches by J. Mordaunt Crook

This is a book which is likely to prove invaluable as a research tool. Future generations will come to regard it as a standard text. Anthropologists, social critics, ethnographic limners – they, and all others involved in the study of the late-twentieth-century, English, white, male, middle-aged architectural historian, will find themselves massively indebted to it.

Dr Crook does not, admittedly, vouchsafe to his readers whether he gets his hair cut twice a day at Trumper's, or whether he wears a detachable celluloid collar, or whether his waistcoats are triple- or quadruple-breasted, but, in most other regards, his self-portrait is detailed and rounded, even if his method is, inevitably, oblique.

The choice of those monuments to themselves built by the (predominantly) Victorian nouveau riche is masterful: it allows our author to show off his prodigious and exemplary researches into an architectural backwater, yet not one so recondite that its very existence is unfamiliar. And it allows him, too, to write with what is by any measure a finely gauged hauteur about the milieu of ostentatious opulence whose Edwardian autumn he characterises, wonderfully, as 'all baccarat and onyx, all ptarmigan and champagne'.

Crook allows his precursors such as Harold Nicolson to be the ones to utter the word vulgarity, but there is not a sentence of this work which doesn't exude an aesthete's keenly contemptuous delight in the splendours paid for by guano, shipping, opium, arms, copper, malted milk, meat, meat extract, coal, jute, etc.

Crook's subjects' favoured style for their interiors was "'tutti Louis", as the decorators say'. (Do they? I can imagine the pre-grunge Nicky Haslam relishing that epithet – but the generality of that calling?) And outside they went for something to match, the Rothschild idiom of grossly distended and promiscuously mixed late French Renaissance. A scholar of a different sort would no doubt have sought to trace the provenance of the motifs used in such exhilarating aberrations as Minley Manor, Waddesdon and Chateau Impney. But Crook (Athenaeum, Brooks's) is a gentleman scholar and is thus required to wear his learning lightly. This is for the good. He declines to foist on his readers the minutiae of Bearwood's debt to Blois or chapters entitled 'The Ascendancy of the Roof: Mansartian Paradigms 1867–1874'. He elects to compose his book like a swell who has learned to read and write.

His model is not Pevsner, not even Osbert Lancaster, but Chips Channon. He conceives of architectural history as the higher gossip – and in certain instances one can lose that 'higher'. Crook displays a trait which is the *sine qua non* of the successful newspaper diarist – he implies an intimacy with the people he writes about. But these mercantile buccaneers and landlords, and *horizontales* in ostrich feathers, were dead before he was born. This is the architectural historian as (modest) time traveller. It must be said that he carries off this trick with some aplomb; there is a first-hand freshness to even the most familiar tales – he wasn't at Tranby Croft the night that Gordon Cumming was accused of cheating at baccarat in the presence of the Prince of Wales, but he makes one feel he has heard about it from someone who was.

It goes without saying that much of the gossip he reports is contaminated by a sort of consensual anti-Semitism. He is, incidentally, quite wrong to confuse the discreetly ugly sentiments of George Ponderevo, narrator of *Tono-Bungay*, with those of his creator, H. G. Wells. That an architectural historian should concern himself with judgements about buildings is perhaps too much to expect. Crook doesn't bother to distinguish between the exuberantly vulgar, the crassly vulgar, the risibly vulgar, the timidly vulgar (of which oxymoronic idiom there was more than one might expect).

And I wonder if he realises how closely this energetic book resembles the houses it purports to scrutinise – its structure is portmanteauish, it is packed with indiscriminate detail, it can't tell the gold from the pinchbeck, it achieves its effect through the sheer quantity of facts that it hurls at the reader who, much of the time, may be forgiven for believing that he has happened upon some sort of annotated inventory of names, bank balances and probate figures. (1999)

The end is nigh

After Progress: Finding the Old Way Forward by Anthony O'Hear

Politics (Aristotle), pop art, pop culture, postmodernism . . . There's something missing here. But had portentousness been included it would have required an entry for every one of this book's 251 pages, and that's no way to manage a handsome index. Because of his timing, O'Hear invites his audience to regard him as a Special Issue Millenarian Doomster. If, however, we ignore the calendrical fortuity, it is evident that he is just another cab driver who covets Paul Johnson's role as the People's Saloon Bar Philosopher.

It has to be admitted that he is well equipped. He made his name outside academe as the author of a pamphlet berating the vulgar gullibility and emotional infantilism and religiose feebleness manifest in the Toni-driven 'national outpouring' which followed the

death of the People's Princess. And now that he has turned his attention to the big subject of why the world has gone down the chute over the past 250 or 25 years (times vary according to chapters and moods) he reveals himself as a nicely foaming-mouthed ranter: 'humanity is in a morass . . . modern man is Faustian . . . we are at the end of the twentieth century'.

So where, according to O'Hear, did it all go wrong?

Well, how long have you got?

The *fons et origo* of our woeful state was the Enlightenment. But there are plenty of other causes too: cultural relativism, scientism, revolutions, such quaint bedfellows as Jimi Hendrix and Nikolaus Pevsner (whose name O'Hear can't spell), utilitarianism, determinism, modernism (but not that of Henry Moore and David Bomberg who, because O'Hear evidently approves of them, are cleared of the charge of modernism), sport, drugs, animal rights, the vacuity of Birt's BBC and, of course, newspapers – excepting, presumably, our author's own contributions to them and those of Chris Woodhead's representative on earth, Melanie Phillips, whose back-cover plug will have them queuing round the block for her chum's rant.

Of course, given such a promiscuously catholic approach to putting the boot in, it would be astonishing were O'Hear never to strike apt targets. His stridency and the coarseness of his mentation and his proud philistinism are almost enough to persuade one that a bathtub full of lard can be art and that Saint Toni is something more than a prefect in messiah's clothing. Almost, but not quite. No matter how ham-fisted O'Hear's expression, a certain proportion of what he has to say is unexceptionable if truistic.

History's direction, as we know from Butterfield, is not predetermined . . . It is not, as we have learned from Watkin, a sign of intellectual or moral stupidity to be out of touch with one's time (he means out of sympathy) . . . The archetype of managerial codes of practice is Polonius's advice to Laertes, which Shakespeare intended

as satire . . . Displacing one establishment does not get rid of the establishment. And although he doesn't articulate it thus, O'Hear is worried that a verruca-like, self-referential exclusivity is almost the defining condition of current institutions and cultures, and that such a tendency is both a cause and a symptom of fragmentation or – should you welcome it – of 'diversity'. He is even more worried by the effective opposite, by monolithic utopianism, which he sees as the Pelagian heresy in action. It doesn't worry him, if he is apprised of the fact, that Hitler shared his views on the Enlightenment.

The sort of precursor whom O'Hear welcomes is, rather, Michael Oakeshott, who ascribed political rationalism to the influence of the Enlightenment. And political rationalism, in O'Hear's priceless phrase, 'elevated consciously thought-out technique, calculation and analysis over settled, unconscious ways of doing things'. The author's preferred settled, unconscious way into the next millennium is to achieve redemption through a 'higher power . . . a higher quasi-personal purpose [which operates] through and behind the material processes revealed by natural science'. Oh dear. By the time he reaches his grand conclusion, he seems to have quite forgotten his strictures about the indiscriminacy and credulousness of New Ageism. (1999)

Sick building syndrome
Spike Island: The Memory of a Military Hospital by Philip Hoare

The Royal Victoria Hospital at Netley on the eastern shore of Southampton Water was the longest building in Britain, almost 500 yards, half as long again, that is, as the artillery barracks at Woolwich and much flashier.

The barracks is all late-Georgian martial sobriety. The hospital was built between 1856 and 1863, the very years when British architecture was at its least constrained, least harmonious, least

contaminated by either the picturesque or, much the same thing, an eagerness to please. Stylistically it was akin to the contemporary Royal Hospital for Incurables in Putney and the military hospital in Aldershot. Its cheerlessness was epic, its coarseness risible, its unfitness for its purpose so manifest even in its designs that Florence Nightingale, who had inspired the project, complained both to Victoria and to Palmerston. A fat lot of good that did. The prime minister failed to prevail and the secretary of state for war, Lord Panmure, got his way: the construction, by workers housed in hulks, of a patently outmoded building, proceeded.

This is a story of Hampshire. Nightingale lived (and is buried) at Wellow, ten miles north of Netley; Palmerston was her neighbour at Broadlands; Victoria's preferred residence, Osborne House, is just across the Solent.

And Philip Hoare grew up in Sholing at a time when, unless you made a protracted detour, it was connected to Southampton's inhospitable hospital across the estuarial Itchen only by a chain ferry, optimistically known as 'the floating bridge'. In *The Buildings of England: Hampshire and the Isle of Wight*, David Lloyd observes that 'few people would go to eastern Southampton to look at architecture'. I must own up to being one of the few.

It is a singular place: bitty, marginal, constellated with industrial greenhouses, fruit holdings, market gardeners' boxy brick cottages, urban villas in fields, urban tower blocks, scraggy copses which look as though they harbour sex criminals, streets with names such as Vespasian, in memory of the settlement of Claesentum, roads that lead nowhere, a horizon dominated by the pipes and flames of Fawley – this is Spike Island, though, having known it all my life, I've never previously heard it so called. Hoare's evocations of it and of the great hospital that stood at its edge are visually sharp if strivingly melancholy. He possesses a pronounced and refined sense of place; he is wrong, incidentally, to ascribe the coinage 'subtopia' to

Pevsner (it was Ian Nairn's), just as he is wrong to call the hospital Gothic.

But he is clearly not interested in taxonomical precision. He wants to go way beyond the bounds of topography. He invests his place with a carousel of excess baggage. This is no straightforward history of the hospital, of doctors' inhumanity to conscripts, of changing fashions in psychiatric procedures – or of its unwitting role in the foundation of 'anti-psychiatric' ones: the young R. D. Laing worked at Netley in the early fifties, the last whole decade of its existence.

Appended or, according to taste, sutured to this central core is a heterogeneous mix of familial reminiscence and conjecture, aesthete's *Bildungsroman*, countless fragments of lives, countless fragments of anecdote, meditations on the nature of romanticism and of the Gothic – Netley Abbey was a quasi-sacred place to Horace Walpole. This is a book which has swallowed many other books – there are thirty-two pages of bibliographic notes and eighteen of index – and which doesn't pretend to integrity: someone who isn't in the index, the Edwardian church architect Ninian Comper, described his compositional method as 'unity by inclusion'. Which means, I believe, ignore the classical unities, shove anything in, hope for the best, only connect and, if there's sufficient energy, it'll come off. There's certainly a furious energy at work here.

Underpinning it all are a wobbly, home-made animism, an inchoate conviction that buildings are more than the physical marks of the past, an eager receipt of the gift endowed by the chance of having been raised in a particular place and an obsessive quest for manifestations of unreason, for myths of the Solent. (2001)

Time bandits

We are twenty weeks and a day away from the 250th anniversary – the word is hardly appropriate – of the first of the eleven days that

went missing when this country converted from the Julian to the Gregorian calendar: 2 September 1752 was followed by 14 September. England was, unastonishingly, lagging behind Roman Catholic Europe, which had begun to convert in 1582. The Gregorian was not a clean break with its 1,600-year-old predecessor but an overhaul. Both systems, for instance, adhere to the seven-day week, which is creationism's most enduring legacy to the secular world: a coarse Judaeo-Christian folk myth pervades every day of our life. But this dubious provenance is, today, of as little moment as the objection that the Gregorian calendar is some sort of a papist plot.

The calendar's overwhelming virtue is that it has been pretty much universally adopted as a chronometric analogue of what Esperanto might have become but of course didn't, not least because that very name, all hopeful aspiration rather than achievement, is a barely disguised admission that it would fail. It is deemed to be part of that insidious echelon of givens dignified as the 'natural order'. We are loath to question it. We take it for granted even though its artifice is emphatically illumined by leap years. It is what we measure change against, a linear reassurance, the template of history's narrative. To tamper with time is an act of insolent hubris, of godlike presumption, akin to hoping to dictate the weather's patterns.

Some miles south of the Hansa town of Neubrandenburg there is a remote village called Alt Rehse. It is sited beside a mere, the Tollensesee. Its cottages are cutely saccharine, folksy dreams of yesteryear. Neubrandenburgers were led to believe that Alt Rehse's model cottages were built as billets for rowers and scullers training on the mere for the 1936 Olympics. The high security surrounding the village might, to a less credulous people, have signalled a deception.

Alt Rehse was one of the places where the German medical profession was all too willingly turned, where doctors were transformed from healers into harmers. We don't elect what affects

us, we have no control over what squats in our subconscious. Alt Rehse has turned out to be more terribly present in mine than Dachau or, even, Ravensbrück. It infects my nightmares. Not because of the immane perversion that was taught there but because the devil is in the details of the woodwork. The exterior beams of the cottages are incised with the dates when they were built. The dates are *Jahr II, Jahr III, Jahr IV*. All in the jagged Gothic that is the script of mass murder, all measuring from 30 January 1933, the Day of the Seizure of Power. The dates are monstrous tokens of the infantile earnest that pervaded that regime. They are a tiny, telling proof of its secession from Western norms, from the continuum of the Enlightenment as well, obviously, as from calendrical consensus.

The conceit is chilling. It implies, with horrible correctness, that if a nation's time is reordered then its people too can be reordered. The pronouncement of Year Zero, of a fresh start, is not an indication of a desire to improve temporal measurement. It is a tool of the social engineer, a coercive instrument for perfecting a race, a staging post on the road to Utopia, which always turns out to be Dystopia: twelve years of it in this instance.

The French revolutionary calendar endured longer, from 1792 until 1806. It went far beyond the Nazis' litany of festivals, such as the Commemoration of the Movement's Fallen. It was a work of radical pragmatism, poetic invention and such determined secularism that it even dispensed with the seven-day week. Fabre d'Eglantine's names for the months are delightful. The first month of the year, which corresponds approximately to late September and early October, was named Vendémiaire, a nonce coinage derived from *la vendange*, the grape harvest. The next, Brumaire, alludes to mists, Frimaire to cold weather, and so on.

So far so good: the names apparently proved popular. However, each month was divided into three ten-day periods called decades. Each day comprised ten hours and each hour 100 minutes. That,

anyway, was the general idea. But there were limits to the degree of perfection to which the newly republican populace could be pushed. While the contemporary introduction of metric weights and distances caught on, the 100-minute hour was resisted: it seemed like an offence against nature.

Although that was not the reason that the calendar was abandoned. As ever, in the case of this form of measurement, it was an external political force that determined its demise. Napoleon quashed it in exchange for the Vatican's acknowledgement of the legitimacy of his position. It was one of the few concessions he made to Pius VII, but it was hugely significant. The pope, forced into relinquishing his claim to Church properties that had been seized, understood that the Gregorian calendar's presence in daily national life was a more potent instrument of ecclesiastical coercion than any number of formerly sacred buildings. He appreciated that a calendar is never neutral, that it does much more than measure. (2002)

Book of revelation

Sacred Causes: Religion and Politics from the European Dictators to al-Qaeda by Michael Burleigh

In *Michael*, Joseph Goebbels' *Bildungsroman* published in 1929 and based on his post-First World War diaries, the sometime Catholic wrote: 'It is almost immaterial what we believe in so long as we believe in something.' The dictum combines grasping opportunism and indiscriminate credulity, but is hideously revealing of a mentality by no means exclusive to Goebbels. In Michael Burleigh's *Sacred Causes*, a sprawling trawl through the squalor of totalitarian creeds and voluntary religiosity, it is dismally commonplace.

Time and again, those with the promiscuous capacity for belief are shown to be those with the equal capacity to promote and

sanction inhumane crimes. We repeatedly witness the migration of believers – 'spiritual persons' – from one cult to the next. Believing in something all too evidently means believing in anything. One of Goebbels' aptitudes as a manipulator was to sate this appetite for belief by forever creating new idols, new hate figures, new 'initiatives'. He understood that the attention span of the credulous is finite, that any cult or political faction or communion will lose adherents unless it espouses what appears to be a constant revolution. The otherwise well-positioned German Social Democrats of 1945–47 did not understand this. They wished merely to turn back the clock to before 1933, to Marxist orthodoxy and coarse anti-clericalism.

The Christian Democrats, on the other hand, were protean and cunning. Despite the broad rupture between the Protestant denominations and Rome, there was a greater divide between Germany west of the Elbe and that to the east, which had remained pagan until the fourteenth century (totem poles are still common in the Baltic states). A broadly Christian government was more acceptable to both a guilt-ridden German people and to the Western Allies than one which shared a dogma with the Soviet Union.

Burleigh traces a coherent if twisted thread that leads from Lenin to today's noisy, intellectually stunted Islamicists. The thread is one of liberally tolerated intolerance, of Western materialism's apologetic self-hatred, of the Christian churches' mutability, of every doctrine's willingness to abandon its defining catechism in the fight to preserve itself and of the universal political preoccupation with religion – whether imitative or antagonistic. Hence the hooked cross, the biblical quote, the evangelical grin and Ronald Reagan, who 'appointed Him an honorary member of his cabinet'. Hence, too, the murder of clergy, the suppression of texts, fatwas, persecutions and pogroms. Hitler was more or less right when he said 'the Enlightenment is dead' – it certainly is so far as the political classes

are concerned. Were it alive, religious faith would be treated with the amused contempt that is visited on flat-earthers and ufologists, and factional schools teaching their particular exclusivities and hatreds would not be sanctioned by government.

Yet it was tolerant, blaspheming, relativist Enlightenment figures such as John Wilkes who hoped that mosques and synagogues might become established in England, as much to threaten Anglicanism's primacy as to promote Islam and Judaism. The first mosque in Paris was built by the state in the 1920s in response to secularist petitioning for a memorial to the Zouaves and Spahis, First World War cannon fodder of Maghrebi origin. In the next war a number of Muslims would don the black of the SS. Catholics fought in Spain for both nationalists and republicans; the Basque country, birthplace of St Ignatius Loyola and strenuously devout, was infamously used as target practice by the Luftwaffe. Ad hoc alliances and compacts of convenience also exist across time. With their self-pity and sense of entitlement to martyrdom, today's Islamists resemble fascist thugs. And the notion propagated by unarmed Muslims that they are treated like Jews in Nazi Germany would be laughable were it not historically warped.

Carlo Ginzburg long ago drew attention to the kindred myth systems exploited by the early Nazis and the ayatollahs. Burleigh does not concur. He contends that much Islamist dogma from Sayyid Qutb onwards belongs rather to the late-nineteenth-century European tradition of anti-urbanism that calumnises cities as licentious and decadent, calls for moral renewal, equates pastoralism with goodness and is covertly anti-Semitic.

But the difference between Islamists and their supposed precursors is that William Morris, and others like him, did not have much of a career as a suicide bomber. Printing expensive wallpaper is not traitorous; blowing up your fellow citizens is – even if you refuse to acknowledge that fellowship, in the manner of Gerry Adams'

father, who lit fires to guide German bombers to Belfast targets. In an aside, Burleigh tells us that Adams' party, Sinn Fein, holds an annual celebration in honour of the IRA chief of staff and German spy Seán Russell. It is this sort of information that makes *Sacred Causes* so valuable: the tiny details that might be written off as mere human interest, but that over and again reveal a sub-human sump of murderous impiety. (2006)

The tyranny of mumbo jumbo

Earthly Powers: Religion and Politics in Europe from the French Revolution to the Great War by Michael Burleigh

A secular cultist who was failing to attract adherents asked Talleyrand what he should do. 'I would recommend you to be crucified and rise again the third day,' replied that consummate opportunist. He was, of course, right. Religion is a matter of the survival of the fittest cult. And the fittest cults are those which have equipped themselves with the bulkiest apparatus of irreason: creation myth, miracles, incantations, liturgical quirks, eschatological fictions, sartorial disfigurements, silly hairdos, omniscient other, genital mutilations, dietary proscriptions, populist iconography and so on.

The shabby ineffectuality of Anglicanism (precisely, that Anglicanism half-heartedly practised in Britain) and its cultural consequence of misapprehending more exigent doctrines derive from its having not demanded all that much belief of its congregation and having thus contained the germ of its own secularisation. It is an add-on. As Clement Attlee (a veteran of Toynbee Hall who's outside the chronological remit of this remarkable book) sanely stated of Christianity sixty years ago: 'Believe in the ethics. Can't accept the mumbo jumbo.' Our current Labour prime minister – Labour is an approximate epithet in the circumstances – seems to have it the other way round.

There is nothing new in this. One of Burleigh's recurring themes is the problem of people in power, secular or sacred, who possess faith – which is nothing but borrowed imaginings dressed up, a susceptibility to institutionalised fantasies dignified. These people are generally far more obstinately dangerous than such devious agnostics as, say, Harold Wilson or Talleyrand himself, who was, variously, the concupiscent and absent bishop of a Burgundian see, the celebrant at one of the Festivals of the Unity and Indivisibility of the Republic choreographed by J.-L. David (the Painter of Bray, Sir, and a forebear of Albert Speer), an excommunicant, a minister and diplomat who ingratiated himself with successive regimes and was more imperial than the emperor. He was an exemplar of the truism that the gross appetite for power exists initially in a sort of void and seeks an arena – it may be political, it may be ecclesiastical – in which it can be sated.

Michael Burleigh has Go! There is a furious energy at work here, and a sensibility which relishes the paramountcy of subject matter to the point where argument is sometimes undone by conflicting testaments. The beguiling eclectic Ninian Comper described his approach to church architecture as 'unity by inclusion'. A detractor might characterise Burleigh's kindred indifference to purity and structural elegance as an inchoate exercise in shoving in as much material as can be mustered and hoping that it adds up to something or other. The sheer volume of information presented here is startling and thrilling. And despite the tendency of parentheses to breed parentheses which breed yet more of them, it does add up because of the writer's passionate preoccupation with exploring or exhuming what has hitherto been a partially occluded foundation of his *oeuvre*: that is, the essentially theocratic nature of the most immane regimes mankind has yet devised, or is liable to devise – we can be certain that the caliphate with a nuclear armoury will be nothing if not godly.

Lurking everywhere are presentiments of the tyrannies which will be scrutinised in Burleigh's sequel. The French Revolution, for

instance, invented the boy martyr – Joseph Bara – whose avatars would be the Soviets' Pavlik Morozov and the Nazis' Herbert Norkus (the original of Quex); David had to obliterate discredited (and guillotined) figures in *The Oath of The Tennis Court* just as Stalin's operatives airbrushed this week's enemies of the people from photographs; the Jacobin conviction that humans are empty vessels anticipated determinist nurture by a century and a half; place names were changed, Bourg-la-Reine became Bourg-Egalité; Saint-Simon, certain of whose wheezes Burleigh describes as having 'the cabbage whiff of the east European people's palace circa 1950', was equally a utopian, technophiliac proto-futurist with a creepy line in that *trahaison des clercs* which idolises strong men of action. And during the early years of the nineteenth century, Germany witnessed the foundation of *Burschenschaften*, societies of spiritually belligerent, anti-urbanistic, morally regenerative young body-culturalists whose great-grandsons, 'uniformed bohemians', would march in the *Freikorps*. Their cause was nationalism, a religion defined by xeno-phobia as much as by an invented past: the Irish harp was lifted from Guinness's trademark, not vice versa.

Like all causes, all denominations, all churches, all movements, nationalism shouts about its muscle and potency yet reveals its frailty by demanding statutory protection against alleged libels. The history of special pleading, special whining, sacrilege laws, blasphemy laws and censorship is a history of licensed bigotry, sometimes mur-derous, moralistic at best. Diderot's *La Religieuse* was, unsurpris-ingly, not published till seven years after the Revolution, by which time he had been dead for more than a decade. Perhaps the sole trick that the omniscient Burleigh misses is to mention the fate of Jacques Rivette's 1965 film adaptation, which André Malraux banned for two years prompting J.-L. Godard's once-famous open letter addressed to 'Le Ministre de la Kultur'.

Rather astonishingly Burleigh frequently succeeds in making this gruesome chronicle of superstitious self-delusion and its terrible ramifications very funny. The 1905 separation of church and state (which the grinning Nicolas Sarkozy, an aspirant Blair, rashly proposes to overturn should he become president) was effected by the virulently anti-clerical French prime minister, spiritualist and freemason Emile Combes, who boasted of taking office for the sole purpose of destroying the religious orders. He closed thousands of what were not then called 'faith schools' yet spared those run by Trappists on the incontestable grounds that because they did not speak they were useless proselytisers. He appointed a seventy-six-year-old as bishop of the mountainous diocese of Ajaccio, 'doubtless mindful of the septuagenarian cleric wheezing up and down his inclined see'. A century before rational dress became a craze the Aveyronais monarchist Louis de Bonald advised that citizens should wear a uniform according to their function and that members of the nobility should be obliged to wear a gold ring. His contemporary, the constitutional bishop of Caen Claude Fauchet, whose soutane was shot during the storming of the Bastille, attempted to reconcile revolution and religion by declaring that Christ had been crucified by 'aristocrats'. The founder of positivism, Auguste Comte, threw knives at his common-law wife, a prostitute turned bookseller, while reciting Homer and imagining he was a Highlander in a Walter Scott novel. Charles Fourier anticipated a world in which the oceans were composed of lemonade and inhabited by 'anti-whales' who were friends of man. Burleigh is as fine a comedian as he is a historian. (2006)

Honoured in death

The Memorial to the Missing of the Somme by Gavin Stamp

It is impossible to imagine an English popular singer acknowledging the sacrifices of his grandparents' generation and the terrors they

suffered. Michel Sardou (born in 1947) wrote a song in the late 1970s called 'Verdun'. It is grave and melancholic, horribly apt. And in a small way it is compensation for his nation's failure to honourably commemorate its dead by architectural means. Sure, the Voie Sacrée, which runs from Bar-le-Duc to Verdun, is a memorial of a sort: ninety-year-old tanks detrited by rust constellate a landscape that recalls the steppe and is furrowed with gun emplacements and redoubts. But the vast ossuary at Douaumont is a matter for shame. It is shockingly inappropriate.

Léon Azéma, Max Edrei and Jacques Hardy were not architects of the first rank. And they adopted an idiom peculiar to French and Belgian sacred architecture of the 1920s and 1930s. In the hands of Paul Tournon (the architect of Sainte-Thérèse in the Renault garden village of Élisabethville and Saint-Esprit on avenue Daumesnil, Paris 12e) or Jacques Barge (Sainte-Odile, Paris 17e), this wilfully exotic, vaguely oriental art deco is charming: if you like your churches to resemble cinemas, it is just the ticket. But even had Azéma and his collaborators been less ham-fisted, the very style, which might derive from an illustration by Willy Pogany, could only be counted a frivolous mistake – a mistake exacerbated by its proportions (the ossuary is almost 150 yards long). The architecture of pleasure, monstrously distended, is inimical to meditative remembrance. The designers seem not to have had the nerve to address the awful purpose of their monument, and shamefully made light of it – they effected a betrayal of the dead.

Gavin Stamp is neither chauvinistic nor Francophobic in his assertion that the monuments and cemeteries erected by the architects of the Commonwealth War Graves Commission possess a fitness manifestly lacking in the indigenous works. Rudyard Kipling, who lost his son among the millions of dead and who selected the inscription 'Their name liveth for evermore' from the Book of Ecclesiasticus, described the campaign of building as 'the biggest

single bit of work since any of the Pharaohs – and they only worked in their own country'. It is a proper comparison, for the greatest of the monuments – that which gives this fine, austere book its title – is as elementally potent as the pyramids.

The architect was Edwin Lutyens. Stamp considers the arch at Thiepval, between Arras and Amiens, to be his supreme creation. Despite the rehabilitation that Lutyens' reputation has enjoyed over the past thirty years, not least through Stamp's own persuasive championship, this is a far from orthodox view. It is the precocious early Lutyens of spellbinding, almost hallucinatory informal villas for Randlords and *Tono-Bungay*-ish entrepreneurs who is more routinely valued. Pevsner's opinion is typical: Thiepval reveals 'little of the best of Lutyens'; his art was 'petrified by the cold, never wholly relaxing grip of Palladianism'. But then Pevsner was nothing if not *parti pris*: he couldn't – more likely wouldn't – see beyond the matter of a generalised idiom which he reckoned *retardataire* (one of his favourite words), regardless of how infected with genius this work might be.

This silly aesthetic factionalism fails to acknowledge modernism's incapacity to devise a commemorative mode. Such artists as Richard Gilbert Scott in the Roman Catholic archdiocese of Birmingham, Le Corbusier at Ronchamp in Haute-Saône, and Sáenz de Oiza and Laorga at Arantzazu in the Basque country, made churches of signal architectural merit: but whether they fulfil the needs of their particular communion is another matter. And anyway, the arch (or arches) at Thiepval is not a religious monument; it was certainly not constructed with a denominational bias.

One might, in a Whiggish way, suggest that Lutyens' tectonic ecumenicism was 'ahead of its time'. Equally, it was a case of respectful manners, a courteous recognition that those who gave their lives for a still predominantly Christian country were not themselves necessarily believers: it was not war and victory that

were being trumpeted, but innocent, mostly conscripted victims who were being honoured. There is, further, the matter of Lutyens' own beliefs.

It is telling to note among the architects who contributed to this unprecedented programme the name of W. H. Cowlishaw. He belonged to the folksiest tendency of the Arts and Crafts, and his greatest work, the determinedly eccentric Cloisters at Letchworth, was built for his fellow theosophist Annie Lawrence. Lutyens wasn't much of a joiner, but he was a fellow traveller of theosophy, despite more or less losing his wife to it. Stamp describes him as being 'sympathetic to its pantheism'. That he designed the Theosophical Society's headquarters in Bloomsbury (now the British Medical Association) cannot have escaped his detractors. The *Catholic Herald* dismissed his earlier Cenotaph as 'a pagan monument', and his refusal to include Christian motifs, specifically the cross, at Thiepval excited wrathful questions in Parliament and the indignation of Randall Davidson, then Archbishop of Canterbury.

Lutyens was fortunate. His adamancy was doggedly supported by his patron, the founder of what was initially the Graves Registration Commission, Sir Fabian Ware, a sometime imperial administrator who did not conform to the clichés ascribed to that caste. Stamp has always possessed a gift for the demolition of received ideas, and his economical sketch of this singular and selfless man is salutary. Of course, in Lutyens, Ware had an artist whom it was not difficult to defend. By the end of the war he was fifty, the designer of New Delhi and the most celebrated architect of the Empire, if not a figure of the establishment (as it wasn't then called) like that fulminating devotee of demolition Sir Reginald Blomfield: it is enjoyable to imagine the outrage that Blomfield's louche nephew, Edward Burra, must have caused him.

Stamp is surprisingly sanguine on the subject of Blomfield's ponderous Menin Gate at Ypres. Siegfried Sassoon wasn't:

> Was ever an immolation so belied
> As these intolerably nameless names?
> Well might the Dead who struggled in the slime
> Rise and deride this sepulchre of crime.

The futility of stylistic taxonomy could hardly be better illustrated than by comparing Blomfield's clodhopper to Lutyens' refulgent creation. 'Classical' is rendered meaningless – or is, rather, an epithet so broad in its application that it can signify almost anything. Lutyens wrote about his struggle to master the orders as an adept of free verse might write about a prosodical leap to pentameter: 'You cannot copy . . . If you tackle it in this way the order belongs to you, and every stroke must become endowed with such poetry and artistry as God has given you . . . You alter one feature (which you have to, always) then every other feature has to sympathise and undergo the same care and invention.' Invention is key: Thiepval's 'classicism' was as new as anything the modern movement devised; newer, indeed, for by 1932, when it was completed, modernism was already frenetically feeding off its brief past.

What it wasn't was modern 'in our specialised sense', as Hugh Casson once quaintly put it. Stamp considers that early Lutyens presaged the Lutyens of Thiepval by playing the 'high game' of classicism from almost the beginning of his career. It is also the case that his genius remained consistently powerful when applied to apparently different idioms. He seldom failed to create a genre of his own. The link between houses such as Marsh Court or Tigbourne Court and Thiepval is the breathtaking deftness of the architectonic mind that is revealed. Unlike those houses, Thiepval has the advantage of might. It dominates the killing fields in isolated grandeur and is the beneficiary of the illusory phenomenon called size constancy: our brain persuades our eyes that the distant object is larger than it is. This is a book of remarkable emotional restraint. Few

works of architectural history are so founded in admiration for their subject, and few evince such indignant scorn for the negligent callousness without which that subject would have had no cause to exist. (2006)

A self-sophisticated man

Architect: Pugin and the Building of Romantic Britain by Rosemary Hill

Rosemary Hill writes with furious aplomb. Her prose is driven. It possesses the attribute known in her subject's brief lifetime as Go! It is improbable, given his fastidious euphuism, that he'd have deigned to use that word thus. Architecturally it was applied to an idiom of the decade and a half after he died (presumably of syphilis, presumably contracted as a formidably precocious teenager working at Covent Garden theatre). A. W. N. Pugin would have hated buildings invested with Go!, the 'modern Gothic'.

He was a great hater. He hated his immediate precursors. Some justly: James Wyatt ('the Destroyer') was a hack. Some questionably: Sir Robert Smirke had a gift for urbanism that Pugin quite lacked, or despised, or never had the chance to display. Some preposterously: John Nash – a tart, a charlatan, the widest of wide boys – was a marvellous architect. But Pugin was blind to talent, susceptible only to genre. He was a single-issue fanatic. That issue was the restoration to England of the pre-Reformation confession with its commensurate buildings: Wells, Lincoln and Salisbury cathedrals; the churches of Louvain and Nuremberg – neither of which are precisely English. It was through his succulent fondness for such buildings that he had arrived at his religious certainties. This is not such a weird way of going about things. The visual preference came first, the faith to give it earnest buttresses second. He invented a gamut of reasons to prove that what was tectonically appealing to him was ethically vital. And he wrote captious polemics in his self-support.

Hill loves her mad, maddening, self-pitying, restless, prodigious subject and she persuades us to at least like him too. She draws him with minute detail on an epic scale, a Hilliard making a mural of a life that was seldom less than chaotic: his three marriages – the last to 'a first rate Gothic woman' – his unrequited love affairs, his fractious friendships are brought to startling life. She is equally excellent in her neat evocations of numerous disparate milieux he frequented and of those that his self-aggrandising refugee father had known. Auguste Pugin was a figure of London's lower bohemia, as it was not then called, and had been John Nash's perspectivist in Carmarthen, where Nash was both an architect and a sleazy actor-manager.

Pugin, like anyone of any interest, was a self-creation. As a youth he educated himself through the theatre, by persistent travel with a sketchbook, by collecting. But behind every autodidact there lies some sort of ad hoc pedagogic system. He frequented antiquarians. Antiquarianism meant dodgily partial scholarship, bibliophilia, flogging misericords, dreaming of Rome, looting ruins and putting together furniture from fragments of different eras – a process known as 'sophisticating'. Pugin taught himself to sail in order to smuggle Gothic booty from Flanders. He ever after affected nautical dress and clearly cut a most outré figure.

He connected well. He got to know the Catholic aristocracy: hence the Earl of Shrewsbury's commissions for Alton Towers and the buildings around it, a theme park of the old faith which would be the new faith if only the clock could be turned back. Hill doesn't speculate on how he encountered Edward Cust, but there seems every likelihood that it was through his antiquarianism: the Cust family's church in Bedfordshire is a repository of furniture from the Low Countries. It seems to have been Cust who effected the most important meeting of his professional life, with Charles Barry. Their relationship was rocky. Seventeen years after they had begun

to collaborate (an approximate word in the circumstances) on the Palace of Westminster, Pugin complained, 'I am now nearly 40 and am handled as a boy as a clerk upon work of which I only have the key.' Barry apparently destroyed correspondence that proved Pugin's authorship of Big Ben. Even after they were both dead their families slugged out the battle of the palace's attribution in public.

Hill is rightly indignant that Pugin has been pigeonholed as an early Victorian. If he was anything it was a precursive High Victorian. He was dead by the time that many of his coevals were just beginning to make their mark. How much posthumous influence he exerted is moot – for what is not in question is that his weird refulgence was inimitable. (2007)

Fog and net curtains

The Tiger in the Smoke: Art and Culture in Post-War Britain by Lynda Nead

Lynda Nead's study of the ways in which post-war Britain was represented by what was not yet called its media is tirelessly oblique. She contrives to see everything through the reductionist lenses of colour and colourlessness. She leans heavily on Raymond Williams's 'the structure of feeling' which supposedly defines 'the particular and characteristic colour of a period'. What Williams intended by 'colour' was ever-changing mood, constant only in its intangible slipperiness. The idea of mood demands faith in the collective conscious and mass consensus, which was obviously evanescent, resistant to analysis and not capable of articulation save by example. Mood is closely related to if not exactly synonymous with the received idea or *la pensée unique* or, heaven help us, the zeitgeist – save that it has not quite arrived. It is on the point of arrival, it is not quite yet standard issue, it has yet to become the spirit of the times. Vagueness is hardly explained by further vagueness. Feeling

rather than thought is indeed key to it. Searching for something tangible to hang on to, Nead takes Williams's 'colour' literally, treating it as indisputably essential. She runs with it: skin colour, housecoat colour (really), food colour, bombsite colour, Sunday afternoon colour, kitchen sink colour and, most insistently, meteorological colour.

Fog and smog are ubiquitous. They are past and present, a continuum from the High Victorian age to the New Elizabethan age which was also the first neo-Victorian age. They possess a palette that is specific to them and to the gobs of phlegm they provoke, known in Partick and Govan as Glasgie oysters. London Peculiars and London Particulars excite more genteel expectorations. They don't do the job. Dickens's monumental fog in *Bleak House* is perhaps correctly reckoned by Nead to be metaphorical. She doesn't state what it's a metaphor for. Presumably the torpid sclerotic chaos of Chancery. But the impasto fog and smog (a coinage not made till 1904) were, equally, real. They were insouciant evidence, *avant la lettre*, of what we now recognise as the grubby dawn of the Anthropocene Era.

The questionable maxim in *Our Mutual Friend* that England suffers a 'national dread of colour' is surprisingly overlooked by Nead. It should be there for it explicitly supports one of her disputable cardinal points. It should also alert us that Dickens was a fabulist for whom exaggeration was a norm. His most engrossing works were hyper-realist and chromatically inaccurate. He lived in an age of polychromatic brickwork, dazzling bright inflammable crinolines, gilded smoking rooms, saturated ottomans, luminous painting, garish advertisement hoardings and the Great Exhibition. Its gaudy vulgarity appalled such aesthetes as William Morris and, retrospectively, Pevsner, who wrote accusatorily of Victorian manufacture's 'rank growth'.

Dickens was neither true to life nor to his age. He was a cartoonist rather than a documentarist – not that the veracity of documentarists

is to be trusted any more than that of cartoonists. He railed against social ills of his own invention and living conditions that had disappeared by the time he described them. The adjective Dickensian is so widely applied that it is meaningless: urchins, smuts, back-to-backs, urban indigence, foundlings, gluttony, gross sentimentality – they all answer to it. To evoke a society through reference to its most distinguished, most protean artists is usually a hazardous enterprise. In seeking a record or snapshot it disregards the manipulations, the omissions, the wild anachronisms and the very inventions that cause the artist to be reckoned 'great'.

Nead is apprised of this but sometimes forgetful. She has a taste for the exceptional. She admires Bill Brandt, notes that as well as making exquisite photographs he collected Victorian furniture (from which part of that reign is not disclosed). She goes on to say that these two endeavours combine to signal 'a deep longing for an essential national heritage and identity'. She illustrates this claim with several works which exhibit Brandt's sedulous *mise en scène*. One is of Shoreditch back yards. Brandt's demonstrative art mitigates the photograph's efficacy as illustration. It is specific, ordered, an obvious pastiche of Gustave Doré, rather than displaying the generalised 'Victorianism' which Nead finds lurking like the living dead, absolutely everywhere.

By piling film upon painting upon print upon (a single) novel, Nead exaggerates this fashion's role in 'the structure of feeling'. 'Victorianism's extended cultural reach' evidently strained every sinew. It apparently infects the 1947 film of *Brighton Rock*, based on Greene's 1938 novel. With the exception of Ida's Pierrot troupe there is little in the film to suggest any link to Victorian England. But then 'the structure of feeling' is a woolly conceit, akin to a faith. Proof is not required. A Brighton film of two years earlier, Robert Hamer's delightfully sinister *Pink String and Sealing Wax*, set, to judge by the costumes, in the 1880s, does indeed have 'Victorianism' written all

over it, as does that doomed director's subsequent *Kind Hearts and Coronets*. But neither of these is scrutinised by Nead. Maybe because they are pure period pieces and – I surmise – 'the structure of feeling' is only satisfied if there is perceived to exist a reciprocity between present and past. One has, perhaps, to be an initiate of 'feeling' to detect this temporal exchange. Thus, when Miss Havisham's Satis House in David Lean's 1946 adaptation of *Great Expectations* is described by Nead as 'a Gothic bombsite', which it wasn't, we can be assured that it exhibits the 'colour of the period', i.e. low-key lighting, glutinous blackness, overwrought decor.

Cinema is, equally, an auditory medium and should be treated as such. A film's cinematography is merely one element. *Great Expectations'* score is in the mid-century, modernist-lite idiom created when the Second Viennese School was instructed not to upset the children. The dialogue is at functional pitch, tending towards Classics Illustrated. Nead calls this adaptation 'Dickens Noir', an epithet which would be more useful had Noir not become such a hackneyed suffix. 'What,' she wonders, 'did this fabulous cinematography mean to post-war audiences and how did it relate to the greyscale aesthetics of the fog and the bombsites?'

The answer, probably, is consciously very little indeed. Cinema was mass spectacle, an entertainment, a story. The habit of analysis had yet to be widely learned. Tellingly, the book's copious notes refer to few sources contemporary with the films she discusses. There was no British equivalent of the theorist André Bazin. British film studies were still *in utero*. Lindsay Anderson and Gavin Lambert did not start the student magazine *Sequence* till a year after *Great Expectations* appeared: Anderson, it goes without saying, despised David Lean.

Another energetic hater, Wyndham Lewis, wrote of London in *Rotting Hill*: 'a monstrous derelict of a city, built upon a bog and cursed with world famous fogs: every home in it has a crack from

the blast of a bomb and dies at last of chronic dry rot'. This was a commonplace opinion. Anti-urbanism had been an English (though not Scottish) norm since the 1870s. The city was reckoned toxic. The suburbs were favoured because they were thought to offer safe shelter and an unpolluted atmosphere. When Lewis wrote that, in 1951, the year of the Festival of Britain, the middle class's stuttering reclamation of the inner city was some years in the future. That demographic shift, i.e. 'gentrification' (Ruth Glass's coinage was of 1964), was at least partially occasioned by the 1956 Clean Air Act. That act's effects were, however, only gradually noticed. One of my teenage pleasures in the mid-sixties was getting lost in pea-soupers the colour of a flasher's mac. The fog and smog, *pace* countless cinematic representations, did not swirl. It was a static wall without end.

Nead's title, *The Tiger in the Smoke*, is lifted from a 1952 thriller by Margery Allingham, filmed four years later. London is a site of danger and menace. Hark, hark, the dogs do bark – a band of peripatetic buskers, stumbling single file, begs importunately and steals. Its leader (played by a chunk of period beefcake called Tony Wright) is a murderer. They might be revenants from a Neue Sachlichkeit painting. Fog permeates every shot. It seeps into houses. According to Nead: 'The fogs of the 1950s were different, however, from the fogs of Conan Doyle and Henry James. They drew on the accumulated meanings of the Victorian fogs, but they were also distinctively modern.' This is, at best, questionable, quasi-anthropomorphic. It seems to ascribe to fogs memory and mimetic capacities.

She goes on to generously grant meaning to other inanimate objects which, *ipso facto*, can have none: immigrants' clothes, knick-knacks, domestic appliances, packaging. There is an unwillingness to accept that the world is neither meaningful nor meaningless but that it just is. The 'kitchen sink' painters insisted that they had no political or social programme, that they did not constitute a 'school'.

Too late. As Nead observes, they were 'rendered ideological by the critical discourse of the period', that's to say by John Berger's insistence that they were 'engaged' whether they liked it or not. Of course, their drab everyday subjects and their exaggerated reprise of the Camden Town Group's brand of murky domestic realism lent plausibility to Berger's interpretation.

'Rendered ideological' is the fate of just about everything Nead herself surveys. Sundays are portrayed as slow hours to be fought over by the Sabbatarians of the Lord's Day Observance Society and just about everyone else save enslaved 'mothers' who spent the morning preparing a contender for the three most depressing words in the language, Traditional Sunday Lunch. She quotes part of a letter to *Picture Post* from the Reverend Marcus Morris who refers to the LDOS's members as 'cranks and fanatics': there is no indication that she knows that Morris was the founder and publisher of *Eagle*, the most instructive of 1950s comics and the most colourful. Mass Observation's investigations into behaviour on Sundays were perhaps not widespread but they did give that organisation's reporters something to occupy themselves with. Nead's fascinating assumption that 'social investigation and spying might be numbered amongst the customary activities of the English on post-war Sundays' suggests that net curtains across the country hid an army of prying grasses to rival the Stasi's.

Bert Hardy's model for a *Picture Post* feature entitled 'Big City Loneliness', a state exacerbated on Sundays, was the young Katharine Whitehorn, described as 'a journalist who went on to work for *Picture Post*', which is a bizarrely emaciated description of the most celebrated woman journalist of her era. The reliance on *Picture Post* as a point of reference is both extensive and partial: Nead uses it intelligently though is perhaps disinclined to acknowledge that its world view was as *parti pris* as that of, say, the *Daily Telegraph*. She also overlooks the defining role its former journalists played in the

establishment of BBC Television's reportorial and documentary conventions. Kenneth Allsop, Fyfe Robertson, James Cameron, Trevor Philpott, Robert Kee and Slim Hewitt, 'the scourge of Nuneaton', all worked for it. The roles of writer, photographer and even picture editor often overlapped.

According to Nead: 'Memories of the late 1940s and 1950s are monochrome; people recall these years through veils of mist and shades of grey, conjuring images of black and white photography or newsreel.' Do people? People, I suspect, have been so often told that this was the palette attached to that decade and a half that they unquestioningly accept it. It is a hoary chromatic cliché.

Edward VI's coat of arms are twice displayed in a small town in Dorset. One, very grand, is above a gateway. The second, smaller and framed by fluted ionic pilasters, is above a door in a courtyard; its heraldic beasts look doltishly rancorous. Both devices are painted gold, muted cherry red and a chalky gouache-like royal blue(ish), supposedly azure. The last is a colour seldom used for many years, so seldom encountered. It seems to be faintly bleached but then it always was. When I do see it – and it has to be precise, and it has to come as a mild shock – it is an instant trigger of distant infancy. I am sharply returned to the mid-fifties, to my child self. I am once again, for a fugitive moment, a New Elizabethan.

This hue that works on the colour receptor in my head is impervious to simulation. It is unknown both to Pantone (though not that far from 18-4537) and to the British Colour Council's 1951 chart which included 'Nigger Brown'. An RGB toy on my computer fails to conjure a plausible likeness that might provoke a frisson: again, all it can manage is an approximation and, anyway, a surprise staged by oneself is no surprise. It is evident that means of reproduction inhibit accurate imitation. Colours are amended beyond recognition or disappear: the technology which determines them is overtaken; capriciously, they go out of fashion; maybe they self-destruct like early acrylics. Even

today's 'black and white' – aesthetic choice or affectation rather than necessity – is instantly distinguishable from that of *Picture Post*. Not just the magazine's chiaroscuro photography which, like cinematic neo-expressionism, derived from Weimar and the diaspora after 1933, but its film stock, its printing methods, page layout and its paper quality – as soft and shiver-making as high-grade blotting paper. (2017)

Chipping away the veneer
The Age of Decadence by Simon Heffer

Simon Heffer has assembled a cast of hundreds which forms a sort of linear pageant. Like a puppet master he has the most important (or retrospectively important) figures of the long prelude to catastrophe pop up and flit out of his thematically configured, temporally jumbled chapters in endlessly mutating roles.

Thus, here is H. G. Wells, a 'scientific Jules Verne' – the epithet is Oscar Wilde's – corresponding with the young Winston Churchill, a fellow enthusiast for eugenics, about the pace of social change, shocking the professedly unshockable with his lavish promiscuity, incurring the wrath of St Loe Strachey who combined editing the *Spectator* with running the National Social Purity Crusade, being patronised by the risibly snobbish Virginia Woolf who wasn't fit to tie his bootlaces (nor James Joyce's, come to that), squabbling with more orthodox Fabians, preaching feminism but practising domestic servitude, preaching socialism but deprecating trade unions and commissioning a house at Sandgate from the *ne plus ultra* of architectural nostalgics, C. F. A. Voysey, presumably as an insurance against the baleful future of technological belligerence he soothsaid – not the word he'd have used.

Here is another man of marked inconsistencies, the chilling hypocrite Edward Carson – Heffer felicitously calls him 'cemetery faced' – prosecuting a Parnellite MP, representing the Marquess of

Queensberry against Wilde, agitating against Home Rule, trying to goad H. H. Asquith towards civil war, brandishing the threat of an armed militia, ignoring the rule of law by quietly condoning that militia's – the UVF's – smuggling a vast arsenal of rifles and ammunition from Germany to Larne. Within a year Carson was attorney general.

Here is – well, pretty much everyone, everything . . . Tranby Croft . . . Cleveland Street (including personae named Veck and Thickbroom and a young barrister H. H. Asquith) . . . Startlingly boorish royals demanding deference and acting as role-supermodels for the oikish upper classes – oh, where were the regicides when they were needed? The supremely autolycan Lloyd George is for ever on the thinnest ice. An officious suburban bank manager is overpromoted to the post of lord chamberlain's theatrical censor. The trade unionist Ben Tillett is shown at a meeting on Tower Hill exhorting: 'O god strike Lord Devonport dead.' God didn't oblige. But then Devonport was a generally lucky man. He had hilariously refused to pay for a peerage after being gazetted.

Heffer evokes a world of boastful neo-baroque department stores, ostentatious neo-baroque town halls, blowsy neo-baroque hotels – there was much more neo-baroque than there had been baroque in Britain almost two centuries before, much more neo-baroque than there was Arts and Crafts architecture, which was an almost exclusively domestic mode: houses for the arty rich, cottages for the 'pioneers' of the First Garden City. He scrutinises the somewhat surprising lack of consensus on Empire. He gives us dismally familiar playground scenes in the Commons and the atheist Charles Bradlaugh's struggle to take his seat: his eventual admission is noted as 'a triumph of secularism . . . a new moral and intellectual settlement in Britain'. It ought also to have presaged a legal settlement like France's Law of 1905. Instead, the insistent special pleading of the superstitious has caused that settlement to be overturned by an

inane cross-party consensus blind to the dangers of denominational schools.

Praise is heaped on W. T. Stead, spiritualist, muck-raking journalist and scourge of whatever he adjudged worthy of his condemnation. His investigation into the trafficking of children inspired G. F. Watts' magnificent *Minotaur*. Whether he 'proved the value of a free press' is moot given that press's indefensible abuse of its freedom and his own obsessive pursuit of easy quarry such as Charles Dilke. Among his fellow alpinists on the moralistic high ground was the MP Henry Labouchère, whose loudly professed misogynistic, homophobic, anti-Semitic opinions were, of course, commonplace. They were, for instance, shared by Rudyard Kipling and Hilaire Belloc. Saki complained that clubland was peopled by 'Hebraic-looking gentlemen, wearing tartan waistcoats of the clans of their adoption'.

Robert Hamer's *Kind Hearts and Coronets* was drawn from Roy Horniman's novel *Israel Rank* (1907). Heffer has written elsewhere that a film whose hero, even anti-hero, is a Jewish psychopath would have been crassly insensitive – somewhat Edwardian, it might be said – forty years later. Hence the alteration of Dennis Price's character's ethnicity. He becomes Louis Mazzini. Heffer is wise to avoid this matter here for any discussion of it would get stuck in treacly Whiggishness, the self-congratulatory present officiously ticking off the past. A historian's job is not to measure yesterday's mores by today's and find the former wanting. Nor is it to pick interpretative fights with other historians. Even the best succumb to these parish-pump stramashes. It is to Heffer's immense credit that he doesn't.

The Webbs' anti-Semitism is not mentioned and their future useful idiocy is outside the book's time span. Happily, however, Beatrice's priceless characterisation of British activities in southern Africa as 'underbred' is within its remit. There was a chasmic gap – of class, language, material provision and life expectancy – between the metropolitan Fabians and the frustrated, exploited,

breadline workers in the provinces and colonies whose only weapons were strikes, civil disobedience, mutiny and riots but never, despite governmental fears, real rebellion. At least, not on the mainland: that inevitability, much of it due to Carson's handiwork, would occur on the other side of St George's Channel.

The Fabians were formed as the result of a schism in the cultish, communal Fellowship of the New Life whose sometime secretary was Ramsay MacDonald. Its members, however, were, according to G. B. Shaw, sitting 'among the dandelions' while the newly minted Fabians 'organised the docks': G. B. S., stevedore, would have been a sight to behold. His was wishfully dumb thinking but there is no doubt that the Fabians, officer-class practical utopians, were more capable agents of change than the dreamers they had left behind arguing over Ruskin's small print, Tolstoy and farm colonies. The Fabians were also better and earlier organised than the enlisted manual workers with whom they claimed to hold common cause. What would become known as champagne socialism had pre-empted socialism *tout court*.

The many milieux that Heffer portrays with maximum detail and minimum editorial intervention hardly add up to a country, let alone a country at ease with itself. His method is cleverly designed to emphasise a riven nation, compartmentalised, unjust, inequitable, whose component parts were mutually mistrustful and where agitation was a quotidian necessity. Public libraries, nascent trade unions, adult education, suffrage and bettering oneself might broadly be reckoned facets of that great movement of theirs directed towards the democratisation of knowledge and the achievement of rights. But nothing was so simple. Solidarity is not born of desperation, a state which favours what might be called micro-factionalism, i.e. *sauve qui peut*.

There is, throughout this massive book, an eschewal of caricature in favour of measured nuance. The tribal disputes of aristocrats, of

politicians and of the ragged proletariat demand minute detail. Again, there is no point in condemning, say, Kitchener when the man condemned himself with his every action, with every yard of barbed wire. His prosecution of the Second Boer War really was decadent. There was nothing decadent about Wilde's infatuation with a dull pretty boy. There can be no comparison between, on the one hand, the pleasurable, well-paid activities of off-duty soldiers entertaining dukes' younger sons and, on the other, their comrades of the Worcestershire Regiment shooting unarmed civilians in Llanelli. Violence is decadent, consensual sodomy and fellatio are not. They are, inter alia, effective means of contraception, especially when practised between men.

Heffer has given us a magnificent account of a less than magnificent epoch – or, rather, an epoch which he renders less than magnificent. It was an age of veneer, opulence, ostentation. But he has got it right: decadence. Though not in the way that we have been previously instructed. The Decadents – capital D – were not decadent. They were as vital and energetic as Heffer himself. There certainly existed decadence, however. It was to be found in the slothful presumptuous aristocracy, in cruelly exploitative employers, in complacent army officers who would soon come into their hellish own, in the new middle class which aped its 'betters' and doffed to them even as it clung to the wreckage of the status quo. (2017)

Dance of death

A People Betrayed: A History of Corruption, Political Incompetence and Social Division in Modern Spain 1874–2018 by Paul Preston

The historian whom Sir Paul Preston most recalls is Francisco Goya. In this relentless book, year after year, decade after decade, regime after regime, chapter after chapter, atrocity is piled on atrocity: executions, mutilations, assassinations, violent strike-breaking,

martial barbarity, state-sanctioned 'reprisals' for crimes that it had itself committed – all these are presaged in Goya's *Disasters of War* prints, which were made in reaction to the Peninsular War of 1808–14 and the French occupation of Spain, but may equally be read as a horrible diagnosis of a priest-infested nation which has no appetite for agreeing to disagree or for the practice of compromise. Whatever form of governance it burdens itself with, the result will be the same, condensed in the title of Goya's print of a firing squad and its victims, 'And there is no cure'.

Nor will there ever be one. *Plus ça change* and all that. Spain remains, in Preston's view, irremediable. To his subtitular corruption, incompetence and social division might be added repression and political charlatans claiming that they embody the will of the people in order to silence their opponents and justify despotism. He makes clear at the very outset that these hideous traits are not peculiarly Spanish: he composed the book during a squalid period of 'lies, governmental ineptitude and corruption' that culminated in Britain suppurating as a result of ruptures wrought by a right-wing cult.

Franco's Nationalists called the bloodbath of 1936–39 the Holy War. *The* Spanish Civil War is a perhaps inadequate moniker. The unequivocal definite article grants that war a sort of exceptionalism. *A* Spanish Civil War suggests what Preston implicitly proposes, that Spain, for over half a century before that conflict actually happened, rehearsed for it. Trouble was forever kicking off all over. During the years covered here three prime ministers were assassinated: maybe Spain is on to something.

The narrative begins with restoration of the complicatedly inbred Bourbon monarchy after the brief and chaotic First Republic. The frail seventeen-year-old Alfonso XII assumed the throne. It's a clever Bourbon that knows his father. Alfonso's was probably a member of his mother's guard. So he fortuned to escape the gene pool that had diminished to a puddle.

He was, however, not a lucky man. Although he survived two assassination attempts – one by a pastry chef, the other by a cooper, both garrotted – he lost his first wife to typhus and died of dysentery at the age of twenty-seven. It is evident that the Spanish monarchy was as politically impotent and as vacuous as the British. The business of bent government and outrageous peculation continued no matter who was on the throne. The two main parties, conservative and liberal, enjoyed a cosy mateyness. They took it in turns to rule.

This *turno* system was 'an exclusive minuet danced by a small privileged minority'. More or less rotten boroughs and de facto hereditary seats abounded. The status quo took advantage of high illiteracy and a dependent, all but enslaved, landless agrarian population. Bread shortages and food riots were commonplace even as the country caught up with its neighbours.

Not that the wealth so accrued translated into political muscle. The northern, mainly Atlantic regions which had been the earliest to industrialise – the Basque Country, the Asturias, Galicia, plus Catalonia – militated for secession because they were excluded, unrepresented: of the almost thousand ministers who held office in the half-century between the two republics only about twenty were Catalan. The power remained with the *latifundistas* who ruled vast estates with private militias under the command of stewards like Scottish factors. The military and the church also clung to power and would of course side with Franco's Nationalists. The philosopher Miguel de Unamuno who was too internationally famous to execute would describe the Nationalists as 'Catholic without Christianity . . . they practise ancient militarised Spanish traditions that are not Christian'.

Spain lost Cuba and was humiliated in Morocco, not least because of King Alfonso XIII's interference. Patience with forever mutating but reliably weak governments grew thin. As is so often the case, a 'strong man' was called for. Alfonso, a characteristically dim-witted

monarch fond of fast cars and with a tendency to make speeches which were own goals, connived in Primo de Rivera's coup without realising that it undermined his own position. In an apparent competition to demonstrate lack of self-awareness, Primo published a manifesto condemning the very nepotism and favouritism which had enabled his rise. Unamuno decried it as 'pornographic' and described Primo as 'a pleasure-seeking general of below average intelligence'.

Primo was a textbook dictator. He suspended parliament and censored the press. He was laughably mendacious, notably in his promises to Catalonia whose secessionist parties were banned and whose bilingual street signs were removed. His reign was informed by cronyism and clientelism. He surrounded himself with yes-men. He imposed martial law which, with a change of name, transmuted into a 'civilian directory'.

Among its brass was the sometime military governor of Barcelona, Severiano Martínez Anido who — and he was not alone in being in such a position — was blackmailed by the organiser of his hit squads. Among Martinez's achievements was securing for his son a national monopoly on rodent extermination: Unamuno called him 'an epileptic pig'.

He was merely a small-time vengeful gangster with a high rank and a gaudy uniform, one of hundreds who stain these pages. He was insignificant beside the ubiquitous figure of Juan March, a sometime tobacco smuggler, petroleum industrialist, banker to impecunious royalty and fixer who developed into a fully formed, free-range, totally legit 'philanthropist' with a pretty much global reach. Here he is under suspicion of murdering his wife's lover, fleeing to Paris disguised as a priest; here he is denounced in the Cortes, backing a failed coup against the Second Republic, using his five newspapers to spread anti-Republican propaganda, fixing elections, buying immunity from prosecution, receiving money to spy for

Britain, bribing liberally, being sarcastically proclaimed 'the Sultan of Spain', paying for the charter of the aircraft (at Croydon) which would, in 1936, take the still dithering puppet Franco from the Canaries to Morocco. That was when rehearsal ended and the Holy War began.

Preston does not pretend to impartiality. He does not for a moment buy into the entirely bogus notion of an equivalence between the two major factions in the Holy War, a notion born, of course, of governmental lies and victors' propaganda. The proposition that western Europe's bulkiest lump of devotional kitsch, the basilica of the Valle de los Caidos, is a monument to all who died in the war, irrespective of side, can be believed only by the gullible, the delusional, Catholic naïfs and sick nostalgics – who will doubtless still flock there even now that El Caudillo has been removed to a family crypt. His body ought to have been dumped on a skip.

A People Betrayed is the work of a very great historian who knows all there is to know about his often sanguinary subject and who, beyond that, can impart his knowledge in swift muscular prose. His bias towards the underdog is humane and tonic. In an interview with another great historian, Ian Kershaw, he suggested that it derived from his lifelong support for Everton FC. Well, we all have our mis-hit cross to bear. (2020)

12

Language

R(I)P

Does Accent Matter? by John Honey

The French, who occupy a land more than twice the size of Britain, express incredulity at the failure of, say, a speaker of received pronunciation in southern England to understand what a Geordie is saying. They would be yet more incredulous were they told that the French footballer Michel Platini speaks more comprehensible and fluent English than the Geordie footballer Bryan Robson, whose retention of his accent may be an act of 'sentimental Hoggartry'.

This is the mundane face of the regionalist aspiration, the urge in the backwaters of the world – in response to the spectre of horrible uniformity created by the invention of the Global Village (*c.*1966) – to do one's own thing. Accentual chauvinism is available to everyone and, regrettably, everyone avails himself of it: if you're seeking evidence of the impotence and lack of influence of radio and telly, you need only listen to the accents of So'ton and Brum and Hull to appreciate that all over the country a war is being waged against the RP that predominates in broadcasting.

How witting are the basilectal foot soldiers in their action? I believe that they are totally witting – accent, like handwriting or hairstyle, is as least partially self-determined. And for every Cecil

Parkinson resolving to expunge all traces of his natal Carnforth, there is a Michael Parkinson clinging to his South Yorks vowels in a show of grittiness. In what John Honey refers to as 'the hierarchy of accents', Yorkshire is apparently rated 'higher' than cockney, Scouse, Glaswegian and west Midlands; Honey is not too explicit about the means by which this hierarchy has been constructed, and like many of the generalisations in what is, necessarily, a book of generalisations, it is wide open to question.

However, he does make a most astute point: he asserts that the prestige allegedly enjoyed by rural accents is part of that peculiarly English scheme which elevates the rustic and depreciates the urban. This agrophilia is even manifest in what should be the most urban of places, London – is there any other great city on the planet which so diligently strives to dissemble its essence and to delude itself that it is not a city? Of course, the happy sylvan pretence of Forest Hill and Gospel Oak and Nine Elms is rather mitigated by their accents. Whether rural accents are as highly rated as Honey suggests is a different matter.

It would be wrong to dispute another of his well-founded hunches, namely that the ubiquity of southern Irish accents in broadcasting is prompted by their classlessness – the one thing that the 'classless' accent, which we heard so much about twenty years ago (though rarely actually heard), never achieved was classlessness. That accent, which has now almost disappeared, belonged on the contrary to a specific caste – rag traders, photographers, rock 'n' rollers; it survives intact in Keith Richards though not in Mick Jagger, who, because he shares her jaw structure, sounds ever more like Janet Street-Porter in drag. The 'classless' accent was a form of RP, insofar as it was deliberately affected by persons whose previous accents ranged from Scouse to the elevated – hyperlectic, this linguist would say – form of conventional RP that the Prince of Wales speaks.

Honey gives too much credence to a *New Society* report in 1986 which referred to the 'mock Cockney accent' of upper-class Oxford undergraduates interviewed for an article about the use of heroin. Such an accent, known in its day as mockney, is probably no more widespread at Oxford than is the dalliance with the drug. On the contrary, my ears tell me that public school-educated youth is far less embarrassed than it was a generation ago about advertising its background – accents are, like everything else, prone to fashion, and I hear (literally) that Talking Posh is back in a big way, along with brogues (I mean the sort of shoe the French call *style-Richelieu*, not dialectal idiosyncrasies), tweed, country houses, the past.

This probably means that in a decade or so RP will have moved closer to its current hyperlect. Thus, instead of the levelling that Honey predicts and prescribes, a new and more marked heterogeneity will emerge, and the divisions that accent both witnesses and causes will become even more marked than they are today. Honey's own unmarked RP will seem as dated as that of the Kenneth More school does today. Every generation creates its own RP, and that RP is as much a mark of age as it is of class, aspirations, region, etc. And the answer to the titular question of this intelligent and contentious work will be: 'Yes, but not in the same way it did in the late eighties.' (1989)

Eu and non-eu

The Faber Book of Euphemisms by R. W. Holder

In *Who's Afraid of Virginia Woolf?* Albee has the Sandy Dennis character wanting to go to the toilet. She doesn't know how to ask, which prompts Burton to say to Taylor, 'Show her where the euphemism is.' 'Euphemism' is the supreme euphemism, a real stroke on the playwright's part, an acknowledgement that there are certain acts, certain places which are more often referred to in

periphrasis than directly. The comfort station that dares not speak its name has so many names, so many vocabular beards, that we can choose the apt one for the circumstances: one man's euphemism is another man's vernacular.

I use the word toilet because it offends those half-wits whose idea of 'good' English is derived from dreary old Nancy Mitford; the sort of usage called 'U' is subscribed to only by the brain-dead, the boorish and the barmy – mostly the boorish. It is small wonder that the British upper classes cannot write – their tiny, circumscribed vocabularies confine them to a prison of non-thought.

Words prompt ideas just as much as vice versa. The words in Mr Holder's 400-page inventory prompt many ideas, not least of which is the unkind one that he does not really know what a euphemism is; or, rather, that he may know what a euphemism is, but tends to bend the boundaries to admit all sorts of slang, catchphrases and items of jargon that capture his fancy.

Forget Fowler's definition, which Mr Holder takes as authoritative: Fowler, like Gowers, is not to be relied upon for anything other than the composition of company minutes and unreadable letters. Forget Fowler, and remember Greek. The prefix *eu* means *good, well*: eupepsia is good digestion, euphony is a pleasing sound. Euphemism means a happy way of putting something; it is the low art of the kindly lie – but it is not to be despised. Euphemism is also a solace, a courtesy and a diplomatic tool. It may be a form of kitsch, the analogue of putting a TV in a neo-Chippendale cabinet, but it is also valuable in its capacity to obviate hurt. Plain speaking is all very well for soldiers and navvies and judges but these are not persons whose example is necessarily to be followed – plain speaking, like plain food, is a puritan virtue and thus no virtue at all. Deprive the language of euphemism and all that one is left with is an apparatus of joyless utilitarianism. Deprive the language of slang and the end is the same.

Euphemism and slang are at contrary poles of unofficial usage. An object, a state, a mood, an action has its conventional signifier ('dead', say), then it has its gamut of slang synonyms ('kicked the bucket', 'threw a seven', 'stiffed', etc.) and its gamut of euphemisms ('passed over', 'gone on', and so on): it is characteristic of euphemism that it denatures the signified, and of slang that it emphasises its quiddity. To use a current system of euphemism – slang is sunset, euphemism is sunrise. Of course what gives euphemism its unhappy name, what brings it into serious disrepute, is the kind of person who resorts to it. Politicians, churchmen, light entertainers are amateurs of euphemism. But, equally, slang has some bad fans – crims, streetwise louts, effortfully demotic highbrows. That, anyway, is how it might be represented on the Kiddies' Map of Speak. But the truth of the matter (that very phrase sounds euphemistic) is that the two poles meet, intertwine, couple and pup. Because Mr Holder is so enthusiastically indiscriminate, his book reflects this miscegenation. He gets a result by a fluke.

I would have thought that readers in the Field of Lex (Jonathon Green, Philip Howard, Paul Beale) might feel a bit hacked off by this – it is like one of those freak cup ties where Brechin scrambles a draw with Celtic by dint of doggedness and a lucky bounce. Holder's bibliography – i.e. his written sources (and I suspect he has no others) – is a source of despairing amazement. He cites: one book by Anthony Burgess and ten by the thriller writer Ted Allbeury; Goebbels and Genet *in translation*; a dozen by Paul Theroux, whose ear for spoken English is woven from blanket cloth; an airport display-caseful of adventure hacks; titles such as *The Semenov Impulse* and *The Ropespinner Conspiracy*; some ancient repositories of folklore. His (presumably self-imposed) remit is without limits of time and place: Faber's indulgence might be chided for its lack of rigour, but it has had the result of letting Mr Holder get away with an anthology that is diverting, even if it is not especially instructive.

Part of the diversion is spotting wrong-headed etymologies. On page 247 Holder tells us that a 'plater' is 'a person who engages in fellatio for payment'. And he adds, inelegantly, 'from the concept of eating presumably ham, as fellatio is also known as "a plate of ham"'. First: payment doesn't come into it. Second: the felicitous 'plate of ham' is rhyming slang with *gam* which is an abbreviation of *gamahuche* which is one of the many words the French have for 'French' and which was current in this country well before the middle of the last century.

This is obviously toilet-book-of-the-month, and it possesses the further attraction of inviting the reader to ponder the author. My guess is that he is a retired beak in a cardigan whose life has been so tirelessly devoted to the bogus idol of 'standard' English that in his pre-senile dotage he has had his revenge the only way he knows how; the product of his driven eclecticism must taste sweet to him. (1989)

Clichés 1: Lex Luther

Clichés and Coinages by Walter Redfern

This is the work of a nonconformist word-drunk. But, then, more or less explicit in everything Redfern writes is the proposition that there is nothing more conformist than nonconformity. (Unless, that is, it's conformity.) So: this is the work of a conformist logomane who mainlines lex. Redfern is proudly and defensively non-U. He tirelessly scouses about frilly-knickered English and demurely skirted French hoping to get lucky. Madame Life's a piece in bloom? In that case Madame Lingo's positively bursting out, and Redfern is along for the ride, clearly relishing every moment and determined not to 'get off at Redfern'. The man's name is Sydney slang for non-consummation, *coitus interruptus* – Redfern is the last station on the line into one of that city's rail termini. His demeanour is that of a

poet from Liverpool 8 who's learned to read and write. His subject is the twin poles of the commonplace (cliché) and 'originality' (coinage).

He is preoccupied by their collisions, congruences, interdependences, tensions. He writes with the rapt enthusiasm of the bookish buttonholer. He doesn't give a fig (as he wouldn't say – but then he doesn't have to, for books go to the toilet while newspapers don't get outside the lounge), he doesn't give a fig for sequentiality, good manners, common sense, proportion, restraint – i.e. those bumbailiffs of the imagination that so dog the English. The fecundity and density of his thought, his tap-room swagger, his lack of coolth and couth, his sideshow display of all the knowledges he's magpied down the years – these are tonic.

They can be tiring, too. We need, or can take, only so much bracing air, only so much novelty, so much paranomastic legerdemain. Redfern knows the dangers inherent in the expressions of the ludic temperament, he knows that if you add a 'y' to pun you get puny. He knows this but he doesn't act on it. If he preaches anything, he preaches a compromise between commonplace and neologism, but he preaches this compromise with such convoluted rhetoric that his epitaph will have to be: 'Everything in Moderation (Apart from Excess).'

Redfern's text is woven from quotes, borrowings, filchings. His manner is obfuscatory. His method is to go where the last sentence has pointed him: one might opine that this is no method. But it's pointless to regard this as a piece of conventional (or indeed unconventional) *criticism*. It's an imaginative meditation on the nature of influence; on the receival of ideas; on words, catchphrases, and the viral creeds they breed; on team players versus solo artists. And as a meditation it is salutary. Time and again he shows how the hideous gregariousness of humankind and the solace of the familiar combine to prevent us seeing the present, save through figurative lenses that so colour it that it seems *just like* the past; our language, any language, is a shackle tying us to yesterday; the present's peculiarities and its

essence are not to be corralled merely by new coinages. The present is much harder to understand than the past, which is finite, *set*. The present is slippery, a liquid with unruly properties.

It is knowledge that is the mother of invention. (Necessity bore bricolage.) Redfern's knowledge is massive, and the greater it grows the more he is implicated in the common crowd of humankind, everything he (or we) learn links him to more people. The more he invents and imagines, the more he is akin to precursors he has never even heard of. And he's heard of a few. He's in the tradition of Flann O'Brien, G. V. Desani, Sterne, Queneau – and every step he takes forward is one back into the sumpy, opaque pool of that tradition. Paradox and oxymoron are meat and drink to this mob. What did the global village achieve? 'Conversation [that was] parochial on a universal scale.' I'd go further and say that it prompted the rash of nationalism and regionalism that has informed the past two decades.

Redfern is an enemy to what he calls 'English miniloquence . . . the rhetoric of litotes and anti-intellectualism'. He says: 'The distaste for freshness betrays a fear of life itself.' He seeks freshness like a man with his nose to loaves, knowing very well that he's liable to be duped by the counterfeit – he's especially acute on the psychology of the plagiarist and the degrees of plagiarism. One of the causes of plagiarism is the conviction that nothing is worth saying unless it has been said before, by someone else. This, really, is the same as the fear of the new – of tomorrow. I don't think I've previously read a work by an English academic whose secret but persistent message is to be brave in the face of the unknown. (1989)

Toilet humour

The Penguin Book of British Comic Writing, edited by Patricia Craig

Robert Frost, whose work was famously bereft of it, proclaimed (pompously and predictably) that 'all humour is a defence'. This

sort of easy belittlement is not exclusively peculiar to dour old ver-
sifiers: Woody Allen is reckoned to be wildly funny. I don't see it
myself, but am prepared to acknowledge a blind spot; I've sat in the
literal dark, too, as rows of ABs have hooted at the tiny myope's
assertive self-deprecation. The point is, Allen proudly ranks his wit-
tingly unfunny films, the sensitive Chekhovian ones, above the
knockabouts.

This apostasy must come as sweet ruddy Tchaikovsky to the ears
of the earnest, to all those who believe that solemnity is the *sine qua
non* of seriousness, to all those who are happy to see the comic
mode institutionalised and forced into the ghetto on Mirth Street.
And, of course, even those professional humorists who still believe
in the paramountcy of the comic don't help ('professional humorist'
is close to being an oxymoron).

Patricia Craig's anthology could have been much worse than it is.
It could have been composed exclusively of pieces by the sodality
of sidesplitters (it's catching), gluttons for pun and wacky wisen-
heimers. Mercifully, the lady has hedged her bets. The emasculated
faction *is* represented in all its jocular, after-dinner, Rotarian bathos.
There are names on the book jacket to make the cruel heart sink. I
shan't give them. 'What's all this about writers being sensitive?'
wondered Joe Orton (who's among the missing). Very well, I *shall*
give them: Arthur Marshall, A. P. Herbert, Robert Robinson,
Beachcomber (a classic, I know, but . . .), Patrick Campbell.

Craig has, though, for the most part fallen over backwards to
include those rare creatures, the funny humorists and the wantonly
improbable. Finding E. M. Forster, George Orwell and Denton
Welch (an affecting remembrance of Sickert, but not comic) in this
company is like encountering A. N. Wilson sporting Versace bondage
nappies in Stringfellows. Still, Craig's method and her eschewal of the
Punch tradition gets a result, if not the right one. As an inventory
of lightish journalism by the smaller giants of twentieth-century

Eng. Lit., writing left-handed, this is pretty much unexceptionable, the very model of the higher toilet book, a choice gift for one and all. Of the fully formed giants, only Evelyn Waugh cuts the mustard with his deadpan assassination of the unwanted callers, Nancy Spain and Lord Noel Buxton.

The first Lord Beaverbrook reckoned that his father had taught him one important thing: 'to hate, to hate'. I believe that Waugh was a self-taught hater, a first-generation misanthropist, who clearly did a fine paternal job on *his* eldest son. The boy Bron is the consummate English comic journalist of the past twenty years, and he didn't attain that position by too much attention to the legend L-O-V-E that is tattooed on his right knuckles. He is (typically) rather poorly represented by Craig's choice of his work. It is one of too many items here that use as their springboard the solecistic or hysterical drivel spouted by lesser writers or any actor.

Indeed, much of the funniest stuff in the book is *unwitting*. Nicol Williamson is revealed by Michael Frayn to be a hapless precursor of Nigel Planer's Nicholas Craig; and Miles Kington shows – as though any further evidence were required – that the logorrhoeac oenophile Jilly Goolden is badly in need of remedial writing counselling.

The inanities of wine writers and actors' restless maxims are not the most taxing or imaginative subjects. Their conventionalised targets, the biggest in the butts, their very familiarity, obviates the incitement of loathing. Craig shares with too many humorists the fear of giving offence. Swift, Waugh *père et fils* and Lenny Bruce were rarely inhibited by such a nicety. The well-mannered comic is not comic at all. The middlebrow funny turn does no more than foment easy laughter.

What we have here – apart from the stuff that isn't funny at all – is insufficiently polarised. At one end there ought to have been work that recognised the happy ponderance of comic and cosmic, and at the other some tokens of vital vulgarity. Flann O'Brien –

not, I'd have reckoned, a British writer – knew all about the former, exemplified it in *The Third Policeman*; Craig displays him as a bibulous bore, which in his premature dotage he had the capacity to be – but that wasn't the point of him. And as for vulgarity, smut, ginny coarseness, the leering laughter of lechery recounted – no ma'am, there's absolutely none of any of that; no Anthony Burgess, no Jeff Bernard, no taproom stuff by those animals called men. Maybe Craig subscribes to some inchoate version of comic correctness.

Sex – a messy business certainly, but an ecstatically funny one – is primly avoided, save when alluded to by women: Brigid Brophy on the braggadocian donkeymanship of Henry Miller (an exhilaratingly damning review of *Tropic of Cancer*, but not comic); Fiona Pitt-Kethley on Sicily and Sicilian kerb-crawling (astute reportage, but not comic). This gyno-positive discrimination can, I suppose, just about be sympathised with. But Craig's ghastly good taste cannot. Niceness is not a quality that one seeks in genuine humorists or in their anthologist. She is doing her *galère* of malefactors no favours by petitioning on their behalf.

By what warped standard did she select Sir Kingsley Amis's lame account of judging a South Walian beauty contest when she could have had his Ripperish handiwork on Woody Allen (him again) from the *TLS* a couple of years back? Anyone with a taste for (im)proper comic invective should seek out that 100-degree-proof tour de force. It's almost as funny as the fact that Sir Kingsley once wrote an article about a drink called tea. (1992)

Iconically iconic icon

Every era suffers a lexicon of invasive usages. Words are as subject to fashion as morals and lapels, as political systems and popular music. Today's merely tiresome coinage is tomorrow's infuriatingly

ubiquitous cliché. Journalese thrives on cliché. It is the jargon of the linguistically insentient whose job is to smother page upon page with words. And there are today more pages than ever, thus more marginally literate word-operatives struggling to smother them.

Where would they be without the following, the props of their desperate trade?

Nouns: culture, driver (meaning cause), genius, guru, hub, legend, mentor, myth, narrative, national treasure, tipping-point.

Adjectives: challenging, controversial, cool, edgy, default, diverse, holistic, multicultural, postmodern, troubled, sustainable, vibrant.

Newly transitive verbs: to grow, to impact, to source.

Where, above all, would they be without iconic?

PR, which rules the world, would sink without this most dismally enduring of vogue words. Most television reporters, presenters and continuity announcers, and the entire BBC press office, seem to know no other adjective. The dependence of magazine headline and caption writers on it is as pathetic as an addiction. It's a standby of journalists for whom writing is a joyless chore: almost four decades ago Graham Greene observed that 'Media is simply a word for bad journalism.'

Here are some nouns and compound nouns prefixed by iconic. These are all found constructions of recent provenance. None is my invention.

Iconic albino, iconic assassin, iconic baby lotion, iconic brand . . . bridge, bucket, building, button fly, camper van, car, cassoulet, CCTV camera, celebration, chainsaw, chair, chef, chimpanzee, children's entertainer, clock, cocktail, comb, combover, comedy, cooling tower, Coventry City football shirt, cricket bat, crisps, diaper, doll, dreadlocks, drinker, earthmover, episode of *Emmerdale*, escalator, enema, field armour, film star, fishing reel, flat cap, garden, goggles, gorilla, grocery, guitarist, hair style, halo, hand cream, handshake,

hanging laundry, hazard, helmet, high heels, hitman, house, ice cream, icon, injury, injury-time winner, itinerary, jihad target, jigsaw, jingle, jockey, joke, kitchen utensil, knife, knowledge, lawnmower, leprechaun, light fitting, lion, lip balm, mascara, milkshake, mittens, moment, moustache, mouthwash, movie, murder, noose, ointment, orang-utan, palace, panda, penis, perfume, philosophy, photograph, pig, pimp, piston, playwright, plumber, pub, pylon, radiator, relationship, restaurant, retail mall, robot, rodent, saddle, sandwich, sausage, shampoo, shoe, shoe horn, shop, silhouette, sister, snack food, soft drink, sound system, steeplejack, stethoscope, submachine gun, sunglasses, surgeon, taxi, terrorist, toaster, toby jug, toilet paper, toilet seat, tracksuit, tractor, tree house, trench coat, typeface, vending machine, vindaloo, wedding dress, welder, wheelchair, wig, wine, yak, yoghurt, zip hoodie.

The scope here suggests that there is nothing which cannot be deemed iconic. Iconic, that is, in the sense acquired through recent abuse. Though quite what that sense is is not readily determined.

The *OED*'s earliest citation for iconic as 'designating a person or thing regarded as representative of a culture or movement; important or influential in a particular (cultural) context' is from *Newsweek* in 1976. One might, then, hazard a guess that it was current some years previously in the jargon-dense groves of academe where truisms are pompously dressed to lend them importance. According to Jesse Sheidlower, the *OED*'s American editor, the *New York Times*'s usage has increased from 11 instances in 1988, to 141 in 1998, to 442 in 2008. He warns that this is an extremely crude gauge of a word's currency. But if a normally scrupulous newspaper such as the *NYT* employs iconic more than once in every edition it is all too easy to figure the word's incidence in less linguistically prescriptive British broadsheets.

It is evident that the *OED*'s definition is no longer adequate, for this is a word whose meanings have forked and forked again in a delta formation. What the word currently signifies is fuzzily

approximate. Yet, despite its promiscuous ascription to improbable bedfellows (bucket and lion), it is far from meaningless.

Indeed, it seems to have a multitude of meanings: notable, celebrated, zealously promoted, revered, long-established, covert, authentic, enviable, easily recognised, memorable, important, estimable, stereotypical and atypical, representative and unusual, cliquey and popular, recherché and accessible – and, like the word itself – unavoidable.

Perhaps I should withdraw that 'far from meaningless'; if a word can signify anything it will eventually signify nothing. It may have already achieved that literally insignificant state.

Nonetheless, its very ubiquity is, unwittingly, telling. It betrays – self-evidently – its users' slovenly logophobia. More pertinently it reveals a collective longing, a wishfulness. For, like cult (used adjectivally) and like regeneration, it carries a chummily sacred, cosily religiose, softly spiritual connotation.

We live in an era of incontinent celebration and exponential hyperbole. No one has given a mere one hundred per cent in years. One hundred and twenty per cent is normal and one hundred and fifty per cent is far from exceptional. World class is old hat, it's outclassed by different class. An innings which might once have been described as solid is today awesome. Any rock band that survives narcotic depredation and managerial peculation to reform in wizened middle age is legendary. Artisans going quietly about their business in the back of beyond, baking loaves or gutting herrings, find themselves declared food heroes. Every area of enterprise enjoys preposterously grandiose awards ceremonies: the Organic Semiconductor Industry Awards, the Demolition Oscars, the Contract Cleaning Baftas, and of course, the Awards Industry Awards. All of them strive to replicate the Academy Awards, all of them make temporary heroes of hod carriers or logistics resource analysts, all of them succeed in adding to the human sum of bathos and

meretricious vacuity. Al Jazeera is soon to host the Martyrdom DVD Awards, though the winner will obviously be absent. The ladmag *GQ* lamentably names an 'Icon of the Year'.

Given the collective appetite for idolatry – an unashamed appetite that borders on the pathological – it is peculiarly apt that iconic should be the adjective of the age. For although icon derives ultimately from a Greek word that signifies no more than a likeness, a portrait or an image, it is undeniable that it has for centuries been indissolubly linked to Christian images of Jesus, Mary, the agony, the deposition and so on. Such images were the targets of iconoclasts who abhorred the temerity of those who dared give visual form to the Trinity. Even before it was first adopted by the Eastern Church, the word icon was tainted by association with the superstitions that humans fortify themselves with. The Anatolian city of Konya was formerly known as Iconium. It supposedly got that name from the shrine erected there either to its alleged protector Ares, the merciless god of war whose Roman incarnation was Mars, or to Perseus who decapitated the gorgon Medusa – her dead serpentine head was transformed into a sort of amulet whose representation is called a gorgoneion, i.e. gorgon icon.

Implicit in the modern use of iconic is the perhaps deliberate, perhaps insouciant, aspiration to invest things and people with properties which render them miraculous and superhuman, magical and godlike. It's today's expression of humankind's perennial bent towards aggrandisement and worship of other humans, of human inventions, of things: rocks, clouds, forests, tides, charms, relics. And if those why not E-types, Zippos? Why not rock stars (whose debauches are puny beside those of Greek or Hindu gods)? But no matter how puny, how could the insipid, anodyne, desperately reasonable, ever so nice, milk-and-one-sugar-please god of the Anglicans – a figment of that thoroughly atypical period when Britons were restrained, reserved and stoical – have possibly competed with such

antic Pans as Jagger, such Dionysiac groins as Plant's: Farrokh Bul-
sara's renaming himself Freddie Mercury was prescient; he became a
mythic prophecy he had to fulfil. If churches can't provide appropri-
ate gods, we must make our own. Or allow ourselves to be seduced
into worship of self-appointed gods and antinomian furies. One of the
dafter ideas propagated by the credulous is that the immane tyrannies
of the twentieth century owe their enormities to their atheism.

This is wrong-headed. The Third Reich, Stalin's Soviet Union
and Mao's China were theocracies whose dependence on the iconic
was as great as their dependence on terror, on neighbours grassing
each other up, on lies as gross as those of any established faith.
Dictators routinely attempt to kill god so that they may usurp him
then act like malevolent forces of nature, wreak divine vengeance,
massacre innocents. They sack churches, raze temples, burn texts.
The next steps on the road to genocide are all art direction and
liturgical choreography.

Until his triumph in the Great Patriotic War, after which he was
depicted as a genial orphaned absolutist, Stalin would often be
shown in paintings as a peripherally positioned member of a group
of equals or as Lenin's acolyte – as though Lenin was the father in
heaven and he the mere son doing his father's will on Soviet earth.
The implication was exculpatory, the living son's errors might actu-
ally be the dead father's. The largely illiterate population of his
empire knew Stalin only pictorially, through 'accessible' icons. The
iconic figure and the man were indivisible.

Hitler was more audacious. His appearance was as measured as
his rehearsed ranting. He reduced himself to a few pictorial marks
and gestures – the salute, the moustache, the bang of hair. So no
matter how protean he might be, no matter whether he was repre-
sented as a Teutonic knight, a little guy fighting for his people's
entitlement, a reliable provincial station master, a mountain vision-
ary or a revolutionary vanguard, he was instantly recognisable. The

modern world's Apollyon turned himself into something literally picturesque, something iconic.

The swastika was a logo. But it was neither an abstraction nor a theft from Jainism. It was a calculatedly didactic icon, pregnant with meaning. In German it is the *Hakenkreuz*, the hooked cross. It was, then, a graphic twisting of Christianity's paramount symbol. The Nuremberg rallies were rites that underlined the link between the martial and the sacred. They were as terrifying as an Aztec ceremony, as hokey as amateur operetta. But they remain indelibly fixed on the retina that witnesses them.

Their decor lives on in the stadium-rock stage sets designed for the Rolling Stones, Pink Floyd et al. by Mark Fisher, who is among Albert Speer's understandably few apostles. These shows are unintentionally mock-heroic while aspiring to be heroic *tout court*. And they're otiose, they're pompous – altars for flashy pasteboard messiahs. Yet the tawdry grandeur is potent, just as cheap music is meant to be, and the spectacle can stir us, rouse us, despite ourselves. Despite ourselves . . . here is the very quality that is:

Condition A of the truly iconic. It affects us whether we like it or not. We should apply the Victor Hugo Test. When André Gide was asked who the greatest French writer was, he replied: 'Victor Hugo. Alas.'

Condition B is that the image transcends its subject.

Condition C is that the subject should be legible in a sort of visual shorthand. Jesus's faces may be those of painters' catamites but the crown of thorns and outstretched arms are unmistakable. A severed head in a charger stands for his cousin John the Baptist. Napoleon is a silhouette and hand tucked in his greatcoat. Churchill is a V-sign. Chaplin is a walk, a bowler, a moustache. Tommy Cooper a fez. Jagger is lips bloated as Dalí's Mae West sofa. Dalí is another moustache. Mae West is an inflatable.

Condition D is immediacy of recognition. This demands immutability, a quality more readily achieved in objects than humans unless they are dead – Che Guevara, Jimi Hendrix or James Dean, a film star whose invariable role was himself. An actor who is a chameleon (Sellers, Guinness, Olivier, de Niro) could never become an icon. The icon has to be the visual equivalent of an unmistakable catchphrase, such as Lord Owen's 'When I was foreign secretary' or Andie MacDowell's 'Because I'm worth it'. And if a catchphrase is a repetitive soundbite then the icon is a strenuously rehearsed sightbite.

The people and things that observe these conditions are few, infinitely fewer than the prevalence of the debased word iconic would have us believe. And they are becoming fewer. The half-century of television's predominance has occasioned the gradual decline of oratorical expansiveness, of theatricality, and has prompted naturalistic discourse. Further, the multiplication of means of representation and the ease of images' dissemination provide ever more potential low-key idols. The hegemony of the big beasts is already dissipating save in isolated nations like North Korea and Turkmenistan whose Stalinist statuary seems laughably out of date.

More typically, virtual villages will increasingly make icons of figures that are peculiar to them, just as real villages did in the distant past when the people in the next valley paid obeisance to an alien gamut of gods and incomprehensible totems. The more the media grow, the less appropriate the prefix mass. The globalisation of localism and, beyond that, of atomisation will very likely mean that such niche characterisations as 'a living legend among the vertical matrixing community', 'a myth in the Sutured Albino thread', 'an iconic figure in Gremlin Pastures' can be made without leaden irony. (Now, ironic – when did that word come to mean coincidentally?)

Equally, the trade in wilfully gesticulatory buildings, aka light-house or landmark buildings, will stutter to a halt. The beneficiaries of the urban regeneration projects 'driven' by such buildings have

been the construction industry, the time-serving operatives of regional development agencies and, of course, countless infrastructure consultants. In times of plenty, money was spent with prodigal abandon on what were nothing but vanity projects, vacuous lumps of architectural bling whose only purposes were to be noticed and photographed. Now that the money has run out, we can only rue the day that a town hall dullard on the make thought that Anyborough would be improved by synthetic modern 'luxury' apartments and consequent class clearances, vibrant dockside chain restaurants, pointless pedestrian bridges, loud public sculptures and structures so bereft of right angles that they must be iconic. (2009)

WTAF?

ETA is an acronym. E.T.A., on the other hand, is not: it is an initialism. The first is pronounced as a two-syllable word. It stands for Euskadi Ta Askatasuna. The second is spoken as three distinct letters, unelided. It means expected time (of) arrival. What these near twins have in common is: (a) they are abbreviations and (b) they are of military origin. Perhaps in the case of our friends the Basque murderers that should be adjusted to paramilitary.

Take another acronym and another initialism, GOPWO and O.G.S. These are British Second World War coinages. Conscripts soon learn to behave with the doubtful decorum of professional soldiers. Men forced into close proximity with their fellows will find ribald solace in competitive, vulgar linguistic inventions which mimic the formulae of such 'official' straitlaced martial constructions as A.D.C. (aide de camp), G.O.C. (general officer commanding), SHAPE (Supreme Headquarters Allied Powers Europe), AWOL (absent without leave), etc.

The most cunning or pithy or brutal of these inventions will be adopted by the group and, as with any other form of word craze,

will spread from platoon to company to battalion. A GOPWO is (or was) a grossly over-promoted warrant officer. It is wittier than its synonym ranker, a denigratory epithet for an officer who began his career as a private and gained promotions through the non-commissioned ranks rather than graduating from Sandhurst, Woolwich, Mons or, during the war, an OCTU (officer cadet training unit).

In the society of U and non-U (the U stood for upper), of marginal gradations, class markers and fraught snobberies which persisted for several decades after the war, an officer's 'background' remained an object of scrutiny. Civvy street's female near-equivalent of a GOPWO was a counter jumper, a shop assistant supposedly on the qui vive for a nice rich gentleman customer: during the war, the initialism O.G.S. might have been just the ticket for her. Officer's ground sheet was a jocularly misogynistic but, again, undeniably witty epithet for an opportunistic sexual partner in uniform – a WRAC (Women's Royal Army Corps) popsy, a member of the A.T.S. (Auxiliary Territorial Service) or W.L.A. (Women's Land Army).

It's a commonplace that the development of transport, medicines, meteorology, information technologies, construction methods and materials, propaganda and, of course, weapons has depended on the prosecution of wars. Such a commonplace, indeed, that it has become an unquestioningly received truism which flatters our paranoia, our fearful fondness of sombre forces, our willingness to believe in conspiracies. What Eisenhower called the military-industrial complex may not be the omnipotent bogey that its enthralled detractors claim. It may not be the creative mammoth its champions boast of.

Nonetheless, no matter how wildly exaggerated the spread of its tentacles and influence, the images of armed conflict, secrecy, adrenalin, ruthlessness, dirty tricks, machismo, going over the top, gadgets and kit exert a vast attraction to those who have

never known war. Its allure overlooks the actuality of boredom and body bags.

It is no coincidence that Tony BLAIR (Brit lackey anilingualises illiterating redneck), the Ceausescu of Connaught Square and the most bellicose British prime minister in 150 years, was the first prime minister in that time to have grown up without any experience of war or its aftermath. And, it might be added, without any but the most approximate sense of history: the young war criminal (as the late Alan Watkins called him) seemed to believe that Britain declared war in 1939 on behalf of Jewry. Happily, the overwhelming majority of wannabe Christian bombers and delusional fantasists are granted no opportunity to declare themselves the world's prefect and invade sovereign states. They may romanticise war but they can't prosecute it, so they have to be content with substitute activities.

Much as he might wish to, the C.E.O. (chief executive officer) of, say, a greetings card and soft toys chain cannot even take out Clintons Cards' management with a crack squad of self-detonating Smurfs or Gonks trained by Mossad (not an acronym). Philip Green can't whack Stuart Rose with a Scud (again, not an acronym) that fell off the back of an Azerbaijani lorry. Post-literate newspaper executives may boast of their familiarity with Sun Tzu's *The Art of War*, but the editor of the *Grubby* can't literally wage war against his counterpart on the *Smutty*. When fully grown men – let us call them BBC executives – black-up, don balaclavas and fatigues, and crawl around as though freedom-fighting in a bog near Newry, the weapons they drag through the mud can fire only blobs of paint.

All this simulation and all this wishfulness are mere clutching at martial straws. The further removed we are from living the military life at first hand, the more seductive become its methods, its supposed characteristics. A corporation's or institution's ends will very

likely be different from those of the armed forces – less killing, for instance. But the means are there to be aped, the stylistic tics to be flatteringly imitated, the strategies to be brazenly nicked: the speed, the modernity, the purposefulness, the directness, the can-do. And, above all, the language – which supposedly expresses these characteristics.

Polysyllabic words are very bad things. No officer, no N.C.O., no private soldier is permitted a given name of more than one syllable or, at a push, of one syllable suffixed by y. Every Michael is a Mike, every Christopher a Chris, every Timothy a Tim, every Andrew a Drew. Why? Because curtness equals efficiency. It saves time. Just add up all the saved seconds. They grow into minutes, hours, days. It saves breath – tons of the stuff – which can be expended on achieving important goals and challenging targets. It says think positive: it says it loudly.

These nomenclatural curtailments have been greedily plagiarised in COWO (corporate world) because of the blight of Managerialism. For those who, these last twenty years, have been comatose, looking the other way or have had something better to do, Managerialism is the faith (no other word suffices) that all enterprises, no matter what their field of endeavour, are susceptible to the same nostrums, theoretical models and invariable systems of a managerial caste which is independent of the enterprise's specialism, services, products.

Thus, a trainee dog food executive – let us call it 'Adam Crozier' – will rise and rise through media sales, advertising, sports administration, public utilities, broadcasting, etc. A team of consultants moves from devising arts regeneration strategies in Rotherham to low-fat transport initiatives in Charleroi.

This quasi-hieratic caste employs a language dense with acronymic codes that are martially derived. It is the exclusive patois of an ideology which pretends to be post-ideological yet possesses a distended catechism – conformism, obedience, seizure of power,

'measurable' results (of immeasurable phenomena), service delivery, primacy of economic performance, contempt for non-vocational learning, invariably justifiable means, outsourcery, I.R.P (inhuman resource patterning), B.P.D. (best practice diagnostics). Managerialism's grip on Britain's governance is an inevitable consequence of the growth of a regiment of professionally political class whose members enjoy little experience of anything other than committees, 'research', disinformation and slogan creation. Given the centrist tendencies of the major European countries, the worship of social Thatcherism, the volition that the public sector should not only mimic the private sector but breed with it, it is hardly surprising that the reliance on technocratic managerialism is ubiquitous. Welcome to the bankrupt world of the P.F.I. (private finance initiative) and the P.P.P. (public private partnership).

Military signage and memoranda recall the worst set of Scrabble letters you could ever be burdened with. Transcripts of Manager-speak show what really happens when monkeys are issued with keyboards.

Language is debased, mangled. It is no longer a means of communication and discourse. It becomes an emblem of a cadre that seeks to blind with managerial science and series of letters that signify bogus concepts and are very-hard-to-remembers. It demands decryption just as a heraldic device does. Those who sedulously retain astonishingly indecipherable regional accents claim that, were they to adopt R.P. (received pronunciation), they would be sacrificing their 'identity', which suggests a frail hold on the self and a fearful adherence to a mumbling past. Indeed, the very proposition that R.P. is actually both a useful and an egalitarian tool is as non-P.C. (non-politically correct, obviously) as it gets.

Britain's feeble-minded encouragement of 'vibrant diversity' and 'communities' dissolves the glue of society, dismantles nationhood,

makes clannishness a virtue, rewards minoritarian special pleading, inhibits mobility, sanctions apartheid. In the consequent centripetal havoc, mutual incomprehension is so prevalent that it is taken for granted. That between 200 and 300 languages are spoken in London is nothing to be proud of when, as is the case, many of their speakers are monoglot.

The SAP (swelling acronym pile) and BIT (burgeoning initialism tip) merely add to the babel. The affectless jargon of the managers constitutes a sort of *trahaison des clercs* by linguistic means: it occupies the position that Latin did 800 years ago, it is the language of the new masters. Big tent: sure, the tent may be big, but that does not mean that it's inclusive. The managerial elite is, it goes without saying, anti-elitist. Given names are obligatory, neckties dodgy, and to address someone as Mister is a faux pas unless underlined with leaden jocularity. So because its accent is glottal-estuarial and pretends to be dead common, it has to differentiate itself from the managed with ever more arcane constructions which are decaffeinated slang, jargon, colourless – and therefore serious. Real slang is base poetry. Nothing glitters like the gutter. The coinages of football terraces, crack dens, stoops, cottages, barracks and bars are vital.

Like life itself they are grimly funny, wounding, mocking, unfair, harrowing, disrespectful. These are attributes which have no place in the preposterously po-faced world of spreadsheets, chickens and ducks, dum-dum bullet points, Cranfield, vertical sausage matrixes, round ovalling, trunk-branch-trunk, M.B.A. (master of business administration), extrapreneurialism, helicopter views, Niel's Curve, U.S.W. (*und so weiter*).

Slang is joyfully dystopian. It caricatures and exaggerates the manifold imperfections of an already imperfect world. It goes without saying that jargon, of which acronyms and initialisms are important

subsets, is not joyful. Nor is it dystopian. On the contrary, it aspires to that most lethally infantile of programmes, the prescription of the conditions of a better world, a tidier place, the playground of tyrants.

One agency of such a programme, the N.S.D.A.P. (Nationalsozialistische Deutsche Arbeiterpartei, the German Workers' National Socialist Party), was a prodigious creator of acronymic entities, the most notorious of them the morally squalid apparatus of state terror, the GESTAPO (Geheime Staatspolizei, Secret State Police). The titles of Nazi organisations and the acronyms that derive were far from euphemistic. There is no dissemblance of purpose. For instance, RuSHA (Rasse und Siedlungshauptamt, the High Office of Race and Settlement) was established to effect Walther Darré's blood and soil policies which applied horse-breeding practices and 'recessive crossing' to human procreation.

The Soviet Union was equally tireless. After it was called the Cheka and before it was called the K.G.B. (Komitet Gosudarstvennoy Bezopasnosti), the Soviet secret police was, successively, the G.P.U. (Gosudarstvennoye Politicheskoye Upravlenie), O.G.P.U. (Obyedinyonnoye Gosudarstvennoye Politicheskoye Upravlenie), N.K.V.D. (Narodny Kommisariat Vnutrennikh Del), M.G.B. (Ministerstvo Gosudarstvennoy Bezopasnosti), M.V.D. (Ministerstvo Vnutrennikh Del). In northern Moscow there is even a bizarre acronymic park, a former exhibition site full of social-realist kitsch: VDNKh (Vystavka Dostizhenij Narodnogo Khozjaistva, the People's Economic Achievement Show, pronounced Vedenkah).

The reckless and the suicidal apart, no subject of such a regime would have dared to re-engineeer an acronym so that it came to stand for its opposite or something entirely different – in the way that the American military has had the cheek to adapt S.F.A. (sweet fuck all) to stand for security fault analysis.

Before the 2006 World Cup, celebrated for Zinedine Zidane's headbutt, the French football team was routinely described – in an access of multicultural, multiracial smugness – as B.B.B. (*Blanc. Black. Beur.*) (*Beur* is *verlan*, back slang – *à l'envers* – for Arab. Though since it went mainstream it has been re-reversed so that the word in the *banlieue* is now *reub*.) In an interview the excitable contrarian Alain Finkielkraut injudiciously suggested that, taking into account the make-up of the team, B.B.B. should mean Black. Black. Black. His almost accurate observation predictably infuriated the French anti-racism establishment, whose censoriousness is more appropriate to that of a totalitarian dictatorship than a liberal democracy: it should be noted that France is just as trammelled by P.C. as Britain, though it sulks about it more, agonises more before accepting its primly pious strictures. To mess with vowel-free constructions, nonce words and neologisms is a language crime, an insult to the will of minoritarian tyranny.

This fuss over very little demonstrates, if nothing else, that acronyms and initialisms are even less neutral than other sorts of word. They are fluid, dangerously susceptible to lurches in meaning: it took a generation for the epithet 'piss artist' to move from signifying a braggart to its current meaning of drunkard. It took however long it takes to say 'black' three times to change the meaning of B.B.B. and shatter a national delusion. All words can be weapons. Acronyms are potentially loose cannons. They should be handled with care by the sceptical, the undogmatic, those who lack all conviction.

No one who writes about English on the black can do so without referring to the works of Jonathon Green to whom I am especially indebted. (2010)

BURMA: Be undressed ready (at) midnight angel (written by Second World War troops on envelopes destined for their sweethearts).

NORWICH: (K)nickers off ready when I come home (written by less literate Second World War troops on envelopes destined for their sweethearts).

PUMPIE: Previously upwardly mobile prat (City of London, 1980s).

FILTH: Failed in London, try Hong Kong (City of London, 1980s).

LOMBARD: Lots of money but a real dickhead (City of London, 1980s).

E.L.O.: Electric Light Orchestra – the fourth cellist in the 1970s West Midlands rock band's sixth line-up was Yasser Arafat, who had just graduated from SCABAT (Sutton Coldfield Academy of Baking and Allied Trades). He quit as a result of scarf and beard differences to found his own band.

P.L.O.: Palestine Liberation Organisation. Like E.L.O., they had many hits. Unlike them, many bombs.

POSH: The folk etymology port out, starboard home is another backronym, i.e. wrong. Probably derives from a Romany word for money which came by the late nineteenth century to signify someone who appeared wealthy.

SNAFU: Situation normal, all fucked up (US military, Second World War).

FUBAR: Fucked up beyond all recognition (US military, Second World War).

FUBIS: Fuck you buddy, I'm shipping out (US military, Second World War).

KISS: Keep it simple stupid (US military, 1960s).

CREAM: Cash rules everything around me (hip hop, 1990s).

ADIDAS: All day I dream about sex (hip hop, 1990s).

B.M.W.: Black man's wheels (London, 1980s).

B.O.: Body odour (a copywriter's coinage for a Lifebuoy soap campaign in the 1930s).

NED: Non-educated delinquent (UK probation service, 1970s).

E.S.N.: Educationally subnormal (UK, 1950s).

D.A.B.: Dull and backward (UK, 1950s).

M.D.L.: The expression mutton dressed as lamb is of the late eighteenth century, the initialism is of the 1970s.

M.T.F.: Must touch flesh = a groper (UK, 1970s).

N.S.I.T.: Not safe in taxis = well-spoken groper (UK, 1930s).

D.O.M.: Dirty old man = potential child molester (UK, 1950s; predates *Steptoe and Son* where it was Harry H. Corbett's catchphrase).

N.M.C.: No mates club = an unpopular child or loner (UK schools, 1990s).

WILCO: Will comply (US, late 1930s).

H & E: *Health and Efficiency*; 'naturist' magazine from which small boys learned about airbrushing (UK, 1950s).

T.G.I.F.: Thank god it's Friday (US, 1930s).

POET'S DAY: Piss off early, tomorrow's Saturday = Friday (UK, 1970s).

T.G.: Tiny gangster, a gang member under the age of ten (US, 1990s).

P.L.U.: People like us (UK, 1980s).

S.Y.T.: Sweet young thing = rent boy (US, 1970s).

O.G.: Own goal; minor tragedy.

O.D.: Overdose; minor tragedy.

T.T.F.N.: Ta-ta for now.

All together now

Globish: How English Became the World's Language by Robert McCrum

A quarter of a century ago Robert McCrum co-wrote *The Story of English*, a telly series whose spin-off book was on a rather higher level than most such exercises. Ignoring Picasso's advice to 'copy anyone – but never copy yourself', he revisits that book to recount the creation of the many (hardly unfamiliar) conditions propitious to the ascent of Globish. What-ish?

Jean-Paul Nerrière has spent most of his career in *'le marketing'*. The fact that France has no word of its own for this vital endeavour is pertinent. At high-powered conferences and important presentations all across the globe he observed that when, say, a western Arabic speaker from Casablanca would strategically interface with a Tagalog speaker from Quezon their shared language was a form of improvised English. He can hardly have been the first person to note this commonplace.

What distinguishes him, however, is that, true to national stereotype, he set about codifying and rationalising this often infantile pidgin. And since the mid-nineties he has developed an internet industry propagating it as a utilitarian business tool, a key to success. The key: learn it on your computer, learn it on your iPhone. He cleverly abbreviated the generic 'global English' to Globish. He less cleverly rhymes the first syllable with yob and gob so that the

word irresistibly recalls a hawked expectoration. At least it does to me. If McCrum is so struck he stays shtum.

Globish is a privatised lingua franca, a commercially driven 'world language' unencumbered by the utopian programme of Esperanto. As taught by Nerrière's enterprise, the tellingly named Globish Solutions Inc., it combines the coarseness of a distended phrase book and the formulaic optimism of self-help texts – themselves a sub-literary genre characterised by linguistic paucity, catchphrases and religiose simplicity. It is no surprise to find Malcolm Gladwell, coiner of 'the tipping point', delivering a front-cover plug for this book.

Globish comprises 1,500 words, a vocabulary that is not much smaller than that which Simenon tried to limit himself to in the cause of 'universality'. It dispenses with certain vowels; it avoids idioms, jokes and, in theory, figures of speech; it makes a virtue of its limitations. The Globish pupil is not deluded into believing that he or she is learning English. Nerrière's Global Solutions Inc. is of course only one outfit competing in a crowded market alongside Basic Global English, Easy English, Special English, etc. What distinguishes Globish is its slick marketing. It positions itself far away from the milieu of language schools, sandals and spelling reform.

McCrum is fired by a massive enthusiasm for Nerrière's work. Indeed he is *parti pris* to the point of evangelism: 'English plus Microsoft equals a new cultural revolution . . . a global means of communication that is irrepressibly contagious, adaptable, populist and subversive . . .' He is so fond of this latter formulation that he repeats it. It could easily have turned into special pleading for what he evidently considers to be a fait accompli. But McCrum is out to entertain and inform as well as to preach. The book is excitingly energetic. He leaps with polymathic abandon from one discipline to another: lexicography, history, demography, linguistics, reportage. The pages on the expanding American frontier deftly evoke the excitement of a nation being built.

Throughout, the sheer volume of detail is startling. Of course, much of the material is familiar: the resistance to French after the Norman Conquest; Caxton, again a man driven by commerce; the Great Vowel Shift; Shakespeare and his contemporaries; (the wearisome question of what if New Amsterdam had remained Dutch is not addressed); Noah Webster; Empire; Hollywood; the American century. And the manner in which all this is marshalled is Whiggish. The growth of English is a form of progress. Thus, Globish is the end to which it must inevitably lead. This is moot.

One might dispute anyway that Globish and the 'Anglosphere' are quite as potent, quite as ubiquitous, quite as established as McCrum takes for granted; he admits that, despite their spread, babel has not yet been replaced. But the assumption that it will be replaced is implicit. He quotes with apparent approval a *Sunday Times* article of eighteen months ago which advises that: 'to be born an English speaker is to win one of the top prizes in life's lottery'. Such linguistic jingoism tempts fate. And it fails to take into account the unpalatable truth that Globish disadvantages native anglophones.

The recent paramountcy of an English-derived lingua franca was partly founded in the web's comparative failure to accommodate any but alphabetic languages, of which global English is the most widely understood. The recent introduction in Egypt, UAE and Saudi Arabia of web addresses that contain no alphabetic characters presages the same process in China, Thailand, India, etc. This will undoubtedly have some effect on written if not spoken Globish which will, anyway, mutate – that's what languages do, with ever increasing speed. Jean-Paul Nerrière's syntactical strictures, grammar-lite edicts and 1,500-word lexicon will be as staunchly effective in protecting Globish as the French Academy has been in resisting such constructions as 'Top Glamour Mass Relooking' – the coverline of a TV guide I noticed the other day at a Leclerc supermarket checkout. (2010)

Bigger, thicker, filthier

Green's Dictionary of Slang by Jonathon Green

The stats: 3 volumes; 6.7 kg; 6,085 pages; *c.*110,000 words defined; the price – a chimpanzee. These magnificently bulky lexblocks are the culmination of Jonathon Green's thirty years' submersion in all the language that ever fell off the back of a lorry – the illicit rhymes, the injurious neologisms, the coinages from the groin, the iffy oaths and the smut, the filth, oh the filth!

Green's submersion has been a slimy, gritty, gelatinous nose trip through all the word bowels that Bosch might have made up. This is not a work for the squeamish. Nor, even, for those most inured to the casual enormities of the verbal imagination, who will now and again wince and wish they could rid their brain of, say, Green's definition of 'mung'. We should perhaps be grateful that he over-looks 'hot lunch', 'thally' and 'bif' (in its 1980s playground usage).

Much slang recalls criminals. It is so flash, so vaunting, that, like your bling and your armpiece, it advertises the very illegitimacy it pretends to occlude. It is a secret that shouts its secrecy. It is a code that publishes its key. The commonplace that slang is necessarily private is a misreading born of the prosaic notion that language is merely a means of communication rather than an expression of boastfulness, posing, preening, vanity, of self and identity. Vocabulary, like accent, is a marker of who we are. Green suggests in his introduction that one of slang's foremost characteristics is that it is the 'subversion of the norm'.

One might in turn subvert that very contention with the proposition that slang *is* the norm. It reveals, or allows us to reveal, the savage within, the raw creature that, for all its flash duds, might as well be in woad and untreated skins – or in school uniform. It is a reversion to the pre-moral, pre-social. Slang is the converse of jargon, which is all obfuscation, pomposity, euphemism and thus

'civilised'. Slang is misanthropic, misogynistic, misandrist, xenophobic, racist, sexist, sizeist. And when it is not hating it is flying on psychotropics or having messy sex. Or, with luck, both.

No previous work of lexicography has ever stood as such a monument to mankind's baseness and wilful disinclination to self-improve. Should we be ashamed of ourselves? Not at all. For it is also a monument to our unflagging creativity, to our monstrous capacity for sullied invention, to the verbal manufactory each of us has a stake in. The true author of this wonderfully energetic gallimaufry is Anon.: the barrack-room artificer, the poet in tronk, the show-off in the trench, the potman with wings. Anon. is of course assisted by those writers who coin words, but these are few; most writers are more preoccupied with mere transparency, with language as a tool rather than as something that can be made in order to express what has previously not been expressed: 'standard' English, set in stone, precludes representation of what is new. The novel is ill-named.

Jonathon Green is an opinionated collector, a taxonomist, a cautious etymologist (an accusation that could never be levelled at his now overtaken predecessor Eric Partridge). His scholarship is multi-faceted and unflinching. As a Jew he might have baulked at devoting over five pages to mostly deprecatory and opprobrious uses of 'jew'. That he has done so will earn him a posthumous plaudit from Bernard Levin, who in the mid-seventies wrote a stern defence of the *OED*'s inclusion of 'jew' in such senses, even though they were offensive: dictionaries are, primarily but not exclusively, records. They are neither prescriptive nor proscriptive. Green, ever evenhanded, gives us 'arab' as, inter alia and oddly, 'a derog. term for a Jew (coined by *Variety* magazine writer Jack Conway *c*.1925)' and more conventionally as 'any dark-skinned person, esp. one suspected of being a terrorist'. It goes without saying that *Green's Dictionary* is untainted by the combination of cowardice, evasion

and hypersensitivity which travel under the handles of political correctness and linguistic correctness. One might infer a covert polemic which questions why we should be nice to our enemies, appease tyrannical minorities, suppress mistrust. Green's astonishing, peerless collage is a depiction of the actual, of what we think rather than what we are enjoined to think. It is the entire anglophone world unmediated.

Jonathon Green is to skidmarked words and hazchem constructions what Cecil Sharp was to folksongs, Elizabeth David to French vernacular recipes, Nikolaus Pevsner to England's buildings. He belongs to a rare pantheon. (2010)

Clichés 2: Overused and over there
It's Been Said Before: A Guide to the Use and Abuse of Clichés
by Orin Hargraves

Towards the end of this obsessional work Orin Hargraves wonders, yet again, about clichés. This time he asks: 'Why do writers continue to use them? What genuinely motivates the cliché, when there is nearly always an alternative that, if it is not a cliché, is *ipso facto* more original and probably a better expression of the idea at hand?'

The answer is provided by a character in Tom Stoppard's *Night and Day*, who says: 'People think that rubbish journalism is produced by men of discrimination who are vaguely ashamed of truckling to the lowest taste. But it's not. It's produced by people doing their best work.'

I doubt that an audience today would laugh as fulsomely as it did almost forty years ago when the tabloidisation of everything was unthought of. Now it has been achieved: the American presidency, formerly non-tabloid newspapers, the professions — they are all demeaned. This Ostrogothic cheapening has not been occasioned by cliché alone.

The coarsening of life is, rather, ascribable to: boastful pride in xenophobia and regional identity, the pretence of elites that they are not elite and that they are what the dangerous lout Trump calls 'people persons', a fetish for bogus informality, the evaporation of *noblesse oblige*, the evaporation of shame, the evaporation of magnanimity, the spiv as 'role-supermodel', the rise of PR, the triumph of accessibility, the legitimisation of bullying, the growth of 'soft' slavery – and so on, *ad vomitum*.

Clichés are off-the-peg signals, the linguistic badges which characterise and advertise this dismal order. They are paltry constructions which convey paltry thoughts, though 'thoughts' is not the word for the utterly conventionalised, usually mendacious, sometimes criminal formulae spouted by business 'leaders', god botherers, pundits, politicians – people who insensately condemn themselves as soon as they open their mouth. Constructions such as, say, 'a perfect storm', 'play the race card', 'fuel speculation', 'a country mile', 'bite the bullet', 'not rocket science' are warnings that one is in the company of the slovenly and the grimly orthodox.

'Not brain surgery', more or less synonymous with the last of those, does not appear here. Maybe it's peculiar to England's English. Hargraves is a Colorado lexicographer. His bias is more towards American usage than he perhaps realises. Although many of his sources are, he claims, English, he is disinclined to give examples which are exclusively English, and thus lack 'traction' (his word) among his compatriots, for whom this book is intended. So, thankfully, no 'national treasure', no 'cult status'. When he does include an example, for instance 'a game of two halves', his annotation suggests that in England it has currency outside football. Has it? I haven't seen or heard it so used but that is no reason to disbelieve him. He is, after all, the one who's up the moral void of tabloid creek and far deeper steeped than any linguistically sentient person deserves to be in the gross usages of vicious, phone-hacking,

insider-dealing, chokey-dodging moron journalists who are easy and deserving targets.

Academics are, too, or should be – especially those professing 'humanities' at universities such as Ann Arbor and Minneapolis. Over the past half-century they have coined a clogged obscurantist lexicon, dense with cliché, self-important, formidably inelegant and ultimately derived from now exhausted French pseudo-disciplines. Hargraves ignores it even though it is as offensive as journalistic cliché. Too close to home? Maybe. Just as likely, though, is the proposition that while he himself avoids his profession's cant he is inured to it, he can't see it, so fails to acknowledge how foreign and risible it is to those without that milieu. The academic tic that he does exhibit is a fondness for taxonomy. There are many ways in which clichés might be classified. He elects to determine them syntactically. He offers seven categories: adverbial clichés; predicate clichés; 'modifier fatigue', etc.

His method with each category is invariable. He gives examples which he makes cursory comments on. A very few of these examples, stripped of context, are engagingly strange: 'In this rush to reduce populations, untested or untried contraceptives have been introduced in the Third World countries, literally making these women guinea pigs.' 'The Federal Reserve had had its head buried in doomed policy sand.' 'We wanted to make a sturdy commercial mower that can take the abuse, but that bridges the gap and doesn't cost an arm and a leg.' But most of the constructions Hargraves cites are necessarily dull and overworked – that is the very nature of cliché: 'tipping point', 'legendary', 'quote unquote' (even without hand gesture), 'bright eyed and bushy tailed' (though this is useful if applied to, say, Mike Pence).

Hargraves is liberal about usage. Maybe too liberal. He doesn't acknowledge that there are fields of endeavour which positively encourage the use of cliché as a badge of belonging rather than as a

means of communication: England's regeneration and television industries and the arts administration lark are particularly culpable. Their grim, straitened vocabulary is that of the joiner, the team player, the sycophant. The cliché speaker is obedient, does not except itself from the norm, issues and follows orders. Hargraves' work is a depressing monument to the paucity of human imagination, and to the suppression of that imagination.

Now, slang – that's a different matter: as Jonathon Green, its greatest scholar, observes, it's the poetry of the gutter. Cliché, on the other hand, is the deadening prose of the executive estate. (2017)

Tongue twisters

The show's title should give it away. *Matrix Hubbing Performative Pain Badgers* purports to be about jargon. Slang is low-level linguistic invention. It mocks. Jargon, on the other hand, crawls on its belly, giving great forelock, hoping for promotion. Users of jargon often can't speak because they are stifled by having their head trapped in the jejunum of someone senior to them. And that person, for example a high-flying multi-platform forward-planification colleague, is also unable to speak due to the position of his or her tongue.

Jargon lacks all grace. It is merely an expression of self-importance, self-validation and a means of self-aggrandisement. It's the mode of speech employed by corporate middle management with its eye on the rung above. It's the mode of speech favoured by yes-men, yes-women, the yes-community.

Twelve years ago I made *On the Brandwagon*, about the regeneration racket which was then in its infancy. Apart from the laughable claims made for arts centres and theatres as implements of social renewal, the aspects of this endeavour which most astonished me

were its participants' total reliance on jargon and their inability or unwillingness to explain their pseudo-science in the vernacular. Now, this presented a problem: for thirty years and sixty shows I have clung to the precept 'copy anyone but never copy yourself'. It's a counsel that is evidently impossible to live up to.

Nonetheless, in order to obviate the likelihood of repetition, or repetition in disguise, I decided to make jargon only a part of this show. I expanded the scope, I decided to venture from that often infuriating topic to other crimes against the language. The routinely mendacious lexicon of politicians who, as a cross-party caste, find it easier to lie than to tell even an approximation of the truth. The self-important and mangled obfuscations of the curatocracy which has turned art galleries into temples of rubbish. The meagre clichés of sports pundits struggling to compose an entire sentence. They have nothing to say and they say it, as Oscar Wilde put it without having watched even a single edition of *Match of the Day*.

His contemporary G. B. Shaw wrote in the preface to *Pygmalion*: 'It is impossible for an Englishman to open his mouth without making some other Englishman hate or despise him.' *Plus ça change.* Is that so? Speech has indeed changed. I don't mean usage, vocabulary and so on – that is, always has been, always will be, in perpetual mutation. I mean the very purpose of speech. It is no longer exclusively a means of communication. There exists a wrong idea that mass media has caused regional accents to disappear. Television is supposed to have killed them off. It is an idea without foundation. Television is forever telling us that regional accents are 'under threat' – not least by television. That is because television regards itself as more influential than it actually is.

Its effect on accent is rather the opposite: people all over Britain have reacted against the medium's supposedly homogenising tendency, which is anyway, as I say, much exaggerated. Supposedly homogenising, supposedly. Speech is increasingly employed as a

self-conscious badge of identity. That is, of separateness, of difference. Mancunian usage is not that of the Lancashire towns. Tyne and Tees do not elide. Nor Cardiff and Swansea. It's a badge of pride in your particularity, in where you come from, a tribal sign. Dialects and jargon are shamelessly used as signs of identity, of communitarian exceptionalism, of fealty and allegiance to a place, rather than as a means of communication. Language is our primary means of communication, even among persons who have bugger all to communicate.

A linguistic monoculture of sorts has been replaced by a regressive linguistic multiculture. Received pronunciation, RP, is the linguistic monoculture which disappeared. It was practical. It was a sort of glue, a force for uniting a country rather than an incitement to division. It enabled a pyromaniac from Elgin to understand an assurance assessor from Port Talbot. A palliative nurse from Norwich, a chemist from Wrexham and an undertaker from Gateshead were mutually comprehensible.

The widely held misconception about received pronunciation, a misconception propagated by champions of regional dialects, is that it was a means by which people traitorously sloughed their 'natural' identity, whatever that is, in favour of essaying that apparently most baleful condition – poshness. One might wonder what is so pernicious about poshness? What is so toxic about self-improvement? What used to be called bettering oneself is better than worsening oneself. But that's not the point. What is germane here is that RP was a successful lingua franca, an auxiliary language, a sort of second language which did its job.

RP was simply functional. It merely meant supressing accentual tics and quirks of usage – thus a pan-British form of comprehension was achieved. J. B. Priestley's celebrated wartime talks were obviously those of a Yorkshireman – but a Yorkshireman who could be understood in Yeovil.

I had a lifelong friend, thirty years my senior, born into abject poverty in west London. He became director of Porton Down, he used LSD before Huxley did, he was head of the Scientific Civil Service: his accent was neutral, unplaceable. Not that of his indigent childhood, nor of Westminster let alone Wiltshire. He might have come from anywhere south of the Midlands plain, where the long 'a' prevails

RP was not a disguise. It was an instrument of a social mobility which no longer exists. (2019)

13

London

Blue, blue, electric blue

Four years ago, I bought an apartment, a sort of Dutch barn affair on top of a dismal ill-wrought pastiche nineteenth-century warehouse and across the road from an only slightly less dismal late 1950s warehouse. I was lucky. The Tory MP it had been under offer to was told, in January 1997, that he couldn't get a mortgage because he was going to lose his seat in May.

Thus, I bought a shell. It was easy to figure out the interior. But it came with a wraparound roof garden/terrace, 320 degrees, say, which forced me to address the walls. They were dull, dun, an aggregate of slurry – think mildly polluted estuary at low tide.

From this terrace, I can see London's most potent landmarks, Big Ben and Tower Bridge, as well as G. G. Scott's Salvation Army tower at Camberwell, Canary Wharf tower, the former NatWest tower, Guy's Hospital, the Barbican and the transmitter masts at Sydenham. I can see how lacking in tall buildings London is. I gape at the bereft skyline and wonder if the entire conservation industry wasn't devised for sad dorks who yearn for stasis, who can't acknowledge that, whatever they do, the future will happen and it will be different, it will have to be tall.

I can't, unhappily, do anything about the lack of tall buildings other than proselytise for them. I can point out that a handful of failures thirty years ago is not enough to condemn the type: we have not abandoned air travel because planes sometimes crash. I can suggest that if views of St Paul's are really so important, every building within a mile of it should be razed to the ground in order that the dean, a man who believes in 'god' and is thus not to be listened to, can show it off to best advantage.

The other lack that was and is apparent is that of colour. London's exteriors are drab. It is still, nearly a century on, as subfusc as the Camden Town painters represented it. In my tiny way, this was something I could help rectify. The said walls could be improved. Dusty eau de nil, duck egg, carmine?

I was driving through the South Lambeth Road when I saw a blob of startling blue – Gitanes going on Gauloises – which resolved itself as I got closer to an elegant health centre. I parked and entered. Of course, nobody knew who had designed it. About a dozen calls later, I got the name. That colour is Keim cobalt, said Helen Eger of Eger Architects.

So now my walls are Keim cobalt. This column is not sponsored by the Bavarian firm of Keim, whose UK office is at Bridgnorth. Nor is it sponsored by Eger Architects, which uses colour audaciously, as an integral part of a design rather than an add-on to 'brighten things up' (that's for bodgers like me).

The late 1950s warehouse that I mentioned earlier has also been transformed by colour. Ricardo Legoretta and Alan Camp have turned it into Zandra Rhodes' Museum of Fashion. I am proud to have contributed to a canyon of colour. Why do so few architects pursue this route? Why are Eger, Camp, Alsop, Gough and Cullinan the rare exceptions that prove the rule about our national dread of colour? Is that dread learned? I mean, is it a facet of a broader culture that is mistrustful of artifice, display and divergence from the drear

dictates of common sense, and that is horribly in thrall to good taste? Possibly. But the manifest delight with which Zandra's building is routinely greeted suggests to me that there is a public appetite for colour. Not for the reticent hues used in pomo makeovers of 1960s council stock, but for the big colours that are essential to the Mexican tradition that Ricardo Legoretta is heir to and propagator of. It is an appetite whose satiety is conspired against in London not simply by aesthetically nannying planners (whose colour sense comes from Henry Ford), but by many clients. Why? Because colour requires maintenance.

And there you have it. It was the failure to maintain high-rises that did for them as a social housing type. We maintain our bodies, our cars, our streets. But buildings, evidently, are different. So, no Grand Bleu here – and note that Alsop's masterpiece (so far) is known and defined by its colour. No Grand Bleu despite the existence of innumerable paints and pigmented renders and vitreous materials that will endure as well as brick or stone and that demand as little maintenance.

Remember Ruskin: the purest and most thoughtful minds are those that love colour the most. Me? Well, I'm not sure about the purity . . . (2001)

Seen and herd

When I first heard about the cows I was in deepest moose country. These amiable beasts do not share the shyness of British deer. They are evidently inured to being photographed by the leaf-peeping tourists who travel mob-handed through autumnal New England. Indeed, they exhibit a high professionalism as models, adopting one statuesque pose after another. They are so practised, so apparently rehearsed, that you wonder if they might have been trained. They might even be animatronic artifices.

I was staying at a remote 'inn'. I was too green to realise that 'inn', in New Hampshire, means a B & B. The ——— was the B & B from hell. The owner was threateningly dotty. Over a glass of warm medium sherry (so it's not merely a British habit) she asked her guests: 'Are any of you hugging folk?' She talked bitterly of her absent husband whom she had probably buried in the garden. She then served a dinner of chicken cooked in jam: it had to go into a handbag. Our fellow victims – though they did not think of themselves that way – were two couples from Lubbock, Texas, which owes what fame it has to the fact that it was Buddy Holly's home town. These folk were Holly's contemporaries, they had folk memories of him. Other people's memories are anaesthetic. It was not till very late in the evening, round about 8.30, that they got on to the cows. I was comatose from boredom. So I hardly listened to their enthusiastic gush about a herd of fibre-glass cows in Houston. Not so different, I told myself, from Milton Keynes.

I was hopelessly wrong. But I did not realise it for a couple of years. Then last summer I learned that in a disused factory near BBC Television Centre there were 500 verisimilar fibreglass cows which belonged to something called Cow Parade: I was reminded that the Houston cattle travelled under the same name. This is where it begins to get farcical.

They were in quarantine. Yes, I know . . . But Britain was, of course, in the throes of foot-and-mouth. I wanted to get hold of some cows for a film. It sounded as though they were subject to MAFF movement orders. The man to see was an ebullient ex-army officer called Charlie Langhorn. Again, yes, I know . . . But the world is full of bakers called Cakebread, of butchers called Cleaver, of greengrocers called Gage. Langhorn explained that Cow Parade had been postponed out of solidarity with farmers. How far can sympathy go? Are we to believe that a dairy farmer cannot distinguish between nature and artifice, between a cow and a full-scale

representation of a cow? Especially when that representation has been painted and amended in such a way that only the essential shape of the model resembles a cow. How many 'real' Day-Glo cows have farmers ever seen, how many which are topiarised like poodles?

Cow Parades have taken place in half a dozen cities other than Houston. The cows are not on floats. They are positioned in public spaces, sponsored, and eventually auctioned with 75 per cent of the takings going to charity. Of course this worthy end would be no justification for Cow Parade were it dull or meretricious. But it is not. It is the sheer profusion of the sculptures which makes them efficacious as popular public art or, if you prefer, gaudy street furniture. Yet there has been opposition. Cows in public spaces require planning permission. And the forces of insipid good taste have decreed that there will be no cows in either Kensington and Chelsea or the City (save at the Royal Exchange). The burghers of the Royal Borough have worked themselves into a right lather – rather in imitation of those residents of Regent's Park who more than twenty years ago effected the removal of Nicholas Monro's outsize Morecambe and Wise, which was also in fibreglass, also loud. More recently Southwark Council bowed to St George's cathedral's objections to Sokari Douglas Camp's grand, ritualistic figure on a nearby traffic island: what strange gods was it deemed to invoke? It is astonishing that the painted dinosaurs in Crystal Palace Park have endured so long. Maybe it is their age which renders them impregnable.

London is notoriously inhospitable to publicly displayed art which neglects to conform to the precepts of 'traditional' material, chromatic drabness, self-effacement. The vitality which is apparent in galleries stays there, in the closet. The message from our parks and squares is that art is an extra, an add-on. Imagination is a dangerous property which should not be released into the streets lest it stampede. It should not afflict our everyday journeys. We must be

protected from rhapsody and delight. We must be spared colour and cattle. (2002)

Culture clash

Old pop songs are obviously madeleines, mnemonic triggers. Thus, John Leyton's 'Johnny Remember Me' unfailingly transports me back to a traffic jam on the Exeter bypass, to the first time I heard that song, to the newsflash which followed it reporting the A6 murder for which James Hanratty would be convicted. I can't hear the song without thinking of that *cause célèbre*. I once mentioned this to Mr Leyton. He looked at me as though I needed treatment.

Another summer (the next), another car radio, another newsflash. I was beside a Welsh estuary under a pewter sky when I heard that Marilyn Monroe had died. The song which preceded the announcement was 'Bobby's Girl'. The peculiarly sinister aptness of that juxtaposition would not, of course, be vouchsafed for years to come.

When I set out to amble through Tooting the other day, nothing could have been further from my mind than grey Portmadoc and sunny Los Angeles. But there you are: events.

It was intended that Tooting should magic-carpet me to Bombay or Kampala or Madras. No sooner, though, had I parked my car than a poster in a shop window caught my eye. This Christmas's panto at the Ashcroft Theatre, Croydon, is *Aladdin*, and the role of the empress is taken by none other than Susan Maughan, the singer of 'Bobby's Girl'.

Now, I have to admit to a certain dereliction in not having followed Ms Maughan's career as closely as I should have these past forty-one years. Indeed, I even thought her name was Maugham, like Somerset and Sharon. Anyway, here she was, just as glamorous as in the days of her flick-up hair, smiling at me from beneath the legend

HALAL. Was she making a comeback? Had she converted to Islam?

Before taking another step, I called this column's Pantomime and Vaudeville Consultant, Christopher Biggins. Now, I've known Biggins since the beginning of time when we set out together down life's lonely highway. But I have never known him at a loss for words or, more importantly, uninformed about the arcana and lore of showbiz.

'As in "Bobby's Girl" Susan Maughan/m?'

'The very same.'

'You're . . .'

Here follows the loss for words. This is the consultant who was indignant that Patrick Mower had had to read for a part in *Emmerdale*, who has Jess Conrad's discography by heart, who can tell you Sidney Greenstreet's cup size and Madame Vestris's inside leg. He makes an ungallant guess at Ms Maughan's age and proffers the intelligence that she will sing 'Bobby's Girl'. Even I knew that. Of course she will. If I was a bookie the only thing I'd give a price on would be what minute she'll belt it out in. I went into Tooting's William Hill: whites and Afro-Caribbeans only, no Asians. The woman looked at me as though I needed treatment.

Halal. The conceit that the meat of an animal can somehow be 'blessed' is an offence against reason and sanity. This is not to discriminate against Islam. The immane barbarity of its way of slaughter is not the point. The Mosaic method is equally preposterous, just as laughably daft, just as stupidly cruel. But animals are bred to die. It is the superstition that is posthumously attached to the animal that is troubling.

For equity's sake I should suggest here that beliefs in, say, transubstantiation and parthenogenesis are equally problematic. But old European Christianity is self-secularising. It's just an add-on, it does not contaminate daily life. What is apparent in Tooting today – in comparison with my last walkabout five years ago – is that Hinduism

and Islam and evangelical Christianity have taken hold. Where once there was thrilling gaiety and gaudiness, there is now drabness and the pall of ancient superstitions. Saris are not worn because they are attractive garments (and sexy), but because the body must be covered. There are scarves everywhere. This used to be a beguiling place because it was a triumph of untrammelled mercantilism, a bazaar. Anything went – from all of the subcontinent and east Africa.

These are a few of the problems I had to face as I slothed south.

Further: I was cold. Two pashminas for £88? No. What about – just for the sake of the warmth – my putting my frozen head between another man's hot legs? No, no, no – not like that. I'm talking scrummages. You're never cold when you're a rucking hooker. Bec Rugby Club is recruiting. On an Asian high street? The only Asian rugby player I can recall is Leicester's scrum half of the mid-nineties. Still, a twenty-point printout taped to a shop window invites manly men of any race to call the club.

A second problem was the number of fruit and veg shops using the word 'fresh' in their name. Is this unimaginative plagiarism, or does it suggest that Asian immigrants to Tooting in particular and Britain in general have accepted the British notion of freshness – which is measured in weeks rather than hours, as it might be in Italy or Spain. So, which sells the 'freshest' fruit and veg: Nature Fresh? Daily Fresh? Fresh Food City? (Fresh Sugar Cane Juice was off.)

Third problem: religion (again). Why is it that the more established a religion becomes the more crassly institutionalised its icons become? It suggests that the spiritually bereft who sign up to these cults must also be aesthetically bereft if it doesn't matter to them whether their representation of Mecca or Calvary or Shiva is highly crafted stone or industrially produced plastic.

Sacred meat. Sacred scarf. Sacred kitsch. When did a religion last promote art rather than a debasement of it? I walked for two hours. It doesn't get better. After the Mitcham Lane junction, Tooting's

susceptibility to religiously inclined commerce diminishes. One departs a dismal multiculture for a dismal monoculture. Noxious curry gives way to noxious fish and chips. (2003)

Do not pass go

I first heard the word *ostalgie* a decade ago, in Bremen. Today it signifies an indiscriminate and affected fondness for the DDR, often expressed by the young who never experienced it. Then, only five years after reunification, *ostalgie* possessed a specific meaning which was different from that which it has acquired in the meantime. Sure, it signified a longing for the lost east but only in so far as the east had represented an untroubling paucity of material choice.

Those generations which had grown up with privation as their norm could not cope with the multiplicity and variety and abundance of goods which flooded into their towns and cities. They might have drunk beer, smoked cigarettes, driven cars, spoken on (tapped) phones. But they were depressed rather than elated by the arduous novelty of having to select between Erstenbräu, Zweitenbräu and Drittenbräu: beer is beer is beer, went the thinking.

Countless competing brands prompted confusion and bewilderment: life had been so much simpler when you coughed on a high-tar Roth-Händle, when you stalled in a high-emission Trabant, when you shopped your neighbour on a Grasfon. No-Choice is both institutionalising and comforting. It is a controlling tool of totalitarianism and authoritarianism: hence its deployment in prisons, monasteries, garrisons, utopias and, formerly, in muscular Christian schools. Individuality is quashed, hermetic communality is incited.

In an open, prosperous Western capitalist society, the notion of No-Choice can itself be a choice. You know: this house will be built with stone quarried from its site, wood cut from the trees where it will stand, and when it is inhabited, we will live on the

fruits and vegetables we grow. Such indulgent anti-mechanistic, anti-industrial fantasies have contaminated Britain for a century and a half. They are, of course, the luxury fantasies of a guilt-ridden, hair-shirted, air-headed stratum of the bourgeoisie.

More usually in this country No-Choice is a facet of indigence. Here, then, is Lidl. The Old Kent Road in London is all deprivation and squalor of a sort that made the very term 'inner city' shorthand for those qualities a generation ago. The idea that a regenerative gesture here and a spot of loft living there have altered the essence of inner cities rather than applying tokenistic spots of slap is wrong-headed. The OKR is rough and unremedied. It hasn't fallen from grace, because it never attained it in the first place. Though not for want of trying: one of its predominant industries is religion. It is, as ever, poverty that breeds the superstitious hope of a better life here-after. The engines of such hope line the road and its byways: the Eternal Sacred Order of Cherubim and Seraphim; the Latter Rain Outpouring Revival Church; the Beneficial Veracious Christ Church; the Dynamic Gospel Ministries; and so on. A light indus-trial shed of the asbestos era carries the bold legend 'Victory House – A House Of Prayer For All Nations' and, beneath it, the lesser legend 'Security Camera With 24 Hour Video'. Security is, of course, another well-established industry.

Down the road, at the edge of a trading estate behind a spiked fence presumably modelled on a medieval torture tool and finished in no-climb paint, you can study the Meaning Of The Bible. You can speak in tongues on Sundays and dance and beat your hands together till they're bruised.

Yet still you have no choice but to keep your earthly body together at Lidl, a store owned by a German chain which must be the cynosure of all who suffer *ostalgie*. Both its site and structure defy caricature. It is beside a flyover, overlooked by late-Victorian tenements and sur-rounded by deck-access council flats of the fifties. The car park is full

of cars whose success in the MOT suggests that the referee was bribed or threatened. The building is laughably banal even by the standard of supermarkets, so banal that it's almost exciting. Did someone really design it? If so, who? I am genuinely curious. There are many cheap buildings around. But there are few in which the designer can resist the attempt to mitigate budgetary straits with some pathetic flourish of the imagination.

As for the interior. Think Chemnitz a quarter of a century ago. Goods are stacked on pallets. They don't do 'presentation' at Lidl. They *do* do quantity. Two-litre bottles of Irn-Bru, two-litre bottles of Coca-Cola.

These brands are, however, atypical. Most of the produce derives from factories in Germany and Poland. Little account is taken of British taste, whatever that is. Great account is taken of the British disinclination to spend on food, a disinclination which is a necessity in Giroworld. The prices are astonishingly low. Tinned tomatoes are 58p per kilo. I set myself the Lidl Challenge: could I make a palatable meal from the stuff on sale? Yes.

But it would exclude meat, or should that be 'meat' as in 'Meat 60 per cent Chicken (mechanically separated), Pork'? I admire the candour. There is stuff with names like 'Bacon Grill'. I haven't eaten corned beef since the Aberdeen typhoid outbreak and Lidl isn't going to change my mind.

What about dried fruit or, rather, 'sulphurised fruit except the plums which contain sorbic acid'? Over there in a cold counter is a sign 'Extra Manure'. When I got close it turned into 'Extra Mature', a description of some sort of 'cheese'. My meal would, I realised, have to be built around German staples: chocolate liqueurs, marzipan (the only item available in Multi-Choice), Knabber Frisch paprika crisps and bottled Schwabenbräu, which is again astonishingly cheap (£1.25 per litre) and probably better than the stuff with German names brewed under licence in this country. To add

493

sophistication to this meal I'd spray myself with either Maverick or Eruption aftershave. And I'd give my dinner date a lovely gift. A folding saw or mitre saw (1,400 volts), a crested *bierstein* or a pair of felt slippers, a pack of heavy refuse sacks or a stepladder. And then I'd pray that there's an Iceland in heaven. (2003)

Munster munch

Six years ago the EU issued a directive to the effect that we would all be much healthier were we to drink more cow's milk. When this silly edict was delivered I was in Toulouse, where the local telly station sent a reporter on to the streets to canvass opinion. The consensual reaction was that of bemusement, puzzlement, incredulity. The most memorable interviewee was a deadpan traffic policeman who replied: 'Milk? I thought it was poisonous unless it was turned into cheese.' Whether he actually believed this is hardly the point. Cow's milk as a drink is gross. Baroness Thatcher performed an admirable service in her role as 'milk snatcher'. If only one of her predecessors as secretary of state for education had had the nous to relieve children of their break-time obligation when I was still at school. Cow's milk prompts migraines and sinusitis. Even if it tasted OK it would be worth avoiding in order to obviate the thumping numbness in the temples. But cheese is irresistible. The Toulousain copper was spot on: the transformation of milk is one of humankind's greatest gastronomic achievements, a sort of beneficent alchemy. Base material is raised to stellar heights.

Dean Martin was once asked by a chat-show host what his favourite cocktail was. He considered for a moment then drawled: 'Gin Martini!' Then paused. 'John Collins . . .' Another pause. 'White Lady . . . Screwdriver! Sidecar! Manhattan Perfect . . . Gimlet! Old Fashioned!' And so on, and on. The litany of the known and the unknown continued for several minutes, a protracted testimony

to a life misspent, to dives and good-time girls and the smoky early hours. I might try it with cheeses. Roquefort, Ossau-Iraty, Perail, Cabécou, Tomme d'Aveyron, Ricotta Salata, Pecorino Sardo, Wigmore, Beenleigh, Spenwood, Harbourne, Berkswell . . . Enough. That inventory, I see, sends out a different message to a list of drinks. It speaks of hanging around dairies at dawn, of good-time ewes, of lurking in markets, of furtive sniffing and tasting, of searching for the Greek human milk cheese Jocasta, of studying the Artotyrites who celebrated the Eucharist with cheese, of leading the life of the gastro-anorak.

Thankfully it's possible, just possible, to so indulge oneself in Britain today. Cheese is a pleasure that we were long denied. It was something that happened to other peoples. It still remains a luxury. The era of such grotesque palatal affronts as Dairylea and Cracker Barrel may be past, but for the most part 'cheese' remains a vac-wrapped slab of anodyne chemicals.

This stuff is to real cheese what keg (or top pressure) beer is to real ale. And here arises a besetting problem. Pasteurised industrial 'cheese' demands of its retailer no care. The same goes for keg. They are inert. Real cheese and real ale are living things. The supermarkets' range of real cheeses has increased. But they store them negligently, like factory products, which is all they know. While it might be a delight to discover bargain-price Vacherin or Epoisses in the aisles, it is anything but a delight to taste them. There is no possibility of their attaining perfect ripeness − for that does not come about by chance. It takes a craftsman, an *affineur*: Britain lacks such craftsmen just as it lacks butchers and *charcutiers*. It also lacks proper cheese shops. There are a mere few dozen.

At the top of the pile? I could have composed an equal paean to Randolph Hodgson of the Neal's Yard Dairy, to Ian Mellis in Edinburgh and Glasgow, to the Fine Cheese Company in Bath, to

Paxton & Whitfield. They all specialise in the products of the revival of British artisan cheese making.

While Patricia Michelson does not overlook such cheeses, the name of her two London shops, La Fromagerie, indicates where her tastes lie. Well, certain of her tastes and in a generalised way: specifically, she is a devotee of France between the Rhône and the Alps. This is manifest in a geographically convoluted way: her fondness for Vacherin is such that she has discovered a clone made from goat's milk in the foothills of the Pyrenees. Oh, and she is a lifelong fan of Johnny Hallyday. There is no shrine to him in either of her shops: a bust in Mimolette would be appropriate.

The first shop is a tiny treasure house near Arsenal stadium. The second and larger occupies a neo-baroque building in Marylebone. Both are delicious, meticulous, proper and patently born of this lactic evangelist's beautiful obsession. Both, too, possess a hidden maturing room and a public, high-tech cheese room (double-glazed and centrifugally humidified to maintain an appropriate temperature): the occasional loutish customer doesn't bother to shut the door. These rooms foster dreams of incarceration among toweringly fantastical Piranesian cheesescapes. There is simply so much, in so many forms (and Fourmes) and in so many colours. And the smells! As Wayne Clent once had it (in a different context): 'It's a symphony for the sinus.' (2003)

Up the junction

This year is the centenary of the Man on the Clapham Omnibus (MOCO). The first recorded usage of this epithet is attributed to Lord Justice Bowen, though that doesn't mean to say it was also his coinage: it may have been doing the rounds of pubs and variety halls before 1903. It is, of course, the epithet that has endured rather than the 'typical' citizen it aspires to signify. The word omnibus is

an anachronism that survives only in abbreviation and the fortunes of that south London suburb have fluctuated no end.

In 2003 the Geezer on the 19, the 35, the 39, the 49, the 77, the 219, the 295 or the C3 – all of which pass by Clapham Junction – is very likely on the lam, on the skids, on benefits, on smack. He is certainly late, because the bus is in a queue of further buses; unmoving twenty-metre-long red behemoths are evidence for Mayor Livingstone's case that London is hopelessly congested (by buses with three people on them). It is, perhaps, missing the point to conceive of buses as a form of transport. We should, rather, think of them as a form of slowly processing shelter, a metal bender for the unhoused.

In 1903 the omnibus was a habitual and respectable means of transport to and from the burgeoning suburbs of which Clapham was evidently reckoned characteristic. It was mostly new, had mostly been constructed within living memory. With the exceptions of Old Town, the early-eighteenth-century houses on the north-east side of the Common (in one of which Graham Greene would live) and the copybook Regency stucco Crescent Grove, the place is Victorian with a vengeance. Where fifty years previously there had been vegetable fields and orchards there were now exemplars of every stylistic whim that the second half of the nineteenth century could come up with – French Renaissance palaces, Swiss chalets in London stocks, art nouveau-ish mansion blocks, mad terraces in the industrial terracotta which remains as harsh as the day it was baked. Clapham had the lot. Well, almost the lot.

There was never a spa like the one at Norwood. And in 1903 it still lacked the device that would turn it from a mere suburb into an integral part of the metropolitan entity – a department store. If you think that there's anything new about the rebranding of places (Leeds, Manchester, Brum) through grand retail spaces think again.

Mr Harding and Mr Hobbs resolved to match Mr Gamage,

Mr Gorringe and Mr Whiteley. Anxious to attract trade from *ouvrier* Battersea, where strictly speaking it is situated, they tossed to see who'd forfeit his aspirate. Harding lost. Hence the store they built became Arding and Hobbs. That was their sole concession to the proletariat's way of speech or life. They commissioned the rather grand architect James Gibson, whose best-known building, the Middlesex Guildhall on the west side of Parliament Square, is his least typical: it's both Gothic and *sui generis*. More usually Gibson worked in the revived baroque style. Yes, Harding and 'Obbs were bringing a West End architect to Clapham. But they brought him to a site in a declivity, to a combe. And they brought him when baroque was giving way to mannerism. In those five years before the First World War, English architecture lost its way. The Gibson of 1910 was not a patch on the Gibson of fifteen or even ten years earlier.

Geezer has stumbled off the C3 or the 77 and is looking for further shelter. The first two doors he alights upon are closed. Strip banners announce 'We've Got The Builders In But We're Still Open'. Having eventually gained entry, Geezer wonders: how many years too late are these builders? That, anyway, is what I wondered. Ardnobbz is remarkable. The shop with nothing to buy. The shop that is incapable of triggering covetousness. Just up the road the Clapham Grand advertises Ultimate Seventies nights with Dr Glitz and the Fabulous Flirtations every Saturday. This terminally exhausted department store provides a more characteristic (and displacedly provincial) seventies every day of the week.

A hundred minutes, one for each year of MOCO's existence. That's how long I spent in Harding and 'Obbs. A hundred wonderful minutes. I could spend weeks there. Indeed, I have spent weeks there: I realised that every bed and breakfast and 'family' hotel in the UK is furnished by A & H. Every sunset home too – this is the kind of store where we go to die, wrapped in a plaid rug taking

baby food through a straw. The bloated sofas in beige and cherry, the glo-log fires with real wood-alike or real reconstituted stone surrounds, the loud post-post-post-Impressionist landscapes in the colours of aneurism, the fluffy pastel towels, the characterfully patterned plates, the vegetal light standards . . .

I walked through cheap suits, jeans with low-relief appliqué, non-erotic underwear, casual clothes, kiddy clothes that assume that kiddy's spectrum is restricted to baby blue and ice-cream pink, alps of white goods. When I shrink to 5 ft 3 in I can cross-dress at Petite. When I swell to size 23, at Ann Harvey (with the considerately provided extra-wide fitting room). My garden will one day be an installation of potbellied Chinamen and pathos-stricken bears.

The current (if tardy) building works are worrying. Is this singular monument to stylelessness on the point of a makeover, is it about to be dragged into the nineties? Please say no. There are few remaining metropolitan sites that so eloquently broadcast the comforts of banality and the reassurances of utter dreariness. It brought back childhood afternoons with vegetative relations whose power to jabber was spent: we only appreciate such times past in distant retrospect. It also recalled, inter alia, milkshake powder, nylon sheets, matted cardigans, Cracker Barrel (not that I saw any of these). The compromised building and its thrillingly dismal contents merit aspic. It should be preserved as a Museum of the Overlooked. Mediocre, yes, but what magnificent mediocrity. (2003)

Mists of time

A schoolfriend died aged seventeen one Friday the 13th in a freak accident on the Hog's Back (a pantechnicon in a high wind). He had lived his last couple of months at his sister's flat at Observatory Gardens in Kensington. When I visited him, I made my way there on autumn nights through copybook pea-soupers which might have

been devised by special effects. Save that they weren't swirly. A London Peculiar was doggedly, eerily still, an apparently infinite wet, lard-coloured wall that warped street lights and window lights into stretched ovaloids and hyperbolic trapeziums and caused them to hang suspended as if they were sourceless. It owed, then, an affinity to the Cheshire Cat. Cinema's self-granted licence to animate fog and smog, to render them as mutating wraiths, is understandable. Here, after all, is a medium that is defined by, and which takes its sobriquet from, its reliance on movement. Which equates movement with drama.

Yet the drama of fog and smog resides, contrarily, in their stasis. They are terrifyingly homogenising of place. They annul clock time. Getting lost is indissolubly associable with fog and its sure capacity for disorientation. It also conjures up embarrassing memories of the diagrammatic map of the London Underground devised by Harry Beck, an artefact that occupies in the British collective conscious a position close to that of the shipping forecast's place-name litany. My mistake when I first embarked on my teenage project to explore all of London was to believe dumbly in that map's literality, to assume that its disposition of Tube stations corresponded to cartographic norms rather than to the exigencies of graphic perfection. The map was a false ally. Thus, I walked 180 degrees in the wrong direction, in fog. I pounded occluded streets heading away from my destination, often unable to discern the buildings which lined them, wondering where I would end up, now terrified that I might never find my way home, now thrilled by my reckless wanderlust and revelling in the freedom of the sheer pointlessness of my tireless ambulations.

I had no idea what Observatory Gardens and its immediate environs on Campden Hill looked like. But I did surmise that stripped of their brumous decor they would seem wrong – like Glasgow in sunshine, like Fez in a blizzard. Every place has climatic apparel appropriate to it. *Il y a toujours du brouillard dans les Jardins de*

Kensington. That line, incidentally, does not come from the work of a London-obsessed French writer such as Louis-Ferdinand Céline or Henri Thomas. It is the work of Anthony Powell. And from the point of view of mood and *mise en scène*, it is – or was – correct. This city's bronchioles may have benefited mightily from the Clean Air Acts, but its ambience has gained little from the loss of its formerly pervasive atmospheric cliché. Equally, it has gained little from its secession from the nation of which it is capital and its membership of a superleague of 'world cities'. Big money extinguishes shabby gentility, tatty dilapidation, the solaces of untidiness. Those, I discovered, were the conditions of Campden Hill when fogless.

So it would be pleasing to claim that this quarter of the Royal Borough has today been stripped of its essence by its multiple refurbishments, and to express a longing for a time of which Muriel Spark could write: 'In those days all the nice people were poor.' Pleasing, but thoroughly inaccurate. For despite being among London's most affluent neighbourhoods, the equation between money and crass vulgarity is not made. There are no quadruple garages piled high with Rollers. The boorish boastfulness of Bishop's Avenue is absent.

There are, however, a number of Victorian developments that can hardly be accused of modesty. Observatory Gardens itself, top heavy with two levels of *oeil-de-boeuf* dormers, is in the Victoria station French style of the late 1850s, though it was not built until a quarter of a century later. There are two contemporary adjacent terraces – one well-known from a Bill Brandt study – which were equally old hat but none the worse for that. And there is the overwrought church on Aubrey Walk, which screams its ignorance of Gothic forms in a dozen incompatible materials.

These exceptions serve only to emphasise the area's otherwise invariable thraldom to arty good taste. The arty good taste of different eras: the styles may change, but the sensibility is constant. There are

no local templates to adhere to other than the building lines. The impression is of endlessly resourceful infilling as the norm, of gaps plugged with ingenuity, of awkward sites proving inspirational because they are limiting. The combination of quality and variety is strangely un-English. These characteristics belong more to the inner suburbs of Brussels, where every house is determinedly different from its neighbour. Even the blue plaques suggest an aesthetic diversity: Dusty Springfield and two writers who have as little in common with each other as they do with her, Siegfried Sassoon and Charles Morgan. It is probably only by that plaque that the latter is remembered in this country, although he remains, mysteriously, Big in France.

There are, of course, some buildings that do more than contribute to the whole. A terrace of 1950 by Raymond Erith is a totally convincing forgery of a terrace of 1810. The late, largely unsung Douglas Stephens' cubist group of apartments is not only crisply beautiful but also of signal importance: this was the first instance, in the mid-1960s, of modernism looking back to its roots of thirty or forty years previously, thus questioning the shibboleth of perpetual progress and opting for stasis-like fog. (2004)

Kinks from the norm

English art nouveau buildings are akin to English wines: not many of them and seldom of the first rank. Which is not to say that those buildings which exist are not notable. They are, but because of their scarcity. It is worth braving the nail clinics and footballers' cars of Knutsford to spend quality time with Richard Harding Watt's tonic Ligurian fantasies which constellate that Cheshire town. They comprise not merely the greatest concentration of the idiom in England but the only such concentration.

The lack is hardly surprising. Art nouveau was urban, sinuous, worldly and reliant on machine production. Furthermore, although

(with the clamorous exception of Antoni Gaudí's expiatory temple in Barcelona) art nouveau was seldom employed for sacred buildings, it flourished in cities where the baroque and the rococo had been commonplace: Brussels, Antwerp, Paris, Nancy, Prague, Vienna, Turin and Genoa. These cities were or had been Catholic. The baroque was self-consciously representational of Rome's might. Art nouveau was the secular descendant of a faith that had never shied away from propagating itself through buildings as extravagantly irrational as its superstitions.

English Arts and Crafts architecture, with which it was contemporaneous, was the antithesis of art nouveau (which Patrick Abercrombie, the most influential English town-planner of his age, described as a 'horrible epidemic'). It was an explicit reaction against industrialisation, against agglomerations and the depravities they supposedly fomented.

Given that the 'special relationship' England enjoyed until shortly before the First World War was with northern European countries, a sort of ecumenical meeting of Arts and Crafts and art nouveau was always a likelihood. The fact that these idioms stood at opposite poles is irrelevant: the history of architecture is the history of the persistent triumph of appearance over ideology — it is, after all, a plastic medium, more practised by non-readers of manifestos than by determinist utopians. The type of development most associable with the Arts and Crafts was the garden city. In this country such developments would lead to the LCC cottage estates: the increase in the number of houses built was matched by a diminution or at least stasis in the quality of design. It was as though the architects lacked the nerve to diverge from the templates established at Letchworth and Hampstead Garden Suburb. In Belgium and the Netherlands no such inhibitions were felt. There the inventiveness that had characterised art nouveau a generation earlier was applied to innovative exercises in social housing.

Two minutes out of Amsterdam Centraal station on the shuttle to Schiphol stands the hallucinatory skyline of the Eigen Haard housing association estate, designed by Michel de Klerk, a sublime and original artist in a trade routinely professed by copyists and plagiarists. De Klerk's work (there is not much of it – he died at the age of 39 in 1923) is more thrilling than Gaudí's for it does not smack of mystic derangement or hint at the self-administered therapeutic balms that typify 'outsider' art. It is, however, in Brussels rather than in his native city that de Klerk's legacy is most ubiquitously apparent: in, for instance, garden cities such as Le Logis-Floreal and Kapelleveld and in the work of the latter's prolific architects Fernand Bodson and Antoine Pompe (who lived till he was 106).

Why are these names not better known?

The brief answer is that they belonged to the wrong school of modernism, to a school of individualism and richness: Pompe bitterly referred to himself as a 'false modernist'. That was because his brand of modernism succumbed in the early 1930s to the impersonality of international modernism, to the whiteness and rectangles and glass prescribed by the totalitarian aesthetes of the Bauhaus. This is the old-fashioned modernism whose retreads we see about us today.

London is all but bereft of buildings which took Arts and Crafts models as a springboard to invention rather than to the little Englishness of waney wood and cutesy inglenooks. But not entirely bereft. What were they putting in the feed in Muswell Hill in the first decade of the last century? This precipitously perched north London suburb is closer to Brussels than anywhere else in this country. The former Express Dairy, now the Village Bar, is an exemplary work of art nouveau, hideously defaced. Close by, an amiable joker has infuriated the local council by giving a shop a Gaudí-esque front which is deemed inappropriate; a cheap Boots fascia is, of course, OK. The further

west you walk along the Broadway, the better it gets. George Baines began to practise as an architect in Accrington. He contributed to that town's pleasing civic and communal buildings, and perhaps got a taste for Accrington Reds. While his eximious Presbyterian church here is built of bricks from Flintshire, they are as stridently, violently coloured as their Lancashire counterparts. They form only a sort of frame for thousands of flints. The place is the wildest exaggeration of the Nonconformist perpendicular then current. Fittingly, it is now a boozer.

Then we reach the perfect building, Birchwood Mansions in Fortis Green Road. There is no better apartment block of its era in London. It is horizontally emphatic, boldly articulated, faced in brick and pebble dash (which was then the render of tomorrow); there are mansard roofs, angular oriels, wrap-round windows and a general air of verdant, storybook sweetness. It is worthy of de Klerk or of Lutyens before he lost it. The builder was W. J. Collins. His architect was his son, Herbert, who subsequently worked at Welwyn Garden City and who created much of the enchantingly pretty Southampton suburb of Highfield. But he never matched this prodigy of his youth, an unsung masterpiece. (2004)

Seoul food

It took me four years to get to New Malden. It took me an hour and a half to get to New Malden — which is why it took me four years. I mean, I had anticipated that it would be a hideously slow journey from what we are now enjoined to label South Central. So it was a journey that I kept putting off, despite my curiosity having been whetted by an email which I received on 17 June 2000. The historian and curator Phil Reed rather specialises in the obscure and the arcane. He was alerting me to the existence of a 'ghetto of Korean life' near the Kingston bypass.

South-east London fascinates me. The equally inchoate sprawl to the west of the A23 Brighton road leaves me cold. Inexplicable, whimsical, capricious, silly, I know. But there it is. There are certain places I don't want to discover. That I don't need to discover. I appreciate that this is a delusory state, a topo-pathology. It is one over which I have little control. I yield to . . . well, what? Why am I drawn to Birmingham and Turin but not to, say, Milan and Leeds – despite my conviction that Revie's team of the early seventies was the most accomplished that England has produced, despite my delight in the wayward Cuthbert Brodrick, who designed that city's marvellous town hall? A delight that prompted me to explore the west Parisian garden suburb of Le Vesinet in search of the house where he lived much of the latter part of his life. Nothing pulls me towards SW postcodes. It's not until Surrey's heaths and birches, oaks and ceps, that I unslumber.

New Malden doesn't own a London postcode, but it is, de facto, part of London. How to get there. Find someone who lurves you. Promise them the promised land. Milk, honey, kimchi, dog cutlets. Persuade this someone to drive there. Take book to read in car. Take iPod (don't own one). Take irritating sleep mask. Take it off and remember why south-west London is so dismal: it's architecturally banal, entirely bereft of the pragmatic fantasy and queeny toughness of the south-east.

I doubt whether there is anything in the south-west to match the dreamhouse where the reflective genius Martin Rowson lives. The £1 million-plus piles in Clapham, Balham, Wimbledon . . . I quite fail to understand why anyone would want to live in these places given the wherewithal to live in Forest Hill. Again, I own up to it: placelack, bad empathy, strange compass, hypersensitivity to sleeping policemen (who fatly abound in the south-west. And so do the awake rozzers, mowing down kiddiz with their siren cars. Who supplies the Filth with speed?).

Now, it's not that I've never been there. I've been through it. I admire Seifert's Tolworth Tower, there are flat-roof houses in northern Chessington which I glance at, though I have never in thirty years bothered to get off the A3 properly to inspect them: there's a group of kindred buildings in Tetouan which I'm much keener to revisit. The architects Michael and Jonathan Manser, who have designed some terrific stuff in Surrey, once drove me down to Patrick Gwynne's extraordinary early house at Esher (which is now, deservedly, the property of the National Trust). They winced along a lot of the way. Splendid at tutting.

I hate to think how they'd have expressed their distaste had we swung off into New Malden. It's the kind of place that makes me despair of England – and as for the Mansers . . . Sure, there are high points. The former RACAL factory/offices beside the A3 are just the works for those (very) few of us who admire boardmarked concrete. And then. Then that's it. Why do London's Koreans live here? What was the pull? Dog availability? Have you ever seen one o' them Koreens in acshun? Where a normal tattooed Brit geezer wiv a St George's Flag painted on his face loves to just pat his dog Prince them Koreens will take a bite out of Prince's wump on the 'oof, like: 'eathens.

Me, I don't have a problem about eating dog. My old friend, the Morgan-driving philosopher Zog Ziegler, claims to have eaten one, comparing it to fox. My late ex-father-in-law Bill Bentley was obliged to eat it when he was Her Majesty's ambassador in the Philippines and high commissioner in Malaysia (where he also consumed fruit bat): this, graduates, is where King Charles Street leads you.

Lapin des rues – street rabbit – is a Bruxellois euphemism for cooked cat (ah, maybe that is why I so like that city). The butchers in New Malden are just like those on Arthur Avenue, 183rd Street, North Bronx, NYNY, where fully fleeced lambs hang by the neck. I lie. There are no butchers. There are many Koreans. Fat, sexy,

acne'd, languorous, beautiful, squat, laughing, drab, glamorous, cycling, BMW'd . . . If nothing else, New Malden teaches us that racism is a property of the strenuously stupid.

All Koreans are evidently different. Lumping together persons on grounds of nationality, gang, colour, tattoo, taste, choice of motor car is soppy. End of lesson. Yet Koreans gather here. I ate in a monoglot bar whose back yard was full of a guy chopping wood with a murderous fury. It made me feel good. I couldn't understand a word that was said to me. I was taken to another state linguistically, physically rather than psycho-tropically. The supermarkets, which are not that super, are confusing. Much of the produce is Chinese or Japanese. According to a London-Japanese restaurateur I know, Korean cooking is much admired in Japan. Another mystery. Why should that gastronomically subtle nation wish to eat crude food?

I was released into the community outside Hamgipak. Mrs Meades drove to somewhere called Furzedown, where one of her sisters and brothers-in-law and insufficiently respectful children — that's U2: Morgan, Tatum — live. I spent an afternoon trying to summon Korea. I sat on a bench and drank a soft drink called Rice Beverage. Then I swallowed Five Cereal Drink. God, if Jeff Bernard could see me now. (2004)

Let's all go down the ramblas

Utopia may be unattainable, but that is never going to inhibit a part of humankind from driving in its direction. The way in which we talk of this perennial urge is important. If the goal is understated, if the utopian aspiration is modestly represented as practical and specific, why then it seems reasonable and trustworthy. The unhappy associations of starting from zero — clean slate, megalomania and hubris — are removed. So, the laudable ambition to, say, improve our cities is uninfected by such qualities. A plan may be touched by

'vision' but not by 'a vision' – the introduction of that unassuming indefinite article suggests that someone is downloading messages from the clouds. Unqualified 'vision', on the other hand, signifies clear thinking, pragmatic intelligence, problem-solving nous. Unqualified 'vision' is an unqualifiedly good thing. It is earthed. As earthed as the seductive conceit of linking Primrose Hill to the South Bank in London in the form of a continuous promenade. 'Vision' in this instance belongs to Sir Terry Farrell acting in his capacity as a tardy ambassador from John Nash, who's been pushing up daisies in the Isle of Wight these past 169 years.

Farrell's proposal, recently launched and debated at the Institute of Contemporary Arts in London, is to rehabilitate the spine of central London – which was as much Nash's creation as Regent's Park and Carlton House Terrace. And although those parentheses remain, what stood between them has all but disappeared – just as acknowledgement of Nash's supreme achievement disappeared for more than a century after his death. Nonetheless, the course of his route through London is unchanged. It possesses a potential for coherence that is seldom found elsewhere in the city. But then no other architect so much enjoyed the patronage of the only British monarch since the Restoration to have built on the scale of a European autocrat. And therein, I'd have surmised only a few years ago, would have resided a ghostly hurdle. It is the atypical monumentalism of Nash's planning, its un-Englishness, which caused it not to be so much disliked as misunderstood and overlooked. We may have paid lip service to the architect-planner's *beau idéal* of squares and boulevards and the public space they afford, but we were seemingly reluctant to use such space either recreationally or commercially.

Farrell is far from the first architect to have championed the greening and sweetening of central London. But he is the first to have the breadth of ambition to appreciate that the Paddington–Euston–St Pancras–King's Cross axis of evil toxins is not lost for

ever. And beside that, Park Crescent to Waterloo Place is a cinch.

What truly distinguishes him from his precursors is his serendip-itous timing. Mayor Ken may not be a European autocrat but he is a strategic *dirigiste* in a tradition that derives from the bosses of con-temporary European cities (Juppé in Bordeaux) and from the great Victorian cities (Chamberlain, obviously). Second, travel has famil-iarised Londoners with the delightful Europe-wide practices of hanging out, lounging around and ambling aimlessly. The tentative provision of usable – as opposed to tokenistic – public space in London has created an undoubted demand, an appetite.

But this supply of what might be termed pedagogic public space has so far been achieved in a piecemeal fashion. Of course: this is the London way. London's essence is its heterogeneity. Nash went against the grain when he endowed a small part of it with a uniformity pre-cursive of that which Haussmann achieved in Paris. Farrell's project is audacious for it is concerned with exploiting the new(ish) taste for public space in order to regenerate that space in a way that shipped-in landmark buildings never can. It is a solution that is generously humane and thus to be fought for. The odd thing about it, given its author, is that it isn't really architectural. It relies on a series of com-paratively small gestures, clever amendments and good traffic plan-ning. The name Nash Ramblas sounds to me as though Farrell has got his American cars of the late 1950s in a twist. To others it will sound like the promise of unlimited transsexual hookers. So he is a utopian, after all. (2004)

Magic flashbacks

Mr Bunning's parents had a sense of humour. Or were malevolent. Cloth-eared, maybe. They landed their boy with two Christian names. He would be James Bunstone Bunning. The effect of a name on its bearer cannot be overestimated. That thumpingly dumb

homophone must have done something to Bunning. He grew up to become an architect of an almost clownish – and enthralling – coarseness. 'Immensely elaborate and crushingly tasteless' was Pevsner's verdict on the Coal Exchange, built in Bunning's fourth year as clerk of the City of London's Works. That was no reason to demolish it.

This most singular artist has been cruelly treated. The mad castellated entrance to Holloway Prison disappeared in the seventies. His greatest remaining monument is a few hundred metres away, and even that is partial. The Metropolitan Cattle Market was built in the early 1850s, when driving beef and sheep on the hoof to Smithfield had become problematic. At that epoch, Lower Holloway was just piecemeal developments among orchards. (There is still a street called Stock Orchard; there are ancient apple trees and pear trees in back gardens.) What remains of the cattle market among nylon hockey pitches and council blocks is Bunning's Italianate campanile and his fat hotels where drovers who got lucky might retire with fast ewes.

The cattle eventually shared the site with antique dealers, junk-mongers, totters, Steptoes. It became known as the Caledonian Market, after the nearby thoroughfare where I ate the one and only doner kebab of my life, and vomited. The surrounding area, which included tripe bleachers (more later), industrial bakeries and a cork-mat factory, is described in Beckett's *Murphy*, set in 1936.

Bunning's market was redeveloped in 1960, and the traders moved south of the river to Bermondsey Square. The name was retained. So the weekly event that begins in the small hours of Friday morning is still called the New Caledonian Market. 'New' could hardly be less appropriate. This small and engrossing market deals in oldness. It is even situated beside some of the most ancient domestic buildings in London, a group on Grange Walk that formed part of a long vanished medieval priory.

One stallholder was, fittingly and presciently, whistling 'Magic Moments': I'll never forget the moment we kissed the night of the hayride (what is a hayride?) . . . dadadada sleigh ride . . . the penny arcade, dadadada, the fun and the prizes, the Hallowe'en something, the funny disguises. Time can't erase the memories of these magic . . .

Erase, no. Bury or hide or misfile, yes. We need devices that will exhume what we have forgotten. The pleasure of a market that gathers together the quotidian gear of the recent past is that there is inevitably much that might be expressly displayed to transport us back like that potent cheap song. Every stall is piled with potential mnemonic triggers.

A second stallholder described the place as Memory Lane. And he was indisputably right. In a vain attempt to recapture our own past, certain of us surround ourselves with yesterday's just-found trifles, which have only a flimsy, oblique, illusory connection to our former life, and are certainly not blessed with any intrinsic value or beauty or charm. And though we may crave the effect that they may have, we do not really seek them, for it's fruitless to do so, self-defeating.

The more we long for this time travel, the more elusive it becomes. Rather, it is objects that pick us out; they choose us, they beckon from among the buttons and stamps and cracked ashtrays to tell us that they can open a cranny in our cerebral cortex. And the objects that are possessed of this capacity (or that we unwittingly invest with it) are seldom those that we might otherwise be interested in, let alone covet.

I had, so far as I know, so far as I remember, never previously seen a photographic booklet entitled 'Princess Margaret in the British West Indies'. It duly unlocked a loaded cupboard from which issued a slew of recollections: both generalised – of cinema newsreels and deference, and a specific day when, armed with a Union flag printed on celluloid, I stood, an unquestioningly loyal

New Elizabethan in short trousers, beside a boy whose surname was Lovell in a street in the liberty of Salisbury Cathedral Close to salute the queen, the mother of the nation, as she processed past in a car that had less roof than it should.

The fact that it was a facile catalyst did not, of course, make me want to buy the booklet. It had worked its beneficent magic without my even having touched it.

Here is a qualitatively different incitement to remember. Here is a pair of novelty cufflinks in their box. Made by Stratton, they are called Butcher, which is the name of the trout fly encased in Perspex. This was quite extraordinary, going on spooky. I have only once previously seen a remotely similar pair. I owned them. They were manufactured as a promotional gimmick and were given to me in my early teens by the late René Ragot, whose company, Mouches Ragot of Loudeac, used to mean as much to a French fisherman as Hardy still does to an English one. I held this box as though it were the Eucharist. Which is apt, given that the sacrament is an inducement to remember, even if the subject to be remembered is too long dead to preclude any but constructed memories. These cufflinks were more heady than bad wine from Crediton and an unhygienic wafer stuck to the palate. They summoned people, places, cars, incidents – the first DS I ever rode in, a heart attack on the willowed bank of an English river, a gyroscopic Mitchell reel, the name Kermarrec, a chugging outboard fighting against estuarial tide, a fragrant bowl of tripe with prunes. (2004)

Kowloon on Thames

The Dome! Remember? It seems a lifetime ago. The bright gleaming dawn, the herald of our new age, the chrysalis before the imago of tomorrow (when there will be jam), the harbinger of something, the overture to something else. It was dumped full of tat and it

reeked of McDonald's. Yet it was the apogee of structural elegance. And so it remains, an empty building that was far grander than the tacky, dismal, anti-elitist trade fair for slow learners that it ingloriously and briefly housed.

It will have its day. These things take time. Due allowance must be made for the English incapacity to create infrastructure. It has to be recalled that the development of Docklands began a quarter of a century ago. It has a two-decades start over the Greenwich Peninsula at whose northern tip the Dome stands.

This area is gradually being developed with dual carriageways, roundabout clusters, colourful modern apartments, eco-conscious houses, a nature reserve. It is an altogether good-looking place, quite unencumbered by the ugly whimsy of, say, Poundbury, the Prince of Wales's greenfield eyesore on the edge of Dorchester. Unlike that escapist stage set, it prompts a kind of optimism. And like any real townscape, no matter how adolescent it may be, it springs surprises.

There is, for instance, a startling yacht clubhouse in the tradition of the Royal Corinthian at Burnham-on-Crouch: that's to say it is something special. No one could make such a claim for the Holiday Inn Express. At least not on the grounds of its mass-produced appearance. It stands alone between roundabouts and close by a flyover surrounded by a car park that is always crowded. This is due to the popularity of the Peninsula, the vast and beguiling Chinese restaurant which occupies the ground floor and whose clientele is predominantly Chinese – which is not invariably a sign that a place is any good. This one is, though. While you're piling down the Peninsula's delicious dim sum you can attempt to learn Cantonese from plasma screens that advertise insurance and travel services, furniture, cut-price speed-camera detectors and a nearby Chinese supermarket.

Mayor Ken has lately announced an exercise in what we are no longer allowed to call social engineering. He wants to create a new Chinatown immediately north of the Dome on the other side of the Thames near the site of London's first Chinatown, which in the twenties provided the subject matter of the local-colourist Thomas Burke's *Limehouse Nights*. It seems, however, that the free market has beaten Ken to it, that there is already a thriving Chinese community just a tunnel's length away.

SeeWoo Cash & Carry is a few hundred metres from the Peninsula in one of the seemingly endless series of retail parks which stretch from Greenwich to Thamesmead, relieved only by grease caffs, tyre exchanges and pubs: the last remaining London gin palace with the nineteenth-century Francophobic name The Antigallican is here. Every other big shed is called World Of: World Of Teak, World Of Meat, World Of Lycra, World Of Prosthetics, World Of Bling, World Of Conditioner, World Of Dogfood, World Of Mixers, World Of Bandages, World Of World.

Worldless SeeWoo summons up a world of unabashed gastronomic enthusiasm and shameless greed in a way that no occidental British supermarket comes close to. It occupies two hangars beyond another justifiably crowded car park. One is devoted to the needs of the restaurant business. Pallets stretch to the sky, laden with sacks of rice the size of a cabin trunk. I recalled a seed warehouse where in my teens I established myself as a potentially deadly forklift driver. There are sixty-eight-litre casseroles that can, in an emergency, double as a font, life-size laughing Buddhas, tinfoil and glazed-card takeaway containers, clumps of chopsticks, spoons, lazy Susans, a wok to stir-fry a Labrador in, leaning towers of plastic plates from Thailand, and the stock obsessive's cynosure, an 18 cm oil skimmer manufactured by Camko: the barcode tag mysteriously says 'Best Before'. It cost £7.06. Bamboo steamers are a snip at £1.06. Ditto an ice pincer (not that I'll use it that way) at £1.45.

The greatest pleasures of SeeWoo are not, however, its cheap utensils. It is, rather, its unselfconscious exoticism which is so appealing. There's no heavily applied national colour of the kind that the Peninsula and indeed most restaurants go in for. No concessions are made to London. It might have been airlifted from Kowloon — as, obviously, many of the goods are. *Choi sum, pak choi, yau ma choi, kai choi, kon choi, tong sam choi, ong choi, gong choi, go bo* roots, durian, bitter melon, which looks like an aborted cucumber, chicken feet, duck tongues, shredded pork skin, grouper, climbing perch, spiney eel, apple snails, cuttlefish as big as a baseball bat.

I guess the stuff for sale here divides into that which is specific to the Cantonese repertoire and that which can be used in different kitchens. I am sceptical about the wisdom of Westerners attempting oriental cooking either professionally or domestically. It's akin to appropriating a sentence because we like the sound of it from a language which we do not otherwise understand, a sort of cultural pilfering which is also an inchoate insult.

Having said which, the southern Chinese kitchen has itself borrowed widely and weirdly from Britain. The use of Worcester sauce in Hong Kong is well known. But Carnation milk? And R. White's lemonade (whose old advertisement with the rubber-limbed Julian Chagrin is apparently inerasable), Daddies Sauce, OK Sauce, Sarson's vinegar . . .

The vivarium is magnificent. A notice requests: 'Please Do Not Wash Your Hands In The Fish Tanks'. It's difficult to imagine who might be tempted to do so, for certain of the creatures here are not to be messed with: massive crabs and vicious lobsters and conger eels. It's like being in a pet shop where all the merchandise is to be eaten. Bliss. (2004)

A spell in Holloway

At the northern end of Upper Street there occurs a collision of sensibility, style, colour and scale that, even though I know it's coming, never ceases to astonish me. A standard-issue, late-Georgian Islington stock brick terrace is coarsely interrupted by a vast, red, High Victorian church which is tall yet squat, boorish yet lovable. Or lovable because it is so boorish, so inappropriate, so determinedly a bloody-minded cuckoo.

Then the terrace reprises. But not for long. The Union Chapel is a sort of epigraph. It signals the beginning of the end of Islington and the promise of something other than row upon uniform row of mean, boring houses which have come to represent drearily unimaginative good taste, like an urban Cotswolds.

Holloway, Islington's immediate neighbour, is much more the ticket (just as the Severn Vale is). It is varied, energetic, unpredictable, messy and conventionally derided – that is, it is derided by the victims of Islingtonian good taste. Their message has got through. This is the suburb whose name estate agents dare not speak. Chirpily self-deluding, they euphemise it as Highbury Borders or Camden Heights or Tufnell Park or Tollington Village, despite having their offices on the Holloway Road.

London Metropolitan University (LMU) is a former poly which has also been euphemised. Kingsley Amis warned in a Black Paper thirty years ago that in tertiary education 'more will mean worse'. He was, of course, right. Still, no matter how bizarre their courses, no matter how pre-literate their students, these institutions are useful as patrons of 'adventurous' buildings. Daniel Libeskind's 'adventurous' block for LMU has prompted predictable comparisons between it and the Holloway Road which it leans over.

It is, actually, thoroughly formulaic: Libeskind is a one-trick pony. And it is in this instance the wrong trick. An opportunity has

been missed. If ever there was a case for commissioning Quinlan Terry this was it: who better to give London the world's largest cottage *orné* as a memorial to Holloway's most assiduous cruisers, the contemporaries Joe Orton and Joe Meek, who died violent deaths within six months of each other? The LMU, after all, already acknowledges these martyrs by offering a leisure and mathematics learning module entitled Fluid Exchanges: Paradigmatic Aberrancies and Societal Othernesses from Wolfenden to Jenkins.

Let us console ourselves. The Holloway Road already abounds in minor monuments to these artistes. I don't know whether the collection of library books which Orton and Kenneth Halliwell defaced so hideously that they were sent down is still held at the branch library there, but I do know that any self-respecting leather queen would reckon Sondel worth sniffing out. What a shop! What a smell! It is intended, supposedly, for bikers. Middle-aged men who aspire to emulate the wannabe Lee Marvins who gather at Burford Bridge beneath Box Hill on Sundays should start here. So, too, should the severely disturbed whose *beau idéal* is the governor of California at his most robotic. Which came first? Costume design or functional footwear? *Terminator* or knobbly polychromatic boots with sole-rigidity systems, speed lace-closure systems, closed-cell and gel (no, I haven't a clue), torsion bars . . .

Much as I admire Sondel, it's not for me. The only leather I have ever worn has been on my feet and the only items here which aren't leather are these boots: I am not about to join a Village People tribute band. And as for motorbikes – many years ago I rashly accepted a five-minute ride on a Norton Commando. Those five minutes' terror remain with me just as, throughout them, the pit of my stomach did not.

Feet have much to offer as a means of transport: slowness, for instance. I ambled past the psycho and mastiff, crossed the roaring road towards The Little Shoe Box and gave thanks that I was not

shod by it – for had I been I'd never have made it to the (comparative) safety of the pavement. I'd have been teetering, then I'd have been roadkill in eight-inch heels. TLSB was born in the age of glam rock when it made the most outrageously vertiginous and deafeningly coloured platform boots – stage wear that found its way on to the streets. It has subsequently made the most outrageously vertiginous and shinily vinyl stilettos – dungeon wear that has found its way on to the streets. This is surely the footwear of choice of that guignolesque cartoon type called Orton Woman who is comprised of pedal fetishism and Donald McGill bawdy, high camp and low camp.

Now follows an anaphrodisiac interlude: sixties and seventies furniture including some handsome Spanish desk lights (at Back in Time); austere shop fittings of a slightly earlier period (at D. A. Binder); the purple-fronted 'Social Club Members Only' whose windowlessness is no encouragement to join; a monumental mason with heartfelt and pitifully jejune epitaphs incised on black headstones.

I crossed again through the now static traffic to Showgirls and its neighbour Zeitgeist Licensed Sex Shop, which was, unhappily, closed. The former takes its fetishism much more seriously than The Little Shoe Box does. But then so it should, for the first rule of any aspirantly pornographic enterprise is that its self-referential hermeticism should not be ruptured by humour.

My flat heels were scraping along the pavement towards Meek's extemporised studio when another monument to Orton caught my eye – a Moroccan tea room. Which turned out to be a caff on the site of the somewhat indifferent Royal Couscous House. I once wandered round the medina in Tangiers with a delightful former teacher of mine at RADA who never found the right girl. He kept returning to the topic of how summers in that city just weren't the same without Joe, who had so loved Morocco, especially its people.

Had Orton lived he could have pioneered stay-at-home, on-your-doorstep sex tourism. (2004)

Freedom of the city

The City of London on Sundays is alluring. It may even hold some attraction for those who work there during the week. Townscape is the highest form of museum, one that appeals to me more than purpose-built museums with their accessible pedagogy, interactive sideshows and curatorial caprices. Unpeopled townscape is necessarily seldom encountered, save at dead of night when much is occluded, or in the earliest hours of a summer morning. The Sunday City is still sometimes akin to how Paris used to be in August: streets narrowing to a vanishing point with not a person to be seen.

There is a serenity to be found in ambling along these canyons, then ducking unnoticed into alleys and courts when far-off voices promise vitality, when the desert stage threatens to become more than a frozen set, when the frail illusion of a solitary compact with the inanimate might be ruptured. I admit that this is on a par with inciting a bear attack should one step on the pavement cracks, but having the City to oneself is a signal luxury.

It is also free. And about as close as we can get to time travel: there remain a few streets where the imaginative, olfactorily deficient myope can make-believe it is still 1870 or 1900. There are many more streets where the generalised monochrome past of the age before mass car ownership is readily summoned. Humankind's intrusion inhibits this kind of willed reverie.

For all our careless prodigality with monuments of the unfavoured parts of the past, for all our perennial drive to renew the fabric of the City, there is much that a revenant from a distant age of bad smells and bad dentistry would still recognise. People change with far greater alacrity than their surrounds. They give the game

away: at least, they give the date away. The majority of buildings are, so to speak, anachronistically dressed. They are not of our time. Yet they are the rule. People who are anachronistically dressed or coiffed or accented or scented are the exception: we are nearly all captives of our time, our generation. Witness what we people buy. Follow me.

I stepped out of solitary on Botolph Lane and into Eastcheap. No one on the pavement. The City's north–south arteries are always busier, I assured myself. As if to prove it two Balks or Balts – I could hardly hear, let alone recognise their language – were standing side by side on Gracechurch Street, spraying steaming pee against a doorway and, no doubt, doubling their pleasure by so sharing it. Leadenhall Market was closed but that is no reason to ignore it: its order and uniformity are admirable, atypical of a megalopolis which is all collisions of idiom and dichotomies of scale.

Though there is not a voice to be heard in the streets off, and there's no one to be seen, Bishopsgate is humming, but under its breath. Middlesex Street is a fantastical and depressing babel. Here are some happy clappers of several harmonious races and several harmonious instruments: drums, guitars, tambourine. They do seem happy. When they importune you with a card asking 'Are You Ready' they are courteous. They may be horribly deluded – but each to his or her own delusion. They don't get in the way of commerce. What gets in the way of commerce is the trash they sell in markets. It's as simple as that.

Look: I bought a belt to replace the belt I bought in a market in Lyon three years ago and which now has Alzheimer's (it has forgotten how to buckle up). I paid a barely anglophone Pakistani with a small stall £5. At Therapy, a very similar if not identical belt – I don't spend enough time on my knees to be a belt expert, Lord – would have cost me £55. In any currency that is a saving of £50. Therapy also had a sort of duster coat that I'd have bought had I been

twenty years old with an aspiration to be a Carradine: £350 saved.

I don't know how to calculate what I saved at Oliver Sweeney shoes. I admire his craft, am thankful he doesn't do trainers, and tolerate the design, provided it's someone else who's wearing the things: but the formulation 'such and such with a twist' is a turn-off. Across the road Soho's Original Books is a betrayal of its name: it sells, disappointingly, unsalacious remainders. Bare Necessity is the last thing I need, since it promises permanent hair reduction: the clean-shaven Jenni Murray was on about women's moustaches the other week just as I was driving into the Rotherhithe Tunnel. So I sadly missed her observations. The Back Pain Centre is pointless if you know the great osteopath Frank Ying.

This was once Petticoat Lane. My hardback *Master Atlas of Greater London Edition 6B (revision) 1992* represents it as MIDDLESEX (Petticoat Lane) STREET. But the last time any Londoner called it Petticoat Lane was in a different century, in ye olden days when they wore body perms and narrow ties. Today, the only kiddiz that can tie a tie are the ones in two-tone tribute bands. Ska? Rock Steady? Got it. A stall run by a scowler with a portable generator plays and flogs CD compilations of Derrick Morgan, Desmond Dekker, all those we loved at the Q Club in 1969: their being on CD reminds us it isn't 1969. Nor is it Festival Year, 1951, when *London Night and Day*, a wonderfully idiosyncratic guide, was published by the Architectural Press (illustrator: Osbert Lancaster, editor: Sam Lambert). You could buy 'blue jeans, muffins, wet fish and shell fish, atlases of Israel, motor scooters, lino, a sideboard, an accordion, a camera . . . The language of persuasion is rich and rewarding. The crowd consists of Hebrew race gangs, cockneys in mufflers, wide boys in belted coats, Aldgate Jewesses, lascars, publicans, lodging-house keepers, old time costers.' No more. The only demand for atlases of Israel is likely to be from fundamentalists researching targets.

The East End, whose frontier this is, has been diminished by Jewry's departure. Its subsequent inhabitants lack the self-interest, will and civility to assimilate. That's why babel is depressing. France has an acknowledged problem with the veil: Britain has an unacknowledged yet far greater and far more potentially dangerous problem with language. Come and hear for yourself. (2004)

Capital offences
Slow Burn City: London in the Twenty-First Century by Rowan Moore

London's architecture has become laughably boorish, confidently uncouth and flashily arid. Neo-modern bling and meretricious trash are the current norms. Without exception big-name architects turn out to be horizontals who happily put their knees behind their ears at the first sight of an oligarch, a Gulf princeling, a central Asian dictator, a modern slave driver or a property swine, while lecturing us on sustainability, low emissions, affordability, bicycles, ethical regeneration and whatever other right-on shibboleths are in the air this week.

London is a magnet for a caste of designers who seem hardly to notice that the milieu they inhabit is chasmically remote from the lives of those affected and afflicted by their creations. It is the city – sorry, 'the world city' – where reputations built through decades of imagination and toil, strict image control and rigorous PR are frittered away in a blizzard of self-parody and voracious cupidity. The tectonic gerontocrats Rogers, Vinoly, Piano, Foster, Nouvel, Shuttleworth, etc. are apparently locked in a perpetual competition to vandalise the sky with big banality. There are outsiders in there, too, architectural practices which, all too evidently, never had a reputation to lose – for instance, the visually impaired incompetents culpable of Strata at Elephant and Castle, Broadway Malyan, whose destruction of Vauxhall has deprived London of a valuable *terrain*

vague. A few hundred metres west the ineffable Gehry has his head in the corpse of Battersea Power Station like a vulture in a lamb's ribcage.

Despite all this – actually despite does not come into it; *because* of all this the standard of English writing about urbanism, architecture and its mostly unintended or unforeseen consequences has risen to dizzying heights. We may live in an era of architectural bathos but we live too in a golden age of architectural criticism. The mocking scorn of these critics will of course inhibit further titanium excursions into the heavens just as, in Peter Cook's formulation, the Weimar satirists' warnings prevented Hitler coming to power. The notion that architects let alone developers can act on or even understand what the despised 'lay' critic writes about their trade, their work, their practice is not credible. Anything other than puffery which takes them at their own estimate foxes them. Nuance eludes them. If this sounds like a sweeping generalisation too far just try reading any starchitect's vanity-published thoughts. 'A Sèvres vase in the hands of a chimpanzee' does not begin to capture the linguistic massacre these people, fluent in the charmless pidgin of International Architecture Speak, habitually prosecute. And spare us the hackneyed mentation, epic humourlessness, risible self-importance and cracker-barrel philosophies.

Rowan Moore is a dauntingly well-informed critic, a broadsheet journalist of signal distinction. His sinewy prose is usually infected by a very English understatement. Sure enough, *Slow Burn City* begins with a series of obliquities: a history of the zoo; how Canary Wharf came to be; a journey along that marvel of hydraulic engineering the New River; waste and Byzantine pumping stations; visits to a few sex clubs and to the extravagantly asexual (or presexual) work of Ernest Trobridge in Kingsbury.

After this eclectic and fairly temperate start Moore gradually turns up the volume. He increasingly eschews nuance. He writes

with a strident anger that even the most boneheaded urban regenerator will understand is directed at him. This is not a posture. What has happened to London infuriates Moore: the class clearances; the governmental and local governmental betrayal of the most easily betrayed; the blurring of public and private; the willed chancre on the city's body tissue; the absentee proprietors; the greedy planners who answer to volume builders rather than to the boroughs which employ them; the pointlessness of the 'idiot critic' Prince Charles; the tangible inequalities you trip over in doorways; houses as currency; the market, always the market – Margaret Thatcher's and Tony Blair's poisonous and apparently irremediable gift to the country they misgoverned to the point where London's secession is total and its corruption, its very English corruption, entire.

It is too early to categorise the business of the garden bridge as corrupt. Let us merely say that it stinks. It brings to mind Cowper of Olney:

> This queen of cities . . .
> . . . is rigid in denouncing death
> On petty robbers, and indulges life
> And liberty, and oft times honour too,
> To peculators of the public gold.

Boris Johnson, a provenly mendacious mayor; Joanna Lumley, a gurning veteran dolly bird; Thomas Heatherwick, a cute salesman for himself with an abject record of design failures, astonishingly compared by the dotard shopkeeper Terence Conran to Leonardo da Vinci. These three 'national treasures' should take note of Moore's startling description of the bridge as 'digital jism', a useful addition to the architectural lexicon. They are of course not alone in their antinomian arrogance. One longs for a National Treasure Island, to which the professionally characterful and the strenuously

lovable might be transported, there to anecdote each other to tears and expire in a storm of names dropped from a great height. The only good thing that can be said for their odious vanity project is that it has attracted attention and stirred resistance in a way that countless other equally prodigal, equally worthless but quieter projects have not.

Many of these projects were nursed by Peter Rees, for almost thirty years the chief planner of the City of London. Rees's hobby, according to Moore, is cruising leather bars. That might be of no moment. But this frivolous man's sexuality colours his professional life. He believes that families with children ought not to live in inner cities and that those quarters should be places which stimulate a frenetic social life: he gives a new meaning to party planner. The City's grotesque pile-up of embarrassingly nicknamed trinkets – the Grater, the Gherkin, the Walkie-Talkie – is due to him. So too is the 'culture' of City bars in the City clouds where City yobs drink champagne as though it was beer.

Moore ends this engrossing and 'committed' book with a manifesto for a better and more humane London. If only. The conditions which 1945 threw up are not going to be repeated. Working for the common wealth is not going to happen. The dissolution of self-interest takes more than legislation. And Moore's all too reasonable proposals do not include an incitement to armed insurrection. (2016)

14

Magnetic North

A cruise around the Baltic

The names on the menus compensate for the dishes themselves: Salmon salty; Salad of cancer necks; Stuff of meats; Mystery field; Calf fist; Snails over cap; Foetus; Serpent in assorted; Cutting from cheese; Mush potato under scabs; Pig with weed at garden; Intestines filled; Pike perch at the natural plate; Udder from a fire; The most glue salt; To the broiler crispy; Cake of mother . . . Whatever they are, they will be covered in dill.

Herrings, schnapps

About ten years ago I proposed to the BBC that I make a series of films about the Baltic. One teenage executive, no doubt a graduate in media studies, got to hear about it and told my agent that he thought it was a really, really cool idea – because the Baltic was one of his favourite bars and the cucumber martinis were the best in London. The Baltic in question is in Blackfriars Road and is incidentally patronised by members of the Inland Revenue's dauntingly clever legal department as well as underage telly people.

It was of course an easy mistake to make. It's not really all that surprising, given the level not so much of ignorance but of incuriosity about the Baltic, the Baltic Sea, that is, and the countries that

surround it – a baffled incuriosity that you evidently don't share, otherwise you wouldn't be here. But you are in a minority. The reaction of more experienced, presumably more knowledgeable telly people who did not have the excuse of callow youth was just as depressing and less laughable. It included comments along the lines of: I've never seen a programme about it so there can't be anything worth doing. So, what is it with the Baltic – I mean, it's just a turn-off. This Riga – is that a potato dish? If it had anything going for it, I'd know about it – wouldn't I? What does this Bothnia Gulf look like? How do you pronounce it, Kara-ites? Sounds like some sort of skin condition? Hahaha. I've never heard of Trakai. Who cares? Our ignorance and incuriosity about these Northern countries has bred lame jokes and a sort of racism or, at least, intolerance. We know little of German culture, still less of Polish. Sweden is Abba and suicide, Denmark is bacon, Russia is gangsters and vodka. The reaction of friends to whom I attempted to transmit my enthusiasm was equally puzzled, though not so boorishly expressed.

The point, of course, is that the Baltic is to the north and Britain looks south. The south is where we all want to be, what we hanker after. It's both an actuality and an ideal, it's both mythical and available. It happens to share a name with a cardinal point of the compass. To the Vikings the north of Scotland was the south – hence the name Sutherland. But that was then.

To Britons today the south is exuberant vines, guiltless hedonism, excitable olives, the immemorial ruins of immemorial civilisations, primary-coloured emotions. It's a promised land. And a role supermodel, it is to be emulated. We vertically tan in order to look southern – oranges do come from the south, from Valencia and Seville. And of course an orange patina covers up blue skin when you're wearing next to nothing in snowbound Newcastle because you believe you're still in Ibiza. Or wherever.

British architects are forever going on about remaking run-down Pennine towns as Tuscan hill villages. Barnsley is really San Gimignano. Todmorden is uncannily akin to Pienza. Bacup and Monteriggioni – hard to tell one from the other. So far as they're concerned, Britain and Italy share a common culture and a common climate. Hence, every urban scheme includes piazzas for something called café society, which comprises hardy folk who are immune to hypothermia and capable of spending day after freezing day in a T-shirt sipping espressos while surveying a public space miraculously free of dog-on-a-string operatives – odd how architects never include them. But then there is something utopian about that trade.

The south causes Britain to suffer a collective delusion about itself. We deny our northernness. We deny it to the extent that we are unfamiliar with countries that share our climate. They might remind us of ourselves. They, too, are engaged in a perpetual battle denying their northernness. Muscovites, for instance, eat Georgian and Azeri dishes; that is to say, dishes from a thousand miles to its south. To be northern is to be for ever ill at ease with yourself and with your geographical lot. Who'd eat cabbage when they could eat aubergine? (I would actually.)

Exoticism doesn't have to depend on garlic and ouzo. On palms and parakeets. And if the north, like the south, is more than a point of the compass, where is it? Where does it start? Maybe the English north begins where the sense of humour changes. That's to say, on the other side of what might be called the Irony Curtain. To the south of that divide there exists a humour defined by self-deprecation, by understatement, by irony. Thus, Birmingham is very definitely not in the north. Brum talks against itself. There is none of the straightforward 'call a spade a spade' plain speaking that one finds in, say, Yorkshire.

Crewe is in the north, but Lincoln which is further north isn't. Puzzling. Better perhaps to ask what are its characteristic qualities?

It comes back to the same conundrum. One of its qualities is that very defiance of the compass. Lille, Tourcoing, Roubaix are south of southern England, but feel infinitely more northerly. They kind of own up to this. They are in the French department that is baldly named Nord. Brick back-to-backs, brass bands, fierce communality, pitheads, the ruined vestiges of heavy industry. You have to wonder if the north has drawn the short straw. It gets slag heaps while the south gets sybaritism.

But there is another side to this northernness. Take the former tapestry town of Arras, which gave its name to the kind of screen Polonius was hiding behind when he suffered his unfortunate accident. The first time I went there was in the mid-seventies, en route to Italy for the first time in my life. Nothing I subsequently saw in Sienna or Luca or Orvieto impressed me the way that Arras's great squares did. Nothing imprinted itself so indelibly in my memory. There was obviously something wrong with me. The man who preferred the Flemish to the Florentine. Who still prefers it. In 1500 Arras had a population of less than 10,000. Yet it built fantastically stately urban spaces and a splendid town hall. Of course, what one sees today, what I saw then, is mostly repro – the town was levelled in the First World War. But that doesn't mitigate the sheer operatic vigour of the place. And of the countless places that are like it. All of which are to its north. Go south from Arras just a hundred miles to Reims and you find yourself in a city that is wholly French: architecturally, gastronomically, bibulously. Go north from Arras for over a thousand miles to Tallinn and you find yourself in a city that is architecturally, gastronomically, bibulously kindred.

When excavations are made in Flanders for roads and rail construction, the bones of men slaughtered in the First World War constitute the first stratum that diggers encounter. Further down are multitudinous herring skeletons. The people of Arras ate 2 to 3 million herrings per annum. That's between 200 and 300 each. They

were doggedly faithful to this northern staple – they had no choice. That's what a staple means. But what a staple: this supposedly humble fish – infinitely preferable to lobster or sole – is an admirably versatile fish. No, that's not right. Rather, it is invested with posthumous versatility by human ingenuity. It can be cold-smoked as kippers, which are gutted, as bloaters or *bouffi*, which are not gutted. Bucklings are gutted and hot-smoked. Bismarck herrings originated in Stralsund, a city with a skyline to die for: sugar and vinegar pickle: I first tasted them in the Lyons Corner House in Coventry Street in 1956. Rollmops are a vinegary step too far, an assault: Bismarck herrings rolled round gherkins or other pickled vegetables. Bismarck himself was also keen on a breakfast of fried fresh herring with a sweet and sour onion sauce and a bumper of champagne.

Schmaltz herring is brined with salt and brown sugar with the guts intact; it gets its name from the now rare practice of preserving it in chicken or duck fat. Matjes herrings, the best of the lot, are lightly brined and eaten with raw sweet onion. Our forebears have also sweet-cured herring, sour-cured it, salted it, buried it, even fermented it; they've eaten it raw, poached in beer, soused in gin or vinegar. Smoked herring with waxy potatoes, hard herring roes, soft herring roe in batter . . .

Herring is still a staple. From Flanders to the furthest shores of the Baltic there exists a gastronomic homogeneity as distinctive as that of the Mediterranean. A homogeneity which is much more than gastronomic. A homogeneity fractured by neighbourly murderousness down the centuries, but which remains manifest in architecture, in art, in food and drink, in distillates and beer. It was once manifest in language.

As I say, the Baltic is off the map, out of the loop, ignored by western Europe (although, interestingly, not by North America, where the sheer number of Swedes, Finns and Latvians who settled

there means that there are Hanseatic League re-enactment societies flourishing to this day in Florida and South Carolina). It's not just a question of an unpropitious climate and a temporarily shrunken world that have militated against our achieving familiarity with our close neighbours. Two wars with Germany and the long years of the Soviet Tyranny have prompted a bias towards other directions, a bias which is only lately being corrected. But even before the First World War and the Russian Revolution, there was also a broad cultural shift which has hardly begun to be rebalanced.

The word renaissance was a coinage of the nineteenth century French historian Jules Michelet: a genius or a charlatan according to taste. A not altogether original coinage. The Italian *rinascita* was current in the sixteenth century but had fallen into disuse. Michelet revived it. The Renaissance was crudely and ludicrously represented as a point in the fourteenth century when Florentine artists and scientists had made a clean break with the past and had dragged learning out of the so-called Dark Ages. The Gothic ages – the Gothic was essentially northern. From northern France, from Saint-Denis, Laon, Beauvais, it had spread north – and east – like an architectural pandemic to Cologne, Ulm, Lübeck, Gdansk, Marienburg, Salisbury, Lincoln, Glasgow, Vilnius, Tallinn. Its dispersal south was hesitant, erratic. The cathedrals of Burgos and Milan and Bordeaux are intruders that prove the rule. It's worth noting that the application of the word *gotica* to buildings was an Italian coinage – an explicitly pejorative term which castigated the Gothic as barbaric. But what is so barbaric about the great cathedrals? The literality of the beliefs they propagated may be absurd to the modern mind, but as feats of engineering they are stupendous. *Gotica* recalled the Visigoths' sack of Rome in AD 410 – Italians were still smarting from it a thousand years later.

The Renaissance found plenty of followers in late-Victorian Britain, despite or maybe because of the Gothic revival, which

attempted to sanctify train stations and schools. The superiority of southern art, of Italian art, of classicism and its revivals became the unchallenged *pensée unique*. The Renaissance meant the Italian Renaissance. What happened in Flanders and Germany had to be qualified by the adjective northern: the Northern Renaissance – patently the junior partner, the one scurrying along in the wake of the real thing. No matter that this was historically nonsensical, the bias towards the south found ever more means of expression.

On the contemporary front, Impressionism and post-Impressionism were unstuffy, novel, daring – you can tick the boxes: they outraged the bourgeoisie, the artists were misunderstood and so on. The very idea of the avant-garde, with its manifestos and movements and obsessive pursuit of novelty, came from the south. English painters and writers felt that they had to head there. They gave great forelock to the Mediterranean, indeed to anywhere on the other side of the Channel. Southern subjects gave them a sort of legitimacy. Successive generations succumbed to the siren song of what Serge Gainsbourg correctly identified as Sea, Sex and Sun. Of course fellow travellers of the south, such as Roger Fry and the Bloomsberries, D. H. Lawrence, Lawrence Durrell, Somerset Maugham, Cyril Connolly, Norman Lewis, Norman Douglas and his protégée Elizabeth David didn't put it quite that way. Nonetheless . . .

There was drip-down (as they used not to say); rather akin to artists colonising quarters of London which are then opened up for the bourgeoisie. The taste of an aesthete caste was gradually popularised. What really mattered came from the Mediterranean. Braque. Matisse. Dalí. Above all Picasso. Household names. No matter what you thought of them. No matter whether or not you even knew their work.

And largely because of Elizabeth David this southern bias spread to cooking. It infected our diet. Her fantasies of the art of living in

Provence – you know, markets, garlic, the gently bubbling rata-touille, the venerable gnarled peasants and so on – fostered a mass delusion which was propagated by scores of her followers. We kidded ourselves. We still kid ourselves. We drink ever increasing volumes of wine of which we produce domestically less than 1 per cent. This is globalisation gone mad. For at the same time, Britain's beer consumption declines year after year, despite the growth in the number of microbreweries producing a remarkable range and quality of ales that do not taste like the disinfectants which the industrial brewers foist on the public through chain ownership – a system that is even more iniquitous than that of tied houses, which it replaced.

Herring is one staple of the northern diet. Beer is the second. Distillates such as gin and its relations such as schnapps are the third. It is worth considering that all of these take over, so to speak, where viticulture becomes problematic. So where the climate is too rude for most varieties of grape, they are replaced by cereal crops which are climatically appropriate. Rye, barley, corn, wheat.

The beers brewed in northern France and Belgium give the lie to the idea that drink is simply an agent of oblivion – though medieval monks did apparently often drink as much as twelve pints a day. Beer from those parts is also delicious and varied. Saffron beer, liquorice beer, honey beer, apple beer, chestnut beer, beer that tastes like Virol – if anyone can remember that malt extract. Belgium produces almost a thousand different beers. Wales, a country the same size, can't begin to match that figure. But then the land of Dylan Thomas and Richard Burton is famously abstemious.

Distilled grain goes under many names: Mother's Ruin, Vera Lynn. In French Flanders it's called Houlle, after what was a single-industry village: 200 people, six distilleries. More commonly it's *genièvre*, the French for juniper, the most common flavouring agent. That word is not far from the Flemish *genever* used in half of Belgium and in all of Holland.

Genever is abbreviated in English to gin. And was once known in London as Hollands. It had been introduced to London with the monarchy's restoration in 1660. Charles II had spent much of his exile in Holland. It wasn't just gin that Britain owed to the Low Countries. There was Dutch courage. There was William of Orange. There was also the quiet, harmonious, sash-windowed Netherlandish architectural style that Britain copied from such towns as Middelburg and Breda.

Gin was to that era what crack and smack are unhappily to our own. The difference was that it was a coveted source of revenue. It was said of the United Provinces' inhabitants that 'They hate their states – yet love their liquor, and pay excise.'

Fruits such as grapes ferment naturally. Cereals don't. So malting was arrived at as the means to stimulate fermentation in cereals, because intoxication is an elemental human need. A need that increases as the climate becomes hostile towards cultivation while at the same time demanding to be countered – by dreams, by walls of blankness. Thus, where the need is greatest there are the fewest means of satisfying it. Where the living isn't easy, higher levels of resourcefulness are required to create the chemical illusion of ease which is a vital compensation.

The north is as much an ideal as the south. It's the unpromised land of darkness, of the Gothic in all its forms, of thrilling grimness, exhilarating harshness, inky canals, fog, glistening cobbles, of buildings that respond to flatlands and vast skies with spires, fantastical rooflines, wild gables, pointed arches. The slag heaps were made by man to compensate for the lack of mountains. A lack of mountains which renders much of the terrain panzer-friendly.

Northern art down the centuries has eschewed bold brushmarks in favour of minute detail. It revels in the grotesque, in the discomfiting: it is born out of disgust at our bodies, despair of our mores. The northern spirit is one of baleful neurosis, grinning cynicism

and gleeful misanthropy, it is excited by bleak deformities. It is characterised by existential gloom. It relishes horrible laughter, fear, mockery and joyless perversity over the pursuit of happiness. It is not immune to beauty, but its idea of beauty is far from classical. It is jagged. The north, as I say, is seldom at ease with itself.

The great painters of the northern tradition – van der Weyden and van Eyck, Bosch and Bouts – never allow their subjects, which are sometimes religious, to occlude their worldliness. This tradition continues today. The pietism of their subject matter is undermined by high artifice. The aesthetic austerities and the humility of the south are nowhere to be seen. Sacred art in the north does not dissemble technique, flair, brio: the painter is omnipresent, never letting you forget that all this is achieved through human skill.

According to Bosch, heaven is a place that's very much to Dominique Strauss-Kahn's taste, a celestial hotel rendezvous. And so too is hell – the difference being that in hell pigs are dressed as nuns. You get the feeling that the artist is more interested in fantasising than in preaching. He's too enthusiastic about his invention to warn anyone off.

Northern religious architecture is also made to the glory of god. It creates spaces where mankind can abase itself before an imported spiritual idea. Yet this sacred architecture, like the painting contemporary with it, is just as concerned with a markedly earthbound showing-off. Of course sumptuous carving and abundant sculpture signify civic might, a town's pride and wealth – but they also boast about the craftsman's prowess.

There is a paradox here. The human maker's omnipresence is apparent in Gothic in a way that it is not in classical structures. But it is classical structures which are, notionally, founded in proportions derived from the human body. Classical architecture is based on a set of prescriptions as strict as those of, say, an alexandrine or iambic pentameter, limerick or clerihew. Gothic architecture is akin

to Shakespeare's art – sublime and vulgar, monstrous and tender. It steals from everywhere.

The Gothic is not underpinned by an intellectual formula, least of all by an abstraction that precedes the work, a generic rulebook. Man does not base the Gothic upon his measurable body but upon what occurs in his immeasurable mind and imagination. Gothic belongs to the school of wilful individuality: autocrats and tyrants have seldom espoused it for it doesn't represent order. Hitler loathed the Gothic. He quaintly thought it was oriental. Gothic belongs to the cult of originality. Gothic buildings may acknowledge their precursors, but they do not copy them. The Gothic was progressive, always seeking to improve or at least to be different.

When two Dutch people meet, they form a cult; when a third joins, one of the first two leaves. There is a schism. A new cult. The consensual force of Catholicism is absent in Protestantism, which is private rather than collective. And which inevitably leads to self-secularisation. Food is not sacramental in northern places, in Protestant places. Feast and fast are not imprinted in northern mores.

Water and wine, the feeding of the 5,000 – the greatest ever feat of mass catering – come from the source of Abrahamic religions. That is, from the desert. So, too, do such practices as fish on Fridays and Ramadan and the proscriptions of pork and of mixing dairy and meat. They are not necessarily adhered to: pork is available in Israel under the names white meat and king rabbit. A Jewish restaurant that I frequented when I worked in Rome served prosciutto: I asked the owner why. He gaped at me as though I needed my head seeing to. Because I like it. A Muslim builder who was working for me gave up Ramadan's fast after one day. He was also anxious to know whether I was familiar with something called Eeze-lay . . . Ebbreed. When I looked blank, he wrote it down: I S L A Y. Islay. In the Inner Hebrides. Had I been there? Hebrides yes, Islay no. Why? It was where his favourite whisky came from.

These tiny gestures towards a repudiation of religious strictures are heartening. The more taboos are broken, the less primitive myth systems imprison their adherents. The desacralisation of food that we see in northern Europe is a symptom of tolerance, of universalism, of fanaticism's failure and reason's triumph. It's also a cause of those qualities. If we choose what to eat and drink on gastronomic grounds rather than for religious or cultural or nationalistic reasons, we are making a tentative step towards the demolition of communitarianism, that voluntary apartheid which locks people into their racial or religious tribe. Or football tribe. At the end of a meal in Hamburg I once ordered a Rostocker kümmel. The waiter glared furiously and belligerently asked me if I had heard of Rangers and Celtic. Of course. That, he said, is what Hamburg and Rostock are like. I assumed this was in jest, part of an act. It wasn't. The poor fellow really meant it. He turned on his heel and stomped off. It goes without saying that Rostocker kümmel and Hamburger kümmel are indistinguishable. Save for the all-important label on the bottle.

Southern Europeans hold their liquor and shun mass drunkenness. That, anyway, is the myth. The corresponding myth is that northern Europeans escape from themselves – by drinking for oblivion and then through suicide – if they haven't succumbed to cirrhosis first. Neither proposition is accurate. But we believe the latter because we have so little experience of the north.

It was not always like that. Before 1914 the largest non-English grouping in England was Irish, the second-largest was German. Stepney was nicknamed Little Germany. There were sizeable German populations in Sydenham, Manchester and Bradford: from the last of those came the painter Richard Eurich and the satirist Michael Wharton, whose pen name was Peter Simple. The descendants of these immigrants are invisible today because many – most notably the royal family and obviously Wharton – changed their

name during the First World War. Others were cruelly deported to Germany although they no longer had family or contacts there.

Equally, for a century or more up to 1914, German was the foreign language most widely spoken by the British. No foreign country fascinated the High Victorians in the way that Germany did. Hock, piesporter, riesling, mosel were widely drunk in Britain. We sang German hymns – in translation of course. The Rhine and the Black Forest were popular destinations for that fragment of the population which could afford foreign travel. So were spas such as Baden-Baden, Bad Homburg, Bad Ems and Bad Nauheim. George Eliot, Disraeli, Thackeray, Meredith, Henry James and, best of all, Ford Madox Ford – born Ford Hermann Hueffer – all set parts of novels in spas. Goethe and Heine were promoted by Thomas Carlyle. Kleist and Schiller and the Brothers Grimm were widely read. German scholarship was revered – and envied. Music invariably meant German music. Mendelssohn was Victoria's favourite composer. To a degree, serious music still does mean Germany; but that and the Christmas tree, a Victorian import from Germany, are just about all that remains of what was – though it was not so called – a special relationship. Which was reciprocal.

Shakespeare was an honorary German: after all it was only some terrible accident of fate that had given him to Warwickshire rather than Wismar. Beethoven wanted to move to London. Years later Richard Wagner became preoccupied by the foundries and factories of the Industrial Revolution as, in a rather different way, did Karl Marx and Friedrich Engels. Houston Stewart Chamberlain was born in Portsmouth to a distinguished naval family and educated at Cheltenham College. He married Wagner's stepdaughter. His eulogy to Aryan Supremacy, *The Foundations of the Nineteenth Century*, was praised by the party newspaper *Völkischer Beobachter* as 'the gospel of the Nazi movement'. Hitler attended his funeral. On a happier note, in 1904 Hermann Muthesius, architect and cultural attaché at the

German Embassy in London, published *Das Englische Haus*, a survey of the Arts and Crafts movement which changed the course not just of German but of European domestic architecture. That questionable invention, the garden city, consequently spread from Letchworth like a merry English rash. Indeed, Muthesius himself designed the first German garden city, Hellerau near Dresden. He was assisted by Martin Wagner, no relation, who went on to become Berlin's city architect. There, then, is the reason why in that city one comes upon slightly baffling developments that are obviously approximations of those in suburban London a century ago. Martin Wagner was dismissed in 1933. For in January that year had begun the reign of Apollyon.

That, incidentally, is how I managed, after five years of trying, to get my Baltic shows off the ground. I said the magic word, the only word that, depressingly, every telly executive wants to hear: Nazis.

Cabbage, beer

Hamburg's architecture is in the north's own idiom – Gothic. Or neo-Gothic: the Nikolaikirche was an early work of George Gilbert Scott, the amazingly industrious architect of St Pancras, which is an amalgam of northern European models, the space between whose structural columns was measured not in imperial, not in metric, but in beer barrels: this is where Burton upon Trent, the brewery of the Empire, delivered itself to London. Hamburg is a city that shares Scott's northern virtue of industriousness – its only god is the god it shares with the beerage, the northern god Mammon, who is indifferent about how money is made. This city is bereft of ideals. Maybe what W. B. Yeats wrote about individuals can be applied collectively: 'the best lack all conviction, while the worst are full of passionate intensity'.

Hamburg is realistic. It has no illusions about mankind's appetites, no taste for correcting them. Pimps and tarts are Hamburg's

holy people, the saints of the north. The northern mentality acknowledges that life is bleak and coarse, that humans are flawed. It revels in gallows humour. It accepts that others' unhappiness is a source of joy, that northern gloom is glorious, that darkness is inescapable, that the grotesque is beautiful in a way that prettiness never can be – but it's still grotesque. Most of all, Hamburg physically represents the northern longing for escape. Docks – and thus the notion of somewhere else – stretch into the very centre of the city. Downstream the Elbe forms the horizon. And over that horizon is the promise of a world far from removed from the north.

More than half a millennium has elapsed since the Hanseatic League dissipated. Yet Hanse cities have continued to define themselves as belonging to that confederation of the distant past and to the Baltic rather than to Germany – Germany was Bismarck's comparatively recent creation which has defined itself by means other than trade. Hanse cities have seldom lost sight of their gastronomic heritage and their architectural past.

Expressionism is a variety of modernism – the variety of modernism which didn't prevail against the white, cubistic, rectilinear idiom of the international style. The fact that expressionism was peculiar to the north indicates its indebtedness to a specific regionalism. Far from breaking with the past as the international style attempted to, it is an embrace of the past, a reworking of local practice. This is the only way in which Hansestadt Hamburg is parochial. It is Germany's most cosmopolitan city. No doubt because as one of the world's largest ports it is open to everything and everyone.

The Hanse traded, they pursued wealth. A pursuit that ceases to be mere greed if it's divinely sanctioned, if a proportion of that wealth can be spent appeasing god by building churches to his glory. Then god will in turn offer divine protection to sailors, put wind in merchantmen's sails, provide abundant harvests on land and

at sea, and ease the way to heaven. The Scottish sceptic David Hume noted of gamesters and of sailors: 'Of all mankind they are the least capable of serious reflection. Though they abound most in frivolous and superstitious apprehensions.'

And because religious observance is the insurance policy of the gamester – that is, the chancer, the mercantile wide boy – such entrepreneurs clothed their meeting places in sacred garb, just to be on the safe side. Guildhalls and cloth halls imitated churches. Wealthy boroughs built town halls that are like giants' shrines. Out-size versions of the rich's tombs and chantries that constellate cathedrals. Merchants are commemorated by statues. Mere builders, however, are commemorated by gargoyles – it's a hoddy's fate to become a waterspout.

Not being subject to dogma, secular buildings weren't obliged to deprive themselves of frenetic ornament when iconoclasm became the rage in churches. As is so often the case, clerical zealots were out of step with their congregations – who yearned, as ever, for ornament as the physical manifestation of the supernatural. Just as they yearned for theatrical ritual. So the taste for ornament came to be satisfied in secular settings – which is not to say that the ornaments were ornaments for their own sake, that they were meaningless. In Lübeck and other Hanseatic port towns one finds outsize maquettes of vessels slung from beams. The Schiffergesellschaft house is a fine example. It is the hall that formerly belonged to the society of *schiffers* – skippers. They're evidently emblems of a profession. They're also good-luck charms which are more use at protecting man from hostile elements than equally exquisite representations of saints. They fulfil the same superstitious need, but they were also teaching aides, used to instruct tyro sailors. On top of that they are decorative.

Today the Schiffergesellschaft house is a restaurant whose speciality is *labskaus*. Its version comprises beef and potato hash. It is a

means of making a little meat go a long way. To style it a dish is to undersell it. It's history on a plate. More often than not the meat would be corned beef. Not the sweating delicacy in a tin that caused the 1964 Aberdeen typhoid outbreak but corned beef meaning, simply, salt beef. A corn is a granule of salt. *Labskaus* is served with fried egg, salted cucumbers and salted herrings.

Germany without potatoes is as unimaginable as a repetitively offending suicide bomber. *Labskaus*, however, predates the introduction of the potato to Europe from South America in the 1500s. Till then the meat had been mixed with root vegetables. Not with swede – which is actually Czech – but with rutabaga or turnip. Or with cereal, often in the form of crushed sea biscuit, hard tack. That was the version that was taken to Liverpool by Baltic sailors visiting that port, or by Liverpudlian sailors returning home. There have of course been other exchanges between Liverpool and northern Germany. Liverpool transformed *labskaus* into something closer to Lancashire hotpot. But the name hardly changed. It became naturalised as lobscouse. It was so widely eaten that the inhabitants of that independent city-state acquired its name. Whether they adopted it willingly or were given it mockingly, as a jibe, is moot. But 'scouse' stuck. So did *kiekefretter* – what Flemish speakers in Brussels call that city's francophone inhabitants. So did 'frogs' – though whether that derives from the practice of consuming frogs' legs is unproven. An instance of a people being called after what it supposedly eats is a vernacular form of the literary device called metonymy. The nickname Scouse is, ultimately, due to trade.

Wood and fur, salt and grain, cheese and pitch, wool and amber, tar and wine, meat and cheese, herring and schnapps were of course firstly commodities which, by fulfilling needs and sating appetites, were means of creating the north's wealth. Wealth is as here-today-gone-tomorrow as any politician, any herring, any side of beef. Commodities themselves may not endure. But their transport is also

the cause of cultural, linguistic, gastronomic, artistic and architectural migrations. It is through these secondary or tangential migrations that trade's legacy comes down to us. The traditional cheese of Bordeaux, for instance, was till very recently old Gouda. It didn't need to be. It was habit, custom, rather than lack of local cheeses.

Such exchanges are not necessarily balanced or fair. One partner will be dominant even in an association of supposed equals. For approximately 300 years – from about 1250 till 1550 – Lübeck was the capital of northern Europe. De facto capital, that is. It was officially just one of many city-states. But its mercantile power was without peer. That power is graphically demonstrated in the city itself. The early years of its pre-eminence coincided with the arrival of the Gothic from northern France. The template was amended as buildings took shape. This was the idiom arrived at in the diocesan cathedral – which is vast and magnificent, but on the periphery of the city.

But the contemporary city church, the Marienkirche, is vaster still. And more magnificent. And it is central. And attached to the town hall. This was just one of half a dozen churches built by wealthy merchants. They might be sacred structures but their intention was temporal; they showed where the power resided in Lübeck. It did not reside with the bishop and the cathedral chapter.

Merchants also built dwellings for themselves and their employees, and docks, and almshouses, warehouses, prisons, fortresses. Brick, and stepped gables – crowstep gables – are everywhere. Brick because there was little building stone that would withstand the weather. And decorative gables because . . . well, because one day a mason thought of it, others liked the result and it caught on, it crossed the seas. A shaped gable has no structural purpose. Its purpose is to appeal to the eye, to make a grand silhouette against the northern sky, to allow both patron and craftsman to show off. It is, then, purely ornamental. Occasionally used on buildings such as warehouses and forts,

frequently used on houses – which were also workplaces – it is associated with brick architecture but not peculiar to it: think of the similar gables in granite or harl in the east of Scotland.

Brick is not among those building materials that dictate form, the way that impacted mud does in west Africa and New Mexico, or cob does in the west of England. Brick is pliable, versatile. It does not constrain the designers who use it. Their decisions are aesthetically based. So the predominant characteristics of northern architecture are deliberately willed. Precise, lugubrious, stern, morbidly fantastical, exhilaratingly gloomy, pompous, worldly, industrious. These qualities are not the products of chance. They indicate how the north projected and glorified itself, how it saw itself, has continuously seen itself, still sees itself. It may be collective delusion – but after 800 years delusion becomes self-fulfilling. Cities, as much as people, become accustomed to the roles they have adopted. Pretence becomes actuality, not least because the buildings around us infect our very being . . . they may be inanimate, but they work on us, they are mute teachers. And the densest concentrations of buildings – cities – are the barometers of a civilisation.

Lübeck's mercantile power was translated into legal power – the Hanse cities adopted Lübeck Law – and into aesthetic power. Lübeck's language, Plattdeutsch, the German of the coastal plains, became the lingua franca of the Hanse cities. The Hanse lasted 300 years – as long as the British Empire, longer than the French and Belgian empires. Longer than the Soviet empire. Much longer than the twelve years of the Thousand Year Reich. Those two tyrannies both occupied former Hanse territories and built prolifically. Yet their architectural legacies do not begin to compare with that of the Hanse. In either beauty – which goes without saying – or in sheer quantity.

The Hanse was wealthy and long-lived. Its buildings are multitudinous. They are instantly recognisable; deliberately recognisable.

The Hanse used buildings as logos, trademarks, brands. Nonetheless, there are differences within the sameness. And sameness within the differences. Yet despite or, as likely, because of this imposed uniformity, there existed alongside the mercantile cosmopolitanism a fervent nationalism. These countries were as much divided as they were united: divided by languages, religions, myth systems, the vestiges of imposed political regimes, size of population.

The fluidity and movements of the population can be illustrated by two contemporaries. Alfred Rosenberg was born to a Latvian father and an Estonian mother in 1893 at Reval, as the Germans called Tallinn, and educated in Riga and Moscow. He would become one of Nazism's major ideologues and would be hanged at Nuremberg. Sergei Eisenstein was born at Riga in 1898 to a German Lutheran father of Jewish ancestry and a Russian Orthodox mother and was educated there and in St Petersburg. He would become the most acclaimed of Soviet film directors; the most criticised, too. Much of his work was not exhibited till five years after Stalin's death. You might say that these contemporaries manifested a murderous neighbourliness. They almost certainly ate the same dishes, even if they went by different names.

The Baltic states themselves – squashed and pushed and pulled in turn by Sweden, Russia, Germany, victims over centuries to invaders, Crusaders – were battlefields of beliefs and chose not to stick together, but instead turned in different directions for inspiration, patronage, protection and succour: so while Estonia looked north to Finland, Latvia turned east to Russia, Lithuania south to Poland.

In Wismar, for instance, there is blatant evidence of Sweden's occupation. Lübeck – once, incidentally, the marzipan capital of the world – had an empire in all but name. Its architecture became formulaic – but that's no bad thing when the buildings are enchanting. Hanse cities 700 or more miles apart resemble each other far more than they resemble the non-Hanse cities in their immediate hinter-

land. They dissociate themselves architecturally from their surroundings, from localism.

Because the Hanse's mercantile bourgeoisie was not in thrall to the aristocracy, their cities do not take their cue from the castles and country redoubts of nearby grandees. And it was not till the 1800s that new suburbs of villas in parks – a pan-German idiom – were added to them. Greater Germany, not yet a unity, could be said to include Danzig, Riga, Tallinn.

These cities possess an identity that is collective and corporatist. They effected globalisation when the globe was not yet a globe. They wear an imperial uniform. However, the Hanse has not been retrospectively considered an empire any more than its modern successor the EU – formerly the European Economic Community – is considered an empire by anyone other than enthusiastic nationalists, of which every member state has a clamorous faction.

It is not a paradox of nationalism that such factions have close links, international links, to each other – because nationalism is an internationally professed ideology and it requires succour from all the devotees who speak mutually incomprehensible languages yet spew the same dictum, the babel delivers but a single message.

Despite having created a homogeneous culture, the Hanse is overlooked as an empire because it was rooted in trade rather than in the desire to impose some toxic religion or noxious ideology on people who didn't want it. It was not in the business of capturing hearts and coercing minds. The parts of the body that preoccupied it were the pocket and the purse. Its only significant belief was in the creation of wealth and the communal benefits that derived from wealth. There were no murderous emperors, no tinpot caliphs, no lethal autocrats, no self-aggrandising prefects setting the world to rights.

It was a bourgeois, collectively organised, proto-liberal confederacy which in the pursuit of its commercial self-interest resisted both

the Church and an often jealous aristocracy – the dynastic, blood-determined hierarchy of electors, grand dukes, margraves, landgraves – whose power was tribal. Its aims were otherwise political only in so far as political concord was a means of maintaining trade routes and securing mutual mercantile advantages between collaborating city-states and towns. It was itself cannily pacific. It preferred diplomacy and economic sanctions to belligerence. It took to arms with reluctance, and then only in self-defence. War not only interrupts trade, it is expensive. It wastes revenues that might be better spent in the exercise of civic consolidation, in the construction of better cities, in the pursuit of comfort. Still, in what would become the dubious tradition of neutral states, the Hanse was happy to ship weapons – other people's wars were profitable.

Hanse cities suffered Nazism as a form of internal colonisation. At least that's the myth they've created. And it's not without foundation. The majority subsequently found themselves under the yoke of the Soviet empire for almost half a century. Yet another era, then, to be eradicated by resort to a prouder distant past. These places reach back to the Hanse because that confederation was the best thing that ever happened to them. It was also what made them. Hitler loathed the Hanse cities in general because they were born of pragmatic materialism and internationalism and were thus deemed un-German. He especially loathed Lübeck because it had forbidden him to canvass there in the 1933 election campaign. The Hanse cities in the GDR were further prohibited from proclaiming their ancient identity under communism, which sought to expunge regional distinctions – and of course failed.

Thankfully, it had no appetite for demolition. The most exquisite of the Hanse cities is Stralsund. It has a heartbreakingly beautiful skyline marred only by a boorish new aquarium. Is this the Venice of the North? Maybe. But is there any city which is not the

Venice of the North? T. Dan Smith wanted to make Newcastle upon Tyne the Venice of the North. Other Venices of the North are Bruges, Aalborg, Amsterdam, Birmingham, Manchester and, I kid you not, the Maryhill area of Glasgow. The question is: why should Venice be the measure, the standard? Because it's in the south. Which rules our brain because of the PR that travellers have done on its behalf. The number of books devoted to Venice in the past sixty years is 700. The number of books devoted to the Hanse cities is seventy. Across the bridge from this Venice of the North is Rügen, Germany's largest island.

The cliffs made famous by Caspar David Friedrich's paintings are accessible only through the densest, scariest forest I've ever entered – a linear, sylvan nightmare, a place of primal fright, of perpetually intersecting beech naves. It is a key to the German Gothic and to German fairy tale. And at the end of it, at the end of the tunnel – there is Light. This is a notion that the Nazis were obsessed by, hence its place in their mythology.

Rügen has always been a place of recreation. There are faded resorts of the 1830s. During the Weimar years it was a gay play-ground (*vide* Isherwood). It is also the site of the Nazis' colossal holiday complex of Prora, built by KDF (Strength Through Joy) to house 20,000 vacationing *Völker*, but never used other than as a refuge from bombed cities and subsequently as barracks. It is now being refurbished to fulfil its original purpose. It was the first industrialised holiday complex to be built in Europe and set the dismal tone for the despoliation of countless coasts.

One summer afternoon in the 1990s I drove here to see Friedrich's cliffs. He was born not far away, in Hansestadt Greifswald. It's futile, I know, to visit such sites. The point of art is just that. Art. Hardy's Dorset is in his prose. Housman's Shropshire in his verse, Cotman's Greta Bridge is mere – mere! – marks on paper. Friedrich's painting is the mediation of place through mind – a mind touched by mysticism

and intimations of sublimity. The place itself could never match its representation.

Nonetheless, I ticked the crass philistine box – I am grateful that I did so. I left my car and walked through the forest towards the cliffs. That afternoon turned out to be – well, epiphany is perhaps overdoing it – but it was a kind of revelation. The forest was the darkest I have ever been in. The sky was, frequently, occluded. The forest floor was barren save for twigs and beech nuts. Whatever lives in the forest lives by eternal night. The boughs of immensely tall beeches stretching to the sun link to form vaults which can only be called Gothic, cathedral-like. This, evidently, is a cliché.

But so, too, is a road traffic accident caused by overtaking on a blind bend. Being a cliché doesn't make it any less terrible. I was, I guess, susceptible to a reversion to the childhood memory of hiding beneath bedclothes to escape from the hideous crones, malevolent toads, trolls, gnomes and evil woodcutters who inhabit forests in fairy tales, the most affecting expressions of Gothic literature. Nothing good ever comes of broaching forest cabins. My only solace was that the return journey – should I ever get to make it – would be shorter. Return journeys always are. The Brothers Grimm rendered all children who read their stories German, they gave them German nightmares, German fears.

But the fear that overtook me was primal. It went beyond that German conditioning even though I was in Germany. Brain and body were united in foreboding. It was sufficient to persuade me that another memory might exist, an atavistic memory. I was the distant legatee of some woad-smeared forebear's fear of the forest. In places like that forest, reason does not sleep. It is concussed by a heavy blow. So I would not have been surprised to see berserker warriors in bloody skins and furs and armour made from bark, mythical stags with shining bez tines, knots in trees mutating into witches' faces, gangster wolves, enticing wood sprites whose kiss is fatal.

The place contained an inventory of horrible possibilities. And it retrospectively prompted the questions: Why on earth were forests worshipped? Why were certain groups of trees deemed to be sacred groves? (Retrospectively, because whatever analytical faculties I possess took industrial inaction.)

Then, after a mental eternity which was maybe less than thirty minutes of the lie called clock time, I arrived at the cliffs. I have never in my life been more glad to see a tourist group of men sporting kindergarten leisurewear and beards without moustaches. I had arrived – at a site of blinding light. Light on the Baltic. Light in the sky. Light reflected by the sheerly white cliffs. Here – literally – was enlightenment . . . And the Enlightenment. The Enlightenment was internationalist, cosmopolitan, it dreamed of a universal language, a world without boundaries and so on. It looked outwards.

Yet . . . What C. D. Friedrich's painting does not reveal is the forest behind him, behind the figure staring transfixedly at the sea and at a limitless world. For Friedrich, as for the Brothers Grimm, forests were places of real and metaphorical darkness which mankind had ceased to dwell in and worship in. Which mankind had escaped from. But which still exerted a morbid attraction. An attraction that Friedrich was far from immune to. Friedrich's Baltic Sea, on the other hand, is not infected by any such ambiguity. It is not a hostile element. It is a turquoise balm.

Friedrich was born in 1774. He belonged to the first German generation to enjoy sea bathing. It was not initially a pleasure, but a health cure – an alternative to taking sulphurous or iodised waters at a wells. Germany abounds in place names prefixed by Bad – that is, wells or spa. Here again was Germany looking outwards. Sea bathing was an English craze whose earliest resort, Weymouth, owed its success to its patronisation by the royal family . . . the German royal family. German resorts, Baltic resorts, developed differently from English resorts, and for that matter from those of

southern Europe and the Black Sea. They are neither sites of sybaritic flash nor of gorblimey, kiss-me-quick tat. They are not the haunts of sexual predators and their willing prey. They do not welcome reeking hot-dog operatives. They are, rather, sedate, staid. Perhaps one should say they have not developed. They remain largely true to their origins. That's to say that they are uncomfortable with the pleasure principle.

Unless, that is, pleasure is to be found in submission to cures, in bodily punishment which differs to that ministered on the Reeperbahn in Hamburg. They remain devoted to health. The Baltic coast was the cradle of modern naturism in the early twentieth century. A cult of studied asexuality – there is nothing erotic about an entirely naked body. Naturism is broadly political. It was one of a host of reactions to the supposedly deleterious effects of cities on the mind and the body.

Juvenal said that we should pray for a healthy mind in a healthy body. He may not have meant it. It's a mistake to take poets literally. The idea that a healthy mind and a healthy body are mutually dependent is laughable. The minds of Beethoven, Flaubert, Blixen, Proust, Kafka, Borges, Pope, Bousquet and an army of consumptive syphilitics suggest otherwise. So, too, do the bodies of professional athletes and muscle builders. Heinrich Pudor's 'The Cult of the Nude' was the first of many manifestos to make utopian claims for naturism, which might enable its adherents to overcome the awkwardness they felt about their body. This was tied to the cult of youth, to the pursuit of health through gymnastics, dance, vegetarianism and teetotalism. Naturism was inspired by ancient Greece, particularly by Sparta, where boys were required to relinquish all individualism to the homoerotic militarism of a warrior cult.

Spartans may not actually have been so spartan as the many Germans who took off their clothes to play tug of war, hurl medicine balls and pose fetchingly in modesty pouches of the finest

chamois. The southern Grecian climate is more hospitable to body culture than the Baltic's. Northern nudity is pleasurable only through suffering. It is masochistic. It is punishing. And it is self-deluding – it challenges the body to convince itself that it is exhibiting itself in warm southern climes. Brain – if that's the word – is obliged to overcome shivering brawn.

The triumph of the will persuades its owner that he or she is not suffering gooseflesh. Antoine de Saint-Exupéry – evidently not a German, but a devotee of Nietzsche who evidently was – wrote: 'Adversity is more vital to man's nature than any artificially induced felicity.' But to the northern mentality adversity is artificially induced felicity – they are indistinguishable. That's the way the north likes it. That is northern adversity. The north relishes challenge. It takes pleasure in pain; that includes gastronomic pain. It shuns the sweet life and embraces the sour life.

Why else would it so relish:

Surstrommen – fermented herrings, generally eaten outdoors on account of the smell and banned by several airlines.

Lutefisk – salted cod or stockfish, air-dried cod, rehydrated in water and lye (i.e. caustic soda, more familiar as an oven cleaner and clearer of blocked pipes). It's borderline toxic.

Hakarl – fermented shark, whose flavour is that of ammonia.

Seal's flippers preserved in whey.

Igunaq – fermented walrus.

Kiviak – auks fermented in a seal's body.

After which *rakfish* – fermented trout, which merely carries the risk of botulism and should be avoided by the pregnant – is evidently one for softies.

These methods of preservation were once necessary, vital for survival. Today they are not. They are cultural mementoes rather than utile processes. Mementoes infected by putridity, obviously –

and by a kind of folksy gastro-machismo, by the gustatory side of identity politics, by a primitive yearning for exclusivity. The breath of bearded blond gods from the north is to be avoided.

Crispbread, aquavit

Gdansk. You can count on anywhere in the northern Baltic having at least two names. Two languages. Two cultures. Two former colonisers – at least. Gdansk, formerly Danzig, is today's Polish maritime capital. The city was comprehensively trashed by the Red Army at the end of the Second World War, but since then its fine Hanse buildings have been restored. St Mary's Basilica claims to be the largest brick church in the world (105.5 m long, it can accommodate 25,000 people – and often does. Catholicism survives even though it no longer has the *raison d'être* of being a thorn in communism's side). Gdansk is, currently, in Poland.

The Polish corridor joined Danzig to Germany. Danzig – you hear German spoken as much as you hear Polish. Throughout its history it has been occupied and reoccupied. Subjugated and liberated. Fought over. Ethnically cleansed and recleansed – to use that horrible euphemism. What we are really talking of is murder.

A city of coveted orchards and allotment gardens which did not belong to hobbyists. They were near necessities, sought after throughout long decades of shortages. Such plots are de facto monuments to oppression, and hunger caused by oppression, in a part of Europe which abounds in official, that's to say bogus, monuments – it's the unofficial monuments from which we should learn, but seldom do. They were one means by which people might usefully escape the massive weight of regulatory inefficiency that tyrannical bureaucracy inevitably imposes.

Gdansk might be said to be the founding city of modern Poland. The shipyard strikes initially occasioned by the sacking of the crane operator and former welder Anna Walentynowicz were led by Lech

Walesa and led in turn to the founding of Solidarity. Which in further turn led to suppression, martial law and state-sanctioned murder. This is where the Soviet empire first started to crumble. Where communism, toothless and weakened by itself, began to capitulate in a way that it hadn't during the Hungarian Uprising or the Prague Spring.

This might be considered appropriate, for Gdansk is a Hanse city which was born out of something other than an ism, which grew rich out of enterprise, out of trade. The Hanseatic League, god's first try at the EU, that monopoly of trading guilds, made sure the Baltic (and beyond, to the North Sea) and its resulting city-states were very much on the map between the sixteenth and seventeenth centuries. It is this history that forged the links on the Baltic countries' shores, of the dietary staples of herrings and schnapps, among other things, of dependence upon this shared sea, and their fear of it. There is a remarkable architectural homogeneity manifest from Bruges and Ghent in Flanders to Riga and Tallinn in the Gulf of Finland, more than a thousand miles distant. The Hanse cities used architectural patterning as a sort of trademark, a 'brand': gauged brickwork, crow-steps, Gothic idioms.

Of course trade may also be an ideology – but it's an ideology with a small 'i' and it's practical, flexible, undogmatic. The Hanse were civilian. Their virtues were civic. They made cities not war. They did not raise armies. Nor did they put to sea in men-of-war. To have done so would have been to risk conflict with the Church, and with the principalities and the fiefdoms of margraves and landgraves who jealously sought to limit their political influence. Such a conflict would have inhibited trade.

Nonetheless, Hanse shipping required protection against pirates and privateers such as the Victuals Brotherhood who were based on the island of Gotland – which may or may not be the original home of the Goths. And Hanse cities, too, needed defences.

Security solutions were outsourced. The mercenary muscle with whom the Hanse entered into an enduring contract was the Order of Teutonic Knights, a sect of muscular Christian warriors formed in Palestine during the Crusades. They had a taste for tournaments and their buildings are tournament pavilions frozen for ever in brick.

They were supposedly celibate, supposedly chivalric, certainly militant, given to hunting and practised in faith-based belligerence initiatives. They were hungry for territory, which they received in return for their freelance campaigns. Missionary zeal is invariably a beard for colonisation, which in turn further incentivises trade ambits: crudely, it opens up markets. The Teutonic Knights and the Hanse became mutually dependent. The Order built castles.

Castles such as Marienburg – now Malbork – in the hinterland of Gdansk. Its sheer immensity had not previously been seen. It remains startling today, a red-brick Carcassonne – largely unknown in Britain because, unlike Carcassonne, it belongs to the north. These castles protected the Hanse's land-born interests. The quid pro quo was that the Order had access to the Hanse's vessels, thus to supplies, and to arms.

The Teutonic Knights considered conversion by force to be legitimate even if the non-believers in question – that is, non-Christians – posed neither the ideological nor the political threat that Islam did in the countries bordering the eastern Mediterranean. It was considered especially legitimate if the unfortunate non-believers occupied lands that were rich in minerals and natural products: trees, furry animals, fossilised resin such as amber, aurochs, tar, peat.

The Order's Crusade or land grab was directed against Lithuania, the last pagan country – sandwiched between the easternmost dioceses of the Roman church and the westernmost outposts of the Russian Orthodox. It is entirely due to those churches' black propaganda that we have been brainwashed into believing that paganism means incivility, coarseness, violence and so on.

It didn't — and it still does not, despite its having being crudely co-opted by various sorts of heavy metal band: Stag Metal, Moose Metal, Wolf Metal, Forest Metal, Elk Metal, Oak Metal, Sacred Metal, Troll Metal, Elf Metal, Metal Metal . . . Pagan was a blanket term, born of fanatical zeal and bigoted incuriosity, which dismissed countless different sorts of belief. It is a synonym of 'heathen' and comes ultimately from the same root as 'peasant'. It signified nothing more than belonging to the country. It came to mean that non-believers lived in the country, that is in the forests, rather than in towns.

During the Middle Ages Lithuania was the most organised, most powerful state in eastern Europe. It was officially pagan, polytheistic. It was however religiously tolerant and did not persecute Christians or Jews. Its people mostly venerated nature; they were animists — that's to say, they regarded everything as possessing a sort of spirit or soul . . . something along those lines anyway. They were polytheistic. Their pantheon included a god of the sun, a god of the moon, a god of lightning, a god of rain, a god of drizzle, a god of light winds moving to the north by afternoon, a god of sunny spells with squally showers, a god of possible precipitation by the end of the eleventh day after the first berry ripens.

People ritually dressed as storks, boars, bears, bulls, stags, goats and horses. Flowers and fruit, crops and trees were worshipped — most especially trees. Humans were reincarnated as trees. Trees formed sacred groves. The forest, as dark a place to medieval Christians as it was to the thinkers of the Enlightenment, was to these pantheists the site of their civilisation. Their religion or system of superstition was born out of the places where they lived. It was indigenous and as appropriate as religion ever could be, since it revered the materials that their life depended on — wood, water, horses, pigs, berries, fungus, et cetera — and thanked the imaginary gods for them. It still exists to an extent: occasional animal sacrifices are made, and these have been deemed legal because they form part of a religious ritual.

Which must be cheering for the animal concerned: his throat is being cut to satisfy gross superstition rather than sadistic bloodlust.

The ubiquitous forests are full of beasts, they are dark, enclosing, monotonous, frightening. The bark of birches compensates for the lack of venomous snakes. Grass snakes were worshipped for want of other species. Deserts are also monotonous and frightening: but in the desert you are evidently surrounded by a contrary sort of nature. Sand, the overwhelming sky, fantastically shaped rocks. They incite a different kind of fantasy or superstition or hallucination. The fantasy of monotheism. At least that's what it seems like – for the three Abrahamic monotheistic cults, Christianity, Judaism and Islam, emerged from the same Middle Eastern deserts and believe in the same god. The fun and games down the years has, preposterously, been about which particular prophet owns the exclusive right to the god franchise.

So these faiths might be considered singularly unsuitable in the cold dank north of birches, pines, mosquitoes, bogs and bog bodies. However, Christianity thrived. The Teutonic Order knocked the love of one god, one fictive delusion, into people who had previously had many gods, many fictive delusions. The Order's evangelical assault suggests that a religion is no more than a cult with an army attached to it. The indigenous religion was not extinguished by the imported one but driven underground, to be periodically exhumed by those with elephantine folk-memories. The imported religion promised that no matter how dour this life may be – and life in the north was dour – everything will be just dandy in the next life if you believe in and worship the one god. So it enjoyed an understandable appeal. The number of churches in Vilnius might be held to attest to that appeal. The city is as triumphantly baroque as Rome. The Counter-Reformation style of the Catholic Church was gross, vulgar, populist, energetic, thrilling – but it was hardly Lithuanian.

It is Italian by way of Poland, which had annexed Lithuania. Its

churches were mostly designed by Poles. As most architects have been since time immemorial, they were enthusiastic followers of fashion. They doggedly ransacked the Italian pattern book for ideas. It was then a double colonisation, a double invasion. But that is Lithuania's fate. It has been so frequently invaded and colonised and annexed that its buildings are the calling cards of its violators. Who of course did not see themselves as violators. Its churches may imitate Italy's, but they could never be taken for Italian – their surroundings, their conjunction with the street, their materials, the light that illumines them . . . All these are unmistakably northern. And so is the routinely vain attempt to appear southern, to seize at a link with the sun if only by association and not by the worshipful entreaty of polytheism.

Christ talked of his apostles being fishers of men. The profusion of decorative vessels, barges, boats of all sorts in Baltic churches no doubt refers to that trade. But boats in churches also reminds the Church's communion that their faith has been transported, that it has been brought from elsewhere – Rome. To which that communion is subject. More than half a millennium after it was Christianised, supposedly Christianised, Lithuania still clings both to vestiges of its pagan polytheism and to a preoccupation with its forests.

One reason for this is because forests are ur-Lithuanian: they represent an independent nation which is not under the yoke – of Rome or Poland or Sweden or Germany or Russia or multinational stag parties. Most of its history is almost unimaginable to the privileged British. We have to make a huge empathetic effort to understand what it is to inhabit a small, flat country that is constantly invaded because it possesses no natural defences, no defining boundaries, no impassable mountains, no unfordable rivers, no surrounding sea.

Another reason for this preoccupation with forests is that forests are larders. Full of partridge, boars, bears, beavers. The last is not

recommended. It's like spaniel dipped in cod liver oil. Watch out, too, for a variety of the fungus morel. It is deadly poisonous unless boiled for four hours in several changes of water. I didn't know this when I bought a kilo from a toothless hag on a forest roadside.

Lithuania's lakes, too, are larders. Freshwater fish are much prized in the Baltic states and indeed throughout eastern Europe. Perch, roach, tench, chubb and most especially pike and carp – they're caught for the table, not to be put in a keepnet, photographed and thrown back. The British divisions of game fish (salmon, trout, seatrout) and coarse fish (all the rest) is based in social class, snobbery. It has little to do with the culinary qualities of these fish.

Smoking is a craft practised in many ways and with many materials burned to lend flavour. The scent of woodsmoke is familiar and delightful. The Jewish, specifically Ashkenazi, culinary repertoire includes countless recipes for freshwater fish: sweet and sour, jellied, formed into dumplings, fried and eaten cold, fried and subsequently pickled, salted.

Prior to murdering their victims, the Nazis devised many minor humiliations for them. It is, for instance, specifically forbidden by Leviticus for a Jew to be tattooed. Again, Auschwitz possessed a grotesque appeal as the site for industrial extermination because it was a place which had hitherto been renowned and revered throughout the Jewish world – for the quality of the carp that had been farmed in ponds there since the 1600s when Jewish merchants first brought them from China.

Jewish cooking has all but disappeared from Lithuania: a way of life was extinguished with a race. What remains is a curious anomaly. The Karaites in Lithuania are believed to be of Crimean or eastern Turkish origin. Because they accept the literality of the Torah and do not acknowledge rabbinical interpretations of the Talmud, they were considered apostates. For this reason, and because of their Tartar bloodline, the SS's race and settlement office,

a pseudo scientific bureaucracy which held the power of life and death over millions of people, decreed that the Karaites were not to be considered Jewish. Thus they were spared. In the town of Trakai a small community still prospers. It worships at *kenesas* and runs a series of cafés which specialise in *kibinai* – which is what Cornish pasties ought to be but seldom are. The dish and word *kibinai* are evidently related to *kibbeh*, which are found throughout the eastern Mediterranean. This is not just cooking for tourists, this is cooking as cultural identity.

The Karaites' cafés stare out onto a medieval castle – lavishly over-restored and better seen from this distance. Admittedly, along-side the Teutonic Knights' Malbork it is little more than a starter castle. Nonetheless, it's a graphic illustration of Lithuania's former might. But only a few minutes away on the far side of the lake stands a neoclassical house of unmistakably Russian appearance – it, too, is a graphic illustration, of one of this country's long periods under the cosh of its giant, persistently colonising neighbour. Fewer than 20,000 Jews survived the Second World War in Lithuania. Probably a quarter of a million had been massacred; in the camps, by firing squads, by mobile gas chambers.

Forests can be made as beautiful or as ugly as humans want them to be. They lend themselves to hidden burials, mass graves. The victims were of many nationalities. Some were of families who had lived in Lithuania for generations, some had sought refuge there. Others had been transported from across Europe to what were to become the earliest killing fields in the war on unarmed civilians. The majority of the murderers, however, were not Germans but Lithuanians who considered themselves to be partisans and enthusiastically collaborated with the Nazis. To them the Nazis – who drove out the occupying Soviet army – were liberators.

Here, perhaps, is the defining tragedy of the Baltic states: the way that their people have been forced to make the most terrible

compromising choices between murderous regimes. The Soviet occupations, which totalled more than half a century, actually cost more lives than the Nazis. Soviet memorials are, then, merely victors' memorials. They smugly and mendaciously obliterate the USSR's crimes while quite properly drawing attention to those of the Third Reich. They are of course official memorials. Yesterday's official memorials.

The Hill of Crosses near Šiauliai in the north of Lithuania is, on the other hand, entirely unofficial, home-made, extemporised, a site of collective piety and melancholy remembrance, a national shrine. It is said to have been a site where pagans worshipped. It is certainly a place where crosses were erected as early as 1831 at the time of the revolt against Russian rule. While it uses explicitly Christian imagery, it is evidently a vestige of the more ancient faith, which survived, hidden underground during the long years of totalitarian suppressions. During those years, folk art was the faith's only expression. That art had a vital purpose as a form of solace: it was a covert way of being Lithuanian, of taking pride in the nation that would one day be restored to its people. The purpose of the Hill of Crosses quite overcomes the roughness with which it is put together. It is no doubt somewhat artless – like the dead flowers at the site of a fatal road accident. But it does show that the clichéd manifestations of faith and grief and pathos and sadness and – who knows? – gratitude are more important to a certain mindset than are any aesthetic considerations. The Hill of Crosses turns us all into outsider artists. It is the most striking site of impassioned and meaningful inarticulacy that exists. The untutored, naive work of outsider artists is nothing if not a cry for help, a desperate inchoate plea to an uncomprehending and cruel world.

Unlike, say Lourdes, which is a temple to gullibility and mass-produced kitsch, the Hill of Crosses has the capacity to move because it really is an unselfconscious national shrine born out of

suffering and made by the people who suffered. Inevitably the Soviets bulldozed the Hill of Crosses on several occasions. They burned and smelted the crosses and icons, and spread sewage on the site. Equally inevitably, like some stubborn plant, it reasserted itself. It was tit for tat.

In its long decline after Khrushchev's deposal in 1964, the Soviet Union – never dreaming that the game might one day be up – persisted in imposing its architectural will on its colonies. The former hydrotherapy centre at Druskininkai on the border of Lithuania and Byelorussia offered the 'rain mischiefs', the 'salty moments', the 'embrace of neptune', the 'healthing shower'. This was a mecca of re-educative rectal tampons, sulphated mud wallows, peat packs, ideologically improving freezing hoses, climatological cures such as air therapy – going for a walk – and solar therapy – sunbathing. There were over 10,000 such spas across the Soviet Union, treating – if that's the word – 60 million people each year. Hypertension, sterility, endocrine dysfunction, psoriasis, thyroid imbalances: there was nothing that these places couldn't cure.

It is of course just conceivable that they were merely placebos in concrete and stone, places which institutionalised the folk cures and nature remedies which a gullible public was attached to, not least as tokens of an old, superstitious irrationalism. An irrationalism expressed in buildings that are gaudily bombastic and recognisably futuristic. These exercises in the dogs-in-space style possess the same menacing frivolity as Stalin's distended fantasies of the forties and early fifties. They owed nothing to those years – but they partially derive from the very architecture that Stalin had annulled, the constructivism of the 1920s which also had attempted to achieve a rapport between the ornamental and the new.

At another spa, Mariánské Lázně, the former Marienbad, in the not yet former Czechoslovakia, during the last years of Soviet dominion, the medical director – a tiny man with a mad boffin

hairdo and mad boffin spectacles – told me with a worrying giggle that 'Patients getting rid of the negative effects of everyday life. We reprogramming them. Yes, we reprogramming people.'

Today, the negative effects of everyday life are excised by other means. Communist sexual puritanism – public sexual puritanism, anyway – has abated. Spa patients are now punters. Steroid-enhanced psychiatric nurses who could toss a caber are now Botox-enhanced artistes – who can also toss a caber. Hotels and clubs in improbably rural, improbably sylvan settings offer fauna and massage. Every country in the Baltic has its own distinctive form of traditional dancing. Poland has Pole dancing. Lapland has Lap dancing.

Of the Baltic states' capital cities, Tallinn is surely the most captivating, the smallest, the most northerly and the most easterly, thus the closest to Russia – yet of these cities it feels by some measure the furthest from Russia. Indeed, it's hard to believe that it is a former satellite. It has more successfully extinguished traces of Soviet occupation than Riga and Vilnius. This is not a risk-free position to adopt. When in the spring of 2007 it decided to shift – not destroy, merely move to a less conspicuous site – a Soviet monument to what are laughingly known as Soviet freedom fighters and to exhume eight bodies, Estonia was deemed by Moscow to have insulted the sacred feelings of the Russian people.

Needless to say, the protests against the dismantling of the monument were the work of *agents provocateurs* from the Putinjugend, the freelance paramilitaries happily known as the Nashi. Putin himself, who has a personal animus against Estonia due to his father's treatment there during the Second World War, reacted with predictably hypocritical rage. You can take the man out of the KGB . . . The Russian Federation threatened unspecified retaliation which came in the form of cyberattacks on businesses and institutions. This aggression was not taken particularly seriously by the

self-hating Western liberal media; that is, most of the Western media. Compare that same media's reaction when in 2006 neo-Nazis polled a whopping 6 per cent of the vote in the eastern German province of Mecklenburg-West Pomerania. It was as though the 117-year-old Adolf Hitler himself had returned from his Paraguayan *estancia* to reclaim power.

The point, of course, is that despite nearly half a century of Cold War, despite the enormity and extent of its crimes, despite the totalitarian nature of Putin's regime, there still exists in western Europe a risible tolerance of communism and neo-communism. Old commie and Nazi sympathiser carry entirely different connotations, the one a lovable class warrior, all Marx and cardies, the other an inadequate, embittered, foaming paranoiac. The same obloquy should be visited on both. They are both beyond the pale.

The ghosts of the recent past hang over the Baltic like a toxic cloud. The museum that opened in Tallinn in 2003 was pointedly called the Museum of Occupations. Plural: the short Nazi occupation and the long Soviet one. Russia acted with its usual indignant hypocrisy, claiming that the exhibition puts the USSR on a par with Nazi Germany – which was surely the intention. In much of the former eastern bloc, in the former satellite states, in the former Soviet Union itself, you are constantly forced to wonder – what is it, precisely, that is so former about them? The fearfully cautious mentality, the xenophobia and insularity, the longing for regulation and state dependency, the *ostalgia* – these are just some of the signs that, although structures may have changed, minds, conditioned over decades, remain set in concrete. The only consolation can be that someone usually got the aggregate wrong and thus the concrete crumbles.

None of this seems to be the case in Tallinn. Tallinn is thriving. It is also elegant. It owes much of that elegance to Estonia having been both independent and prosperous between the First and Second

World Wars. Latvia was independent but economically devastated. Lithuania was a Polish serf nation and economically devastated. Estonia linked itself by trade to Finland, to Scandinavia, to Britain. Architecturally it was alone among the Baltic states in adopting modernism. Rather, modernisms. The first sort of modernism it went in for signals that Estonia with a population of less than 1 per cent of the Soviet Union was daring to define itself as the antithesis of its vast neighbour, whose architecture increasingly suggested that communism was nothing but age-old Russian nationalism. This sort of modernism is northern European – it's of specifically Hanseatic origin. The Hanse cities' modernism links with their past. Like all former Hanse ports, Tallinn had a large ethnically and culturally German population – who called it Reval.

The second form of modernism Estonia embraced was the style that came to be called international modernism. Rectilinear, cubistic, white-walled. The bourgeoisie of the newly independent state after the First World War was massively enthused by it. Thousands of houses were built with state loans to encourage property ownership. Each house was designed by an architect: the antithesis of British speculative building of the same period. The resultant suburbs are as beguiling as those of Brussels. Modernism's attraction may not have been so much that it presaged the future, which it did, but that it carried no baggage. It was as far as could be from the architecture imposed by its former coloniser. It wasn't, save in the brains of such begetters as Le Corbusier, even European. But it didn't come from out of the blue.

Le Corbusier had studied the vernacular architecture of North Africa, just as Picasso studied the sculpture of sub-Saharan Africa. He created something new by reproducing something very old from a previously ignored yet fantastically copious culture. So, through a few influential and persuasive conduits, an architecture

deriving from Colomb-Béchar and Casablanca, Tunis and Taroudant, was replicated beside the Baltic. This is what is called looking south.

There can be no other small country – the entire population is hardly more than that of greater Glasgow – with such an appetite for architecture, especially domestic architecture, and with such an abundance of accomplished architects to satisfy that appetite. But there is seldom anything specifically Estonian about the work of architects like Emil Urbel – unless specifically Estonian means well made, highly crafted and wanting to be somewhere that it isn't yet. It might be said that this is the elemental purpose of architecture. To create somewhere else. To create a new common identity.

In the later nineteenth century, localisation, folk music, national traditions and national consciousness were an international craze all over Europe. In Estonia rocksport, banned by Peter the Great in 1714, was revived. And so was cake-dressing of the dead – the custom whereby the eldest child smears a dead parent's face with batter to ensure that the parent will not go hungry in the journey to the afterlife. Such practices have been self-consciously revived since independence. Corny? Maybe. But necessary, since they were for so long suppressed.

Every year, thousands of hideously dressed, young or youngish ambassadors for British manhood visit Tallinn to enjoy – an approximate word – what are called stagger nights: to get legless, get lurching, get loud, get laid (should they be capable), and get a sexually transmitted disease to take home to Blighty. These free-spending lotharios are impressive contributors to the country's annual billion-euro tourist income. They are tolerated. Of course they are. So are their paid dates – mostly itinerant operatives from Russia. And their paid dates' kindly guardians. It is a city which has been in a hurry to ostentatiously remake itself as part of free-market Europe. Estonia may be a member of the EU. But the economic model that it

has keenly embraced is not precisely that of the EU. Or perhaps of only a specialised part of the EU. It has cherry-picked with abandon, choosing to ape . . . the absolute equity of the equity trade . . . the financial probity of French corporatism . . . the City of London's ethical capitalism . . . the fiscal stringency of Andorra . . . the rigorous transparency of Italian business . . . and the enlightened profit-sharing of Hamburg's sex education industry.

The extent and the sheer volume of Tallinn's new commercial building projects are the outward signs of this headlong rush. There is a planning authority. Its Four As policy – Assent, Accept, Agree, Affirm – is to say yes. To anything. The triumph of laissez-faire and the subjugation of *dirigisme* are creating a city which – unlike the splendid old town and the meticulously disposed bourgeois suburbs – is out of control, a kind of developers' Klondike, the Wild East. The fact that certain individual buildings are distinguished is not the point. It is the cumulative free-for-all that is so disheartening, so similar to much of Britain. Incoherence rules. Sites, materials, styles, scales – they all collide. Buildings shout each other down in a cacophony of boastful machismo. I was going to say: it's anybody's guess if this remarkable skyline will endure. But it's too late for that. We know it won't. No city has the audacity to turn back the clock – especially when yesterday was so terrible.

I was on a Baltic ferry twenty-five years ago; a courteous, smiling passenger handed my then six-year-old twin daughters the contents of his wallet, then walked away, showing a surprisingly good turn of speed and the exaggeratedly poised equilibrium of the very drunk. I felt obliged to return the money. It took an age. How do you distinguish one slumped, blond, courteous, smiling, oblivion-seeking giant with a blood alcohol level twenty times over the driving limit from the next slumped, blond, courteous, smiling, oblivion-seeking . . . Oblivion achieved, actually. They'd already achieved the northern goal of being somewhere else. In their head.

About a quarter of the population sobers up in its own sauna. And about a fifth of it will die from alcohol-related diseases. This is a higher proportion than in any other country in the world.

Northern Finland abuts on southern Lapland, a partially commercialised wilderness. Father Christmas tourism has become more economically important than reindeer breeding. Santa's red and white garb and flying reindeers derive from Sami folklore's celebration of *Amanita muscaria*, fly agaric, the red and white toadstool of fairy tales, a potent drug whose hallucinogenic properties are increased if passed through the human kidney and the resultant urine drunk. It can be drunk over and over – it is an intoxicant which magically refills itself. The end is more important than the means.

Somewhere else, and some time else too, in a perpetual 1920s, in Recoleta in Buenos Aires, in a bordello where Carlos Gada is singing for ever . . . Helsinki! Home of the tango! Second home anyway. The Finnish preoccupation with tango is a mystery unless you consider it an attempt at escape which has become naturalised. You escape from the forest to the city and you escape from the city to an illusory city. Although Jorge Luis Borges, an occasional writer of tango lyrics, named one of his protagonists after Elias Lönnrot – more of whom later – Helsinki and Buenos Aires have little in common. Buenos Aires is devoted to psychoanalysis, *la bella figura*, the keeping up of appearances, sex – and sobriety. Without which the other four might run aground.

What they do share is an almost fetishistic preoccupation with architecture and design. In Helsinki everyone knows who built what. Cab drivers, taxidermists, fish-gutters, students, gamblers, waitresses . . . They all know the name of the peripatetic German Carl Ludwig Engel, sometime city architect of Tallinn who came to the attention of the Russian court. He was commissioned to turn the then colonial city of Helsinki into somewhere worthy of the

Russian empire – in other words, into a lesser St Petersburg. He worked in Helsinki through the second quarter of the nineteenth century and built so prolifically that he turned a central area of the city into a homogenous whole. Stately, calm, somewhat undemonstrative. This is efficient, sober neoclassicism. It is proper and neat – and boring. There's none of the flashy charlatanry and theatrical genius of John Nash in London. None of the gravity of Hamilton and Playfair in Edinburgh. None of the melancholy of Leo von Klenze at the Walhalla on the Danube. And of course none of the horizontal bombast, let alone sheer size, of St Petersburg itself.

Finns take inordinate pride, a small nation's pride, in the fact that the architect Alvar Aalto achieved such international recognition that, Sibelius apart, he is perhaps the best-known Finnish artist of the twentieth century. Aalto's reputation is less comprehensible to me than his compatriots' tango mania – or their taste for *eau de vie* flavoured with pine tar, *Terva snapsi* – rather like drinking a liquefied creosoted fence or licking vodka off an asphalt road. You could call it a specialised taste. But it's a bibulous way of connecting with wood, with logging. The Baltic dependence on wood cannot be overestimated.

Forests are not only sites of reverence and fear that have prompted a multitude of superstitions – or religions. They have also provided the material to build ships and houses, churches and bridges, sledges, skis and even roads. The vernacular, as opposed to representative, buildings of all these nations are predominantly of wood. There are infinite varieties: log cabins, boat-lap houses, essays in classicism, carpenter's Gothic and the rococo – it is a material that lends itself to being worked decoratively.

Aalto's architecture was the architecture of false modesty. His buildings shout about their sensitivity. They boast how humane they are. They don't leave me cold. Far from it. They infuriate me . . . with their coy just-off-90-degree angles, their tweely audacious detailing, their insipid contrariness, their precocious undulations,

their whimsical asymmetries, their precious tastefulness, their good manners that keep reminding you of their good manners. They are unmoving: cuteness always is. I am obviously missing something. For Aalto is not merely a national idol. An entire generation of British architects was in thrall to him. This was probably the last time that Britain was widely culturally beholden to the north. Though he had no direct involvement with it, the Festival of Britain in 1951 had his fingerprints all over it. It was really the Festival of Aalto. Consequently Aalto, more than any other single architect, influenced the course of British design for more than a decade. His example is to be seen in numerous artlessly arty houses built by architects and all-purpose beardies – for themselves.

Aalto is to Helsinki what Charles Rennie Mackintosh is to Glasgow. Industries have grown up around both. More than cottage industries: substantial villa industries. Such commerce has caused their reputation to eclipse – to unjustly eclipse – that of artists who were their superior. Aalto's domestic renown today is at least partly due to the very fact of his having achieved international acclaim. In his lifetime it owed much to his work being an explicit rejection of the self-consciously inward-looking, specifically Finnish architects of the previous generation . . .

A generation whose inspiration had been predominantly literary. Its architecture is encrusted with allusions to the Kalevala, the folk saga compiled from oral sources – and partly invented – by Elias Lönnrot in the 1820s and 1930s. The Kalevala was a spur to nationalism. It is an inventory of revenge, creation myths, spells, fratricide, giant pike, the land called Northland, revenge, magic, elks, hags, beserkers, challenges, revenge, shamans, incest, virgin births, reincarnation, revenge . . .

Nationalism had become an international fashion by the turn of the twentieth century. It was a widely prevalent mood to which the majority of Europe's smaller countries and aspirantly autonomous

regions subscribed. They each attempted to create their own fittingly national architecture, an architecture that was specific to them. Catalonia, Liguria, Bohemia, Latvia, Georgia, Belgium, Lorraine. The problem was that these very different places tended to define themselves by kindred, sometimes identical means – they all adopted art nouveau. Which perhaps defeated the point . . .

Finland took a different route. Finnish romantic nationalism was contemporary with art nouveau but owed little to it. Whatever precedents it has are to be found on the north-eastern seaboard of the United States and in Scotland. Lars Sonck seems never to have left his native country. This of course may account for his comparative obscurity. As a young man he belonged to a school of high and wild originality. The taste for back to basics – very basics – that Sonck and his contemporaries demonstrated goes far beyond that of H. H. Richardson in Boston or F. T. Pilkington in Edinburgh.

Between 1895 and 1905 a small group of Finnish architects created some of the most elemental buildings imaginable. Well, pseudo-elemental. For the devices are decorative rather than structural. They are calculated – sophisticated essays in appearing entirely unsophisticated. Highly accomplished works that try to look crude and unmade. They succeed. This is an architecture that borrows from geological phenomena just as music may incorporate or mimic the rush of the wind or a stream's gurgle or birdsong. It is a form of heightened naturalism. These buildings also refer to folk architecture just as contemporary music referred to folk song – there is an element of ancestor worship here, very distant ancestor. It was hardly by chance that Jean Sibelius chose Sonck to design him a house. Sibelius is the musical equivalent of Sonck.

Nationalism no doubt came to be regarded as parochial. To many Finns today, dogged devotees of modernism, it seems embarrassing. Romantic nationalism was strangely necessary. It wasn't whimsical. It wasn't fanciful. It had a purpose. Its formal exaggerations, its

groundedness, its shunning of elegance, its rough and ready butchness may seem like Village People turned to stone but there was an earnest purpose. This was architecture as civil disobedience, aesthetics in the service of collective identity and political agitation in the face of Russian colonialism. It pretends to a sort of almost prehistorical primitivism. This is rustication in its most literal form.

Before it was used in an architectural context to describe the differently textured and incised surfaces that relieve a building's predominant material, the word rustication meant returning to the country. To rusticate an undergraduate for a misdemeanour meant to send him to the country. Massive, rocky rustication suggests not merely returning to the country. It represents a north that does not escape from itself by faking the south, by deluding itself about its climate, by making believe it's somewhere it's not.

It is an architecture of realism, founded in a pragmatic response to the place where it is built. Which is not to say that it shuns escapism. But its escapism is of a contrary kind. It is elemental. The flight it implies has no wings but feet weighted with stones. It offers the heavy solaces of the set, the warren, the dark warmth of hibernation. This was the architecture of a nation seeking a different state. The doorways of these buildings are tiny apertures in cliffs of rough stone. Like the entrances to caves in the country, to barrows or tumuli. This is surely the proper response to the benighted north. To burrow into the loam and peat we came from, to drink from the mother and so satisfy our uterine longing. There's a letter's difference between womb and tomb. Who's to say which is the darker. (2012)

15

NSDAP

Unholy relics

Sachsenhain comprises some 4,500 standing stones or menhirs. They are aligned in double file to create avenues through woodland near the confluence of the rivers Weser and Aller at Verden in Niedersachsen. Now and again the avenues open out and the stones describe circles. There are apparent affinities with Carnac and Avebury, although there are none of the associated and adjacent structures that exist at those places or at Stonehenge. There are no barrows, dolmens, ditches. Nor are any of the stones incised. But the site is nonetheless impressive on account of its sheer extent.

It is not, however, habitually mentioned alongside the celebrated relics of the Beaker Folk and the Bronze Age. It has no place in archaeological literature and is not even acknowledged on maps. This is because it was created in 1935, in the Year Three, at the behest of Heinrich Himmler, Reichsführer-SS and author of the Holocaust.

It is probably the most comprehensive work of ersatz pre-history ever undertaken. The means of its construction were commensurate with the era that was to be evoked – it was built by slaves and forced labour. Far from being a folly, a despot's mere hobby, this neo-pagan prodigy is intimately connected to Himmler's zealously pursued

vocation for genocide. It is a monument to the willed irrationality and religious certainty upon which the programme of extermination was founded.

Even a people so doggedly obedient as the Germans could not be enjoined to mass murder by mere political exhortation. The SS was an order whose structure borrowed from the Society of Jesus; Hitler referred to Himmler as 'my Loyola'; the death executives did not regard themselves as murderers with an uncommon thirst for their work, but as idealists, purifiers of German blood. They believed themselves to be conducting something akin to a crusade.

They were not mad – the exculpatory myth of collective insanity is one that has, understandably, enjoyed a certain currency among subsequent generations of Germans. Rather, they were in thrall to a form of messianic cult that disguised itself as a political party: the very names of the NSDAP's immediate precursors indicate what sort of body it was: the Order of the New Templars and the Germanenorden.

Sachsenhain was constructed for a number of reasons. The menhirs were intended to commemorate the 4,500 Saxon captives slaughtered at the site by Charlemagne in 782, a few years after that Christian emperor had laid waste to the pagan oak grove and temple at Irminsul; the erection of the menhirs was, thus, a gesture against Christianity and a memorial to its opponents. It provided a place where Himmler could conduct ceremonies for up to 10,000 members of his order. The winter solstice ceremonies here and at the Externsteine rocks at Detmold in Westphalia celebrated the birth of the sun child born from the ashes of Jesus Christ.

Himmler, who had been a devout Catholic and had the religionist's capacity for credulity, wanted his men to abandon their baptismal names and to adopt pre-Christian ones. (He wrote to the commandant-doctor of Alt Rehse, suggesting that the man's Swedish wife should change her name from Sara, which is Semitic, to Ara, which

sounds Aryan.) There was patent method in all these devices. The new order was conditional upon the extinction of the old order; Hitler announced that the 'Age of Reason is finished'; the Christian humanistic tradition had to be vanquished and its orthodoxies replaced if the fantastical utopia was to be achieved.

Certainly, there was an ignominious history of Christian anti-Semitism, but that does not mean to say that the Christian Church actually sanctioned mass murder (although it has at certain periods not been unshy of it). The resort to pre- or extra-Christian forms of worship was intended to prompt compatible forms of thought and action. It was, clearly, a hideously effective stratagem, but it was only one of many dreamed up in the pursuit of a mass moral inversion.

Just as Sachsenhain may at first seem tangential to the enormities committed by its begetter, so may the projects of the Deutsches Ahnenerbe, the SS's ancestral research department at Detmold. But these crankish essays in bogus science, anti-medicine and the rehabilitation of discredited conceits were central to the effort to create an autonomous German culture in deliberate defiance of Western thought. Thus the new order would not only possess its own rewritten history, but a cosmology that was peculiar to it, its own creationist myth, its own meteorology: there would be such a thing as German weather. Here are some of those projects.

1) Jesus Christ was an Aryan. 'Genealogical' proof for this contention was sought or invented. Pre-Nazi devotees of this particular heresy included Houston Stewart Chamberlain and Richard Wagner. It is absurd to follow a historicist line and to suggest that Wagner's anti-Semitic nationalism led, inevitably, to Nazism. It is equally absurd to deny that Nazism created its own precursors, the wretched Wagner among them; the Nazis blithely co-opted a vast *galère* of dead Germans in their pursuit of validation.

2) A team of archaeologists was dispatched to Tibet to dig for the fossilised remains of the race of giants from whom Aryans were descended. None were found.

3) Research was conducted into whether the *volk* would better understand the link between the macrocosm and the microcosm if every family was provided by the state with a telescope and a microscope.

4) A two-year-long experiment was conducted with radar on the Baltic island of Rügen with the purpose of demonstrating that the earth is the inner core of a hollow planet. This theory was the brainchild of a man who called himself Koresh, a name we've heard more recently.

5) A system of divination akin to dowsing was employed in the search for British submarines: a pendulum was held over a map.

6) The key to the cast of mind of the English ruling class is obviously the sort of top hat worn at Eton College. A branch of the Ahnenerbe, in conjunction with the foreign intelligence service, worked on deducing the significance of this garment.

7) If Tibet wasn't the wellspring of the Aryan race then Atlantis was. This lost city, the hobby horse of dangerous halfwits down the ages, had been situated somewhere near the North Pole. Or it had been situated in the Hoggar desert: the thinker who thought up that one had no doubt read *L'Atlantide* by the French philo-Nazi Pierre Benoît, a book that enjoyed a great vogue in Europe in the twenties but was never published in England because of the threat of legal action by the estate of Rider Haggard.

8) Efforts were made to demonstrate that Nordic runes shared a common ancestry with Japanese ideograms and that the Germans and their allies were thus descended from the same stock.

9) The Cosmic Ice theory was devised by a sometime blacksmith and amateur astronomer called Hanns Hörbiger in the early years of the century. It states, inter alia, that when the cosmic water – i.e.

ice – comes into collision with the metallic stars, new stellar systems are formed. A further tenet is that the moon collides with the earth every 20,000 years and that the only knowledge we retain of the earth as it was pre-collision is held in myths and legends. The Ahnenerbe devoted substantial resources to this one because both Hitler and Himmler believed in it.

So what have we here? Hippies in uniform? Early on, the NSDAP was indeed dismissed as 'armed bohemians'. But Charles Manson, the aforementioned Koresh or even Jim Jones never took over an entire nation. The Third Reich's irreason was so devastatingly potent because it was applied with such signal single-mindedness, such plodding determination.

The Ahnenerbe ran its pseudo-academic projects with the same earnest sedulousness that informed its supervision of 'medical' experiments and with the same blind idealism: gynaecological and ocular operations performed without anaesthetic, throwing people from aircraft without parachutes, employing humans as testing grounds for wayward vaccines, vivisecting babies, measuring decapitations in order to prove the racial link between Jewry and Bolshevism.

These and nameless other atrocities were made possible and could be undertaken for the sake of betterment of the *volk* because the moral system, the code of behavioural norms that had pertained with ever more refinement down hundreds of years, had been trampled upon, not least by a contempt for learning and by the championship of anti-scientific empiricism, charlatanry, visions, twilight beliefs that could never be corroborated.

Himmler believed in the efficacy of homeopathic pest control, in astrology, numerology, folk remedies, reincarnation. Promoting the risible programme of selective breeding called *Lebensborn* he said: 'A child who is conceived in a Nordic cemetery will inherit the spirit of the dead heroes who are buried there.' And the SS's newspaper duly published lists of suitable sex cemeteries.

It is small wonder that when Rudolf Hess flew to Scotland, Ian Fleming, then an intelligence officer and yet to become the creator of a series of Hitlerian villains, suggested that the ideal man to interview the fugitive deputy Führer was Aleister Crowley, the black magician, Beast 666, *soi-disant* 'wickedest man in the world' and former initiate of the Order of the Golden Dawn whose salute the Nazis had borrowed.

It is not necessary to believe in such folk myths as fairies at the bottom of the garden or Jesus Christ's resurrection or the augural properties of magpies to appreciate that other people do believe in them. So it is with ley lines. The Renaissance castle called Wewelsburg in Westphalia is at the conjunction of several such lines: that, anyway, is what those credulous enough to accept their existence claim. Himmler was, and he duly concluded that it was the centre of the world.

In 1934 he requisitioned the castle and began to both reconstruct it and build a private fiefdom around it. The concentration camp established for this purpose imprisoned Jehovah's Witnesses, since the work was reckoned to be too noble for Jews, homosexuals, dissenters, communists, etc. In a tower there are two rooms which suggest an appetite for ritual. Both are circular. One had a round table, is decorated with tessellated swastikas and has a floor that bears a zodiacal pattern.

Beneath this is a crypt that is chilling. It would be chilling even without the knowledge of who had it built. When you enter you feel you are entering the site of some sort of psycho-sensory experiment. It contains twelve plinths, each of which was to have had placed on it an urn containing the ashes of the SS's highest initiates. When you stand in the centre of this terrible place you hear your voice in a quick echo which creates an aural *doppelgänger*: the speaker doubles himself, becomes twice the man he was, advances towards masterful supermannishness. Testifying at Nuremberg, Himmler's

acolyte Walter Schellenberg compared Wewelsburg to a monastery. Much of the new building was destroyed on Himmler's orders, to prevent it falling into the hands of the Allies: the castle itself was impervious to explosives.

There remain also a variety of peripheral buildings including a barn that was rebuilt and grossly expanded to become the SS's mess. It is an inflated piece of bogus half-timbering, akin no doubt to a contemporary English arterial roadhouse. But while those places are vaguely laughable, properly characterised as joke oak, this mess, now a Gasthaus, renders agrarian kitsch creepy and makes corn dollies the secondary props of mass murder.

There are settle ends decorated with runic devices and death's-heads. There is an air of musty oddness, of a vestigial animism. This sort of vernacular revival building was stripped of its innocence by Nazism. It was politicised and turned to monstrous uses. *Völkisch* certainly means folksy, but it also connotes that which is tribal, nationalistic; it also signifies some load of balls about a people and the sacred soil they spring from, racial exclusivity, etc.

Völkisch buildings were obviously intended to evoke a pre-industrial past, the usual golden age of simple agrarian order, rosy cheeks and purity. There is, evidently, nothing peculiarly Nazi about such aspirations. The earnest – as opposed to skittish, Marie Antoinettish – revival of humble building forms began in England with the Arts and Crafts movement.

England was industrialised before Germany and its reaction against urbanism was duly earlier than Germany's. But despite the examples of William Morris and of Arthur Mackmurdo, who abandoned architecture to devise utopias based on the beehive, and despite the existence of such mystical back-to-nature brotherhoods as the Woodcraft Folk and the Order of Woodcraft Chivalry (some of whose log cabins are still standing on the edge of the New Forest near Fordingbridge), and despite the agitation of anti-capitalist,

anti-usurious, anti-Semitic movements like Guild Socialism and Social Credit, the *völkisch* tendency in England was always marginalised, mostly harmless, if only because it commanded so little support.

Given the English bents towards spiritual sloth and intellectual incuriosity, what we dignify as scepticism, it could hardly have been otherwise. Whereas in Germany *völkisch* proselytisers like Walther Darré ascended to positions of terrifying power. There's a certain irony in the fact that Darré, like Hess (who was brought up in Egypt), von Schirach (who held an American passport) and Rosenberg (a Moscow-educated Estonian), was not a native German but a German by choice. Germany was, in the years immediately after the First World War, a magnet for malign cranks, a vessel into which they might pour their poisons.

Darré was born in Argentina and was partially educated at King's College School, Wimbledon, which is where he was initially enthused about eugenics, by his housemaster, Mr Carrodus. By 1923 the NSDAP had yet to beckon – he was a member of the same Bavarian back-to-the-land band, the Artaman League, as Himmler and another young utopian idealist, Rudolf Höss, who became the commandant of Auschwitz. Darré's poisonous gift to his adopted country, for which he got two years (remission for good behaviour), was this: a slightly more advanced agronomy student than Himmler, he convinced the future Reichsführer-SS that human beings could be bred according to the principles of cattle-rearing, that if stud books worked for longhorns so might they for Aryans; here is the genesis of *Lebensborn*.

As Hitler's minister of agriculture, he attempted to put into practice the precepts of the Artaman, that is, to 'return' the *volk* to the soil in agrarian smallholding communities – back-to-basics, small-is-beautiful, strongholds of self-sufficiency. These communities were to have littered the conquered lands to the east. As it is

they litter the (former?) Reich. They are sedulous examples of regionalist kitsch, ur-Holsteiner, ur-Bavarian, ur-this or that. But no matter where they are sited, no matter what obeisance they show to local building style, they all adhere to the same ground plan, the same dimensions. Regionalism is merely cosmetically slapped on.

In the former Federal Republic, the piggeries are now garages for the fruits of the economic miracle. In the former GDR, the piggeries are still piggeries. Wherever they are, they look like the displaced lesser offspring of English garden cities and suburbs; like LCC estates of the twenties that have been airlifted to Franconian fields or Pomeranian plains. It should be noted that among the earliest German champions of garden cities was Theodore Fritsch, who combined designing a number of (unbuilt) projects with producing virulently anti-Semitic pamphlets. But we should not blame Letchworth, the first garden city, for what it presaged, even though it was teetotal and predominantly vegetarian; even though John Buchan, who called it Biggleswick in *Mr Standfast*, characterised it as a nest of (First World War) German spies.

At Letchworth, after all, the communards wore togas and Greek robes. And even though Hitler flatteringly declared that his *volk* were 'Nordic Greeks', he did not go so far as to make them dress that way. Darré, however, dreamed of neo-peasants in neo-medieval dress. He organised annual pageants of sackcloth labourers at Goslar and encouraged the garment industry to turn out appropriate apparel which was available by mail order (a retail method unknown in the Middle Ages) from the NSDAP's homesteading magazines.

At Neu Rhäse near Neubrandenburg there is a settlement so indigent, so unaltered that it would not be astonishing to see small-time farmers dressed in habits. A mile and a half away, Alt Rehse (the different spellings commemorate a parish-pump feud)

comprises several streets of chocolate-box cottages. Lovingly coif-
fured thatch fringes, lovingly pointed brick, lovingly blackened
beams. Oh! There's the village pond. Look at the ducks. Can they
swim that fast because they have extra webs?

Alt Rehse is Port Sunlight out of Milton Abbas. Cute going on
hyper-cute. This is where the SS 'doctors' were trained. Each cot-
tage is named for a German city: Leipzig, Munich, whatever. Each
is inscribed with the date of its construction: the second year, the
third year, whatever. Mengele, Rascher and 1,100 others passed
through this place. It took forty-six weeks to turn a willing doctor
into an anti-doctor, to turn the healing art into the harming art.

And of course it all started early: the year two was 1934. That's
when the courses in racial biology and racial hygiene and the iden-
tification of unworthy life forms and euthanasia and sterilisation
began. Two years before the Olympics, four years before the
English football team and the Duke of Windsor acknowledged the
Führer with stiff-arm salutes. Alt Rehse is a hallucination of some
idealised ancient Germany which would be regained, which would
also be the new Germany, once the anti-doctors had done their bit,
once they had maimed and murdered.

Since reunification, a German equivalent of the BMA, the
Kassenärztliche Vereinigung, has been trying to prise the village from
the people who live there. It was a precursor of this organisation
which, sixty years ago, happily ceded the site to the NSDAP. Karl
Hedenkamp, who edited a professional journal and who had called
for the expulsion of Jewish doctors before the Nazis took power,
arranged for his brother Hans to design the village. The situation
has now arisen where second-generation post-Nazis who happen to
be doctors are bringing suits for trespass against the freeholders of
what they believe to be their particular bit of *Lebensraum*. Jens
Korth, an officer of this organisation, recently wondered: 'How

long can it go on? They took Jews to Auschwitz by train, I know. But me, I'm still willing to travel by rail.'

This sort of near-syllogistic obliviousness is not unusual: at the women's concentration camp, Ravensbrück, the prisoners who had not been beaten or starved or experimented upon were made to work at a plant owned by Siemens, situated 300 yards away across a leg of a lake. No bridge was built. Of course it wasn't. The women were made to march there at dawn and to march back at dusk, all through the little town of Fürstenberg. Siemens, a sponsor of the current Deutsche Romantik jamboree, has made no amends to those slaves. Nor has the collaborationist Church of Rome.

We all know stories of Nazis sheltered in Catholic monasteries until they grew old. There should be nothing surprising about this: the credulous always respect the credulous – the object of belief is irrelevant. Fascism was defeated by non-believers, by ad hoc alliances. Nazi Germany combined the two most pernicious human traits: the religious and the nationalistic.

Innumerable Catholic and Lutheran priests were imprisoned and murdered. But, nonetheless, a programme of church building continued. Most of these churches are banal, typically dutiful exercises in *völkisch* dreariness. Now and again there is one that is not architecturally woeful – e.g. St Wolfgang at Regensburg by Dominikus Böhm. But Böhm was the finest ecclesiastical architect of the Weimar Republic (as his son Gottfried would become the finest of the sixties and seventies).

The churches Böhm designed before 1933 are wonderfully audacious and original. His work at Regensburg may be superior to the run of Third Reich churches – and its secular buildings, for that matter – but beside his earlier buildings it is paltry, conventional, revivalist, accessible; a paramount aspect of Nazi aesthetic control was the insistence that buildings should be immediately comprehensible.

Ultimately St Wolfgang would, like every other sacred building, have been requisitioned by the National Reich Church which was to have exterminated irrevocably 'the strange and foreign Christian faiths imported into Germany in the ill-omened year 800'. The Bible was to have been replaced by *Mein Kampf*, 'to the German nation and therefore to God the most sacred book', the cross was to have been replaced by the swastika, the *Hakenkreuz* (the hooked cross) – the word is important for it emphasises that the Nazis' ubiquitous symbol was a perversion and denial of the Christian cross. The hooked, crooked cross is an ancient sun symbol. The NSDAP merely lifted it from the quasi-masonic fellowships that had been using it since the turn of the century.

The National Reich Church was apparently going to settle for the appropriation of existing places of worship. It did not build any of its own. Given the Third Reich's paranoid fear of contamination by alien cultures, it is surprising how close to the European mainstream so much of its architecture was. The proscription of modernism, which prompted the emigration of even Gentile exponents of the new architecture, was more preached than practised. On the coast of Rügen there is a vast development called Prora which not only derives from modernism but also anticipates the vacuous repetitiveness that characterised modernism's decadence.

Prora was designed by Clement Klotz for the 'leisure' organisation called Strength Through Joy, the brainchild of Robert Ley, who was to hang himself with a towel in his cell at Nuremberg. Ley was a sort of national cheerleader. He announced that 'there are no private individuals any more'. His idea of leisure for anyone other than himself was compulsory communal walks, compulsory communal gymnastics, compulsory communal lectures. All this suited the tragically obedient *volk*. They were proud to belong to a nation that was a sort of hearty, outdoorsy cadet club. They enjoyed cruises on such vessels as the *Robert Ley*. And they'd have

just loved Prora, had their Führer not led them into war just before it was finished.

Prora consists of three slab blocks, each of them getting on for two-thirds of a mile long. Twenty thousand Aryan gods and their breeder goddesses were to have been accommodated in tiny rooms that are like cells. The place became a barracks after the war, which was apt enough, for it certainly demonstrates the Nazis' militarisation of civilian life. It also suggests that when it came to trashing coastlines the Third Reich had some valuable lessons for post-war Europe.

In our retrospective abhorrence we have tended to collude with the Third Reich's notions of its exclusivity. We have tended to delude ourselves that it existed in some sort of cultural vacuum. Well, it did and it didn't. The type of architecture which is lazily dismissed as 'Nazi' can equally be found in Sweden, Holland, England. Stripped or undecorated classicism was a ubiquitous middlebrow idiom between the wars.

It met with Hitler's approval for a number of reasons: it could not be accused of vulgarity – the Führer possessed a watercolourist's abhorrence of kitsch. It bore some affinity (not much) to the neo-classicism of the early nineteenth century, the only period when Germany had been architecturally pre-eminent. It lent itself to gigantism; Hitler valued size over stylistic niceties, he wanted to outdo the past.

His poodle Albert Speer came up with a self-importantly titled conceit called 'the theory of the value of ruins'. This states that great civilisations are revealed to future centuries, future millennia by their ruined buildings, and that for those ruins to be impressive the buildings they formerly were must be impressive too. Some theory. Speer certainly built big. The unfinished congress hall at Nuremberg is vast. But impressive? No. He had a sense of size but not of scale. The same gestures are repeated over and over again.

There are no accents, no interludes. It is quite bereft of articulation. It is now a car pound.

Speer and his megalomaniac master presumably thought that the ruins of their great civilisation would be venerated like those of Greece and Imperial Rome. Speer, a war criminal who died after a particularly energetic personal massage in a west London hotel room, should be regarded with contempt. He stage-managed the party rallies whose central rite was the introduction of the blood flag of the Nazi 'martyrs' to the flags of regional divisions. Hitler's ritual gesture has been compared by Michel Tournier to that of a cattle breeder introducing a bull's penis to a cow's vagina.

As an architect Speer was a third-rate hack who succeeded only because he attached himself to the coat-tails of a tyrant; his schemes for the transformation of Berlin into Germania are all pompous grandiosity and mostly plagiaristic of the French neoclassicists of the late eighteenth century. They are the urbanistic projects of a regime that hated urbanism and despised cities: the Nazis abhorred the messiness, the vitality, the potential for free thought that cities spawn.

It must not be forgotten that they started out as resentful hicks. Cities are mankind's greatest collective achievement; it is (back to) nature that is unnatural. Like Leni Riefenstahl, who cannot be considered an artist, Speer has his devotees, the Speer carriers, the keepers of the toxic flame. Chief among them is one Leon Krier, who believes Speer to have been the greatest architect of the century. This is a piffling opinion, and would be of no moment were it not for the fact that Krier has been one of the Prince of Wales's architectural advisers.

It's as well to be apprised of the genealogy of those dim, populist opinions. It has become increasingly usual for revisionist commentators to find merit in the Third Reich's buildings while making dutiful noises about the enormities of the regime. This is, no doubt,

very big-hearted of them. But aesthetics should not be separated from morality; to do so is to pretend that there is no connection between architecture and the society it serves.

In the case of the Third Reich that connection was total. No regime has ever been more architecturally dictatorial, no regime has ever been more opposed to individual expression. Furthermore, the Reich's distended monuments were built with forced labour and slave labour. By the end of the war there were 1,037 concentration camps and, in addition, some 7.5 million other slaves in greater Germany.

It takes an aesthete to overlook the source of labour and the means of construction and, indeed, the purpose of the Third Reich's buildings. They are all contaminated, even the rare ones which display any flair. These mostly belong to the architecture of belligerence and desperate defence. And they were designed by engineers rather than by architects.

The Hoch Haus in Hamburg is an air-raid shelter of gargantuan proportions. Its walls are three metres thick, its roof four metres. Fifty thousand people hid here. They burrowed like animals, which is fitting enough, for they belonged to a nation that took its behavioural standards from animals: 'We, the Aryans, have more in common with animals than we do with Jews,' said Hitler.

Even more sculpturally plastic than the Hoch Haus are the coastal gun emplacements and watchtowers on Guernsey. Polish workers were transported to build them and subsequently massacred. The structures they put up use the imagery of visors, helmets, armour; they are also like crouching beasts. They form the missing link between the expressionism whose individualism the Nazis had proscribed and the neo-expressionism of the late fifties, sixties and seventies called brutalism. You could say that the South Bank was Nazism's gift to London. (1994)

Horror films

A Portrait of Leni Riefenstahl by Audrey Salkeld

Leni Riefenstahl didn't menstruate until she was twenty-one. Such tardy lunar maturation does not necessarily imply a kindredly sluggish emotional development, but it does accord with the troubled sexuality and protracted infantilism from which so many leading Nazis suffered.

Not that, according to Audrey Salkeld, Riefenstahl was a Nazi. No, sir. She never joined the NSDAP, a fact which – so this idolatrous biographer seems to believe – acquits her of all the charges that have been informally levelled at her down the years. Salkeld is not, of course, alone here. A series of de-Nazification tribunals – empowered sheep considering the careers of wolves – came to the same conclusion. So have countless style-fixated film critics and school-of-Peterhouse thinkers who are loftily capable of separating the 'aesthetic' from the moral, the medium from the message, technique from subject.

It is an approach which, in the case of Riefenstahl's work, captiously overlooks its purpose – at best it betokens indifference towards a hideously successful attempt to harness the most modern form of representation in the service of a self-proclaimed return to pre-Enlightenment despotism.

The case of Leni Riefenstahl is not analogous with those of Céline or Pound or Henry Williamson, fellow travellers of the distant right, self-made pariahs, but artists whose work, while it may be seen in retrospect to be infected by the germs of their aberrance, is free-standing. Riefenstahl's wasn't. The films for which she will for ever be remembered are 'official' art, that is to say instruments of propaganda, advertisements for a terrorist state.

They aren't *about* Nazism, they are pure expressions of its mystical morbidity, preposterous romanticism, satanic ceremonial and hero

culture. There is no gap between subject and witness. Riefenstahl was Hitler's poodle. As a cineaste she was made by his patronage and his (and Rosenberg's and Himmler's) terrible, childish determination to bend reality to fit myth.

Like Speer she would have amounted to very little in a democracy, but the Third Reich provided wonderful opportunities for the amorally opportunistic: loyalty was everything, talent nothing. In the latter years of the Weimar Republic, Riefenstahl had been just another actress in *bergfilme*, mountain sagas which, unusually for that era, were filmed on location and whose appeal partly derived from the audience's knowledge of the dangers that had to be faced in making them. Their appeal to the ideologues of the NSDAP was different: it was something to do with the attainment of the unattainable, the purity of peaks and ice, their congruence with myths of the Aryan descent from the pole *und so weiter*.

These films were a sub-division of the genre which was abbreviated as *blubo*: *blut* and *boden*, blood and soil. Salkeld is mistaken in her belief that blood and soil was a Nazi creation — it was merely one of the crank cults they co-opted. Similarly, the Ordensburgen were not SS schools but run by Ley's Arbeitsfront; and Anthony Eden was not a member of the diplomatic corps. Still, what are a few details when there's a reputation to be salvaged?

Bergfilme were works of tedious kitsch, but then so was just about everything the NSDAP approved of: Pevsner's dictum that there was no such thing as Nazi *art* seems unexceptionable. Hitler was a fan of the one film Riefenstahl had directed, *The Blue Light*, and she set about falling in with him at the first opportunity. He, typically, played her off against Goebbels, who attempted to seduce her in her car in the Grunewald. Her rejection of him was a rare instance of discrimination.

Goebbels considered her difficult and vacuous. Certainly her 'mas-

terpieces' are unremittingly dumb. As a director Riefenstahl was Busby Berkeley with a political and racial purpose. *Triumph of the Will* is spectacularly bereft of narrative or thought: it is all martial patterns and repetitive liturgies. It leaves us in no doubt that Nazism was a primitive, paganistic religion rather than a political phenomenon. There are moments when you are enjoined to think that this is what Aztec ceremonial must have been like.

Riefenstahl is the last major figure of the Reich still living. Her life is defined by those twelve years and her life since then has been duly blighted. As Salkeld puts it with her characteristic sensitivity: 'there was an orchestrated campaign to stop her working. Many of the activists were Jewish. We should seek to be sure in our minds if this represents a natural and acceptable watchfulness that the memory of the Holocaust is not diminished, or whether it has become polarised into a more specific and personal vendetta.'

It may also be the case that even those who discern 'genius' in her propaganda would agree that her capabilities were rather specialised and that a tyrant-patron tends not to come along more than once in a lifetime. Still, she would doubtless have done well in commercials and rock videos.

This signally unsatisfactory book has the reek of an official biography, even though its author seems to have enjoyed no access to her subject: now that's what I call forelocking. Salkeld is an alpinist and owner of 'Britain's most comprehensive archive on mountaineering and exploration'. She seems to believe Riefenstahl's physical bravery and all-purpose outdoorsiness are exculpatory traits rather than corroborations of the anti-urbanism and anti-intellectualism which were the *sine qua non* of preferment in that green autocracy. (1996)

Swingtime for Hitler and Germany

Hitler's Airwaves: The Inside Story of Nazi Radio Broadcasting and Propaganda Swing by Horst J. P. Bergmeier and Rainer E. Lotz

The Third Reich has occasioned some 60,000 books – that is to say, more than a dozen for each day of its existence. The combination of sheer volume and moral enormity means, of course, that a large proportion of the stuff is barking, sick or plagiaristic. In this crowded and competitive field it is rare that anyone comes up with a fresh approach, but that, I believe, is what co-author Lotz has achieved. He is the first man to have applied Pete Frame's methodology to the swing bands who, although proscribed within the Reich itself, were a ubiquitous feature of propaganda programmes directed at Britain and America. And Pete Frame? He is the dogged anorak who, for over a quarter of a century, has diagrammatically depicted the mutating personnel and genealogies of rock groups in neat, costive handwriting, and who inspired the sometimes comical BBC2 series, *Rock Family Trees*.

'In May 1942, Joop "Tip" Tichelaar briefly joined the roster of Templin musicians from the van 't Hoff orchestra as alternate pianist and third trumpet player. In 1933, he had been a member of the short-lived Swantockers, directed by clarinettist/violinist Antoon Swaan and drummer-entertainer Eliazer "Eli" Tokki, which included the famous Dutch trumpeter Louis de Vries and German star-saxophonist Ernst Höllerhagen. In January 1940, Tichelaar joined the Willie Lewis band, replacing Freddy Johnson who had left in October 1939 to form a trio for an engagement at Amsterdam's Negro Palace. From the summer of 1940 . . .'

And so it goes on, page after page after page of German, Dutch and Belgian musicians who considered plying their trade on behalf of the Nazis more congenial than, as one of them put it, 'filling shells like all my mates', and no more compromising. Or so they

claimed in retrospect. Few of the Germans were party members; they were playing their music in the only circumstances in which they might do so without putting themselves outside the law; they mostly felt themselves to belong to a predominantly anglophone 'brotherhood' of jazzers – witness the almost obligatory nicknames: 'Baby', 'Freddie', 'Bob', 'Teddy', 'Meg' (a male guitarist), 'Charlie'.

Few were forced to subject to de-Nazification procedures after the war and many enjoyed successful careers even after the coming of rock 'n' roll. Typically, their wartime output was pastiche Glenn Miller and Harry James, or recent hits (the word was current then) with oafishly amended lyrics – e.g. 'Picture Me Without You':

> Picture USA without a Jew –
> Roosevelt without ballyhoo!
> Picture Winston Churchill without a licking!
> Picture India without pig-sticking!
> Picture Canterbury without a prayer!
> Picture old New York without a mayor!
> Mix them together and what have you got?
> Just the picture of the whole damn lot!

The more pragmatic Nazis, and Goebbels was among them, were happy for them to borrow from the idioms they despised as Jewish and Negro, and to abjure the hermetically Aryan culture they sought to propagate at home; but they were foiled by their fabulous German sense of humour and by their extraordinary misconception – born both of insidiously crackpot racial 'science' and of hicks' ignorance – that the British and the Germans were sort of brothers beneath the skin. The collective and, for some years, admittedly understandable solipsism of the Nazi leadership quite blinded it to the fact that the British and Americans subscribed to a different moral programme, that they lived in secular states, not a messianically religious one. The

trouble with the British and the Americans as targets of propaganda was that they simply weren't German enough, simply not close enough in political delusion, either, to the necessarily atypical Britons and Americans and Irish who wrote and broadcast the stuff.

This sad *galère* of losers, chippy inadequates, BUF veterans and, of course, idealists, served to give Goebbels' ProMi further bum steers towards the nature of the Allies' mentality. Many of them are familiar: William Joyce, John Amery, Norman Baillie-Stewart, Railton Freeman (the latter two Sandhurst graduates), and a couple of dozen others, most of whom are more fully dealt with in Adrian Weale's *Renegades: Hitler's Englishmen*. One who is not was the actor Jack Trevor, who was by no means the only Englishman employed in the Berlin film industry. (John Heygate, the cuckolder of Evelyn Waugh, worked there and took the unrepentant Hitlerian Henry Williamson to his first Nuremberg Rally.) Trevor seems to have been unlucky, or at least careless: his family was effectively a hostage, and he was persuaded against his will to broadcast, and to play in propaganda films.

The means by which English speakers were recruited were manifold and chaotic. But no less chaotic were the broadcasting agencies themselves. Like most Nazi organisations, they were in a state of perpetual struggle, within themselves and with each other. Preferment went, as it always does in authoritarian organisations, to the loyal who demonstrated 'serf-like diligence'. The taxonomical mania which might elsewhere be devoted to the criteria determining what life forms are unworthy of life was here brought to bear on definitions of 'musical bolshevism' and 'musical race defilement'. Such infantilism would, had it led elsewhere, be laughable. In a way it did lead elsewhere: a notable feature of the biographical sketches of German propagandist personnel is their inventory of post-war achievements: while the highest echelons of Nazism were hanged, or topped themselves, the lieutenants strolled into the newspapers and

broadcast media of the FDR and changed their tune with an ease as indecent as the terrible utopia in whose studios they had served their apprenticeship. (1997)

One man's balls

Explaining Hitler by Ron Rosenbaum

I had never previously made the link between Henry Kissinger and Craig Raine. But one is aping the other – either that, or men with crinkle-cut hair think alike. The poet asserts that his trade is so competitive because there's so little money in it. The Nobel peace laureate (oh, that fabulous *Swedish* sense of humour!) is quoted by Ron Rosenbaum as suggesting that academic infighting is so bitter because the stakes are so small. Now, in the course of making this book, Rosenbaum has witnessed so much infighting that he must be beginning to hurt.

He acknowledges that one of his inspirations was Don DeLillo's *White Noise*, whose protagonist is a big cheese in the all too credible discipline of 'Hitler studies' at a hick campus: 'I invented Hitler studies in North America in March of 1968 . . . [The chancellor] was quick to see the possibilities . . . The chancellor went on to serve as adviser to Nixon, Ford and Carter before his death on a ski lift in Austria.' But despite DeLillo's grimly comic example, and despite his exposure to an often gruesome *galère* of *soi-disant* scholars, obsessives and fantasists, Rosenbaum fails to see the comedy of his subject.

He is perhaps incapable of transmitting it, perhaps unwilling to breach the boundaries of propriety. He is what Bernard Levin once deprecated as a 'responsible journalist' – dogged, literal and too even-handed: he is thus prone to grant equivalence to the sane and the crank. He doesn't dare admit that while there is nothing funny about Hitler, there is something funny about the spats and mutual

character assassinations and hubris and lifelong resentments that inform the Hitler industry.

Hitler is as susceptible to interpretation as Hamlet. Every director has a particular version of the prince which excludes all other versions; every historian and theologian and philosopher has his or her own take on the tyrant. Rosenbaum's invariable stratagem is to read what this or that writer has posited and to go and interview them, throwing in a little local colour along the way: 'To reach Yehuda Bauer's office on the Mount Scopos campus of Hebrew University, I found myself crossing Nancy Reagan Plaza, passing by the Frank Sinatra Student Center, before winding down some steps to the more modest edifice that housed the Vidal Sassoon International Center for the Study of Anti-Semitism.' This American magazine convention is endlessly repeated, and it's endlessly redundant. So, he meets Lords Dacre and Bullock, George Steiner, Daniel Goldhagen, David Irving et al.

The point of the interviews appears to be that Rosenbaum expects the writer to vouchsafe in casual conversation some vital aperçu that he has overlooked throughout years of sedulous research. These interviews also allow Rosenbaum the opportunity for pop psychoanalysis of a breathtaking vulgarity. He ascribes Dacre's antipathy to the notion that Hitler was a 'mountebank', a position that the historian has held for half a century, to 'the animus he still feels for the mountebanks who sold him on [*sic*] the counterfeit Hitler of the diaries'.

The diaries, incidentally, were bought by the *Sunday Times*, not *The Times*; and the notion that the bank vault where Dacre read the forgeries 'was his own bunker' is contemptible. Rosenbaum's mistaking the Cherwell for the Isis is more excusable. But the flawed method and the coarse infelicities do not occlude the sheer mass of information that Rosenbaum has gathered. His paramount preoccupations are the sources of Hitler's anti-Semitism, the point at which

Hitler determined to annihilate European Jewry, the question of whether Hitler believed he was doing good.

The first of these has fomented a school of charlatanism whose bickering adherents attempt to 'explain' Hitler by inventing, or giving credence to, folkloric stories of psycho-sexual traumas: Hitler's mother was allegedly mistreated or misdiagnosed by a Jewish doctor and died; Hitler may have contracted venereal disease from a Jewish prostitute – these speculations are hateful because they seek to make individual Jews culpable for the enormities their race was to suffer. There are, inevitably, one-ball theories and satanic-abuse theories. There is the ludicrous tale of the infant Hitler having his penis bitten by a goat into whose mouth he was attempting to urinate.

The begetters and disseminators of this bunk are subscribing to the pseudo-science and renegade scholarship that the NSDAP's ideologues tried, too successfully, to found their pan-Germanic culture on. While Rosenbaum cannot be faulted for his scrutiny of the crankier end of Hitler studies, he is bizarrely willing to display a tolerance towards this stuff and to grant it as much weight (and implied validity) as the work of more sober and less fanciful historians.

This sort of relativism is unhelpful when it becomes evident that Rosenbaum has devoted so much space to red herrings at the cost of any considered perusal of the anti-Semitic underground of Vienna and Munich before the First World War – the poisonous backwater which Hitler was to divert into the mainstream. It is difficult to disagree with Milton Himmelfarb's 'No Hitler, no Holocaust'. Without Hitler, the texts of Houston Stewart Chamberlain and the fantasies of the blood-and-soil novelists would never have been acted on because without Hitler the NSDAP would never have seized power.

Hitler was, mercifully, unique – and so were the economic circumstances and messianic longing which gave him his opportunity.

There is no more absurd claim in this inventory of the absurd than the we-are-all-guilty proposition that 'there is a Hitler in all of us'. If that is the case, why has the Hitler within manifested only once? (1998)

Little Hitler
Speer: The Final Verdict by Joachim Fest

O lucky man! These are some of the many flukes Albert Speer enjoyed: he was lucky that his drawing was so poor that the fantastical expressionist Hans Poelzig rejected him as a pupil and he thus had no choice but to study under, and be inculcated by, Heinrich Tessenow, whose own work was strangely mute and uninflected; he was lucky that a mere three minor commissions from the Nazis, which he had joined because it was Hitler's party rather than for any other reason, led him straight to Hitler; he was lucky that the heavy-handed Paul Ludwig Troost, who was Hitler's favourite architect, died just a year after the seizure of power; he was lucky not to have swung at Nuremberg; in death he has been lucky to have attracted biographers who, while not exactly apologists, have accorded him such cautious and unseemly respect that he has become the very model of the 'decent' war criminal.

Why has he been so posthumously lucky? The notion that he was 'an artist', hence somehow exempt from moral norms, probably comes into play. His ponderous sophistry and talent for mutability evidently took in those who met him. But most of all, it was his sheer demeanour of courteous normality that served him so well: he was the apparent straight man in a *galère* of fanatics and freaks. Equivocation is the bane visited on Speer's assessors. The man was surely too urbane, too civilised to have been complicit in the enormities and terrors of the Third Reich – from which he gave the impression of having been semi-detached.

Joachim Fest is the author of what remains, after a quarter of a century, perhaps the most scrupulous biography of Hitler. He scrutinises his new subject with coolness, poise, obliqueness. He creates a Speer who is credible. You know the type: it is never at ease with its own level, it can only hero-worship or despise. He has Speer as diffident yet supremely ambitious, passive but infected by architectural megalomania. The man is presented as a chameleon with a worrying capacity for self-delusion.

He possessed the ability to shed his former selves. How else could the slave master have become the 'Titan of penitence'? He protested his criminality with an expiatory zeal bordering on the masochistic and thus abetted the creation of the moral template to which Germans of generations after his rather routinely adhere. They confess to the crimes of their grandparents with the same eagerness that informed their grandparents' commission of those crimes.

Speer's confessional candour was not, of course, entire. While, as a member of Hitler's government, he admitted responsibility for its crimes, he denied that he actually knew of the genocide although he 'sensed' it and would allow merely that he owned 'a tacit acceptance of the persecution and murder'. Fest has no doubt that Speer was indeed quite apprised of the annihilation. But this is a question to which Gitta Sereny has devoted much attention and Fest is disinclined to rehearse the repertoire of Speer's casuistical evasions. So far as he is concerned, the paramount question is the nature of the relationship between Speer and Hitler. Speer was not the first fastidious aesthete to have been seduced by the aura of a 'primal being' (that epithet is the historian Otto Hintze's). Fest shrewdly notes that the bond between them is seldom inspected from Hitler's point of view. Speer enjoyed a licence in the presence of Hitler that was granted to no one else.

The envious hatred this fomented is well recorded. Speer was, to use an archaic public-school expression, Hitler's 'little boy'. This does not suggest an even platonically homosexual relationship but a

liaison characterised by the elder's flirtatious patronage and the younger's insolent idolatry. Speer lit up Hitler's being in a way that no other human did and Hitler, in gratitude, made Speer, empowered him and caused him to blossom into the architect that he himself had wished to be.

Speer's work, *pace* Fest, is much more than a bombastic continuation of Troost's banal classicism. It is infected by a frightening primitivism. Speer was the Nazis' liturgist. Standing in the ruins of the Zeppelinfeld at Nuremberg, one feels oneself in the presence of horrible and ancient mysteries that were invented only seventy years ago. It is the site of the ceremonies of a barbarous cult that seems as remote as the Aztecs. The only solace to be had is in the knowledge that Speer's cathedrals of light have been appropriated by rock bands with effeminate clothes and satyric groins. (2001)

Bad science

The Master Plan: Himmler's Scholars and the Holocaust by
Heather Pringle

Given the unstaunchable haemorrhage of books about Nazi Germany, it is surprising that this should be the first in English devoted exclusively to the Ahnenerbe, the ancestral heritage branch of the SS. The Canadian historian Michael Kater's exhaustive study was written in German, published in Stuttgart in 1974 and has not been translated – though it has been liberally ripped off: the Ahnenerbe's opportunistic racial scientists, dodgy ethnographers and wishful genealogists populate countless works on Himmler's occultism, the Thule Society, the esoteric dungeons of Nazism. And its plundering archaeologists are Indiana Jones's rivals.

Heather Pringle, another Canadian, a scientific journalist, writes, however, in the presumption that this bizarre and ultimately murderous organisation is virtually unknown. Nor has she much faith

in her readership's broader knowledge, and explains, for instance, that ochre is a red mineral pigment. And then there are her novelettish flourishes: local colour daubed in the manner of Pierre Loti; trite essays in human interest, 'almost certainly the genial priest rolled and lit a crumbling cigarette – he was seldom to be seen without one'.

These are blemishes, mere irritants. They do not detract from the substance of a work which is a thorough and depressing chronicle of multiple *trahisons des clercs*, of academe's ignominiously wilful self-betrayal in the service of a regime which had no respect whatsoever for learning but sought plausible foundations and excuses for its programme of enormities. Adolf Hitler, however, was dismissive of it. He did not require excuses.

Heinrich Himmler, until the last months of the war his most loyal servant, was more fastidious. Encouraged by Walther Darré he set up the Ahnenerbe in 1935. Its intention – and all its expeditions and projects were to the same end – was to establish the historical and prehistorical primacy of the Nordic or Aryan race and the inferiority of Jewry. Now, had their consequences not been so monstrous, this endeavour's procedures would, properly, be regarded as farcical and its personae as clowns.

Darré, who was born in Argentina, had developed an enthusiasm for eugenics as a schoolboy in Wimbledon and was convinced that humans might be bred according to the principles of a stud book. For an organisation devoted to ultra-nationalism, the Ahnenerbe was signally cosmopolitan. Finland, the Netherlands, France and Sweden were also represented among its ranks of runologists, musicologists, philologists, folklorists.

They were not in the least hampered by the scorn of the mainstream of European researchers or by the seemingly insurmountable problem that Aryanism was an English taxonomical whim of the late eighteenth century or by Himmler's belief that he was the reincarnation of a medieval king whose grave he had moved to a more propitious site or by any

of the lesser metempsychotics around the Reichsführer or by the collective acceptance of Hörbiger's World Ice Theory or by evidence-free new ageism or by Thor having been a living person with a hammer – treating myths as literal was part of a wider Nazi pathology.

The Ahnenerbe's renegade scientists measured skulls in Tibet, vandalised tumuli across Europe, attended pagan ceremonies on the far Baltic shore, sought Nordic remains in the Andes although, as everyone knows, this master race had descended from the North Pole. When the desired evidence was not forthcoming it could be manufactured at the Allach pottery factory. There was also a certain amount of espionage and informal diplomacy to be carried out while on expeditions: notably in the Middle East, where Muslim opposition to Jewish occupation could usefully be exploited. The mufti of Jerusalem would, infamously, subsequently raise an SS battalion and Nasser's Egypt was as uninquisitive as Argentina about the former careers of its German immigrants.

All pasts are to a degree invention. Those contrived by the Ahnenerbe's 'scholars' had a genocidal purpose. It was in the interests of 'research' and 'racial hygiene' that the most terrible experiments were conducted in the camps under the direction of doctors who had long ago lost sight of Hippocratic probity and who had embraced the inverted morality of Himmler – a man of a little learning, who, as a struggling chicken farmer, had come to believe in something called biological pest control. The lesson of the Ahnenerbe is that once we cease to believe in nothing, we will believe in anything. (2006)

Busby Berkeley's Black Mass

Speer: Hitler's Architect by Martin Kitchen and *Hitler at Home* by Despina Stratigakos

Luc Tuymans' *The Walk* shows Hitler and Speer silhouetted towards the end of day on the Obersalzberg. The photograph which the

painting is based on is mute. Tuymans' manipulation of it is any-thing but. His Hitler, the Führer, the guide, is indeed guiding, just. He is stumbling awkwardly towards the last of the light while the upright Speer holds back, following certainly, but cautiously, tentatively, allowing his idol and besotted patron first dibs on divining the future – which may of course prove to be less golden than the sun's shafts promise. What if the guide has lost his touch, can no longer read the entrails? Speer's detachment and poised ambiguity were not entirely affectations. He was a provincial snob who regarded himself, with cause, as belonging to a superior social class to Hitler ('never mastered the difficult art of kissing hands') let alone such freakish botches of Aryan manhood as Himmler, Göring, Ley and Goebbels.

It was easier than he expected at his trial for this aloof, offhand man to escape the scaffold by dissociating himself from the milieu at whose very centre he had occupied a favoured position for more than a decade, while smoothly inculpating its fellow denizens. There was nothing about his mien which suggested fanaticism or a capacity for grotesque cruelty. The ethical resonance of his appear-ance belied his ruthlessness, occluded his indifference to the terrible suffering he caused, masked his absolute bereavement of imagina-tion: he possessed a near-sociopathic absence of empathy, a careless incapacity to understand the consequences of his orders. He was actorishly handsome. This somehow rendered his barely credible expressions of ignorance plausible, it undeservedly gained him the benefit of the doubt, it irrationally supported his preposterous claim to be a morally neutral artist and technocrat rather than a mere armaments minister and slave driver.

Speer was lucky not just in his looks. His life was a trail of felic-itous opportunities which just came his way without obvious effort. Of course he strove to make his luck. But he had too great a sense of entitlement to be seen to scramble for preferment. He gave the

impression that he was the insouciant recipient of chance's benefi-
cence. He was, however, genuinely lucky to be rejected as a student
by the great expressionist Hans Poelzig. He was obliged then to
study, initially reluctantly, under the super-twee Heinrich Tesse-
now, whose precursively *völkisch*, Arts and Crafts saccharine he was
indifferent to, even though it would become the almost invariable
idiom of bucolic settlements, agrarian expansion and, on a larger
scale, Ordensburgen and Napolas.

Unastonishingly, Tessenow was keenly anti-modernist, going on
Luddite. Speer was impressed. He thus acquired a cast of mind and
gamut of tastes which would soon allow him to ingratiate himself
with Hitler, whose ranting in a Berlin beer hall prompted him to
join the NSDAP in January 1931, two years before the *Machtergrei-
fung*. During that period Speer became, *faute de mieux*, the impecu-
nious party's interior designer of choice. His willingness to work
initially without a fee eased his way. He was, too, lucky enough to
be the only party member in Wannsee who owned a car, a prized
asset with which to ingratiate himself during the constant election-
eering and manifestations of that time. His first client was the
future SS general Karl Hanke, then a local party organiser. As soon
as the NSDAP was in power, he was rewarded with a further com-
mission from Goebbels. Which in turn led to what was to be the
first cautious step towards the cathedral of light, at Tempelhof on 1
May 1933.

Tessenow slighted Speer with his scorn: 'All you have done is
create an impression.' The derision was prescient. Such was the sum
of Speer's artistic gifts. As much as anyone he created the potent
decor and ritual choreography of this most facade-obsessed regime.
He was less an architect than a Busby Berkeley with a penchant for
Black Mass. It irked him that the 'immaterial' light shows at
Nuremberg were reckoned his greatest achievement. In Spandau,
with time on his hands to rewrite history over and again, he deluded

himself that he would have produced a work to match the Parthenon had he not been appointed minister of armaments. But when he had been offered the post, he had not demurred, had indeed accepted with indecent alacrity.

This was the second job he owed to luck's efficacy in removing obstacles. Before Hitler fell for Speer, the leading contenders to be anointed architect laureate of the Third Reich were Paul Schultze-Naumburg and Paul Ludwig Troost. Schultze-Naumburg was the author of the Norman-Shavian Cecilienhof where the Potsdam Conference would be held. He was the author of *Art and Race*, a sniffer-out of degenerate art, an opponent of corporatism and decorative excess. His friend the racial theorist, eugenicist and future, ill-fated minister of agriculture Walther Darré wrote *Race: The New Nobility of the Blood and the Soil* at his estate near Jena. Both belonged to the primitive, woodworking, neo-peasant, maypole-hugging ideological left of the NSDAP, in which broad church they were about as distant from Speer as it was possible to be.

Schultze-Naumburg was unquestionably an architect. Troost was an interior decorator. Much of his career had been devoted to blinging the opulent state rooms of Norddeutscher Lloyd liners. Yet, as Despina Stratigakos observes in *Hitler At Home*, Hitler considered him 'the greatest architect to grace German soil since Karl Friedrich Schinkel'. Most members of the German architectural trade had, during the Weimar republic, turned to international modernism or expressionism. Hitler was hardly spoiled for choice among the few remaining revivalists. Further, Gerdy Troost, who had his ear, rarely failed to excoriate her husband's rivals. She appears to have single-handedly engineered Schultze-Naumburg's fall from favour in revenge for a catty comment made after her husband's early death. Learning that she was going to continue Atelier Troost he remarked: 'I would not let a surgeon's widow operate on my appendicitis.'

The beneficiary of these risible spats was of course Speer, the court favourite without portfolio who, such was his good fortune, had not had long to wait. He surefootedly negotiated the poison labyrinth of Nazi high command. Uniquely, he hardly needed to remind his many antagonists of his special relationship with Hitler. He was untouchable. Like his peers he built a kleptocratic empire within a larger kleptocratic empire. That was what was done. The boundaries of ownership between state, party and private were wittingly blurred. Procurement was haphazard. Agencies duplicated each other. Departments were perpetually engaged in internecine strife. Speer acquired the ability to convince himself that what he knew to be mendacious propaganda was true. This was a quality that he shared with Hitler, may even have learned from him. He knew better than to burst illusion's bubble. Till almost the very end he fed his patron a diet of welcome lies. The truth was neither to be accepted nor imparted. In this Speer was at odds with his predecessor as minister of armaments, Fritz Todt, whose pessimistic candour may have cost him his life. In Joachim Fest's estimation, 'his sense of reality particularly distinguished him in Hitler's entourage'. He had been in the habit of telling Hitler what Hitler didn't want to hear, specifically that the war on the eastern front was unwinnable. A dictator's *Weltanschauung* is necessarily not that of even his grandest minions, it is not an empirical construct susceptible to challenge or correction.

Todt died when his apparently sabotaged plane crashed on take-off from Rastenburg, where Hitler had his eastern HQ. Speer, en route from Russia, had happened to drop in informally and unannounced the previous day anxious to see Hitler after a gap of a few weeks. He was offered a flight on to Berlin with Todt but, having talked long into the small hours with Hitler, declared himself too tired to travel. Within hours of Todt's death Speer succeeded him. It all seems remarkably neat. The inconsistencies of Speer's accounts

of the crash and reactions to it multiplied with every telling. Whether he played any part in what was effectively an assassination has never been established. And, among the cannibalistic elite of the Third Reich, there was no shortage of persons anxious to be rid of Todt.

Speer's earliest war crimes had largely been restricted to evicting Jews from properties that Nazis coveted or which might provide shelter for the victims of bombing. He had also effected the demolition of many homes to make way for the bloated white elephant of Germania. These clearances were paltry beside the consequences of his work on concentration camps. He had no part in running them but it was part of his brief to get them built, to quarry and fire the materials. He was close to Himmler and enthusiastically subscribed to the Reichsführer SS's dauntingly simplistic policy of Annihilation Through Work. Those worn out by labour on such projects as an autobahn through the Ukraine were executed. Those who survived 'must be treated appropriately since by the process of natural selection they would form the kernel of a new Jewish resistance'. The childish brutality of these measures hardly accords with the post-war persona burnished during Speer's long lucubrations in Spandau. A persona which has had a toxic appeal for a particular sensibility – gullible, cheek-turning, risibly generous, smugly liberal.

Martin Kitchen does not possess that sensibility. *Speer: Hitler's Architect* is not a biography. It is a 200,000-word charge sheet. Kitchen is steely, forensically dogged and attentive to the small print. He shows Speer no mercy, nailing his every exculpatory ruse and demonstrating time and again how provisional the notion of truth was to him. This was a man who persistently invented and reinvented his past. His memory was biddable. He was clever in gauging the weight of guilt he would admit. He was certainly not so crude as to attempt to entirely exonerate himself: he calculated

the degree to which he could profess ignorance of this or that enormity. He differentiated between what it was known that he knew, what he knew, what he might have been expected to know, what he suspected, what was rumoured, what was kept from him, what was in the archives and what was not. This was, not that he acknowledged it, a game of his devising in which he toyed with a series of mostly awed apologists, interlocutors, historians, biographers, journalists, psychologists and groupies – who always lost.

They failed to rumble him as many of his colleagues had begun to in the Reich's death throes. Goebbels had his measure. He wrote: 'I don't believe Speer any more . . . he makes up for the missing airplanes and tanks with phoney statistical fairy tales.' Joachim Fest and Gitta Sereny were less willing to see through Speer. Fest deliberately overlooked material that was presented to him because it failed to accord with his biased conception of his subject. He knowingly wrote in bad faith. Sereny was unhappily predisposed to believe the best of anyone. Kitchen notes that she had form in this regard; her studies of Mary Bell and Franz Stangl 'show considerably more sympathy for the perpetrators than for the victims'. His work is not, however, untainted by that of his predecessors. He blithely concurs with them that this 'hollow man' (oh dear) was 'highly intelligent'. Here, once again, we are treated to the received idea about Speer, an assertion made without corroboration, indeed made in defiance of all that is now known about him. The grandly titled 'theory of the value of ruins' is hardly the conceit of a highly intelligent man. It is merely a truistic observation that an empire – the twelve-year, four-month Reich, for example – will, many millennia hence, be judged by the ruins of its buildings. As Hitler said: 'It is only through the art of building that a political order can experience its most beautiful immortalisation.'

And what of Speer's architectural intelligence? The remains at Nuremberg are tatty. 'Beautiful immortalisation' is not what comes

to mind. But then it's a stage without its players. The models of Germania (of which Andy Warhol and the Prince of Wales's adviser Leon Krier were fans) indicate that the twin attributes of his buildings were laughable vastness and imaginative impoverishment matched only by the basilica at Yamoussoukro in the Ivory Coast.

The title *Hitler at Home* promises an exciting war crimes edition of *House and Berchtesgaden*. It is actually an unfamiliar, diligently researched, illuminating account of the means by which a singular private and social life was invented. Stratigakos asserts that 'scholars of architecture and fascist aesthetics have focussed on monumental building projects and mass spectacle, overlooking the domestic and the minute'. This is unexceptionable. But leaving aside the knotty business of whether National Socialism ought to be described as fascist, the academic disregard for its quotidian vernacular architecture, which is every bit as 'representational' as the grandiose set pieces, is hardly going to be amended by scrutiny of the least typical domestic buildings in the Reich.

Until he was forty Hitler lived like a bohemian or ragged student. He believed such an arrangement was electorally advantageous when the NSDAP's appeal was chiefly to the working class. His move to a large, expensive apartment in the Bogenhausen quarter of Munich was met with accusations of hypocrisy. His niece Geli Raubal's suicide there provoked graver and more damaging newspaper coverage, in response to which he embarked on a vigorous PR campaign, bogus going on mendacious, which emphasised his normality and the modesty of his home life (by a dictator-in-waiting's standards).

After he came to power the Atelier Troost set about creating interiors which suggested respectability, solidity and propriety which 'had nothing to do with a dangerous radical'. They were costly and dull. Gerdy Troost, a court favourite of whom Speer was wary and Hitler's sometime walker, had the knack of second-guessing his petit-bourgeois antipathy towards anything that might be considered

bad taste. He had a horror of kitsch which he was capable of discerning in the most improbable devices. If the Berghof, the grossly distended chalet on the Obersalzburg, was decoratively understated, it was nonetheless fitted out to satisfy a rich man's infantile tastes. There was, for instance, a basement bowling alley. That, according to his valet, was the only exercise he took 'except for the expander under the bed', a detail unsurprisingly absent from the photographer Heinrich Hoffmann's *The Hitler Nobody Knows*, foreword by Hoffmann's son-in-law Baldur von Schirach: 'his library of 6,000 volumes, all of which he has not just leafed through but read'. This volume set the sycophantic tone for dozens of others. Hitler the Yeoman Seer takes inspiration from mountains, he feeds animals, he holds hands with kiddies, he strides out with dogs (inevitably loyal) while Hitler the Photo-Opportunist receives the world's press in the sure knowledge that journalism feeds off journalism, that American *Vogue* could be relied upon to publish gushing drivel which would spawn more drivel. The rather less vacuous Social Democratic paper *Vorwärts* said: 'The great Adolf has spent the better part of his life having his picture taken . . . this is how Adolf has worked quietly for his people and satisfied their desire.' It was closed down in 1933.

Among Hitler's most doting fans was the Anglo-Irish devotee of Strong Men, William Fitzgerald (aka Ignatius Phayre), who wrote about his idol for, inter alia, *Country Life, Current History*, American *Kennel Gazette*, single-issue publications with a tenuous grasp of political morality and a mostly unquestioning readership. The note that Fitzgerald and many other dutifully credulous journalists struck was remarkably consistent and testifies to the manipulative efficiency of Hitler's publicity machine. The same words recur: destiny, toil, youth, culture, music, authentic, sacrifice, oh the sacrifice. That publicity machine was also sedulous in courting useful idiots, none more useful than Lord Rothermerde, who happened to own a newspaper and whose potential as messenger boy to the British

establishment Hitler exploited, just as he exploited the *New York Times Magazine*, which on 20 August 1939 enthused about his love of chocolate and gooseberry pie and his rapt attention to the petitions of 'widows and orphans of party martyrs'.

Plenty more of those presaged in the clouds. (2016)

16

Obituaries

Muse and moral dandy

Lesley Cunliffe, 21 May 1945–28 March 1997

Lesley Cunliffe was an exotic, an adventuress, a dilettante, a dandy. She died on Good Friday, aged fifty-one, with a timing that would have appealed to her appetites for self-dramatisation and for ecstatically morbid Catholicism: she was born to that faith and had returned to it in the last five years of her life with a conviction that was all the stronger for her appreciation of its camp irreason.

She was peripatetic, a beauty, a woman of singular verve and wit, who lived, in a way that had been unusual among her generation and milieu, through men: only three weeks ago she said, 'I don't seem to be dying quite yet – who shall I marry next?' She was muse rather than maker: she wanted to be the latter but something always got in the way. It might be her chronically low self-esteem, her fretfulness, her aptitude for too many bright ideas and too little resolve to see them through – or it might be her latest beau.

She was determinedly discriminate in her choice of men and it's appropriate that the last piece she ever published was about her precursor Barbara Skelton, who entwined, inter alia, Derek Jackson, Cyril Connolly and George Weidenfeld. But Cunliffe was

not poisonous the way Skelton was, and quite lacked the seemly heartlessness which is the *sine qua non* of the career femme fatale.

She was generous to a T, a perpetual innocent, and though she was not impervious to the lure of name, she was far too easily bored to frequent any other than bohemian society. Though she often worked at such forcing grounds of straitenedly orthodox snobbery as *Vogue* and *Tatler*, she was wayward, original and airily dismissive of others' conformist hierarchies: she had her own pantheon and was loyal to it.

She was born Lesley Hume in Springfield, Massachusetts. She was farmed out for months on end to her maternal grandparents, who led a quasi-colonial life in Mexico. When she returned from one unusually long sojourn there to her school in the all-Wasp town of Bronxville, Westchester County, she had blossomed into a startling adolescent – which earned her the envious resentment of her classmates; boys, of course, reacted differently.

Her first boyfriend was John Sebastian, who was later to form the Lovin' Spoonful and to compose such songs as 'Younger Girl'. After a year at a liberal, progressive university in Vermont, she headed north to Alaska with her new love, Eric Saarinen (son of the architect Eero). He made films about bears. Her self-creation began in earnest, however, when she moved to England in 1971. She had met and married, as the second of his three American wives, the literary and military historian Marcus Cunliffe, who more or less invented (non-uxorious) American studies in this country and held a chair at Sussex University.

He was twenty-three years her senior. Nine years later she was living with Craig Brown, who was twelve years her junior. In between times she had suffered TB, become a thirty-something punk, shacked up in an insanitary squat. The lurch from a man in his late fifties to one in his early twenties was characteristic; so were the moves from urban boxes to bothyish cottages in the middle of piggy fields. She left Brown for Jonathan Raban. She subsequently

referred to him as Rabies – out of animus rather than from homo-phonic playfulness.

The last protracted relationship of her life was with the cartoonist Michael Heath. It endured almost a decade and was what is called stormy – i.e. doting, cruel, mutually abusive, passionate, frequently conducted in a state of alcoholic extremes which, happily, turned to alcoholic oblivion the next day. Jeffrey Bernard remarked: 'I wish I'd got to her first. I could have saved her from all that.' But of course Lesley did not want to be saved. Eschewal of excess would have been a kind of dishonour, as would espousal of the sort of behavioural norms which she had left behind in middle America: like Princess Margaret she invariably drank whisky throughout a meal, smoked between mouthfuls, spoke her mind.

If her career was all fits and starts and false dawns, it was only because she put her talent into her life rather than into *Harpers & Queen*, or the *Sunday Times*, or the *TLS*, or the *Evening Standard*. And if her life absorbed her talent, her death occasioned a streak of genius. From soon after inoperable stomach cancer was diagnosed sixteen months ago, she processed towards death with a grave curi-osity and wonderfully weird stoicism: 'How are we going to make this fun?'

She prepared in style, as though her demise was the culmination of a most subtle, serene and defiant work of performance art. It was inspiring to behold so bold an act of moral dandyism, one which gave meaning to the void ahead. (1997)

Matron to anarch
Jennifer Paterson, 3 April 1928–10 August 1999

My 1950s were full of Jennifers. I mean that, although she was formid-ably individualistic, evidently inimitable, a one-off, *sui generis* and all that, she was those things at a personal level. Socio-economically she

was a type, almost the last of a type: she was getting on for a generation younger than her precursors who were my mother's age, b. 1910–15. I grew up surrounded by these Jennifers. My mother collected them and might, I suppose, have been like them had she not had a husband. They were spinsters, war widows, divorcees – a rare breed in those days. One had even born an illegit (an ugly epithet but the contemporary usage). They were powerful characters, middle or upper-middle class by birth, intelligent, outspoken, defiantly untwee, mostly deficient in formal education, mostly unqualified for anything other than the housewifery which had lately eluded them.

Despite the presence offstage of well-heeled and often fairly grand relations, they were perennially on their uppers. Occasionally there was talk of a man friend, but these men friends were invisible men. One, a radio producer, had more than one man friend and led a fast life – I knew this because her home, atypically, was a flat, and flats still retained the etiquette attached to them sixty or seventy years previously. More usually they tended neither to own property nor to have a sufficiently reliable income to rent. They moved around a lot, taking live-in jobs or ones that at least provided accommodation:

Matron at a public school for boys who couldn't get into the public school of their parents' choice, perhaps: a position which my father jocularly and ungallantly ascribed to Doreen P——'s having been the headmaster's 'groundsheet' when he was a naval officer.

Companion to an author of a certain age: for four Christmases on the trot my parents received an effusively signed copy of Compton Mackenzie's latest, but then Lucy H—— left his employ to move back south and that particular strain of unreadability ceased.

Now and again one might demonstrate her entrepreneurial ineptitude by helping to open a language school or lending a hand at running a pub and ending up even more out of pocket than when she had embarked on the misadventure. As Muriel Spark had it: all the nice people were poor. And they sometimes had to do a flit.

Gentlefolk? Maybe. But distressed – never! For all their pecuniary worries and their concerns that the covert sources of school fees might dry up, they were a spirited bunch who signally disallowed themselves outward signs of despair. Putting a brave face on it was in the grain. The next cloud would be the one. And in the meantime there's always gin and It, Seniors, the races.

The correspondence between Jennifer and these occasionally calamitous women may be frailer than I suppose. (I am not after all certain that the standard CV presented in the papers as a profile with its standard accompaniment of a Greek beach photo was anything more than the usual accretion of former cuttings.) But I initially met her long before telly celebrity was thrust upon her in the last three years of her life, long before the papers had to recycle each other's half-truths to explain the season's cathode phenomenon. And from the first she struck me as being like the younger sister of one of Mummy's *galère*, which had by then seemed to evaporate. Jennifer already possessed a sort of parochial celebrity, one based on acquaintance rather than mediation, manipulation and illusion. She was an off-centre cynosure in whatever milieu she found herself. In the milieu where I first encountered her there was plenty of competition.

Round new year 1967, through a friend who was going out with the elder, I was introduced to the orbit of two Persian sisters. They lived in a cramped, overheated conversion in Cadogan Gardens with their mother, whose specialities were big sulks and pungent stews. They were forever trying to escape her presence and their smells, so spent much of the day walking the King's Road, hanging out in the Picasso with hirsute mutts, lunching in the Casserole with velvet mutes. For their part they wore cwts of kohl, pioneeringly short skirts and floppy hats. Late in January when I rang, their mother told me they had returned to school.

School! That two such exotics should do something so mundane as attend school was near inconceivable. But then, as I was to

discover, Padworth College was no ordinary school, even if it did occupy standard-issue private educational premises, a large dour Georgian house near Aldermaston. Otherwise it rather broke the mould. Or, rather, if it had models they were fictional: Ronald Searle's St Trinian's and Roger Longrigg's Passion Flower Hotel. The pupils were all girls between the ages of about fifteen and nineteen, the majority of them from outside Britain.

A current member of the staff told me: there is an international aspect to the college. I didn't enquire whether young male teachers are still permitted to exercise *droit de prof* over their pupils or whether the weekend curriculum still includes bacchanalian parties like those which the dumpy, distrait headmaster Peter Fyson would pass through deep in conversation with Bernard Levin and quite oblivious to the drunkenness, joints, couplings and other teenage staples.

Presiding over the ad hoc saturnalia was the college's matron whom, much as I enjoyed the licence of these singular events, I adjudged to be both entirely unsuitable for that post and just the matron I'd like to have had at school. Matron was Jennifer. She was imposing, boozy, brassy, bonhomous, loud, and she clearly considered that keeping her charges on the straight and narrow was not part of her remit. Indeed, rather the contrary.

I can't have met her more than three times in her matron guise, but I still wonder at the sheer improbability of her having ever obtained the post. Maybe Peter Fyson had a perverse sense of humour, for Jennifer was no more interested in youth as a generality than she was in monkeys or soldiers or circus clowns: she pronounced herself uninterested in children but was captivated by my daughter Lily's precocity and Jesuitical ratiocination.

She was capricious, she liked according to criteria of her own devising, according to how taken she was by an individual's

quiddity. Which is not to say that she was insensitive to name or to status. But in the hermetic world of that bizarre school she didn't bother to dissemble her affections or antipathies. The very force of her presence daunted some of the girls. Others among them must have been misled into believing the notion that the English are indeed as eccentric as they are reputed to be, something which familiarity with the breed suggests is founded in national self-delusion rather than in actuality: still, if you were sent here to learn English at a country house in Berkshire and encountered Jennifer you could not but be confirmed in your prejudices.

She was welcoming and generous towards me because (a) I was voluble – I never learned the mores of silent cool that were de rigueur on the King's Road and (b) I was at RADA and was green enough not to have yet begun to loathe what would, two decades later, come to be called luvviedom: I was still in thrall to the idea of acting and this rendered me an object of some fascination to Jennifer, who did not, I am pretty sure, refer to her own brief spell in the theatre but devoted herself to imagining an ideal role for me – she hit on the alluring psychopath Danny in Emlyn Williams' *Night Must Fall*. She could flatter all right.

Some time in November 1978 Terry Kilmartin, the literary editor of the *Observer*, for which paper I then worked, commissioned me to compose the Christmas quiz. No sooner had I delivered it than Terry discovered that Donald Trelford, the editor, had commissioned a quiz from Christopher Booker. I was thenceforth decommissioned and had to sell mine elsewhere. Thus I happened to be at the offices of the *Spectator* early one afternoon correcting proofs of a hundred questions and answers in a freezing room while from a floor up came the hoots and cries, burps and farts of gentlemen at lunch. At some juncture, round about the time of the tenth cognac course, one of the gentlemen remembered that a minion was slaving downstairs: Geoffrey Wheatcroft fell into the freezing room,

generously banged down a couple of bottles of wine and did his level best to articulate the sentiment that these might help.

An hour or so later Jennifer processed through the door with a cup of coffee for me. We did not immediately recognise each other. She had by now achieved a semblance of the appearance that she would retain for the rest of her life. She was unimpressed that I had quit acting when I finished at RADA, even more unimpressed that I worked for the *Observer*, which she regarded with a distaste that was genuine. But that would figure; she was tolerant of most traits save priggishness: I'll never forget the face she once made, like that of the world's most sourly malevolent child, when the name of the Ur-Prig Blair was mentioned.

The yelping and whooping had rather abated, they were getting tired in the playground. Jennifer went back upstairs to egg them on in her role of anti-matron.

Jennifer was a touchline anarch who enjoyed watching others get their retaliation in first. She cut such an extraordinary figure that it was easy to overlook the fact that she was, for most of her life, a deuteragonist rather than a main player. Her wit was considerable but it was reactive rather than initiatory. Drink coarsened it, always does. But better that than periphrasis. She never stooped to euphemism. She was a bit on the truthful side for certain tastes. She didn't set out to offend, and rarely did. But she did ridicule and she did embarrass – she was more a mocker than a hater. I can think of one poor sod, an academic not so much sensitive as uptight, whose invariable reaction to Jennifer's calling a spade a spade and a fairy a faggot was to contort his face in a rictus that summoned up Edward's at Berkeley.

Just as Jennifer achieved at the age of fifty an immutable look, so did she achieve an immutable mentation and set of attitudes or affectations – there's not so much difference between the two, we grow into our affectations, it's the means by which we create

ourselves. Once Jennifer had created herself she didn't tinker much with the result. The world changed around her and she eagerly neglected to keep up. She may have enjoyed stasis, may even have enjoyed presenting herself as a throwback to a golden age of her own whimsy when mass had rhymed with arse and people still talked of receipts: these were actually a couple of affectations to which she lent such emphasis that I wonder if she ever really did grow into them.

Jennifer was usually more convincing in her locutions. En route to a party in Somerset I took her to meet Alan Yentob at his medieval house outside Bridgwater. This was soon after *Two Fat Ladies* had become a hit. 'Which one is she?' Alan whispered urgently as Jennifer got out of my car (which she had instructed me to drive at 100 mph so that we did London–Bristol in under ninety minutes). Jennifer was taken by the place, by Philippa, by Alan. By the next time I saw her they had met on a few further occasions and they were clearly mutually appreciative (gourmand, generous, gregarious, socially adept, party-going, loquacious, etc.). She referred to him as 'your nice little Jew'. This would no doubt be taken by the Ur-Prig's government as further conclusive proof that the elderly are conservative and 'racist' rather than as the expression of unmitigated affection it was intended to be, an expression which would have passed unnoticed by the generation Jennifer belonged to by preference if not by age.

Most people who appear on telly want to be on telly so badly that they are willing to do anything to be there, they're happy to make ingratiating berks of themselves. It was Jennifer's good fortune that she was able to give the impression that she was indifferent to what anyone thought of her, that she didn't mind whether or not she was adored. Her demeanour spelled it out: this is what you're getting, like it or lump it. This of course was merely a facet of her performance. She was as eager to be there as she was to play down that eagerness, whose extent may be measured by the fact that she

accepted a grotesquely paltry fee for her first series. Or maybe she simply didn't know what she should have been paid. The worldliness which informed her observation of the human circus did not extend to pecuniary affairs, her instinct for material was not sharp. Which makes it so satisfying that she belatedly hit the jackpot – though, as I told her during the last lunch we had together a few weeks before she died, being the beneficiary of the Terminal English taste for cooking as entertainment was like taking candy from babies. She grinned in cordial agreement. (2001)

The man who made food hot

Alan Crompton-Batt, 23 March 1954–21 September 2004

The all too visible faces of the restaurant boom of the past twenty years belong to two seldom overlapping cadres: a gallery of genuinely gifted chefs and a gang of telly chefs. These persons of chasmically differing aptitudes and aspirations are however united by their overkeen sense of their worth, their formidable *amour propre* and their insatiable appetite for publicity. An appetite which has been cravenly pandered to by a massively indiscriminate and untutored media. Gastronomy and restauration are areas of endeavour in which anyone and everyone is reckoned to be expert. Ignorance is no bar to success. The cricket commentator who admits to not knowing what a googly is; the fashion editor who boasts of never having heard of Schiaparelli; the political columnist who doesn't care about confusing Crossman and Crosland: these are improbable figures – or people talking themselves out of a job. Yet the food 'writer' who believes wasabi to be mustard or states that sweetbreads are testicles or counsels that bouillabaisse can be made from North Sea ingredients is a commonplace.

No one understood this better than the tireless, ubiquitous PR Alan Crompton-Batt, no one exploited the institutionalised vacuity

of Britain's gastronomic press with more gleeful gusto – and no one more regretted this woeful status quo.

Alan Crompton-Batt was a most unusual man and a most unusual PR. His was – to the public at any rate – the invisible face of the restaurant boom. That he single-handedly invented modern restaurant PR in this country is indisputable. That PR should be the most professional, most accomplished part of restauration in this country is, inevitably, seldom acknowledged. For, after all, the PR cannot blow his own trumpet; the media which owe everything to the PR are unwilling to admit to that debt; the restaurateur/chef is so consumed by his genius and acumen that he too stays shtum.

Crompton-Batt's achievement was, however, more than the invention of what might seem like an overblown adjunct to restauration. He went further. In many instances he created what he would subsequently represent. He manipulated his clients as much as he manipulated his press: and it was his press. He assiduously courted editors and encouraged them to devote space to his product, to appoint restaurant reviewers, to commission food features. He was astonishingly successful. It would be going too far to say that an engagingly enthusiastic cynic such as Crompton-Batt ever idolised anyone – but he was much indebted to Andrew Loog Oldham. He unashamedly attempted to apply the Rolling Stones' first manager's precept that 'We piss anywhere, man.' In his early twenties he ran a punkish band called the Psychedelic Furs, but gave up on them when he discovered that such a job mainly entailed being a sort of therapist to teenage egos. He realised, though, that cooking and chefs and restaurants were susceptible to the same shock treatment. He was also indebted to the *Sweet Smell of Success*.

He was, however, far from the caricatural, boorish PR schmoozer. He was courteous, funny, subtle, witty. His own success was due to a baffling combination of opportunism, genuine

charm, hard-nosed prescience and a scholarly, near encyclopaedic knowledge of gastronomy and restauration. Indeed he possessed such a knowledge of countless topics. However, he wore it lightly. During the years of his pomp he had around him a quasi-harem of beautiful, young, well-connected women – Rebecca Churchman, Victoria Ewing, Catherine Fairweather and Elizabeth Moody, whom he married in 1987 – which rivalled that of Naim Attallah.

His initial contact with the world which he would inhabit for the rest of his life was, improbably, as an inspector for the Egon Ronay Guide: a spell during which he let a room in his rather grand north London mansion flat to his fellow inspector, the future chef Simon Hopkinson. His first client as a PR was a very different chef, Nico Ladenis, a peerless craftsman whom Crompton-Batt reinvented, encouraging him to behave as an intemperate monster. It was an unconvincing impersonation. But it made news. The bad-boy chef was born. The better the chef the worse he behaved. Marco Pierre White and Gordon Ramsay leaped from the same mould – living, breathing, cussing clichés. But as his creations prospered so did he flounder. He admired and bonded with Jeffrey Bernard. They were introduced at an epic lunch in the Ivy: Jeremy King recalled that had they been ordinary punters they'd have been thrown out five hours before they actually left.

Alan Crompton-Batt enjoyed a peripatetic forces childhood which was gastronomically enlightening. When his father, an RAF officer whom he adored, left the service, he bought a grocery store called Russell Chinn in the culinary desert of Salisbury. He didn't prosper. As his son would, he died in middle age. Alan was educated at Bishop Wordsworth's School in that city, to which he would sentimentally return, only to remember why he wanted to leave it and hit the big wide world. (2004)

Spirit of the night
Liam Carson, 23 May 1954–6 July 2005

The Groucho Club was established in 1985 by a group of publishers and literary agents, the majority of them women. They wished to create a place which they would themselves find congenial. A place which might occupy the chasmic gulf between the grim, pompous, buttoned-up 'gentlemen's' clubs of St James's and the squalid old Soho drinking clubs such as the Colony and Gerry's, where alcoholism was de rigueur and world-famous painters and actors peed on their shoes and addressed each other by pudendal sobriquets. The best laid plans . . .

The model for this venture was the Zanzibar, on the Holborn fringe of Covent Garden, which during its short life in the late seventies and early eighties had attracted – had perhaps even created – a clientele which belonged to a recognisable if yet undefined caste. Publishers don't actually run clubs. So the entrepreneurs behind the Zanzibar – Tony Mackintosh, the architect Tchaik Chassay and the wine merchant John Armit – were sought out to bring some sort of professionalism to the Groucho. They in turn brought in as the general manager Liam Carson.

This was an inspired choice. For the next decade Carson, more than anyone else, more certainly than the actors and writers habitually associated with it, set the tone of the place. Rather, he set the nocturnal tone of the place. In his early thirties he retained the looks of an unusually dissipated cherub, and carried with him a faint but distinct whiff of danger – and the inchoate prescience of future self-destruction. He was, unmistakably, a deep-diver, a hedonist who led by example yet who knew very well the price of libertinism. It is hardly surprising that Carson should have served a rackety apprenticeship with another lapsed Irish Catholic, Peter Langan, whom he rather perversely regarded as a sort of exemplar.

Liam Carson's mien was similar to that of many people in his trade. He drifted into the world of bars and restaurants by chance. After dropping out of Bristol University, working as a hospital porter in that city and abandoning accountancy articles, he found himself sharing a London flat with a group of people that included Chris Corbin, the future proprietor of the Caprice, the Ivy and the Wolseley. Corbin got him a job as a washer-up at the Blitz Club. Such was the turnover of staff that he became manager within a few weeks. He then went to work with Corbin at Langan's Brasserie, which was in 1977 the hottest restaurant in London. The kitchen might have been baleful but that was no more a drawback to its success then than it is today.

The point of the place was that it was a circus of misbehaviour. The manager Andrew Leman was the ringmaster while the owner was an antic and not invariably benevolent clown. Langan's champagne-fuelled feats – performing cunnilingus on customers he liked, pouring wine over those he didn't – became the stuff of urban legend. Carson learned quickly. Perhaps too quickly, for no sooner had he been appointed assistant manager than both he and Leman were dismissed behind Langan's back by his surly business partner, the chef Richard Shepherd. But Carson was now hooked on a life of late nights, perpetual parties, intoxicants. He went to work for the extrovert American restaurateur Bob Payton, opened a couple of theme outfits for him, and then moved on to Richard Branson's Roof Gardens with its clientele of Middle Eastern wide boys and their paid escorts.

He had so far worked in establishments that were gastronomically indifferent. This rankled: Carson was both gourmet and gourmand. The Groucho was, in this regard, a challenge for him. And while he was seldom able in either of its restaurants to achieve a persistent consistency that satisfied him, he proved himself an astute judge of chefs, organised countless one-off lunches and dinners, and

embarked on a complementary career as a culinary contributor to Robert Elms' BBC London radio show and as a food writer for *GQ*, whose editor, the late Michael VerMeulen, might, according to Carson, have lived had he kept himself fit by partaking of vigorous sex rather than passively relying on fellatio.

During the day the Groucho was akin to a trade fair. Dull journalists and dull 'creatives' pitched derivative articles and second-hand formats to dull editors and dull producers. Craig Brown called the former 'projectiles' – ever ready with a project to projectile-vomit over anyone who might listen. These long days were alleviated only by such drunken miscreants as the (by then also literally) legless, wheelchaired Jeff Bernard and Daniel Farson, who, despite his friendship with Carson, had his membership cancelled when one of his rent boys ransacked the rooms of other guests. When Farson was readmitted he peed against the bar, perhaps believing himself to be in the Colony. Carson argued on his behalf that this was not unreasonable given that he would probably have fallen over and injured himself on the way to the toilet. But he was again banned at the behest of members whom Carson regarded as over-squeamish killjoys.

At night things were different. The behaviour that was normal would not have been acceptable in a suburban golf club. But then the Groucho was not, is not, a suburban golf club. Under Carson's benign, louche, amused eye it became – famously, notoriously – a zone of tolerance, and a better party than Langan's ever was. By the mid-nineties attendance to the milieu which he himself had largely devised was taking its toll. His wife Gabby insisted he should quit. They moved to the *arrière-pays* of Nice, near the Verdon Gorges, where he attempted to write a sitcom. But occasional journalism and hanging out with slumming writers are no preparations for composition itself – and whatever other aptitudes the indefatigably gregarious Carson possessed, disciplined solitude was not among them.

On his return to England he embarked again on a peripatetic career in restauration. He was one of the group that, with Damien Hirst, set up Pharmacy, a venture which he realised from early on was liable to prove ill-starred because it was too founded in fashionability and gimmickry: his restaurative instincts were thoughtfully conservative. Plans to open a pub serving simple food in rural Norfolk came to nothing. Later he worked at Levant in Marylebone and at a short-lived enterprise overlooking Leicester Square. But he never recaptured the exhausting *joie de vivre* that he had enjoyed and suffered during the decade he was the greatest of London's professional hosts, and one to rank alongside Muriel Belcher, Rosa Lewis and Peter Langan. (2005)

Something and nothing
Alain Robbe-Grillet, 18 August 1922–18 February 2008

Alain Robbe-Grillet died in Caen in the early hours of Monday 18 February. By the end of that day *le vioc terrible* had posthumously established a thriving, pan-European cottage industry devoted to his valediction. Artisan moralisers, celebrity denouncers, AOC provocateurs, free-range score settlers, craft-based bashers, grand cru groupies. They all had their say and are continuing to have it. Precisely . . . so long as he is being talked about, his shade can rest happy. As in death, so in life.

The daughter of Nathalie Sarraute and widow of Jean-François Revel, Claude Sarraute, responded to Robbe-Grillet's death with what she evidently reckoned to be righteous ire. In fact, she conducted herself like an *idiote savante* who unwittingly hits most of the nail on the head. She told *Le Nouvel Observateur* that Robbe-Grillet had nicked everything from her mother, was a self-publicist who had exploited a literature invented by her mother for his personal profit in American universities, had based his *Pour un nouveau roman*

on her mother's *L'Ère du soupçon*, and would go to any lengths to attract attention.

Now, this inventory of charges is both damning and broadly indisputable. But Sarraute has quite overlooked her late husband's dictum that there are no schools, only talents. A truth which should be self-evident but which is subjugated by the ineradicable tendency to classify, to ascribe artists to particular movements, to think in terms of genres, to survey creative endeavour in, so to speak, communitarian rather than individual terms. This is difficult to ask when artists congregate in cosy squadrons, give themselves a collective name, publish manifestos, enact aesthetic legislation, issue compositional edicts.

Robbe-Grillet may have been proudly amused to be known as *le pape du nouveau roman* – a second-hand sobriquet borrowed from André Breton, *le pape du surréalisme* – but it caused him to be defined as a literary politician, a spokesman, a figurehead, an aesthetic tyrant whose theoretical essays had the disastrous effect of instructing an audience how to read his texts. Most of the best of these texts had appeared before *Pour un nouveau roman* was published and so, too, had his two greatest films. I had chanced upon *L'Immortelle* and then – thankfully, innocently, unsystematically – sought out *L'Année dernière à Marienbad*, *La Jalousie*, *Dans le Labyrinthe* and *La Maison de rendez-vous* before I was aware of the existence of *Pour un nouveau roman*. I didn't know what I was meant to make of these films, which had the movement of dreams and nightmares, or this wonderful insidious prose that seemed like it was releasing something that was already there, in your head, occluded in its deepest vaults.

I thus didn't know there was no psychology in his work, because the depiction of impotent jealousy in *La Jalousie* seemed horrible, painful and psychologically acute. I didn't know there was no characterisation because the pimp or protector in *L'Immortelle*

was immediately recognisable as a hideous character. I didn't know there was no emotional affect because the soldier's plight – lost, mistrustful, seeking shelter in a snowbound city – in *Dans le Labyrinthe* is so vividly realised, so elemental that it's harrowing. *Marienbad* was as hopelessly, mysteriously, swooningly, endlessly romantic as Chateaubriand. I didn't know a writer is someone with nothing to say because Robbe-Grillet said so much, with such gleeful obliquity and with no recourse to an editorial voice. His work evoked moods, provoked unprecedented states of mind, forced its readers to look anew at the physical world.

But all this was a long time ago. He was the supreme novelist of *les trente glorieuses*, France's thirty years after 1945. And he would come to be regarded as the supreme self-parodist *of les trente moins glorieuses*, an ancient modernist, a drummer for a dissipated avant-garde, a salesman with nothing left to sell. The propagandist is supposed to have vanquished the artist. His luminous early work is alleged to have been buried beneath his arty pornography and his very public reputation, both as a libertine adept of S & M and *échangisme* with a famously open marriage and as the contrarian who broke the boundaries of taste as he had once broken those of style, has proved too much for the squeamish. This was the Robbe-Grillet who has been lately written about. One imagines he is grinning all the way to hell at one literary journalist's inane observation that because his last book, *Un Roman sentimental*, included graphic descriptions of child rape and incest 'he has blown his farewell'. Really? Memories are short and taste has changed. It is not just in the Anglo-Saxon countries that publishers have assumed that readers crave 'accessibility', that is, being told what they know already. It is not just in the Anglo-Saxon countries that restrictive prudishness and sexual correctness have reasserted themselves.

In the autumn of 1970, I braved the CRS who were out looking for trouble during the trial of the Nanterre rabble-rouser (and,

predictably, future minister) Alain Geismar. My destination was a party to which I had been invited by a girl who worked for *Les Éditions de Minuit*. Robbe-Grillet would be there. And so he was. I got my five nervous minutes, drooling to him as many had drooled before me: the bogusness of omniscient narrators, the necessity of writing in the present tense, the futility of linear narrative and so on. He heard me out, then asked with a delightful smile and his hopeful hands held about 30 cm apart: 'Just how short are skirts in London this winter?' (2008)

Piloti and polemic
Address to the Twentieth Century Society remembering
Gavin Stamp, 15 March 1948–30 December 2017

Gavin was a multitude. He was many men. The titular man of Hardy's poem 'A Man' is offered work as a hired dismantler of a noble Elizabethan house:

> No wage, or labour stained with the disgrace
> Of wrecking what our age cannot replace
> To save its tasteless soul –
> I'll do without your dole. Life is not much!

This may of course exaggerate Gavin's position. He didn't adopt the Bobby Sands Diet Plan. His weapon of protest was not dirty. It was prose, limpid prose, which could be absolutely venomous. It was not a means of making friends. He was concerned to tell the truth rather than to make salon compromises. He was the kind of writer who did not dilute his opinions to suit an audience or readership. He was the kind of writer who believed that if he was not giving offence to someone or other, he was not doing his job.

Historian, above all historian, scholar, campaigner, journalist, researcher, traveller, dragoman, draftsman, a trustee of this society

and its sometime chair . . . in all these roles he exhibited a scrupulous integrity.

Gavin, like any sane, reflective person, was fervidly opposed to Brexit, to the willed isolationism, to the philistine cutting of social and cultural ties that unite and link. They are not chains. He wrote, prophetically and pertinently, that 'men with no sense of history have no confidence in the future'.

He wrote of xenophobia, its causes and its propagators: 'Nothing is more international than nationalism.' The specific nationalism he was discussing was that of Finland which, when it was still a grand duchy of Russia, was attempting to proclaim its exceptionalism through the work of Lars Sonck, endowment unknown, Jean Sibelius and the elder Saarinen, both of whom, Gavin delightedly reminds us, were unusually impressive performers in what we must call the gentleman quarters.

The irony of what became known, in Finland and the Scandinavian countries, as national romanticism is that this highly mannered form of architectural expression was very close to the highly mannered architectural expressions of other states and regions which sought autonomy or secession or simply an idiom to call their own: Catalonia, Lorraine, Bohemia, Georgia. They all prove Gavin's point. He could confidently dismiss the discernment of national characteristics in buildings as bogus and divisive because he was familiar with the march of the Gothic, which plonked down German cathedrals in the Meseta of Old Castile and in Bordeaux; or, say, neoclassicism: the Parthenon is to be found in Nashville, Tennessee and on the banks of the Danube downstream from Regensburg; or, subsequently, international modernism.

Architecture like poetry is founded in copyism and plagiarism — both vertical, looting the past; and horizontal, stealing from the present. The obscure past, of course, and the geographically distant present. But both stratagems are increasingly threatened by ever

speedier, ever more proliferating means of reproduction. The well is dry. Little remains to be ripped off. Much remains to be destroyed: why bother with preserving a building or a landscape when there exist millions of photographs and videos to lend it virtual life. Among Gavin's pejorist fears was that of Mrs Thatcher's vision: 'the Green Belt covered by Barratt Homes'.

Thatcher was one of Gavin's *bêtes noires*. He was among the most vociferous opponents of the new British Library – a late work of Italian fascism – and of what the British Museum – a fount of jargon and illiteracy – calls the 'reimagining' of the reading room. Thatcher was persuaded to approve all of this by Sir Fred Dainton, a fellow chemist, fellow philistine and supreme committee man who accused the objectors of not using the room or having passes to it: which is akin to stipulating that only an observant Christian has the right to deplore the destruction of a church.

The Church, upper-case C, the Church in England – not just of England – the Church, whether it be Anglican, Catholic, Best Ever Redemption, Shiloh Metropolitan or what have you, was a persistent irritant to Gavin and a source of his contempt. For the Church failed, still fails, to appreciate its churches, lower-case c. It regarded them as encumbrances, like jabbering incontinent relations who should be shipped to Switzerland for Dream Topping or the Ultimate Sleepover. The clerics with whom Gavin was once friendly in the late seventies and early eighties were exceptions to the anti-aesthete norm. They were Anglo-Catholic ritualists who defended exquisite buildings and relished the language of the King James Bible. I ran into one of them after a number of years. Where once he had worn the garb and gaiters of a Victorian bishop he was now in mufti, if you can call Savile Row and Jermyn Street mufti. He told me that he had entirely lost his faith and was determined to make up for it by living well. When I reported this to Gavin, he was astonished: 'He never had any faith – he liked the clothes.'

He wrote of Stephen Dykes Bower's work at St Edmundsbury cathedral, a perhaps over-promoted parish church: 'The sadness is that the scheme is unfinished: the completion of the tower and cloister were halted in 1970 by a new bishop, Leslie Brown, who felt it more Christian to spend the money of the Faithful in Africa than on new architecture. Had his medieval predecessors felt the same, the Church of England today would, of course, lack the visible structure and presence given to it by fine buildings.'

Brown's previous diocese had been Uganda, where Anglicanism's role was different: pastoral, pedagogic. And thanks to the power and persuasion of his Christian mission that country was spared the tyranny of Idi Amin.

'As a man,' wrote Gavin, 'William Burges is possibly more appealing to modern readers than many of his contemporaries. Unlike those strict characters Butterfield and Street, he did not work in Gothic because it was the only true Christian style: he just liked it. He was not an Anglo-Catholic; his architecture was divorced from morality. He also took opium, which, combined with his extreme myopia, may well have encouraged the dreamy, fantastic side of his medievalism.'

David Watkin's *Morality and Architecture* was published in 1977. Thanks to Alexander Chancellor's *Spectator* – which Graham Greene described as the best written magazine in the world – Gavin was becoming known outside the ingrown milieux of architectural history and architectural journalism. Forty years on it remains astonishing that Watkin's brief book should have prompted such division when it merely suggested that to attach ethical properties to inanimate structures was philosophically boneheaded – whether those structures be anointed by Viollet-le-Duc, Ruskin or Pevsner.

Architectural discourse stopped being moribund. For the first (and perhaps last) time an arcane academic spat became a pop record. Orchestral Manoeuvres in the Dark made an album called *Architecture*

and Morality. Reyner Banham accused Watkin of 'the kind of vindictiveness of which only Christians are capable': like many true-believing modernists he could not see beyond Watkin's gauchely graceless criticism of his sometime teacher Pevsner.

Gavin defended Watkin. In many articles over many years he chipped away at the stubborn doxa which held that the modern movement was the only modern architecture. Just as miniskirts and Mini Mokes are supposedly – and wrongly – representative of the sixties, so were white orthogonal structures retrospectively deemed typical of the thirties when they were in fact exceptional: that's why the same few examples are always shown; there is not a limitless stock.

Gavin believed, unexceptionally, that the modern movement was just one strand of modernism. It was not so much the buildings that he objected to as the shrill manifestos, pious bombast and ludicrously pretentious claims which were attached to them. Most of them, incidentally, were commissioned by wealthy victims of architectural fashion: so much for the idealistic social project. He frequently mocked the courtier Hugh Casson – Britain's greatest after-dinner architect, in the bitchy words of Philip Johnson – and considered his excluding phrase 'modern in our special sense' to be specious. An art deco villa built in 1934 is just as modern as a modern-movement villa of the same date. Nothing can escape its era. Modern-movement buildings were no more modern than the work of, say, Oliver Hill, Harry Goodhart-Rendel, Owen Williams, Giles Gilbert Scott, architects who spurned schools, shunned theory (as Gavin did, militantly).

He agreed with Vladimir Nabokov: 'There is only one school of writing, the school of talent.' He agreed with Jean-François Revel: 'There are no genres only talents.' He agreed most of all with Gavin Stamp: 'With any style of architecture what matters is whether it is used well or badly.' Hence his enthusiasm for Vanbrugh and Hawksmoor – they handled their thefts from Palladio 'with a boldness and originality of which the English Palladians were incapable'.

The plurality of 1930s architecture was not, however, represented in the vast portmanteau exhibition *The Thirties: British Art and Design Before the War* at the Hayward little more than eighteen months after *Morality and Architecture* was published. The curators had learned nothing. An entire room was devoted to the – yes, typical – modern movement, while everything else from joke oak to stripped classicism to the Hollywood Andalusian of the Surrey Hills was crammed together under the banner 'A Spectrum of Styles' – the modern movement not being, of course, a style but a faith.

One can hardly call Gavin, Gavin the Apostate, because he had never subscribed to the faith. But he did edit and write much of a special edition of *AD* as a corrective to the official catalogue – it is no doubt one of his lesser-known works: undeservedly, for it is superb. It accords with what is or what was – rather than with what the MARS group, its descendants and even Pevsner wished for, which didn't exist. Gavin believed in what he saw. The dogmatic and the doctrinaire saw what they believed in.

That autumn in 1979, the Thirties Society was founded and at the RIBA annual conference Tom Wolfe gave the lecture which would be expanded into *From Bauhaus to Our House* which, for all its manifold faults, made wobbly architectural history and entertaining architectural polemic fashionable. British architectural journalism was generally pitiful. Ian Nairn had already drunk himself into an incoherent stupor, a man who felt betrayed by the architects in whom he had invested such hope. That left on the one hand a cadre of hopelessly out-of-touch ancient modernist ostriches who wrote with hands dipped in lard and congratulated each other as their great cause disintegrated before them, sometimes literally. On the other there was a new breed of sycophants who were even less to Gavin's taste. Their journalism was hardly dissembled PR. They were eager to cosy up to the coming men who, among other

curtailments on a free press, attempted to control photographic rights to their masterpieces.

The crumbling Architectural Press was presided over by Colin Boyne, a delightfully witty old dandy with cuffs on his dove-grey suits. Like many dandies, he was tough: one is reminded of Bunny Roger saying: 'I've shot so many Nazis, Daddy will have to buy me a sable coat.' Boyne was in perpetual pain from a wound suffered while serving in the Indian army. That didn't stop him building a house in the Weald with his own hands. And he was of course fighting a rearguard action in a stylistic war, which was also a generational war.

Colin Amery, then an editor at the *Architectural Review*, commissioned Gavin to write about the genuine apostate Andrew Darbyshire's Hillingdon Centre. Gavin had the temerity to praise it. Boyne sacked Amery. Gavin had failed to follow the party line. This spurred him on. He continued to put the boot in. There was a job to be done. His gleefully *ad hominem* assaults could be breathtaking. Lionel Brett, Lord Esher, got off mildly. He was perhaps too easy a target, merely a central figure 'in this establishment who have exploited the nexus of patronage and influence created by such bodies as the Royal Fine Arts Commission and the RIBA or by a favourable press in the Architectural Review, recommending and approving Good Modern Designs by their respected progressive friends'.

Esher had some years earlier, as president of the RIBA, instructed the editor of the *Observer*, David Astor, to dispense with the services of Ian Nairn. Astor, who never really subscribed to the OPA – the Old Pals Act for the young among you – stood by Nairn and sent the presumptuously impertinent lord packing.

Pevsner exasperated him. He respected as any sentient person would his tireless scholarship and his dry humour – which abandoned him when confronted by kitsch – Ernest Trobridge's castles

and hairdresser's thatch in Kingsbury, for instance. Gavin astutely likened Trobridge's work to the Amsterdam school's rural exercises. He did not respect Pevsner's ludicrously straitened idea of Englishness, which excluded Shakespeare's vulgarity and Butterfield's sod-you-ishness. Nor did he respect Pevsner's covert *parti pris*, his contamination of fact by propaganda, his paradoxical stance as a progressive who did not believe in progress. For Pevsner architecture achieved its peak with the modern movement, and what came after was not, he decreed, progress but regression: worse, brutalism was nothing more than expressionism exhumed. Gavin castigated him by proxy. One need only know that Pevsner called Arne Jacobsen's St Catherine's College, Oxford, 'a perfect piece of architecture' to appreciate Gavin's subsequent characterisation of it as 'that supremely necropolitan creation'.

Architecture may not so dicey a calling as acting, but it can be somewhat parlous and it can be corrupt. In the very early eighties Gavin compiled for the RIBA drawings series a delightful book called *The Great Perspectivists*. He had to suffer what he considered the indignity of a foreword by the then president Owen Luder, whom he thoroughly disliked. The composition of the book led him to track down Raymond Myerscough Walker, whose nocturnes rival Atkinson Grimshaw's. Walker turned out to be a bucolic bohemian who lived in the woods near Chichester. A tent in summer and a caravan in winter. He stored his archive in an old Rover which didn't run.

Later that decade I introduced Gavin to the principal of a small London practice who had been offered the job of designing a shopping mall in a southern town . . . nice work if you can get it, and by far the biggest scheme the practice had ever had. There was one drawback: 20 per cent of his fee would have to be paid to a local architect who was thick with the local planning authority and council – and oiled the wheels. This party had already been

suspended by the RIBA but continued, barefaced, to cream off considerable sums. Gavin was shocked. He had no experience, no knowledge of such malarkey. He would soon become used to it.

In 1991, Gavin moved to Glasgow to teach at the Mackintosh. His *Private Eye* column became Alba-centric, his unqualified admiration of Greek Thomson who was also Egyptian Thomson and Cyclopean Thomson was plain for all to see. His loathing of crass, corrupt councillors and morally decayed municipal officers was also plain to see. He dived headfirst into the quagmire of Glaswegian architectural politics. I recall that on one of my trips up to Glasgow to talk to his students he was indignant that so long as they preserve Mackintosh – whom he admired as much as he did Thomson – they know they can get away with anything, they can demolish whatever they like by Burnet and Campbell, Gillespie, Salmon, MacLaren . . .

When Gavin wrote journalism, he never wrote journalese. When he wrote scholarly books such as *An Architect of Promise* he did not descend to the ugly, self-important jargon that has marred academic discourse since the late Sixties. When he wrote his late elegiac masterpiece *The Memorial to the Missing of the Somme*, he avoided all poetic effects. The prose is terse, stripped down, laconic. The tone is constantly that of understatement. He did not let himself get drawn in to contrasting Lutyens' great monument with Blomfield's Menin Gate at Ypres.

But he did quote Siegfried Sassoon's reaction to that clodhopper:

> Was ever an immolation so belied
> As these intolerably nameless names?
> Well might the Dead who struggled in the slime
> Rise and deride this sepulchre of crime.

The Menin Gate is also classical. The futility of stylistic taxonomy could hardly be better illustrated than by comparing Blomfield's

creation to Lutyens' refulgent hymn. 'Classical' is rendered meaningless or is, rather, an epithet so broad in its application that it can signify almost anything. Lutyens struggled to master the orders as an adept of free verse might struggle to make the prosodical leap to pentameter. Invention is key: Thiepval's 'classicism' was as new as anything the modern movement devised; newer, indeed, for by 1933 when it was completed, modernism was already frenetically cannibalising its brief past.

That is about 1 per cent of what I could say about this remarkable and absolutely original man.

So, as Gavin would never say: Have a nice day. To which, according to Paul Fussell, the correct response is: Thank you but I have other plans. (2019)

17

Out of Town

The hills are alive

There's no easy way of putting this. Should you not be the owner of a chunk of prime downland, ideally within sight of a motorway or major road, I think I'd prefer you to proceed to the next page, where Mr Watkins is preaching to a less exclusive congregation. If, however, you fulfil that condition, you may read on, smugly. In addition to that land, it would be useful if you're also in possession of an appetite for patronage, a libertarian aesthetic sensibility, a seigneurial relationship with the local constabulary . . .

It was thirty years ago next month that my father noticed the swelling in his throat, felt the constriction to his breathing. The same Salisbury GP who had once assured me that my hay fever was the result of my clearing my nose too violently took one look at it and told him there was nothing to worry about. The next day, close to asphyxiation, he called the burns specialist and cosmetic surgeon Jim Laing, who took one look at it, bundled him in his E-type with a Clarence House windscreen sticker (he had tucked certain royal faces), drove him to Odstock Hospital, anaesthetised him and performed a tracheotomy to remove an obstruction the size of a golf ball. It was an accretion of chalk.

It is perhaps surprising that such occurrences should be so rare. Chalk is ubiquitous in Wiltshire and Hampshire. The rivers that drain Salisbury Plain and the downs are chalk streams and it was the particulates in the water extracted from them that accumulated in my father's throat. The thatched terraced house where I spent the first decade and a half of my life was built of pug – pulverised chalk mixed with mud and water poured between boards in a manner precursive of shuttered concrete.

Just up the road, a late-Georgian officers' mess maintained its privacy behind a long pug wall with a thatched top: this material is as enduring as the sculpted mud of Mali, provided it is kept dry. Characteristically, the army, in its mission to deface Wiltshire, neglected to maintain the thatch so the wall crumbled: mission accomplished. A mile further west, signalled by whitened roads, was a commercial chalk pit and, close by it, an overgrown former pit.

Pug, like the slightly more exalted cob in Dorset and south Devon, was essentially a material used for cheap buildings. Clunch is different. This deep-bed chalk is as hard as limestone. The scarcity of buildings made from it is due more to the expense of its extraction than to its geological rarity. It is beautiful, polished, reflective: on a high summer's day Lutyens' Marsh Court, a palace above the Test Valley subsequently owned by the never-knowingly-underhoused Geoffrey Robinson, gleams a pale azure.

The white horses incised in hillsides do not gleam, because the top layer of chalk revealed when the thin covering of soil and turf is removed is peculiarly matt. None is so large as the Victorian one at Kilburn in North Yorkshire and none so elegant as the monument to George III at Osmington near Weymouth – the horse might have been cut by Stubbs himself. Quite the greatest density of these horses is in Wiltshire: there are about a dozen scattered around the county. There are also the once-famous Anzac cap badges beside the A30 at Fovant, and the rather less celebrated and

now overgrown giant panda's head beside the same road just east of Salisbury: this was cut one night in 1969 by a group of Southampton students without the permission of the farmer who owned the field above the Bourne. He took a dim view of the addition to his stock.

Hence my appeal to landowners and to farmers, who are going to have to do something with those of their fields that are too steep to accommodate caravans . . .

There are already enough white horses: the most recent is a 'millennium' horse at Devizes, close to the sight of a vanished Victorian horse. A public inquiry into a plan for another, just outside Folkestone, has just finished hearing evidence. But given the abundance of potential sites in southernmost England and through the contiguous chalk belt that curves through Berks, Bucks and Beds into East Anglia, there are puzzlingly few chalk works representing non-equine subjects.

At the time of the Queen's Silver Jubilee in 1977, a waggish designer proposed that three large corgis should be cut into downland, but it came to nothing. More recently Steve Bell's Y-fronted John Major was done in the Brighton hinterland, not far from the Wilmington Long Man, eunuch cousin to the Cerne Abbas Giant and according to, inter alia, the historian Ronald Hutton, just as much a 'fake'. I, indeed, hope they are fakes: the idea of pastiche symbols of invented fertility cults is beguiling in a way that sheer ancientness isn't. And, besides, the importance of these works is not historical but aesthetic.

In a television film that I'm shooting later this summer I want to show a new chalk work, one that contains the spirit of the Cerne Abbas Giant and which is also appropriate to the programme's alleged subject – the irrational tradition most codified in surrealism but which has existed ever since humankind drew imaginary monsters.

I proposed this to Martin Rowson. A couple of days ago he faxed me his first design. It would, as they say in gardening catalogues, grace any chalk hillside, especially when inflated to the proportions of the giant, circa 200 ft high. Mr Rowson's drawing is typically masterful: it shows, in the best possible taste of course, a mitred bishop buggering a donkey. And before you complain that that's tough on donkeys, let me assure you that this donkey is demonstrating that he is more than pleased to see and feel the right reverend's staff of life.

Any takers? Commission this chalk work. No charge. We make it, you keep it, they pay for entry. These are hard days in the country. Give yourself a break. I await your communications. (2001)

Full Metal Carapace
Address to the Caravan Club

That film which you've just seen a clip of – it's actually called *Full Metal Carapace* – was one of about twenty that I made during the last decade. Early in 2000 I rather idly went through my diaries for that decade and calculated that I had, during the making of those films, spent more than a hundred weeks – two years – in British provincial hotels.

Now, some might say that that sounds cushy enough. That it must be jolly nice not having to make your tea, make your breakfast, make your bed. That it must be the life of Riley – whoever Mr Riley was – and that more to the point it allows you to get on with the job in hand without distractions. Well, some might say that, but they'd be counting without taking into consideration the financial responsibility of the BBC towards its licence payers, which from the vantage point of those who work for the BBC looks like old-fashioned meanness. The hotels you get to stay in are very definitely not the hotels you'd patronise if you had any choice in the matter. Indeed, they would appear to be chosen as some sort of

hotel aversion therapy: stay with us mate and you'll never want to stay in a hotel again ... save that you've got to because there's another film to be recce'd and shot. And even when you're filming in the Home Counties – I live in central London – you have to stay in hotels unless you want to get up at five in the morning and get home at ten at night. So you're a sort of captive.

At the – let us call it the Incompetent's Arms – in King's Lynn, the car park was full. I was given a windscreen sticker and asked to park in front of the hotel in the marketplace. Which I duly did. And at 4.30 a.m. reception phoned me to instruct me to move my car because I had parked it in the wrong part of the marketplace, although they hadn't earlier told me that there was a right part and a wrong part. At the Moron's Head in Birmingham, I went to the bar to get some matches. The barman looked at me as though he had never heard of these common-or-garden objects; then they evidently began to ring a bell. He replied: 'Oh matches! They're on order.' In Edinburgh at 6.45 a.m., the empty breakfast room was playing Phil Collins. No, it can't be turned off because it is part of the hotel's style. In Sheffield, the bedroom I was dispatched to had more flies in it than I have ever seen in my life: the ceiling was black with them. When I complained I was told it was normal. It's not normal in London, I replied. Ah – but you've got a different climate down there. In Portsmouth, I stayed in a place where the receptionist had bags under her eyes which had subsidiary bags of their own. She was there the night I got there, the next morning, that evening, the next morning again. She was on a thirty-six-hour shift. Which was a terrible abuse of an employee and hardly the means by which a smooth-running establishment is achieved. Then, of course, there are the run-of-the-mill hazards of mildew-ridden Nissen huts, house music at full volume, posses of rodents – and the food. Which is seldom available when you want it and is so habitually inedible that I became inured to a diet of whisky and crisps.

The point with hotels is that all but the very best are run for the convenience of their management, who are trained by the big chains in the really important aspects of hotel-keeping – for instance, how to spot a potential suicide and how to secure his or her credit card and put it through before the death is reported so that a lengthy and troublesome claim on the estate does not have to be made. This is not made up – indeed nor are any of the incidents I've mentioned. Hotels have the effect of stripping away their clients' self-determination. You dance to their tune – and I don't want to dance to house music or Phil Collins.

After about seven films I had got the measure of these places I was spending so long in. I petitioned the BBC to hire me a Winnebago. That was met with incredulity. You must be joking. Well, I can't say I was surprised. The BBC is nothing if not a bureaucracy, and caravans, even super deluxe Winnies, somehow fail to fit in with the way that bureaucracies like to do things.

Indeed, my childhood exposure to caravans taught me that they are the props of a rather extreme eccentricity. My father had two brothers. My Uncle Hank and my Uncle Wangle. They were, to put it mildly, somewhat bizarre characters. Hank left Evesham for Birmingham University in 1925, left Birmingham University for Birmingham Town Hall in 1928, qualified as a solicitor, left Birmingham for the post of deputy town clerk at Burton upon Trent in 1936, and was eventually appointed town clerk twenty years later. He never married, lived all his life in digs with two spinster sisters and went home, as he called it, to his mother and his own spinster sister in Evesham, and when he retired he moved back permanently. It was an odd, straitened and constrained life.

But beside Uncle Wangle's it was a beacon of ordinariness. When I first remember him, in the early fifties, Wangle and his frail, sickly wife Ann lived in a flat in the Bournemouth suburb of Southbourne overlooking the sea in which he would bathe every day of the

year – snow, blizzards, hail, nothing would deter him. But this proximity to and immersion in the sea wasn't enough for him. So he gave up the flat, bought a caravan, second-hand, and towed it to the beach a couple of miles east between Mudeford and Friar's Cliff and parked it there, wedged between groynes where waves would lap at it and on squally or stormy days actually break over the metal, which he had taken the precaution of painting with yacht paint. He was, incidentally, a reckless sailor with a tiny dinghy and a naive belief that motors would always give way to sail – they don't.

Half a century ago the countryside and England's shoreline was much less regulated and controlled than it is now. If you owned a caravan or a tent you could park up or pitch it beside the road, or you could seek out a sympathetic farmer. Things were conducted in a much more ad hoc way. The unbuilt environment was not yet perceived as a precious and finite resource. Nonetheless, the positioning of Wangle's caravan apparently breached whatever lax regulations were then in force and he was obliged to move it – probably for his own good, since the sandy cliffs there are subject to landslides and the configuration of the beach was forever changing: a lagoon I was particularly fond of disappeared overnight.

So he took his caravan to a site in the grounds of a then abandoned Regency house behind a not very sound sea wall. I have to say that I rather rued the move: when you are four or five there's tremendous excitement to be had from the sound of waves hitting the metal walls. There's an almost primitive thrill: it's akin to hiding in a tree house or a cave. But it does beg certain questions about the kind of adult who wishes to be subjected to such an experience. One adult who was not entirely enthusiastic was Wangle's wife Ann. Still, they lived by the sea wall for a couple of years, and then moved because of Ann's ill health to another site, now built over, at Walkford Woods close by the line on which the Bournemouth Belle used to pass.

I spent several holidays there and loved it: I liked the casual cama-
raderie and the fact that there were always new kids to play with –
about a third of the site was comprised of vans to let. The one thing
I didn't like was Shirley, who was three years older than me – a
great gulf at that age – and who one summer insisted on playing a
novelty record by the Starlites called 'Close the Door They're
Coming in the Window', which I was convinced was about a
plague of locusts. It frightened the life out of me. Compared with
that the – let us say basic – toilet arrangements were a doddle.
When Wangle got promotion – he wrote technical manuals for de
Havilland aircraft, which was based at Christchurch – Ann prevailed
upon him to move to a proper house. A curious octagonal lodge
where the floor of the sitting room was marked with masking tape
so that they could position their armchairs to get optimum benefit
from their first-generation hi-fi.

Was that the end of Wangle's adventure in the outdoors? No sir.
In the early autumn of 1962, Ann, whose health had deteriorated
exponentially, had pioneering open-heart surgery at the Royal
South Hants in Southampton. When she got out of hospital,
Wangle took her to convalesce, to recuperate, to regain her strength.
How do you take someone to convalesce in those circumstances?
Where do you take them in October? You take them in your
open-top Morris Minor, you take them camping, you take them to
the Scottish Highlands. Ann caught pneumonia and died.

I guess that my experience of this singular uncle should have left
me with the conviction that caravanners are careless, selfish, obses-
sive nutters. But oddly – or perhaps not so oddly – it's exclusively
the good times that I mostly recall from those days: the fun, the
adventure, the discipline of making-do and the liberation from the
tiny house with a tiny garden where my parents lived. And I knew
even then that Wangle was in every regard atypical – an atypical
uncle, an atypical boffin, an atypical human being: children have

such a basic instinct for what is normal that they know the abnormal when they see it, and, besides, I knew that about Wangle because my mother, who had misgivings about him, was always telling me so behind my father's back.

Many children of my generation had experience of caravans. I was astonished when I first suggested that the practice and culture of caravanning might be an engrossing subject for a film that I was met with a combination of disbelief and of an assumption that I was being deliberately perverse. 'Whatever is there to say?' enquired someone called a unit manager, who actually had no authority to make editorial decisions but who nevertheless held the departmental purse strings – you get the picture.

This person was American and immediately launched into a misanthropic diatribe against what she called 'trailer trash'. I did my best to explain that an American perception was bound to be different. Different country, different mores. And that there was, anyway, far more to American caravans than immobile homes inhabited by the economically and socially disadvantaged. What about Airflows, what about the extraordinary winter migrations of by no means indigent retired people from the freezing cities of the Midwest to Arizona and New Mexico? It cut no ice.

So in that series back in 1989 I made a film about a plotlands community in the Severn Valley near Bewdley, a place that was in fact far more socially marginal and environmentally incorrect than any British caravan site of the period, but which could be represented as a folkloric hangover of another age, an age when Brummies had built themselves shacks with their own hands using old railway carriages, kit-form chicken coops, indeed any material that they could lay their hands on including in one case the fuselage of an early glider.

It wasn't till some six years later when that unit manager had ascended to higher things that I was able to get the go-ahead. I was

still, of course, asked 'Why do you want to do it?' And I replied quite truthfully that if I knew why I wanted to do it, and if I knew what I wanted to say, there would be no point in proceeding. Virtually every project that I have undertaken, whether on TV or in print, has been prompted by a spirit of enquiry – call it idle curiosity if you must. There is nothing so fascinating to me as getting inside a society that is everywhere observable, that is so taken for granted that people on the outside hardly bother with it: it's finding the exotic in the everyday. In the same way I've done programmes about the society of sailing and how boat design affects land-born design, about the hermetic world of the army, about the hermetic world of New Age communities, about golf, golfers and golfing landscapes, et cetera, et cetera. It's rather like going to live with a tribe. And in all instances apart from one – which wasn't caravanners – I've been made most welcome, treated with great courtesy and to great hospitality.

The caravanners I met turned out to be a much more variegated bunch than I could possibly have anticipated. They almost all had a developed sense of humour about their pastime – I mean, for instance, that they knew that such rituals as reversing competitions might appear comical to the outsider. I met a delightful vicar from Gloucestershire whose caravan was done out like a yacht with portholes, and I found myself laughing with him and with it rather than at it, as I might cynically have expected myself to. There were many such people with agreeable fantasies and private worlds of their own creation. This is important. In one regard a caravan is more a mobile potting shed or mobile beach hut than it is a mobile home. It is a mobile hobby house. It may demand a certain discipline, but it does remove us from the stresses of home because the routines it imposes aren't those of home.

But you must know much better than I do the attractions of caravanning. There are over three-quarters of a million caravanners in

Britain, and one can be pretty sure that they don't share the same reason for their hobby. What they do have in common, without much doubt, is the way that they are perceived by the vast majority of the population who aren't caravanners. One comes up here against the force of majority prejudice fuelled by ignorance. Like I've explained, I have particular familial and professional reasons for not sharing that prejudice. I believe that one of the qualities you necessarily have to develop if you write for a living in a predominantly personal vein is the preservation of your former self or selves: you have to be able to recall your childhood and teenage and twenties, not with hindsight's amendments, but as scrupulously and it must be said as embarrassingly as you are able to. I don't exempt myself from majority prejudice in certain other areas and I know how pernicious it can be: to be frank, I never could stand golf and when I spent an entire summer investigating it, writing about it and filming it I discovered that my small store of sympathy evaporated into nothing. It's something to do with having pompous people in blazers bellow *jumbo-gee-and-tee-ice-and-slice-thrice* into your ear as you quietly wait at the bar to be insulted by a suspicious golf club secretary. But there you are, I'm merely parroting the received idea.

The received idea of caravanning seems to me quite wrong. We live in a densely populated country which is becoming ever more submerged beneath exurban sprawl, a tendency which for all the government's words no one acts to check. Yet at the same time caravan sites, which are often boons to a rocky rural economy, are routinely slated as environmentally squalid, visually disastrous, aesthetically bereft . . .

OK. Let us suppose they are those things. It is not beyond the wit of government and local authorities to move sites . . . caravans are by their very nature not permanent. They offer a form of flexibility which a house with foundations, services and attendant infrastructure can never match.

As a matter of fact, I don't believe they are environmentally squalid. Indeed, the very opposite. It was fairly evident to me that the caravanners I met were acutely conscious of the way they were perceived and were thus extraordinarily conscientious about keeping sites in a proper state of repair, not depositing their litter all over the place, and so on. Those of who you tend sites may tell a different story, but there appeared to exist a manifest sense of responsibility.

As for the notions that caravans are visually disastrous . . . My film ended with a plea for more caravans. This was not merely a plea to join the awkward squad, or to be deliberately contentious. It was rather a way of acknowledging a truth which I believe as a nation we are loath to face: namely that the countryside is rarely a natural thing, that it is as much the product of humankind, of agriculture, field systems, silviculture, clearances, deforestation, successive transport technologies, successive power technologies, successive building technologies, as it is of purely geological factors.

This is surely obvious. But we deny it. We seem to want it preserved in the aspic of yesteryear. We oppose bypasses, bridges, wind farms, dams. It has to be said that Britain is just about alone in this environmental Luddism. The things we rail against are those which make no attempt to dissemble the fact that they have been imposed. Oh, if they were imposed in the past they are of course all right. Clifton suspension bridge and Salisbury cathedral didn't, oddly enough, just happen – nor did Cotswold cottages, or ye half-timbered tea shoppes of Old England. But metal caravans are imposed and are modern. They are victims of a sort of collective antipathy which is founded in self-delusion, in a wrong-headed perception. And until that irrational antipathy is skewered the way it has been in continental Europe and America, I believe that caravans will be snootily disregarded.

But that would be an unduly pessimistic note to end on. Since the end of the last recession an important cultural change has

occurred in Britain. It may be generationally determined, I'm not sure. But it's certainly for real. Modern architecture has at last been welcomed here. There is an enthusiastic urban appetite for it. That appetite may well spread to the country. And the one quality that all the various strains of modern building share, even the rather synthetic, user-friendly stuff we've seen over the last decade, is that it doesn't appear to grow out of the ground. It proclaims the fact that it was put there. Sounds familiar? (2001)

Shop till you drop

By the time the last and largest essay in postmodern architecture in Britain was finished in 1999, it seemed hopelessly *retardataire*, an instant anachronism, ten years out of date, a victim of the seemingly unavoidable torpor that afflicts massive projects. But Bluewater could hardly hide its distended and outmoded clothes. Indeed, it had to advertise itself. It is supposedly the largest retail development in Europe, though quite what it has to do with this continent is moot. In scale, aspiration and gauche corniness it is as middle American as its architect, as peculiarly middle American. Its buildings, however, quite lack the bald utility of the big-shed supermarkets which line the way into American cities and, increasingly, into French towns.

There is nothing at Bluewater which is not fancifully dressed, smeared with slap, made-over, disguised. It comprises some 300 shops yet yearns to be something other than a place of banal commercial transactions. One wonders if the architect Eric Kuhne was prey to some notion of a quaint British reticence about buying things.

There is certainly abundant evidence to suggest that Bluewater's impasto ambience is intended to dissemble its crude purpose; that customers must be soothingly persuaded that they are doing

something other than exchanging cash for goods; that they are participating in a collective rite. Curiously, worryingly, the architect may have got it right. Sure, the majority of shops, cafés and restaurants are those that pock every town in the country. And their juxtaposition is familiar. Yet the sum of the humdrum parts is oddly fascinating.

The sheer size counts, but it is not such a factor as the relentlessly stressed singularity of the place. Douce kitsch is employed as a tool of architectural determinism, as an injunction to civil behaviour, to enjoyment. What is notable about this apparently successful stratagem is that the devices employed to achieve the undeniably pacific atmosphere would have been considered risible, trivial by the high-minded proponents of that determinism in the 1950s and 1960s or, for that matter, by their utopian precursors. Kuhne's devices are 'accessible', populist, sententious, hick, religiose rather than religious, about as demanding as lift music. But they work.

Bluewater is unthreatening, yob-free, almost cosy. The questionable decorative means are perhaps justified by the end. Among the means in question are: Figurative sculptures in niches representing numerous trades. Flashily wrought ironwork, ostentatiously crafted wood. Gaugedly worn benches and stools, like dolmens. Chunky lumps of glass.

There is a wilfully non-standardised feel to the place. Wherever you look there is an obviously bespoke element – a lamp standard, a handrail, a column. Ludicrous maxims are incised here and carved there: e.g. 'Nothing is lovelier than moving water, the diamond element. Invulnerable jewel. Brittle and splintering under the sharp sun. Yet softer than doves [sic] feathers. And more smooth than down of swan.' The author was the poetaster Gerald Bullett.

There is an awful lot of this homilistic, hearthside tosh at Bluewater. It afflicts both the fabric of the malls and some of the shops themselves: 'Camper is not a shoe. Camper is the result of a dream. The dream of a family from Mallorca . . . As in ancient

myths Camper is a modern David challenging with quality, irony and imagination the Goliaths of style and fashion . . .' But Camper is a shoe. And it is, presumably, made by an international company: what, otherwise, is it doing near the Dartford Crossing?

Bluewater's self-proclaiming handcraftedness serves not just to temper conduct but to create an illusion of localness, of being grounded. It's a thin illusion but an affecting one. The malls are industrially built shelter for global (or, at least, international) brands. I doubt that many punters are taken in. Rather, they very likely consciously respond to the energetic if insipid 'niceness', considering this a more congenial locus in which to shop for the same old stuff than an 'impersonal' mall.

Kuhne and his craftsmen have made an effort with their manifold add-ons: they may be calculated to appeal to the sentimentally impaired and spiritually soft-centred but they have low-level benefits for anyone who wants to spend a day shuffling past the Natural World (a voyeur's paradise of high-powered telescopes and a connoisseur's paradise, too: here's the Diane Fossey Gorilla Collection handcast in 'Ebonyte'); past Past Times (Mockintosh gewgaws, horrible garden whimsy in the form of elves); past Transit (Lee jeans which look as though they've been marinating on rusty wasteground); past Dockers ('liquid repellent pants' for the incontinent); past Jacques Vert (hats and suits for a provincial wedding); past Beaverbrooks (why a jeweller should name itself after a porn film is beyond me); past Sephora (no Habit Rouge); past the Perfume Shop (no Habit Rouge and no testers); past a shop selling clothes to women who are size 16 or larger in the forlorn hope that drabness will cause them to disappear. It won't.

Funny how quickly time goes when you're having a ball. I headed off to get some lunch. Guided by my nose. If I could smell it, I went elsewhere. I had just about reached the ever-reliable Carluccio's when I realised I had nothing to read. Several chains

hedge their bets and have more than a single outlet at Bluewater: presumably few punters are as energetic as this reporter and walk every metre of the place. There are two branches of Waterstone's. I think it's fair to say that I was the only person reading Tennyson's *In Memoriam* over lunch in the smokers' outdoors bit. It seemed vaguely belittling to it, to pore over that grave consummation of melancholia in a place which fuses the chummily sacred and the cosily spiritual in order to incite purchasers to prodigality. But so long as I kept my head down I could avoid getting into conversation with the chirpy folk on the next table, who were, interestingly, up from So'ton for the day. (2003)

Cloud cuckoo land

By the time I reached adulthood I had spent precisely one week in East Anglia: a godparental bungalow at Mundesley, aged twelve. There was a day trip on the pretty Broads: oh, do look at the funny sheep. A caravan park at Gorleston was the largest that I, already a connoisseur of such sites, had yet seen. The Fens terrified and fascinated me. Water above land incites something akin to vertigo, a state that is evidently alluring for I return eternally to Denver Sluice, where I never fail to experience a thrilling tremor of that primal fear.

It was not until many years later that I became acquainted with the south Suffolk coast and its hinterland of sandy heaths. This is a country that I love as much as the western side of the New Forest, as the valleys of the Taw and the Duddon, as the Blackdown Hills and Brendon Hills. This is a country that unfailingly transports me back to a dreambright childhood. But to whose childhood? The western side of the New Forest, etc., were my playgrounds. I cycled their sunken lanes, walked their woods, swam in their streams, birds-nested, picnicked and larked. I was familiar with them,

possessed a detailed knowledge of such arcana as the construction of trout traps, dirt farms, wooden shacks, beech hedges, self-propelled linesman's vehicles. This was an arcana peculiar to them. Site-specific, as was not said then.

My kindredly detailed knowledge of Suffolk is practically non-existent. As I say, I was in my mid-twenties before I went there. Yet certain parts of its coast open lockers in my memory as surely as a certain hue of chalky royal blue or Peter Pears singing 'The Foggy Foggy Dew'. That Pears and Britten are for ever associated with that county is entirely coincidental: it is simply that their folksong collaborations are the first music I can recall. Are, then, these memories which are prompted by Suffolk false memories? They certainly propose a childhood that I did not actually experience at first hand. Perhaps that is the very reason why they are so potent. Perhaps these places are keys to a generalised childhood, to an archetypical childhood, to a childhood which, while not enjoyed as a primary reality, was the childhood I longed for. The childhood imagination is covetous. It certainly creates, for instance, fictive friends because such friends are perfect in a way that we are not: they are what we wish to be. It very likely creates fictive places too: hidden dells, secret gardens, places that are susceptible to being ordered. Scale models are utopias: dolls for girls, cars for boys, villages such as Bekonscott or Bourton-on-the-Water for both. In these microworlds the playful child is omnipotent despot, god fiddling before the fall. The protraction of this trait into adulthood doubtless accounts for middle-aged sads with train sets and for the authoritarianism of most politicians.

Thorpeness was planned and begun in the years before the First World War. It is in the tradition of Port Sunlight, Letchworth and Bournville. It is less celebrated than those planned enterprises. I guess that this is because it was not intended for 'the people'. It was neither an exercise in social engineering nor a philanthropic

venture. It was originally – and for many years remained – a holiday village for the middle class: to this end its owner G. Stuart Ogilvie and his architect Forbes Glennie worked in a variety of exaggeratedly picturesque idioms.

Whimsical, kitschy, stagey, cute . . . it's all of these. Nonetheless, it is impressively affecting because there is so much of it, because it is done with such blinkered confidence, because it is a three-dimensional representation of an ideal village in a children's book, a model that has swollen to life-size. The tallest building – and the flatness of the land exacerbates verticality – is a feyly disguised water tower called the House in the Clouds. But both in scale and disposition it is atypical. So are a couple of neo-medieval barbicans atypical, though they do remind us that the Gothic revival persisted well into the twentieth century. The ubiquitous norms are waney wood cottages, lavish false beams, herringbone brickwork, wicket fences and pantiles so curled that they have a quiff. Despite some crass infilling the integrity of the village is undiminished.

And so, too, is its delicious artificiality: it is this above all other qualities which lends it such associative potency. I only recently discovered that the Mere – sure enough an artifice – was originally named both the Children's Paradise and the Home of Peter Pan. One might have guessed, for Thorpeness also summons up that creepily sunny conception of childhood which stretched from Jefferies through Barrie through Ransome to Blyton, whose Famous Five, incidentally, would have holidayed here had they not had Kirrin Island to prat about on in their false innocence. This conception of childhood – which took it as a given that childhood was a separate state, a distant country which we all migrate from – was a by-product of the early-nineteenth-century separation of workplace from home and of the protraction of education.

Of course, the suspension of disbelief at Thorpeness cannot be too long maintained. The illusion is ruptured by cars, by the clothes

people wear and, most fetchingly, by Sizewell nuclear power sta-tion. It looms on the northern horizon, a sullen rejoinder to the village's douce playfulness. Raw power – the power to warm the sea and change the climate and strip the flesh – is represented by elemental geometry, by gigantism, by the eschewal of dainty niceties and cosy frivolities. Its capacity to sate an appetite for a delusory past is, however, moot. (2004)

Domestic peace maker

'Chart' occurs in several Kentish place names in a sense which is not to be found in the *Oxford English Dictionary*. Nor, for that matter, is the old English 'cert' from which it derives to be found there. Both words signify uncultivated land. Such land is the exception in Kent for several reasons, among them:

1) The sheer fecundity of the earth caused land to be enclosed earlier than it was elsewhere – its commercial potential as the 'Garden of England' was long ago acknowledged and exploited.

2) Gavelkind, a favourite topic of a certain history teacher, is a form of inheritance, the opposite of primogeniture. It was practised in Kent well into the twentieth century. When a landowner or tenant died, the estate was divided among all the sons and, were there no sons, the daughters. This accounts for the routinely diminu-tive size of Kentish landholdings and, more evidently, for the preponderance of buildings. Grand(ish) or yeoman houses are situ-ated close by each other and in grounds that elsewhere in England might not seem commensurate with their status. Such proximity is commonplace in France, where estates are similarly divided.

3) The nearness to London. The county's desirability as a dormi-tory may be indicated by the fact that oasthouses were being converted into dwelling places as early as 1860. The first to be so transformed was at Meopham.

Winston Churchill's house Chartwell is certainly not a country house, in that it is not the centre of an autonomously hermetic, self-sufficient mini-nation in the manner of Chatsworth or Belvoir, Harlaxton or Elvetham, with thousands of acres, farms, villages of tied cottages. It is a world away from his family's palace of Blenheim, to whose emulation generations of barrack-room shrinks have ascribed Churchill's drive. In his achievements he exceeded his predecessor the first Duke of Marlborough, but did not come close to creating a place like that heavy load outside Woodstock.

Nor is Chartwell really a house in the country. The views across the Weald may be extensive. As many greens as there are names for, warm red bricks, the white cowels of oasts. It is on the slope of the sandstone ridge just south of the M25 and the A25. This is not quite countryside. It is, rather, outermost, swishest and loveliest suburbia: the artful, deceptive land of sunken lanes, oak and birch, contented foals, post mills and perennially surprising outcrops of rock which might have been placed there by a picturesquely inclined giant. Every time you think you have left London behind, yet another unadopted road leads to half-hidden houses with names such as Clacketts, Rookhill, Bustard Dene, Yaffle Ridge. The aspiration of English suburbs – unlike those of the rest of Europe – is escape. They are centrifugal, bogusly bucolic, anti-urbanistic. Here was something this country excelled at throughout Churchill's lifetime. The domestic revival's beginnings coincided with his birth; its end was signalled by the Second World War.

It seems peculiarly fitting that the greatest man of his time should have inhabited the *ne plus ultra* of the suburban dream. A house whose like is advertised by the score in any edition of *Country Life*, a house that would be hardly liable to fascinate had it been occupied by someone else, a house which conveys the twin illusions that were for so long the English domestic cynosures: rusticity and age. As I say, it's not rustic: its gardens, which include the finest gunnera

imaginable, would not be out of place on St George's Hill. Nor is most of it as old as it vainly attempts to appear. Given his eccentricity and proclivity for going his own way, Churchill's choice of Philip Tilden to rebuild the decrepit and partly derelict Chartwell is odd.

Tilden was a 'society architect', whose clients were plutocrats and aristocrats, together with a few upper-ranking politicians. He was the author of Gordon Selfridge's unbuilt castle at Hengistbury Head in Dorset and of much of Port Lympne, where zookeepers go to die. Tilden evidently possessed several talents. He was a gifted country-house crawler. He connected well. He was good-looking in an arty way. He was spendthrift. He incited a hardly latent megalomania in some of his clients, a middlebrow megalomania. He could turn his hand to many styles, but unlike his exact contemporary Oliver Hill, seldom with flair. Chartwell's exterior is insipid Arts and Crafts, apart from the entrance front – a startling bodge which includes an anachronistic doorway bought from Thomas Crowther of Syon Lodge, the first architectural salvage dealer (now trading as Anthemion).

The interior, however, is absorbing. It is a touching monument to the man which succeeds in suggesting how very unusual he was. And it is, almost incidentally, valuable as an illustration of upper-class taste in the middle of the twentieth century. There are the faintest hints of Hollywood Andalusian, impasto splashes of Vogue Regency and the Syrie Maugham style, acres of limed wood. These were the idioms espoused by a caste who would have considered art deco and joke oak impossibly vulgar and international modernism impossibly modern. The National Trust's stewardship is discreet, though its emphasis on Churchill's sub-Russell-Flint paintings is misleading, for of all his endeavours this was the one at which he exhibited the least proficiency. But what a bricklayer! He seems to have devised his own bond. There is the mark of a true original. (2004)

Get orf my land

There was a time when *Country Life* was an anthology of property advertisements prefacing a ream of articles wrought by buffs for buffs. Mepps' spoons; tracking by spraints; early lawnmower technology; scrapie scares on Benbecula; the Mercian school of stirrup-cup design; the sidesaddle's history; a Lambourn molecatcher's journal; the threat to the crested niel; clunky verses celebrating sewin; diminishing water tables; whither taxidermy; a Lincolnshire thatcher; oasts: pyramidal or conical?; Sussex Munpher – the origins of a pudding; a portrait of the Flaughquharly and Wybbes's MFH; clunch today and tomorrow. And so on.

It carried the whiff of the lucubrations of hobbyist colonels in the Nadder Valley, mottled Parker pens, gentleman ghillies, Purdey bores, triple-breasted and exceptionally hairy tweeds. Most of the stuff presumed either an already developed interest in the topic or promiscuously curious readers with a voracious appetite for arcana. It was a far cry from the *Country Life* which Edward Hudson founded in 1897. That was a magazine that propagated – perhaps even invented – a lavish townee fantasy of bucolicism as dreamily sweet and beguilingly bogus as any of the houses that Lutyens designed for Hudson. The magazine I pored over as a child seemed, shockingly, to have been hijacked by, of all people, genuine countrymen – well, genuine-ish. There was certainly no implicit acknowledgement that it was more likely to be read by actuaries than by farmers.

Today, *Country Life* is once again in touch with its inner fantasist. It is polished, worldly, unmuddied, elegant: it is improbable that any member of its splendidly suited and immaculately shod staff has skinned as many eels as even I have: and how many of them have garphed a stoat or wellowed frash? It is a consummately professional product. So there is no longer any place in it for the sheer artlessness

of fly-tier's prose, nor for brute realities. This may be considered a loss. But it is a loss that can be rectified. Devotees of reeking middens, poisoned streams, boundary disputes, architecturally void agri-buildings and taking pots at ramblers can console themselves with *Country Landowner*, the journal of the Country Land and Business Association (CLA). It is a (probably unwitting) vade mecum to the banal horrors of country life which *Country Life* mercifully overlooks.

Intended as a virtual shop, it may also be read as a barometer of the current rural climate – fearful, resentful, confused, desperate, aspirantly exploitative, aesthetically cautious. The products and services advertised with hard-sell brusqueness are aimed at those who depend on the country, who are economically trapped there, who are beginning to conceive of themselves as a new underclass.

Country Landowner predictably gives great forelock. Viscount Coke (not a Class A drugs dealer) has introduced a range of Holkham beers and has turned a failing estate farm into a hotel. He is all too clearly offered up as a 'role model'. There is not a single reader who is not searching for a profitable wheeze. Log cabins for all-the-year-round income; paint-ball equipment; level a field to create a polo ground; build a modular wooden play centre; run a cookery/watercolour/smithing course; plant mobile homes converted from containers as far as the eye can see; make jam and chutney and perry – make anything.

The range of potential enterprises – that is, of promises – is vast. This is the stuff that low-grade dreams are woven from. Land and redundant buildings really can be made to turn a profit. No one per-sists in denying that the country is a recreation ground as well as a roofless factory. But even the most straightforward change of use is subject to bureaucratic scrutiny. Needless to say, a battalion of 'profes-sionals' – solicitors, surveyors and so on – now specialises in conduct-ing the desperate dreamer through this particular labyrinth. And they have a strong second suit on 'right-to-roam' issues. They are, needless to say, equally expert in obtaining grants for, say, planting conifers.

'Landowner' may sound posh, but as well as the grandee it signifies the smallholder with a paddockful of rusting troughs and shivering ponies. The two share a preoccupation with security. The name Tony Martin is nowhere to be found in the edition beside me but the combination of contradictions that it evokes is omnipresent. The fear of intruders and illegals is as developed as that of rats and foxes. The difference is that the latter can legitimately be taken out with powerful air rifles which do not require a licence: night sights start at £175 – but on the basis that you get what you pay for they can't be much use when you can easily spend £975.

Property paranoia – which like all paranoia has shallow foundations in some sort of experience – can be soothed by such devices as: a repro Georgian chest of drawers that can be clamped to a steel gun cabinet; life-size brown bear cut-outs for target practice; agencies which care for home, animals and land during holidays; fences, hot dipped galvanised wire netting, rabbit netting; guard dogs; beam-type infrared devices, 'not to be confused with passive infrared systems'; vigilante helikites (really); wind-powered scarecrows.

The country industries that I myself intend to pursue require minimal security and attract massive EU subsidies. Here are the troughs I want to get my snout into. The first is the husbandry and training of pigs for advanced adult films, currently a speciality of Emden in East Friesland – due, no doubt, to its equidistance between Amsterdam and Hamburg. The second is llama farming. There is a national shortage of llama salami, llama chorizo, llama lardo. I shall become a role supermodel. (2004)

Chalk and cheese

The word perambulation in the sense of a boundary enclosing a particular area derives from the ceremonial walking of that

boundary to define it and to renew claim to the land within it. The most recent citation in the *OED* is from the end of the nineteenth century. It is, though, still used apropos of the New Forest. How this royal chase's limits were originally defined and how they have been amended down the years is puzzling. The forest's area is largely defined by three natural boundaries: Southampton Water, the Solent and the valley of the Hampshire Avon.

Yet none of Southampton Water to the east and only a brief stretch of the Solent's shore to the south mark the perambulation. The forest's *de jure* boundary seldom coincides with its de facto boundary. The only clues as to what is and what is not officially the New Forest are the plentiful cattle grids (BS 4008 ref. 28 stipulates, incidentally, that a grid should be at least 2.6 m (8½ ft) wide with a pit depth of no less than 250 mm).

The western edge of the forest is different. The perambulation is topographically determined. The forest escarpment falls away to the Avon Valley, precipitously in certain places. A sylvicultural milieu ends and an agricultural one begins. Heath, sand, gorse, birch and ponies are succeeded by the manifestations of a different ecology. Water meadows, leets, mill races, poplars, rich soil, willows, cattle, lushness – and, beyond all that, chalk downland. The contrast is exhilarating.

This is, most literally, border country. Tramping across boggy meadows in the valley, you look up to a cliff whose trees would simply not grow down here. On that cliff, Castle Hill, near Woodgreen, your immediate surrounds belong to a different world from the components of the view before you. Chalk and cheese? Yes: because cheese came from valleys where dairy was practised, while chalk grew wool – hence the saying. The New Forest grew wood for men-o'-war and deer to fell. But the soil is mostly poor. And this is what gives the western fringe its singular complexion.

This side of the forest is the least visited. There are no set-piece attractions like the Beaulieu Motor Museum (I've still never been there) or Rhinefield Ornamental Drive, which puts on an early-summer show of rhododendrons to match those at Virginia Water and at Puddletown Forest, near Dorchester. Here, that rampant Himalayan plant is notable by its absence. And so, too, are the central forest's weekend traffic jams absent. Presumably because the received idea is there is nothing to see. Maybe only hardened devotees of the marginal and of edgelands will ever get the point of such places as Ogdens and Abbot's Well and Mockbeggar.

I am drawn to them with a sort of compulsion that derives from their physicality rather than from any association. I have known them since childhood, sure. But I have equally known many other places which I have little inclination to revisit.

What draws me here is an intimate particularity, a smallness of scale, the sense of a hidden place which retains early in this century something of the whiff of the rural indigence and bucolic scrappiness which we know only from monochrome photographs, genre paintings, Thomas Hardy, Mary Webb and even H. E. Bates. There are a few atypically 'fine' houses: the Edwardian archaeologist and artist Heywood Sumner built himself the handmade Cuckoo Hill; nearby is a handsome early-eighteenth-century brick box.

If these places seem grand, it is only because of the paucity of what surrounds them. Dwellings that are at best rudimentary. Thatched cottages with pugged chalk walls. Mean, grimly urban villas plonked down in the middle of a plot: houses which nonetheless have a sort of melancholy charm because they are patently dislocated. The wooden shanties and converted rolling stock which were everywhere till the 1970s have almost all disappeared, since the land on which they stood was more valuable than they were. They have, thankfully, been replaced by hearteningly ugly bungalows

which are less atmospheric, but which at least suggest that no one has yet had the idea of cosmetically improving the straggling lanes and inchoate groups of houses, clusters of sheds, lean-tos and byres. When holes in hedges are replanted rather than bodged closed with chicken wire and corrugated iron, we lose the ragged imperfectionism which instructs us that the countryside is still not entirely a resort.

The hamlets and aspirant villages in the westernmost forest have not, despite a now defunct Wild West ranch, become sites of week-end leisure or commuters' dormitories. Nor, though, do they depend on industrial agriculture. The lie of the land is too steep for that endeavour. Rather, they continue, maybe for want of anything else, the practices of small-scale farming and market gardening, trades which leave their scrawled mark on the landscape. A satisfying and enduring mark which for all its messiness preserves this place as something special in a country whose mostly flattish or mildly undulating landscape has suffered from an industry which takes as its model the production of cattle feed. Hence the dismal cycle of inedible crops, set-aside, and our consequent reliance on imported fruits, vegetables and pulses. Prairie farming with its toxins and aesthetic want is, I surmise, clean farming.

Down Ogdens way what they do is dirt farming. The landscape is visually beguiling, if you look carefully – as ever, it's all in the details: the ancient Massey Ferguson tractor so covered in creepers it has become an organic construct and might come to life like in a children's story; a blasted tree sprouting shoots like kohlrabi; a wicket fence despairingly mended with adhesive tape; the axle and differential of a lorry dumped in a ford; a frozen cascade of oil drums; a seething midden. Beguiling, but it also has a lesson to teach. This is a warts-and-all picture of the sustainable, our cynosure. This might just be the future of agriculture. (2005)

Back to the land

Hop yards in the Teme Valley, the Vale of Belvoir's crisp hedges, floated meadows beside the Hampshire Avon, beech avenues on the Blackdowns, mill races and sunken lanes, orchards and drystone walls . . .

The astonishing and varied features of landscape that these small islands possess are human creations, custom-made for specific endeavours: brewing, hunting, dairy, wool, etc. They are as particular to their purpose as are sties and churches, barns and maltings. They are no more 'natural' than buildings. Rather, they are industrial sites without a roof. This is perhaps most readily evident in the Fens, marshes reclaimed in the seventeenth century where unerringly straight rivers (or drains) flow sluggishly above the land in a grotesque perversion of water's norm. The brutally orthogonal geometry of these black-earthed acres renders them menacing, disquieting. Denver Sluice near Downham Market is the stuff of nightmare. Water courses of different levels conjoin with merciless power: hydrophobics beware.

It was partly in reaction to the agricultural industrialisation of the country that the glorious artifices of the Augustan landscape were created. There is a certain irony here, for such landscapes were often commissioned by the very grandees who had profitably constructed canals and had enclosed land with hedges – those very hedges whose disappearance we bemoan but which were regarded 250 years ago with the distaste that is today routinely visited on, say, wind farms and polytunnels. Hedges were blots. A discreet ha-ha was a more efficacious means of creating the illusion of the borderless infinity which Alexander Pope reckoned the *sine qua non* of a great (and boastful) park. We regard such parks as the supreme creations of picturesque sensibility.

But we should bear in mind that there are no absolutes in the perception of landscape. Just as the eighteenth century was hostile

to the appearance of the field systems it created, so were the Victorians doggedly unimpressed by the whimsical feyness of sham castles, hermitages and serpentine lakes. They favoured formality, parterres and axially planned gardens. Every age, captive to its own fashions, censures the idioms its precursors enjoyed. Every age worries about the changes that it itself makes. We have cause to worry, for a variety of contrary reasons. It is a commonplace that a collision of demographic desire, economic want, infrastructural neglect and governmental hostility is occasioning debilitating social damage which extends beyond rural areas. An exurban middle-aged migration – of about 100,000 people per year – fuelled by money is matched by an enforced progress of younger people in the opposite direction fuelled by lack of it: a million rural households exist on the poverty line. It seems improbable that this trend will prove reversible. But even if it does, its physical manifestations are already ineradicable. And unlike Georgian dreamscapes or High Victorian churches or even heavy-industrial cities punctuated by thickets of chimneys, it is impossible to believe that the subtopian 'executive' estates and synthetic modern newbuilds which that most promiscuous of midwives, the Office of the Deputy Prime Minister, encourages to multiply across Britain will ever be loved, will ever find a champion. They fail in their duty to architectural civility, to imaginative resolve, to environmental aptness.

There is something curiously amiss here. A reversal of the old order. Throughout most of the twentieth century Britain exhibited a sure feel for suburban building while ignominiously failing in its cities, which it currently isn't. Certainly, the all too familiar, low-rise, low-density sprawl was not, in today's cant, 'sustainable' and was preposterously prodigal of land in so small a country. But arterial-road suburbs, wrapround windows, abundant laburnums and lavishly beamed roadhouses undeniably possess a sunny, kitschy winsomeness – optimism before the storm. Even the post-war Span

estates are infected with a lightness and jollity. The brute charmless-
ness of today's excrescences is in keeping with the charmlessness of
the age.

The volume-building industry unquestioningly accepts the happy
idea that 4 million new houses need to be built in the next decade and
a half. It unquestioningly accepts it because it was party to dreaming it
up. It's a grossly inflated and self-interested guess that ought to invite
the deepest scepticism and the attention of the National Audit Office.
These hutches are of course merely swallowing land which, in the
hierarchy of place, is deemed to rank low – save, of course, when it is
adjudged necessary to nibble at the green belt. Brownfield sites are
expendable. They are valueless till they are reused.

Perhaps: but edgelands and places which resist classification and
marginal plots which appear unloved are covertly courted. There is
a particular sort of artist – Edward Burra, Fay Godwin, Carel
Weight – with an affection for that which is conventionally reck-
oned boring or ugly, and a persuasive means of demonstrating that
we should look beyond the picturesque which we have been condi-
tioned to admire by both the feats of Capability Brown and his
contemporaries and the persistent championship of it by the
National Trust and English Heritage. Rural England is wrongly
represented as picturesque. The atypical is made to stand for the
norm. The actuality is of course more complicated and more fasci-
nating. But an obstinate antiquarian prejudice prevails. Allotments,
glasshouses, marshalling yards, cooling towers, refineries, bales like
latex dolmen, telecommunications towers, cranes and, yes, wind
farms are as visually exciting as Arcadian follies – can we but see it.
There is a dismal dichotomy: we depend upon their productions
and services, but want them swept invisibly under the carpet, under
a giant earthwork.

The edgeland sites that we are losing go unnoticed till they are
covered by houses which are, incidentally, far less architecturally

evolved than industrial structures – not least because they are the work of hack builders rather than designers. These sites represent something important: an unofficial, untidy countryside which has slipped through the net. Imperfect but vital. Their transformation into dormitories of dormitories of dormitories will hasten the imminence of the day when England takes its cue from *Come Dancing* and is tidy, perfect, manicured, insipidly pert, as twee as bunting. We are liable to associate authoritarian landscape with a Bourbon or a dictator: avenues disappearing to the horizon, distended monuments to absolutist vanity, obsessive symmetry.

Control by concrete, meanly proportioned verges, closes, cul-de-sacs is stealthier and less impressive. But it is control nonetheless. The liberty to enjoy the serendipitous balms of accidental places may not be as momentous as certain of the other liberties which this government has quietly removed from us but it is to be prized. We should allow that there must exist land which does not have to work for its living, ragged land that comprises shirkerscapes. (2006)

Picture skewed

Cottages in dereliction. Cottages of 1735 with 1935 Crittall windows. Cottages with corrugated-iron lean-tos against their limestone walls. Thatch so rotten it's greenish black. Roads deep in manure. Fences composed of bedsteads and twine. Outside privies. Today, there is a national shortage of all of them.

Fifty years ago, they were plentiful, going on the norm. At the primary school in a New Forest settlement where my mother taught during the Second World War, a child arrived for the winter term sewn into untreated rabbit skins. When I wrote about it fictively in the eighties, her only reaction was: 'Why did you leave out the people who claimed their daughter had caught syphilis from a towel?'

670

Her So'tonian, lower-middle-class, urban suspicion of the coun-
tryside, its people and their mores, is one I share. It's an attitude
prevalent in France, where the English notion of the rural idyll
prompts bewilderment. The French regard the country as a work-
place. A place for crops, cattle, silviculture, quarrying, hunting (for
the pot rather than for sport), dumping vehicles, murdering chil-
dren and building alarmingly hideous bungalows. It's like an
England that has been erased by the force of a demographic shift.

Landscape is created by humans and the English have transformed
theirs over the last half-century. Despite the spread of roads, indus-
trial estates, science parks and housing estates of an architecture
almost as execrable as France's, the English landscape is increasingly
infected with the artificial perfection of Georgian parkland whose
purpose was to delight the eye: cows and sheep were theatrical
props. This suave naturalism, supplied by Capability Brown to
noble Whigs, has been democratised. The English sticks have been
subjected to a makeover, a wash-and-brush-up. Dirt farms have
turned into clean farms. Canals in desuetude have been redug and
refilled. Cottages have been restored to a state of 'authenticity'.
Advertising hoardings have been proscribed. Rivers have been
detoxed. Hedges have been replanted. Water meadows are once
more 'floated'. Shacks built of corrugated iron and asbestos have
been replaced by salubrious dwellings of no character. Hardly any-
one still lives in former rolling stock.

The idyll has moved from aspiration to actuality. When villages
were inhabited by the sons and daughters of the soil, the land was a
factory without a roof. Now that they are commuters' dormitories,
the land is an amenity whose looks are everything. England's coun-
tryside is today more literally picturesque than it ever was, more
conventionally picturesque, more institutionally picturesque.

The National Trust and English Heritage are merely the most
prominent agencies involved in turning back the clock to an age which

only ever really existed in the brains of Constable and Cotman, Gainsborough and Girtin. The knee-jerk antipathy to wind farms, cooling towers, transmitter masts, pylons and so on is *bien pensant* conventional rural wisdom just as an antipathy to brutalism is conventional urban wisdom. These agencies are instruments of antiquarian prejudice and lobbyists for policies founded on collective nimbyism.

As well as rushing headlong into a fictive past, the English landscape is increasingly managed. That's to say it is subject to countless prohibitions. Do not light fires. Do not park. Do not feed the ponies. Do not drive at more than 40 mph. Do not, do not, do not. To which the only response can be: ignore, ignore, ignore. Tidiness is no virtue. (2010)

The other ways of Essex I

Essex is London's New Jersey. That, anyway, is how this hapless county is persistently represented. Its inhabitants are all ineffably vulgar: the personae of *OK* magazine; post-literate 'reality' TV 'stars'; vertically tanned *EastEnders* actors; hair-extension consultants staggering under the weight of bling and sweet cocktails; footballers incapable of reading their own newspaper column. They inhabit mock-classical houses ('mansions') with fibreglass pediments, abundant water features and books by the yard. Their neighbours are entrepreneurs in the import, entertainment and glamour sectors. The only acceptable form of transport is a smoked-glass SUV with bull bars and a cherished number plate (TON 15 X = Toni's Ex). An important dinner party conversation about the relative merits of Wayfarers and Aviators can last up to two hours. *Und so weiter* (as they tend not to say in Chigwell, the only place in the world named after a ventricle hairpiece).

To deny the existence of such an insistently clamorous milieu is, evidently, futile – no matter that it's peripheral and atypical, no

matter that it's restricted to the part of Essex that is effectively out-ermost London. The importance accorded it by the very media which created the spangly monster has had the effect of promoting it over all other Essexes, of occluding gentler, richer, stranger and infinitely more beguiling places whose scapes are among Britain's most unusual and most overlooked. There is the Essex of pretty villages: pastel-washed, pantiled, pargetted (Dunmow, Finching-field). There is the Essex of sixteenth-century architectural grandi-osity (Layer Marney, St Osyth). There is the Essex of the pre-war modern movement's white cubism (East Tilbury, Silver End, Frin-ton Park, Burnham-on-Crouch). All these, however, have peers elsewhere.

The Roach, the Crouch, the Blackwater, the Colne, the Stour and the myriad creeks and channels between them form an estua-rine labyrinth that is without peer. It is singular, extraordinary and best experienced in bleakest winter. Its components: mud, ooze, defensive walls, saltings, rivers, creeks, yachts, ringing halyards, hulks, beached boats, houseboats, causeways, walkways, quays, purslane, samphire, shells, precisely choreographed bird flocks.

All of which might seem defined and separately identifiable. But the rivers are tidal, the force of the moon is seldom more physically manifest. Day by day, the rivers' courses change, marginally but with certainty. Certainty is actually a quality that is in short supply. This is a world of equivocation and ambiguity. Where the land ends and the water begins is often moot. The components elide. The water appears hard and glassy (it isn't), the land soft and curiously matt (it is). The reciprocity between the elements is beyond our control; they are as liable to combine in hostility as to be harnessed in our service. The rivers are both beneficent highways and, when tide and wind make an alliance, sources of murderous chaos.

We are here on the edge of England. We're on the edge, full stop. And that edge is forever shifting, escaping us. The harsh eastern

light is fugitive. There's a lot of weather on the move, now skittishly cantering, now lumbering with menace. At the end of this provisional waterland there is its border with the vast sky, the horizon. Which is reassuringly static if a long way off. But this, too, seems beset by hazy impermanence. The notion of a fixed point is unfulfilled wishfulness. The liquid land's limits are unfathomable. Relentless, daunting, overwhelming flatness is inimical to us getting our bearings and gauging distance. And so, too, is the confusing gamut of colours which ordains that the sea be tan, the marshes eau de nil, that rivers shift from blueblack to silver.

The elemental wildness is matched by human interventions that winningly snub the insipid canons of good taste: private navigations dug by landowners to gain access to what was called the German Ocean (Beaumont Quay, Mundon); silos and hoppers (Grays); factories like a giant's alembics (Thurrock); wind turbines (Frinton); weapons-testing shelters (Foulness); fortresses (Tilbury); the power station (Bradwell) which is a lesson in size constancy, the paradoxical visual illusion that the further we are from an object the larger it seems; ranks of pylons (everywhere). Such structures are officially sanctioned.

There is, however, a further sort of intervention made without, so to speak, benefit of clergy. At West Mersea there is an exceptional hamlet or fleet of boats and barges which float on or in mud and are linked by wooden gangways. More commonplace were the plotland settlements of, predominantly, the interwar period, the golden age of the self-built shack, the converted railway carriage, the prefab bungalow, the bodged chalet. Many were constructed on squatted land. Roads were not metalled. Sanitation was primitive. They were rural retreats for people of limited means, they were patches of paradise. And they incurred the wrath of local authorities who in the 1950s and 1960s granted themselves the power to raze many of them.

Not all, though: at Jaywick near Clacton there is a valuable throwback. Streets named after long-disappeared makes of car (Alvis, Hillman, Lanchester, Riley) are lined with an astonishing array of what at first glance might be unusually distended beach huts. Eighty years after it was built it retains the air of a frontier town, a temporary encampment. Its ephemerality has somehow been frozen in stone – or, rather, in plasterboard and planks. Yet for all its time-warped quaintness and its potency as a snapshot of another age it is undeniably run-down and a byword for deprivation.

Less populous plotland survivals demonstrate that these places can be renewed. Lee-Over-Sands is a site of atmospheric isolation which were it not beside the sea might be in the rural Midwest. The houses are being rebuilt with a certain restrained panache. The same quality is apparent beside the Stour at Wrabness. Though here the houses on stilts aspire to nothing less than Malibu Beach. Which is, no doubt, also the cynosure of the vertically tanned. (2012)

The other ways of Essex 2

We are forbidden by statute or by custom to discriminate according to the time-honoured grounds of race, sex, sexual orientation, age, tribe, intelligence, religion, physical demeanour, hair colour, apparel, accent, piercings, trade and so on. These multiple proscriptions pose a problem. There isn't much left to hate or even mock without getting our collar felt. We are subject to the tyranny of angelism, of a *bien pensant* misreading of humankind: although not pure, we are supposedly potentially really rather nice – if enjoined to be so, if guided.

The ascent of placeism is, then, hardly surprising. It is perhaps the only permissible expression of prejudice that is left to console a species which craves the ignoble gratifications of judgement,

pigeonholing, despisal, malice. Thus it is just about acceptable to laugh at Sodom but not at sodomites.

We define ourselves by the place where we live and, more pertinently, by those places where we don't live. Our collective scorn was once specific, localised. It was towards the village on the far side of the river or towards the town beyond the forest. Such 'traditional' antipathies still exist. Southampton people are scummers, Portsmouth's are skates. Their local, folksy etymologies are bogus and, typically, involve acronyms. According to *Green's Dictionary of Slang*, both words – the former in seventeenth-century English, the latter in Afrikaans – signify defecation. That's more like it.

Although the mutual antagonism is most evident among the cities' football supporters it is not exclusive to them. It is more than a product of that industry's zealously promoted tribalism. My mother's distended Southampton family led *petit bourgeois* lives of exemplary probity enhanced by tides of Empire sherry and a routine dismissal of Portsmouth as 'common', 'rough', full of 'guttersnipes and street Arabs'. Although less than twenty miles distant, it was of course improbable that any of them ever went there.

Such avoidance is precious in the creation and maintenance of any form of prejudice: the less we know the more we can generalise. The larky mini-industry in civic denigration and place-based wretchedness, exemplified by books and websites devoted to Crap Towns and Chav Towns, would not exist without funds of ignorance and hearsay. Should we happen to be familiar with the place that is being deprecated or misrepresented, the industry relies upon our topographical and urbanistic incuriosity, upon our unquestioning acceptance of received ideas – that sprawl is ugly, that concrete buildings are monstrosities, that tower blocks should be razed to the ground, that cityscapes occasioned by the car are inhuman, etc. But most of us aren't familiar with them save through skewed mediation. Happily, we can be depended upon to believe the worst of just

about anywhere – not merely the village on the far side of the river. We take on trust depictions of places without pausing to ask whether that depiction is anything more than an invention.

At the highest level, the more skilfully wrought, the more persuasive, the more constellated by tiny details of disagreeable local colour which could not possibly have been made up an artefact is, the more likely we are to believe in the good faith of its maker. We should not be fooled. Dickens' London was just that – Dickens': a dystopia based in a city largely disappeared by the time he created it. Much of Hardy's Dorset derived from news stories published in the *County Chronicle* a decade before he was born. John Constable indefatigably moved buildings, steepened slopes, blackened skies.

Constable's Essex is a great fabrication. The mediated Essex of two centuries later – let us call it Essex™ – is a somewhat lesser fabrication, the creation of scum-of-the-earth telly executives brought to an 'accessibly' witless approximation of life by a willing menagerie of Botoxed, buffed, tanned, implanted, hairwoven, brain-dead scholastic failures who want nothing more than to grin at the world from a 42-inch screen. Essex™ and its abundant progeny have achieved an audience a mere painter could never dream of. With saccharine relentlessness it has convinced that audience that it is Essex. Essex™ has taken over. All other Essexes have been vanquished. What we have witnessed is internal colonisation by a clamorous freak show.

Unwittingly, Essex™ invites us to calumnise the county whose name it has besmirched. It legitimises placeism. We can say things about the benighted county that we cannot about, say, Islamofascists lest we offend the Islamofascist community. But, sweet relief, there is no Essex community, no Portsmouth community. Counties and cities are inanimate; lumps of geology and human intrusion randomly defined by administrative boundaries and electoral convenience. They can't answer back – that rubs both ways.

There is no place in Britain that so needs to cry out against the reputation attached to it. There is no place in Britain that is such succinct shorthand. It is the misfortune of the rest of Essex that it should be shorthand for a meretricious, materially crass, unreflective decadence – not the decadence of the Decadents who were actually vigorous, but the literal decadence of decay, of rottenness, of dazzling polychromatic spores.

The rest of Essex, the unheard Essex, has its share of pretty pastel-washed villages; a greater volume of the form of plasterwork relief called pargetting than anywhere but Suffolk; magnificent barns and sixteenth-century brickwork . . . What, however, defines it is its estuaries and saltings, creeks and secret inlets, and their rackety marine life; the elisions between water, land and the vast sky. We should delight that only fifty miles from central London there is a wild, elemental place whose shifting marshes and friable cliffs may be provisional but which seem rocks of permanence when measured against Essex™. (2013)

Water's thrilling edgelands

Utopia dons some unlikely guises, crops up in some odd places. On the sea wall, a couple in their teens stood clutching their baby and gazing half a mile across the opaque river to where streets run down to the shore: spires and warehouses, inns and gables announced a town. The boy asked me if I knew over there. He said that that was where they wanted to go to, where they wanted to be. There's so much happening over there. Not like here. Here there were only vast ships, big sheds, cranes, mean houses. And nothing to do. No life. We were between Tilbury Fort and a pub called the World's End.

On the other side of the water was hope. These kids were on the money. The object of their longing was Gravesend. As with many

– most – estuarial towns, reputation and actuality are at odds. It is not – patronising, snobbish, ignorant appellation – a 'crap town'. No town is a crap town if you learn to look at it without faecally tinted spectacles. Amon Wilds Junior, one of the major architects of Brighton, worked here. So, more than a century later, did Jim Cadbury-Brown, part of the Festival of Britain design team. And just upstream stood Rosherville, a pleasure gardens built, like Buttes-Chaumont, on the site of a quarry. There was a zoo, a bear pit (now listed thanks to the Victorian Society's powerful ursine tendency) and labyrinthine paths. It was 'avoided by ladies of good standing'. Zola's friend Hippolyte Taine, approaching by steamer from London, was foxed by the gleaming piles at the water's edge. As his vessel drew closer, they resolved themselves into nacreous pyramids of oyster shells. There isn't much to see but there is a lot to imagine. As for oysters, we must head east, later.

The kids put their child in a buggy, nodded farewell, went away to dream. I went to join my director Frank Hanly at the flashy watergate of Tilbury Fort, designed by the Dutchman Sir Bernard de Gomme. Where and how this gate, a prodigy of un-English baroque, would fit into the film about utopian Essex that we were preparing did not bother us. If it's striking include it. No justification required. No explanation. No apology. And no apology for returning, four years after we made that film, to this recondite subject which is celebrated next weekend in a series of screenings, exhibitions and walks organised by the Focal Point Gallery in Southend as part of the Radical Essex season.

Disparate modernist set pieces will be scrutinised: Bata, the now abandoned Czech-designed shoe factory and the workers' estate beside it; Frinton, where Oliver Hill embarked on what would have been the largest white wall/flat roof project in Britain had the developer not gone the way of so many developers. Silver End (in whose massive communal hall the screenings will take place) is the garden

village built for Crittall's workers, the 'family' who produced the windows that make Britain's first-generation modernist and moderne houses distinct from, say, Czech ones. Both Bata and Silver End were bastions of communality, joining in, team spirit, games, competitions. More interesting, then, to visit utopia than to inhabit it.

This applies, too, to the Salvation Army's Hadleigh Farm ('where broken men of bad habits might be reformed' and readied for transportation); the few remaining chapels of the Peculiar People (an offshoot of Methodism), who wore beards without moustaches, delusionally rejected medicine in favour of prayer and walked to worship in Indian file; experimental communities like the Q Camps (there was one near Braintree) and the various further projects of psychiatrist Norman Glaister, who was involved in the Order of Woodcraft Chivalry, Braziers Park and Grith Fyrd (which taught handicrafts, logging, eugenics). In what might be taken as an act of expiation, brewer Frederick Charrington established a temperance community on Osea Island in the Blackwater. The soap magnate Joseph Fells set up a land colony for the agrarian unemployed on the Dengie Peninsula. Manifesting the knee-jerk anti-Semitism that the English left displays to this day in its enthusiasm for Palestine and Islam, the Fabian Beatrice Webb, co-founder of the *New Statesman*, dismissed Fells as a 'decidedly vulgar little Jew'.

Formal communal experiments invariably ended in mud, indigence, recriminations and grave doctrinal schisms (you build clinker but carvel is the true way). Essex also sprouted self-built plotlands (Jaywick, Pitsea and a score of others), hymns to recycling and asbestos whose motto should be *fais ce que voudras*, places of low-level pleasures hated by the prim and by the jobsworth guardians of Ingerland's precious sod. The urbanist Thomas Sharp derided 'a romantic universal individualism in which every man glories in his self-sufficiency and separateness'. Separateness? Essex is today the proud possessor of more dogging sites than any other county.

The right bank of the estuary has not – pace Kenny Noye, the Hatton Garden robbers and the Krays' country house – shared Essex's bling-bright infamy. But for devotees of oddball garrison towns, all-purpose weirdness and sturdy recidivism, north Kent still has much to offer. Little was weirder than Jezreel's Tower at Gillingham, somewhere between a Guinness Trust tenement and a neo-Elizabethan warehouse. It was built by James Jezreel (né White), Messenger of the Lord and follower of Joanna Southcott. His disciples, standard-issue dupes, lost interest when he failed to rise from the dead where he had been dispatched by alcoholism in 1885. Three years earlier the chloral-addicted D. G. Rossetti had died further along the coast at Birchington in, aptly, one of that village's greenery-yallery aesthetic-movement bungalows, designed by J. P. Seddon with sgraffito decorations by George Frampton (father of Meredith). A recuperating John Buchan, who scorned artiness in all its forms, is supposed to have discovered that one of the bungalows had a tunnel through the chalk to the beach comprising thirty-nine steps.

Essex may have the more atmospheric and intimate creeks, the finer vernacular buildings such as the sail lofts at Tollesbury. But Kent has the better estuary and it is not that of the Thames. The Medway's is the most thrilling of estuaries. Its tiny affluents are beyond number. Desolate saltings, desolate marshes, leats and sluices, detriting hulks, the site of the only land-born lazaretto in Britain, upside-down Allegros and Mondeos bathed in mud, the echo of age-old joyriding songs, electric murmurations, wrecked explosive factories, cranes, such cranes, the Grain Tower (low tide only), concrete anti-tank defences, power-station chimneys, distant refinery chimneys. Here is one of Britain's most affecting landscapes – and not a pretty hill or cute drystone wall in sight. It is epic, sublime and wondrously impure. All would have been lost had the former mayor of London's halfwitted plan for an airport in the

Thames reached fruition. It was actually a non-starter given the lurking submarine presence off Sheerness of the wrecked explosive-packed liberty ship *Richard Montgomery*, which fascinated Uwe Johnson, the German novelist who had made Sheppey his home, perversely. Sheppey does, after all, have three prisons. And when they leave chokey many cons stay on. They do their reintegrating on site. It's not a place to make eye contact with strangers.

The Estuary Festival later this month aims to 'celebrate' this landscape, this waterscape and the people who inhabit it. Performance artists, audio artists, singers, folk singers, multidisciplinary gestural wailing, well-rehearsed seadogs, installations, meta-fictions. I could append some of the artists' statements. The point is: the only mediations this marvellous place requires are cinematographic (Harry Waxman, *The Long Memory*) and photographic (Frank Watson, *Soundings from the Estuary*). They do not dump on it a pile of occlusive 'art'. (2016)

Off-piste
Living with Buildings and Walking with Ghosts: On Health and Architecture by Iain Sinclair

The Wellcome Trust puts on some of the most engaging exhibitions in London and holds in its permanent collection a number of fine works, notably John Isaacs' magnificently gruesome sculptures of figures so contorted by their own obesity that they are only very approximately human. How these and many other pieces accord with a foundation whose roots are in biomedical research is moot, until you consider that those roots have, with modification, sprouted such a severalty of disciplines and areas of tangential enquiry that it makes perfect sense to commission Iain Sinclair to write about the physical and psychological effects of buildings and places on the people who inhabit them, pass through them, long to

get out of them, represent them, think about them. Sinclair's approach is not that of a sociologist, an off-the-peg analyst of urbanism (density good, sprawl bad) or a travel writer on a journey to 'find himself' (in the way that they wearyingly will).

He is, rather, in a typically oblique way, an investigator into the ashes of architectural determinism, the once fashionable notion, too readily dismissed, that design can dictate behaviour. Of course it can. But maybe not in the way that, for instance, ministers of the environment, mall barons, educational authorities, housing associations intend it to. Buildings change use. They acquire new connotations. Fifty years of shipping containers have freed nineteenth-century warehouses from their original purposes and ceded them to a new bourgeoisie. Mutation is a recurrent theme of his work. He quotes Lynsey Hanley's *Estates*: 'Council houses were never intended to be holding cages for the poor and disenfranchised.' Quite.

His method is never programmatic, most often serendipitous, constantly digressive, constantly connective. He is brilliant in many ways. One is that he has the keenest instinct for drolly telling detail. 'No satellite dishes here, the plague buboes of poverty', he writes of eastern Bloomsbury, with which he was, till beckoned by the Wellcome Trust, surprisingly unfamiliar. He doesn't just amble through an area, some sort of passive *flâneur*. Walking leads to reading. He makes himself an expert in his itineraries' architects and inhabitants, in its obscure poets and obscurer libraries where 'fingerprints and saturated sweat are left for generations on unopened pages'. He gets to know a place's eulogists and deprecators, its activists and folk historians. He digs beneath the crust, a venturesome child gleefully pulling away friable stucco to reveal rotting stock bricks.

Living with Buildings most obviously differs from Sinclair's previous books in the variety of its locations. This is not the first time he has ventured outside the M25. Berlin, Texas and the easternmost Midlands have been among his subjects. But the loci of his harsh

funny poetry have usually been Hackney, Haggerston, Homerton. Places he inhabited decades before 'creatives' with silly beards and grave musculoskeletal problems from an epaulette in the form of a phone roamed a-tweetin', quite insouciant that it is they who have caused the class clearance and gentrification they affect to abhor. And have to an extent deprived the laureate of E postcodes of his raw meat.

Far from those boroughs, life is different. On Lewis and Harris, for instance, houses are treated as provisional, as expendable as the wrecked cars that constellate the landscape. 'When a family member takes sick, the building is blamed. Turn away, put up another.' Or just go away without telling anyone. Take the Destitution Road (built by the ennobled opium dealer James Matheson). This is not just a manifest of superstition in a society oppressed by superstition. It is a matter of survival. Much of the population of the island is so catastrophically indigent it lacks even plague buboes.

One of the sculptor Steve Dilworth's responses to this lunar place he has lived in for many years is a fetishistic piece called *Hanging Figure* which might well be in the Wellcome gallery had it not been prised from the artist by the Chicago collector Richard Harris. Would he have created such a work had he remained in his home town of Hull, or in Kent where he lived as a young man? Is the imagination porous to its surrounds? An artist is a better gauge of this variation on nature/ nurture than an accountant or bus driver: an artist has something to show even if it is not susceptible to verbal explanation. Sinclair's impression of the normally voluble Dilworth was of 'an artist recovering votive objects for a tribe that never existed'. That is Sinclair inhabiting Dilworth, giving him a Sinclairian voice. Almost idealising him as he generously idealises many of his friends and collaborators, me included. (I had no idea I was so nice. That's worrying.)

There are in his *galère* no villains but many deviants who have sought, and in some instances discovered, an accommodation with

spaces that were already extant, more often with the carapaces they have bricolaged around them, ascribing to both sorts of place qualities that are imagined. A stable or a church possesses no more thought or sentiment than the stones it is built from. It is necessarily mute, unfeeling, uncaring. But it can be granted any characteristic that we elect. And those characteristics are more often than not broadly based in the flawed sensation that the mineral responds, that there is a compact. Which is where it gets worrying for this godless materialist who believes, along with J. G. Ballard, that the greatest challenge facing humankind is where to find a parking space and that the animists should be returned to the zoo. (2018)

18

Pevsner

Money talks

The Buildings of England: London 1: The City of London
by Simon Bradley and Nikolaus Pevsner

There is no such thing as a typical Pevsner. Even during the first decade and a half when Sir Nikolaus undertook his extraordinary enterprise without collaborators, the tone, not the methodology, varied from volume to volume, sometimes because Pevsner fell in love with an entire county, sometimes because Pevsner forgot that he was a taxonomical machine and revealed Pevsner the man with a talent for caustic one-liners. And, of course, as the series grew, so did the volumes expand and become ever more catholic and comprehensive.

Each collaborator arrived with a full set of quirks: Ian Nairn, the finest architectural journalist of his day, was wayward, now literary, now demotically odd; the tweedy aesthete David Verey used the two Gloucestershire volumes to mount a snide attack on the modernism which Pevsner had done so much to promote; others were *plus royal que le roi*, anxiously second-guessing their leader.

Each volume has its own specific characteristics, then. Nonetheless, this one on the City is so atypical as to be almost aberrant. This has nothing to do with Pevsner's posthumous co-writer Simon

Bradley, everything to do with the peculiarly rich but markedly straitened gamut of building types in an area which is hardly larger than the aggregate of Kensington Gardens and Hyde Park. The City is all too English in its separation of work from home – its domestic population is puny (though growing). But it is un-English in its density. There is a lot of stone, a lot of design, a lot of plastically articulated mercantile hubris per square metre.

Simon Bradley demonstrates considerable restraint in the face of such incitements to immoderation as GMS's Barclays Bank in Lombard Street and the same firm's ineffable Minster Court, two essays in eighties kitsch which might, I suppose, be reckoned architectural analogues of the deregulated yobs of that decade. They are loud, coarse, bloated, frivolous. And they are, as Bradley notes, 'what in America are called skyline signature buildings'. Which makes the City planners' rejection of Norman Foster's proposed tower on the site of the Baltic Exchange seem particularly wrong-headed and strangely timid.

The City may be crammed and monocultural, but its recent architectural history is one of tempered audacity. It is unusual in this country in its lack of thrall to its past. It does not allow tradition to impede Mammon's progress. It is immune to notions of architectural consensus, pervious to a kind of free-market urbanism. What makes it so exhilarating is the very fact that its buildings are not 'in keeping' with each other. It is precisely the opposite of Bath or Edinburgh. It is a graveyard of grand plans and homogenising prescriptions. It has also always been resistant to the provision of public space. Yet the City is undeniably a city, in a way which so much of London, a web of conjoined suburbs, is not.

It makes for a Pevsner which necessarily presents a partial view of English architecture; I can't think of any other volume which has, perforce, largely to overlook the Gothic revival, the Arts and Crafts, art deco and so on. The City is, on the other hand, a major

site of the Victorian classical survival and of the neo-baroque and of the beaux arts. This last idiom is used in the least successful part of the Broadgate development, which Bradley rightly calls the most impressive of the past half-century. But at least this hunk of Gotham City beaux arts has balls.

Given its predilection towards columnar orders, it is surprising that the City didn't succumb to the twee toytown Georgian of the eighties – but Quinlan Terry has done only restoration work, and John Simpson's vision of Paternoster Square, as a sort of William Hogarth theme world, was happily stillborn. Not, of course, that that helps solve the perennial problem of these immediate environs of St Paul's. The implicit message of this copiously detailed vade mecum is that happenstance must be allowed to have its way. But how do you legislate for tectonically happy juxtapositions? (1997)

Happy birthday

Pevsner is fifty this month. Sir Nikolaus may have been dead for eighteen years but his name and the monumental achievement it signifies are very much alive. This is a golden jubilee worthy of national celebration, indeed of international celebration, for there is nothing in the world so systematically thorough as *The Buildings of England*, which might be described as 'an inventory of the 100,000 most important buildings in this country'. It might be, but that would be akin to calling the *Oxford English Dictionary* 'a list of words'.

Pevsner changed this country's attitude to architecture more than any man since Ruskin, whose inspired earnestness he shared. We owe him (and his collaborators) an immeasurable debt: he opened our eyes, he still opens our eyes. But he doesn't make us see. There is a difference. He was not, and never pretended to be, an evocative writer. He describes, and leaves us to do the on-site ocular work. His approach was that of a scientific taxonomist. He was not merely

an architectural modernist but a literary modernist. From Joyce through Faulkner to Nabokov (a lepidopterist) and Robbe-Grillet (an agronomist), modernist description was preoccupied with occlusion, with an accretion of detail that inhibits our summoning the object in our inner cinema. This is a device that aspires to neutrality, a neutrality that Pevsner seldom ruptures – but when he does . . . His one-liners and taut dismissals and laudatory clauses are all the more potent for their infrequency.

The discipline with which he rationed himself is admirable. And of course it goes against the 'amateur spirit', the heart-on-sleeve expression of enthusiasm. There can be no doubt that he was an enthusiast for the buildings of his adopted country (which he loved more than it loved him) – why would he have put himself through such a gruelling assault course had he been otherwise? He was also an amateur in the now archaic meaning of that word.

What he *wasn't* was an amateur in the sense of dilettante. Builders, masons, surveyors, architects, engineers, carvers, ironworkers – the overwhelming majority of those who have professed these callings down the centuries that Pevsner devoured have indeed been professionals. Yet the study of their work was largely undertaken by passionate dilettantes who sought to pass off torpid imprecision as 'impressionism'.

If we consult a work of, say, mycological or avian reference, we expect exactitude rather than bumbling guff wrought with a pen dipped in lard. So why should buildings be different from fungi and birds? The easy reply is that buildings are humankind's rather than 'natural' creations. But it is, equally, wrong-headed: if humankind can create the Zwinger and Blenheim and the Stupinigi, it should be acknowledged capable of creating an exact way of classifying them.

I use those examples of the baroque because the one aperçu I've enjoyed this past week is to do with Pevsner's taste, and his initial

specialism was the baroque. It is necessary to amend Borges' famous dictum that 'every writer creates his own precursors', which is a neat way of saying that because E was influenced by A, B, C and D, we necessarily come to see A, B, C and D in a fresh configuration and discern a connection between them, even if that connection is only E.

Maybe the same goes for those buildings and architects Pevsner admired. His fondness for Victorian revivalism is as well documented as his antipathy to twentieth-century revivalism; and his antipathy to the expressionistic modernism of the 1960s and early 1970s is consistent with his championing of the international modernism of the 1920s and 1930s.

He was a progressive who didn't like progress when he saw what it produced (which was mostly cantilevered concrete). But when it comes to Arne Jacobsen's St Catherine's College, Oxford, which he described, in the penultimate *Buildings of England*, at the age of seventy-two, as 'a perfect piece of architecture', it is clear that full circle had been turned. Decoratively, no – but spatially and volumetrically, Jacobsen's achievement is baroque. Not the trashy, tarty baroque of Sicily or Murcia, but that cold, northern strain that contaminates *Last Year at Marienbad*. (2001)

Welcome to the Ivy League

A new Pevsner! A thing of . . . ? Yes, joy will do. It may not be the emotion that these austerely rigorous volumes are habitually supposed to incite but the word is, in my case, apt. I doubt, otherwise, that I'd already have owned sixty-four of them. This sixty-fifth, published almost two decades after the great teacher's death, has not disappointed me. I fell upon it with the same unalloyed excitement that I would a *Buffalo Bill Annual* shorn of its Christmas wrapping when I was eight. It was the facts in those books that I delighted in

rather than the corny narratives: although, of course, facts and the Wild West sit awkwardly together.

Facts and architectural exegesis hardly sit more happily. But not the least of Sir Nikolaus's compendious gifts was his dissemblance of opinionatedness, of side. He gave a mimetically scrupulous impression of a deity impartially surveying the tectonic essays of his creatures. He was the driest of writers with none of the evocative potency of Betjeman, Summerson or Nairn. And we tend to equate dryness with objectivity. We are wrong to do so. Dryness is a manner, the affectation of usage that becomes the man himself: objectivity is a vain boast of detachment. Pevsner was as partial as anyone else, but only let on with the faintest hints of his persuasions. Those hints are springs in the desert: everything, in this case, is relative.

This new volume is *The Buildings of Scotland: Stirling and Central Scotland* by John Gifford and Frank Arneil Walker (Pevsner Architectural Guides/Yale University Press). I give the griff in full. Read it carefully. Are you with me? No? Then here's a clue: Sir Allen Lane is turning in his grave. Look at the publisher and weep. Not because Pevsners are now owned by an American house but because of what it says about Penguin, whose founder, Allen Lane, a few months after the end of the Second World War, gave a then fairly obscure fringe academic, a German Lutheran of Jewish birth, the opportunity to create what would turn into the most magnificent work of British popular scholarship of the past half-century.

Not popular enough, clearly. In the lexicon of Lane and such editors as Tony Godwin, popular meant 'for the people'. In the lexicon of their successors and of people like Greg Dyke it means 'of the people', is synonymous with populist. Pevsners have been ceded to Yale to make way, unastonishingly, for Rough Guides, which are merely ploddingly utile vade mecums for the unworldly, whose numbers will ever increase so long as the young are deprived of such didactic tools as Pevsners and are talked down to. As they don't

want to be: dumbing down is far more patronising than herbivorous high-mindedness. Thanks to Yale, which being an American publisher still retains a hard-headed conviction about the long-term integrity of commercial worth and scholarship, they will not be deprived. But talk about selling the family silver . . .

I shall not be deprived, either. Not of the scholarship – Gifford and Walker are in the first rank of avatars – nor of the mnemonic or prospective sensations that these works prompt: I had read certain counties before I had set foot in them.

My matrilineal line is entirely Scottish (Baird, Hogg), which partly accounts for my mother's Francophilia. But before I ever set foot in Scotland, in my mid-twenties, I had lived in England and France, had been to Holland, Belgium, Italy, Castile (often), Tunisia, Algeria, Morocco. Nowhere had prepared me for Scotland. Another country. Foreign. Division by a common language, yet not all that common: I already knew *A Drunk Man Looks at the Thistle*. And, I have to admit, there was a sort of physiognomic unity through pasty freckledness: I inherited my mother's colouring, although not her beauty, and I inherited her fat gene, which she fought against by abjuring the Glasgow diet and living on salads, a necessary denial I have now embraced.

But that unity was nothing to the strangeness of the place. Is that hearse a converted Hillman Imp? It is. Is the combined weight of those four men in a Mini parked in a lay-by more than eighty stone? And are those pints of milk they're swigging? Yes, on both counts.

Strangest of all was driving over Glasgow Bridge at autumn dusk. I felt horribly alone. I inchoately realised why the entire cardinal tendency of the English (and the Scottish: Stevenson, Mackintosh) has been to the south, towards olives and sun. This, I thought, is the Baltic. (I had, evidently, never yet been to the Baltic.)

We ignore this foreignness of compass north, it is quite apart from the foreignness that we apparently crave and get, the obvious

foreignness of easy exoticism. Yet we apparently accept it, docilely, doucely (as they so sweetly say up there). We endure, the 90 per cent of us who are not Scottish despite our forebears, a predominantly Scottish government. We delude ourselves that four centuries of Union have effected a cultural homogeneity.

The depth of that delusion is – unwittingly? – manifest in this new Pevsner. Yale has, thankfully, changed neither font nor format. So there is, as usual, a middle section of monochrome photos, 128 of them showing buildings, details, feats of civil engineering, follies. What is remarkable about them is how few could be mistaken even by the tyro eye for English structures. If a country is, as I believe, as much defined by what it erects for its shelter, civic and commercial self-advertisement, manufactories, defensive necessities and religious observance as it is by its political expedients, then Scotland's separateness is indeed set in stone. And England is closer to Belgium. (2002)

Social climbing

The Buildings of England: London 5: East
by Bridget Cherry, Charles O'Brien and Nikolaus Pevsner

The attribution of part authorship to Pevsner himself is more an act of piety or generous homage than an accurate reflection of the composition of this bulky volume, whose territory stretches from Wapping to North Ockendon where, in 1604, a yucca first flowered in England. Hardly a word remains of what Pevsner wrote about St Mary Magdalene, North Ockendon in the Essex volume (1954). Bridget Cherry or Charles O'Brien has doubled the length of the entry. And a 'very stylised fleur-de-lis capital' is now a 'foliated volute capital'.

Does this matter? Maybe not. But it does suggest that Pevsner's heirs are, if you like, *plus royal que le roi*. They don't exactly parody

this greatest of architectural taxonomists, but they do exaggerate his bent towards a technical vocabulary, and they lack his pithiness, his scornful wit, his gift for the lightest of depreciations.

In *London (Except the Cities of London and Westminster)* (1952) Pevsner disdainfully writes of St Paul, Shadwell, that it is 'cheaply built and designed without fire'. This is tight, apt prose. It is quoted here, but qualified by the warning that it is 'perhaps too harsh' a verdict.

The heirs have inherited the anorak, but the master's sheerly literary gifts are still in probate. Pevsner was both architectural historian and writer, the heirs are architectural historians. However, they are better informed than he was, not least because they have access to the researches of a caste of scholars labouring in a discipline which Pevsner was instrumental in professionalising. They are also less *parti pris*, less inclined to special pleading, and they admit intelligence that Pevsner would probably have considered outside his self-imposed remit – that yucca, for instance.

This inclusion of not strictly architectural material is particularly useful in the case of this volume, which is, in part, an oblique social history. While the East End's demographic complexion has changed down the years, its poverty has been perennial. So it has attracted numerous philanthropists. The architecture of indigence includes churches, missions, workhouses, orphanages, temperance halls, dispensaries, industrial schools, charity schools, 'institutes' and boys' clubs, where the deprived might have Newbolt knocked into them by their betters. We live in houses, they live in housing.

The provision of shelter for those who would otherwise be bereft of it has created a specific gamut of building types, which is probably more copiously represented here than anywhere else in Britain. The built expression of *de haut en bas* stretches from almshouses, through model dwellings, to the post-high-rise generation of what used to be called council estates: the welfare state was *noblesse oblige* nationalised.

Clement Attlee was one of many young men of good intentions who worked at Toynbee Hall, which the authors quite properly describe as 'an institution of national, if not international, importance', while bemoaning its architecture as 'rather depressing . . . very uninspiring'. Which might be repeated on every one of the many pages devoted to attempts to improve the lot of the 'Industrious Classes'.

It is gently implied that the notion of progress to which Pevsner was ideologically committed was chimerical. I wonder: things have got better – despite Ronan Point, despite gleefully mediated demolitions of blocks that possess the same appeal as public executions. Social housing has always been problematic. This is in part due to philanthropists and local authorities not having bottomless pockets. A further cause is the strange lack of interest in design exhibited by social reformers: Ebenezer Howard, inventor of the garden city, was unconcerned about what such a place should look like. It would appear that both his precursors and successors shared his indifference, for their choice of architect was often perverse.

H. A. Darbishire initially owed his career to Baroness Burdett-Coutts. His tenements are bargain-basement Piranesi and might have been created to punish their inhabitants, to remind them of the prison they were lucky not to be in. Even when he was granted a bigger budget for the regrettably demolished Columbia Market in Bethnal Green or Holly Village in Highgate, he produced buildings from a queasy Flemish nightmare. His work of the early 1860s for the Peabody Trust established a template that would be adhered to for half a century.

By which time a gifted generation of architects who had worked at Howard's first garden city of Letchworth was boldly tackling urban problems by treating them as irremediable and building falsely bucolic suburbs such as Gidea Park. Among those who designed there was the fascinating Rob van 't Hoff, an expressionist

in Holland, an eccentric classicist in England. Nearby, almost 170,000 people were, between 1919 and 1935, rehoused in Becontree, which has a peerless concentration of churches of those years, including St Mary by Nugent Cachemaille-Day, the most considerable religious architect of that age.

Neither these escapist solutions nor their successors, the post-war new towns, addressed the problems of inner-city slums. For years, it has been the standard-issue received idea that slum clearances destroyed communities, 'decanting' them into inhumane high rises. This is *bien pensant*, anti-modernist tosh subscribed to by nostalgics for forelock and cholera, shared lavatories and cardinal-red doorsteps.

One of Cherry and O'Brien's many lessons is that in the hands of imaginative architects such as Denys Lasdun and Erno Goldfinger, high domestic buildings, properly managed, work as well in London as they do in cities throughout the world. A complementary lesson is that there is much appalling domestic building of only a couple of storeys. (2005)

Missing the bits between

The Buildings of England: Worcestershire
by Alan Brooks and Nikolaus Pevsner

Worcestershire west of the Severn is ur-English. The most alluring part of any county in the entire country. This is not due to Elgar, nor to Housman, who was a Worcestershire lad – though from that river's left bank – and whose blue remembered hills were not in Shropshire. From Bromsgrove he saw the Malverns, buried camels silhouetted at dusk. To their north the Teme's valley is all orchards and hop yards and pyramidal oasts – it's Kent's that are conical. The last inhabited caves in Britain were only abandoned in 1963. There is a pub on a B-road near Great Witley which seems the most forlorn place in the world.

It is not the job of the formidable architectural catalogues begun by Pevsner almost sixty years ago to list the typical or to address landscape. This causes no problems when dealing with London or Leeds, with great cities and even small towns whose composition and flavour are obviously manmade. In Pevsner's own volumes *The Buildings of England* was brilliant when not obliged to stray beyond its stated remit – i.e. the built environment, as we must call it. That remit has changed down the years. The series' current editor Simon Bradley is an accomplished and catholic writer who realises that architecture ought not to be treated just as art (which it seldom is) or as stylistic whim but as a responsive necessity. So the sorts of building that are included have become increasingly various.

Not, perhaps, as various as is required in this county where natural and created landscapes play such a marked role and in whose south-east the defining structures are mostly sub-architectural. Drive north from Broadway – which Pevsner called 'the show village of England', which architecturally and geologically belongs to the Gloucestershire Cotswolds – and the change of scene is stingingly abrupt. The Vale of Evesham is one of England's major market gardens. Its fruit holdings make no concession to rurality. Austere urban brick houses are plonked down in the middle of asparagus beds. Prefabricated greenhouses glint like giants' looking glasses. There are huts, shacks, corrugated iron sheds, itinerant pickers' immobile homes. It is far from pretty yet visually pungent, more satisfying than limestone villages peddling tea towels and the dream of England improbably shared by William Morris and John Major. It should not be beyond *The Buildings of England* to address such edgelands, but disappointingly no effort is made.

Alan Brooks' energetic and otherwise exemplary revision is twice the length of Pevsner's 1968 original. It includes much that Pevsner must have seen but considered unworthy of inclusion. Given his almost evangelical proselytising for modernism it is puzzling that he

left out his fellow modernist Geoffrey Boumphrey's house at Bredon: Brooks does it justice. The nineteenth-century carpet factories in Kidderminster (or Kid Eye as its inhabitants call it) are dealt with in some detail. Malvern's schools and villas, to which Pevsner devoted four pages, now get over twenty: this is appropriate for the town is a well-preserved anthology of uncompromisingly provincial Victorian fashions – harsh muscular Christian Gothic, Jacobean, Cheltonian neoclassicism, Italianate, etc. The strange, romantic Beaucastle, high above Bewdley, was astonishingly overlooked by Pevsner. Brooks describes it as 'a Ruskinian fantasy'. But he neglects to mention the remnants of a Ruskinian land colony nearby. And while he is thorough on the delightful town of Bewdley itself there is nothing about the shack settlement at Northwood a couple of miles away. This predominantly 1920s compendium of former railway carriages, self-built cabins and DIY chalets is the largest surviving plotland development in Britain and ought not to have been omitted.

Worcestershire's purely architectural as opposed to topographical importance lies in its grand domestic buildings and in its countless follies and eyecatchers, which were sometimes rehearsals for full-scale buildings. Brooks is attuned to their significance. He lacks Pevsner's ecclesiastical bias and has consequently composed a more balanced vade mecum. (2007)

Sacred architecture and sandwich spread

Nikolaus Pevsner: The Life by Susie Harries

Pevsner was a German nationalist. At the age of nineteen, he converted from Judaism to Lutheranism in the belief that to do so might make him more German – whatever that meant – and might gain him preferment as a teacher and rid him of his anti-Semitism. It didn't. A year after Hitler's accession to power, he was forced to relinquish academe in Göttingen for trade in Birmingham.

Yet he remained drawn to certain tenets of Nazism and possessed a snobbish distaste for his fellow refugees. He was a monogamist whose quasi-adolescent and apparently unrequited crushes perennially threatened his marriage. He was a modernist who disliked what was actually modern, a progressive who abhorred the results of progress, and whose notions of national characteristics in art were, like Joseph Goebbels', rooted in Germany's nineteenth century; they derived specifically from Georg Dehio. His antipathies beyond that towards Orthodox Jewry were legion: Weimar art, France, the Treaty of Versailles, gentlemen scholars, S. S. Teulon and F. T. Pilkington, Oxford society, brutalism, art for art's sake and, often, himself.

From this tangle of contradictions, Susie Harries has fashioned an outstandingly good biography. It is thorough, detached, humane and exceptionally skilful in its depiction (or creation) of a protagonist who is constantly mutating. The antipathetic Saxon prig of the early chapters gradually evolves into husband, father, expatriate, internee, rubble-shoveller, journalist, wit, editor, polemicist, historian, broadcaster and much else besides. By the end, he has turned into an often amused and often amusing titan of architectural taxonomy: success, as John Mortimer once pointed out, makes people nicer.

Further – and this is not perhaps what is to be expected from a scholarly life of a peerless scholar – the book is also extremely funny, laugh-out-loud funny. As Colin MacInnes was the first to observe, Pevsner was a writer of great originality and supremely understated style. Harries is as poker-faced as her subject, who called greasy-spoon cafés 'quick and nasties'. She tells us that he 'had been briefed on the theory and practice of masturbation by a solemn and well-meaning schoolfriend' (that theory is priceless) and describes Geoffrey Grigson as 'never needlessly polite'. When they set out to explore south Lancashire for the *Buildings of England* series, Edward Hubbard's mother provided Pevsner and her son

with 'Perfect Packets for their lunches – sandwiches carefully wrapped for each day, the dates decided by the keeping properties of the contents: egg, cheese, sandwich spread and paste'.

A footnote on the page that contains that horribly evocative period menu informs us that Pevsner and Hubbard stayed in the same Bolton hotel as Jayne Mansfield, 'who electrified the dining room with her imposing bosom'. (This begs the question, what was Jayne Mansfield doing in Bolton?)

Harries' descriptions of the journeys undertaken for the *BoE* are a hoot, as enchanting in their way as the magnificent opus those journeys produced: if only Arthur Lowe were alive to play him in the film of the book. She also recounts the sheer slog and his unflagging industry: this was as much a physical as it was an intellectual exercise, stretching over quarter of a century.

The *BoE*'s former bias towards sacred architecture is at least partially explained by the delicious sentence: 'He was not as enamoured of the aristocracy as some other historians of the great country houses.' The many incidental pleasures of this wonderfully rich and satisfying confection, which is rightly subtitled 'The Life' (not, the reader should note, a 'critical biography'), include splendid portraits of mid-century Hampstead bohemia when, as Muriel Spark had it, 'all the nice people were poor', of a Birmingham that recalls Walter Allen's, of dandiacal bitches such as Osbert Lancaster and Douglas Cooper, and of architectural-historical sectarian spats, which were all handbags at dawn. (2017)

Whimsy in Hardy country

The Buildings of England: Dorset
by Michael Hill, John Newman and Nikolaus Pevsner

The first edition of the *BoE: Dorset* was published in 1972: 110 x 185 x 30 cm, 544 pages, 41 g. The new edition: 110 x 220 x 40 cm, 780

pages, 89 g. The sheer weight and the impressively bloated dimensions restrict the book's utility. It doesn't fit into any pocket other than a poacher's, so is fated to be a deskbound encyclopaedia rather than a portable guide.

What has happened to Dorset in the intervening four and a half decades to justify such distension? In 1972 the Jurassic Coast had not been invented and the county had yet to become a de facto architectural laboratory whose whimsical experiments have sullied country, contaminated town, disfigured coast. These experiments have often been conducted by architects who are as deafening as they are cack-handed. They may be stylistically disparate but they are bound together in their determination to lurch headlong into the past. Their work ranges from pastiche to what might be called trashtiche, from the very approximately simulated Old Englishness of the Prince of Wales's Poundbury through some arch exercises in Arts and Crafts revivalism to a coarse neo-modernism which has spread like a flashy rash from Sandbanks and Canford Cliffs to an already defaced hinterland.

Michael Hill writes of Pinedbreh (as its begetter calls it): 'To walk through such a large settlement and meet no reflection of anything that has happened, architecturally, through the Victorian years or after, say, 1914, is to experience a profound sense of displacement.' That's one way of putting it. It's best regarded as an accidental folly or as a fantasy designed by Osbert Lancaster guying various schools of architectural illiteracy. Even after twenty-five years the ever-expanding suburb shocks when it comes into view. Its site is crassly chosen. Dorchester, to which it is appended, was a town with unusually legible boundaries. No more. And then there is the matter of Poundbury's relationship to Maiden Castle, the greatest Iron Age hill fort in Britain, only half a mile away.

Maybe its illusionism does not go far enough: cars should be banned and its residents obliged to dress in late-Georgian costumes,

submit to late-Georgian dentistry and enjoy the scent of late-Georgian plumbing. It's a monument to facadism, exterior decoration and the capacious dressing-up box of previous styles. So it is odd that Victorian models are proscribed given that epoch's mastery of making the past the present. And odder still that parts of Poundbury derive from a sort of *völkisch* Jugendstil.

It has of course occasioned deferential copyism. 'Traditional homes' are evidently not restricted to Dorset. But the traditions followed in the county are arbitrary and, it goes without saying, entirely bogus. Why on earth should a more or less exact copy of Voysey's house in South Parade, Chiswick be built a hundred years later in Shillingstone between Blandford and Shaftesbury? Hill omits this particular aberration but includes a lame attempt to ape a butterfly-plan house by Lutyens – always a mistake. He describes a building by Baillie Scott as 'coyly complicated', which is just about all one needs to know about the precious tweeness of much of the Arts and Crafts, let alone its copyists. Though he doesn't do himself any favours by describing a turret at Guy Dawber's remote downland house Ashley Chase as 'naughtily curved', an epithet that is itself coy.

A gauged sort of retrospection is manifest in the Nash-influenced work of Robert Adam (the very much living one) and at Anthony Jaggard's camp, theatrical, fanatically crenellated Bellamont, another remote downland house that is an inspired invention rather than a reproduction. These are, however, exceptions, qualitatively and idiomatically.

Running the Poundbury style-guide a close second is the Lombard School of sub-architecture. Lombard is a 1980s City acronym: Loads of Money but a Real Dickhead. Branksome Park and Sandbanks are England's California. They are the Lombard playgrounds *par excellence*. They form the epicentre of a breed of neo-modernism whose primary purpose is to express wealth, whose secondary

purpose is to express more wealth, and so on. This is far from the insipidity and cautious good taste of Poundbury, which causes offence by trying not to do so. This is far, too, from the earnest ethical programme of modernism. It is, rather, turbocharged vulgarity, exciting because it's as energetic as cheap music, and about as satisfying. Counter-intuitive features are so much the norm that they become intuitive. Turquoise glass is de rigueur (this month). Blue pantiles are signature tiles. Gardens are heirs to Compton Acres in Parkstone, which John Betjeman described as owning 'unexampled and elaborate hideousness'. Wacky angles and slipways abound. The more expensive materials that can be crammed on to a facade the better. There is no word for restraint in the Lombard lexicon but there are a hundred for dosh.

But these domestic excrescences, together with countless other indignities visited on this blameless county, do not account for the volume's bulk. Nor do Bournemouth and Christchurch. In 1972, shortly before the county boundary changes, they were still in Hampshire. And that, so far as the *BoE* is concerned, is where they shall remain. Which might be taken as a posthumous poke in the eye for Edward Heath and his smooth gofer Peter Walker.

The predominant reason for this growth spurt is the amount of detail that Hill brings to the revision, detail which derives from the increased professionalisation of architectural-historical scholarship. That in turn presumes a more knowledgeable, more architecturally literate constituency of readers than existed forty-odd years ago, a constituency which has been broadly schooled by the *BoE*. Like all great works it has created its own audience. The gulf between this volume and its predecessor is akin to that between a great palace – Eastbury, say – and Vanbrugh's initial sketches for it. Sir Nikolaus's incomparable gift to his adopted country was not merely the volumes that he himself wrote but a template and his example. He set in motion something as vital and as capable of infinite expansion as

the *OED*, a juggernaut of voussoirs, attributions, dates, crisp judgements, minimalist prose and feigned impersonality.

In the 1972 edition the sacred was written by Pevsner himself and the secular by John Newman. With one exception, Pevsner chose his collaborators well. Newman, who also wrote both of the excellent Kent volumes, is a discreet presence, but a presence nonetheless, with a felicitous turn of phrase. Of Upton House near Poole he begins: 'An early c19 stuccoed villa in a small, somewhat rank, park.' Hill amends the entry, perhaps corrects it, certainly increases its length, yet loses that 'somewhat rank' – which is what makes it. Of course it is possible that the park is no longer rank and that remedial gardening has quashed a memorable phrase.

Pevsner wrote that although Dorset was reputed as a 'house or mansion county' its churches caused him to realise 'how very much one has enjoyed'. Hill takes this as a challenge or at least a cue to prolixity. The result is that, like the very earliest volumes, there is a marked ecclesiastical bias. This imbalance was based in a hierarchy of use: the sacred was placed higher than the secular. It was gradually corrected by Pevsner's collaborators. Here, the entry for the minster church of Wimborne is five times the length of that for Eastbury, the third greatest house by England's greatest architect. That for St Mary Magdalene at Loders is twice as long as in the first edition. The nearby strip lynchets now go unmentioned. Perhaps they no longer count as architecture. Perhaps they have been ploughed over. Perhaps they have been overlooked. But in his foraging ecumenicism he has found in that village near Bridport a Methodist chapel and has included it. Indeed the book is weighed down by these joyless Shilohs, off-the-peg sheds, all moralistic brick and no mumbo jumbo. They are seldom of much architectural worth. It is hard to believe that in Verwood, West Moors and Ferndown there is not a single domestic building to be noted. These places are exemplary twentieth-century sprawl on the heathlands to

the north of Bournemouth. They are lazily reckoned to be 'characterless'. No place is characterless. They may not be susceptible to the architectural scholarship in which Hill excels, but they are susceptible to a topographically inclined eye. (2018)

19

Politics

Fool Britannia

On Tony Blair's first Labour Conference speech as prime minister

The messianic balm with which Our Lord Toni invigorates and soothes us has to be taken with a less palatable dose of hard decision (prescription to be announced). Candyfloss and castor oil. But why the latter? Because Toni and the Baptist have calculated that their promise of Beacon Britain might sound too much like pure vision, 100 per cent proof New Jerusalem, if offered without the attached notion of sacrifice. And Toni, a player out of Wolfit's mould, possesses the gestural gamut to show us that he, the embodiment of the nation, takes upon himself its woes, he shoulders the burden. (We've seen all this before, though not in a benign Christian Democrat context.)

Now, it may be the case that an undamaging miscalculation was made. It may be that Tonipower was, atypically, underestimated. It may be that the insurance policy of hard decision was not required. It may be that that cushion is already redundant and that the Toni-folk (that's pretty much all of us) are ready for Heaven UK 2000 plc. They're up for it because Toni has amended and extended the limits of the possible. Like some magical Mesmer, he has persuaded his people to feel well about themselves: one can see the creaky,

hammy mechanism, but it doesn't matter, his bizarre gift is almost conditional upon his charlatanism.

This is the new givingness – and it really is something that Britain is best at, to the amazement and distaste of France, which is currently perceived to be suffering mini-crises and blows to its *amour propre* without a Red Rose Tory to heal and mend the damage. The can of worms that is the Catholic complicity in the Holocaust dominated the French media last week; and then there is the matter of *Impostures Intellectuelles*, whose beef is that the whole apparatus of structuralist and post-structuralist thought is founded in fraudulence, speciousness, hopelessly ill-digested scientism, witting obfuscation and the hubris of a quasi-hieratic caste to whom compatriots meekly submit, lest they be reckoned intellectually Luddite. (*Impostures* is the work of a jokily revisionist American and, horror of horrors, a Belgian.)

It is, of course, sweet Elgar to Anglo-Saxon ears long attuned to pragmatism, newly attuned to mawkishness and proudly deaf to abstraction. Who needs ideas if they possess the all-too-well-named property of *common sense*, another field in which Britain is a world player and one which is routinely cited as the reason why, when totalitarianism was the European fashion, we never embraced it – though that might just as well be ascribed to our winning torpor and apathy, qualities which should not be undervalued but which render us peculiarly prone to passive deference and to an uncomplaining acceptance of curtailed civil liberties and the unchallenged right of the executive to determine norms of conduct.

Compare that with France, where the state is regarded with a certain antipathy and disdain: it is not equated with the nation. One of the roles of the poor abused French clerisy has been that of national conscience and moral judge – this is evidently a world away from the bathetic moralism of Middle Englanders, whom no one would listen to in a culture which respected intellect (even if it didn't understand it).

But there is advantage to a country which honours saccharine entertainers, airport novelists, sitcom artistes and the like. Less emollient creators and performers are lent vigour by official neglect, by being marooned in a sea of indifference, by their opposition to the artless culture into which they chanced to be born: the potent strain of what appears to be misanthropy in so much British writing, film and art of the recent past may be, rather, a raggedly collective expression of loathing for Britain rather than for the mass of humankind. Grimness and bleak humour are born of a society that is not particularly proud of itself.

That is all going to disappear from Heaven UK, where we'll be at ease with each other, will give give give, weep on our teddy bears' shoulders, do the crocodile rock to show our compassion when Elton dies and scale the heights to reinvent the cuckoo clock.

Another way of looking at it is that, shorn of its habitual retrophilia and not of the monarchy but of the monarchy according to Prince Albert, Britain may be in a position to challenge for the curious title of 'best', as Toni would wish. But before you can be best, you've got to be better and, before that, good.

Unfortunately, many of the things that Britain does well (belligerence, yobbery – the French now call us *'les fuck-offs'* – buggering up cities, creating slums, shooting up smack, truanting in order to give birth) are not quite what He has in mind; indeed there is every indication that Jack Straw, who will very likely become the most hated home secretary since Michael Howard, is going to stamp out these areas of excellence with his curfews, man-traps and hulks.

What Toni wants us to be best at is a whole salad of mutually exclusive endeavours: this is a man who believes in unity by inclusion, who rejects *either/or* in favour of *both/and* – rock 'n' roll and the army; commercial excellence and human rights; *grands projets* and social housing; education for all and peanuts for teachers; drug-free

clubs for groovers whose pharmaceutical needs are taken care of because they're high on people power.

Now, this litany may be characterised as serially oxymoronic, but that's the very nature, too, of Tonism. The man's trick is to be the highest climber on the greasy pole while retaining a non-political (rather than apolitical) grasp of what his politically disaffected generation know is wrong or unworkable. He has gone further, quicker, much quicker than Thatch, whose Manchester Liberalism was initially occluded and whose subsequent jingoism was sheerly opportunistic. But just as Thatch had no time for, no understanding of the old Tory salvation through *noblesse oblige*, so is Toni one-eyed when it comes to the Toynbee Hall version of *noblesse oblige* which used to be called the Welfare State. Best at that, too.

But Radical Centrism or Extreme Moderation doesn't give a toss for the shibboleths of the old alignments: 'New' Labour is, *pace* the survival of Benn and Skinner and the impotent elevation of Livingstone, new politics, no quotes required. But new Britain, let alone best Britain? Are we *fuck-offs* ready for it? Are we going to prove pervious to the exhortations to excellence? And, anyway, what's so great about winning an export contract or a soccer tournament if you lack not only the idea of *douceur de vivre* but even a name for it? (1997)

Dear John Major

Do you remember the improbably named Ral Donner's only hit? 1961: it was called 'You Don't Know What You've Got Until You Lose It'. It seems apt as an anthem for those of us who look on your successor, a professionally pious zealot, with increasing alarm – we always knew he was creepily ingratiating, we always knew his gestural ploys to show how he was a conduit for the woes of the nation were Hitlerian, but we didn't expect him to act with such tyrannical solipsism.

But it's too late now – you're not coming back, are you, John? You've turned writer. You were bound to. It's your family's trade. Norma writes. Terry is the author of this decade's comic masterpiece. It can't have astonished you to find your work described as 'surprisingly' well written – you'll be patronised to the grave. But that's the country you love for you.

In America you'd be a hero for having overcome the supposed disadvantages you had to suffer – I once took the John Major Heritage Trail from Worcester Park to Brixton to Huntingdon and I couldn't help but admire what you achieved. What we miss is your very Englishness. You will come to be seen as the last prime minister who had about him the Tommy spirit of the conscript army which won the war: there was something bolshie and obdurate about you and a sense of eccentricity suppressed – beneath your middle manager's disguise there was a true son of the circus, a daring virtuoso who could and did get to the top of the greasy pole without a safety net.

I have no taste for cricket but I enjoyed your public enthusiasm for it, and the way it made us see that you possessed a sense of proportion. And I was delighted that you should have devoted so much of a recent book-signing to talking to Jim Laker's widow – that was the act of a decent man. It is of course your decency that is our greatest loss – well, that and Terry, but we can always find him at the Cabaret of Angels in Stringfellows, which is probably one up from Lord's. Of course your decency does raise one vital question. How could a man of such a demeanour surround himself with such a menagerie of geeks, freaks, psychos and clowns? It's unfathomable till we recall the circus: then we realise that the ringmaster gene within you was just too dominant.

PS: Here's one for Terry. She was only a wicketkeeper's daughter but she could take a full toss in the crease. (2012)

Epic shit in chief

Nincompoopolis: The Follies of Boris Johnson by Douglas Murphy

Boris Johnson's lovable maverick schtick has been to dissemble himself beneath a mantle of suet, to pretend to inarticulacy, to oik about as the People's Primate, to wear a ten-year-old's hairdo, to laugh it off – no matter what it is, no matter how grave it may be – and to display charm learned at a charm school with duff tutors.

This construct is going on threadbare. If one devotes such energy to a simulacrum of oafishness one becomes an oaf. The creature that his panto act was intended to occlude is evident in photographs of over thirty years ago when he still had cheekbones. In those days, the young apprentice liar was only a rapier scar short of the full Heydrich. The supercilious confidence, the hubris, the arrogance of the entitled and the languid bully's hardly suppressed cruelty are deafeningly manifest.

George Orwell was perhaps wrong. Johnson is now a spectacularly immature fifty-three-year-old who doesn't have the face he deserves. Rather, he has the face he has struggled to create, a mask to gull the gullible Little Ingerlanders whose xenophobic legions – think, if you can bear to, of a million Andrea Leadsoms mated with a million beer-bellied fans – are as ever-swelling as their idol.

They feel no shame at belonging to the same species as the creature, no embarrassment. He doesn't make them wince. They applaud his blustering idiocies, his boorishness, his antinomian exceptionalism, his carelessness, his borderline criminality, his incontinent mendacity – a habit which, decades on, he has yet to stem.

And his despoliation of London during eight years of insouciant irresponsibility has, until lately, provoked astonishingly little concerted antipathy outside the milieu of urbanism conference delegates, infrastructural consultants, public-space gurus, despised planners who know their job and megalopolitan studies majors.

These people, no matter how distinguished and how clued up, were impotent in the face of an elected absolutist who listened to no one and would be in chokey for life were pig ignorance a crime. It's all very well spitefully damaging restaurants with your fellow sawdust caesars of the Bullingdon for loutish self-gratification. Spitefully damaging one of the great cities of the world, rendering it formerly great, for loutish self-gratification is a rather different matter.

This was the mayor who shat laissez-faire on London, who marked his territory with heavy loads of foetid bling, whose faecal legacy it will take decades to clear. Unhappily the second-hand water cannon – Wasserwerfer 9000s – which Johnson, evidently in Mayor Daley mood and too indolent to check their legality, bought from some spiv on a back lot in Chemnitz, have been sold on. They weren't legal. The then home secretary Theresa May said so.

Johnson's was not normal autocratic behaviour. In 1977, Jacques Chirac was elected the first mayor of Paris in a century. Chirac used his position to undermine the president, the amusingly pompous Valéry Giscard d'Estaing from whose cabinet he had resigned. So Chirac sacked Ricardo Bofill, whom Giscard had chosen by means of a rigged competition to rebuild Les Halles – which ought not to have been demolished in the first place.

Chirac denigrated Bofill's design as 'Greco-Egyptian with Buddhist tendencies' and after that mouthful declared: '*L'architecte . . . c'est moi.*' And – preposterous as it may sound – he was, insofar as he meddled and 'advised' and censored the designs of Jean Willerval, whom he brought in to replace Bofill.

Willerval was an accomplished brutalist who was ill at ease with the tepid postmodernism that Chirac prescribed. His 'umbrellas' would last less than three decades. Meanwhile Giscard d'Estaing was promoting the Gare d'Orsay as a counter to the Beaubourg, a project which he had wished to cancel when he was elected president.

But once it was renamed the Pompidou Centre his hands were tied in enforced respect for his dead predecessor.

These were certainly proxy political skirmishes, but they were also about surfaces – taste, design, style and the appearance of a city. Two decades previously, Nikita Khrushchev's denunciation of Stalin had begun with a vilification of his kitschy historicist funfair architecture. The subsequent *khrushchyovkas* were grimly functional, prefabricated, standardised, low-cost, spartan and based on immediately post-war French models. No doubt Putin's zealous erasure of them is partly founded in their not being specifically Russian. Like Stalin, Putin understands the Russian sweet tooth for gaudiness. Further, the *khrushchyovkas* do not accord with the look that Moscow should present to the world.

In comparison with these politicians who, whatever their bent, recognised the importance of aesthetics and the politicisation of design, Johnson is stylistically agnostic, artistically indiscriminate and not much concerned about a building's purpose. His campaign manifesto for the 2008 mayoral election included a predictable boast about improving 'the aesthetic quality of new developments'. How, given that all evidence points to his aesthetic blindness, was this to be achieved? By the market, of course. The market possesses 20/20 vision, it is always right. Apart from the grand destiny which awaits him, it is the only thing that he believes in, though that could change if it suits him to change.

The market absolved Johnson of having to make choices. He waved through virtually every planning application that came before him. He 'called in' a number of applications that had been rejected. He overruled councils and local objections and sanctioned developments of which he had only the feeblest knowledge. Plans and proposals demand a concentrated attention to detail that Johnson, by his own admission, lacks.

He consequently created a city fit only for hedge-fund bastards, south-east Asian investors, oligarchs on the run and their Amazonian prostitutes known as 'Russian fur trees'. Through sloth and indifference, he exacerbated inequality and the housing crisis. Having claimed that he would not create Dubai-on-Thames he did worse, he created Houston-on-Thames, Minneapolis-on-Thames. He turned London into a building site, a catwalk of urban regenerators' bums. There is nothing less 'sustainable' than the process of construction.

Throughout his excellent and often shocking book, *Nincompoopolis*, Douglas Murphy is level-headed and generally reluctant to attack Johnson *ad hominem*. This might be regarded as self-censorship or simply an act of courtesy which would improbably be reciprocated. He does not, then, consider the possibility that Johnson, in his overwhelming eagerness to leave a mark which would live on beyond his mayoral term, was often had.

Far from being the big chief, he was a readily biddable patsy, a soft touch for sly operators. Developers, vandals in all but name, circumvented planning procedure by going straight to him and his chummy rubber stamp, safe in the knowledge that he would not have considered the ramifications of their latest offering. He had a scattergun approach to his wretched 'legacy'. If you permit everything, something is bound to stick. He refused only seven of the 130 applications that came before him.

One of these was for an extension to London City Airport which had been approved by the local authority. Murphy surmises, not unreasonably, that Johnson's refusal to endorse the scheme was on spurious grounds – noise, pollution – because he was entertaining a half-witted dream of an airport on an artificial extension to the Isle of Grain at the foggy confluence of the Thames and the Medway. The creature's *amour propre* and faith in his own judgement is so powerful that he quite overlooks or dismisses the project's environmentally catastrophic effects, not to mention that construction

would involve disturbing the liberty ship *Richard Montgomery* which famously sank off Sheerness in 1944 with 1,400 tons of ordnance aboard.

Their explosive status is disputed. That of Grain is not. A beguiling wilderness, its value is increased by its proximity to London. It requires protection from chancers' duff wheezes. One might say that London itself also requires that protection, though that would have precluded John Nash, a chancer of genius and thus an exception.

Johnson is not even in the premier league of chancers. His estuarial airport was partly recycled from the Heath-era scheme on the Essex shore at Maplin Sands, which excited derision at the time. Much of north Kent is a valuable reminder of England before it was Thatcherised. Johnson, like Thatcher, is not, *pace* Murphy, really a Tory, let alone a shires Tory – do those beasts still exist? If he must be classified, it is as a mutant Manchester Liberal.

Like Thatcher and like Trump, with whom he is twinned and whom he embarrassingly calls 'a great global brand', he displays, as Murphy observes, 'a vocal contempt for the state but a consistent eagerness to use it as a source of funds and protection'.

Funds, for instance, to promote his follies which give follies a bad name. They are crude whims and coarse caprices such as the garden bridge. Leave aside Thomas Heatherwick's mediocre design. The evasion of normal procurement processes, the disappearance of millions of pounds, the creepily cosy relationship of Transport for London with the engineering behemoth Arup, the emergence of Joanna Lumley as an urban theorist and the 'casual disregard for the boundaries of public and private', these call for criminal investigation.

Johnson's mayoralty was a consistently splendid demonstration of what used to be called the OPA (old pals' act) in its full, grubby pomp. Heatherwick, for instance, evidently the court designer, was also responsible for the disastrous new buses. He appointed as 'a senior adviser' the far from distinguished former editor of the

Evening Standard Veronica Wadley, whose support of his electoral campaign had been as laughably *parti pris* as her denigration of Ken Livingstone's.

Subsequently he bent every conceivable rule of public job selection to secure her appointment to the chair of Arts Council London, a post for which she had absolutely no experience. Johnson's perplexing anxiety to please Wadley was such that he reran the selection process once the Tories had returned to power in 2010, and obliging Jeremy Hunt was on hand to approve the appointment, which his predecessor Ben Bradshaw had declined to do. Was this quid pro quo? A big drink? Was it down to friendship? To a belief in Wadley's previously untried abilities? No. More likely by far it was a self-interested ruse to deter Wadley's husband, the biographical attack-dog Tom Bower, from writing about him.

In all likelihood, it will turn out that Johnson has miscalculated and Bower will slip his leash, teeth bared. As Murphy, a rather more nuanced writer, repeatedly shows, Johnson has an unerring aptitude for misreading situations. He is a hostage to his own wishfulness. He wants a new toy, a toy he will share with the little people. A £60-million cable car kind of toy. In his access of solipsism he has assumed that the world would want to play with the toy that he has so generously offered them. But the wretched ingrates are indifferent to his gift.

What, then, about an aggressive lump of *soi-disant* sculpture to Johnson-up the Olympics, on whose pristine site he had yet to evacuate himself? The supersalesman connects well. He is lanyarding around the World Economic Forum in Davos when who should he run into but Lakshmi Mittal, then the richest man in Britain. No foreplay, straight to the point. 'Lakshmi, old son, I have a vision . . .'

The consummation was immediate. Mr Steel (Murphy's epithet) coughs up. But for what? Johnson is a highly unoriginal thinker.

His vision was, typically, pre-loved: it was for the kind of structure that endured long after the forgotten expos, the world fairs and the previous Olympics they had originally embellished. Compulsorily vertical, like the Eiffel Tower or the Seattle Space Needle or the Olympiaturm in Munich. Paul Fryer's fine *Transmission*, somewhere between totem pole and cross of Lorraine, was the first work associated with this scheme. But Johnson, *au fond* an off-the-peg, immeasurably vain politician, craved a 'landmark' – his drearily hackneyed word – and a big name.

He convened a jury the far side of parody. The curatocratic *nomenklatura*: Nicholas Serota, Julia Peyton-Jones and the ineffable Hans Ulrich Obrist, engaged in his perpetual struggle to parse a sentence. These institutionalised champions of the ancient avant-garde are nothing if not predictable. They arrived at a shortlist of three of their cronies. This time they chose crony Anish Kapoor and his collaborator, crony Cecil Balmond, the engineer whose job is to make sure *Dummkopf* visions don't collapse. This is a man who never lacks for commissions.

It might be argued that the ArcelorMittal *Orbit* is in the tradition of eye-catchers built in the form of ruins. That would be to exonerate those culpable for the mess. It appears to be the site of a major roller-coaster disaster, a multimillion-pound structural failure. This, presumably, is not what was intended. But it does stand as an apt and unwitting summation of Johnson's London – an ugly man's ugly legacy of chaos concentrated in a single ugly object.

Throughout the years of Johnson's reign, Douglas Murphy was making or trying to make a career as an architect. He lived a life of gas-meter fiction and Gissing-like penury. He casually contrasts his lot, the lot of the many, with that of the few, of Johnson and his privileged milieu, his privileged background.

Murphy is not sparing in his use of 'elite' and 'elitism'. So what?

There is something terribly wrong about a society which allows attention-seeking freaks like Johnson to rise and rise. This is a man who'll do anything for a photo opportunity. Bite off a live European chicken's head? Why not? Dance in Union Jack-patterned Pampers? Of course.

Eton is obviously partly to blame. Its very existence depends on bolstering the inequality and exclusivity which endow its charges with an unmerited sense of superiority no matter how crass the little tossers may be. There are exceptions. Orwell, of course, and Neal Ascherson, who recently observed that, when he was there, his fellow pupils treated their teachers as servants. They very likely still do. OEs such as Robin Cook – aka Derek Raymond – Jeremy Sandford and Heathcote Williams also saw through the contaminatory place and despised it. They belong to an honourable tradition of treachery towards the old school.

Johnson, like the wretched Cameron – a poltroon who, extraordinarily, inflicted even greater harm – is not an aristocrat. Were he an aristocrat he might have some conception of *noblesse oblige*. He is a paltry, utterly conventional, upwardly mobile, morally squalid parvenu who yearns to be taken for what he isn't. There is a parliamentary history of such creatures who believe themselves to be characterful cards – Gerald Nabarro, Norman St John-Stevas, Leo Abse, the rapists Nicholas Fairbairn and Cyril Smith. But no party leader was ever daft enough to appoint any of them to an important post.

Until recently I had hoped that Johnson would, in homage to his doppelgänger Hermann Göring, crack open a cyanide capsule in his cell while awaiting trial for gross abuse of public funds – where are they? I must apologise. We should humanely encourage him to hang himself with a towel attached to a toilet pipe like another characterful card, Robert Ley, director of the Nazis' Strength Through Joy organisation. (2017)

Up against the wall

Any impressively long wall is bound to cause us to recall the mid-field dynamo and philosopher John Trewick. In 1978 Big Ron Atkinson took his bubble-permed West Bromwich Albion team to China on some sort of goodwill tour. The lads' diplomacy evidently rested in their feet, for when Trewick was asked by the BBC crew documenting the tour what he thought of the Great Wall he replied: 'When you've seen one wall you've seen them all.' Good try John, but not quite accurate.

He would, however, have been on the money had he alluded to the common state of mind among men who commission immense walls (paranoiac) and to the loss of life that is, without exception, occasioned by the construction of the things (considerable). In these regards all walls are, indeed, one wall – whatever form they take. For much of its history the Great Wall was not continuous but a series of manned fortifications.

The last major land defences built on British soil, whose greatest concentration is on Portsdown Hill and the Gosport peninsula, were separate from each other, and garrisoned. They were martially redundant by the time they were finished: Palmerston's Follies were the result of a specific paranoia, that prime minister's Francophobia and his mistrust of Napoleon III. This Francophobia did not inhibit the Royal Engineers and the chief designer William Jervois from borrowing liberally from the Marquis de Vauban, who had established the model for this sort of structure 200 years previously (French border and coastal towns *passim*). These citadels were, again, defended. They were also both better-looking and more sophisticated than the chimera proposed by the Lout in the White House which – a further given – will be avoided, as the *Wehrmacht* avoided the Maginot Line by invading through Belgium, or breached, quite probably by the north-eastern intelligentsia fleeing to civilisation.

Unless, that is, the Lout can devise a wall unlike any wall in the history of walls, from the fictive tale of Jericho, to friable levees, to the Bastille, to the razor wire and *chevaux de frise* that disfigured Berlin. This seems unlikely given his previous form with (a) more modest walls and (b) the world, which disobligingly fails to conform to his megalomaniac whim.

Michael Gove is an Aberdonian. It was, however, too much to expect that during his protracted rimming of the Lout's duodenum – a malodorous playspace shared with Nigel Farage and Piers Morgan – he might raise the matter of the leylandii-topped earthworks spitefully constructed around properties which impinge on the Lout's golf course among the dunes just north of Aberdeen at Balmedie. Anyone who has witnessed this boorish narcissist's abuse of people who refused to sell their modest, pleasingly ramshackle homes, must question his suitability for the office he has bought himself as a belated seventieth birthday gift. The Lout is a vandal. The dunes were not just an SSSI, they were magnificent – a place of startling natural beauty and shifting mystery.

He is also a liar. There has been a shortfall of 5,900 on his promise of 6,000 jobs. So far ninety-five jobs have been created. The moronically gullible patsy in this instance was Alex Salmond. He was sold a pup the size of a St Bernard: that's what the Lout does. What Salmond endorsed was a total destruction that can never be undone. So much for the 'sustainability' that the wretched Salmond, along with all other politicians, incessantly bleats about. It is particularly succulent that the Lout's love of land-hungry, ugly golf courses for ugly people in ugly clothes goes hand in hand with a dumb abhorrence of wind turbines, which he claims will 'sully' the sea views from Balmedie. The man is aesthetically as well as morally bankrupt.

The USA has little to offer him in the way of models for a 2,000-mile-long wall – apart, of course, from the wall, or walls, that already exist along almost half of the country's border with

Mexico. The proposed wall is a base fantasy. It is what a paranoiac tyrant might build if the current wall did not impede further construction. Boasts about this most rudimentary security device were effective vote catchers, they were stirring appeals to proudly American xenophobes, even to those who live in the south-western states and are thus familiar with the gappy fences, barricades, border patrols, piles of ladders, shredded clothes and occasional corpses which form the secondary decor of such an environmentally hostile and socially divisive exercise in infrastructure. The threatening proposal that it is Mexico which ought to pay for whatever (if anything) is built is risibly insulting. It is almost certainly founded in a sense of (Presbyterian) American racial and religious superiority. Even if it could be built – and the distance from Brownsville on the Gulf of Mexico to Tijuana on the Pacific is that of Lisbon to Helsinki – it would require a force about 60,000 strong to effectively police it day and night. There's every chance that the coarse earthworks he created to harass his uncompliant neighbours at Balmedie may turn out to be the only walls he will ever build.

But if he did build it what sort of wall would the Wall be? As I say, the Lout is an aesthetic retard who possesses a baleful taste for Louis the Decorator, gold, marble and mirthless kitsch. Can these materials be applied to a wall? In dilute form can they demonstrate the fulfilled aspiration they represent: you know the sort of thing – a plastic putto every five miles, a fibreglass caryatid here and there, atlantes. Abundant crenellations. Loads of abundance. And to top it all extruded plastic selfies of the Lout as Roman soldier, berserker, GI, Tommy, astronaut. His taste is akin to that of professional footballers, gangsters and, most tellingly, central Asian tyrants and African dictators. This is worrying. America may soon discover that the tastes he shares with such gentlemen extend beyond matters of mere decor. In which case we must turn to another wall, a low wall in Dealey Plaza, Dallas.

Where is the man from the grassy knoll now that he is really needed? (2017)

Pedigree chumps

A dozen members of Parliament from the pro-Brexit, pro-gurning, pro-expenses, pro-moronic, pro-attention-seeking, pro-cliché, pro-prolixity Shameless-In-Our-Compassion faction of the Conservative party have come together behind the hereditary backbencher Bill Wiggin to support his Dog Meat (Consumption) (Offences) Bill 2017–19. The bill, which also enjoys garrulous cross-party endorsement, is not, despite its name, intended to prevent humans from stealing and eating meat intended for their pet dog. Such a bill will, however, undoubtedly be tabled in the near future as the store of mores and practices to be banned diminishes further. It will be a dark day for Parliament when there is nothing left to proscribe, nothing that nodding dullards can deem 'totally unacceptable'.

Backbencher Bill is already scraping the bottom of the barrel with this one. Its purpose is to prevent us from eating the flesh and innards of Kylie the Bedlington, Skip the Spaniel, Degsy the Schnauzer . . . Aaah, the poor diddumses, how could anyone be so heartless as to think of doing such a thing to them, these noble creatures, Man's Best Friend (an honorific I dispute).

Does Backbencher Bill believe that Britain is about to witness an outbreak of cynophagy? How does he know? Maybe it's already with us. Does the man have spies reporting on suspicious cuts of meat being gnawed in New Malden, Britain's Little Korea beside the Kingston Bypass? 'Popping down the A3' is probably aficionados' code for going to have a dog dinner. Do these undercover operatives rifle through garbage searching for the collars of pooches gone to be daubes and salmis? Do they burst in on threesomes with their snouts in KFC buckets, the way private detectives did in

Brighton long ago? Does the C on those delicious buckets stand not for chicken, but chihuahua? This sort of intelligence is far too parochial for our crack Dog Protection Unit which aspires to a much grander programme – nothing less than cultural reformation. Its outreach is globally global, pan-planetary – and delusional.

While Rome burns, Backbencher Bill, an obscure prefect from the obscure marches of an obscure country off the north-west coast of an obscure continent, hopes to set an example by banning pooch sandwiches on the Malverns (western slopes only), a ban which he is willing to personally enforce: watch him headbutt a hiker suspected of enjoying retriever on rye (hold the Dijon). The Kennomeat Dozen is pretty damn certain that its example will be followed by China. Yes China! That's the one – the most populous nation in the world, a model tyranny which imprisons without trial, which tortures and brainwashes, which forbids dissent, which censors with abandon.

It is also the nation that positively quakes when it hears that a delinquent chef in Bromyard who braised a puppy in cider has received a custodial sentence. China is forced to look deep into itself and its collective conscience when it learns of the obloquy heaped on a troop of Cub Scouts at Aymestrey who, mistaking it for a cat, roast a dachshund on a campfire beside the Lugg. They will never now be fully woggled scouts.

What the Winalots are undertaking is evidently a form of gastro-cultural colonialism or stockpot pedagogy. A Whiggish sense of geography is asserting itself: what we do and eat here is morally better than what you do and eat there. We are superior people with a superior culture, superior tastes, superior restraints. This doesn't hold. There are countless things to chastise China for. The gustatory habits of a minority of its agrarian peasants are not among them. They should be of no concern to the PALs.

Especially not to . . . well, let's begin with Backbencher Bill himself. He represents a constituency called North Herefordshire. Has

it not occurred to him that Hereford cattle, beasts of greater beauty and intelligence than scraggy pi-dogs, are reared for no reason other than to be slaughtered and consumed? It should have occurred to him because he is himself a breeder.

Shoot 'em, gas 'em. When he's not slagging off the *Hereford Times*, claiming for a non-existent mortgage, shooting pheasants or murdering cattle, Backbencher Bill supports killing badgers on scientifically dubious grounds. When they get wind of this man's CV Chinese dog butchers are not going to be fooled. They can spot dodgy relativism even if it's on the other side of the globe. Badger-worshipping cults in Shanxi and Henan Provinces are doubtless already planning retaliatory measures against these Pedigree Chums who have too much time on their hands and who drink milk, the lactate of species other than their own, the devil's potion, poisonous unless made into cheese.

Were they not so frivolous the Pooch & Mutts might do something worthwhile for animal welfare on their own doorstep. But such actions could provoke the truly unthinkable, the loss of their seat. A quarter of them represent Essex constituencies.

Here's Andrew Rosindell (Romford). Backbencher Andrew is an admirer of Tommy Robinson. His late Staffordshire bull terrier 'served the community'. He's such a card that he used to take the creature to the House of Commons. It's a breed classified as a weapon rather than a pet.

David Amess (Southend) is the gullible ninny who fell for one of Chris Morris's inspired 'investigations' and was persuaded to ask questions in the Commons about the then non-existent drug 'cake'.

Giles Watling (Chingford) is a resting actor and a pet lover who wears a Garrick Club tie, shorthand for Did I Ever Bore You With My Story About . . .

Now, if these elected representatives are wised up, they will be

aware that Essex has an interesting relationship with animals. It is where one of Howard Marks's drug mules went to the mattresses only to discover that the people in the next-door bungalow had a lion in the garden. More pertinently Essex is the UK's epicentre of dog fights. But to actually prohibit or even criticise this degrading spectacle would be electoral suicide, akin to proposing a ban on beer in Burton or on burkas in Bradford. Shivering in a toxic, rusting disused factory and placing bets on which dangerous dog will hideously mutilate and maybe kill another such dog is the very birthright of Essex Man and Woman.

Far wiser, far safer for those wishing to hold their seat at the next election to sweep the whole business, bloody carcasses and all, under the pile of perishing tarpaulins in the corner there. Pretend it never happened. Far wiser, far safer to have a pop at a distant country, at an alien culture, at ethnic otherness. The Gravy Train dozen are negligible people, bumptious twits, abusing public money. They are symptoms of the disease which British politicians suffer: they are riddled with tertiary frivolity. They are damned with a lack of gravitas – a failing made blatantly evident by the contrast with European politicians whose behaviour and cast of mind are reproaches. The most peculiar of the dog lovers – and there is some competition – is Daniel Kawczynski (Shrewsbury and Atcham). Does the left part of his brain know what the right is up to? His enthusiasms are, evidently, dogs, along with his newfound homosexuality and Saudi Arabia. An awkward trio, to say the least. One can only surmise that by proselytising on behalf of pooches and the love that dares not speak its name and cannot because its mouth is full, he is hoping to get banged up in Ulaysha jail, where he can play drop the soap with some excitingly rugged new friends.

What are we missing by not eating dog? Is it as foully emetic as whale – which I, a child of rationing, spat out at the age of four? Or is it delicious like, say, horse tartare and donkey salami? The

clamour five years ago about the 'adulteration' of beef and pork products by horse and donkey meat was preposterous. Dishonest labelling, sure. But an expression of speciesism as irrational as Levitical dietary stipulations.

Dog meat is a challenge for Western diplomats in south-east Asia and the Philippines. Not, however, as much of a challenge as fruit bat. That comparison is unlikely to satisfy the gastronomically curious. Nor is the observation of a friend who ran over a fox, scraped it off the road, took it home and cooked it. What was it like? I asked. Oh, rather like dog, he replied.

Paul Levy is more help. In his tirelessly unsqueamish gastronomic vade mecum *Out to Lunch* he tenaciously scours the world for the taboo, the recherché, the unspeakable: insects, owls, pangolins, testicles, venomous snakes, durian, three-penis wine, small birds and, of course, dog – which he eats in Macao. He describes its flavour: 'very strong, though not disagreeable . . . like mutton, venison or goat'. Dog is probably preferable, then, to teats (nature's Spam, prized in Buenos Aires), fermented trout (a Norwegian horror) and Limburger (a reeking cheese of Liègeois origin).

Here are some recipes. First catch your dog. Or as they say in Foodworld, 'source' it. In most instances 'to source' means to buy it in a supermarket. The redundancy of the Bonio Bunch's vapid posture is evidenced by the impossibility of finding this meat in Waitrose. Even Lidl and Morrisons don't sell it. So dognapping it'll have to be. The choice of breed is no doubt a matter of dispute among cynophages. Once it is skinned and jointed a single former pet will, according to Paul Levy, yield four dishes: fillet, shredded and stir-fried with bamboo shoots and lime leaves; a bouillon of nutritious scraps including penis and testicles; a braise of paws and muzzle; ribs steamed with black mushrooms. Enjoy.

Out to Lunch was published over thirty years ago. Paul has been in hiding ever since. I'm off to join him. (2019)

Rinka for PM

Michael Gove's Wild Animals in Circuses Bill appears at first glance to be nothing more than his latest essay in exhibitionistic compassion. There are, after all, fewer than twenty performing animals left in English circuses; 200 local authorities already have a ban in place. So has Scotland. So have over thirty European countries. The Great Aberdonian Legislator is courageously adhering to current orthodoxy. There's no doubt about that.

But is it a misreading to ascribe this picayune law-making to opportunistic big-heartedness? It's just as likely that Gove, along with a dozen or so mutually respectful backstabbers, is getting in a spot of practice in the base human traits of identifying as, say, a knitting ocelot and feeling the pain of being an eau-de-nil poodle who cartwheels. The circus of Tory leadership hopefuls is busily empathising with juggling camels, skateboarding panthers, zebras who have mastered *ronds de jambe* and, as Mrs Gove mysteriously has it, 'elephants on this column', creatures who have, presumably, been trained as proboscidean stylites: it really shouldn't happen to a jumbo. I hear what you're saying, say the backstabbers to a brown bear who'll deliver a lutz and a triple salchow at the drop of a hat. But of course they don't hear, and if they do they won't act on it. What if the bear (or reindeer or wolf) wants to stay in the circus? What if it likes its life on the road? What if the fellow animal whose habits it most aspires to is the sloth? What if it enjoys regular meals? What if it is cushy and secure in a way that it might not be if released into the wild whose call it doesn't heed?

All the animals in the circus know that the outside world is peopled by unenlightened gamekeepers and murderous farmers, tooled up and waiting for any threat to grouse or sheep.

All the animals prefer to take lessons from the unflinching

realism of Beatrix Potter rather than be soothed by George Monbiot's fantasies of bucolic bliss.

All the animals are insulted by their characterisation as 'wild'. They are not. They are tame softies. They don't want to be deported: they are civilised. Though one can be pretty certain that the Tory contestants will soon give up pretending to emulate them in that department. And there is a fair chance that the hovering bookies will get it wrong.

If the former foreign secretary – 'that epic shit' as Tina Brown, early on the money, described him thirty years ago – is not in tronk, his goose will be cooked by the moralistic fishwife Mrs Leadsom, who believed that Mrs May was unfit for the highest office because she had no children. It turned out, of course, that Mrs May found other means of demonstrating that she was unfit for the highest office. With the backing of SPUC and a squadra of pro-life ultras, Mrs Leadsom will accuse the former foreign secretary of his unfitness due to his working hard to provide the Termination Community with job opportunities. The legendary blue rinses (when did you actually last see one of these creatures) will tut and lurch Raabwards: will it be shown that Labour does not have a monopoly on anti-Semitism? Or Huntwards: can cleverness be trusted? Or Mattwards: surely too much like a human being. Or Rorywards: can a man who looks like Keith Richards on very heavy drugs indeed really cut it (high office, I mean, not the stash, the lines)? Or, indeed, Govewards: will he be grassed up by the animals as their false friend?

At this hour the exemplary animal we need is Rinka, the Great Dane bitch felled in her prime, the victim of the Liberal policy of canine assassination. She gave her life to create a better world and was the founding spirit of the Dog Lovers Party whose sole candidate, Auberon Waugh, hoped that, given the squalid shower who put themselves forward to become our elected representatives, Britain might be governed by a junta of Belgian ticket collectors. (2019)

Exit: This way

1.

In 2019 older bigots and veteran xenophobes still recalled with pride the successful campaign Boston and the parts of Lincolnshire called Holland waged in the 1960s against coypus, foreigners from somewhere foreign with tomato-red teeth who had been introduced to Britain in the 1920s as a fur crop called nutria. Once these shy, intelligent South American beasts got wind of their fate, they began to escape from the fifty or so 'farms' which had imported them, to head for wetlands, breed prolifically, guzzle crops (wheat, beetroot, turnip) and destabilise fen dykes by burrowing into their banks. The situation was later exacerbated by nutria falling out of fashion and the farms failing, so releasing their remaining charges. Teams of trappers and bounty hunters, specially devised traps, pistols and the devastatingly cold winter of 1962–63 killed much of the population, doomily estimated at about 200,000 but probably little more than half that number.

In 2029 even older bigots and hyper-veteran xenophobes recall with pride the successful campaign Boston and the parts of Lincolnshire called Holland waged in the 2020s against Poles, foreigners from somewhere foreign (the clue's in the name), Polski Fiats and *pierogi*. Bostonians were further proud that their town was the place in Britain with in 2016 the highest Leave vote (75.6 per cent). South Holland was second. Indeed, Lincolnshire had three further places in the top (wrong word) ten, which is otherwise entirely composed of adjacent places in the East Midlands and East Anglia. These areas' man-made land and waterscapes and vernacular architecture (pantiles, crowstep gables, etc.) owe far more to the Netherlands, a foreign country, than they do to that of, say, the Weald or the Welsh marches.

The Poles, supposedly 10,000 of them – the figure is the *Daily Mail*'s, so dishonestly inflated – did back-breaking work in the fields

of the potato belt, regulated the dead straight canals, dredged leams, maintained their banks and were paid a pittance. They were driven out by True Blue Bulldog Militias who have subsequently failed to make a link between fields gone to seed, fields perpetually fallow, silted watercourses and rusting combine harvesters and the Great Chip Shortage and the Well Tragic Crisp Drought. The consequent starvation insurrections in the Good Old Fashioned We Are Blighty's Chip Cities were violently countered by the One Inch Free Corps, so called for the maximum forehead requirement demanded of recruits, by Tommy Robinson's Grievous Bodily Army and squads of the tens of thousands of young English males who claim to have served in the SAS and have written memoirs of their deeds. The intelligence that deep-frying in general and fish and chips in particular are of Sephardi origin is denounced as fake news. And the messenger gets a kicking or worse.

2.

The damage is already done no matter what happens at the end of March – and while that might be March 2019 it could equally be March 2023 or March 2029, for this is one that has got legs and then some. The ramifications of Call Me Dave's pusillanimous stupidity will stretch down the years and probably outlive the major players who, whatever side they're on, whatever self-interest they represent, are lost because political lives and governance itself are evidently subject to rules, procedures, protocols. The people who feel fit to lord it over us inhabit a milieu akin to a zealously traditional school, they follow a worn path: Eton, Oxford, Westminster – a tripartite cocoon. The catastrophic Great Chaos released upon the nation by Call Me Dave does not adhere to any rules. And the participants, all of them institutionalised, all of them just following orders (just listen to the ecumenical cross-faction clichés), lack the imagination and gumption to make them up as they go along. The

people who offer themselves to the electorate belong to a straitened breed. The improvisation demanded by the Great Chaos is something they know as well as they know, oh, Latin.

Ten years hence we will not have heard the last of hard, soft, Canada, Norway, Article 50, backstop, blue cheese, soft fire drill, incubator conclusives, independent independence, the squash-court protocols, blunt sharpening, the power elbow.

Early on it was frequently observed that it was merely going to turn into a drearily distended variant of Jarndyce and Jarndyce: the tale told not just by Esther Summerson and the all-seeing narrator who is of course the puppet master of genius. Here, though, there is no puppet master. And certainly no genius.

This wretched saga was told by all the characters, who are as void as puppets. Each of the dullards recounted different stories which varied from day to day and were consistent only in their mendacity. Some of course were more mendacious than others. The French traveller Louis Simond wrote: 'Few people take the trouble to persuade the people, except those who see their interest in deceiving them'.

3.

Among the inmates at La Salpêtrière and Charenton in the first half of the nineteenth century there were numerous delusionists who believed they were Napoleon.

'Well, that's Johnny Frog for you,' bant the lads of the 14th/19th Wetherspoon Rifles.

But this sort of delusion knows no boundaries (no boundaries is obviously very bad indeed). During the years that the former mayor of London, former foreign secretary and self-proclaimed former prime minister spent in Rampton, he persistently claimed that he was Winston Churchill and even subpoenaed Nicholas Soames to take a DNA test to prove it. He refused to accept the result but nonetheless subsequently set his sights lower and decided he was Paulie in the big

house in *Goodfellas*. He sliced the garlic so thin it liquefied in the pan. He would often cook an intimate *diner à deux* for himself and his cell mate Peter Sutcliffe ('top mucker – only blemish is that he was at Harrow'), whom he would regale with details of the state funeral he expected to be granted him. The coffin would be carried by all twenty-seven of his children and above it there would fly in formation a squadron of abortions turned into fairies for the occasion.

The eulogy was given by Jacob Rees-Mogg of the Mendips Ultras and the Committee of Public Safety. He wishes to point out to the ill-educated scum, the work-shy filth, the crippled whiners and the torpid halt that the plural of asylums is asyla.

'*Honori enim erat illi insigni modo sibi servire, neque umquam taedebat aurum publicum peculari, vectigalia illa quae pendebant ei homunculi nullius momenti; religiose quoque liberalique manu sibi consulebat, necnon officiose perseverabat credere se non posse errare; omnes praeterea maiorum leges consuetudinesque contemnebat, neque umquam in dubio erat nobilitas eius, cum necesse esset homines iam iacentes pedibus obterere; iure enim putabat sibi non opus esse acta sua excusare . . .*'

'His honour was to serve himself with signal distinction. He was tireless in his peculations of the public gold, the tithes paid him by little people of no significance. He was unstinting in his righteous selfishness. He was dutifully steadfast in his conviction that he was always right. He was proudly antinomian. He never wavered in nobility when loyally prosecuting such necessary tasks as treading on the downtrodden. He rightly considered the justification of his actions to be beneath him. He stole from the poor to feed the deserving rich because the poor are wretched. He took from beggars with dignity so that they might starve, beg no more and free us of the embarrassment of seeing humans who have failed all the challenges that he relished. He was entitled to lie for his common good because he had granted himself that mandate. He would allow no one to stand in the way of his assuagement of his heroic appetites. He believed that worry and

self-doubt were luxuries enjoyed by ordinary people whose destiny was not worthy of that word – which can be attached to him alone.'

In other versions of this tale of megalomaniacal delusion, the subject believes himself to be president of the United States, the country of his birth, or president of Turkey, land of his forebears. Or maybe both. At the same time? Why not?

4.

A perpetual effect of the Great Chaos, and one which has so alarmed nationalists that they stay shtum about it, is that breaking the mould, taking back control (of what precisely?) meant that British parliamentary politics acquired a new model. Britain came into line with the rest of the continent.

It followed the example of often despised European countries where stability is unknown, where the promise of entropy is ever present, where baksheesh, gangsterism, clientelism, juntas of cronies are the norms.

And where the quality of life is higher than Britain's. Not necessarily despite these characteristics – there is much to be said for feeble government, paralysed government, for government and opposition of such overwhelming ineptitude that nothing is ever resolved. At the end of the tunnel there is blackness and more blackness. This is a status quo with much to commend it. Useless factions divided by ideology but otherwise united: in fiddling their expenses, loving the sound of their own voice, scolding and blaming, and preaching the puritanical orthodoxy of the day. These factions comprise a tiny proportion of the populace. They have shown how fragile they are, how susceptible to direct action.

5.

The nationalist urge to leave was a form of faith. A faith is autonomous. A faith requires no empirical proof. People who are

otherwise deemed intelligent abjure their reason and gullibly believe in miracles. Muhammad cured the blind with spit, created water to end drought, spoke to the dead, cast no shadow, was addressed by trees. Like Muhammad, Jesus was an expert in mass catering and questionable cures. He was also capable of walking on water, rising from the dead, ascending to heaven; he is present in undrinkable wine and wafers that stick to the roof of the mouth. If you believed in this low-grade, anti-gastronomic supernaturalism, your defences were so worn that it was not much of a step to believing in the promised Jerusalem of Little Ingerlandlandlande, the new nation, devised by frivolous charlatans for credulous apes whose cry these many years has been 'Are we there yet . . . are we there?' But, like Harmony-on-Chimera, like Cockayne Scamme, Little Ingerlande is always over the next hill, it's still far far away.

Sooner or later the apes became suspicious. Word spread. These were the years of the Great Revelation which began with the realisation that, though the street names had been changed to honour the Martyrs of Nationalism (Banks Avenue, Farage Square, Fox Passage, Werrity Mall, Analytica Crescent, Dacre Meadows, Redwood Close), it remained the very place they voted to get away from – but worse, far worse, now transformed, indigent and in a state of advanced deterioration and festering decrepitude. Rationed electricity and gas, carburant shortages and vehicles left where they were when the fuel ran out, corned beef and Spam without the key to the tin, abandoned hospitals, ruinous infrastructure, bailiffs everywhere, deserted villages ruled by feral animals, foreclosed houses booby-trapped against squatters.

When the apes saw that they had been sold a pup, indeed an entire kennel, they mutinied. The foot soldiers of nationalism stormed the gated 'communities' and walled fortresses of the 'elites' increasingly held to ransom by the militias who protected them. The graffito 'Bringing you the streets of Derry '72' was seen in

London, Leicester and Manchester. Lieutenant General Sir Tim Martin's Devon neighbour Lieutenant General Sir Frank Kitson's *Low Intensity Operations* was avidly studied by all factions, all in perpetual schism over ideological minutiae invisible to the uninitiated. The Death's Head Korps, The Screwdriver Boyz and the Warriors for Atlantis were so preoccupied arguing about how to audit their hits and lynchings that New Irgun was able to dispose of them over a weekend in the firefight known as the Bilston Shambles.

6.

Divided nations are supposedly reunited by exceptional circumstances. Natural disasters, wars, invasions, public deaths.

On 11 June 2029, Queen Elizabeth II enjoyed her traditional birthday morning kickabout with Sir Alex Ferguson on the all-weather pitch she had had installed in her self-imposed exile at the royal compound on Lundy. She nutmegged him with a cry of 'Just like Giggsy!' performed her characteristic celebration and collapsed.

Did the pomp, rituals and enforced mourning attached to a very distant, very familiar centenarian's death heal a nation which has not been her nation since the first decade and a half of her reign – which is when hats disappeared along with deference (nothing to doff), belief in blue blood and the magical qualities ascribed to the House of Parasite? Was the avoidable Great Chaos, now in its twelfth year, cured by the inevitable but unschedulable Catastrophe, did they meld as a sort of homeopathic ligature for the collective soul of the people?

No. They did not. There was no repeat of the 'outpouring', the national embarrassment of 1997 prompted by shock, young death, a white Fiat, contempt for the Firm's apparent callousness and Alastair Campbell's tabloid opportunism. There was grudging resentment. A few instances of minor civil disobedience. The number of spectators and mourners was smaller than had been forecast.

The predominant mood was one of indifference towards this last embodiment of inherited mediocrity – it is indeed in the blood, this passed-down banality. Many heads of state did not attend because their security could not be guaranteed in a country whose militias such as Jeremy's Gentiles recalled those of the Weimar Republic.

All together now: 'We are waiting for the Strong Man . . .'

7.

Secede to Succeed. London's slogan was as futile as Taking Back Control. It had already happened. Its very secession was one of the causes of the Great Chaos. It was a city apart. But then where wasn't. Taking Back Control was a euphemism for the Balkanisation of Britain, for atomisation, for communitarianism based in ethnicity, class, place, faith. A willing apartheid where the other is to be mistrusted – just like in the Golden Age when we drowned the folk in the next valley because their word for haystack was different from ours.

'Mutton go to the abattoir mute and hopeless. But at least they don't vote for which butcher will slaughter them and which bourgeois will eat them. More stupid than a beast, more mutton-like than mutton, the voter chooses his butcher, he chooses his bourgeois. And he has fought in revolutions to achieve this.' (Octave Mirbeau in *Combats esthétiques*.)

The referendum was democracy by the mob. All mobs descend from the one which voted to set free Barabbas. (2019)

The First Ostrich

The last person to be executed by firing squad in France was the air force officer, armourer and inventor Jean-Marie Bastien-Thiry, whose ambush of the presidential Citroën DS failed to eliminate Charles de Gaulle at Petit Clamart on 22 August 1962. The plot,

known by the name Charlotte Corday, had involved more than 150 conspirators. Even though the only injury anyone sustained in the attack was a shot in the hand, three members of the commando were sentenced to death. Two were then accorded presidential clemency.

Bastien-Thiry was a different case. He was not a mere mechanic, a shooter. He was an officer who believed, with some justification, that his target was a genocidal tyrant and a traitor to his country. Class came into it, as it always will in France. De Gaulle's reasons for not commuting the sentence handed down on Bastien-Thiry varied from year to year. He supposedly remarked, for instance: 'Let's give them the martyr they want.' Sometimes he was bizarrely angered that non-French assailants had been hired. One reason, however, was constant: a gentleman does not endanger the wife of the president of the republic.

Yvonne de Gaulle, sitting beside her husband in the back of the car, was untouched. But her very presence turned Operation Charlotte Corday into a capital crime. She was deemed by her husband to be categorically different from the other people whom the shooters had managed to miss – the detectives, drivers, outriders, son-in-law, etc. Although she held no official secular position her blood, had it been shed, would have been the blue of the Tricolour by virtue of her marriage in the face of God to the president. That he was, according to F. D. Roosevelt and a million *pieds noirs*, a fanatic with fascist traits is irrelevant. With office, even when church and state are separate, there comes a sort of magic that is supposedly transferred to the other party in the union. (Applies only in supposedly monogamous cultures – and no one said it was sympathetic magic.) It is apparently normal for the spouse to want that transfer sanctioned by statute, to crave grateful acknowledgement for showing up to group photoshoots, sporting sartorially inappropriate lanyards against the horror of non-recognition by security gorillas. She (seldom he) wants

recognition for being dumped in the sandpit of soft 'issues' where the implicitly misogynistic menu reads: caring about caring and about baking, consumer rights, pelmet workshops, school food outreaches, mime in education, rare plant awaydays and netball with a smile – all the while pretending to have a proper job or, increasingly likely, actually having one.

Brigitte Macron agitated to be granted the title of *Première Dame*. She was doubtless hoping to emulate not Yvonne de Gaulle but Jackie Kennedy, the point of reference for all such aspirants over more than half a century. Nothing doing, Mush. The National Assembly, the Senate, those of Emmanuel Macron's advisors who aren't under police investigation and even the 'people' press were joined in their scorn at her uppity impertinence. Her overt influence on her husband/pupil has long been a cause of worry and jealousy.

A couple of months ago Stephen Glover wrote a piece in the *Oldie* about Matthew Symonds, one of his co-founders of the *Independent*, who has apparently been cutting him for quarter of a century. It was a rather touching billet-doux, a hardly dissembled plea for rapprochement which sucked up to Symonds by cataloguing his journalistic achievements and ended up with the intelligence that, on top of everything else, 'he seems to have produced a remarkable daughter'.

Steady on. Does rubbing offal with an antinomian, hyper-mendacious, boorish, cosmically embarrassing charlatan really make Glover's mute former friend's daughter 'remarkable'? Reckless or shameless or gormless or opportunistic – any or all of these might be more apt. Over thirty years ago Tina Brown, on the money, described Boris Johnson as an 'epic shit' after she had been on the receiving end of his mendacious malice. The epic shit has matured – not quite the word – into the Prime Shit, a blubbery pink peculator so grand that he thinks nothing of plundering £126K from the public purse to pay for an assisted siesta in Shoreditch.

Given the Shit's pathological need to act in defiance of precedent

he will endow his companion with a title. 'First girlfriend' is too bland. 'First totty' and 'first crumpet' almost certainly figure in the Shit's idiolect but they might be reckoned too elitist to accord with the will of the people.

The essential quality required in the companion is the ability to turn a blind eye – to personal peccadilloes, monstrous policies, barefaced lies, casual cruelty, etc. Ostriches don't really bury their head in the sand but that's just a matter of detail. The First Ostrich. Tina Brown added: 'I hope it ends badly for him.' The shooters must not err from their target. No collateral. (2019)

January thirty-three

In *Staring at God*, his magnificently panoramic account of Britain's First World War at home and in the gruesome field, Simon Heffer reminds us that William Inge was popularly (or journalistically) nicknamed The Gloomy Dean. Inge subscribed to Rupert Brooke's self-generated cult of noble death, reciting 'If I should die think only this of me' from the pulpit of St Paul's *before Brooke had died*. Soon that heady romanticism was properly quashed: Hardy addressed the shysters and brass who were spendthrift in their supply of young men to suffer trenchfoot and blindness before they were exploded:

> Sinister, ugly, lurid, be their fame;
> May their familiars grow to shun their name,
> And their brood perish everlastingly.

The endurance of the name Harmsworth unhappily indicates the sheer impotence of great poetry.

Hardy's letter of condolence to Rider Haggard on the death of his ten-year-old son is unsparingly tactless. It sweeps away

conventional courtesy with truth: 'I think the death of a child is never really to be regretted, when one reflects on what he has escaped.'

Housman wrote that pessimism is 'almost as silly, though not so wicked, as optimism.' Billy Wilder remarked that 'the optimists died in the gas chambers, the pessimists have pools in Beverly Hills.'

Optimism is foundationless expectation promoted by frauds and swallowed by dupes. There lies its wickedness. It's akin to a faith. It relies on the will of the mob – and all mobs, I insist, derive from the first mob, the one which voted that Jesus rather than Barabbas should die.

Mobs seethe with a wishfulness they have been instructed in by mountebanks and demagogues. The poor, according to Inge, are 'intensely gregarious and very susceptible to all collective emotions'. Hence no doubt the collapse of the Red Wall, which is just about contiguous with the Irony Curtain.

This admirably miserabilist sky pilot was generally on the money: 'When an old-fashioned brigand appears, and puts himself at the head of his nation, he becomes at once a popular hero. By any rational standard of morality, few greater scoundrels have lived than Frederick the Great and Napoleon I. But they are still names to conjure with. Both were men of singularly lucid intellect and entirely medieval ambitions.'

If the Prime Shit possesses such an intellect he does his utmost to hide it. He writes terminally jocular prose, like the victim of a Workshopping Wodehouse residential course for sad fucks who think they have a funny book in them. His boorish repetitions, exhausted alliterations and clichéd tabloid slogans – doomster, gloomster, awesome foursome – are far from Churchillian; they are not even the peer of Paisley's. They are more akin to the stuff that used to emerge along with the 100-proof spittle from the mouth of an incoherent, jabbering, badered Oliver Reed grossing out on a chat show and unable to control his flailing arms.

But the People's Piss Artist never held power. His avatar does: the antic squalor that's just about acceptable in an actor is reprehensible in a politician. His lack of doubt, of reflection, is horribly childish; there is nothing to suggest that it's an act. His mendacity about, say, the sunlit uplands of New Model Britain in Year Zero of the Johnsonian mandate is psychotic.

The optimist tells lies that he knows the people want to hear, he knows their will: it's a matter of being in touch with the lowest common denominator. It was said of Richard Nixon 'he lied so much that if he accidentally found himself telling the truth he'd start lying again just to keep his hand in'. The Prime Shit's demeanour makes the sentient wince, constantly. He provokes species shame.

One can just about live with that. But his antinomian lawlessness is genuinely frightening. Who is there to police this creature sculpted from luncheon meat and his out of control right-hand freak? No one. There is no point in looking to a parliamentary opposition. In an elective dictatorship such a body doesn't exist, and very likely won't for a decade. The sovereign's impotence is embarrassing. The necessity for an independent president is urgent. Where is this person to be found?

The lack of a constitution is a kind of negligence which is all too exploitable by the unscrupulous: gentlemen's agreements are old hat, perhaps they always were – fair play is for export only.

It couldn't happen here. It could. It is happening. Optimists will continue to be conned by bread, circuses, infrastructural wheezes. It is in their nature to be had. Those pejorists who have not fled should keep schtum and fight the temptation to say I told you so even though retrospection will prove them right and the couplet 'It's beginning to feel to me / Like January thirty-three' will be shown to have been accurately prophetic in kind if not extent. (2020)

Level

The Prime Shit has, once again, neglected to get off at Fratton. Perhaps, given his affection of convenience for the North and for Levelling Up, that ought to be neglected to get off at Gateshead. No matter which station-stop we go for, the result is the same. The First Ostrich has foregone her right to choose and will give birth on a day when there is further news of Raaaab's vampirism to be buried.

The people's anti-elitist foetus, will, as soon as it mewls, become The First Love Child. Official moniker: Septimus or Nona or Decimus depending on how many of its half-siblings the Shit manages to recall. The nation will be forcibly enjoined to rejoice. There will be an outpouring of golden syrup and manna all round. The yellow press will doubtless issue daily bulletins on the Tory Top Tot. It's straightforward stuff.

Which is more than can be said for Levelling Up, hardly a policy, more a limp slogan drilled into the robotic apes who comprise this cabinet of all the sycophants. It is apparently derived from M. C. Escher: so, fine on paper, but nowhere else. Any attempt to translate it into three dimensions is a defiance of many laws in many disciplines. It's bogus to the marrow. Like drip-down. Or the mandatory prefix of the possessive pronoun 'our' before NHS, a crude shift to con the dupes into believing that they have a stake in the 400-metre-long queue of beds and virtual beds (the floor).

The obvious tool to achieve The Levelling would be a nuanced reprise of Denis Healey's unoriginal but gleefully brutal threat in 1974 'to squeeze the rich till the pips squeak', a threat he carried through with 98 per cent top rate income tax.

It was perhaps a tad overenthusiastic. It prompted the *Wall Street Journal* headline: 'Goodbye Britain. It was nice knowing you.' Five years later Thatcher came to power bringing with her an

exhortation to *sauve qui peut*, and governmentally sanctioned greed. These have been the true fulcrum of cross-party consensus ever since. The chances of The Levelling being effected by fiscal devices are non-existent.

It will, instead, be achieved by a train, HS2. By the time it is operative (supposedly in 2030, pull the other one) its technology will be getting on for seventy years old. Given that Maglev is a domestic invention as well as being cheaper, cleaner, faster and much less land-hungry than HS2, the hostility it provoked in the UK's transport establishment (there is such a thing) was astonishing. All governmentally commissioned reports and white papers into the feasibility of Maglev seem to have been undertaken by members and fellow travellers of that establishment. They are adherents of the doxa.

What buried Maglev and gave them the most potent ammunition was a multiply fatal accident in 2006 on the Transrapid test track at Emsland in Lower Saxony. That it was caused entirely by human error and had nothing to do with the technology was, predictably, overlooked. Spendthrift retrospection has prevailed, sticking with the old ways, yet again. It is worth noting that when Sir Nigel Gresley's sublime A4 Pacific *Mallard* broke the world speed record for a steam engine in 1938, every other developed country had long since abandoned steam locomotion.

While the billions that are being thrown at dated HS2 technology are of course preposterous, the Shit would have been virtually cancelling himself had he cancelled the project: it belongs to the history of white elephants and bankrupt wheezes, a garden bridge from Wormwood Scrubs to Winson Green. Still, even had Maglev been the chosen technology it would still have been a case of the wrong route linking the wrong places, if more thrillingly – the sensation is that of flying on the ground.

Britain is both overcentralised and small. All routes lead swiftly to London. HS2 is, it says here, 'step-changing' and a

'game-changer'. It will unquestionably alter the pattern of work-related travel. The major beneficiaries of cutting the time from, say, Birmingham New Street to London Terrain Vague/The Scrubs from 120 minutes to fifty will be the volume builders, the Tories' friends and funders who will relish the gross distension of the commuter belt.

They will be equally delighted that the East Midlands 'hub' at Toton, south of Nottingham will, if it's actually built, be fifty-two minutes from London. All property prices in Derby, Burton, Swadlincote, etc. will ascend. But those towns will gain little. HS2 will take from them with no return. They will mutate into dormitories. The estates that will surround them will be aesthetically null excrescences founded on the somewhat desperate proposition that a £15k season ticket is good value if it secures an extra bedroom and a handkerchief of lawn.

HS2 represents the guilt of successive central governments about the very centralisation that they occasion, that they even admit to, but which – such are the cultural shackles which bind – they are incapable of correcting. Decentralisation is a dirty word. Almost as dirty as *dirigisme*.

Helmut Schmidt was a practical, non-ideological decentraliser. His representative on earth, Geoffrey Wheatcroft, equally non-ideological, recently proposed on the *Guardian* letters page that that newspaper should return to its Mancunian roots. This makes absolute sense, though whether its armies of minoritarian agitators and protest kids could bear to forsake Shoreditch is questionable.

HS2 is a bludgeon where a scalpel is required. Its very existence is founded in a skewed, crude, centripetal view of the UK. A North/South divide is a fiction save to statisticians. The actual divisions are multiple and require micromanagement. Fratton and Gateshead may both be useful argotic devices and may both be touched by poverty. But Fratton is a stranger to 'initiatives' and

regenerative programmes because it is an exception, situated in what is torpidly conceived of as the Soft South.

Gateshead, protractedly problematic, is rightly bound to command grants and subventions because it is in the Deprived Well Gritty North where aid is oxygen. Dr Johnson averred that we should always give alms to beggars because otherwise they will not be able to continue to practise their calling – which is begging. (2020)

20

Pop Culture

Fluff of the pop pickers

The Faber Companion to 20th-Century Popular Music

Twenty-five years ago Pete Townshend was hoping to die before he got old. However, despite a protracted pharmaceutical essay in self-fulfilment, Mr Townshend failed to deliver – that is, to deliver himself, and us. He should be up there jamming with Jimi, Jim and Janis (with Moonie on drums and Brian slumped behind the amps), but he is not. He somehow contrived to miss the biggest gig of all. The gods took one look at him, and very sensibly elected not to favour him. Their loss is our loss.

Mr Townshend lives. He is a publisher. Faber, no less. Though, oddly, of the *grosses légumes* at that august outfit, he, in middle age, is the one who looks least like a popular entertainer: it is not difficult to imagine Matthew Evans, Faber's dishy chairman, nonchalantly – big pop word of the early sixties, that – crooning pop standards ('Sweet Caroline', 'Michelle', etc.) to a sophisticated after-dinner audience at Caesar's Palace. That's Caesar's Palace, Luton, not the one in the other place. It's not difficult to imagine a kohl-eyed Robert McCrum with the contents of a fruit bowl stuffed down the front of his satin strides strumming a bass axe in a leering heavy-metal outfit. Craig Raine, the poetry editor, is almost

surely in the same band: gnomic lyrics and Moog synthesisers, corrugated hair and high heels, the intellectual of the group (he wears glasses). These gents at Faber and the authors of this 3 lb 2 oz, 875-page compendium of winningly useless information are of a generation, and so probably share a musical subculture, if not a taste.

The point is this: what we have here is not a companion to the *popular* music of this century, but an augmented encyclopaedia of *pop* music and of rock 'n' roll – which is rather different. Of course, there are token entries on Noëls Gay and Coward, on Eric Coates, Ethel Merman, Glenn Miller, the Mills Brothers, Dinah Shore and so on. But the emphasis is unmistakably towards post-1956 – no, not the 1956 of Hungary, Suez and Eoka, but the 1956 of Elvis Presley. Messrs Hardy and Laing are of an age to have grown up with rock 'n' roll, pop, the beat boom, 'underground', art rock, heavy metal, glam rock, punk, post-punk, post-post-punk, ska, reggae and all the other fascinating subspecies into which they fit their subjects like a pair of compartmentalising boffins.

The bias towards the recent past may be illustrated by the fact that Brian Poole and the Tremeloes are granted as much space as Ivor Novello, Lulu gets an entry half as long again as Jack Payne's, Henry Hall's entry is only a line longer than that of a duo called Hall and Oates and Mario Lanza and James Last are outdone by someone called Phil Ochs, who killed himself. How? It would be more interesting to know that than to know that the late Mr Ochs' first song, 'Ballad of the Cuban Invasion', took a pro-Castro stance – what a surprise.

What a surprise, too, that the Who (guitarist Peter Dennis Blandford Townshend b. 19 May 1945, London) should rate a two-page entry. Now, size – *pace* Tom Driberg – is not everything, but it is a pretty fair gauge of the authors' (and, implicitly, Faber's) preoccupations. It is not just oldsters – other than, of course, tetraplegic blind bluesmen – who get a raw deal, but non-anglophones.

747

This is gracelessly acknowledged in the terse introduction, and excused by the startling (and wrong) assertion that, 'Since the Twenties, English-language songs and artists have dominated the world of popular music, and this is reflected in the *Companion*.' The English-language rejoinder to that is C. O. Jones. What is more accurately reflected is either the torpor of the authors, or their deaf chauvinism, or Faber's probably accurate hunch that the sort of people who will buy such a book do not really want to be introduced to the unfamiliar, unless it has the potential to attract a 'cult following' (a horrible, overworked construction eagerly spread about here). So Georges Brassens and Barbara are absent, and though Brel is in, it is in the demeaning capacity of supplier of translatable texts for such singers as Sinatra, Bowie, Petula Clark and Tom Jones: I hope Messrs Hardy, Laing, Townshend, McCrum et al. will accept that they have wrought a book that champions a lowish form of cultural colonisation.

So, how does it do, within its predictable limits? I am bound to pay the authors the compliment of enquiring about their mental health at the cessation of their massive labour. What can it have done to their brains, this gleaning of – an approximation – 200,000 trifling facts? It is all very well to listen to pop music on a car cassette, or to dance to it, or to enjoy the mnemonic potency of particular songs. It is all very well to make the stuff, and enjoy the perquisites of limitless groupies, limitless drugs, limited lifespan. (Actually, it's incredible how many of the creatures have cheated death, in the Townshend manner – that'll be because it *is* the devil's music.) But it is not all very well to write about it with such dour solemnity, to take 'artists' with learning difficulties at their own ridiculous estimates, to fail to discern the bathetic vacuity of, oh, 99 per cent of the music, to indulge in the frivolity of total earnestness. The tiniest prick of humour would have caused the entire distended balloon to deflate.

This is a work that is by, and for, hobbyists, those who collect records rather than cigarette cards; and hobbyism is a sort of *faith*, fundamentally professed. The hobbyist dares not entertain the suspicion that there is something grossly comical about the object of his devotion. Thus Messrs Hardy and Laing employ a debased critical vocabulary, and consistently fail to entice the (this) common reader with the sort of gen that will appeal to the non-hobbyist. I think I could have coped for the rest of my allotted span without the burden of the knowledge that the Impressions' influence 'stretched to Jamaica, where Prince Buster, in particular, made use of Mayfield's allegorical song form'. Or that 'Mayfield's parable of social awareness, "I'm All Right", marked a new level of sophistication in soul music.' Or that Duran Duran's 'preoccupation with a post-Holocaust breakdown of civilisation was reflected in Mulcahy's video'. I swear that I am not making any of this up. My early-adolescent favourite was Dion: I never realised that his (thankfully atypical) '"Abraham, Martin and John" was a rare example of a recording perfectly catching the mood of a country sunk in reflection after the assassination of Robert Kennedy.' I also liked the Dovells, who, apparently, 'brought a degree of commitment to the inane dance records they were given'. I'm rather disappointed by that; it was the very inanity I enjoyed, and indeed still enjoy. I find the high kitsch and pseudo-operatic camp of the Electric Light Orchestra cheaply exhilarating: I am wrong, for they have been 'attacked by critics for their blandness'.

These nugatory observations are not what anyone other than Faber pop scholars want to hear. What we want out here is the size of Brian Jones's liver as revealed in the post-mortem examination (two and a half times the norm for a man of his age). We want to know which member of which early seventies teenybop outfit was literally illiterate and had his girlfriend write his cheques for him — it was a habit she took to; she was later incarcerated for forgery. (I

shall stay mum here to shield the hapless.) We want to know which bass guitarist became a bus conductor on the Golden Valley route from Cheltenham to Gloucester, and tried to touch my friend Zog Ziegler for pub drinks, 'on account of the pleasure I give you in your yoof'. Stand up, Jet Harris. With friends bearing monikers such as Zog Ziegler, I'm evidently keen on names, and this is one department in which the *Companion* will not let you down. It is more fun than a phone directory. Did you know that the drug casualty Gram Parsons was the son of the suicide Coon Dog Connor? Did you know that Rat Scabies' natal name was Christopher Miller? I've heard of many people with surnames such as Scabies deed-polling themselves into Millers, but never before of a move in the contrary direction. What a strange, inverse world we have here, and what a banal world of institutionalised nonconformity and million-aire middle-aged 'rebels', who in the undistant future will be bil-lionaire Zimmer-framed 'rebels'. Pop and rock have changed the world, irremediably, and have fostered something Dionysiac in the formerly Protestant north. But you don't get to the heart of this culture shift by treating the 'music' as though it was music, and the 'artists' as though they were artists. (1990)

Colditz for baby boomers

Hippie Hippie Shake: The Dreams, the Trips, the Trials, the Love-Ins, the Screw Ups, the Sixties by Richard Neville

The collective experience shared and subsequently recollected by hippies' parents was war. That of hippies' grandparents was also war, the war to end all wars, but which didn't. Hard-line hippiedom emulated the condition of the trenches by convening 'festivals' – a singularly inappropriate epithet – in silt fields, suffering bad hygiene and self-administering psychotropics which tattooed young brains as effectively as shrapnel had. Who says these people were soft?

They put themselves on the line; they courted discomfort with the eagerness of Outward Bounders; they did in their ears with riffs which were as loud as gunfire; they enjoyed a dreary diet; they guiltily constructed for themselves a programme of privation which matched the serial lacks, if not the dangers, which their immediate forebears had known and gone on about endlessly. Most of all they knew their place. Hippiedom was no less hermetically hierarchical than the armed forces. Richard Neville was a senior officer, an Anzac who had a good war, or summer of love, and who has been dining out on it ever since.

The Second World War spawned the sub-literary species of the escape story: *Evader* by T. G. D. Teare, *White Rabbit* by Bruce Marshall, *The Wooden Horse* by Eric Williams, *The Colditz Story* by Pat Reid, who followed up with further Colditz titles. Was there a Colditz cookbook? Neville is the Pat Reid of his generation. It's almost a quarter of a century since the magazine he edited, *Oz*, had its infamous run-in with Mr Justice Argyle who, as Neville reminds us in the only interesting part of this book, the where-are-they-now appendix, is president of the National Campaign for the Restoration of Capital Punishment. Argyle was, at the time of the trial, only a couple of years older than Neville is now. Both men belong to the hapless sodality of the time-trapped, the generationally shackled. Argyle's bristly, irate draconianism and Neville's hang-loose, if-it-fucks-you-up-it-must-be-good libertarianism are so typical as to be parodic.

The hippie memoir is the baby boomer's escape story. It is formulaic. Its progress is invariable. The reaction it evinces is predictably comfy – the only people reckoned suitable to adumbrate on the not-so-great ishoos of '66–'71 are those who were 'involved'. I wasn't involved. I am exactly the right age (b. '47) to have been involved, but I didn't give a toss. *Oz* was OK, and certainly wilder than its only rival, *IT*, which was hopelessly in thrall to the beatdom of ten or

fifteen years earlier. It's not by chance that *IT*'s co-founder (Barry) Miles has subsequently written a librarian's biography of Ginsberg, a work which, for all its faults, is that of a grown-up. Miles may trade off his total involvement, cutely dismissing the stone-dead Brian Jones as 'someone I was at art school with', but he is pro- rather than retrospective. Neville seems not only to be helplessly sucked back into the past, but quite untouched by the gulf between then and now. His slummily recovered dream days have taught him nothing.

Neville has a problem as a writer – he cannot write. He cannot parse a syntactically proper sentence. *Oz* was, evidently, a neat job opportunity for clever Australians – but Clive James, Germaine Greer and Robert Hughes never committed themselves to the cause, whatever that was. They could write, they knew how to get the bits in place: 360 pages of someone who can't get the bits in place is tiresome. The imprecation to 'steal this book' is pointless – if you're going to steal a book, steal one which is readable.

The point at which Neville and his *Oz*-muckers, Jim Anderson and Felix Dennis, come together is that of rehearsed late-adolescent rebellion. It's not a well-remembered rebellion. Neville is not totally reliant on Jonathon Green's oral history of the period, *Days in the Life*, but – put it this way – this book would not exist without it. Neville is more than a ghastly writer. He is the *fons et origo* of Dave Spart. Some hippiephiliac on the *Evening Standard* gave him a column in 1970. It was yoofish, moronic, unreadable. And so is *Hippie Hippie Shake*. Neville keeps quoting rock songs, folk songs. He ignores the Kingston Trio – not too cool; they had a chorus which went 'When will they ever learn?' He ignores the people, such as Green, who kept *Oz* going when he was banged up. I rather believe Neville snobbishly believes he has more in common with Argyle than with Green, whom he probably regards as a hippie GOPWO rather than a 'name'.

Neville is pooterishly eager to list his social conquests. He just loved meeting stars. He has a god-given talent for groupiedom –

not such a bad trait in an editor. He connected well. Backstage was his trippy arcadia. His acquaintanceship was wide but, as the index suggests, it was off the shelf: McCartney Paul; MacDonald Country Joe; McGough Roger . . . Page Jimmy; Pallenberg Anita; Palmer Tony, and so it goes on. Predictably, much of the book could have been slung together by any student of the late sixties: the period colour seems learned through representations rather than witnessed at first hand. He has no recollection of tiny details, or, indeed, of anything which didn't accord with the mores and lore of his milieu. The world outside conformist freakdom is represented only by the police and the judiciary. There is no sense of the broader society to which *Oz* presented a retinally challenging 'alternative'. It all feels like a rag week that went on for a few years too long. (1995)

Inflatable Ringo to go

Every day in the Christian calendar a sacred birth or death, a miracle or martyrdom is commemorated. The calendar is of course a fiction, an intervention, an imposition: as 'natural' as a centimetre or a peck, or any other basic measuring tool. The late Anthony Buckeridge wrote a (non-Jennings) mystery story that hinged on a document shown to be a forgery because it was dated on one of the days that 'did not exist': but try telling that to the Georgians who shifted from Wednesday 2 September to Thursday 14 September 1752, when Britain eschewed the Julian in favour of the Gregorian calendar in order to come into line with the rest of western Europe.

Calendar reform was, along with Esperanto and garden cities, rational dress and phonetic spelling, a utopian preoccupation of the early twentieth century (as it was known). Russia persisted with the Julian calendar. The fledgling USSR adopted the Gregorian in 1918 – with the loss of a massive thirteen days. The October Revolution

may have occurred in November, comrades. Later (and I refuse to be drawn on how much later) a Soviet calendar was introduced. But not everywhere. Friday in Sevastopol might be Monday in Perm. This was no way to run the future. The Gregorian was reintroduced.

Just as it had been in France. Napoleon agreed to abolish the Revolutionary calendar with its climatically graphic names – Brumaire, Pluviose, etc. – in order to gain the approbation of Pope Pius VII. The Vatican, then, appreciated, as we all should, that the Gregorian calendar is not just a means of temporal measurement founded in astronomical speculation, but an instrument of Catholic propaganda, a subliminal assertion of a particular mythology, the enveloping affirmation of a hegemony, the deliberate extension of faith into the fabric of every everyday life.

Christian observance may be a minority interest in this country today, but – like spires and oaths and expressions from the Bible and the Book of Common Prayer – the calendar is an unavoidable reminder that no matter how secular we may have become, many of the templates of our life are indebted to Christianity. Any calendar that was to have a chance of replacing the Gregorian would have to be as emotionally loaded and carry a similar heft of associations and connotations.

These ruminations were prompted by, of all things, the Beatles Store, of whose existence I was unapprised till I saw an advert at St John's Wood Tube. One stop away, it said. I am very likely the first punter the shop has pulled as a result of that ad. It is inconceivable that there is any crossover between the residents of NW8 and the hordes who swarm through the nearby yet unconnected world of the touristic streets around Madame Tussaud's where this artless Fabs commerce sits alongside kindred enterprises devoted to Elvis Presley (Elvisly Yours) and Sherlock Holmes.

Big stars, both of them. But with a life and myth which might form the basis for the Calendar? No. Another cult maybe, another

marginal church. Holmes is too bound up with his creator's risible psychical gullibility. And the Tupelo Pudding, whose meaningful career was only three or four years long, is even more of a joke than the surviving Beatles.

Of course, there already exists the Beatles Calendar. For 2004, rather than for the Year 42. It is a tacky production whose small type hilariously warns that it is 'an unofficial product and is not to be confused with any official merchandise'. Some of the twelve photographs look as though they have been magnified on a derelict copier. It is printed in Turin, and is a disgrace to that marvellous city. As for what the photographs represent . . . the sartorial and tonsorial decline from 1966 onwards is pitiful.

Why *the* Calendar rather than *a* calendar? (a) 'Eight Days a Week', a song I haven't heard in about twice as many years, was a hat in the ring. (b) Lennon's observation that the Beatles were bigger than Jesus. Given who made it, only a clot could have taken it literally. One of his most deployed gifts was for deadpan ambiguity. Still, it did acknowledge that the delirium and hysterical trance which the Beatles aroused were quasi-religious and that such idolatrous responses necessarily caused the group to ascend beyond showbiz. (c) The dim, cluttered, poky shop is so patently devotional. And the non-stop videotapes are of Beatles' songs performed by other singers, i.e. by disciples. It initially reminded me of shops I've come upon in dark, rain-slashed backstreets of cities such as Ghent, shops scented with the sweet tobacco smoked by an immemorial benign owner with bottle glasses, where shelves and cases are laden with neatly filed medal ribbons and penknives and cigarette cards and 78s and walking sticks. And there is a whiff of the occult, of a vase which is an amulet, of a painting that grants immortality.

The Beatles Store, however, is single-issue. There is nothing occluded about the faith it fuels. Its mysteries are populist. What it

most resembles are the plaster-saint emporia of poor Catholic areas where Maynooth-fomented superstitions are rife.

Relics: a lock or rather a strand of George's hair: £300. Signed, limited-edition film stills 'numbered with certificate': £750. Old merchandising: Beatles Krunch Coated Ice Cream Wrapper. Beatles Insect Repellent. A 1963 plastic wallet. An inflatable Ringo (happily only a foot tall). Brooches. Necklaces. Lighters. Anything.

Enough. Enough of Georgeday, of the Amsterdam Martyrdom, of John's meeting with Yoko, which according to a recent witless BBC documentary was the world's most important event in the Year 4. I walked round the corner, anticipating the contemplative sanity of Ninian Comper's St Cyprian's, which is among the loveliest, doucest churches in London, all light and peace, only to discover that some young Anglicans were setting up a drum kit in front of the incomparable screen. (2004)

Smell the love

Boulevard Saint-Germain, Paris; Westbourne Grove, London. What have they in common? They are unquestionably streets of two halves. But why restrict them to a mere two halves? If the sometime bobbed goddess of Saint-Germain-des-Prés Juliette Greco could, in the phrase of its sometime god J.-P. Sartre, 'have millions of poems in her throat', then why can't a street have infinite halves? This is one for the late Lewis Carroll. And while he's at it he might also ponder the effect that millions of poems have on the oesophagus. Do the lines scratch? What happens if you swallow a pentameter? Just how much prosody can an average abdomen sustain? Does the body convert blank verse into methane, and if so, can you run a golf buggy on it?

These two streets are also living off their past. My last report from the wilds of W2 prompted a courteously umbrageous

correction that Newton Road was never a slum. Indeed, during the fifties, the incomparable Ronald Searle lived there. That figures when one considers his poignant book of seedy genteel London types of those years. But Nigel Molesworth? Metropolitan? The notion that he was created in what sounds as though it was then the epicentre of highest bohemia is very odd. Incidentally, will anyone who knows what became of Molesworth please get in touch.

That bulletin concluded at Tavola. I omitted to mention that this shop sells the vinegars distilled near Besançon by Vilux. That which is flavoured with lemon is remarkable. Tavola is on the very border of W2 and W11. The latter is a postcode which has long possessed a certain mythic cachet. Colin MacInnes's feature article of a novel, *Absolute Beginners*, horribly traduced on film, might be said to have invented the area. Some rather better, earlier films, of the gas meter and illegal abortion era – Michael Winner MA (Cantab)'s *West 11*, Bryan Forbes' *The L-Shaped Room* and Peter Yeldham's *The Comedy Man* – get the rackety feel of lives lived in bedsit squalor sustained by lavish, unrealisable dreams. That world had already vanished by the time *Performance* was shot in the autumn of 1968.

W11 had become preciously alternative, all chillums and velvet, happenings and head shops: foot soldiers in the great army of hippiedom ventured here to give lank forelock to important bass guitarists and 'underground' impresarios. Astonishingly, it has somehow retained its crummy mystique of thirty or forty years ago. Saint-Germain-des-Prés has pulled the same stunt from even longer ago.

W11 is, of course, as impeccably bourgeois as it was intended to be when the Ladbroke Estate and the Hanging Gardens of Northern Kensington were constructed in the mid-nineteenth century. And the western section of Westbourne Grove which abuts them is expensively chic. Reputation and actuality are at odds. The days when it enjoyed such tiresome qualities as street cred, edginess, hipness, danger and so on are long gone – save in the powerful

delusory systems of its babacool inhabitants, nostalgic for a time when a typical retail transaction on the Front Line outside El Rio's was still a five-quid deal from a charismatic pimp or groovy murderer, rather than ricotta di Nocia, a vulture-down duvet, an organic iPod, an ORV with bigger bison bars than yours, a designer orphan.

There is disposable income to burn. But it is to be burned responsibly, caringly: a controlled fire, not merry arson. Hence the shops. A very different gamut to that of Knightsbridge or Chelsea, both of which support the upscale niche brands that are to be found in the world's major cities.

The shops in the immediate environs of the world's only public lavatory designed by a world-famous architect possess the quirkiness that is a perennial London Peculiar. This city is, according to M. Laurent Delafon, the most exotic on earth.

M. Delafon used to work in the champagne business – which is the only thing he has in common with Ribbentrop. That ambassadorial war criminal had such a skewed map of London in his head that he reckoned Pinner to be the place to build a house – and did so, with shallow bricks imported from the Fatherland. M. Delafon, who lives in Maida Vale, is now in scent; an appropriate progression from wine. Mercifully, the ambient scent of old W11, patchouli, is no more. Don't sniff at me like that: I never wore it – and reek is apter than scent. But I do wear Diptyque's L'Ombre dans l'Eau, Eau Lente and Eau d'Elide. Indeed, since I stopped smoking last autumn, Diptyque has achieved the unthinkable and overtaken Creed in my olfactory pantheon. The fact that Diptyque's shop in the wrong (eastern) half of boulevard Saint-Germain is staffed by congenial human beings and that Creed's, off Avenue George Cinq, by offhand robots is neither here nor there. Bois du Portugal is – how can one put this? – slightly coarse in comparison with Eau Lente. Similarly, my long love affair with Rhône wines is dissipating and I am,

ruinously, heading back to Bordeaux: oh! if only there were cheap clones of Bx as there are of the Rhône.

Creed's sole founder was English. Diptyque was thought up by a Frenchman, a Frenchwoman and an Englishman, the fighter pilot and painter Desmond Knox-Leet who latterly specialised in what Ian McEwan called 'seething trees' (an epithet that I admit to having stolen elsewhere – only steal from the best). One of his paintings adorns the shop, which is high, narrow and startlingly painted according to a chromatic register that is not English, yet not French, and not really mid-Channel/Manche. Individual. I got to gape at a lot of its counter-intuitive greens and yellows the night that M. Delafon invited three of us for a lock-in. What a remarkable occasion. Scents, cheeses, Schlumberger's sweet Pinot Gris, Vouvray (M. Delafon is from Tours). It didn't make me wish to use scented candles. But that was not really the point. The point was an exercise in the exquisite. It was beautifully made. (2004)

The arts for beginners

The television series *Civilisation* was first transmitted forty years ago. The broadcasting industry and its ancillaries love an anniversary. This one is marked by the historian Jonathan Conlin's crisp BFI monograph. There is only the slightest body of scrutiny devoted to the series so the author is happily denied the opportunity to squabble, settle scores and fractiously pick holes in the work of colleagues who have had the temerity to previously venture into his grove: this is a study that is free of academic blight. It is preoccupied with the work itself and with its precursors, its genesis, its protracted shoots, Kenneth Clark's relationship with the producer Michael Gill, its reception and the long shadow it has cast down the years. *Civilisation* – or, rather its subsequent reputation – has been a burden to generations of television producers and commissioners. Barely a year passes

without an attempt to emulate its supposed qualities. Certain of these *soi-disant* 'landmarks' fail less comprehensively than others.

The root of the series' appeal as a continuing model is obvious. Art, to a certain cast of mind, remains an important thing, an improving thing, a good thing. And an even better thing when it is rendered popularly 'accessible' with lashings of grandiloquence, stirring music, doting cinematography, big ideas (that are easy to follow). Television of this sort is nonetheless humble, it knows its place, it gives great forelock to acknowledged masterpieces in media to which it believes itself to be a subservient upstart. It is essentially reportorial. It deals with established subjects. It does not attempt to create its own reality. It soothes with the balm of the familiar and the canonical: the progress the sexagenarian Clark followed was that of any history of art of the first half of the twentieth century. Save in his precocious and influential early book *The Gothic Revival* (1928) Clark seldom displayed taste that was anything other than utterly conventional among his generation of classically educated aesthetes who had not moved to the left. Nor was he an original writer. But he was engaging, authoritative, sceptical, encyclopaedic and, it must be said, civilised. He was also glossily handsome; in his youth he was described by Cyril Connolly as 'a polished hawk-god in obsidian'.

Some of those who have attempted to follow him have come unstuck because they simply cannot write and are, then, reliant on scripts bodged by researchers ignorant of Eliot's or Montaigne's counsels about plagiarism. They get found out. Other aspirant Clarks have merely served up stews of received ideas and exhausted commonplaces in programmes that are little more than advertisements for accompanying books of similarly questionable authorship.

Although unprecedented in scope and length *Civilisation* felt, when it was first broadcast, like the culmination of a tradition rather than an exemplar to the future. As an artefact itself it seemed to belong to a past age. If the Edwardians had had telly, this is what they'd have put

on it. Stylistically it was stately, formal, ponderous. This was the BBC acting responsibly. Then, as now, the lush middlebrow kulchurfest was the stuff to justify the licence fee. It was like wading through the lard of a David Lean epic after immersion in *la nouvelle vague*.

Television, too, had a new grammar. And it possessed in 1969 a vitality which has long since evaporated. It was the dominant cultural force in Britain. It broadcast fiction that was not genre fiction: Pinter, Nicholls, Exton, Mercer, Perry, Halliwell, Potter, Bowen, Rudkin, Griffiths, McGrath, etc. Ambulatory oddballs would slope across the screen, forgetting to smile or chortling alarmingly: Ray Gosling, Ian Nairn, John Betjeman. Of course none of these would ever be risked in a landmark series: humour was (and is) evidently reckoned to be the enemy of pietistic seriousness. And maybe indeed it was – this was the era of Marty Feldman, the Bonzo Dog Band and the Lovely Aimi MacDonald. Arts telly lagged years behind.

For rare directors like Ken Russell (at the BBC) and Mike Hodges (at ATV's Tempo) it was a place to serve an apprenticeship. But most arts telly was artless. It was in thrall to its subjects. It carried the reverent whiff of the WEA. It was fascinated by process: how is this made, rather than why is this made. A dismal pall of commonsensical craft hung over it. The bereavement of imagination, ambition and aspiration were matched by rock-bottom production values and an absence of filmic craft. Subject matter was all. And subject matter was invariably hackneyed. (2009)

Imagine all the shopping lists

The John Lennon Letters, edited and with an introduction
by Hunter Davies

There's scraping the barrel and then there is this dazzlingly indiscriminate collation of letters and memos and telegrams and postcards and doodles and shopping lists and action lists and lists of

records to listen to and lists of books to read and lists of chores to give the staff and lists of stolen clothes (insurance purposes) and lists of diet foods and so on up to an adoring review for the *New York Times* of Spike Milligan's *The Goon Show Scripts*.

'Edited' is perhaps not the first word that springs to mind when one considers Hunter Davies's role in this production. He has all too evidently decided to go for volume; that is, to include every available piece of paper that John Lennon scrawled on or typed or ever sent to anyone. Some he sent to himself. Davies has written at least two previous books about the Beatles and suffers the happy assumption that the entire world is still as fascinated as he is by what David Bailey has cattily described as 'a boy band from up north'. We are instructed that 'to a true Lennon addict, any scrap, any word is of interest, even a shopping list . . .' Whether this surely troubled creature, the true Lennon addict, will be satisfied by mere facsimiles, transcriptions and Davies's tirelessly breezy, ever matey commentary would be questionable were it not for the fact that Davies is himself such an addict and must know what sort of fix is required. Furthermore, he is in touch with countless other dependants and tells their touching stories of acquiring this or that relic with blokeish bonhomie.

The material is organised chronologically and more or less thematically. Lennon's susceptibility to fads is thus well captured. His wonderful singing voice – his only peers in the rock pantheon are Orbison and Presley – was rasping, metallic, harsh, mocking, ironic. It was what the man himself once had been. But after *Sergeant Pepper* it dissipated as the Beatles descended precipitously into half-witted mysticism, Fair Isle pullovers and infantile gullibility. *Magical Mystery Tour*, some of the *White Album*, all of *Abbey Road* and *Let It Be* . . . these can only be regarded with gross embarrassment. Which might also be said of John and Yoko's bed-ins, their wrong-headed causes such as Hanratty and Michael X, their all-purpose alternativeness, their

smiley gurus, their chanting and primal screaming, and the catchily emetic 'Imagine'.

And with each new craze came a new look. The man's facial mutability was extraordinary. But his self-awareness is such that he understands the ephemerality of his guises and enthusiasms. While his public expression is that of a quick-change artiste, the private correspondent is constant. His handwriting is that of an intelligent being. He is often charming, which is maybe surprising. He evinces a generosity of spirit in letters to strangers. He is loyal to his often very odd relations and his ne'er-do-well father. His jocular punning and eternally adolescent verbal extravagance are recurrent. So, too, is a petulant sensitivity towards perceived slights, especially when they concern the tiresome business of who wrote what. He was disproportionately angered by having only a walk-on role in George Harrison's autobiography, though he may equally have been angered by Harrison's star having risen higher than his (or McCartney's) or by Harrison's antipathy to Yoko Ono: there had been no rapprochement when Lennon was murdered.

That crime's hideousness is exacerbated by Lennon's frequent pronouncements to correspondents that, having regained his health, he is going to live to 'a ripe old age' and that as he approaches forty he hopes 'life will begin'. He had just made his first record in half a decade since the birth of his second son. That period had been preceded by his separation from Yoko when he lived with May Pang in California and spent most of his time legless in the company of Harry Nilsson and Peter Boyle. It's perhaps hardly surprising but still regrettable that this fascinating year of his life should have yielded no letters save for contrite, morning-after apologies for too ebullient behaviour in Hollywood bars.

This non-addict picked up two mistakes: in a letter to the teen-age Stephen Bayley, 'Shears' – as in Billy Shears – is transposed as 'Slears'. And Davies fails to recognise a photo of Vladimir and Vera

Nabokov – but then they weren't important figures in the London 'underground'. (2012)

All in the best possible taste
Vinyl, Album, Cover, Art: The Complete Hipgnosis Catalogue
by Aubrey Powell

Three hundred pages of photographs of egomaniacal longhairs trying their utmost to look insolently delinquent (as only the alumni of Harrow, Charterhouse, Haberdashers' Aske's, Oundle, the Perse and numerous other public schools can). An introductory essay weighed down by cliché. A commemoration of the last century's over-denimed, over-flared sartorial nadir. A vanity project that exhumes ephemera – mere record sleeves! – and binds them boastfully in hard covers. That's one way of looking at this book.

Another is to consider this doggedly thorough doorstop as a comprehensive celebration of a gloriously impure mix of photographic surrealism, graphic ostentation, inventive *mise en scène*, darkroom experimentation (Photoshop was far in the future), paleo cut-and-paste (using Cow Gum, of course), hoary jokes, bricolage, inspired ad-hocism and, above all, sheer cleverness.

The 12-inch 33-rpm vinyl LP began to oust the 45-rpm single in the later 1960s. Peter Blake's endlessly imitated design for the covers of the Beatles' *Sgt Pepper's Lonely Hearts Club Band* and Andy Warhol's banana for *The Velvet Underground & Nico* were as inspired as the music itself, and inseparable from it. These were, however, exceptions to the general rule that the cover should be little more than a flattering publicity shot, even if those depicted were dressed in Alphonse Mucha's clothes. During the bad-hair decade and a half of its existence, from 1967 to 1982, the prolific design studio Hipgnosis seldom succumbed to flattery. Instead it relentlessly exploited the freedom and limits of the format in multitudinous ways.

It shunned the creation of a house style or 'signature'. The quality of the work collected here is, then, inconsistent. If you are the kind of artist who insists on starting from zero over and again, it is inevitable that there will be failures. Nevertheless, the triumphs are many. As much as, or perhaps even more than, any of the musicians and borderline-psycho gangster-managers who gave them pretty free rein, Aubrey Powell (who answers to the name 'Po'), the late Storm Thorgerson and the late Peter Christopherson embellished their era with a mix of thefts, 'appropriations' and so on.

At their best they created utterly memorable and oddly moving images. Whenever they could, they did something other than litter their work with mug shots of hirsute interchangeables. The images they created were swift, crisp, neat. These are not properties that can be ascribed to most of their patrons. Popular music by the 1970s had bifurcated. Rock bands were as often as not composed of leaden, ponderous, pretentious ABs who had dispensed with received pronunciation and with the ideal of a tune that could be whistled in favour of plod rock. Proletarian pop groups were composed of graduates of the University of Butlin's put together by end-of-pier chancers who did not allow their charges to diverge from moon/June rhymes. With their matching outfits and close to clog-dancing routines they were throwbacks. Both camps were of course fabulously self-important. Selling 50 million copies of a record really does help with self-importance, even if most of them end up in teenagers' bedrooms.

Nearly all of Hipgnosis' work was for the first camp, which was their natural habitat. Powell, just out of King's School, Ely, in the mid-sixties, describes summoning the courage to ingratiate himself with the slightly older Thorgerson and Cambridge's arty, dope-smoking, acid-dropping, I Ching-inspired, Kerouac-reading caste of middle-class beatniks. In that era every small town had a resistible coterie of solipsists who seldom recognised how

orthodoxly unconventional it all was. The difference with the Cambridge chapter, which included the nucleus of Pink Floyd, was that its members were the offspring of academe and prospective multimillionaires, who were able to give their tyro friends some of their earliest commissions.

Among them was the cover for Pink Floyd's *Ummagumma* (an onomatopoeia supposedly representing a sound of sexual congress). This was the first time Hipgnosis's technical skill kept up with its imagination. The image is a kind of brain-hurting *trompe l'oeil*, fascinating and maddening: a photograph within a photograph within a photograph, and so on and on. What distinguishes it from similar designs is the fact that while each photograph retains the same form, its subjects move from one to the next, like pieces in a game devised by Lewis Carroll for a sunny garden. *Ummagumma* was released in October 1969; the cover was shot in the summer of that year.

In the early spring of 1969 there had been a revelatory and widely influential retrospective of René Magritte's *oeuvre* at the Tate. Two years after his death he was hardly unknown, but he was far from the canonical figure he is today. His posthumous popularity is partially due to his visual trickery and image-making having been stolen by graphic designers and the advertising industry, in which he himself had worked as a young man. Stolen, but not necessarily cheapened, for his ideas succeed as well in photography as they do in his lifelessly painted canvases. He was no master of 'the mark'. Hipgnosis was one of the earliest – perhaps the very earliest – studios to feed off his work, which would subsequently come to be employed to sell Citroëns, Volkswagens, Volvos, scent, floor cleaner, Magnum ice lollies and cigarettes.

Hipgnosis synthesised much that was in the air forty or fifty years ago: the critical re-evaluation of film noir, its English derivative included; the kindred re-evaluation of American 1950s kitsch

and diner architecture, celebrated in different ways by Tim Street-Porter and Robert Venturi; the fashion for typefaces such as Dymaxion and Airstream, created in the approximate style of that decade; Richard Gregory's *Eye and Brain*, which was an obligatory text for art students.

Add to this a marked taste for the gleefully tasteless, which caused the busybody Mary Whitehouse to persuade the BBC to ban *First Offence* by Bunk Dogger, subsequently never heard of again ('subsequently never heard of again' applies to 90 per cent of Hipgnosis's clients). The cover of Bunk Dogger's album shows a uniformed schoolgirl holding her hands apart, presumably to demonstrate the length of a penis. Powell, an improbable victim of the Age of Apology, regrettably counts it an 'embarrassment to the Hipgnosis catalogue'. Thankfully that mood of contrition rarely afflicts him. Had it, he'd have spent much of the book repenting his energetically un-misspent youth. (2017)

Future imperfect

Archigram: The Book by Warren Chalk, Peter Cook, Dennis Crompton, David Greene, Ron Herron and Michael Webb, edited and designed by Dennis Crompton

The cities we inhabit are so relentlessly protean that their two most common building types are the thing half constructed and the thing half demolished. Both incite a dull foreboding: will whatever comes next be bland or flashy or boorish or eager to please? Both types promote anger that developers who have politicians and planners in their pocket are given the green light to turn cities into building sites, playgrounds with hard hats, work boots, scaffolding, effing hoddies, traffic chaos and notices advertising 'proud' adherence to the Considerate Builders' Get Em Orf Darlin Policy.

The City of the Future, however, is far from protean. It is an

architectural type which exists in the grip of stasis, stuck in the preterite. It is as standardised as a Palladian mansion in a verdant park. It's a genre wanting renewal. It is a predictive fabrication which mostly got it wrong, gets it wrong and will go on getting it wrong. It suggests that the operatives divining in this branch of the haruspicatory arts are unwilling to admit that the armature and the conventions hung from it are old hat. Urban futurology's futures are grim because the futures foretold are wearisomely familiar, self-referential, cosily uninventive. And naively optimistic in the belief that architecture is a solace and a balm.

The city of monorails and monocycles, of his 'n' hers space suits, of irrational dress, bulbous flying machines, pterodactylish flying machines, food dispensers, multi-level walkways, vast screens broadcasting the news from Our United Earth's colonies on Mars and the moon, world language, robots, cloud seeding, 'organic' blobs and blisters, multi-pill diets, labyrinthine traffic interchanges, monuments to pioneer space dogs, ectogenic pregnancy, sub-marine settlements, Metropolis and more Metropolis, dictator-friendly tidiness, eschewal of right angles – all these comforting familiars have had their day, indeed their many decades.

The 1970 version of the City of the Future is indebted to the 1920 version whose foundations are those of the 1870 version. And so on. Are essays in urbanistic futures intended as practical maps, blueprints of the actual? Or do they belong to a parallel, uncon-nected endeavour which has no ambition to go beyond drawings, collages, maquettes and whatever a CAD jockey can summon from his machine? Do the begetters of these low-imagination creations themselves know?

The bogusly candid self-denigration that Platoville was never intended to be actually built fools no one. False modesty apart, therein lies a defensive implication that architecture need go no fur-ther than the plan, the perspective, even the back of an envelope or

a slobbery napkin at the end of a three-bottle lunch. To go further maculates the perfection of the conception with the messiness of process. Eighty years ago, Harry Goodhart-Rendel, a quirky architect and sharp writer who belonged to a school of one, remarked: 'Modern architectural drawing is interesting, photography is beautiful, the building is just an unfortunate but necessary step in between.' Both drawing and the photograph are idealisations, or lies. They omit context. Unsuitable neighbours are excised like apostate *nomenklatura*. The City of the Future merely multiplies the optimistic brags made about a single building. It is a happy place where the sun shines, peace reigns, teeth gleam. There is no indication that many of the forms it has stolen were originally conceived out of belligerent necessity. That awkward provenance is wilfully forgotten.

The gulf between architectural and, on the other hand, literary or filmic sensibilities is made obvious by the polarisation of imagined futures. The supposedly three-dimensional architectural future is pristine and welcoming, an advertisement by another name, borderline dishonest, naive, optimistic, softly didactic – all very cosily hearthside, were there hearths in this future, which there aren't. Fiction and film of the future are mostly tilted towards pejorism. They enjoy an insatiable appetite for breakdown, entropy, venality, carelessness, crime, state crime, justified paranoia, the deceptions of successive technologies and their enablement of moral squalor, suffering, the venom in nirvana, tyrannies, cruelty, mass hysteria, drugs. There may not be hearths but there are ad hoc braziers where howling wild men grill roadkill and 'locally sourced' little mysteries.

Architecture's schtick is vaguely deterministic. It supposes that the places it creates can improve us: even a loft extension is an act of utopian wishfulness. The City of the Future does not set out to make the world a worse place, though when it gets built it often does just that.

Archigram was an out-of-hours architectural band of six men whose day jobs were with big commercial practices and local authorities. Their many cities of the future were highly original, sometimes on the money, sometimes woeful, often funny, reliably coarse. They were as much artists as they were architects. Reyner Banham, who can always be relied on to make one wince, called them the Archigram Boys. Archigram was also: a sci-fi serial without a plot; an anthology of wacky improbabilities such as Ron Herron's Walking City which looked like a convention of bodybuilder pangolins; a spanner in the works of 'responsible' architectural discourse, which means timid discourse; an aspirantly polemical comic which relied on fine draughtsmanship, drawing of the highest calibre, shock-tactics collage and inspired design. Like Ballard, who wrote on a typewriter, Archigram foresaw the future with Luddite tools. The collective's precepts and dicta changed by the hour. It created what were not yet called installations. It was supposed to be fun. Sometimes fun can get wearisome – a student jape by pranksters too old to be students.

What Archigram has become in the sixty years since it began is a self-mythologising, energetically self-celebratory bastion of old-fashioned avant-gardism, as tied to its era as putting on a Brentford Nylons quilted housecoat and popping out to a Schooner Inn for a half of Red Barrel. They have sedulously controlled their image. The hype has worked. The surviving members of this collective dedicated to impermanence and expendability have sold their archive for £2 million to a museum, M+ in Hong Kong, designed by Herzog and de Meuron, a practice which Peter Cook, the most visible member of Archigram, has been somewhat dismissive of: Cook enjoys such caprices as a thatched van that used to advertise a restaurant near Fordingbridge.

During those sixty years there have been countless exhibitions, conferences, retrospectives, retrospectives of retrospectives,

catalogues, (un)critical apparatuses, dozens of adulatory books of which *Archigram: The Book* is merely the most recent, documentaries.

And hardly any buildings. That's the only quality Archigram shares with more orthodox soothsayers of the City of the Future. Otherwise it abjured the illustrative tradition of Albert Robida, Leon Bennett, Mathias Sandorf, Warwick Goble, who illumined the texts of Verne and Wells ('a scientific Jules Verne' in Wilde's words).

That idiom was required to show incident whereas Archigram was routinely mute or ambiguous. There is adventure but it is stylistic. There are no characters save the makers, whose marionetting hands are busier than Prince Andrew's. It had little to say but much to show. It broke, too, with another tradition, that of integrated rationalism whose extreme manifestation was Le Corbusier's glum Plan Voisin for the destruction of Paris, a self-advertisement worthy of a base politician. Archigram was a seething reaction to the purity of the white orthogonal architecture of the twenties and early thirties championed by Pevsner, the most conservative of progressives, who described English architecture of the early sixties as 'not functionally the best solution, nor an economically justifiable solution, nor is it acceptable in terms of townscape'.

Early on, conventionally enough, the practice entered competitions, some for hi-vis projects like Liverpool's Catholic cathedral, more usually for motorway service stations, educational buildings, social housing estates, Comprehensive Redevelopments (as life-changingly pharaonic regeneration campaigns were then called). The competition entries gave little indication of what was to come. The more rejections they received the more farouche their work became, the more unrealisable, the more resolute the intent that it was not for building. What was on the page or in the gallery was as far as it would go. The work, it was claimed, was not a blueprint, not a necessary stage en route to a consummation in glass and brick.

This was not a pretence. It was watertight, final. It was an end in itself.

Maybe. An experimental revolutionary architectural soviet has as much right as anyone else to change its mind. And to change it back again. To tie itself in knots redesigning the planet while drawing up plans for Gas Council houses for the aged.

The collective's rather wobbly aim seems to have been to create a representation of tomorrow which for all its fantastical devices was not escapist, douce and cuddly but much closer to the dense, pitted strata of imperfection that all cities eventually yield to in both primary reality and futuristic fictions. There is no flight from the gruesome chaos that flawed humans and their flawed programmes always manage to create. The germs of decay, of mechanical and electrical shut-down are everywhere implicit. There is so much kit inventoried that the Endless City has the potential to be the Endless Systems Failure. The frequently made comparisons with the slightly younger *Whole Earth Catalog* are misleading.

Archigram's members weren't hippies. They were of the generation that did National Service, just too young to have fought in the Second World War. David Bailey once remarked that what *Time* called 'swinging London' was 'just national servicemen gone demob happy'. They were radical materialists who believed exclusively in what they could see and what their imaginations delivered them. Transcendence was not on the agenda. They had a vitality which brain-curdling cannabis would have staunched. Bucolic revivalism, communes, cults, weekend mysticism, twenty-minute guitar solos and terrible clothes were not part of their world. Archigram was opposed to such backwardness. Its aesthetic had, after all, been established in the technophilic early sixties which began circa 1958.

The subcultural change was, according to George Melly, signalled by 'a secret society' he had never previously seen which congregated at the V & A's party for the Beardsley exhibition in the

early summer of 1966. The next future would be looking backwards. Archigram's collages had always included 'dolly birds' and 'get-away people' and 'the fun set' and 'people in a hurry' and other impatient clichés of that hedonistic era. Once the dolly birds have gone from minidresses to Laura Ashley folk clobber and their geezers are wearing patchwork jeans and a grimy halo of Afro hair there occurs a basic disconnect between the collective's imagined decors and the personae who inhabit them. As a graphic force Archigram's Rotrings and whiteprint were briefly pushed aside by a combination of acid and airbrush, Mucha and Pogany.

But as an architectural force this practice, which resisted the label 'practice' and which built virtually nothing, was increasingly potent, maybe for those very reasons. It was a forge of ideas, many of them garbled and incoherent but reliably catchy. Its sightbites were persuasive and covetable. Its rare political prognostications were inaccurate: it bought into the commonplace idea that mechanisation would bring leisure rather than slavery. Its attempts at lapidary apothegms were unconvincing. But that hardly mattered. It was not the speech bubbles in *Dan Dare* that enchanted a generation of future architects but Frank Hampson's drawings. Architects steal with their eyes. They quite properly look rather than read. Archigram were artists not theorists. Magpies not social scientists. Improvisational bricoleurs not adherents to any established school or style.

Like Piranesi and Le Queu, J. C. Loudun and the *Ideal Home Book of Bungalow Plans*, they threw generous scraps to the less inventive. What Archigram drew, its disciples built – in mostly diluted forms acceptable to planning authorities whose taste was three decades in arrears and to clients nagging about budget and scornful of architectural integrity. Among the earlier debts to Archigram was Levitt Bernstein's Royal Exchange theatre in Manchester: an ingenious structure which bellowed 'Design!' Braham Murray, the theatre's

co-founder and long-time director, pointedly declared that all you need to make theatre is players and a stage.

The Beaubourg, the first major building obviously in thrall to Archigram, was equally unfavourably received. How Archigram and their collaborator Cedric Price received it is shown in a television film of the late seventies in which they turn up outside it in a minibus and appear sheerly gobsmacked. Amazed, amused – and increasingly resentful at the sheer effrontery, the diabolical liberty taken by Piano and Rogers. With venomous tact Peter Cook writes of 'the believed manifestation of Archigram ideas in several buildings that have been made by [Norman] Foster and his friend Richard Rogers . . . it raises all those classic issues about origin, innovation and the ownership of ideas'. Indeed. But then so, too, do the off-the-peg Victorian-medieval churches that constellate England.

Archigram's flaw was its timing. Founders seldom prosper. It doesn't do to be too original. It scares the punters. It's the second and third waves that succeed – lords apart, they include Will Alsop, Future Systems, Rem Koolhaas and Coop Himmelb(l)au. Further, while architecture may be 10 per cent bedsit lucubration it is 110 per cent a cut-throat business which demands graft, oily diplomacy, baksheesh, clubbable chumminess, anilingual shamelessness. In their day jobs Archigram's original members worked for Taylor Woodrow, the construction giant which erected several of John Poulson's designs: now there was an architect that got his priorities right. And they learned nothing from him.

A wrong-headed hierarchy of realities grants primacy to a breeze block over a painting of a breeze block, to the sweating dominatrix over Dix's portrait of her. (The Neue Sachlichkeit was often on Archigram's collective mind.) While Archigram's members moved, *faute de mieux*, into academe, their insouciant epigoni made their designs 'real', without necessarily knowing the sources they were

drawing on. The thousands of inventions and wheezes and jests seeped into the collective architectural and sub-architectural consciousnesses to form a language casually picked up piecemeal.

Archigram's ghost, a very colourful ghost, is everywhere: in the recycled containers that have improved conditions in *bidonvilles* from Dakar to Ho Chi Minh City; in the crazily knotted service pipes that spill from Aachen's University Hospital; in the twelve-storey city that looms above two-up-two-down houses then gently moves away leaving a view of the Stour's confluence with the Orwell; in the decorative 'golden brains' on top of Yuri Platonov's Russian Academy of Science in the south of Moscow; in the fruit-gum-coloured spectacle frames by which one architect will always be able to recognise another. And, most satisfyingly, in Archigram's almost very own Graz Kunsthaus, a blue growth designed by Peter Cook and Colin Fournier. It got built. (2019)

21

Regeneration

Onwards and upwards

Speech given at the National Exhibition Centre, Birmingham

Revenge is a dish best eaten cold. They are especially cognisant of that fact in West Brom – which is twinned with Palermo. Two years ago I made a film, a fond film I thought, about Brum and the West Midlands. Not fond enough, evidently. Rob Heap of Ash & Lacy – which is based in West Brom – took me out for lunch a few weeks ago and asked me to come to the NEC today to make a prat of myself. That, of course, is not quite how he put it. He phrased it more delicately. He suggested I come to the NEC to swim with the fishes . . . no, no, he asked me to muse on nothing less than the future of architecture, which is like swimming with the fishes but with only one leg in concrete. Generous.

So I am expected to tompeep into tomorrow's tomorrow, to prospect the world of 2020, to gaze into a crystal ball . . . It's actually another kind of ball, this brief. It's what footballers call a hospital ball – one you have to go for but which is likely to put you out for the rest of the season. Hiding to nothing – all that. But anyway, let's go for it. The world is already littered with dodgy prophecies and bogus prospectuses – one more isn't going to make that much difference.

It's a truism old as the hills that futurology is really presentology in a one-piece Lycra jumpsuit with scoop neck – which is what we're always about to slip into but never quite manage to . . . Odd, that. But then I guess that a sartorial future based on the Young Generation in *Seaside Special* at Weymouth in 1977 is enough to make us all hurl ourselves off the heights of Portland.

The architectural future, like the technological future, exists first in fiction and film. The architectural future has looked the same now since *Metropolis* or *Things to Come* – the future has remained largely in stasis for sixty or seventy years. Indeed, the future is a sort of parallel world: sometimes it's a chimera in the distance which seems almost tangible, other times it is entirely invisible, is barely thought about, and is almost impossible to call . . .

Cast your mind back twenty, twenty-five years to a period when architects were largely regarded as pariahs – probably wrongly so regarded, but that's hardly the point. The fact of the matter was that till very recently, new buildings had come to be regarded by the general public with a mix of contempt and fear. And the architectural profession's tardy reaction to that hostility was the short-lived vernacular revival – which in that instance was a fancy way of saying let's keep our heads beneath the parapet, let's design apologetically: we English are always saying sorry. Sorry I'm not really here, I'm fitting in, I'm slavishly in keeping, I don't mean to offend, timidity is my forte.

And even when penance was done and confidence was gradually regained, it took a while before any sort of bold stroke was attempted. No one looking forward from 1980 to 2000 would have been so soft in the head as to predict that the architectural norm of the millennium would be a sort of synthetic modernism which, while it has so far shunned the plastic and sculptural possibilities of neo-brutalism, has drawn on every other strand of modernism from

constructivism, to glass boxes, to early Corbusier, to late Mies, to those sleek white jobs which remind us of boats.

We should not delude ourselves: most architecture is as retro today as it was during the heyday of the Gothic revival – the difference is that it isn't looking back so far: decades rather than centuries. But we should recall that after the Victorians had done Gothic to death, they started copying everything else – and by the end of that reign they were rehashing the idioms of its beginning. We are no different. We are currently engaged in recreating the late 1950s – all that turquoise and pale blue glass.

Postmodernism is still with us, it has merely amended its gaze. Having done Edwardian and art deco and classical, it has simply settled for the moment on what was, in the rest of Europe, the predominant idiom of the twentieth century, but which we broached gingerly – the English always have to be different, even if that means being backward, especially if it means being backward.

So, what will follow postmodern modernism?

One of today's tributaries will burgeon into tomorrow's mainstream – but which? That is the way all cultural shifts work, not just architectural ones. But architecture, at any moment in history, always tends to possess a homogeneity which other fields of endeavour don't share. I guess you could say that this is because 99 per cent of architects are sheep to the 1 per cent goats. I mean, could the Lowry in Salford have existed without the impetus and example of the Guggenheim in Bilbao?

You do not, as cabbies say, have to be a brain surgeon to work out that these loud buildings may set a precedent for non-orthogonal design in so-called prestige projects – but will there be a trickle-down? I doubt it, since that sort of expressionism is so wasteful of space . . . More importantly, do cabbies reckon brain surgeons to be brainy because they work on brains?

A much broader consequence of the Bilbao effect has nothing to

do with the likelihood of its style being aped. It is, rather, the function that will be repeated, and the true function of that building is evidently not to be a gallery but to be a global conversation piece, to be the cynosure of magazine photographers' eyes and thus to put Bilbao back on the map. This is architecture as monument – something that the second half of the twentieth century, memorious of the first, was ill at ease with. But memories of abominable regimes fade, and now every rust-belt town in the world is dreaming of its Guggenheim, its Lowry, its regenerative engine in the shape of a culture palace. Let's all rebrand. Not much different on the surface here to mercantile Venice or the Gran' Place in Brussels or the swaggering town halls of the Victorians. But in those instances, the purpose was to boast of wealth and power. Now, of course, the purpose is to attract them.

'In 1900,' Ian Nairn wrote of the domestic architecture of that moment, 'England led the world . . . by 1914 it was nowhere.' England hardly leads the world now, but that's not the point: the point is that England has a perennial appetite for doing what it did a century ago, for playing safe, for looking backwards, for retreating into Little Englishness, for pretending that it can maintain the cultural insularity and separateness which successive technologies have eroded: the Englishman's castle of the Hague era – should it ever come to pass – will very likely be a literal castle with an unleashed Widdecombe patrolling those parts of the garden which are not composed of barbed wire, brambles and landmines.

Unhappily, the circumstances really are propitious for another bout of retrospection. The Crowe committee's guesstimate of the number of homes that Britain supposedly needs to build is preposterous; preposterous as the guesstimate by the immunological establishment fifteen years ago that, by the mid-nineties, 12 million cases of HIV would have presented in Britain; preposterous as Blair's boast or wish or whatever it is that the internet will create 20 million jobs in Europe over the next two decades. On which

subject, we must all be delighted that the Nation's First Baby and Saviour of New Labour has been named after Birmingham's top and perhaps only Asian heavy metal band Leo: which is an anagram of ELO – so let's hope that the fates have chosen 'Mr Blue Sky' for the First Baby and not 'Turn to Stone' or 'Confusion'.

But grinning vacuous non-jobs are one thing. English houses are quite another. And the house is set to become the dominant building type of the early twenty-first century. This is bad news on practically every level. This tiny, packed island hasn't room to persist in spendthrift land use. It especially cannot afford to give up a further single acre to the sort of leaded-light, stuck-on beams, two-garage insult to the eye that volume housebuilders and middle-English punters collude in scarring this country with. The prospect wouldn't be so awful if domestic buildings achieved the level of even ordinary office blocks or health centres or rubbish incinerators. Tyrannical aesthetic control – that's what's needed, and I have a pretty good idea who should be tyrant.

I'm evidently straying into the realms of wishfulness here. I wish, too, that we could stop respecting the integrity of second- and third-rate buildings simply because they are old or oldish. Stop respecting it, then clamber all over them. One of the most heartening aspects of central London areas such as Southwark, the Borough, Soho, Farringdon, Hoxton and so on, is the sheer number of buildings which are sprouting buildings on their tops like barrel-vaulted hunchbacks. Now, this piecemeal regeneration may turn out to be just a passing fashion, but I doubt it. It's the norm in Rome to go upwards in an ad hoc manner, so why not in London, and then in Birmingham, Bristol and anywhere else where people want to live centrally in order (a) to avoid the calamities of public and personal transport and (b) to lead a sociable life if, as they increasingly do, they work from home.

It goes without saying that hutches which are to be hoisted onto the tops of extant structures need to do without the wet trades and

to be almost entirely prefabricated . . . to be effective kits – and while we're there: if this country persists in distinguishing itself by being the only one in western Europe to refuse to build social housing, should not local authorities take a leaf out of Lewisham's book and free up awkward or unusable or steep plots for the sorts of self-build schemes instigated by the late Walter Segal?

Actually, they weren't instigated by that remarkable eccentric, merely institutionalised. Self-build is old build. To provide oneself with shelter is as elemental an instinct as providing oneself with nourishment, sex and intoxication. Unhappily, we live in the most inhibited and most proscribed of the developed countries: and the idiocies of planning – macro-licence and micro-authoritarianism – are the environmental expressions of this nannying which would sooner that people slept under cardboard rather than build shanties on waste ground. We are subjects, we are not citizens, we are certainly not French farmers. (2001)

Same old, same old

'You must know by now how deeply committed we are to the heat of the metal, to the sizzling crackle when it's applied, to the headily aromatic scent, to the site and sight (pun for text version only) of the weal, which may hurt, just a little.

'But no one pretends that rebranding is a painless process. On the contrary. Make no mistake, it is not undertaken without painful thought, painful consultations, painful importunacy of our good friends in the plutocratic community. A painful process but a necessary one. Let us take stock of all that has not been subjected to rebranding and we discover a litany of things which have, frankly, not been rebranded. Yet. A vast raft of the yet-to-be-rebranded.

'Failure, for instance. Even now a brand is being forged which will in future designate failures as targets to be achieved. The deep

kernel of rebranding is that it tells us a new truth. Why should we not grasp the nettle of opportunity and let it be known that hubris is hitherto rebranded as humility – that is the new truth of our hubris. A husky is not a husky, it is a poodle.

'But rebranding – despite what the cynics and unpatriotic mockers claim – is no mere exercise in renaming. Far from it. Rebranding is all about thinking positive. If your hip replacement is delayed . . . well, shape up and remember the Transport Department's motto: it is better to travel hopefully than to arrive. So think positively of those weeks or, yes, months as a window of quality anticipation, a big window, a picture window, a fully glazed building, perhaps, inadvertently designed by a junior doctor who has selfishly worked a seventy-two-hour week, left scalpels in countless duodena and who will be augmented by some of Mali's most highly qualified physical education teachers.

'Make no mistake – I say to you hot air is a core value. And let us not forget that air itself is a consumer utility . . .

'Indeed it is. If air traffic control can be so triumphantly privatised – and privatisation is nothing if not a form of rebranding – why not air, henceforth new air? Old air was free, inefficient, used in such places as stuffy, criminally tobacco-ridden gentlemen's clubs, which can of course afford to pay for the stuff. It was liberally imbibed by forces of reaction such as Scargill, Benn, Thatcher, Jim Davidson.

'New air is quite different. New air is now air. Sting breathes new air, Sir Cliff thrives on it. New air keeps Joan Collins for ever young – and that must be worth paying for. There is no truth in the maledictory rumour that the chief executive officers of caring air-providers such as Mittalung, Hindujair, London-Derryair, Sainsburyfresh and Essentially Ecclestone will contaminate the areas of their franchise with the exhaust from their cherished-number-plated helicopters. Of course they won't. They drive private jets.

Each and every one of them. But let me make this clear as spring water: those mountain rescue helicopters whose wake lies heavy on places such as Wasdale will be hit where it hurts – in the rotors, with ground-to-air fire of piercing accuracy.

'The Re-Bated Breath Initiative will advantage the disadvantaged air user. Asthmatics, emphysemiacs, tobacco criminals with self-induced "conditions" will be taxed for their extra dependence upon this finite commodity and the revenues so raised will find their way to the infinitely capacious pockets of . . . No, no, they won't. They'll be redirected, for further redirection, to deserving non-smokers at the Inns of Court and different destinations such as the Temple . . .'

Rebranding – or whatever it's called from one generation to the next – is risible. Risibility is always with us. It's like the poor. And so is the urge to rebrand always with us. It's what humankind was made for. It may be laughable but it's inevitable. It depends on our forgetfulness of what was there previously – and we duly oblige with an access of immemorious blankness, we shut out the immediate past with consummate ease.

It is difficult to summon any area of human endeavour which is impervious to this form of willed change. Its manifestations may be physical or sentimental. The Roman Catholic Church rebranded itself to counter the Reformation by espousing the crude yet extraordinarily effective devices of the baroque. In much of southern Europe and South America its churches are no more than gaudily decorated sheds intended to impress an indigent, illiterate community. Vatican II did much the same 350 years later by decreeing that the churches must be designed in a way that allows the congregation to get close to the host – thus endowing the Eucharist with a coarse literality which was, of course, just the ticket.

The most beguiling exhibition currently on show in London treats the (American) sublime as though the sublime were some sort

of natural sentiment. The very notion is a romantic invention. Land-scapes which till the late eighteenth century would be habitually regarded as bleak, terrible, inhospitable were rebranded by painters who detected in them an apocalyptic magnificence and so changed the Western perception of such places. And once we have learned these perceptions we cannot go back. All we can do is long for what we have lost and look nostalgically back to the days when it was forever summer and each sweet inhalation was on the house. (2002)

Bulldozing with grace

Cranes, tracked earth movers, hard hats, scaffolding, excavations, caring hoddies (a sign says so), deafening jackhammers, artics exe-cuting eight-point turns, pyramids of rusting reinforcing rods . . . You think it's a building site. I think it's a building site.

Berkeley Homes knows otherwise: this almost triangular Southwark plot whose hypotenuse is Long Lane is not a building site. It is an urban regeneration project. Berkeley Homes doesn't do volume building any longer. Volume building is old hat. Three-garage pseudo-Victorian exec houses with characterful diapering and featuring plastic bargeboards dumped on greenfield sites are so yesterday. Today's cynosure is the mixed-use development in a formerly industrial quarter of a rustbucket city: the grislier the former industry the better. Abattoirs and toxic chemical plants enjoy greater cachet than sweet factories or jute warehouses.

The invariable architectural style that defines this vogue is the built analogue of easy listening. Synthetic modernism is promiscu-ous pastiche. It is as retrospective and antiquarian as Tractarian Gothic or officers' mess neo-Georgian. It filches the mid-twentieth century's motifs and materials: glass bricks; white render; timber facing; terracotta facing; extensive glazing; twee portholes, etc.

That modernism was not monolithic and that it possessed many schools is blithely overlooked. Devices are lifted from antithetical idioms and deployed with heavy-handed exaggeration. A development will, typically, include see-through penthouses, 'affordable' accommodation, live-work units, a boutique hotel, lumps of sculpture, functional items used decoratively, water 'features', vertiginous balconies, climate-defying outdoor cafés (architects are taught that London is in Lazio and Liverpool in Liguria).

The coinage Urban Regeneration may be as risibly self-aggrandising as Logistics Solutions is, as Refuse Disposal Officer once was. There must, moreover, be a suspicion that many exercises undertaken in its name are nothing more than Comprehensive Redevelopment exhumed. That discredited nostrum of the 1960s now wears the friendly face of the Smiler with the Sensitive Bulldozer. Like such endeavours as consultancy and motivational empowerment, regeneration is blessed because its alleged benefits are unquantifiable. Or, rather, they may be 'calibrated' in so many ways as to be meaningless: economic, social, demographic, cultural, etc.

When will the sunshine consequences of this or that PFI intervention actually become apparent? Tomorrow, of course. The one effect that is (laboriously) calculable is civic hubris: measure the column inches; count the airtime; just how shrieking is that self-congratulation? One may be forgiven the thought that the only point of the lapel-grabbing 'landmarks' that Frank Gehry and Daniel Libeskind now routinely produce in an access of swervily homogenising globalisation is that the regeneration agency or regional authority that commissioned them can trumpet its acuity and originality (even if that acuity and originality is the same as the next city's). Bilbao retains epic and violent slums despite the Guggenheim; parts of Manc are no-go ruins despite Salford Quays; Brum's soft Selfridges may offer something called salvation through shopping, but that can be of little solace to Balsall Heath's teenage

prostitutes. Mores are not susceptible to improvement by architectural nurture. Especially not when that environment is a cosmetic add-on.

Yet there are exceptions. Not to the proposition that architectural determinism is a chimera. But certainly to the idea that regeneration is necessarily no more than boastfulness. Southwark, a borough which stretches from the right bank of the Thames to distant Gipsy Hill in deepest south London, has commissioned from the architectural historian Kenneth Powell a book on what has been built within its boundaries over the past two decades, and what is about to be built. Ian Nairn wrote in the introduction to *The Buildings of England: Surrey*: 'No history of [nineteenth-century domestic architecture] could be written without mentioning some of these buildings, and quite a coherent history could be written without mentioning anything else.'

This formula might be applied to Southwark since the late 1980s. Predominantly to riverside Southwark and its immediate hinterland, which are further north than the Palace of Westminster, Buckingham Palace, Chelsea, etc., and which have regained their status as a part of, rather than as a grubby adjunct to, central London.

This area, as *City Reborn* demonstrates, contains a greater concentration of new London landmarks than any other borough. There are big gestures by big players: Norman Foster's City Hall, Piers Gough's Circle, Will Alsop's Peckham library, Herzog and de Meuron's Tate Modern, Alan Camp and Ricardo Legoretta's Fashion Museum.

These projects are evidently atypical. They might be attached to any old Manc or Brum. A stranger to Southwark leafing through the high-gloss images of high-end design might suspect that Southwark's regeneration is an illusory deceit. In fact, this area has suffered a vast change. An accretive change. One achieved by the accumulation of small projects, by everyday competence, by reaching what the architect Peter Aldington once called 'a better standard of ordinariness', by

the opportunistic cunning of volume builders with a new moniker and acceptable clichés. Southwark is a fresh chapter in the very old London book of un-grand plans; its current pattern of extempore change mirrors that of this megalopolis as a whole. The most radical grand plan of the last century, the Greater London Plan of 1943, would have razed this area to the ground. (2004)

Logo-go-go

When, in the aftermath of the Toxteth riots of 1981, the then Mr Michael Heseltine, as environment secretary, solved all of Liverpool's social and economic problems by establishing a garden festival, he unwittingly set in motion not a mere gravy train but a luxury Pullman of freeloading self-congratulation. This passionate horticulturalist cum arboriculturist, whose super-abundant tresses show what Miracle-Gro can achieve when daily applied after shampooing, bred an entire industry.

Worse, his baffling act of what at that moment seemed patent and pointless opportunism has created a sort of faith. It is not called Heseltinism. It is called Regeneration. And it is so simplistic, so populist, so right-on, so accessible, so physically manifest, so optimistic and – vitally – so immune to verification that it has spread, creating a quasi-hieratic caste of Regenerators, a caste which is ever multiplying as more and more scoundrels, charlatans and chancers hitch a ride aboard the Pullman.

The new faith is a familiar, discredited faith with an amended liturgy. It is, of course, our old friend Comprehensive Redevelopment repackaged with a compassionate face, with bright infantile colours, with communitarian chumminess, with a PR budget to win over the credulous (not that they take much winning over: that's why they're the credulous).

One of the appeals of Regeneration for those involved in it is its internationalism. Freeloading and self-perpetuating bureaucracy are immutable human endeavours. We may be a species which delusorily dignifies itself by the fact that we create. But we are more readily a species that exploits, that pimps, that peculates the public gold (the phrase is Cowper's). There is public gold swilling about everywhere, just waiting to be mopped up by plausibly worthy causes. And what could be more plausibly worthy than urban renewal? The 2004 Regeneration Awards (I promise you: there's a 'black tie event' at the Park Lane Hilton in late November) are to be made in seventeen categories including Regeneration Personality of the Year, Regeneration Achiever of the Year, Regeneration Contractor of the Year.

If this movement began in one troubled northern city it reached its apogee in another. Liverpool and Bilbao no doubt have much in common: an inchoate sense of grievance, an aspiration to separateness, a sentimental Hibernianism. To judge by a Regenerative conference I went to last year, Liverpool's role as the acorn is largely forgotten, while Bilbao is the faith's or industry's cynosure. Urban and regional development corporations from Swarf-upon-Slag to Klostadt to Etronville look to that grossly indulged city of rain, rust and ETA as, yes, a role model for their dreams.

Which is all very well, save that cities don't quite work that way. The Regeneration industry has yet to come to terms with the unsuitability of global nostrums and spray-on formulae. Centrally manufactured solutions are not means of expressing separateness, heterogeneity, 'distinctiveness'.

Bilbao's ruse was to draw attention to itself by employing three of the very few architects whom an international public has heard of: Gehry, Foster, Calatrava. And Gehry's Guggenheim has become the most famous – because most photographed – building in the world of the past decade.

That's some achievement for a depressed city. All the world now knows what titanium cladding is, all the world has now heard of Bilbao. It is regenerated. The Basque world is a better place. Crime has ceased. There are no longer junkies stalking the alleys where the sun never goes (because it doesn't want to get mugged). Fundraisers for the INLA are things of the past. The masked murderers have seen the error of their ways: today they run donkey sanctuaries and help old ladies across the newly affluent streets.

The Guggenheim pretends to be a museum. Its true function is as logo – and it has fulfilled that function. Money well spent. It will of course take years to determine whether it has effected an improvement in the micro-economy: no city can live off the income from winter mini-breaks. If a 'Landmark Building' such as the Guggenheim is Regenerative Plan A, then Plan B is Retail. Sometimes Plan A and Plan B coalesce. Future Systems' Selfridges store in Birmingham, for instance. You can tell that Leeds and Manchester are regenerated because they have a branch of Harvey Nichols. So those burned-out warehouses and vandalised cars and sink estates and drive-bys and shared spikes and offies with iron grilles and boarded-up shops and third-generation full-time un-employed people who have never enjoyed the luxury of hope are . . . ?

They're out of sight. That's what they are. They do not, cannot, intrude on Plan C – which is gated loft communities with espresso gyms, Citterio furniture, bespoke-moulded bidets, wetter than wetrooms and model inhabitants whose ultrateeth are gleaming manifests of a sybaritic-yet-healthy lifestyle-choice strategy. And Manchester's got the Lowry, too. Let no one whisper that it's a rip-off of the Guggenheim.

Why the Guggenheim? It's not even the most fascinating recent building in the Basque country. Both Rafael Moneo's Kursaal in San Sebastian and Santiago Calatrava's Bilbao Airport are infinitely more satisfying and more subtle structures. There, of course, is the

rub. Subtlety is not what is required in a logo. Calatrava's work is marred only by the fact that the food store dismally fails to represent the wealth of Basque produce. Sure, there are three cheeses made from ewes' unpasteurised milk, but the hams and sausages are industrial. A missed opportunity. The airport is otherwise a delight (how often can one say that?). The architect alludes to Saarinen, Concorde, Gaudí, Nuñez, birds, bones. He creates pilotis which resemble flying buttresses; pigmented concrete interiors which recall the whale; vistas which are, strangely, both epic and comforting. If ever I was to choose an airport to live in . . . But then I heard my call and flew away. (2004)

Fast track to the future

The nostrum called Comprehensive Redevelopment was last heard of in the 1970s. It slunk away, discredited as naively optimistic, as crude, as unwieldy. The received wisdom of the last quarter of the last century – the received wisdom we have inherited – has been that grand plans, by their nature, are unrealisable. That statist intervention not only doesn't deliver but can't deliver. That the very idea of high-minded *dirigisme* is flawed. Along with Comprehensive Redevelopment these are, effectively, dirty words.

Here are some more unmentionables: Vision. Ambition. Can-do. New. Confidence. They shouldn't be unmentionable. They aren't unmentionable in the countries which are our competitors. And nor were they unmentionable in our own past.

But we have allowed our perception of grand schemes to be coloured by a few failures of the mid-twentieth century. Failures which were the exception rather than the rule, but which have nonetheless been allowed to stand as the rule. Failures which were caused by cutting corners, by indifferent maintenance, by allowing ideas to rush ahead of tried and tested technology. Result? We

throw the baby out with the bathwater. Instead of changing tactics we abandon strategy.

We retreat into what might be called fearful nostalgia. It is loss of nerve as much as excess of cost which has determined that the national specialisation should be bricolage. This is nowhere more obvious or more damaging than in the conjoined areas of passenger transport provision and the locations of housing and the relationship of those locations to workplaces. These form an entity. Now, if bricolage sounds rather sexy let me suggest some English synonyms – bodging, patching-up, covering over the cracks . . .

The idea of mend and make do is understandable at the potting-shed level. A length of tarpaulin on the roof where the tiles have blown off. Here's some bubble wrap for insulation. Yoghurt pots for seedlings. A tosh of paint will, with luck, give those rotting clapboards another twelvemonth. There is a resistance to recognising that the potting shed has had its day and needs to be replaced in its entirety. A pecuniary resistance, certainly, but also a resistance born out of uncertainty of how a new potting shed will perform. But is this sort of improvisation an appropriate model for national policy? Astonishingly, yes. And I'm not merely referring to the way in which London Underground tracks have been discovered to be supported by wedges of offcut from a carpenter's shop.

So we persist in throwing good money after bad, in trying – all too literally – to prop up systems which are not merely outdated but which are impervious to further repair. There is a law, known to all dodgy forecourt salesmen, which states that once a gearbox is entirely full of sawdust it can take no more sawdust. A precursor of this law was known to our recent forebears.

When steam power was developed to the point that it was reliable enough to sustain a commercial network, canals were still a comparatively new technology; indeed, there still existed a gerontocracy which regarded them as the latest thing. The only town in

England which was occasioned by that technology, Stourport, is, after all, a mere sixty years older than the railway town of Swindon. Had the timorousness which pertains today pervaded the national and governmental mood a century and a half ago we'd never have built a railway system. We'd still be stuck with canals.

Our forebears demonstrated a pragmatism and a realism in the matter of canals – which were still being built. They abandoned them.

At a place called Whaddon off the A36 one can still see a series of curious hillocks which are formed by the excavations of the aborted Southampton to Salisbury canal. At Higham near where Dickens lived at the end of his life there is a two-mile-long tunnel which was built for a proposed canal in the early 1820s but which was swiftly converted for rail use by the North Kent line. The train time from Higham to London Bridge is, incidentally, no quicker today than when Dickens died there 133 years ago.

Yet we have publicly persisted with this equivalent of valve radios or black and white televisions or piston-engined aircraft or analogue phones. At commercial, bureaucratic and domestic levels we have embraced new technologies. But our public services proceed as if they don't need a PC when they can just repair their abacus.

Nigel Gresley's A4 Pacifics are perhaps the most beautiful steam engines ever designed. *Mallard*, driven by Mr Duddington, famously holds the world speed record for a steam engine: 126 mph. In 1938. Why? The obvious answer is that it went faster than any other such machine. A second, more oblique, more pertinent answer is that by 1938 steam – and Gresley knew this from his trips to Germany – was a form of propulsion that was being superseded in other advanced countries. Investment in steam was already a thing of the past.

Yet on the eve of the Second World War Britain was preoccupied with perfecting a redundant technology in the form of a locomotive that had come off the drawing board at the end of the First

World War – and we persisted in manufacturing steam locomotives until the late 1950s. The innovative energy of the Victorians had entirely dissipated.

Our attachment to the old is not a quaintly whimsical caprice. It is a self-inflicted handicap – which the rest of Europe regards with sly bemusement. The nation that was once the brewery of the world is now perceived of as incapable of organising a piss-up. Which is not to say that it doesn't want to. But collective will is a quality that needs to be relearned. There is a collective mindset to be retuned.

When retrospection takes the form of spray-on Tudor beams or plastic Corinthian columns it is merely laughable. When retrospection takes the form of putting the brake on a project because if it is developed to its full potential it will not accord with the current infrastructure . . . well, there you're looking at the refusal to learn from the past, at the irresponsible stewardship of the present, at the denial of the future. You're looking stasis in the face.

It is a truism that any mode of public passenger transport goes there and back, it's two-way. Economics makes this necessary. Logistics makes this necessary. A stagecoach from London to Bristol was equally a stagecoach from Bristol to London: the perpetuation of the service depended upon its return. Otherwise – in an absurd reduction – a new coach would have had to have been built for every journey, and the Avon Gorge would have become a graveyard of single-use coaches. The mandatory return meant – and still means – that every new route from London to the regions is also a new route from the regions to London. A new opportunity for London to exercise its magnetism. Its alleged magnetism.

The city of which Dr Johnson said when a man is tired of it he is tired of life, was a city of 750,000 people – less than a tenth of the current population and a twentieth of its size. I suspect that anyone who was to parrot Johnson today would be met with hollow

laughter. London is no longer a city but an irremediable megalopolis. Its magnetism is not one that people wish to be subjected to. It is based in necessity not preference. Because it draws an extraordinarily disproportionate slice of inward investment to Britain, it draws an unwilling workforce to enjoy its irreversibly diminishing quality of life.

Why does London draw such a level of investment? Because it has positioned itself as a world city. It belongs to an uncodified but nonetheless real super-league of New York, Hong Kong, Paris, Tokyo, etc. It is more concerned with its place on the international stage than with its hinterland. London has effectively seceded from the country of which it is the capital.

Does that mean the rest of Britain is a sort of foundling? Absolutely not. On the contrary: the very fact of London's semi-detachedness and of its populace's dissatisfaction with it offers a remarkable opportunity to Britain's other cities and their regions.

Again, we need to look to our own past and to others' present. We need to look to Italy, to France, to Spain, to Germany. To the autonomy of cities which aren't capitals but which might as well be – to Turin and Milan, Lyon and Lille, Barcelona and Valencia, Hamburg and Frankfurt. Sure, these countries are spatially larger than Britain, but because of their communications they are temporally smaller. And although it's the latter measure which matters – minutes rather than kilometres – the non-capital cities paradoxically enjoy an international prestige which our non-capital cities do not share. Increased proximity has had the effect of diffusion rather than of centralisation within those countries. Sure, you can claim that those cities' relationships to their capitals is politically determined. And, yes, you can claim that their history is different. But history doesn't just happen. It is made.

And then – apparently it is forgotten. In the late nineties I was preparing a film about Birmingham. After a BBC planning meeting

where I discussed the allotments movement, the city's dependence on the car, the invention of balti, the Saddam Hussein mosque at Perry Bar and so on, an American asked why I had omitted bussing, civil rights marches, lynchings . . . the only Birmingham she had ever heard of was in Alabama. Despite the fact that it was once the workshop of the world, despite the fact that it supplied the Sioux and the Cheyenne with their tomahawks.

We have to return to the days when Britain's great cities were effectively autonomous city-states without a perceived dependence on London – the dependence was the other way round. History can be made; it can be remade. Birmingham suffers two special disadvantages in this regard: one is called Birmingham City, which never wins anything, the other is called Aston Villa, which did win the European Cup twenty-one years ago – but wherever is Aston? One might equally ask wherever is Arsenal?

Manchester, Leeds, Liverpool and Newcastle enjoy instant global recognition thanks to the coincidence of city name and soccer team name. I apologise to City supporters, but outside this country Man U is known simply as Manchester. The team stands for the city. This global recognition is a priceless asset struck in the currency of a global craze. The work has been done by consecutive series of eleven men. Duncan Edwards and Billy Bremner, Tommy Smith and Bobby Moncur would never have heard of branding in the sense that we use it today, no one had – but that's what they were unwitting pioneers of. Inestimable goodwill attaches to these cities because soccer is, for better or worse, an international language: these cities are microcosms speaking to the macrocosm. They are both local and planetary. They possess a resource which will, can the means to exploit it be defined, challenge London's paramountcy and domestic apathy.

Maglev's potential as that means is vast – and it is varied.

In terms of international recognition Maglev will enable the Greater North to go over London's head in the way that, say,

795

Barcelona goes over Madrid's. It goes far beyond the Bilbao effect. The Guggenheim is a photo opportunity, a telegenic structure whose function is to advertise the city. Its job was and is to put Bilbao on the map – Bilbao needed that sort of gesture. And it isn't much more than a gesture. But then Waterhouse's Manchester Town Hall and Cuthbert Brodrick's in Leeds were gestures, displays of civic confidence and pride – but they were also the administrative hubs of their cities.

In terms of its reach Maglev will include London: at one of its peripheries. It is a gift from the Greater North to London. Integrated with a north-western airport using the three extant runways of Ringway/Speke and using the same Maglev technology to shrink Ringway/Speke to the size of Heathrow, Maglev is capable of tilting Britain. That a city's centre of gravity can be altered is shown by the way that in the last decade London has moved east and Manchester has moved west. A country is equally susceptible to such a shift. Maglev can reposition the centre of Britain, it can correct the last half-century's socio-economic list to the south, it can restore stability, it can heal a divide, it can alter the face of the country to the extent that rail and internal combustion did – but at a much lower pecuniary and environmental price.

It is, then, much more than a brand, more than a defining add-on. It is closer in spirit to those town halls of the cities which led Britain when Britain led the world. Both representational and functional – and restructuring. And there are further ands.

Maglev is green. And it is thrifty in its land use. And it can run in currently redundant tunnels, and along the very lines of redundant track. And that prefabricated track can be installed by non-specialist builders. And its technology is proven over two decades. That graft has been done by Germans just as the branding has been done by men in shorts. Germany has taken the risks, we can accrue the benefits.

Our failure to embrace high-speed trains gives the Greater North an extraordinary advantage over its continental counterparts. Their commitment to that technology means that they are locked into it for years to come. We have the opportunity to leapfrog an entire technological generation.

And, yes, it does demand vision. (2005)

Aggregate of rock and memories
Speech given in Bristol

A generation ago, what may be seen today to have been a lavishly audacious sleight of hand or sleight of mind was performed. The conjuror was Lord Lawson of Blaby, as he then wasn't: the chancellor of the exchequer, Nigel Lawson, whom Auberon Waugh once described as the cleverest man he had ever met. Just how clever can be adjudged by the sheer immensity of this act of legerdemain: this was not pulling a mere rabbit out of a hat, but reaching into the crown to find an entire warren followed by all of Noah's passengers, or Noah's clients. It was the catalyst of a momentous shift. It was as if we were told that when the sky is full of stars it is day, and that night is when the sun shines. It was as if we were told that this colour which we formerly knew as red is actually called black. Indeed, there's no as if about that one.

Here, precisely, was Lawson's lesson. That debt is not debt if you say that it's credit — when you're in the red you're in the black. Profligacy, traditionally the province of the younger sons of the aristocracy going off the rails, was suddenly available to all. Living beyond one's means was democratised. Being in hock was officially sanctioned. Acquisition was held to be a moral virtue. The counsel of another more cautious chancellor, Polonius — neither a borrower nor a lender be — was cast aside. But then, Polonius ended up stabbed through a curtain by Hamlet — and Lawson didn't. Point

proven, I think. Ownership was next to godliness, ownership was empowerment.

When James Callaghan had talked in 1979 of a 'sea change' he was prescient: he foresaw the end of the post-war welfarist consensus, a sort of nationalised *noblesse oblige* – more social housing had, incidentally, been built under Conservative administrations than under Labour. What happened in the eighties was nothing short of a cultural revolution. Cecil Parkinson admirably reflected the new ethos when he said that it was every Briton's right to possess . . . a personalised car registration – save that he didn't put it that way, he referred to 'cherished number plates'.

Bread and circuses became a de facto doctrine – which was at the core of government policy and was, by its very nature, popular. Throw us people some scraps and distractions, followed up by more scraps and distractions, and we shan't complain.

It might have been expected that when the recession of the early nineties hit, we would complain. After all, we had to learn a new term, negative equity, we had to become inured to people losing their homes, to business failures as an everyday fact of life. The frailty of bread and circuses as policy was exposed. But the same unchanged mindset was apparent when the other side of that trough was reached and the economy recovered. There was no counter-revolution.

It might have been expected that the English language would come up with a word for *dirigisme* – the fact that it didn't tells its own story.

It might have been expected that New Labour, following its *Machtergreifung* in 1997, would put the brakes on. But it didn't. Far from it – it welcomed loan sharks with logos on every high street. There was a new cross-party consensus. In the fifties and sixties, the Tories had stolen Labour's welfarist clothes. Now it was the turn of New Labour to plaster a caring smile onto Thatcherite Manchester

liberalism where the free market is god; and as we all know from sacred texts – the Koran, the Old Testament, Greek myths and so on – god has what are called behavioural issues: he's a jealously vindictive psychopath who has forgotten to attend his anger management classes and has left his Largactil in a halfway house.

We were informed by a proud Mr Mandelson that he was 'intensely relaxed about people getting filthy rich': well, he's certainly been true to his word. Mr Brown regularly announced that we were beyond the cycle of boom and bust – which was about as astute as the portentous claim that we had reached the end of history: it was a slogan and nothing more. A wrong slogan as it happens – but then economic forecasting belongs more to secular shamanism than it does to any branch of science, and the majoritarian confidence in an entirely unfettered market is founded in nothing more than unprovable belief, it's a sort of faith every bit as grounded as the conviction that eight magpies portends a major lottery win. Will that faith be shaken? We have lived in a soufflé economy, and the oven door has been opened. Will we acknowledge that the thing within is a pancake or delude ourselves that it will rise again? Are we witnessing another sea change? Is a different order likely to manifest itself?

Might we just cut our collective coat according to our cloth – this, I appreciate, is a hopelessly unfashionable, hideously ancient prescription, and one which is perhaps unfamiliar to an entire generation. However, should such a quaint, reactionary measure be adopted, if only for want of any other, it would have some genuinely beneficial ramifications for the built environment.

Constraints are a spur: think of poetic forms such as the sonnet, the alexandrine, the rhyming couplet. Think of structures that owe their form to the availability of a single building material and making the most of it. Clay that can be impacted, or chalk that can be mixed with straw to form cob, create their own disciplines.

Employing blocks of slag from brass furnaces to construct buildings in Severnside settlements at Frampton and Newnham and, most famously, the Devil's Cathedral at Arnos Vale is no more than good husbandry, creative thrift, like using all of the pig but the squeal, or like turning the leftovers of a joint into shepherd's pie – more of which later.

Constraints may also cause us to question what we build, how we build it, where we build it.

Of course, we have always done that – but it does not inevitably appear so in retrospect.

Someone, after all, once believed that cities should be cut through with overhead motorways and pedestrians forced into tunnels that would come to double as lavatories and crack dens: the very idea seems preposterous today.

Someone once believed that cities should be allowed to expand horizontally, at low density, to beyond the horizon. That, too, seems preposterous today.

But we shouldn't be complacent. One era's orthodoxy is the next era's Aunt Sally. We can be sure that whatever we do today will be mocked in the not too distant future and, very likely, corrected. Cities have become ever more provisional. They have increasingly turned into monuments to the erasure of former needs and discredited urbanistic fashions and to the obliteration of former taste. And the cycle of change is forever contracting – or being made to contract. A building whose life expectancy is fifty years is only half as appealing to the construction industry as a building which will be redundant in twenty-five years and crying out for the attention of our friends in the demolition community. The construction industry, like any other industry or profession or trade, is before all else concerned with its survival, with propagating itself. That means building, building constantly, building anything, building anything that won't last too long. As we have seen from its hijacking of the Commission on the

Built Environment and from its inventive exaggeration of the number of new houses the country requires, it means special pleading for more and more building, it means claiming that building is the balm for a society's woes.

George Bernard Shaw's dictum that professions are a conspiracy against the layman is agreeably cynical – but it probably ascribes too much cunning to bodies which are more preoccupied by their blinkered self-interest than by attempting to put one over on outsiders. But maybe I'm too full of the milk of human kindness. Either way, it's not motive which is pertinent but the results.

We need to ask ourselves: who are cities for? Are they for citizens? Are they for those who live in them, work in them, promenade in them? Or are they for hard hats? For builders whom we know to be considerate because they tell us so?

Cities are building sites, the construction industry's boorishly mannered open-air factories without a roof. They are factories which occasion maximum inconvenience for the majority and maximum profit for the minority. Special factories which more often than not are characterised by their having to destroy before they can create. If we compose a song or carpenter a chair or manufacture a car, we do not have to erase for all time 'Ernie the Fastest Milkman in the West' or burn a Lloyd Loom or reduce a classic Allegro to a metal cube to make space for them. New buildings, however, are voracious raptors – they destroy places which have long been precious to those who use them or pass by them, who may have no proprietary stake in them but do have an emotional stake in them, a stake which is not measurable in pounds sterling per square metre. Indeed, it would be immeasurable were it not for expressions of nostalgia.

Nostalgia is of course a nine-letter word in architectural circles, probably throughout the construction industry; it's almost as dirty a word as pastiche – you know, there's no room for sentiment in

business. But it's worth bearing in mind that nostalgia is a kind of poignant, regretful memory which is the underpinning of much literature, painting, music. And we return to former homes – not necessarily to the shelter we occupied – but to the area, to the hometown, to all that was once familiar, in the hope that they will provoke the same sensation they provoked a lifetime ago. It's a vain hope, even if the place remains intact. Which is improbable, for most places are treated like white goods or electronic gadgets – the term consumer durable is a patent lie. This gear gets chucked after a few years, when the point of MDF, manufacturer's determined finition, is reached.

I know that the Marine Café – or more properly caff – on the Triangle at the top of Park Street vanished decades ago, but I still steal a glance at its site whenever I'm in Bristol in case the clock has miraculously turned itself back to the Formica era when I used to be treated to deep-fried egg and chips there – my taste for which caused my mother to discover her vocation as a kitchen incendiarist. The clock hasn't obliged by turning itself back and I rue the loss, the death of this place which might be considered insignificant – but we should not underestimate the significance of the insignificant. Across the street is another restaurant, where I first ate Chinese cooking or, rather, the Californian debasement of Chinese cooking. It's still there in an altered form. Even though chop suey and chow mein never did it for me the way deep-fried egg did, I am heartened by the continued existence of this tiny part of my past.

Places are as much our foundations as people are. We render certain of them sacred, with a small s. We attach ourselves to them through our personal rituals – which we may not even think of as rituals. They equally seem to attach themselves to us – well of course they don't, because they are inanimate: but we don't always have much choice in the matter of what places we come to love. Again, rather like people. I first ate pizza in Bristol – I promise, this

is the last gastronomic virginity that was taken in this city – but even though I've often walked past it I've never revisited the barrel-vaulted former wine cellar turned restaurant, even though it was by anyone's standards easily the most impressive of these spaces. But comparative architectural excellence is no guarantee of our being engaged by a place. The grandest works can leave us cold and unaffected while bodged shacks and beached boats can fill us with joy.

Architecture is merely a component of places, the armature on which we hang part of our life. That is not how the architectural profession sees it. When I worked briefly for the *Architect's Journal* – I was sacked – I was perhaps naively shocked by the extent to which the practice and representation of architecture was cultish, exclusive. And still is: its initiates, unconcerned about the posthumous satisfaction they grant to George Bernard Shaw, talk of the lay public, lay writers and so on – it's the language of a priesthood.

Architects, architectural critics, architectural theorists, the architectural press (which is little more than a PR machine operated by sycophants whose tongue can injure a duodenum) – the entire cult is conjoined by mutual dependence and by an ingrown verruca-like jargon: for instance, 'Emerging from the now concluding work on single surface organisations, animated form, data-scapes and box in box organisations, are investigations into the critical consequences of complex vector networks of movement and specularity . . .'

The cult of architecture talks about itself as if it's disconnected from all other endeavours, as an autonomous discipline which is an end in itself and which is understood only by architects and their acolytes.

Now, it would be acceptable to discuss opera or sawmill technology or the refinement of lard in such a way. They can be justifiably isolated because they don't impinge on anyone outside, say, the lard community – the notoriously factional lard community. To isolate

architecture, the most public, most inescapable of all human endeavours, is an abjuration of responsibility, clerical treason.

If we want to understand how to make places or, rather, place – the terminal s and both definite and indefinite articles went missing a few years back – we should not ask architects. After all, if we want to understand how to make shepherd's pie, we don't consult the lamb. There is an understandable tendency on the part of architects to confuse the physical environment with what they impose on it. But that environment is the product of innumerable other forces. Our surroundings come about through chance juxtapositions, fortuitous collisions, clashes of scale and material, harmonious elisions, violent counterpoints, contrasting idioms, the whimsical expressions of individuality made by the patronisingly named ordinary man in the street, municipal idiocies, corporate boasts . . . By accident.

Just look at Bristol: it is the most visually exciting, gloriously impure and thrillingly incoherent of English cities because there are no consensuses – of style, building material, height or size: it tolerates just about anything. And its site defies control. Like London, the streetscape is constantly changing; unlike London, the contours are changing, too. I know no comparably precipitous cities other than Marseille, Liège and Halifax. It is virtually impossible here to determine the frame that will surround a building – it will almost always be seen from above or below, from some angle you're not intended to see it from – with the result that every structure is compromised, all pretensions are deflated – a stately dowager will discover that she has a brassy barmaid for a neighbour – though the neighbour may be streets away on a different level. The view along Broad Street to St Michael's Hill is a marvel of English cityscape. But then so are countless other Bristol views. The Edwardian church architect Ninian Comper thought up the phrase unity by inclusion – which may well mean chuck it together and hope for the best.

Regeneration

Save in those places where they are granted the licence to do what they yearn to do — that is, to start from zero — architects are less influential than they believe. Their works are invariably compromised or coloured by their relationship to what is already there, by the neighbours. It's as though an orchestral work cannot be heard without competing with a tango coming from next door, a military band playing upstairs and zydeco in the back yard. A building is seldom pure, seldom chaste, save in a photograph — architectural photography is perennially mendacious if only through its omission of context.

Those places where accidents and chance are expunged are salutary. The places where architects indeed had the opportunity to start from zero, where architecture has enjoyed the sort of primacy it believes it deserves. We think of Bath's crescents and circuses, the exiled Polish court's rebuilding of Nancy, the successive Edinburgh new towns. They belong to some notion of harmonious perfection. But there's only so much perfection that we can take. Luckily we can escape from Bath to Bristol, from Nancy to Metz, from Edinburgh to Glasgow.

Still, those are exceptions. The rule is that starting from zero ends in something other than perfectionism. Planned towns, tied towns, new towns, garden cities, communist utopias, national socialist utopias lurch between the mediocre and the disastrous irrespective of the ideology or aesthetic they represent, irrespective of the architectural style they adopt. From Volgograd to Cumbernauld, from Marne-La-Vallée to Welwyn — the first provincial town in Britain incidentally to develop a heroin habit — from Possilpark in Glasgow to Seaside in Florida, from cuteness to high modernism, from beaux arts to the new urbanism. It doesn't matter what fashion is pursued — it is the business of creating places rather than creating buildings that proves such an insurmountable challenge for architecture, which hasn't the wherewithal to devise anything

comparable to what has developed over centuries. How to replicate the layers of collective imprints, the marks of generation upon generation of changed uses, how can untidiness and randomness be made to order. Planning the unplanned is a laudable aspiration – but it's still planning.

It seems impossible to achieve by artifice the parts with no name, to mimic the bits in between, the wastegrounds, the vague plots. Why would anyone want to make something ragged and incomplete, over which they have no ultimate control? The history of architectural design is, after all, the history of aesthetic totalitarians getting their way. A trait which Pevsner evidently approved of. He described St Catherine's College, Oxford as a perfect piece of architecture. It is equally an example of micro-level totalitarianism. Arne Jacobson designed not only the building but every piece of furniture, even every item of cutlery in the refectory. There is no escape from the will of the god of the drawing board.

Multiply that college so that it becomes an entire campus and you multiply the sheer capacity for oppression by a single sensibility. That sensibility may be one of genius, more likely it is not. What is inescapable is the larger the place that is to be made, the greater the number of gods who must make it: think polytheism rather than Abrahamic. What genteel Poundbury, the Thomas Hardy theme park, and dreich Sighthill, the Irvine Welsh theme park, have in common is a complete invariability of idiom. They are on one note. Hardly surprising, because they are both ideological. Point proving comes before pragmatism.

A French publisher who was left paralysed from the neck down after a car crash commissioned a house from Rem Koolhaas. The architect said, you'll want something as simple as possible. Jean-François Lemoine replied absolutely not – this house is going to be my entire world, so I need it to be as complex and as varied and as surprising as the world I've left behind.

Complexity and variety and surprise are what we crave in urbanism. Those qualities are not to be achieved by a master planner who commissions in his or her own image. Indeed, to a mere lay person the idea that architects should also be master planners is mystifying. I'm undoubtedly missing something. But we don't write blank cheques – nor do we trust Hamas to babysit a kibbutz. Or does Mr Fox now advise on chicken security? As I say, some of my best friends . . .

Place is at its most satisfying when there are competing agendas which do not share an underlying philosophy, are not sympathetic to each other. No matter how much it might have been idly coveted or even craved by everyone without a pecuniary interest in the construction industry and many with it, a moratorium on building, or at least a voluntary slowdown, was never on the cards.

But that moratorium has very likely arrived. Maybe it's goodbye to cranescapes. It is impossible to know how long the current enforced curtailment will last. All we can be certain of is that any confidently authoritative prediction will be based on hopefulness, guesswork, bluff, tea leaves and entrails. With luck this slowdown will provide an opportunity to take stock of what has happened to our cities during the soufflé years and to contemplate their future. Stasis does have its uses.

Again, an entire generation has reached middle age without having experienced an apparently unchanging world, a world where things, big things, seemed only to happen far away – in Budapest or on Pacific atolls. It has never experienced a world where tomorrow looked like yesterday and the day before and the day before that. Every taproom psychologist with a masters from the University of Life will tell you that the exciting creative freewheeling Dionysiac revolutionary polychromatic freneticism of the sixties was the babyboomers' reaction to the sheer stultifying dullness and ossified uneventfulness of the post-war childhood their parents imposed on them.

Harold Macmillan's boast in 1957 that most of our people have never had it so good was, it must be remembered, spoken by a patrician politician. Some of our people, in Worcestershire, were still at that time living in caves. Many of our people still had outside lavatories. But, as a babyboomer, given the choice of either lying in a communal outside lavatory or listening to a four-hour guitar solo that would bring peace to the world – I'll take the stultifying dullness. And given the choice of witnessing another chunk of the sixties – insensate Comprehensive Redevelopment – I'll go for ossified uneventfulness.

It was Comprehensive Redevelopment that prompted Yona Friedman to observe, in the mid-sixties, that architecture had entirely forgotten those who use its products. Comprehensive Redevelopment afflicted his adopted country, France – albeit in a different way to Britain. For every inspired scheme by architects such as Claude Parent or Rodney Gordon there were a hundred hack works: my home town Salisbury, for instance, suffered not only the indignity of the great wheeze of the city engineer Rackham who, needless to say, did not live in the city. His vision, if that's the word – and it's not – was an inner ring road which destroyed a park and, worse, cut through the medieval grid that is contemporary with the cathedral, trampling over houses which were valuable not because they were more than half a millennium old but because they were good.

It was also the recipient of a dismally insipid shopping precinct – the work of the developer Hammerson and an architect who wisely remained anonymous. It was offensive because it was created with the express intention of not offending. And it remains offensive, not least because it has survived while sod's law has decreed that Claude Parent's Rafale at Reims and Rodney Gordon's Tricorn at Portsmouth should, shamefully, have been demolished. Exemplary works of modernism destroyed to make way for exercises in neo-modernism or

synthetic modernism or faux-mo – whatever it's called, it looks backwards to yesterday's tomorrow. There is a certain irony here in that the urge is nostalgic and the work is pastiche – that's an observation not a deprecation. It's every bit as retrospective and dependent on the past as the architecture of the nineteenth century was – but rather less daring.

What this architectural pastiche has served is a form of Comprehensive Redevelopment that dares not speak its name. This is not like the love that cannot speak its name because its mouth is full. This claims to be socially responsible, as green as chlorophyll, cheery, unbelievably caring, fun and populist. You cannot have failed to have noticed Cabot Circus, this hotel's new neighbour. Its drooling PR has the temerity to suggest that it's going to put Bristol on the map. Someone should be told that Bristol was on the map centuries before Ronald McDonald embarked on his mission to homogenise the world with the stench of fried abattoir slurry. A shopping 'n' grazing experience unlike any other shopping 'n' grazing experience in excitingly different shopping 'n' grazing spaces such as Gap, Harvey Nichols, House of Fraser, Brasserie Blanc, Café Rouge, the Body Shop, Carphone Warehouse, Jane Norman, Dorothy Perkins, two branches of McDonald's, three of Costa, Starbucks, Top Shop, Pret a Manger, Krispy Kreme Donuts, Clintons Cards for that outpouring moment, La Senza (for another outpouring moment), Carluccio's, L. K. Bennett, Zara, La Tasca, Starbucks and Nando's – which has tactfully been situated way above street level so that this South African chain's punters don't get caught in the crossfire of a drive-by shooting. This could not happen in Spain – I don't mean the drive-by shooting. I mean that in that country there is positive discrimination in favour of small businesses. Chains such as El Corte Ingles and Zara pay vastly higher rates and their opening hours are restricted.

Four decades after Salisbury, here is another development by Hammerson in collaboration with Land Securities. This time the

architects – and the sculptors and engineers – are far from anony-mous. They are there to legitimise this kind of Comprehensive Redevelopment. In the sixties, most top-flight practices considered commercial projects beneath them. They worked almost exclusively in the public sector. Attitudes have changed. That sort of discrimi-nation has dissipated and with it the hierarchy which valued build-ings according to use: a church or an educational building is no longer reckoned superior to a cinema or car park. Indeed, a retail development's buildings are as much the point of the show as the shops and restaurants that occupy them. No one today would dare mention architectural determinism, which carries a strong whiff of B. F. Skinner environmentally programming rats to become better rats and of high-minded welfarists instructing grovelling forelocks that this is good for you. Nonetheless, no one creates a building in the expectation that it will be neutral. Buildings may no longer be con-sidered tools of social improvement or civic instruction but we retain the faith that they will affect behaviour. They make us happy, or aspirational, or – best of all – they make us long to spend money we don't have on something we don't need but which is 120 per cent lifestyle enhancement, maybe a number by Hugo Boss, who outfitted the SS, or by Coco Chanel, who merely slept with the SS: Aryan manhood wouldn't have looked too clever in a little black dress.

This second coming of Comprehensive Redevelopment is urban regeneration. Or was urban regeneration. Cabot Circus may turn out to be the last such project we see. A cycle may be over.

I've coined words which I hoped would enter the language. All they've entered is slang dictionaries. However, an expression I had no ambitions for has taken off. I'm not even sure that it is mine. But I'm happy to take the credit for the 'Bilbao effect' whether or not it's deserved. When I first wrote it, it was intended mockingly. It is a phenomenon which has preoccupied me since I went to see Gehry's Guggenheim the month after it opened and six months

after Tony Blair had come to power. Two events which seem bound to each other. That weekend our friends in ETA were hosting a brotherly series of fundraisers for the INLA. The activities of the Men of Peace were more interesting than the building I'd come to see.

Which – and I realise I'm in a minority of one – is characterised by its hollow vacuity, by sculptural sensationalism, by its lack of actual utility as a museum space. Yet it excels at its two functions. One is to be instantly memorable. The other is to be camera friendly. If architecture is frozen music, Gehry has composed a catchy advertising jingle. And it's been highly successful – the whole world can sing along to Bilbao. It may still be a rustbucket city that harbours violent terrorists or, if you prefer, separatist freedom fighters, but it possesses what is the most celebrated three-dimensional logo of the recent past.

There was nothing new about a building as a logo – as a symbol of a creed or ideology, as an expression of a ruler's might or a city's wealth . . . this notion is indeed very likely older than the notion of architecture as shelter. The Bilbao Guggenheim is the original of the building type that seems almost parodically representative of the Blair era. When such names as Ecclestone, Hinduja, Mills, Caplin and Foster are all but forgotten and the Iraq adventure enters its fourth decade, there will remain a gamut of structures which will all prompt the same question. What was it for? It's easy enough to explain the purpose of such distinctive structures as an oasthouse or a shot tower or a pumping station.

But what were these things other than monuments to geometric delinquency that said Sod you, Euclid. They were the ocular analogues of soundbites – they were sightbites. Appearance was everything. Form and function were fused. But what were they for?

They were there to cause the Bilbao effect – with luck. To improve post-industrial cities and rid them of deprivation. Which

comes about, in the words of someone described – with no irony – as an urban regeneration guru 'by attaching fashion incubators to art installations'. And by being talked about.

The idea that a strategy dreamed up for a Basque port should be applicable to a landlocked German foundry town or a northern English mill town is ill-founded. The assumption that one post-industrial city is akin to another is insulting – it omits all that is specific to a place, its demographic peculiarities, its topographical complexion, its connections to its neighbours and so on. The strategy was widely replicated long before anyone had had the chance to assess the benefits of the Guggenheim to Bilbao.

This is evidence – as though any were needed – that what prompted development agencies to ape Bilbao was not the promise of an improvement in the quality of life but a covetous yearning for non-orthogonal architectural bling. The Bilbao strategy is a two-stage initiative throttle. First comes the sightbite, the challenging focus, the symbolic component designed by a world-famous architect who's so jetlagged he doesn't know what continent he's on today. Then it has to be decided what non-symbolic function is to be sutured on to the structure.

Regeneration remedy-creatives, guru-guys who coalface at the coalface of Armageddon decisions and who insterticise tough paradigms, envision inclusions in big-thought canopies. They brainstorm like they're firebombing Dresden. They leave their synapses on the table. They go into deep thought submersion. Then they announce that the sightbite will contain a museum and gallery, conference facilities for the regeneration community and a cultural logarithm.

Because culture is regenerative. Not DWEM culture. The wrong sort of culture is not inclusive, it's elitist and very bad. Accessibly accessible fun culture beacons lighthouse interactivity within the community of community. You might be so old you're old

Alzheimer himself, you might be so young you're *in utero* – either way, culture will springboard you into the happiness hub. Look what singing along to Tony Orlando and Dawn and watching Chuck Norris movies did for top Albanian Mother Teresa.

What did regeneration achieve? Was it a case of a spendthrift binge on luxury goods, foie gras and caviar, while forgetting to lay down staples for the future – grain and rice? We should remind ourselves of the staples since we are unlikely to be able to afford anything else.

Regeneration certainly emphasised the fact that drip-down is a grotesque lie. The years of gesticulating architecture have witnessed the divide between rich and poor grow chasmically: that may of course be coincidental.

In England, urban regeneration's greatest legacy is almost predictably double-edged. It occasioned a momentous demographic shift. For the first time in three-quarters of a century, many who had the choice to do otherwise elected to move to inner cities. Maybe in more than three-quarters of a century – after all the bourgeois shift to suburbs, which are always leafy, began in the later nineteenth century. Inner city is no longer appropriate shorthand for dereliction, poverty, child neglect and so on.

Inner city now signifies edgy multi-faith street furniture, vibrant therapeutic handshake sheds, diverse landmark bridges, creative bestiality workshops, affordable hutches, holistic pudding shelters and – above all – faux-mo barracks that cluster round former docks, toxic canals and noxious rivers like hard-shoulder crows round a squashed fox. They have brought to English cities a homogeneity akin to that achieved by chain stores and chain restaurants – or should that be retail culture and restaurant culture.

But dereliction, poverty and child neglect have of course not been expunged. They've simply been shifted in a sort of class cleansing. England has adopted the French model. Which means

essentially that those whom Sarkozy graciously described during the riots of three years ago as *racaille* – scum – will in future, in England as in France, be found somewhere out of sight beyond the ring road. So that's OK. We'll become like France. Fine.

Well no, it's not. It's not fine. It has long been French practice to take care of historic cities and to exploit the Malraux system of tax benefits on the restoration of properties – though there are moves afoot to put a cap on the sum which is eligible for these breaks. Under Alain Juppé, regeneration in Bordeaux has meant, as well as a celebrated tram system, a multitude of small-scale, fiscally encouraged interventions. When I lived there in my teens it was known as the black city. Today it is golden. And the Bordelais speciality, *l'échoppe* – the mostly single-storeyed workers' houses of which there about 12,000 – are being inventively refurbished. Great. But get outside the inner city – not just Bordeaux, any French inner city, and you could be forgiven for believing, as George W. Bush might say, that the French don't have no word for planification.

Mile after mile of interchangeable big shed showrooms whose Midwestern road-movie charm soon palls increasingly give way to a sort of stuttering sprawl, the uncontained world of *le petit cité*, groups of as few as three rudimentary bungalows which are conspicuously unfinished: were they finished they would be liable for a building tax but would still be hideous. These nasty blemishes are to be found everywhere from Dunkirk to Biarritz: they all look the same, all betray the same bereavement of imagination. The reason these aberrations are allowed to scar France is, according to a leading architectural historian – who would never dare write this – because of too much democracy. The elected mayors of small communes have immense power. They are liable to be undereducated, aesthetically stunted, opposed to anything they don't know and are happier dealing with builders with a pattern book of house plans rather than overeducated architects.

The grass is not always greener.

The essayist Michel de Montaigne suggested that when writers run short of ideas and need to lift from an extant text, they should cover themselves by following the example of horse thieves who in order to disguise the creature colour the mane, colour the tail and put out its eyes so that it cannot find its way home. This is sound advice which should be followed by French builders and English architects.

One of my coinages that failed to enter the language was 'Badered' – meaning legless, paralytic. Don't let me prevent you any longer . . . (2008)

Sheep's clothing

Go to a fully accredited tourist village in any European country – Ireland, Germany, France, wherever. We all know these places – steeped in the romance of history, sweating heritage, foetid with feudal associations and so on. We will certainly find examples of the vernacular architecture peculiar to their area, to their geology, to their regional building practices and so on. But equally, we'll find shops selling industrially produced objects that purport to be folkloric, supposedly regional foodstuffs, allegedly local costumes that no local has worn in half a century. We'll find dolls and heraldry, gaudy junk and tawdry kitsch. We'll find ourselves laughing knowingly about how any such village – in no matter what country – stands for all such villages. Once you've seen one you've seen the lot.

What we are witnessing, of course – at the basest, most frivolous level – is the globalisation of uniqueness, the internationalisation of the particular, the homogenisation of the peculiar. We are witnessing the specificities that we pay lip service to being rendered generic.

We should not be complacent about this process. At a rather more elevated level it has been going on for a long time. Look back a century to the means by which a gamut of states and cities attempted to assert their individuality and nationalism. Riga, Brussels, Nancy and Genoa all resolved at just about the same moment to renew themselves through the architectural employment of art nouveau. They proclaimed their aspirant uniqueness by resort to a common device. So distant places became similar by striving to be idiosyncratic.

This homogeneity is entirely at odds with the homogeneity of the Hansa cities that wittingly, deliberately, shared an architectural idiom of crowstepped gables – from Bruges to Stralsund to Tallinn – to proclaim the strength and unity of that league, which was god's first try at the EU. Recall, too, the Catholic Church's use of the baroque as architectural propaganda for the Counter-Reformation: again, the intention was to advertise indivisibility and might. Then there was the Roman empire, whose buildings paid little heed to crude vernacular idioms and adhered to the same archetypes from northern Africa to northern England. Again, the aspiration was the proclamation of indivisibility.

The homogeneity we are witnessing in cities across the world at present is not the result of a deliberate strategy of this kind. It is, rather, caused by an unconscious corporatism. By a flock mentality. By the misapprehension that the responsible stewardship of cities is best addressed by copying the ploy of some other city – and that other city is invariably Bilbao.

Gehry's Guggenheim fulfils its function, which is not to be an effective museum or even to be a resolved building. Its function is to be sufficiently unusual, sufficiently photogenic and telegenic to cause Bilbao to be talked about. It has succeeded wonderfully. Like the Veterano Osborne bull, which used to stand on every roadside in Spain, it is a memorable logo. In this case, a 3D logo. Its potency

resides in its novelty, not in its long-term, sustainable utility. But at least it belongs to Bilbao, which it has put on the map – for the moment.

Now the clamour by other former heavy industrial, rust-belt cities to commission a building by Gehry or a building that might be taken for a building by Gehry or at least a non-orthogonal landmark gesture . . . this clamour is as pitiful as it is loud. It presumes that any city is susceptible to the Bilbao effect. This would be rash enough, were the Bilbao effect proven by time. But given that the Guggenheim has only been open for half a decade, the rush to follow its example points both to a failure of imagination and – the same thing, really – to a thraldom to fashion. Which is, of course, hardly surprising: the history of architectural and urbanistic endeavours from single buildings to entire cities is that of one goat leading an entire flock of broadly plagiaristic sheep.

When that plagiarism is confined to decorative styles – round arches or pointed arches, classical or Gothic, concrete or glass – it is not too grave a matter. But when that plagiarism informs devices on which the commonwealth of an entire region may come to depend – then we're in trouble. The notion that inward investment to a region will continue to be attracted by what may be called gestural engineering is surely naive. Especially when the gesture has been made before, elsewhere, and often. These gestures are add-ons. Their very essence is that they are economically, socially and culturally – if not physically – peripheral. They both bypass the core problems of a deregulated, diffuse world and they are agents of a new homogenisation. Gestural engineering is a bit like the UN – set up to provide the solutions to problems that belong to yesterday. For all their synthetic modernism, gestural engineering's products are retrospective. And reactive.

We talk of regeneration. Not generation.

The electronic cottage and the wired apartment that have been

predicted for the last quarter-century have not come to pass. They may one day become reality. But there is a very good reason why they may not. There is a very good reason why we are not eager to work alone in virtual space – and that is that the workplace remains, as it has done since the Industrial Revolution, the primary site of social intercourse. We might all harbour idle dreams of living like a fictive poet in a garret, dying of consumption for the sake of an adverbial clause – but we pretty soon dismiss such dreams. They are idle. We need the workplace because it is a club, a dating agency, a forum, a colloquium, a congregation, a perpetual if too-sober party. It is going to take much more than the telephone, the fax, the web, conference calls, electronic mail, video links and so on to make the workplace disappear. When we discern even the vaguest possibility of its disappearance we act fearfully and we invent quasi-workplaces – they're called conferences. They are workplace substitutes. They are mutable workplaces. But whether the workplace is fixed or shifting it is still physically separate from home.

The extent of that physical separation increased throughout the twentieth century. Suburbs have different meanings in different countries. In the UK and the USA, 'inner city' is a lazy shorthand for crime, for drug-ridden degradation, for despair. In those and other anglophone countries, the word 'suburb' is invariably prefixed by 'leafy' – that is, desirable. In France it's the other way round – you can substitute *banlieue* for 'inner city': I have seldom felt so threatened as when I spent some days filming in Marne-La-Vallée. The fact is that inner cities, whatever their sociopathic potential – which in the UK at least is showing a certain diminution – are, by definition, finite: a few hectares, a few arrondissements. Most of us, *faute de mieux*, live in suburbs, or suburbs' suburbs, or suburbs' suburbs' suburbs – in subtopia . . . which is now dignified by the epithet exurbia. And exurbia is infinite. Look at London, look at Paris, look at the Ruhr, look at Lille/Tourcoing/Roubaix,

look at Los Angeles. Now look at where the locational magnets that draw inward investment are sited. They are in the very centres of those places. Those centres are being fed like ducks and geese whose livers are bloated by *gavure*. Inward investment is currently exacerbating the arterio-sclerotic condition of the developed world. It is diminishing the quality of life that we, as individuals, endure.

I am not so fastidious as to suggest that exurbia does not create a sense of place – but I'm realistic enough to believe that the sort of sense of place it creates is a place to escape from. But where to?

Forty-seven per cent of Britons want to emigrate. The entire population of Holland often seems to be in the Lozère, the supposedly most depopulous department in France. The anthemic 'We've Got to Get Out of This Place' is a condition of exurban Europe. We are obliged to travel increasing distances to where we work and the stress of that process is such that we travel to escape where we are obliged to live. Voluntary travel has become the cure for mandatory travel, a kind of mad homeopathy.

I recently remarked to what we must call a workplace audience – a conference on transport – that the swiftest means of curtailing indiscriminate travel would be to abandon all security checks. Let anybody on: no scans, take the risk. This was intended against itself, ironically, as a jest. Yet it didn't prompt laughter – to my astonishment it occasioned applause: there is a growing recognition that it is our dependence on and addiction to mobility that is the paramount topic to be addressed. But since it is evidently unrealistic to inhibit mobility even by such drastic means as I've suggested, the appetite for mobility must be harnessed as an instrument of renewal.

The curtailment this involves is that of ceasing to increase the capacity of already unmanageable agglomerations. There is here an obvious cultural force that can be allied to mobility. And that is the fact of capital cities having effectively seceded from the countries they supposedly lead. Take the example I know best – an extreme

example, admittedly: London. It has, over the past few decades, turned its back on Britain to first gain and then sustain a place at the high table of world cities. It corresponds with New York, Paris, Tokyo, and so on, in a way that it doesn't correspond with Bristol, Manchester, Leeds. There are chasms between London and the British regions – there is a gap of wealth that is largely created by the grossly disproportionate heft of inward investment; there is a gap of opportunity, there is a gap of economic and social expectation. Yet at the same time the quality of life enjoyed or, rather, suffered by Londoners is diminishing: Greater London now extends 80 km east to west and 60 km north to south. It is incoherent, undesirable and unworkable. It is a Victorian Los Angeles built for horse transport, and dependent on an internal mobility that its very size and exceptionally low density militate against achieving.

London's obese dysfunctionalism is a more powerful spur to the renewal of the UK's regions and of de facto regional capitals than any qualities those regions possess.

This may sound entirely negative. It is. (2017)

City sightbites

The Age of Spectacle by Tom Dyckhoff

At the very beginning of this discursive, knowledgeable though sometimes clumsy book, Tom Dyckhoff declares that an architecture critic is a sightseer, a professional tourist. As job descriptions go this appears perfunctory or falsely modest. But read on and it becomes clear that while it might not apply to the majority of the few persons involved in this endeavour, it gets Dyckhoff to a T: he is referring to himself. He is not a particularly critical critic.

He complains, astutely enough, about the editorial pressure exerted on a newspaper critic to treat buildings as jewelled objects that are made in a vacuum uncontaminated by politics, wrangling,

vanity and money (ideally someone else's), that are pristine, stand-alone entities with no context, no neighbours. This pressure is exacerbated by the sticks and carrots of the construction industry's massive, insidious, mendacious and threatening PR machine, a machine that often does its grubby job rather better than the developers, engineers and architects whom it (mis)represents do theirs. It controls how buildings are written about and, more importantly, how they are visually portrayed – often as not by stooges who have studied those photos from which members of the *nomenklatura* vanish. The critic is further expected to compose endless paeans to the stars in the tectonic firmament, even though these tin men are, with a few exceptions, far removed from the processes by which 'their' constructions are made: for instance, Milord Foster saw 'his' Millau Viaduct for the very first time a few weeks before it was opened when he spared forty minutes of his valuable time to helicopter himself to the wilds of the southern Aveyron.

Yet Dyckhoff frequently adheres to the journalistic programme he abhors. While he is no more than an apprentice starfucker, he does bring to mind Conor Cruise O'Brien's periphrastic admission after meeting the Prince de Ligne, 'I was not insensitive, at a sub-rational level, to the penumbra of a historic name.' Sixty years on 'historic' has given way to 'volubly mediated' or 'celebrity'. He relishes the massive privilege of hanging out with Daniel Libeskind. And absolutely nothing equals getting cosy with Frank Gehry who, we are fascinated to learn, shares a psychotherapist with one Herbert Muschamp. This berk is a 'writer' who writes the most astonishing drivel about Gehry's buildings: the Bilbao Guggenheim is 'Lourdes for a crippled culture . . . it is a sanctuary of free association . . . it is the reincarnation of Marilyn Monroe . . .'

Dyckhoff is more circumspect but that is evidently not difficult. Nonetheless he describes Gehry as the most famous architect in the world, which may or may not be the case. It is certainly indisputable

that Gehry and Libeskind are, together with Santiago Calatrava, the most sedulously auto-plagiaristic architects in the world. Each has an unmistakable 'signature', so the Croesus client at least knows what particular form of dysfunctional folly it's getting. Which is not the case with the ever-protean Milord Rogers or Rem Koolhaas or Rafael Moneo, whose Bilbao library Gehry predictably and gracelessly dismisses for having the audacity to impinge on his importunate Guggenheim, the *fons et origo* of what Dyckhoff calls 'the city of spectacle'.

Cities of spectacle is more apt for they are legion. They are becoming this young century's norm. The bling school of architecture is a global nostrum. Take Pekka Korpinen, till recently deputy mayor of Helsinki. Pekka would like to see an example of jaw-dropping architecture in that city. Is the man blind? Has he not noticed Lars Sonck's magnificent work? Ah, he wants something jaw-dropping and *new*. Unimaginative local politicians, border-line-criminal elected mayors, vain 'philanthropists', thick Rotarians, optimistic local enterprise partnerships and, before them, regional development agencies determinedly assume that non-orthogonal, sculpturally outré, new buildings will foster regeneration (whatever that is). If it worked in Bilbao it'll work in Gateshead and Bremen and Malmö. But has it worked in Bilbao? Gehry reels off statistics to demonstrate the supposed benefits to the city, but quite neglects to mention the considerable increase in poverty since the museum was opened, and the consequently greater dependence on income assistance. And Dyckhoff doesn't challenge him.

In an interesting early chapter Dyckhoff traces the idea of gentrification and its stuttering progress over half a century. The coinage, in 1963, was the sociologist Ruth Glass's. She observed at first hand the phenomenon of inner London being slowly re-bourgeoised. She ascribed this shift to a generation, then in its late twenties and early thirties, shunning the anti-urban bias of its parents and its

grandparents. These were often people who worked in what was not yet called the media: their just-about fictional analogues formed the cast of Mark Boxer and Peter Preston's *The Stringalongs*. She might also have drawn attention to the minimal difference between the cost of a house in Holland Park and one in Worcester Park. London was not at that time a 'city of spectacle'. Indeed, its appeal was founded in qualities architects find difficult to understand – it was dowdy, run-down, seedy, slummy and cheap. The Clean Air Acts had been passed, but the yellow/green smog wasn't to know that. It was a delight to explore in the company of the illustrator and writer Geoffrey Fletcher's *The London Nobody Knows*, which Dyckhoff evidently appreciates.

But London had once been a city of the greatest spectacle. So, at different times, had Glasgow, Hamburg, Marseille, Paris, Rome . . . Just about every city has at some point in its history created monuments to its might. These monuments might take the form of churches, markets, town halls, railway stations, universities, law courts, stadia, and so on. What distinguishes them from the current generation of monuments (whose terminally cool, black-swathed begetters would shudder to think of them thus) is that they fulfil a purpose beyond that of being a sightbite whose roles are to be photogenic, telegenic and outsize conversation pieces. Some of these are sheerly ridiculous. None more so than the £30 million, 170-metre-high Spinnaker Tower in Portsmouth. On the day this 'British national icon and world class visitor attraction' opened, its project manager was trapped in the lift to the viewing platform for ninety minutes. (2017)

Kulchur parrots

Twenty years ago I wrote of the otherwise slaveringly praised Guggenheim Museum in Bilbao:

'I'm in a minority of, apparently, one . . . a consummate gimmick

. . . a fantastically elaborate and rather wearisome joke. Has mankind spent all these centuries perfecting Euclidian geometry and orthogonal engineering in order to have it overthrown by massively expensive crazy cottages clad in titanium? Apparently mankind has.'

So much for the building. What of the 'Bilbao effect', an epithet I am accused of having coined (I can't remember, but it's inappropriate because there is, typically, no effect). Even before Frank Gehry's earth-shattering masterpiece was finished word was out, and post-industrial cities on several continents were competing with each other for the favours of a handful of egomaniacal narcissists calling themselves architects to build them a landmark, a regenerative beacon, a photo-opportunistic sightbite (that one definitely is mine). The point of these distended three-dimensional logos was, of course, to 'rebrand' the place in question, to give it a visual identity other than that of wrecked warehouses, junky estates and swarf pyramids (which abound in Bilbao's docks). They were spendthrift, mostly trashy monuments to thoughtless optimism. The profligate process sanctions the construction of an advertisement which is itself the product.

I made a telly film called *On the Brandwagon* which ridiculed regeneration as the most bloated, most risibly corrupt of gravy trains, a racket. It goes without saying that no one heeded it, my first and last essay in didacticism. On the contrary, excitable mayors, development agencies, the heirs of Alderman Foodbotham, enterprise zones and go-ahead partnering partnerships grew ever more hungry for flashy chunks of architectural bling. They hardly stopped to notice that a century and a half earlier Britain's burgeoning cities had competed to equip themselves with a town hall gradlier and grander than the next burgh's and had usually ended up failing to emulate Cuthbert Brodrick's sublime achievement in Leeds. Nor did they observe that a town hall has an administrative as well as a

ceremonial purpose. The problem with logo architecture should be finding a role, an excuse, for the structure beyond the catchy sightbite that is supposed to put, say, Barrow or Barry on the map from which the Ordnance Survey had forgetfully omitted them.

That role is almost invariably 'cultural'. Hence the Factory, the scrambled aggregation of computer-generated lumps that the Dutch architectural corporation OMA is about to inflict on Manchester, is some sort of 'cultural' centre. Of course it is, for just as architects are stylistic sheep, so are their clients doggedly in thrall to whatever purpose the fashion of the day dictates. The craze for theatres, galleries, museums, performance spaces et al. is based in the presumption that 'inclusive culture' is some sort of collective tonic, brain balm – all the more efficacious when dished up in staggeringly expensive new buildings which assuage the vanity of cities and their bosses. (The estimated cost of the Factory – the name shouts about what 'culture' means – will no doubt have increased by several hundred thousand pounds since you began reading this article.)

How much longer can this presumption endure unquestioned? In the twenty years since the Guggenheim opened in Bilbao it has attracted 20 million visitors. Yet unemployment in the agglomeration has increased and with it the number of people on welfare. The economic beneficiaries of 'regeneration' are limited to, initially, the construction industry and, subsequently, the tourist trade. There is no more drip-down from these projects than there is from supply-side tax breaks. This has at last been acknowledged.

We may come to speak of the Helsinki effect. That glorious city rejected the Guggenheim Museum that was to be foisted upon it by, of course, the Guggenheim Foundation which, astonishingly, would charge 20 million dollars for the use of its precious name and access to its collections while demanding that the Finnish government (the people) pay a third of the building costs. Who do these

wretched entitled panjandrums of the curatocracy think they are?

London's music establishment has for many years whined that the city's concert halls are inadequate for what Simon Rattle calls 'a fifth of the repertoire': has this frizzy hairdo never heard of bricolage and extemporisation, of making do? Evidently not. The LSO is now to get a new £250 million building on a site which currently houses the Museum of London. This is a startlingly dotty idea. As anyone who has visited that museum knows it occupies the centre of a round-about. The constant hum of traffic may not be invidious to the contemplation of paintings or photographs but the chances of even the most skilled acousticians achieving a noiseless and airless environment are slight. Aficionados of rebranding will be delighted to learn that a couple of months ago Nicholas Kenyon, director of the Barbican, got every member of the thousand-strong workforce together to hear a massively important announcement. The Culture Hub was to be no more. No – henceforth it would be the Culture Mile.

It is not too late to scrap this folly. It is even perhaps not too late to scrap the Manchester project, pay off OMA and use the money for building accommodation or, better, converting mills, warehouses and factories to that end. A moratorium on the construction of art hubs and miles, culture sheds and bothies might precede a moratorium on building anything other than housing. The actual need for further galleries and so on is non-existent. The other day I selfishly enjoyed the Otto Dix exhibition at the Tate in Liverpool's former docks (designed by Jesse Hartley, a great engineer, not an architect). I say selfishly because there were no more than a dozen people in the large gallery. The day before I had popped into the Tate Modern to do a spot of preparatory comparison with its two works by Christian Schad. London is more populous than Liverpool and the gallery in question was proportionately fuller, but still quiet. However, the main hall was far from quiet.

Regeneration

Here was the cheery embarrassing face of art in 2017, art to make you wince — an already squalid carpet and various playground climbing bars and swings installed by a trio of Danish thinkers for the kiddiz to maim themselves on. We should think hard before subsidising such terminal mediocrity let alone building garish shelters for it. (2017)

22

Richard Rogers

Top cat's philosophy

Architecture: A Modern View by Richard Rogers

When we want to know about the state of the zoo, it is not the lions whom we should consult, for even after a full and frank exchange we are liable to end up with a view that is partial and simplistic. Partial because they cannot begin to see it from our side of the bars, and simplistic because your lion is unused to the medium in which he is being invited to express himself. Lions talk with their claws and jaw as surely as soccer players talk with their feet, and architects with their buildings.

Richard Rogers is a top cat architect, the author of two of the masterpieces of the age, which may be as much abhorred as they are admired, but that is not the point. The point is that the Pompidou Centre and Lloyd's are peculiar to him (though they have their precursors); they are particular, specific, pretty much unlike any other contemporary built projects. Rogers' *Architecture: A Modern View* bears no such signature. This hard-bound pamphlet is the text of an annual lecture given at Birkbeck in memory of Walter Neurath, Thames & Hudson's founder. When you commission Rogers to design a building, you get something special. When you commission him to deliver a lecture you get the lion's view: the titular 'modern' means old hat.

Richard Rogers

Rogers has made a titanic effort to ensure that he says nothing that has not been said a thousand times before; in this he owns a bizarre kinship with the Prince of Wales. They may be polarised in their tastes, but they share a sort of manifesto mentality, and a bold commitment to original ideas, so long as those ideas are original to somebody else. Furthermore, they are both keen on 'visions', grand plans. Rogers can at least plead dyslexia, and does so. This is rash or brave, according to taste; not that his writing is any better or worse than that of most other architects. Three-dimensional design tries one chamber of the brain, the struggle with the eels called words quite another. The book which Rogers should prise from himself is an auto-analytical one about the correlation of his affliction and his art; buildings as extraordinary as his cannot simply be explained away by woolly expressions of trust in successive technologies, nor by near-meaningless utopian pieties: 'The city and its citizens will be one inseparable organism.' Hey-ho.

There's quite a bit of that sort of stuff, but then there always has been. Among the many great fibs propagated by modernists of the past seventy years is that modern buildings are technologically rather than aesthetically determined, that modernism is not a style. Rogers duly subscribes to this – something would have been amiss had he not. He conscientiously deprecates postmodernism: 'A shallow decoration, a self-indulgent playing with symbols, which has no integral relation to the functions of the building.' This seems unexceptionable enough. The same charges might, of course, be levelled at Rogers' own work. But he is an original artist and draws on a decorative gamut a world away from the screw-on pediments and toy-town classicisms of middle-of-the-road postmodernism. Rogers decorates with industrial icons, the found objects of petrol refinement and electricity generation. It requires an exceptional imaginative leap to perceive the 'integral relation' of such devices to insurance underwriting and the provision of exhibition spaces.

Rogers suffers the characteristic guilt of the architect which expresses itself in the invention of extra-aesthetic (or non-architectural) justifications for this or that idiom. Architects find it impossible to admit that they design a particular building in a particular way because they think that it looks nice. That would be far too easy. So they load their creations with a spurious social or moral baggage, rabbit about imperatives, inevitabilities, and so on. The fault, Rogers claims, was with cost-cutting public authorities, greedy developers, the quality of patronage in general. Nobody other than an architect could any longer subscribe to so preposterous and disproven a notion. It is not as though Rogers was personally involved, nobody is pointing a finger at him; he is more than a generation younger than the majority of the culpable, his work is the very antithesis of the British moderns who went before him.

What he writes here seems weirdly dissociated from his work. But then he does not regard his two (so far) greatest works as technophilic follies, meetings of Le Facteur Cheval and Frank Hampson. Hidden within the socially aware, ecologically right-on robot who has wrought this banal little book is a fantastical artist, a boy boffin, a lover of vertiginous displacement and fairgrounds, a gleeful innocent who makes buildings that are sensorily thrilling and visually awesome, buildings which overwhelm. Thankfully this oddball is a more enduring figure than the pamphleteer making grown-up noises with all the conviction of a serious-minded pop singer. Gonna save the planet, yeah! (1991)

Prosecco socialism: A user's manual

A Place for All People: Life, Architecture and Social Responsibility by Richard Rogers with Richard Brown

Baron Rogers of Riverside comes on so wood-fired, so extra-virgin, so biodynamic, so ethically sourced and cloudily unfiltered

that he might be an obscure Umbrian goatherd's dish served at Lady Rogers' River Café. A lesser man would be crippled by the very yoke of the angelism which burdens him and afflicts everything he does.

But, somehow, over the past fifty years this virtuoso has, in various partnerships and configurations, designed a number of sheerly thrilling and stylistically various buildings. Most of his near-peers in the architectural firmament (Gehry, Calatrava, Libeskind, etc.) are doggedly plodding one-trick ponies. Rogers is a very different sort of dobbin – a Lippizaner stallion with a modern jazzer's hairdo, a deafening apple-green shirt and a capacious store of axels, salchows and triple skips.

He has been reluctant to copy himself, to supply a predictable product with a recognisable signature. There is no such thing as a typical Rogers building. The Pompidou Centre, the law courts in Bordeaux and Antwerp, Lloyd's in the City of London and the later Lloyd's Register, Madrid Barajas airport and Heathrow Terminal 5 – a few chromatic and gestural quirks apart, these might all be by different hands. Which suggests that he is an unusually protean artist with the mutability of Picasso or, more probably, that 'his' work pays more than lip service to the practice of collaboration.

He (or his ghostly collaborator on this book, Richard Brown) writes, clumsily, that his dyslexia made him realise 'at an early age that there was more strength in a group, in creative collaboration, than there was in the solo high achiever'. This would come as news to such 'solo high achievers' as, say, Beethoven, Hardy, Dix and so on ad infinitum. Quite how or why dyslexia should prompt that revelation is undisclosed. And, anyway, it appears that his idea of collaboration is somewhat straitened. After Yale he was briefly employed in the San Francisco office of the architectural colossus Skidmore, Owings and Merrill: 'I quickly came to realise that working in someone else's architectural practice was not for me.'

The implication of that sentence permeates this portmanteau-ish book. But it cannot of course be made explicit. For in the open-necked, given-name, anti-elitist elite of which he is a *capo* and whose mores this book unwittingly portrays, rank and hierarchy are as unmentionable as, say, sex was in the nineteenth century or as death remains today. There is a disinclination in this establishment to acknowledge that it is the establishment. Rogers, who agonised over whether to accept a knighthood, which he did, then agonised over whether to accept a peerage, which he did, keeps what he claims to be his one and only tie at the House of Lords. The rest of the time he goes rebelliously tieless and, crucially, collarless.

The first part of the book is a brisk memoir of his early years. Florence, where he was born in 1933; bourgeois, doting, intelligent, atheist parents with English and Jewish forebears; flight to London then Surrey at the very beginning of the war; hideously violent boarding school; less hideous day school; teenage hitchhiking and getting banged up in solitary on trumped-up charges in Venice; national service in Trieste, where he spent much time with his evidently inspiring cousin Ernesto Rogers, architect of the Torre Velasca in central Milan. Now, all this is peculiar to Rogers, but it amounts to no more than a sketch wanting detail. A literal *Bildungsroman* but a very thin one.

As architecture begins to preoccupy him, he manages to muster greater interest in his former self. Architecture and the sort of architect he will become start to define him. The text gets fuller, richer. However, at the same time it becomes more generalised. It might be a personal history that he attempts to recount but much of it is an utterly familiar trawl through post-war Britain. The overstated resistance to modernism, the Festival of Britain, discovering Le Corbusier, the ineffable Smithsons, Stirling and Gowan, an Aldermaston march – and then Yale, where he would meet another

Fulbright scholar, Norman Foster, who would become his first collaborator.

He rather predictably ticks off Yale's campus for being 'a strange pastiche of a Victorian Oxbridge college . . . Gothic revival buildings'. (Pastiche is a scornfully pejorative word among architects of Rogers' generation and aesthetic bias.) He writes interestingly if, again, too briefly about his first professor there, Paul Rudolph, whose untheoretical approach and insistence on the primacy of appearance seem to have rather shocked him; though Lloyd's obvious debt to Rudolph's great Art and Architecture Building, opened the year after Rogers left Yale, suggest that he absorbed a lot from this famously querulous teacher. But he tucked that behind his ear for later.

The more immediate future would be coloured by the work of the Californian Craig Ellwood, as energetically heterosexual as Rudolph was homosexual. Rogers' only mention of him is in a list of West Coast architects whose work he and his first wife Su drove to see in a Renault Dauphine which now and again spontaneously combusts. I think the reports of these fires are intended to be funny.

The house Rogers designed for his parents in Wimbledon owes much to Ellwood and the Californian Case Studies Houses sponsored by *Art & Architecture* magazine in the forties and fifties. Pared down, but hardly austere or threatening, and comfortably non-didactic. Family-friendly modernism.

One moment Rogers is scratching round doing houses for friends of friends, in-laws and low-cost factories and wondering whether he should jack it in, the next he and Renzo Piano have won the competition to design what was to be called the Centre du Plateau Beaubourg: 'We had no idea what we were taking on.' That becomes all too evident. Designing a building whose only forebears had been the paper dreams of the Archigram group and Cedric

Price was one thing, maybe the easy bit. Coping with the constant barbs and brickbats of French architectural panjandrums, French politicians, French planners, French community groups, French steel manufacturers and the French press was something else again. An organisation called Geste Architectural was established with the sole purpose of bringing lawsuits, an echo of those received by Le Corbusier in Marseille twenty-five years previously. Robert Delaunay's widow Sonia said that she'd rather burn his paintings than have them exhibited in the building. Not all the attacks were founded in chauvinism. The British press joined in too. His long chapter on the making of this astonishing creation is by far the best thing in the book. While the building itself has proved inimitable, its example has, usually regrettably, been copied: 'cultural' regeneration seldom achieves anything beyond the self-congratulation of the arts loop.

After five years living in Place des Vosges, he and his new wife Ruth move, in 1977, back to London, where 'olive oil was sold in chemists for cleaning your ears out'. This is balls. It was widely available in Cypriot Camden Town and Harringay, Italian King's Cross and Clerkenwell, everywhere in Soho. Again, Rogers slips into easy (and wrong) generalisation.

His account of his ascent to the very peak of New Labour's Great and Good is more precise, though it's constellated with a litany of praise for those whom he meets en route. He is generous with such words as 'genius', 'poetic', 'excellent'. It's difficult to recall the names of his many 'close friends', most of whom are almost as successful as he is. Some of them, the fawnocracy, have lined up to supply a few back-cover plugs. He himself has a good word for everyone apart from volume builders, 'arch conservative' planners and the Prince of Wales.

There are some predictable omissions. Just as his old friend and rival Norman Foster puts his knees behind his ears whenever a

central Asian dictator drops by, so has Rogers developed a peculiar late-life fondness for auto-destruction. Quite why the greatest architect of his age, who has militated for equality, social housing, improved cities, multicultural handshake sheds and countless other right-on causes, should all but shred his reputation by designing obscenely expensive and very ugly flats for very ugly property developers is a mystery. Do As I Say Not As I Do is not a happy etiquette to bear. Should there be a further edition it should be entitled *Prosecco Socialism: A User's Manual*. (2017)

23

Sex

Around the horn

On the Nature of Things Erotic by F. Gonzalez-Crussi

One of the few things that Dr Gonzalez-Crussi appears not to know is the archaic French locution *je suis allé en Cornouaille*, which means 'I have been cuckolded'; there are obvious variations such as *elle m'a fait partir en Cornouaille*. The main point is the pun on *corne*, a horn – which is the cuckold's mark (though, given the significance of ram and goat and, indeed, horn, it may seem a rum one). A secondary point, and no doubt a fortuity, for puns are notoriously prone to being guided by homophony, is that Cornouaille – which may be Brittany, may be Cornwall – is, in either case, a peninsular land, somewhere far away, *an exile*. And, if we are to believe Gonzalez-Crussi, cuckoldry is a state of exile as well as a state of mythic horndom.

Now, this exile – a banishment into paranoid secrecy and the sort of madness that Buñuel represented in *El* – is not literal; horndom however is, or can be. There exists a syndrome of pathologic skin processes that prompt keratinous protrusions like horns. Such cancerous growths are improbably caused by the psychotic jealousy associable with cuckoldry (though the genetic map when it is complete may indicate otherwise), but they are surely spurs to the adulterous infidelity that is the cause *of* psychotic jealousy and uxoricide. To put

it bluntly: if your old man has a horn growing out of his head you may find his appeal diminished and happily consort with a geezer fortunate enough not to suffer *cornu cutaneum.*

I don't say it's likely, but it *could* be that the apparently sourceless myth had its origins in actuality, in a specific instance of betrayal of the infirm. Gonzalez-Crussi does not entertain this sort of possibility, a neglect that characterises the most recurrent failing of his speculative essays: the erotic world he conjures is, if not an ideal, one that is curiously unsullied by practice. Again, to put it bluntly or crudely, the mundane congress of the mutually attractive (or desperately colliding) seems not to be worthy of his attention. Like some sort of Platonic pornographer he forever pursues deviations from the commonplace – the happy, recreative, sometimes reproductive acts that are the only link between the variegated persons on this planet don't grab him: he's interested in speciality acts, in the highbrow (and bizarrely sexless) analogues of *Five Go To Bed*, *Rover Gets It On With Trudi*, and so on. This man warms to extreme states but keeps them at a distance. This was a pose that worked fine in *Notes of an Anatomist* and fairly fine in *Three Forms of Sudden Death*, where his voyeuristic aestheticism rubbed up against subjects (freaks, taxidermy, body 'language', senility) that can, conventionally, be treated to exclusively cerebral scrutiny.

It is not necessarily a condition of the aesthete that he be amoral, but it helps, usually. This Hippocratic aesthete addresses himself here, however, to a gamut of subjects that ought not to be dissociated from moral considerations. He must know this, yet he proceeds, with witting insouciance, to deal with, say, le Marquis de Sade as though that prolix loony and his dreary *oeuvre* existed in a void, merely suffixing to the piece entitled 'The Divine Marquis' an inventory of cases of institutionalised sadism, and arguing with sophistical fatuity that the genocidal programmes of Hitler, Kissinger, Pol Pot, etc. render abhorrence of de Sade hypocritical.

His aberrations are mostly, however, more modest; but they still fail other than as self-referential *exercises*.

There's no illumination to be found in all this opacity. He knows everything and feels very little; his sponge of a brain quite overcomes his heart. His works lack a core – they are centrifugal – but they are buttresses in search of something to support. He seems to absent himself, something that his precursor Georges Bataille was either disinclined or too sage to do. When Gonzalez-Crussi writes, 'It is a formulation of today's male intelligentsia that the erotic must be opposed,' he is presumptuous if he believes that he speaks for anyone but himself; though he might have more accurately represented himself had he written 'evaded' rather than 'opposed'. And evasion is the effect of fear; love is to be feared 'because it produces a state of mind that is not subject to the command and moderation of the reasoning faculty'.

Gonzalez-Crussi is on the side of reason; he's also the victim of it – he allows this system of ratiocination a position of primacy in his approaches to the world. Given that what he's dealing with here is partially, as someone once said, Greek myths rubbed on to the private parts, reason is maybe not the aptest instrument. But is not this unwillingness to abandon reason also born of fear? For who knows what will happen when the brakes are released? One thing's for sure – the writer, no matter how hard he may try to limit his self-licence, will have to face his own eroticism. What we have here is too much *pudeur* and too little *pudendum*. He allows himself moreover to be circumscribed by another sort of evasion, that of the pre-Sadean literature that he liberally draws on – this is the source of much of his circumlocution, of his genteelness.

But it's also the partial source of the most persistent tension in these essays – the collision, peculiar to this author, of a wayward (you might say wrong-headed) literary sensibility with an insatiable scientific curiosity. The two should, of course, elide not collide.

The prang occurs because Gonzalez-Crussi's professional patholog-
ical nous is incompatible with what he has to glean from such a
gang of writers as Lope de Vega, Charles Baudelaire and Walter
Scott: 'East is East and West is West! In our part of the world, the
young at heart vibrate with emotion at the prowess of medieval
knights, in tales by Sir Walter Scott.' They do? This assertion seems
no less inventive than Scott's Middle Ages themselves. Again, read-
ings of Anaïs Nin and Erica Jong lead him to a conclusion that is
insulting in its generalisation if not its sentiment, and is odd only
because of the unorthodox means by which it is reached: 'Not bed-
ding, but "a relationship" is what women seek.'

His gaugedly fantastical prospectus for the future of the human
generation is, since it has more to do with sci than fi, beguiling: he
posits a not-too-distant future in which, as usual, the technical
capacities of medicine are pushed to their full without any thought
of the consequences, and a man is cut and tucked so that he can give
birth. In other words, our corporeal choices will become even
greater than they are today. Gonzalez-Crussi's tempered relief that
he will not live to see his grandson give birth is one of his rare sen-
timents with which we can for once sympathise. (1988)

Dirty little secrets

The Erotomaniac: The Secret Life of Henry Spencer Ashbee by Ian Gibson

If the English are really that bad at sex, how come there are getting
on for 60 million of us?

But, of course, reproduction is one thing and pleasure quite
another. The manifold effects of this country's practices of denial,
proscription and sweeping-it-under-the-carpet are, quite properly,
both a joke and a source of wonder to our neighbours. It was ever
thus. The current home secretary's ban, three or so years ago, on
the sale of decoders for a Dutch satellite channel which merely

transmitted the sort of stuff that is available on terrestrial television throughout the rest of the continent belonged to a long and boorishly authoritarian tradition of state and church interference in private mores: the English apparently require protection in a way that the French, say, and Italians don't. And a nation which is treated like children will behave like children. It will be in perpetual reaction against its lack of licence. It is taboo, embarrassment and sexuality's enforced covertness which foment 'sauciness', prurience and the notions of filth, disgust and obscenity.

Ian Gibson quotes John Davenport quoting Swift: 'the greater the squeamishness of a man's ears, the nastier were his ideas and thoughts'. Davenport is a cameo, a supporting erotomaniac, one of the sodality surrounding Henry Spence Ashbee aka Pisanus Fraxi. These Victorians might have considered themselves scholars of pornography, but they were also pornographers. They might have considered themselves libertine bibliomaniacs, but they were as smutty as schoolboys poring over dirty words. They might have travelled widely and libidinously, but you can't take the England out of the man.

They were conditioned by and victims of the society and moral programme they railed against – from behind closed doors, through the medium of private presses, in a spirit of guilty connoisseurship. 'God . . . slays desire with shame,' wrote Swinburne: that surely demands qualification as the English god, the High Victorian god, the god of his time and milieu.

Ashbee was the poet's contemporary, though hardly as posh. He was born in 1834 in Hounslow, worked in the City from the early 1850s, was in Spain, France and Germany as a young man and, in Lord Soames' graphic phrase, 'got his cock in the till' in 1862, when he married the daughter of a wealthy Hansa merchant who set him up in London in an export business.

Their son was Charles Robert Ashbee: it is impossible not to see his life as the socialistic, quasi-utopian, back-to-the-land, veg-and-sandals, Arts and Crafts extremist as filial atonement for the father's all-consuming and secretive obsession. Secretive but hardly secret, certainly not posthumously secret: Henry Spencer Ashbee left 15,000 books to the British Library (as it has since become), and the sheer extent of Gibson's bibliography demonstrates how thoroughly this particular midden has been sniffed and sifted by academe over the past three decades.

Indeed, we are now very likely as familiar with the myth that our male forebears were flagellant pervs as with the one that decrees that they wrapped up table legs in an access of respectability. Ian Gibson's self-appointed task is to put two and two together in a way that Steven Marcus, who set the ball rolling with *The Other Victorians* (1966) didn't, and to demonstrate firstly that *The Secret Life*, the most (in)famous work of nineteenth-century erotica, was not the sexual memoir it purports to be, but a work of fiction, and secondly that its author was Ashbee.

If Gibson's engagement seems intermittently detumescent one can hardly blame him. This is a formidably tiresome text with a capacity to corrupt only those who are inured to boredom and repetition. Gibson's trawl through *The Secret Life* comparing phrases, observation, constructions and loci with those of Ashbee's diaries is heavy going and, as he admits, inconclusive. And his Ashbee never lives as anything other than Onan's own pedant: the lives of writers may be dull; the lives of dull writers are duller. The irony of it all is that Gibson was initially inspired to this undertaking Twenty or so years ago by the late Gershon Legman, an extraordinary academic renegade whose energetic etymological work and discourses on off-colour jokes suggest that he'd have been a much worthier subject for Gibson than the dirty old sad's dirty old sad. (2001)

Sexed up

This is Issue 69 of *AA Files*. The number doubles – an apt word in the circumstances – as an ideogram. It has been proposed, then, that a column which loiters here by the back door ought to reek of carnality or give lubricious delight or be sexually provocative.

After all, it is well known that oldsters a year short of three score years and ten spend all the time they can spare from gardening, macramé and forgetting to take their medication conjoined in mutual oral-genital stimulation (lumbago allowing). So, too, does the majority of inhabitants of the Rhône department of France, their pleasurable practice sanctioned and even encouraged by the archdiocese of Lyon as a form of natural contraception. Incidentally, 90 per cent of current cardinals approve the Vatican's birth control campaign slogan, '*A genoux, c'est l'heure de la pipe!*'

What place has this in a (usually) learned review devoted to architecture in its manifold guises?

What tenuous link can be conjured? C.-N. Ledoux's approximately phallomorphic brothel is paper architecture, it belongs to the history of graphics, not that of realised construction. The same goes for his despised rival J.-J. Lequeu's labial portals; this is the man who doubtless invented that staple of surrealist anti-clericism, the erotic nun (Franju, Buñuel, Robbe-Grillet, Borowczyk). The historian Tom Wilkinson can, according to Jonathan Glancey, discern a thong in the curve of a banister at a thousand metres: but can we be sure that it's not his fervid imagination working overtime? The banal and undeservedly famous water tower at Ypsilanti outside Detroit was most likely given its wearisome nickname, 'the brick dick', by some wishful college jock whose onanistic vigour had exacerbated his myopia. Without knowledge of that name the passer-by would see only a cylinder with a weird top that does *not* resemble a glans. Callow schoolboys and beery blokes see breasts in

domes, no sentient male does. It is improbable that anyone who has not read Updike's 'Fellatio – A Poem' would discern penile properties in a farm silo. We have to assume that the Swiss Re tower's supposedly sexual characteristics can only have been ascribed to it by a chandelier of frustrated nuns – them again, not so erotic this time.

It is evident that sex, omnipresent in painting and sculpture, verse and fiction, music, film, drama, seldom raises its many heads in architecture; and when it does it is out of focus, imprecise.

Bernini was an architect. His sublime studies of female masturbation (St Teresa, Ludovica Albertoni) belong wholly to the realm of sculpture.

Hardy was an architect. 'The Ruined Maid', that most charmingly cynical and morally complex account of sex, money and reputation, is a poem of five quatrains.

Vanbrugh was an architect. It was his plays that were vilified as depraved and profane, debauched and immoral – as, indeed, they were in the eyes and mind of Mary Whitehouse's ignoble precursor in bigotry, Jeremy Collier, who wrote of *The Relapse*: 'I almost wonder if the smoke of it has not darkened the sun, and turned the air to plague and poison.' The maledictions Vanbrugh's buildings suffered were mild in comparison, the partial demolition of Eastbury excepted.

It's not as though architects as a group are any more or less interested in sex than, say, playwrights: witness Stanford White, Frank Lloyd Wright, Louis Kahn, Bernini himself. And not all playwrights are as preoccupied with a handsomely turned groin as Top Cottager Joe Orton was: Frank Harris wrote that George Bernard Shaw 'cut a swath through the theatre and left a trail of virgins'. Playwrights, however, practise a representational endeavour. They work with words and gestures, with fluidity, suppleness, nuance.

Architects do too. But their 'vocabulary' is, in comparison, a mere series of primal grunts, ecstatic whinnies and ill-defined noises

– now gruff, now pleased to meet you. Virtually identical buildings carry entirely contrary meanings. A half-timbered cottage of the mid-1930s in Edgware suggests home, hearth, security. A half-timbered cottage of the mid-1930s in Erfurt suggests home, hearth, blood and soil, a subscription to *Der Stürmer* and a yearning for *Lebensraum*. We do not know what such buildings 'mean' until we are instructed by an accompanying text. Even *l'architecture parlante* demands subtitles. And the meanings that can be attached to bricks, glass, breeze blocks, corrugated iron, etc. are few. We learn, inter alia, that: a spire is a token of piety; columnar structures are grand unless they are the houses of footballers; the gleamy, Blairy synthetic modernism of the past two decades is unbelievably up-to-the-minute and loaded with aspiration. These are (very) approximate characteristics but they are as precise as architecture can get.

A few years ago I found myself in Stornoway on a Sunday. Calvinism is no more or less half-witted than any other form of theism. But it brings with it in the distant Western Isles observance of the Sabbath and exceptional quiet – which is a rare luxury, seldom encountered. Somewhat kindredly, an unintended consequence of architecture's inarticulacy is its flight from sex. Unintended and rather welcome, for sex infects virtually every other area of our life. We should celebrate this aseptic blank, this lack, this sterility. We *should* give thanks . . .

But I'm afraid I'll have to pass – there's someone waiting to be fucked. (2014)

24

Showbiz

France *profonde*

We are a long way from France, divided by a common sea, burrowing beneath which will merely abbreviate the journey there – it will not bring it closer; it will not enable us to know this alien land any better than we do now. I do not mean the France of Eurocracy or that of Dordogne gîtes, nor that of the carnal beaches of the south. I mean the core, France's France, that which is peculiar and private to the nation and, especially, to the silent majority, *les petits gens*.

Now that French is no longer the lingua franca, the insularity of francophone popular culture is reinforced; its artefacts are not fabricated with one eye on the American market, and a singer such as Michel Sardou – not that he has any living peer – can address a constituency he knows with an intimacy born of a shared culture, with a wilfully self-conscious Frenchness.

Sardou's show at the vast, ugly, pyramidical Omnisport at Bercy on the night of his forty-second birthday – one of eighteen shows he has just played to a combined audience of 215,000 people – was, indeed, self-consciously French to the point where it seemed less an entertainment, more a quasi-nationalistic rite. A rite informed by chauvinism (we must never forget that Chauvin was a Frenchman),

religiosity and the dutiful adoration of a popular singer who, to his audience, is evidently the embodiment of France.

This, of course, is something that he has courted throughout his twenty-year career – it would be an unimaginable aspiration in a British popular singer, but then the appellation *chanteur populaire* is only misrepresented by its literal rendering as 'popular singer', and 'pop singer' is even wider of the mark.

Michel Sardou belongs to a tradition that has no anglophone equivalent – the tradition of Piaf, Brassens, Barbara and Brel; that the last was Belgian doesn't lessen his Frenchness as an artist. This is a tradition of (mostly) intelligent lyric writing, of anecdote, social realism, political engagement, specific topographies – and even when the sense of place is applied to Amsterdam (Brel) or Göttingen (Barbara), the sentiment, the angle and the vision are unequivocally French.

The litany of American place names that contaminate some of Sardou's songs possesses the innocent exoticism of Pierre Loti, tempered by the wry admission that the places never live up to the mythic names of cinematic fiction. A Frenchman can embrace America with a wholeheartedness born of the knowledge that his culture is less pervious to American colonisation than that of, say, Britain.

Sardou made his name in the late sixties, the epoch of *les événements*, with a series of popular songs wittingly designed to enrage his *pavé*-throwing, LBJ-taunting coevals: 'Les Ricains' (The Yanks), in which he says: 'Had the Yanks not been here you'd all be in Germany.' 'Monsieur le Président de France': 'I'm writing from Michigan to tell you that there's a white cross at Avranches which bears my name – a guy who didn't give a toss about you left Georgia to die in Normandy at your side. Who are these bastards who are burning my flag?' 'Si J'Avais un Frère': 'If I had a brother in Vietnam, I'd write to him as though I was his girl.'

You wonder what he would have written had his career begun a few years earlier, at the time of the OAS: 'Le Temps des Colonies' gives some indication: 'In those blessed colonial days I had endless black flunkeys and four girls in my bed.' I didn't see a single immigrant at Bercy among the mainly middle-aged, mainly *petit-bourgeois* punters. Sardou is 'their' singer, 'their' voice. However, he is not a balladeering Poujard, he is not an agent of Le Pen: too bright, too witty, too sceptical for that.

He possesses a sheerly wonderful voice, a voice of complete authority which – like that of a consummate actor – persuades his audience to believe in what he's singing. It's a voice that lends itself to anthem and epic. This facility prompts the composition of certain songs that are all vacuous grandiosity, a tendency that was aggravated at Bercy by his accompanying band of guitars, synthesisers, massive drum battery.

Still, when this epic idiom works, as in his recording with the LSO of 'Les Lacs du Connemara', it works better than well, it achieves a sublimity, a congruence of voice and verse and music, that is unparalleled in popular song anywhere. It's a bizarre meld of jig, soaring John Ford-style film score, dorsally electrifying sound effects, terror and lyric beauty. It mixes myth ('Lake monsters that appear certain summer evenings then dive again forever'); the story of one Maureen and of Sean Kelly who saw her dive naked into a lake and married her in the granite church at Limerick; a frightful meteorology; republicanism: 'In Connemara the truce with the kings of England is not accepted.'

This song, the penultimate of the show, was the only one represented in a manner different from its original recording; it was the only one, too, in which this great singer deigned to perform in a way that matched his voice – I'm referring to a little Hibernian reel he did as he disappeared upstage. For the rest he merely went through the motions, restricting himself to a gamut of two gestures

and to a grimace of liverish petulance – understandable given that the composition of the band appeared to have determined the repertoire and forced him to omit much of his best work.

Perhaps, though, the collusion with the audience was such that the object of idolatry was not expected to be anything more than a simulacrum of himself. Even when a hologrammatic cross appeared behind him and he stuck out his arms like Jesus ('I believe when I need to') he did so with a lack of physical conviction, even though his voice was, as ever, mighty and awesome.

The show culminated in an extraordinary *tableau vivant*: the insalubrious leather-clad band disappeared and a couple of hundred extras dressed for *A Tale of Two Cities* struck a variety of poses while Sardou, still in black jacket, jeans, T-shirt and black leather trainers, sang a new song, about the compromises and excesses of the Revolution, whose chorus, a masterpiece of either bathos or retrospective wisdom, is: 'It had good intentions, the Revolution.'

The *tableau vivant*, so the programme notes, was staged 'thanks to the participation of the mayoralty of Paris and its bicentennial committee'. Michel Sardou, Order of Merit, Chevalier of Arts and Letters, is the embodiment of France, a macho Marianne – official. (1989)

Twinned with Benny Hill

A British Picture: An Autobiography by Ken Russell

I am separated from the sexagenarian cineaste, boozer, sometime snuff addict, sometime Catholic, music lover and (now) confessionalist by a generation, a depression, a world war. But the lore and bonds of lower-middle-class Southampton are strong enough to bridge that gulf.

Ken Russell is old enough to be my father, yet our childhoods, or at least the topographies of those childhoods, are uncannily akin.

Portswood, St Denys, the Common (where Russell, who has enjoyed a lifelong preoccupation with penile dimensions, clocked his first flasher), the beach huts at Highcliffe – he limns these places with bright delicacy; he's a good enough writer to render his prose the analogue of watercolour, which, he says, is the mnemonic medium of childhood.

But it's not just the places I'm burdened with foreknowledge of. My grandparents lived a couple of hundred yards from his parents; my great-aunt was thick as suet with his aunt who moved, poshly, to the Manor House at Hythe; the first school class my mother taught included his cousin Beryl. I mention such familial connections in order to correct an impression that the author seems anxious to convey, so anxious that he trumpets it on the cover: his background, despite his invertedly snobbish protestations was *not* working class. It may have been (clearly was) culturally stunted, but it wasn't indigent; far from it. His family owned shoe shops. His grandfather pioneered, in So'ton at any rate, the selling of shoes on the drip and moved thence into modest usury, leaving his offspring reasonably well-off.

The grandson is reticent to the point of muteness here. He is also reticent about the identity of the man who sold him his first condom. In a passage of graphic excellence, he describes a surgical goods shop near the docks, in an area otherwise flattened by bombs in 1941: 'A pathetic memorial to all the ruptured and randy sailors . . . a veritable shrine of douche bags and trusses.' And the manager of the shop: 'His mouth was a slit in a bladder of lard. He resembled a condom himself. "You'll want a washable. I've Torpedo, Conger, Neptune."' Perhaps Russell is reticent about the man's identity because he didn't know it. This party, whose catchphrase was 'Wash it with Lifebuoy and it'll last a lifetime,' was the father of Benny Hill.

Hill and Russell are almost exact contemporaries, were brought up within a mile of each other. But while the *soi-disant* prole Russell

went off to Pangbourne Nautical College, Hill went to the confusingly named grammar school, Taunton's. What can it have been in the Solent breeze, in So'ton's water supply, in that great dockscape that melded these two boys, twinned them, turned them into two sides of a coin whose – apt name – head shows a fellatrix, whose – apt name – tail shows a McGill bottom?

Russell alludes only twice to Hill, as a facetious suggestion for casting (in *The Rainbow*!) and as a subject of one of his impersonations. Even if they didn't know each other, they rest insolubly bound. Their circumstances are beyond coincidence. Their *oeuvres* are the two backs of the same beast. Russell's art, though, is more, of course, than the ferment of his childhood and adolescent longings. It is difficult, maybe impossible, to imagine Huw Wheldon – this book's dedicatee and its author's tutor at the Univ. of Kulchur – commissioning Hill.

So where's Ken's kernel? Now, there's a problem – *le style est l'homme même*, but only so far. Sure, the mixture here of good writing, 'fine' writing (which is institutionalised, thus worthless), nervy passion and nerveless kitsch (he is hearteningly indiscriminate) . . . sure, this mixture matches and unwittingly mirrors his entire career, the whole opus till now.

But he avoids – and it's a signal detour – the tale of his creation. No one ever got to be anything as a result of just their genes and the pool they first swam in: you have to will yourself to be what you wish to be, what you *want*. Russell has done the knots but he cannot make diagrams of them – his writerly gift is akin to that of a Powerful Storyteller: big marks for filmable anecdote, two out of ten for analysis.

This man is no essayist. He can *show*, with verve; but it hardly occurs to him to contaminate the demonstrative idiom with, say, reason. He posits the notion that to be a director you have to be some sort of shrink, but when it comes to himself he throws in a moist towel.

Actually, this may be as much the result of disinclination as it is of inability; Russell, who has no fear of cliché, believes and broadcasts the ancient whopper about artists being children at heart. Even the coarsest self-scrutiny might tell Ken that he's not a child but a whitehair who has throughout adulthood harboured a sort of intellectual innocence – which is not the same thing. He sees, he hears, he feels, but his speculative faculties are untutored.

Russell's provenance is rare. He belongs to no school, no gang. His has always been a world of one, or two if you take into consideration his collaborations with his wives. So he has remained a maverick – that, anyway, is the impression he's eager to convey; and his candour is such that one is forced to believe it. He lacks the guile of the professional outsider, he is the *echt* article.

There is nothing particularly calculating about his antipathies; if he despises he says so. There is a certain base joy to be taken in his kneecappings of Bryan Forbes and David Puttnam. But he's not really a great hater; for someone who has suffered so many slights at the hands of lesser humans, he's exemplary in his lack of bitterness, and he doesn't take the opportunity to settle scores. Nor to do the contrary – this is as far as you can get from showbiz fawning; his tongue is as pink and clean at the end as it was 293 pages earlier. (1991)

Peacefully in his sleep

Crying With Laughter: An Autobiography by Bob Monkhouse

Showbiz autobiographies have to have photographs. And this one doesn't disappoint. Here's the author (that doesn't require quotes; he may be a gag writer, but he can write) with Dean Martin and Jerry Lewis, with Bob Hope, with showgirls (he can't remember the names, only the lines the costumes left on their thighs), with Ken Dodd and Anita Harris, with Hugh Laurie (to prove that he's still in there) – there's the usual complement of such souvenirs.

Then there are the more-or-less posed portraits, some misdated from down the years, the many years . . . I can hardly remember a time when I'd never heard of Bob Monkhouse. But what is striking in this mini-album are three photographs that have been double-exposed, to give two Monkhouses in the same frame. One specimen of this hackneyed genre might be thought sufficient. But three? They didn't get there by chance. The man must be trying to tell us something, something big, important – about, oh, dualism or the gulf between the 'real' and the perceived, or the private and the public, or is he saying that he doesn't know who he is?

Whatever it is that he's saying, he doesn't articulate it in the text, which amounts ultimately to another mask. He's far from evasive and is, winningly, almost bereft of sentimentality and all-round luvviness; indeed, he's waspish, not least about his serial peccadilloes and his scams and infidelities and petty dishonesties. He's often hard on his former selves; there's no lack of candour. But at the end of 120,000 often genuinely funny words, we're none the wiser.

Monkhouse always knew he was smart and verbally adept. It may be, of course, that the public performer has entirely subsumed the private man; he knows there's someone else there, but has quite lost the knack of making contact. He admits to a carefree insensitivity towards virtually everyone around him; it seems that he also possesses an all-too-satiable incuriosity about himself.

Now, this would be comprehensible in, I think, any other light entertainer that you care to mention; but then no other light entertainer could write a book of such fluency and occasional subtlety. What distinguishes Monkhouse from virtually everyone else in illegitimate theatre is the fact that he has a lot to spare. He's not stretching himself; he doesn't *believe* in it. The rest of the sorry *galère* of household names – Brucie, Tarbie, Little and Large, Cannon and Ball – are tabloids; they are lowbrow troupers who are steeped in a

lore of 'the profession' and whose taste runs to other lowbrow troupers (and golf).

Monkhouse is a broadsheet posing as a tabloid. He has made a career out of abasing himself, out of sedulously refusing to realise his potential. This is a bright man who has competed in an arena where brightness is deemed a luxury. I don't believe he's ever really fooled the punters; despite the longevity of his career, he has never been taken to the nation's heart the way that Morecambe and Wise or Tony Hancock or Les Dawson were – he's too slick, too patently clever, too much the smart alec for that. And he seems not to possess a pathological need to be loved. When he invented himself, he quite forgot about 'sincerity'.

He was also handicapped by being too handsome: geekish, or at least freakish, looks are the *sine qua non* of comic heroism. Well into middle age, Monkhouse retained the features of a juve lead. He wouldn't have done so had Denis Hamilton had his way. Hamilton was Diana Dors' first husband – a psychotic voyeur who was to die of syphilis. When he discovered Monkhouse's flingette with the former Miss Fluck, he hauled him outside at a party of Larry Adler's, pulled a knife and uttered the terrifying words: 'I'm going to slit your eyeballs.' Monkhouse had the good sense to kick him in the (non-eye) balls. Hamilton then put out a contract on Monkhouse, something Monkhouse learned of from Jack Solomons and Freddie Mills.

This flashy, violent milieu (Mills was murdered) is one that Monkhouse describes well, if, characteristically, as an outsider. He has no aptitude for belonging. He is a man of few friends and innumerable acquaintances, among them his emotionally reticent parents, who brought him up in bourgeois Beckenham, sent him to Dulwich College and seem to have regarded him as a sort of inconvenience. With the exception of his second wife and his disabled son (who died

last year), there are few people who prompt affection in him – which is not to call him a misanthrope. The performer for whom he displays the greatest fondness is Max Miller, who gave him a masterclass one night in 1949, in a car outside the London Coliseum after they had been on the same bill.

Monkhouse is now just about the only working link to the halls – brassy, vulgar, ignorant of PC, with an edge that's blue and another that relishes the unspeakable. It's difficult to think of anyone who has so graphically described the act (or attempted act) of copulation with a transsexual: 'not unlike plunging your feet into an apple pie bed . . . try pulling on gloves that have the fingers sewn closed halfway up'. There is an encounter with Frankie Howerd: 'As he forced my head towards his naked lower trunk, he exclaimed, "Come on! Come on!"' And another with Tyrone Power, who attempts to get Monkhouse to share a bath with him in the Midland Hotel, Birmingham: '"Take your clothes off and climb in . . . Cure my headache for me."' Power, Howerd, Dors – all dead, none of them a possible litigant.

Monkhouse brings the dead to life with sure dispatch; he is necessarily cagier with the living. Hence the latter part of the book is clouded by tact – or maybe it's just that (comparative) happiness and monogamy don't make great copy. I wonder; the world is full of aspirant Denis Hamiltons and many of them are involved in provincial nightclubs.

It would have been good to hear more about La Ronde in Loughborough, the Golden Garter in Wythenshawe, the Candlelight in Oldham ('a fog of armpits and chip fat'), La Strada in Sunderland, La Marimba in Middlesbrough – I mean, Las Vegas is the boondocks with neon and its Wearside clones are likely to be sites of glittering hickdom. But Bob stays shtum in the best interest of his eyeballs, the organs that register surface. (1993)

Ne me quitte pas

'*Dans le port d'Amsterdam y a des marins qui chantent . . .*' Yes. No doubt. But the last time I looked Amsterdam was in the Netherlands. And the man who hymned it thus was a Belgian who lived in France. *Ladeez and Jennellmeng*: M'sieu Jacques Brel. '*Les rêves qui les hantent au large d'Amsterdam*' . . .

There are lines in this marvellous singer's *oeuvre* which do what all great art should do. They touch not the head, not the heart, but the base of the spine. I am just old enough to remember those days when Brel was in his pomp. I never saw him live. An English friend of mine, now a celebrated novelist and essayist, once went to watch him in Rennes. Oh, lucky man. A Bordelais friend who now lives in Belgium attended about a dozen of his performances. Luckier man.

Me, I make do with video and CDs – oh, and tape, there's always a Brel tape in my francophone French car. Brel wrote as a cursed poet, performed as a strenuous vaudevillian. The combination of the two modes is instructive. He kind of asked not to be taken seriously. Or maybe he was apologising for his gravity. Then again, he was agile enough to make himself populist. Ish.

Brel is at the head of the trinity of francophone singers/writers who have, in the words of New York's greatest singer/writer, walked down life's lonely highway with me (Lou Reed, since you ask). I've listened to these French singers most of my adult life. Brel supported and championed Monique Serf, whose *nom de chanteuse* was Barbara. There are few days when I do not play her stuff. She was Jewish, weirdly asexual, and possessed the most beautiful voice I've ever heard. My Bordelais/Belgian friend tried, the other day, to sing her song 'Nantes' (about her father's death) to me on the phone: this guy has perfect pitch and, indeed, used to be a professional musician. But could he sing 'Nantes'? Regrettably, no.

The basest part of this trinity is Michel Sardou. Given my preoccupation with this man, who was born the same week as I was, I seldom write about him: one piece sixteen years ago and asides when I ate in restaurants after his shows.

Going to see him in Les Halles Garnier in Lyon a couple of years ago was a delight: every concierge in that city was there, I fell in with Middle France, with what Richard Cobb would have called *les petits gens*. Sardou sang in *un smoking*, a dinner jacket with a negligently untied tie. I have never seen a performer hold an audience (2,800 bodies) with such aplomb. But then, I've rarely been part of an audience which so much wanted to love the performer.

I'd imagine that Sardou's record sales in the UK are, per year, in the low hundreds. Barbara's are non-existent. And Brel's? Well, no one ever got rich selling French and, on occasion, Flemish lyrics to *les angliches*. Brel's misfortune was not to have spoken the world language of popular song.

Which makes Belgium's current initiative seem, well, rather wobbly. A brand planner or marketing guru or public relations boffin has dreamed up the wheeze of designating 2003 'The Year of Jacques Brel' in the hope that tourists will flock to Brussels and enjoy, say, the Jacques Brel Sauna Experience. Some hope.

The converted will already have visited the museum devoted to him, will have done the sites associated with him: I'm so pathetically sad that I've even been to his paternal grandparents' house. The unconverted will remain unconverted. At this juncture it's incumbent on the writer to make a lame gag about Famous Belgians (Eddie Merckx, René Magritte, Paul Delvaux, Georges Simenon, Johnny Hallyday, Tintin) and to point out that that fissured country has so little going for it that it must clutch at any straw, even one who's been dead for a quarter of a century.

The desperate paucity of the Brel stratagem is such that one is persuaded to wonder if Belgians have as low an opinion of their

country as their neighbours have. I suspect that I should offer my services to these Plucky Little People as a propagandist, for, did they but know it, theirs is a delightfully strange country.

Imagine: a place the size of Wales which produces more than 800 beers; which conjures *alcool blanc* from celeriac; which has a Museum of Underpants; whose cooking is the best in northern Europe. Etc. It's also the butt of jokes told by both the French and the Dutch, the very same jokes in two languages. How does a Belgian tie his shoelaces?

Ten years ago I made a film about the place. It was based on the obvious proposition that Magritte was not a surrealist but a reportorial realist who merely observed the quotidian oddities of his country and his compatriots. I spent days trying to think of a title. I translated Brel's bittersweet anthems to his folk: surely, therein, was a snappy phrase which would sit handsomely . . .

Since everyone to whom we mentioned the project was incredulous, my producer David Turnbull had the right idea. Just call it *Belgium*. We won an audience and some tinpot trophy in France. The French seem to consider Brel as a man who came over to their side, an artist who ridiculed his own country. I'm not so sure. When I was young and very Francophile I wanted him to be a satirist, indeed, convinced myself that he was. That's what I made myself see in him.

Nowadays I find him poignant, melancholy, regretful and peculiarly celebratory of the flat land and the bourgeoisie. He's still not going to put British bums on Belgian seats, though. (2003)

Auntie Beeb's uncle

The Fun Factory: A Life in the BBC by Will Wyatt

Will Wyatt disclaims the notion that his bulky memoir is either an autobiography or a history of the BBC during the three and a half

decades that he worked for the corporation. He is, inevitably, wrong on both counts. He provides, perhaps unwittingly, a self-portrait of a genial, eager operator who ultimately lacked the shard of ice in his heart which might have enabled him to reach the very top (he was successively MD Television and chief executive Broadcast). It would be insolent to euphemise him as a 'nearly man' but there is unquestionably something of the perennial bridesmaid about him, sometimes a bridesmaid in Pooter's clothing. It is difficult to determine whether his apparent self-mockery is actually intended: Wyatt is here working in a medium at which he is unpractised and his prose is hardly supple. And as for this account not being a history: well, pull the other one. At its basest it is merely an annotated inventory of programmes with which he was directly or, later, as an executive, peripherally involved.

It is far more persuasive when it deals with internal politics, jobbery, the juggernaut of giant egos, corporate cupidity, dirtyish tricks and so on. Wyatt sat close to the centre of power. He is a witness who, relying on diaries and contemporary notes, will tell you more than you ever wanted to know about the shafting of Alasdair Milne or the introduction of Producer Choice or the rivalries of the governors. He is bereft of retrospective self-justification, for which we should be thankful. But he is, equally, bereft of an appetite for gossip and the settling of scores.

The very fairness and scrupulousness which inform this memoir (or whatever it is) render it rather flat. He appears not to have a bitchy gene in his body. Can he really have admired so many colleagues, so extravagantly? His generosity of spirit is seldom tried. He has a good word for practically everybody. Only the improbable duo of Charlie Drake and Michael Grade excite his ire. He is otherwise lavishly laudatory. He routinely prefers to say nothing rather than to mete out adverse criticism. I should, for instance, have been interested to know why he so stubbornly blocked a particular

candidature for a senior appointment in the mid-nineties. His outmanoeuvring of this pretender's champions was extraordinarily deft. Yet he makes no allusion to it, simply suggesting that his own man's preferment was a *fait accompli*. Perhaps he has chosen to deny his capacity for cunning. But no one who lacks that quality, however guilefully dissembled, could have survived so long at so elevated a series of positions.

A further quality which is implicit throughout is that of mutability. Regimes have to be adapted to and Wyatt was a practised if sometimes reluctant chameleon. Again, survival was dependent on it. The majority of us who are not students of strategy reviews, negotiations of rights to sporting events, minutes of forgotten committees and the like, may get the impression that the BBC's higher echelons were, for most of Wyatt's career, worryingly hermetic, self-referential and as ingrown as a verruca.

The Fun Factory improbably offers much to the common reader, whoever he or she is. This creature will, I fear, be disinclined to agree with David Attenborough's back-cover encomium that it is 'entertainingly tactless'. It strikes me as being rather the opposite. It is all too discreet. The most telling details are almost asides, and occur early on. The author's keenness on 'sandwich lunches' in order not to incur restaurant expenses is touching. He repeats what is now a rural myth about an idyllic mill in Dorset which deals in bondage gear. He claims that John Simpson was a Christian Scientist. He owns up to having passed on to *The Times* a letter in which Greg Dyke had admitted to the *Independent* that he had funded both Tony Blair and various New Labour shadow ministers: since it was already in the public domain this hardly constitutes a leak. Nonetheless, Wyatt clearly believes that he behaved in a regrettably unbecoming way: it may have its amply padded *longueurs* and it may want rigour, but this is at least the work of a gentleman with a conscience. (2011)

25

Sport

Foul is fair

If I were the Tory rentaquote MP Mr Terry Dicks, the first thing I'd do after changing my name (to Dick – this is an age of monogamy and sexual restraint that we're supposed to be living in, Tel) would be to invoke Clause 28 of the Local Government Act against rugby football and, specifically, against scrummages which do not merely 'promote' homosexuality but are, obviously, shameless exhibitions of it: scantily dressed men in studded boots and hot pants putting their heads between each other's legs.

Why, they even have their very own social disease, scrum pox, a form of impetigo which is gloriously contagious and can afflict anyone, not just members of front eights. Get rid of scrums and you're clearly going to knock a major medico-socio-sexual 'problem' on the head.

The same sort of beginners' determinism appears to be the foundation of the government's thoughts on spectator hooliganism. The crude equation, sibling to the one which links violence to its representation on telly, is that 'bad' behaviour on the field of play is liable to foster knife fights and broken-bottlescapes on the terraces.

Hence the weekly appeal by this or that junior minister – call it Moynihan, call it Luce – for 'a return to sportsmanship and the

abandonment of gamesmanship'. Leave aside the fact that these appeals are pretty rich when made by members of a government which learned its sportsmanship from Nobby Stiles and Norman Hunter; they are much more fascinating for the several cans of worms they open.

Sportsmanship, like most other British traditions, was a Victorian invention; it was part of the programme of progress and perfectibility that prevailed well into the third quarter of this century. It was a literally Arcadian notion whose genesis, like much else in the second half of the nineteenth century, was to be found in a bogus past.

Encoded in such high-minded, High Victorian canons as the Queensberry Rules (1867) is the paramount idea of mitigation: i.e. you can still beat the hell out of someone but you can't beat him to death because you're wearing gloves and have, besides, to stop beating him every three minutes.

So, to borrow from the vocabulary of a not-unrelated form of spectacle, the hard core was proscribed and the soft core institutionalised. The trouble is, though, that the soft core is unsought save by the ref (and by nature's refs – who tend to be MPs and sports administrators) and sports writers, whose massive reserves of piety, virtue and moral indignation are matched only by their stores of such words as tarnished, disgraceful, squalid, unforgivable, etc.

I am afraid that I have to admit to a total bereavement of such punctilios. Formula One crashes, stiff-arm tackles, doped horses – these are the things that the true amateur of sport relishes. And I'm afraid, too, that I'm by no means alone in owning to a sporting pantheon that includes Ian 'Chucker' Meckiff, Steve Williams, Billy Bremner, Jim Smith, Paul Ringer, Colin Meads, Mark 'The Man Not the Ball' Dennis, Mike Burton, Peter Storey. Every time I hear Bill McLaren refer, as he always does, to 'ill-mannered whistling' when Messrs Webb or Hastings or Thorburn are having a pot at goal, I want to throw a six-pack of Brain Damage at the screen.

And when I've finished that six-pack there is no more sumptuous pleasure than to close my eyes and take a mnemonic ramble back to Clough's Derby v Revie's Leeds, to Jeff Thomson v Dennis Amiss's head, to games uncontaminated by sportsmanship and thus elemental in their conflicts, struggles and jungle mores.

Such spectacle is genuinely cathartic: far from fomenting crowd violence it is as likely that rough stuff on the park satisfies the audience appetite for it through provision of true drama. There is no obvious correlation between soccer teams with poor disciplinary records and spectator violence – the fighting at Heysel stadium, remember, occurred before the game.

Liverpool were and are a shamefully clean side (even Steve McMahon, who looks as though he has the potential to mix it, also looks as though he has the potential to emulate St Bobby Charlton). 'Soccer' violence is no such thing – the purpose of the arena that is hijacked for expressions of belligerence is fortuitous. Far more violent sports than soccer, such as ice hockey and rugby union, are so far unassociable with crowd trouble even though neither is any longer habitually played with deference to Corinthian niceties – it's just that a different sort of yob 'supports' Paisley Tigers or Wasps RFC from the one that supports Millwall or Luton.

It is not for nothing that the rugby teams whose followers tend to put themselves about are those like Bath and Gloucester which represent cities with no tradition of Association Football; so the bother gravitates towards what used, wrongly, to be considered the gents' code.

The fact that Bath are a famously (and drearily) unsporting team is irrelevant; indeed, the antic examples of Messrs Hill and Chilcott are proof of the antithesis to all the above, that fouls are not necessarily fair to behold. Bath are a monochrome team: Hill plays like a forward and Chilcott plays like someone auditioning for the freak

villain in the next Bond movie. And Bath's fouls, like their play, are so dismally uncreative – they obviously need a few more policemen in their team, urban gladiators in the Dooley/Richards mould, men who you know are in the right because the maintenance of right is their daily round.

Terry Dick can be assured that with those two in a scrummage there'll be absolutely no funny business going on, just the legally sanctioned routine questioning of suspects who'll willingly bite a constable's studs. (1988)

Dear Terry Venables

We all accept it is well-nigh impossible for English footballers and English football coaches to speak English. Clive James has cruelly pointed his finger at your apparent unfamiliarity with basic constructions – 'theirselves . . . his self'. These solecisms make it clear that you have a teensy problem with the language you were born to in Dagenham.

No matter. You were meant to speak with your feet. I remember twenty years ago, when you were playing for QPR, you devised a neat free kick, a lob over the scrotum-clasping wall for a pair of sideburns in the same shirt as you to run on to. That was your one good idea.

Your younger contemporary Michel Platini enjoyed one such idea every minute. He conducted the greatest of modern European teams. When he quit playing and was managing France, he noticed there was a footballer with a French-sounding name making a splash in the port of 'Sousetampon'. Because he is a Guernsey man, Matthew Le Tissier belongs both to Les Îles Anglo-Normandes and to the Channel Islands. The Guernsey phone book is crammed with Le Tissiers. All of them, presumably, possess from the point of view

of sport dual nationality. Platini, who knows about these things, invited Le Tissier to play for France six years ago. Le Tissier, rather unwisely as it turns out, declined. He had his sights set on England. He knew how good he was. And under any sane regime he would by now have picked up fifty or so caps.

It probably surprised no one that Graham Taylor overlooked him. But you, Tel, were assumed to have a spot of nous as well as a laddish grin, a reputation as a crooner and a track record (extraordinary, this, given your syntactical ineptitude) as a 'writer'. You were supposed to possess an eye for talent. But your animus towards the only gifted and fit player in England suggests that you are out of your depth, that you're the wrong man for the job, that you have no conception of what is required for international success. England is currently and quite properly ranked 22 in the world by Fifa.

Contemporaries of yours who were much better players than you – Osgood, Channon, Ball – reckon Le Tissier the finest player in the country. What is your problem? Could it be that Le Tissier is simply not one of the lads, that he doesn't hang out in your tacky nightclub, Scribes, that his face doesn't fit?

The effect of your moronic neglect is to alienate a large part of that audience which wishes England well. When Brazil took England apart a few months ago, I – along, I suspect, with many other disaffected armchair experts – was cheering for the boys in yellow. Tonight, I will be rooting for the cocaine barons.

Next summer, in the European Championship, which your no-hopers would not have even qualified for without the fortuity of England's hosting the tournament, I will be rooting for a French team with Eric Cantona and Matthew Le Tissier playing up front. After that, what are your feelings about the chief executive job at Wrexham?

Yours contemptuously, Jonathan Meades (1995)

My Bergkamp days

We all have a bit of Gary Lineker in us and, yes, the lucky ones have a large bit of Gary.

When I was a child, I wanted to be Dawn Fraser. I swam in county championships. My last race was so humiliating a defeat I have seldom been in a pool since.

I occasionally took a point at squash off a friend who reached the semi-finals of the national under-16s.

My topspin in table tennis was legendary – to me.

Playing in central defence for a team of Parisian actuaries against a team of Algerian telephone engineers, my vision was such that I could see the fifty-metre pass that needed to be made to our left winger: unhappily my feet don't match my fine footballing brain. I kicked the ball into touch and was substituted.

Still, I can recite the names of the Manchester United players who perished at Munich. When Peter Collins was killed at the Nürburgring, I dreamed that Churchill had died. I was at Old Trafford the day David Beckham met Victoria Adams: 2–0 against Sheffield Wednesday since you ask. I saw Cruyff, Neeskens and Migueli play at Nou Camp. Billy Bremner was a foundling from Stranraer. St Johnstone is the Perth club, Raith Rovers the Kircaldy club. A few seasons back Sunderland fielded a side nine of whom were called Steve. I once killed an hour at Guernsey airport reading the several pages of the phone directory listing the subscribers called Le Tissier. The two people named Richard Hill who have represented England at rugby, the excitable former scrum half and the current forward, were both pupils at Bishop Wordsworth's School in Salisbury. Oh, and I have a cruciate ligament injury.

It must be blindingly obvious, then, that I am a sportsman.

So I went to Canada Water, a strenuously monochrome station on the Jubilee Line. It is grey: a colour and not, in this instance, a

depreciatory, figurative adjective. At ground level it owes something to Charles Holden, who designed the Northern Line stations of the thirties. When you exit the grey, you might be in Milton Keynes. There's a lake, presumably Canada Water itself. Reeds, swans, ducks, moorhens, nests, jetties, fishermen. Four boys have jumped a padlocked gate to get a tan sprawled on a jetty.

And here is the sportsman's destination – two mega-sheds inscribed 'Decathlon'. There's an awkward wedge of space between them. Ten acacias have been planted and pollarded. Four of them are dead. Two others are on the way out like Tommy Simpson on Mont Ventoux. Burger boxes and popcorn cartons turn cartwheels around their trunks.

The further Decathlon shed (averagely ugly – but no uglier than its sibling) is the one for sportsmen like me. It's a mecca for us sad asterisks, for the sporting equivalent of air guitarists, for banal fantasists.

I attempted to juggle a football and struck the calf of a woman who turned to my wife and said, with resigned good humour: 'You can't take them anywhere.' Spot on. The middle-aged man magically mutates into the small boy who dreams of sporting glory. It may be decades too late to imagine scoring for England but then the very nature of idle delusion is that we entertain the impossible. Decathlon is in the profitable business of pandering to unachievable whims. It is fetishistic and curiously asexual.

There are balls everywhere, in nets and traps, balls of every colour: golf, cricket, soccer, snooker, basket, table tennis, tennis, squash. Some of them aren't round. They are all inviting. At 14.00 I was still Jonathan Meades. At 14.01 I was mortifying my calves and thighs on a stepping machine and, more importantly, undergoing a major identity change. You know the score: the mild-mannered prof turns into a slavering lycanthrope. After a hundred steps I was, oh, Mario Kempes. A couple of minutes later I was Platini, Giresse,

Amoros and Tigana. All of them. As I say, we entertain the impossible. I went round a corner into an aisle of rugby boots and discovered that I was now Phil Bennett. I set off on a jinking run.

The vast building which fosters these fantasies is functional going on utilitarian and far from fantastical. But it doesn't need to be. It is the contents which do the trick, and the cornily overused word 'professional' which is promiscuously appended to virtually every piece of kit. We're invited to kid ourselves that if we have the right racket or shin guard or iron or shirt we will be in with a chance of emulation. We know it's not going to happen but nonetheless have what must be described as a sort of faith in the transformational efficacy of equipment. Beer-gutted couch potatoes whose only exercise is opening ring-pulls are given false hope by squeezing themselves into the shirt worn by Bergkamp. These replicas are like relics of the modern gods.

The gulf between the musculature of professional athletes and Decathlon's punters is chasmic and risible. The place is a magnet for the demonstrably unfit, victims of a white-flour, high-carb, high-fat diet. The Lard family, dad and two sons, were trying out squash rackets. It occurred to me that were they to step on to a court they would probably have heart attacks.

They adhered to the dress code which might as well be mandatory. It is apparently forbidden to tuck in a shirt or singlet. Trainers are de rigueur. Long shorts are the pants of choice, though there's also a good showing of trousers which end on the calves and of shiny nylon tracksuit bottoms. Sportsbloke tends to be lavishly tattooed. Sportsmissus is hugely sunburned and evinces nostalgia for the halcyon days of steroid-enhanced *mädchen* from Dresden and Leipzig. Their nutritional supplement might be Cyclone or Promax Extreme or Myoplex or Progain or Ultramass or Glutamax or PSP22 High Energy Sports Fuel. Whatever it is, it comes in catering packs. I just said no. But I couldn't resist an ST1000 stair-climbing simulator. I'm back in training. Watch out. (2003)

Criminal defending

On 24 April 1976, the recently appointed UK foreign secretary Anthony Crosland, who died too young, took the American secretary of state Henry Kissinger, who exhibits disturbing intimations of immortality, to Blundell Park to watch a Division Three match between Grimsby Town and Gillingham: the home team won 2–1. This was not a mere man-of-the-people gesture towards Crosland's constituents. He was famously a fan of *Match of the Day* and would leave the dinner table to watch it.

Three decades previously, when Grimsby were still in the First Division, the world was black and white, the predominantly male, predominantly working-class spectators wore caps and mufflers, some carried wooden rattles and boys read Charles Buchan's *Football Monthly*, which reeked of Brylcreem and dubbin. Even though the foreign secretary Ernest Bevin had come into politics through trade unions and Baptist chapel, the idea of his taking the visiting American secretary of state George Marshall to a football match was unthinkably infra dig (to use an expression of that era).

In the intervening years a shift had occurred in football's demographic. This was in part ascribable to the excitement of England having won the World Cup. But more to the ubiquity of television, which had, even before it enabled millions to witness that questionable victory, begun to rid football of its proletarian status in the stiff hierarchy of games. League football was professional so hadn't accorded with the Corinthian lie propagated by Newbolt and his ilk. The maximum wage was abolished in 1961, though many players continued to have part-time jobs (plumber, PT teacher, coach driver, greengrocer). A year later cricket moved in the same direction when the last Gentleman v Players match took place. (Gentlemen had initials before their surnames, Players didn't.)

Sport

By the time *Match of the Day* made its debut in 1964, the names of footballers were known to 'neutrals', the bulk of the non-partisan, non-sports-page-reading viewers who had watched the infrequent and haphazard live transmissions of matches, or – seriously – one half of a match. The merits of Shankly and Revie, Greaves and Law became the stuff of widespread interest, of conversation with people other than cab drivers. Football became a kind of social Esperanto – for a while. We are now well past that happy moment.

In its role as a mirror to the world, it now percipiently reflects division, greed, gross inequality, corruption, vanity, pomposity and – a certain paradox here given its global reach – hermeticism. It is as much a law unto itself as the great delusory machines of Christianity and Islam. And it would be as easy to dismiss as those base phenomena were it not for the spectacle its greatest players and greatest teams provide. The correspondence with theatre is imprecise, it has no meaning outside itself. But it is a sort of improvised art: Keith Johnstone, the godfather of improvisation, likens that sort of performance to sport rather than to rehearsed, repetitive plays which eschew spontaneity.

Not that football, liquid chess, is entirely spontaneous. Moves and formations are not relentlessly practised for nothing. Where it most resembles theatre is in its cast of good guys and sour villains, in its provision of the extraordinary skill of Cruyff, Zidane, Maradona and the extraordinary brutality of thuggish cretins like Vinnie Jones, Andoni Goikoetxea, Kevin Muscat, proud to end the careers of players whose fists don't drag along the 'park' like theirs do. These 'defenders' tend also to be satisfyingly inarticulate as though they have taken lessons from John Cleese's Jimmy Buzzard: 'I 'it the ball first time and there it was in the back of the net.'

The *Monty Python* sketch in which Buzzard appeared was broadcast almost fifty years ago. The successive waves of grotesquely overpaid football 'pundits' have learned nothing. They don't of

course realise that they are helplessly self-parodic. Whatever BBC halfwit thought that former players were fit to comment on games was ignorantly unaware that 'pundit' derives from *pandit*, a wise man, a scholar, and equally deaf to the truism that if you want to know about being dead you don't ask a corpse.

Their sociolect would be funny were it not so straitened. But week upon week of 'nutmeg', 'half a yard', 'criminal defending', and of course 'back of the net' – where's its front? – leave the linguistically sentient bruised and wishing for commentary by people who can read and write. And 'not at the races' and 'put in a shift' are particularly egregious: expressions which they insouciantly employ with no regard for their roots in a working-class life of hardship that largely disappeared with tripe in vinegar, pigeon lofts and whippets. (2018)

Team spirit

The Wales v England match at Cardiff Arms Park in 1987 was a brawl. From the kick-off both teams were determined to get their retaliation in first. Alan Watkins described the nineteen-stone prop forward Gareth Chilcott as 'the Japanese wrestler from Bath' and observed that a generation earlier, in the corresponding fixture of 1963, the occupant of Chilcott's position, Nick Drake-Lee, weighed just over twelve stone.

Today the game abounds in Chilcotts. Twenty-stoners are the norm, hardly worth a mention. A neck the girth of a thigh is standard issue. The recent World Cup was a festival of biceps boosted with subcutaneous medicine balls. Packs of 150 stone are everyday items. Backs are commensurately vaster. The greatest player I have ever seen, the Welsh outside-half Phil Bennett, was eleven stone. South Africa's extraordinary scrum half, the bottle-blonde Faf de Klerk – out of Miss Piggy by former teen idol David van Day –

may be only five foot six but he weighs fourteen stone and isn't scared to kick the sand back in the bigger boys' faces.

Ever more distended bodies are an effect of the game's quarter-century of professionalism. No doubt in the last years of shamateurism players were rewarded (gifts, sinecures, business introductions, etc.) but with rare exceptions they did not appear to belong to a developing genus of human-beast, a manimal bred specifically to pulp and be pulped on Saturdays in the way that Kobe, Wagyu, Angus, Limousin, Charolais and Hereford are raised for the table.

A second effect of professionalism has been to turn promising flankers and outside-halves into DIY genealogists, unearthing distant relatives whose late existence may validate a claim to be eligible for selection by one of the 'major' rugby nations, which in this regard ape both football clubs and national squads. Better an Australian reserve than an automatic choice in Vanuatu's starting line-up. Little ponds are less lucrative.

Conversely, some years ago a Millwall footballer, a south-east Londoner, who had spent most of his career in the lower divisions and was resigned to never playing internationally for England, was happily astonished to discover that he had been chosen to represent the Republic of Ireland because his great-aunt had once holidayed on the Dingle Peninsula. He subsequently discovered that he also had Scottish and Italian 'ancestry' and could have played for those countries too.

One aspect of watching the World Cup or indeed any sport on French telly is that the excitable commentators adhere to the risible sentimental myth that the country is 'colour blind', so this nationalism of convenience is not remarked on, a delusory egalitarianism which more hard-headed editorialists (Rioufol, Zemmour, Finkielkraut) routinely deride.

It is however cheering that TF1's commentators are strangers to the dismal pieties that their evangelical British counterparts proudly

and repetitively display: that sport is somehow morally improving, that so-and-so with the daft haircut is a great 'role model' for any youngsters watching, that sports fields are sacred and that to build on them is environmentally wicked and culturally catastrophic, that team spirit is to be encouraged as the *ne plus ultra* of comradeship. Sport – more properly games – has turned into proxy religion, a very primitive religion whose theologies are few and simple but whose theolatries are legion.

The apostate is the person who simply doesn't care who wins, whose supreme indifference undermines the whole enterprise, who doesn't give a toss if gloating Goliath, Jeff Thomson, takes out plucky David, Dennis Amiss, with a 100-mph ball to the unprotected head. My choice of players from almost half a century ago suggests, correctly, that I don't know the names of today's *guys* in Day-Glo pyjamas with motorcycle helmets. I am unbothered by my ignorance.

I do, on the other hand, know that 'team spirit' is a euphemism for 'only following orders', for collectivity, for joining in, for being strengthened by the mob whose force of numbers steals individuality, for abjuring personal responsibility and free will, for bullying those who neglect to sign up.

I do know that one of the delights of London Overground is the unofficial metropolis: ragged back gardens, bonfires and alleys by Carel Weight; ground elder and buddleia; *terrains vagues* in countless versions; fences collapsed by creepers; jerry-built extensions; sprouting pyramids of cinders and sand; rows of lock-ups; sports grounds. That is: deserted sports grounds, surrounded by poplars, bereft of all human activity whether sodden in winter or parched in summer. It is as though the kiddy hordes who are supposed to be inspired to emulation by professional sportspersons are inspired only to spectate, to sing the club song which is invariably a version of 'When the Saints Go Marching In', to 'take pride in the badge'

on this season's kit, to get hammered en masse at 11 a.m. because the kick-off time is determined by the demands of Thai TV. We are passive footballers and rugby players.

The PE teachers and flag-wavers for the Olympics and out-to-grass footballers paid a fortune by the BBC to display their micro-lexicons have their antecedents, not that they are aware of them: Newbolt's preposterously gung-ho 'Vitai Lampada', written in 1892, is a prediction of the carnage just over twenty years later. Its pure-corn public school patriotism was derided in the trenches, just as we should deride the champions of brawn over brain. (2019)

26

Urbanism

A modest proposal

No small unbuilt building project has for years received so much press and telly attention as Piercy Conner's proposal for six – yes, merely six – upscale bedsits in King's Cross.

Now, this flurry of gushy articles and unquestioning news reports, invariably illustrated by the same computer-animated design of the building on the road that used to be known as 'the Cally', is, at first glance, just another instance of the media's susceptibility to PR and to the guile of Conner's publicist. Every week of the year about twenty press releases are sent to me. They don't reach me: I have personally trained a highly skilled cadre at the *Times Magazine* to bin them. But it is all too evident that many journalists proceed in the contrary direction, suffixing their column with an appeal for gossip, 'news', 'titbits' and so on. I think we all know who is likely to mail the e-address so considerately provided.

At second glance, this project's coverage, which is in inverse proportion to its size, is further evidence that most journalism's source is other journalism, already published journalism – and I am hardly refuting that mundane observation by writing about this most publicised of domestic-architectural future gimmicks. Nonetheless, it is conceivable that there exist some more founded reasons why an

unknown practice's 'pod-flats' should grab the collective editorial imagination when grand schemes pass by without exciting comment save from the robot-mouthed antagonists of tall buildings.

Well – there you have it, part of it. Tall is bad. Small is lovely. Very small – and each of these apartments is less than twenty-five square metres – is even lovelier. Very small summons the most profound uterine nostalgia. And after that – this is a chronological piece – it recalls childhood, tree houses, secret setts in hedges, tunnels, burrows. It prompts dreams of the idyll that we never actually experienced but read about, the idyll of self-sufficient resourcefulness, of the maroon's improvisatory cunning – a tradition that extends from Defoe through Jefferies to Masefield and Tournier (who rewrote Defoe).

The amount of space that we demand to live in is as culturally determined as the language we speak. Look at *De Particulier à Particulier*, a French weekly property magazine, and you'll find countless advertisements for Parisian apartments beside which the pods on the Cally seem palatial: 'studios' of fifteen or eighteen square metres are commonplace. I indeed lived in such a space in Bordeaux when I was young. And in my jabbering, slobbering dotage I'll probably end up in another. But not in London. The point is that restricted personal space in Bordeaux or Paris, Barcelona or Turin, is complemented by the provision of public and semi-public spaces – which are, perforce, actually used. Such spaces are rare on the ground in land-greedy English cities whose inhabitants perpetually petition for more low-rise private space. Communality, however, is, in some measure, determined by the frequency with which we have to resort to public space. The English increasingly regard public space as a sort of skip or toilet. No wonder – we don't actually need it because we have too much room at home. And because we demand ever more room at home, ever more privacy tempered only by electronic communality, we trash not only the few remaining green fields but the very ideal of society.

Baroness (as she then wasn't) Thatcher's dictum that 'there is no such thing as society' was not an observation about the state of the country she ruled. It was a prospectus, an expression of wishfulness, a forecast of what she might create by such means as the sale of the nation's social housing stock. This act of governmental vandalism was not corrected by Major and has been cravenly accepted as part of the status quo by Tony and guys. Of course London is grinding to a halt. It's an inverted pyramid, and it cannot teeter thus for ever.

Twenty-two years ago, I met a great man with a small satchel. He was called Walter Segal. In his past was a flight from Nazism. In his satchel were plans for high-density, self-build housing. The commissars of the *Architectural Press*, for whom I mistakenly worked in those days, prohibited me from writing about him, regarded him as a pushy eccentric and – far worse – a propagator of prefabs. By the late seventies, prefab was a very dirty word. It brought with it an etiquette of building failures, scams, ugliness. I believe that Segal got it right, in a way. There are two roads of 'his' houses, named for him, in Honor Oak and Brockley in south-east London.

The prefabs planned by Piercy Conner do not demand hands-on. What I'd love to see is this clearly clever, clearly self-advertising architectural practice do what is needed: that is, build not six of these pods but 600 in a 600-metre tall block. And then another. Stuff English Heritage and 'the views of St Paul's' argument: if the capital of Europe is not to concede that title it has to work as well as Paris does. Social housing (of some sort) must be reinvented. Conner's fault is that they're too modest. Too English. (2001)

It's great up north

There is implicit in official encouragement of regionalism the wrong-headed idea that Britain was till recently culturally homogeneous. It

is, no doubt, only politicians and those that share their hermeticism who believe that the absence of a corrective apparatus to promote 'difference' must actually have signified the existence of some mono-cultural accord.

If, the wobbly thinking goes, no action was taken to engineer change, then there can have been nothing to change. The unsenti-mental spirit of a less interventionist epoch decreed that regionalism – cultural, social, linguistic and economic – did not require but-tressing. It could survive centralism's advance without added (and costly) new strata of government, cosmetic devolution and initia-tives to create identity. The Union provided a framework in which a complex multiplicity of microcosms might exist. The great bor-oughs of the north and Midlands were de facto city-states.

This is most evidently manifest in their municipal monumentality, which is invariably Victorian and Edwardian. But their autonomous potency endured until the breakdown in manufacturing, whereupon they were declared sick and, like any patient thus diagnosed, began to behave that way. Certainly no one visiting those cities in the seventies and eighties could fail to be struck by their forlorn decrepitude and resignation – and by their contrast with Europe's provincial centres. Equally, no one visiting them today could fail to be struck by the vitality and breadth of their regeneration.

This is too often represented in such formulas as Leeds-Manchester-Brum gets a Harvey Nichols, as though that was truly indicative of a city's newfound destiny. And it is just as frequently represented by the hubristic plugging of projects such as the Lowry or the Imperial War Museum North, which are essentially essays in the Bilbao effect. They do, however, differ from the Guggenheim in that rust-bucket of a Basque city, for they are supported by a comprehensive infrastructure. They are part of a renewed whole, rather than stand-alone boasts. Perhaps I should say as well as stand-alone boasts, for buildings of this sort fulfil multiple functions, just as their Victorian

precursors did. The greatest town halls and city chambers were not merely advertisements of a city's self-perceived might: for all their fancy dress they were also utile structures.

So it is with the current gamut of gestural statements in steel, glass and – material of the moment – titanium. Every age possesses a particular building type which it sets about reinventing with grandeur and confidence: such buildings pinpoint the generalised aspirations of that age. They remain as monuments to what was newly considered important. The ritualistic churches of the first half of Victoria's reign were antithetical to Georgian preaching boxes; the gleaming arterial road factories of the 1930s showed that manufacture and soot were separable; the universities of the 1960s established a tertiary-educational third way between 'privileged' Oxbridge and 'non-U' red brick.

The problem with today's representative buildings is that their non-branding functions include such pursuits as leisure, tourism, enjoyment. All of which are apparently perceived as frivolous. The government (along with its predecessors) neglects to acknowledge the strength of this 'sector', even though it is economically buoyant.

A century ago a great demographic shift was getting under way: that section of the populace which could afford to was moving from urban centres to suburbs. Thirty or so years ago the reverse began to occur – though exclusively in London – with the gentrification of slums: in those days the Hanging Gardens of Northern Kensington and the rest of Notting Hill were all gas meters and Rachman.

It is too early in this century to predict what its characteristic shift will be. But the signs are there. We are already witnessing the first stirrings of a reaction to London's overpriced squalor, its defunct public transport system, its belligerence to the private motorist, its invisible police force, its lack of affordable accommodation.

This reaction is not mimicking that of a hundred years ago. The new metropolitan migration will not be to suburbs or exurbs, which are, after all, dependent on transport. It will, rather, be to the recently recast centres of those Midlands and northern cities which were for so long off the map, yet which now offer a quality of urban life which is beyond the grasp of all but the richest Londoners. The young, priced out yet eager to live in a city, will desert the Smoke for walkable miniatures such as Nottingham and Newcastle. It is already happening. This would have been unthinkable ten years ago.

Unhappily it remains unthinkable to the deputy prime minister. With an irresponsible obliviousness to a trend which is today a mere brook but which will expand into a torrent he is proposing that swaths of the old industrial heartland be razed and that, 'instead', a de facto city of a million inhabitants be built around Milton Keynes and that three others, only marginally smaller, be built near Cambridge, on the north Kent shore and near Ashford.

There is, here, an evident offence against the already compromised green belt. There is, more tellingly, a failure of speculative imagination at play. There is a blindness to the irony that a genuine devolution prompted by talent's migration will occur at the very moment when a form of crude social engineering based on an outdated model is being implemented in order to further overcrowd a south-east which has ceased to be a cynosure. (2002)

London transport 1: Travelling, hopefully

My first bus was the No. 55. It ran every ten minutes. Five to the hour, five past, and so on. I could time the one into town by that which went west past my parents' house, also No. 55 – a banal coincidence which made me feel favoured.

The eastbound would arrive two minutes later at the stop down the road beyond the Rose and Crown, which smelled of stale beer

before the avuncular Austrian took it over and it smelled of cooking. The other smells never changed: congealed blood in Sid the butcher; coke, anthracite and burning nail in Curtis the blacksmith; Hawk Bowns' dairy, where the milk was always on the turn because Hawk's missus had a moustache. The Wilts and Dorset livery was red going on terracotta. Destination: New Canal.

There was no canal. I consoled myself with the strange, sandy, pine-topped tumuli at Whaddon which I'd pass on Hants and Dorset No. 36 (grass-green livery, numbered for the A-road) when I went to competitive-swimming training in Southampton. They were the workings of the abandoned Salisbury and Southampton Canal. It was just as well it was abandoned: it was a questionable attempt to realise the commercial potential of conjoining the Test and its tributaries to the Hampshire Avon.

The only thing I know about Gwen Newman, my mother's teenage best friend in Southampton, is that her bike tyres got stuck in a tram rail. She rolled away, just in time. There's a history in this country of towns dependent upon transport systems put out of business by the opportunism or luck of the next town, the neighbour. Take the Severn and its estuary: Bristol lost out to Avonmouth because steamships' keels were too deep for the Avon Gorge; Bewdley lost out to Stourport because of anti-mercantile snobbery; and because of bends in the river, Gloucester lost out to Sharpness.

Stourport is, according to Pevsner, the only town in Britain wholly occasioned by a canal: I'm the wrong side of idolatry with that man – but is he right? *Worcs* is one of the last he wrote alone and possesses the spare weirdness of *Transparent Things*, *A Winter's Tale* and the last quartets, a great mind winding down.

We all know the towns the railway made: Crewe, Swindon, York. Buses are different. There is very little bus architecture. Stockwell bus garage is all curved rationalism. The bus terminal at

Victoria is less distinguished borax/streamlined than the Louis-SNCF rail station there.

The best bus terminal in Britain is about to be demolished: the bus 'station' in Preston is vast and magnificent. Unhappily it was built in the 1960s, and is all concrete, sculptural, exciting. It's better even than that town's library. Demolish a library and you're in trouble. Demolish a sixties bus station and the people are ever with you. Stuff the people. But a bus station cannot make people good people. That might be because alongside Salisbury bus station there was the Tap, a scrumpy bar, squaddies and indigent teenagers for the use of.

Ideology isn't as dead as it's said to be. It's just slumbering. It crops up now and again. It may not affect the big picture but it's there in the small photos. It's micro-ideology, obviously, that assumes that buses can solve London's transport problems: no pragmatist would think thus.

The not-very-bright mayor of London, Ken, subscribes to the Lord Rogers Remedy: you know, turn London into a series of cobbled Italian villages. London – *pace* Rogers, *pace* all estate agents, *pace* just about everyone – isn't what it's supposed to be, it's not villages. It's conjoined suburbs: sprawl, subtopia, exurbia, call it what you will. It is Los Angeles's precursor, an LA of the horse. It is a low-density agglomeration. We might wish it to be otherwise. But it's not.

The Angeleno mode of transport is the car. So should ours be. Looking to San Gimignano for solutions is wishfulness. Looking to New York, the quintessential European city, is equally redundant. Were London as densely packed as New York, or even Paris (which accommodates a hundred people in the space that London does fifty-eight), it might be feasible to learn from them. But there's no point in taking a lesson in a language one doesn't understand. Forty-year-old Routemasters and the preposterous articulated bungalows

on wheels that Ken has shown off this week merely exacerbate the problem.

I stood the other day, mid-afternoon, at the crossing of (New) Oxford Street, Charing Cross Road and Tottenham Court Road. I inadvertently realised I was doing fieldwork. During three minutes fourteen buses came by bearing a total of eleven passengers. The day before yesterday I drove one of my daughters to Waterloo. Epic. Cyclists – a near homophone of psychos – hurtled towards me; they were, of course, going the wrong way down one-way streets; yes, they were monosyllabically articulate and useful with their finger code. And belching buses. Useless polluters. No one on them, natch. Slowly does it, son. Slowly round the daft, cycle-riding traffic planner's utopian roundabout-cluster at the southern end of Westminster Bridge.

Collective farms were not initiated by farmers. If Ken had a brain rather than a cretinous ideology he'd realise that his absurd misuse of space – a bus takes up four times as much road as a car and is, save at rush hours, emptier than most cars – is a crime against the people.

We may be better than them at football today. But we still can't do a city like Buenos Aires, Borges' labyrinth and Le Corbusier's ideal. Cheap, municipally funded taxis – that's the answer, guv. (2002)

London transport 2: Followed by a handbrake U-turn

At Beckenham, in south-east London, there is a 1920s garage in the form of a pagoda. In the outer suburbs of all great cities, and more or less contemporary with that garage, there are distended pubs, formerly known as roadhouses. They sport lavishly bogus beams or Hanseatic gables or Loire-ish *tourelles* or Hollywood-Andalusian pantiles. These buildings are eagerly frivolous. Their message is clear. Motoring Is Fun.

And maybe it was, then. The notion of pleasure was further encapsulated in such locutions as 'going for a spin' and 'What about a little jaunt?' But despite the advertising industry's equation of cars and their fuel with sexual prowess, escape, self-determination and freedom (deserted roads), we are no longer Getaway People. We eff and blind and rage and scream into our mobiles that the M42 is at a standstill so we're going to have to get off and divert through Meriden. We are Tailback People. And, what's more, we know it. We know the game is up.

The most significant effect of London's congestion charging is not the diminution of road traffic in the core, which comprises less than 1 per cent of the area within the M25. It is, rather, an evidently unquantifiable but, equally, undeniable collective mood swing. A marked shift has occurred. It is as though a massive sigh of relief has been uttered. Overnight this city has acquiesced. Opposition has evaporated and has been replaced by a grudging gratitude for having been prescribed the right medicine.

There is, no doubt, a risky lesson here for the prime minister: it is that the anticipation of an event rather than its actuality occasions the greater protest, foments the greater fear. These are still what soccer commentators call early doors in the mayor's scheme. Yet by forcing the matter it has caused us to rethink our relationship with and our reliance on the car: it has taught us what we already knew but were reluctant to admit. It has extended the realm of the possible by getting the measures right. If it can work in one part of London it can work in further parts, and in other cities. But why stop at cities? The roads of these small, crowded islands are so clogged they are due a traffic laxative. Within a generation we will be inured to tolls.

Sure, fundamentalist double declutchers and evangelical Clarksons will very likely claim that humankind enjoys an inalienable right to roam in metal boxes: it is, after all, at the heart of their faith. But if the example of central London over the past two weeks

is followed, the majority might gradually be persuaded to accept that personal transport is not to be taken for granted, that it is a habit which can be broken. That's the thing about habits. Smoking tobacco was till recently a social norm. Drink-driving was hardly a social norm but it was jocularly tolerated and certainly not regarded as a crime to which opprobrium attaches.

The prices the developed world has paid for the twentieth century's equation of speed with progress, its addiction to mobility and its characterisation of travel as a necessity are obvious. Britain has probably paid a higher price than any other European country by allowing the car to determine the pattern of its urbanistic and, more especially, its exurbanistic growth. For every linear suburb occasioned by and served by train there are numberless settlements from the 1920s onwards whose very existence is conditional on cars. The combined good intentions of William Morris, anti-urbanist utopian, and his namesake William Morris, manufacturer of cheap cars, has had the gravest physical consequences which cannot be undone.

But we can at least learn from a century of sprawl and declare that enough is enough. And we can amend our attitude to mobility – or we can be forced to amend it by those who jump on the Livingstonian bandwagon in the realisation that a policy founded in ideological spite can turn out to be pragmatically beneficent and the first shot of a revolution. We are an adaptable species. There is no reason why we should not be capable of acknowledging that we currently delude ourselves by dignifying the desire for mobility as necessity. It is not beyond the powers of government to establish a hierarchy of necessity. It is merely beyond its will – the small matter of the next election inevitably looms. A government which, for example, considered electronically tagged cars would be staring the wilderness in the face.

We can, however, be dissuaded from certain forms of 'leisure' travel. The maxim that this activity broadens the mind is risible. I

cannot find its source but would guess that it was some Grand Tourist chappishly justifying the characteristic combination of sites by day and debauches by night – as Pope had it in *The Dunciad*: 'The Stews and Palace equally explored / Intrigu'd with glory and with spirit whor'd.'

The suspicion that indiscriminate travel might actually have the opposite effect was increasingly frequently aired as the means of travel multiplied and the price of travel plummeted throughout the nineteenth century. It is a suspicion that we presently ignore because we are so used to itinerant hedonism, even if that's not quite how we describe it to ourselves.

We convince ourselves that it does us good, that it's more than indulgence. I wonder. It's always dangerous to cite works of fiction, but consider Franz Kafka's *Amerika*, Alain Robbe-Grillet's *La Maison de Rendezvous* (which is set in Hong Kong), Raymond Roussel's *Impressions d'Afrique*. The writers had never been to the places they invented. Each of these novels would have been mitigated had they been contaminated by the actual, had inner space been infected by outer place. (2003)

The unofficial town-planner handbook
The Endless City, edited by Ricky Burdett and Deyan Sudjic

Fretting about cities is as old as cities themselves. The literature of complaint, disgust and exhilarating misanthropy probably begins with Juvenal, whose inventory of Rome's foul shortcomings includes getting robbed, getting ripped off, getting trodden on, malodours, noise, traffic, disease, falling tiles, load-shedding carts, fire, sewage, dogs, immigrants, whores, drunks, other people, other people's food and so on. Revelling in the despicable and thirsting for the reviled is pretty much a tradition. Cities are mirrors of our manifold imperfections. Our greatest creations are our most flawed.

In the eyes of, say, James Thomson or Louis-Ferdinand Céline or Joseph Roth, cities are irremediable and terminal – but they won't die, because there is always a new generation of the hopeful (or deluded), eager to devise novel means of repeating the old mistakes. Among the hopefuls are urbanists. Their maxim might be the late king's: 'Something must be done.' And that something should not be relishing seediness and celebrating sordor.

Urbanism, if it signifies anything other than what used to be called town planning, is an ill-defined pseudo-discipline that covers research into the economic, infrastructural and demographic ingredients of cities and supposedly draws upon such research in the creation of schemes to improve cities. Such schemes usually mean, in practice, building. Hence the construction industry's conversion to urbanism. There no longer exists such a thing as a builder. That man in the Day-Glo hard hat wolf-whistling is now an urban regenerator and the tempting cleft peeping from his waistband announces his urban regenerator's bum. The question, of course, is: what is he building, and where?

Urbanism is a response to what the climate scientist Paul Crutzen has declared to be the Anthropocene era, that is, the past two centuries of industrialisation, during which man has crucially tilted the planet's balance not least through the creation of unprecedented concentrations of population. Fashions in urbanism have lurched vigorously: high or low density, cottage estates or deck-access flats, high streets or exurban malls, new towns or streets in the sky, local-authority deportations or refurbishment, mixed use or zoned activities, the primacy of the car or of pedestrians . . . Each has, at one time or another, had its champions. Yet cities continue to expand irrespective of fashion. Cities are the random accumulations of antagonistic past crazes snuggling up to each other. Theoretical urbanism's effect on our cities has been marginal. Its ability to control their development is akin to meteorology's to stem a tsunami.

Its acolytes can research and warn and advise and predict but are, ultimately, impotent against the might of corporate ownership, global markets and of governments in thrall both to those markets and to the whims of electorates. This happy compact leaves little space for the implementation of prescriptions that might, just might, encourage, say, civility.

Although it is the work of two editors and thirty 'writers', and although it carries the Phaidon colophon, *The Endless City* is a door-stop that emits the unmistakable odour of vanity publishing, which is a form of onanism and thus usually solitary. The cost of this atypically collective stab at blindness and palm hair has been gener-ously met by Deutsche Bank, which funds a 'forum', the Alfred Herrhausen Society, named after the bank's sometime chairman who was murdered by the Red Army Faction in November 1989.

One cannot doubt that the forum and its managing director, Wolfgang Nowak, have good intentions. Such bodies are impressed by conferences and probably ignorant of the post-Shavian conjuga-tion 'and those who can't even teach, confer'. The Urban Age Project at the London School of Economics was granted the means to stage conferences in six 'urban-age cities'. Here is that gravy train's summation or spin-off. It must all have had a purposeful feel to it when it was proposed to Nowak by Richard Sennett, one of the rare contributors who is capable of parsing a sentence uncon-taminated by the grossest jargon; he is also among the few who don't subscribe to the conventional, *bien pensant*, old-fashioned 'progressive' festival of received ideas and consensual platitudes of which the book is mostly composed.

The Endless Cliché would have been an apter title. Vibrant, driver (meaning catalyst), sustainable, multicultural, challenge, iconic, diversity, holistic, tipping point, knowledge economy, street life, world city: every page is strewn with these comforting locutions which demonstrate their authors' obeisance to today's shibboleths.

Urbanism shares the properties of a cult. No matter which particular physical or ideological remedy it happens to be peddling, it is always with the faith that this remedy will succeed where the last one failed, that people can be improved by their surroundings, that such and such a conjunction of architectural form and public space will inhibit crime and antisocial behaviour. Such optimism is not so much touching as moronic. The real beneficiaries of the new cityscape of synthetic-modern 'affordable' apartments, gesticulatory buildings, landmark bridges and lumps of 'accessible' public sculpture are merely the begetters of such stuff (usually Libeskind, Calatrava, Foster and so on) and the bodies that commission them, self-congratulatory regional development agencies that just adore 'regeneration' because its effects are wholly unmeasurable.

The Endless City comprises investigations of New York, London, Shanghai, Johannesburg and Mexico City. Berlin is included, almost certainly as a sop to the sponsor, for Tokyo is excluded, according to the co-editor Deyan Sudjic, on the grounds that its 'comparative ethnic uniformity has kept it from fully transforming itself into a true world city'. While Berlin, the most hick of all capitals, has transformed itself? Really?

It goes without saying that the very epithet 'world city' is meaningless. Sudjic's last book, *The Edifice Complex*, was an unforgiving study of the boorish vanity of patrons and the sycophantic cupidity of architects. Here he is wearing a different hat, and his essays are, in comparison, emollient. He recognises the trap of proposing that remedies appropriate to one city are necessarily appropriate to another, but then falls into it by suggesting that public space 'is at the very heart of any definition of a city'. This is unquestionably what urbanists and architects believe ought to be at the very heart . . . But in the case of London it simply isn't so. London is, perforce, a city of private spaces because, whatever its inhabitants might want – and there is little evidence that they want anything other than

what they've got – it has very little public space that is more than functional. Its narrow pavements are discouraging to the *flâneur*. Its climate, whatever meteorologically insensible architects may think, is not suited to outdoor cafés. Sudjic goes on to allude to Bernard Rudofsky's great hymn to human resourcefulness, *Architecture Without Architects*, and suggests that attention should be paid to 'urbanism without urbanists'.

This is sound counsel. However, it ignores the blindingly obvious fact that attention is paid to such 'vernacular' spaces by painters, photographers, novelists, film-makers, travel writers, documentarists, *soi-disant* psychogeographers – in fact, by everyone who represents or depicts or studies topographies with the exception of urbanists and architects. Urbanism, if one takes *The Endless City* as illustrative, is ingrown and self-referential. Urbanists repeatedly quote other urbanists. They really should get out more.

For instance, how often and in what circumstances has the Sorbonne professor Sophie Body-Gendrot visited the outer Parisian *habitations à loyer modéré* (subsidised housing schemes) whose problems – she typically refers to riots as 'riots' – she ascribes to sensationalist reporting and to the desire of a 'minority of mobilised young men . . . to express their pain, their anger and, most of all, to be seen on television'?

Has Ricky Burdett, a cultural commissar who teaches at the LSE, cheerleads for Ken Livingstone and is 'chief adviser on architecture and urbanism to the London Olympic Delivery Authority', ever actually looked at this city on which he is helping to impose that grotesque white elephant? He seems not to know that the Thames becomes tidal less than five miles from Heathrow. He writes, incredibly, that central London house prices 'could lead to the creation of a "ghettoised" city with pockets of rich and poor neighbourhoods, rather than the greater diversity and social mix that has served London so well for centuries'.

He refers to immigrants 'from Poland and other ex-eastern European nations'. Where, precisely, are those countries now? One can only assume that placemanship takes up a lot of time. Rudofsky wrote of 'the tendency to ascribe to architects – or, for that matter, to all specialists – excessive insight into the problems of living when, in truth, most of them are concerned with business and prestige'. There are some decent photos and pages of comparative statistics. And we should all be fascinated to learn that London, Manchester, Liverpool, Birmingham and something called Leeds–Sheffield form a single megalopolitan city region. (2008)

Le Corbusier 1: The hands-on modernist

Le Corbusier Le Grand with an introduction
by Jean-Louis Cohen and chapter introductions by Tim Benton

Le Corbusier Le Grand is doubly well named.

First, the book is the size of two breeze blocks and notably heavier. It is, according to Jean-Louis Cohen, not a coffee-table book but the coffee table itself: all you need do is fit legs to it. Ho-ho. But he has a point. It is the least wieldy book I have ever been propelled across a room by – it is 0.67 metres wide when opened, and demands a physical as much as an aesthetic will if it is to be appreciated. This is peculiarly apt for Le Corbusier's buildings themselves require the attention of every sense you can think of and then some: they need to be swooned through. They are not comprehensible by intellect alone.

Second, this was a great artist, among the greatest of his century. And one who must evidently be judged by what he himself achieved rather than by the 'influence' he supposedly exerted upon two or three generations of keen plagiarists, groupies who gave great forelock and dimwit thieves who, characteristically, stole everything but the gift. Why are architects so dismally and blatantly

derivative? They are obviously unfamiliar with Montaigne's counsel that the copyist should disguise his sources by following the example of horse rustlers who 'paint the tail and the mane and sometimes put the eyes out'. It is, of course, at third or fourth hand, by way of these slavishly dependent and creatively stunted apes, that such thinkers as Simon Jenkins and the Prince of Wales, Tom Wolfe and Laurence Llewellyn-Bowen have gained both their knowledge of Le Corbusier and the confidence to vilify him as though he were a genocidal despot. He remains, more than forty years after his death, the hate figure of tectonically blind anti-modernists, though one wonders whether they had eyes to put out in the first place: Le Corbusier was merely blind in one eye. And given that he was protean, a multitude of men, which one is it that is so abhorrent? It is, needless to say, one who didn't exist, the 'Corbusian' architect of mass housing.

Despite what he himself claimed he was not a utilitarian, not a functionalist, not a rationalist, not an anti-romantic. The prescription that form should be determined by function is a nonsense which he toyed with in his writing but didn't practise: should form actually follow function we would have Lequeu's dairy in the form of a cow or a brothel in the form of labia. Nor was he notably adherent to the contradictory shibboleth of form as an expression of structure. Many of his works betray no sign of his 'five points'. Further, he is hardly more 'true to materials' than, say, the inveterate stuccoist John Nash was. The problem is that both his detractors and his acolytes want to believe that his written manifestos, urbanistic visions, utopian ideologies and theories are compatible with his buildings. But as a writer he is hectoring, prone to crass slogans, naive, pompous and often resentful – a chippy Jura peasant who senses himself endlessly conspired against. His most direly celebrated epithet, that a house is a habitable machine, has been captiously held in evidence against him because it lends itself to

being taken literally, though in sentiment it is unexceptionally Ruskinian and novel only in its bald expression. His monomaniacal 1925 Plan Voisin, which entailed the destruction of Paris's right bank and its replacement with ranks of cruciform skyscrapers, was properly greeted with derision; not perhaps enough derision, for its example would be coarsely followed twenty-five years later by such architects as Boileau and Labourdette in places like the all too 'Corbusian' northern suburb of Sarcelles.

Le Corbusier, writer, has little in common with Le Corbusier, maker of the century's most profoundly sensuous, most moving architecture. They are different people working in different media. The one a self-advertising propagandist whose schemes, Cohen astutely notes, were confected in the hope of becoming *causes célèbres* rather than as realisable projects. The other an artist-craftsman of peerless originality. Still, the reflective genius and the brassy charlatan were probably needily dependent on each other.

His domestic buildings are nothing like machines. On the contrary, due to his instinct and sheer capacity for invention, they are bespoke one-offs. The overwhelming impression they leave is of sedulously fastidious workmanship: they are handmade. The 'machine aesthetic' is often cosmetic. Over and again the appearance of machine production is achieved by hand and, further, with an apparent spontaneity – which is no doubt well-rehearsed. What pretends to be dashed off is as much a process of trial and error as, say, Roger Excoffon's seemingly casual typefaces of the 1950s. Le Corbusier's art was an art of illusion and legerdemain. This, astonishingly, is as true of the then revolutionary, large-scale, raw concrete Unités d'Habitation of the late forties and fifties which housed over 1,500 people as it is of the individual villas of the 1920s – expensive, 'purist', white, and built for a clientele of what would now be styled *bobos*. The jolt to collective senses of these early works can best be understood by appreciating that the mainstream

of France's architecture in the years after the First World War was even more *retardataire* than England's, trapped in an eternal belle époque.

This vast book is neither a biography nor a critical exegesis. J.-L. Cohen's thematically ordered introductory notes are dry, brief and bereft of interpretative speculation which, given his subject's lavish gamut of eccentricities, religio-sexual peculiarities, hygienic obsessions and political improbity, indicates a laudable restraint. Tim Benton contributes even more cursory prefaces to the chronologically arranged album or scrapbook which occupies all but thirty of the 750 pages.

There is method in their terseness and lack of mediation. This is a sort of archive between hard covers. The browser can immerse himself in photographs (of buildings, fancy dress parties, studios, lectures, scaffolding, travels, maquettes, etc.), subscription lists, paintings, diary pages, Malraux's eulogy, business cards, drawings and scribbles, exhibition posters, travel permits, cartoons, tapestries, postcards, illegible letters, plans and sections, advertisements, newspaper cuttings, pornographic sketches, perspectives, colour charts, sculptures and so on. It is formidably wide-ranging – over 2,000 items. Even so, it is obviously far from comprehensive. The editing is partial and programmatic. Its bias is gauged in such a manner to persuade us that Le Corbusier was a plastic artist rather than a theoretician, a dandiacal exquisite rather than a retentive Calvinist, a painter and sculptor whose practice of those disciplines fed his architecture. He was a considerable painter if often reliant on the examples of his friend Fernand Léger and on Picasso of the 'neoclassical' period (fubsy women joyfully working out).

The sculptures he created in collaboration with the cabinet maker Joseph Savina are formal experiments of the greatest beauty which, though made for their own sake, informed much of his later building at Chandigarh and at the churches of Ronchamp and Firminy

(which was only recently completed: it was duly and proudly exhibited on a postage stamp). It is also made apparent here that the natural and 'primitive' forms – of humans, insects, caves, trees – which preoccupied him were incorporated into his work at a much earlier stage of his career than is conventionally acknowledged. The seeds of the post-war masterpieces were planted years before. He was making small-scale essays in what would, twenty years later, come to be known as brutalism from about 1934.

Le Corbusier Le Grand is a feast. A homage to a giant and a reproach to the midgets who decry him. Every page is dense with ideas. It is also a source book for the modern world. Buildings, of course. And the germs of things one would never have considered: the Colibri cigarette lighter, the Mitchell gyroscopic reel, the decor of 1950s coffee bars . . . Beyond them is all that is yet to come, all that will be born from this posthumously fertile compost. (2008)

The sprawl turns

They are rigorously planned. They are chaotically laissez-faire. They are horizontal. They are vertical. They are stucco. They are tile-hung. They are all bungalows. They are all terraces. The houses have stone columns. The houses used to be railway carriages. They are modern movement. They are merely moderne. And so it goes on.

Suburbs are so disparate, so various, that to speak of 'the suburb' as though of a monolith, is both futile and lazy. To speak even of, say, 'the 1930s suburb' indicates a failure to appreciate that a suburb's essence (anything's essence, come to that) is in the details, the specificities. Take two London examples: the astonishing half-timbered area around Queen's Drive in West Acton is entirely different in character from the astonishing half-timbered area around Buck

Lane in Kingsbury. The one is formal, repetitive, claustrophobic; the other pretends to randomness, as though it all happened by merry English chance. Nonetheless, there is one quality that suburbs have had in common, which justifies the use of 'the suburb' in one context alone – their centrifugal bias. Many cities can be read as though by dendrochronological rings – the old walled town, the earliest extramural developments, the parks and villas beyond, the villages that are incorporated, the arterial roads and so on.

Cities push outwards. This is especially the case in England, where suburbs have a tendency to imagery and place names which belong to the country rather than to the city from which they thus seek to distance themselves. They promote the illusion of bucolicism. It is no more than an illusion. But in the case of such delightful mid-nineteenth-century exercises in *rus in urbe* as Nevill Park and Calverley Grounds in Tunbridge Wells, or the Park in Cheltenham, it is a mighty powerful illusion. And suburb breeds suburb breeds suburb. Always moving out, always shifting away from the original core, always creating a new edge which is of course provisional, a crust which will be ruptured by the next wave. Suburb is virtually coterminous with exurb.

However, over the past decade or so, we have witnessed the creation and spread of a breed of suburb which does not conform to this pattern. It is centripetal. It does not acknowledge that it is a suburb because it is situated in or close to the middle of the city. The people who inhabit such places would doubtless be insulted to be called suburban: quite why this word remains a term of denigration is puzzling, for about 80 per cent of Britain's population lives in suburbs even if it is seldom willing to admit it.

This new form of suburb – situated like an organ rather than a limb – has several provenances. The polarity of the inner city (deprivation) and the 'leafy' suburbs (affluence) is propagated by unobservant politicians and indolent journalists: it's as accurate as

claiming that Indian restaurants are decorated with flock wallpaper. Such a division has been disappearing for half a century since the process which came to be called gentrification began in a *faute de mieux*-ish way: properties in many inner-city areas (which had actually begun life as suburbs) were affordable because they were little more than slums.

In the early 1960s a house in Notting Hill was cheaper than a comparable house in Beckenham. Of course, London is atypical of Britain; indeed it has largely seceded from Britain. But the 'reclamation' of the inner city by what France calls *les bobos* – the new bourgeoisie which believes itself bohemian – has spread. It can be seen most obviously in Manchester and Salford. But Bristol, Birmingham, Leeds, Southampton and Portsmouth are all in on the act, too. The process has inevitably changed: it is, after all, now in its third generation. What began with the restoration of clapped-out houses mutated into the residential transformation of warehouses, factories, schools, etc. Since the accession of New Labour thirteen painful years ago, countless sites have been consumed by new buildings which conform to the urban idyll – synthetic-modern towers, a few neo-modern townhouses, Ikea-modern 'continental' piazzas impasted with Carluccio's, Costa, Monsoon, Nero, DKNY, Starbucks, Tesco Metro, Accessorise, Pret a Manger. The dismal sameness of the self-proclaimingly ethical businesses is matched only by the sheer hackneyed dreariness of the self-proclaimingly sustainable domestic architecture.

This species of burb has further causes or – in the debased patois of the corrupt regeneration racket – 'drivers'.

The desirability of high density has long been conventional wisdom among architects and planners, even though it owes more to faith in a (sub)urbanistic panacea than to an appreciation of the decidedly non-European way that England's towns and cities have actually developed hitherto. It is, supposedly, not the conventional

wisdom of the majority who suffer the misfortune to be neither architects nor planners. Nonetheless, over the past decade and a bit it has gained both political patronage and commercial feasibility: volume builders who formerly constructed exurban estates of approximately Victorian triple-garage villas have transformed themselves into urban regenerators energetically plagiarising the early modern canon.

They have been the beneficiaries of western Europe's most unreliable public transport which has turned commuting into an overpriced nightmare. It is no doubt more convenient for those who work in, say, the City of London to live in Southwark and walk to work than to live in Chislehurst and wait for a train that never comes. That tendency is repeated all over the country.

High density is most ostentatiously and most obviously represented by schemes that are virtually free-standing, typically on brownfield sites where such density can be absorbed. A greater, though less noted increase of density is being achieved by stealth, by a sort of infill that dwarfs the host. It is no longer a matter of houses being built in back gardens here and there. Rather, of entire quarters of towns, within their boundaries, being restructured to accommodate estates and the roads that serve them. This is a seemingly perpetual process. Victorian gardens were long ago swallowed up. Now the gardens of the houses which occupied them have gone. And soon those gardens will disappear too. The long-term effects of such construction are immeasurable, whether or not they are bruited as 'eco'. Did anyone ever build an ecologically right-on tarmac'd road?

This expansion is analogous to that of the new gated synthetic-modern burbs. What it amounts to is a form of inner sprawl. Where towns and cities were once afflicted by warts that conventionally spread out, they are now prey to verrucae that grow inwards. Combine that with the UK's doctrinaire refusal to build

social housing, and the result is class clearance. The haves are reoccupying the inner cities, centrally situated high-rise blocks which are being gradually gentrified. The have-nots are increasingly forced out beyond the ring road. Which is just the way things are ordered in most of Europe.

It would be rash to claim that there is no reason to question that this model will be adhered to for years to come. But so long as the chasm between rich and poor increases (in a Third World rather than European manner) it is difficult to foresee a return to what was the norm only throughout the late nineteenth and most of the twentieth century – which, it must be said, constitute a demographically atypical era, the only era when cities were rendered insalubrious by reeking industry, when those who could afford to moved out. With the exception of such blighted cities as Leicester and Bradford where minatory inbred Muslims have prompted 'white flight', the initial trickle back to the centre has swollen to become a stream, if not yet a river, let alone a torrent. It is the way things are going. The dystopias of the future are, reciprocally, already presaged too. (2010)

Ordinary lives
Estate by Robert Clayton

The Lion Farm Estate is at Oldbury in the Metropolitan Borough of Sandwell and Dudley. This is the eastern fringe of the Black Country where it seamlessly elides with Birmingham. It is a place of former mines, former forges, ruinous factories, little-used canals and big sheds. The estate was built in the first half of the 1960s when the area was pre-post-industrial. It comprised three 13-storey towers, six 16-storey towers, several terraces of maisonettes, some streets of two-storey semi-detached houses and some of shops, some iffy public sculpture, much lawn, a kind of drop-in centre, a

pub (Mitchells & Butlers), a school, a church to which would be attached a signboard announcing, hopefully, that Jesus Is Alive.

When construction began Harold Macmillan was prime minister; when it was completed Harold Wilson's first administration had just put an end to what the people's party's propagandists called 'thirteen years of Tory misrule'. Peter Griffiths, who stood, successfully, in the Tory interest in adjacent Smethwick in that 1964 election, campaigned with the infamous slogan 'If you want a nigger for a neighbour vote Liberal or Labour' and found himself branded a 'parliamentary leper' by Wilson. Such deserved antagonism was actually rare. And in one area there was – and there would remain, till the advent of Margaret Thatcher fifteen years later – a cross-party consensus so entrenched that it was a given: the need to build public housing (the epithet social housing was in the future) was not challenged, or challengeable. To question it would have been as squalid and grotesque as Griffiths' winning formula.

Beyond satisfying need, there existed the conviction that it was the duty of local and national government to provide a home for those who could not afford one. There were, it must be recalled, people living in caves only twenty miles from Oldbury, at Wolverley, Kinver and other sites in the Severn Valley until the turn of the 1960s: no running water, no gas, no electricity. They were exceptional. But my grandmother, the widow of a man born in Oldbury, was not. She was one of hundreds of thousands of people whose house, at that date, a decade and a half after the end of the war, had no bathroom, no indoor toilet. Hers happened to be in Evesham but it might have been anywhere in Britain. Modernisation was a necessity rather than a luxury. Speed of construction was vital. The sheer number of homes that had to be built was daunting. Aesthetic ideology, political exigency, volume and urgency proved to be an often-baneful combination. Schemes were not thought through. Infrastructure was overlooked. Unproven technologies were

employed. Little consideration was granted to the suitability of novel forms to domestic life. Nonetheless, new communities did flourish, house-proud communities. The present was materially better than the recent past.

When Robert Clayton made his photographs of Lion Farm Estate, even its most recent buildings were more than a quarter of a century old. That was in 1991. The consensus on housing was long since ruptured. The right – right! – to buy had been introduced and with it a fiasco of unintended consequences, one of which was the establishment of a hierarchy of social housing, de facto a two-tier system which defined what was desirable, and would be bought, and what was, no matter how cheap, unsaleable. The latter tended to be flats. That multiply occupied buildings might require constant maintenance was a notion that was no longer entertained, had in some instances never been entertained. Perhaps the elected representatives and housing department personnel all drove cars which did not have to be serviced. The neglect of public housing stock increased. Yet despite that neglect there was no marked diminution in the quality of life. What changed the complexion of social housing for all time was the practice of 'decanting' into second-tier projects sociopaths, recidivists, junkies, the unemployable, the wilfully dependent and the ranting, mumbling, cast-out victims of another cruel wheeze of that era, the mendaciously named Care in the Community. Clayton captured Lion Farm on the eve of this calamitous invasion, which would result in the partial destruction of the estate.

The strength of his vision and his work's usefulness (and poignancy) are founded in its balance. It shows a place which is worn, far from perfect, rough at the edges, where civility is perhaps provisional, where the promise of worse to come has not yet been fulfilled. Clayton resists drama and melodrama. He eschews exaggeration. In his landscape compositions he does not make the towers appear

'heroic'; his method is antithetical to that of institutionalised architectural photography, which flatters buildings and their makers, often by excising their surroundings so that they look like stand-alone objects: a trick, one that we fall for time and again. Until we are reminded by work like this that everything has a context, a place in the unruly jigsaw. In this case a place which is difficult to define.

The estate was built on former agricultural land. And while a cursory scrutiny suggests that it was intended to start from zero, it incorporates a few earlier houses which had spilled out of — what? The fringes of something? The outskirts of somewhere? There is a palpable air of dislocation. It is centrifugal, or would be had it a centre to flee from. There is no such thing as a non-place. But there are places whose incoherence and shapelessness render them bewilderingly illegible. Their identity is frail. Where do they belong?

Lion Farm is further puzzling: the Black Country is among the most populous areas of Britain yet the estate seems both far from anywhere and, more astonishingly, deserted to the point of desolation. Sure, Clayton makes portraits of some of the inhabitants. These compositions are artfully artless: the camera is often only just above floor level; sometimes the shot is gently skewed; a pair of shoes protrudes into frame; the subjects no more reveal themselves than they would in a passport photo — they are not 'sitters', they are seldom animated. Few frames contain more than one person. Communication between people is perhaps the exception. The estate harbours a worrying number of dogs, mostly of breeds that are really quadruped weapons. The overwhelming impression is of want and emptiness, a void in the heart of England, a zone bereft of people. Raggedy grass stretching to the horizon, vast concrete car parks with no cars, a removal van in the distance, pylons, blank walls, minimal graffiti, deserted lift wells.

Clayton's reluctance to push colours is indicative of the entire project. There is no moral virtue in avoiding saturation and there is

nothing 'dishonest' about availing oneself of post-production tools. But there is unquestionably a documentary virtue in recording what things were like without caricature, without attitude, without exaggeration, without intercession – so far as that is possible, for naturalism is, after all, a form of artifice which occludes its artifice. Still, he convinces us that this is what it was like a generation ago.

His Lion Farm was obviously not the green and pleasant land which the post-war consensus strove for and did, sometimes, achieve. But nor was it a dystopian slum. Only the faintest germ of its potential to become one is apparent. (A vandalised car, boarded-up windows.) It could go either way. Tomorrow is, as ever, ungraspable, and anyway the photographer is not a soothsayer. Indeed he wilfully avoids predictive signs. Within a few years six of the tower blocks would be demolished – in accordance with fashion's dictates. It was not the lives that were transitory but the buildings. The average life of a building shortens just as we 'enjoy' ever more longevity. Clayton was there just in time. What he recorded is valuable precisely because it shows neither a model estate, a showplace, nor a sink. The typical is elusive. It's a hard thing to capture because it surrounds us and doesn't shout. It is the 90 per cent which is habitually overlooked as we set our sights on the exceptional 10 per cent: on the one hand picture-postcard tourism, on the other frissons of delight at noxious slums.

There was nothing special about Lion Farm Estate. It could have existed in more or less any British conurbation which was on the cusp of losing its *raison d'être*. What is special is Clayton's humane rendering of it as a time capsule which emphasised ordinariness. This was how it was for millions of people in the early nineties. This was Britain between Thatcherism and, well, the smiley neo-Thatcherism of New Labour. A new political consensus was in place, an insidious consensus which blithely disregarded the sort of people who lived on such estates, the invisible people, the little

people who had not the wherewithal to exercise their precious right to buy. Again, Clayton leaves us to reach such conclusions. He has a broad and important socio-political point to make. It is all the more potent for being made so quietly. (2014)

Conquer and divide

French colonies were founded in the wonderfully immodest proposal that there was no human fate finer than to be a French citizen. Hence the bewildering sight of children in west Africa being taught 'their' history: the St Bartholomew's day massacre; Ravaillac's body being eaten by witnesses to his execution; the Sun King's furniture; Napoleon's Egyptian campaign; and so on and on. The British empire entertained no such grandiose notions of achieving linguistic and cultural coherence. It was not in the business of recruiting for the mother country. It did not seek to dissuade Hindus or Zoroastrians of their beliefs. Save in the matters of cricket and business, it exhibited a combination of laissez-faire and incuriosity.

In the long half-century since decolonisation was messily effected, both countries have continued to cling to their colonial model – at home. France deludes itself that its millions of disaffected north and west African immigrants are on the road to assimilation as citizens, even though many of them are patently travelling in the opposite direction, refusing to shun the veil, demanding single-sex swimming pools and halal for all, praying in the street, attacking Jews on behalf of Hamas. Britain, astonishingly, congratulates itself on the fact that in certain London boroughs more than sixty languages are spoken. It apparently neglects to notice that 'vibrant diversity' is merely a euphemism for an elective apartheid which is duly pandered to. Language is the glue of a society, its paramount means of communication. It is, or should be, only secondly a badge of identity, belonging and exclusivity.

Britain 'celebrates' differences and chasms of separation, presumably considering that they cannot be overcome, so why bother? France optimistically 'celebrates' whatever it is that peoples supposedly have in common – a hangover from the Enlightenment, whose universal values are indeed universal if France is the universe, as it has often reckoned itself to be. The two approaches – the pragmatic and the idealistic – are so gravely and complicatedly flawed it's difficult to decide which is dafter. They will end in tears.

Both are susceptible to architectural representation. Not in the way that, say, a town hall is wilfully representative of a council's authority or a law court of the judiciary's. Rather, they are giveaways, unwitting witnesses to the ethos of the societies that created them. From the balcony of my office I can see, as much of Marseille can, La Rouvière and Super Rouvière, an extravagantly XXXXXL development of two blocks which between them house 8,000 persons. The second stands so high on the precipitous foothills of la Marseilleveyre that it occludes the natural horizon. From here, two kilometres distant, they look like a fortress. From up there, not much more than five minutes' drive away, they look like a fortress. They are a fortress. At ground level they are blind and mute, and no doubt have olfactory problems too. Welcoming is not the word.

If I go to my wife's office I can see from that balcony la Résidence Cadenelle, Super Cadenelle and les Jardins de Thalassa. These immense and sybaritic buildings of the 1960s and 1970s are 'gated'. One could easily never go off-campus: hairdressers, *traiteurs*, *charcutiers*, dry cleaners, bakers, greengrocers . . . Retailers have a captive audience of Prozac'd paranoiacs. Many of the inhabitants are the dispossessed of Algeria and their descendants – the *pieds noirs* whom Charles de Gaulle betrayed by treating with militarily defeated terrorists – the same terrorists who went on to turn that tragic country into a sanguinary nightmare. These inhabitants, many of them Jews, still fear Arabs, perhaps wrongly since most

Arabs are engaged in dealing drugs on the other side of town – think *The Wire*, and then some; ten-year-old kids 'earning' 1,000 euros per week as *guetteurs*, lookouts. The guards at sites like les Jardins de Thalassa are very definitely not kids. And if they are concierges, they belong to the primate chapter of that calling.

So France behaves urbanistically in contradiction of its dream of wholeness. It may in theory abhor *communautarisme* and segregation but in practice, in the field, it candidly acknowledges the gulf between haves and have-nots. Britain's have-nots – floundering without a common language, divided and ruled – seem incapable of achieving the levels of resentment that are easily reached in the *banlieue*. No doubt they embody the vaunted British attribute of tolerance. Tolerance of oligarchs, tolerance of Dubai princelings' hideous cars, tolerance of hedge-fund spivs, tolerance of grotesque architectural bling. (2014)

Constructive insider dealings

Four Walls and a Roof: The Complex Nature of a Simple Profession
by Reinier de Graaf

Rem Koolhaas's provocative *Delirious New York* begins with a paean to Luna Park on Coney Island, 'a new technology of the fantastic' which, he speculated, was the model for Manhattan. Thirty-nine years on, Reinier de Graaf neatly ends his equally provocative *Four Walls and a Roof* with a chapter about the ever-changing architectural fate of the Rockaways peninsula, a mile or so south-east of Coney Island across an inlet of Lower New York Bay. Part of it was once a plotlands development known as the Irish Riviera. It has been subjected to social-housing experiments, gated 'communities' and the attentions of hipster surfers. This edgeland of beached whales has been a sort of testing ground for prevailing theories translated into political machinations. The book abounds in similar cases.

Koolhaas is now among the most celebrated architects in the world, and de Graaf, in his early teens when *Delirious New York* appeared, is one of his partners in OMA. Most architectural practices, even those with offices across the globe, have no one in their ranks who can write. OMA has two, which must be some sort of record. It is of course hardly surprising that both these architect-writers should be Dutch, and so have a better command of English than most inhabitants of these linguistically sundered islands. Maybe he regrets his fluency. Early on he recalls being taught by Herman Hertzberger, a compatriot of the generation before the Dutch became routinely anglophone: 'Somehow his flawed English carries great profundity and demonstrates deep knowledge of the architect's ultimate secret: packaging dependency as authority.'

De Graaf is not out to make friends among architects. Indeed, one of his recurrent preoccupations is the self-aggrandising baggage that the subtitular 'simple profession' has gathered in an effort to occlude the obvious – the architect is the servant of the patron and architecture has limitations which its practitioners are reluctant to admit. He gets his retaliation in first. He teases Richard Rogers. While he admires the architect's achievements, he is less taken with 'the twenty-first century homo universalis' whose speech he phonetically renders with gusto: '"Citieaaahzz." He pronounces his topic as if he is tasting vintage wine . . . With each new sentence a new location, topic or domain is added to the theoretical competence of architecture.' Thence he moves on to Renzo Piano, whose 'constructions tend to be hidden under thick layers of moss, meant to demonstrate his commitment to the green cause'. If only the Shard and the ghastly, chromatically infantile St Giles development had been so cloaked. Next target: the boorish, menacing American 'academic' and architectural groupie Jeff Kipnis, submitting an audience 'to a kind of intellectual waterboarding' when discussing

the Guggenheim Helsinki – a project which has now, mercifully, been binned.

De Graaf has no fixed method. But the impressive extent and depth of his knowledge persistently inform his many subjects. His mood is invariable. He is constantly and exhilaratingly cynical; he is pretty much contemptuous of architecture's presumption that construction is some sort of panacea; he has not allowed himself to be infected by any of the received (and often bogus) ideas that the architectural flock gullibly subscribes to: 'sustainability', 'greenwash', 'community', 'participation'. A decade henceforth there will be a new set of shibboleths. It comes down to fashion.

Sustainability is a fashion – and a lie. The very process of making a building is about as unsustainable as it gets (London *passim*). It makes no difference whether the construction is a volume builder's neo-neo-modern block of (inevitably) luxury flats with a showy, non-utile greenwash wind turbine on top or a Big Name's 'responsible' chunk of corporate bling with negative emissions and the carbon footprint of a one-legged sprite; the energy used in the making, the confusion caused by the accumulation of equipment, pits, debris and Dagenham smiles brings cities to a halt. 'Business as usual' signifies the city as a building site in all perpetuity, for in its lust for ground to build on, the construction industry, like Saturn with a taste for glass and Corten, must destroy its own recent award-winning products.

Because he displays such candour – albeit polished candour, and such a perfectly gauged lack of tact – it is easy to forget that the author is an architect, an insider, part of the system he dissects: OMA is about to dump a load of absolutely unneeded, absurdly costly, kulchur space on Manchester, a project signed off by Little George Osborne as a part of the chimerical Northern Powerhouse. De Graaf is likely to remain an architect for decades to come. Given

those circumstances, his enthusiasm for biting the hand that feeds or, even more, the hand that might have fed, is admirably risky.

Despite having lived there for some years London puzzles him. But then he is dealing with the BBC, which, extraordinarily, gives him 'media training' (presumably instructing him to wave his arms and mangle language with glutinous sincerity) in order to improve his presentation to the Corporation's high command. He has a paranoiac suspicion that London is a city where decisions about planning and land use are liable to depend on 'a local councillor bumping into a local resident and informally discussing the plans over a cup of coffee'. Should it be true, this succinctly illustrates a predictably homely English form of corruption. If de Graaf is to be believed, everywhere – China, Dubai, Moscow, etc. – possesses such localised tics in addition to the pan-global gamut of sharp practices, deceit and worthless contracts.

The book comprises more or less theoretical essays which combine brilliance and gibberish, an interview with Khrushchev's great-granddaughter, reminiscences, random historical investigations, a dash of economics, thirty pages of photographs of social housing failures being demolished in explosions, diaries and reports. There is no sign of editing, no index, little evidence of authorial discriminancy. If it has at some time been committed to paper or screen it is reckoned to be worth publishing. No matter. The diaries in particular illumine the murky practices and tentacular reach of the construction industry, which might just as well be called the destruction industry.

They also demonstrate that the actuality of architectural practice – a morass of compromise, horse trading, maniacal hubris, brinkmanship, unjustified optimism, tantrums, slobbering sycophancy and frequent humiliation – is far from its sleek, mediated representation: 'architecture and marketing become indistinguishable'. And, astonishingly, they do so despite the widespread quasi-academic

attention that is increasingly granted to urbanism, infrastructure and their problems, despite the unprecedented discourse surrounding 'the city' and megacities, which is joined by representatives of every conceivable discipline who claim expertise yet are, as de Graaf puts it: 'united through the frank admission that we do not have a clue'. The vacuum occasioned by such jolly ignorance is quickly seized as an opportunity by politicians, their certainties and their clientelism: the architect is just one sullied beneficiary of the construction industry's fabulously generous, big-hearted donations to political parties – bribes is another word to describe them.

De Graaf offers a two-page squib entirely composed from Big Names' squalid hypocritical quotes about the morality of working for totalitarian regimes. This grotesque exhibition of mass exculpation and shameless appeasement would be chilling were it not so predictable and so feeble. Koolhaas, for instance, excuses himself with: 'We simply have to realise that the right of the individual, which we hold so holy, has no tradition in countries like China.' So much for architecture as an instrument of even modest change. The participants give whoredom a bad name – and they are proud to do so.

In francophone Belgium '*Architecte!*' and '*Espèce d'architecte!*' are grossly abusive insults. (2017)

Le Corbusier 2: Stitch-up in a concrete overcoat

The 'revelations', fifty years after he drowned, that Le Corbusier was a 'fascist' and an anti-Semite are neither fresh nor startling. Indeed, they're old hat. And it defies credibility that the authors of three recent books about this tainted genius were ignorant of what anyone with even the frailest interest in architects' foibles and tastes has been aware of for years. Not that this has deterred them; nor has it deterred newspapers from filleting the books for supposedly sensational titbits.

What next? The hot news that the cuckold Carlo Gesualdo murdered his wife and her lover? That Jean Genet has been discovered to have been, you know, on the light-fingered side? But of course Gesualdo is not accused of providing the inspiration for vertical slums the world over. Genet did not fill the impressionable minds of baby architects with the ambition to start from zero by razing Paris to the ground.

Alive, Le Corbusier was a great architect. Posthumously, he has been a great scapegoat, an Aunt Sally who can be tirelessly derided for all of urban life's ills because he rendered thought crimes concrete — and people know his name. Those crimes are, of course, primarily aesthetic.

The 'revelations' prompt, once again, the question of the extent to which his political thought between the early 1920s and the liberation of France was dependent upon and even determined by his proposed architectural and urbanistic programmes. The question has to be posed that way round: the contrary notion that his aesthetics were politically fomented is a non-starter. He might compromise himself but he never compromised his art. His manoeuvring was risibly opportunistic, obvious to all his targets. He shifted unconvincingly between the ever-mutating factions of French fascism.

The short-lived far-right party Le Faisceau, while keen on technocratic Taylorism and Fordism, was equally infected by a blood-and-soil folksiness derived from Barrès and was inimical to Le Corbusier's 'internationalist' abstract purism: 'internationalist' meant Jewish. So Le Corbusier sidled up to Le Redressement français, a movement of industrialists that placed rather less emphasis on collectivism: this apparently accorded with his enthusiasm for monks' cells. The next object of his sycophancy was Hubert Lagardelle, the future minister of labour in the Vichy regime; his regional syndicalism preached anti-capitalism, localism and direct action.

It is improbable that these parties, whose ideologies were all but indistinguishable save to the engaged, had any effect on the schemes Le Corbusier wanted to realise. He was an architect, thus a promiscuous tart: it goes with the job. An intrinsic facet of servility is to flatter whomever it is that holds the purse strings by professing to share his convictions. Show me an architect who genuinely believes in this or that doctrine to the exclusion of all others and I'll show you a low-waged specialist in loft conversions, a high-minded purist who would never betray his 'principles'.

Le Corbusier was so committed to fascism that his first building on a vast scale was the Centrosoyuz in Moscow. This work was among those that caused him to be vilified as a communist – or at least a communist sympathiser. Now, Le Corbusier's fellow Switzer Alexander von Senger really was a fascist. He devoted a book entitled *The Trojan Horse of Bolshevism* to lambasting Le Corbusier, whom he had already had excluded from the Federation of Swiss Architects. When von Senger himself was expelled from Switzerland as a Nazi informer, he went to live with his paymasters. He wrote *Race and Architecture* and became a contributor to the *Völkischer Beobachter*, whose sometime editor Alfred Rosenberg appointed him to a chair at Munich architecture school.

This was a far grislier involvement than Le Corbusier's with Vichy, which was, yet again, an exercise in fruitless opportunism and, retrospectively, blustering self-exculpation and stage-whispered hints of resistance activities. He spent a year and a half in that spa town, chosen as the seat of government because of the sheer number of hotels. Nothing came of it – despite meeting Pétain, despite the championship of Lagardelle, despite being appointed as head of post-war reconstruction. The nearest he came to actually building rather than pleading was a scheme in Algiers: von Senger and Rosenberg were among those who blocked it.

Among Vichy's other petitioners for architectural commissions was Le Corbusier's original master Auguste Perret. He was appointed first president of the Order of French Architects, whose laws stipulated that no more than 2 per cent of members could be Jewish. This is anti-Semitism of a different order from Le Corbusier's, which was confined to snidery in letters to his mother; he never made a public statement of anti-Semitism, it was a squalid secret of a sort that many families shared in private. Yet Perret's (at best) passivity on the matter attracts little obloquy. And – a very different case, of course – what of St Albert Speer, the slave-driver who so charmed Gitta Sereny that he is today the acceptable face of war criminals, doted on by bloated classicism's clownish admirers, his complicity in enormities forgotten?

Had Le Corbusier really been the bolshevik the paranoiac von Senger claimed he was, one can be sure that the fiftieth anniversary of his death would not have prompted this rancorous little storm. But to have been a fellow traveller of the right, no matter how sluggish and lame a traveller, is a guarantee that you will be periodically exhumed and given a kicking by gnats.

Old lefties, cause-whores, apologists for collective farms and famines, pogroms and Beria, *bien pensant* supporters of the FLN, Palestinian terror and theocratic executioners can, however, sleep the sleep of the self-righteous knowing that they have left the world a better place, and that their 'ethical' anti-Semitism was wholly justified. They will not be exhumed. (2017)

A place for people
Building and Dwelling: Ethics for the City by Richard Sennett

According to the Dutch architect Reinier de Graaf, the people – planners, utopian environmentalists, sociologists, quango soldiers, free-range urbanists, demographic strategists, 'place makers', *soi-disant* visionaries, soothsayers and, of course, architects – who

attend portentously entitled, quasi-academic conferences on The Final Favela, The Shapes of Sprawl to Come, Agglomerative Control Theory, The Future of Futurology, etc. are 'united through the frank admission that we do not have a clue'.

Cluelessness has done nothing to inhibit a thriving cottage industry publishing countless tracts and manifestos wrought in the deadening locutions of conference-speak. Urbanist shall speak unto urbanist. And only unto urbanist because any passing civvy or 'lay person' can only improbably be bothered to decipher what's being said. The ideal of the open city is described in closed terms which unwittingly emphasise the gulf between those who confer and the overwhelming majority who don't, between those who build or, more likely, try to influence what is built, and those who dwell — whether as passive patients or as engaged participants.

Despite a few uncomfortable instances of 'outside the box', 'world class city' and 'tipping point' (which, *pace* Richard Sennett, is hardly 'everyday language' save among the lexically deprived), *Building and Dwelling* is pretty much jargon free, which is quite an achievement given the milieu the author evidently frequents. It is, too, far from clueless.

But anyone seeking the key, the clue, to the mysteries of ever-shifting urban populations and how to manage them must look elsewhere. This ineptly edited but constantly stimulating book is a lateish life appraisal of what Sennett has read, written and, most vitally, witnessed on the street or in the marketplace in the tradition of the sharp-eyed, sharp-nosed *flâneur* taking in every sensation. He goes against the doxa. For instance: those shifting populations are not necessarily increasing. He notes that 'Remitting money home . . . modern migrants treat the places in which they alight as five- or ten-year work sites rather than destinations into which they integrate for good.' 'Home' signifies, inter alia, Morocco or Turkey and the remittance villas built accretively over those five or ten years.

They will typically be sited outside cities which, for many under-privileged people, are open prisons to flee from. In an atypical chapter Sennett considers another sort of flight from the city: Martin Heidegger's, to his Black Forest 'hut', a place to escape, among others, the Jewish colleagues he betrayed.

He proposes the existence of a dialectical tension between *ville* and *cité*. The former, broadly, is the physical actuality of the place. The latter is the life that is led in that place – neighbourly or hostile, inclined to sloth or to energy, exhilarating or debilitating. The possibilities are many. How *ville* and *cité* respond to each other is his recurrent motif. Is it possible to engineer a *ville* which will condition, maybe improve, the lives led in it? Human history glistens with ideal places, none more perfect than those which remained staunchly on the page or, even better, in a bedsit visionary's backbrain.

Once these places are built the goal of urbanistic determinism becomes actually more distant, not least because urban theorists – the Chicago School, Lewis Mumford et al. – are, unlike the people who inhabit their now three-dimensional wheezes, strangely unconcerned with what their dreams should actually look like. They are preoccupied, rather, by abstract conceits such as 'resistance', which in John Dewey's opinion fed the creative impulse and might be said to prompt behaviour which reacts against the impositions of the *ville*. Aesthetics is not among their preoccupations. It is only shallow people who do not judge by appearances: Ebenezer Howard, the least Wildean of men, was a lucky plodder. In his numbingly dull manifesto, *Tomorrow: A Peaceful Path to Real Reform*, which would lead to the foundation of Letchworth, the first garden city, there is no mention of architecture, of buildings' scale or style.

However, the construction of Letchworth coincided with the apogee of the Arts and Crafts. So, by happy chance, it contains the largest concentration of houses in that peculiarly English, potently Luddite idiom. Two decades later, when the second garden city,

Welwyn, was built, domestic architectural fashion had shifted. The result was an unconvincing mix of beaux-arts planning and officers'-mess neo-Georgian buildings. And, more recently, an unusually healthy appetite for hard drugs which may or may not be stimulated by those surrounds, and which implies displacement and discontinuity without travel or migration.

Sennett uses the word *erlebnis* to signify an experience which is spontaneous, surprising, susceptible to innovation and keen to break with the past as opposed to *erfahrung*, the gradual accumulation of experience which grows ever more onerous and seemingly precludes personal reinvention. Usually *erlebnis* is contingent on porousness. It thrives on cosmopolitanism's openness to cultural mixity. It is, too, a bulwark against poisonous doctrines and duff practices set in stone – nationalism, monotheism, monarchism. It values fluidity, toleration and indifference to difference, provided these qualities are tacitly understood rather than loudly proclaimed, provided the differences are not spoken of, provided social intercourse remains at the level of courtesy, which was Sennett's experience of the Clerkenwell area where he lives, till culpability for the now doubly filmed Hatton Garden heist fomented Muslim anti-Semitism.

'Superficiality is no vice,' said Jane Jacobs, defending the empty yet meaningful rituals of everyday corner-shop courtesy which all parties know is a sham. The author, in 1961, of *The Death and Life of Great American Cities* is everywhere in this book, a ghost but a far from passive ghost. She is even to be found with the author in a photo taken at the White Horse Tavern in Greenwich Village, circa 1963. The third member of their party has collapsed against the bar. Drink? Battered by words?

Jacobs was a handful, the doyenne of agitprop urbanists, a fierce opponent of big-tech comprehensive development and especially of the boorish but necessary Robert Moses's megalomaniacal infrastructural projects in New York, notably the Lower Manhattan

Expressway. It has to be said, however, that New York's magnificence owes vastly more to Moses than it does to Jacobs. But she undoubtedly articulated the attitude of a certain *bien pensant* liberal public towards mid-twentieth-century planners' willing sacrifice of cities to the car. Her work was reactive. She favoured small-scale remedies, ad-hocism, the nubbly texture of 'difficult' neighbourhoods. Her perception of such places' potential for renewal has bizarrely brought her into line with planners and urbanists of a very different mettle.

There is a rule, or ought to be, which states that whatever is built or renovated or rescued, whatever cracker-barrel philosophy is applied to the disposition of streets and parks, there will occur reactions and repercussions which are unforeseeable or, as likely, idly unforeseen by the people responsible (Baron Haussmann, Frederick Olmsted, Ildefons Cerdà, etc.), yet these reactions will be embraced by the next generation and will be accepted as orthodoxies. In fact it didn't take a generation. The sociologist Ruth Glass, four years older than Jacobs, coined the word gentrification in 1964. She read the entrails correctly: a three-room flat in St Stephen's Gardens, one of Rachman's Notting Hill slums, is currently for sale for just short of 2 million; like the *ville*, the individual house is mutable according to the life led in it and the money thrown at it. Sennett advises that 'the ethical way to build in cities accepts the primacy of adaptation'. Glass further observed that the majority of the late-Georgian and Victorian houses and 'ouvrier cottages' being transformed in the sixties, notably in that area and in Islington, were so insalubrious that building societies and banks would not lend against them. Thus they were bought by people with family capital who didn't require loans. Arty, rather than artistic, people who when they grew up begat trustafarians who begat further trustafarians; a new urban upper-middle class was created and with it a new 'street' patois and the delusion that the Grove was 'edgy'.

This process was analysed and formalised by Jacobs' populist successor Richard Florida, who has cut a swathe through urbanism and left a trail of free-trade quinoa and class clearances. This tireless self-publicist enchants slow learners with his precious gift of stating the blindingly obvious yet making it seem original. Sennett is unimpressed by his highly unoriginal aperçu that city quarters where 'creatives' settle will invariably become attractive to heavy money. 'Creatives' in this context is a grossly flattering epithet for brainstormtroops, multiplatform contortionists, important synergy gurus nuking an outmoded logo from the face of a polo shirt. What it does not signify are actual makers, writers and artists, who in London increasingly have the choice of being forced out to Zones 5 or 6 or leaving the metropolis altogether, an ever more enticing prospect given the curious instance of the *ville* becoming inimical to the *cité* because swathes of it are underpopulated, hence largely deserted, thus dangerous. There is more security in density than in isolated gated 'communities'. (2018)

27

Writers

Moth to the flame

Vladimir Nabokov: The Russian Years by Brian Boyd

The armature of this life is known, teeters on the overfamiliar. Scion of a politically influential and intellectually potent liberal family. Enchanted childhood in St Petersburg and on the family's estates outside that city. Sexually precocious pubescence. Massive inheritance – when Vladimir Nabokov was eighteen years old he owned £2 million. When he was eighteen years old the Bolshevik revolution robbed him of it. Serial exiles: Crimea, Cambridge, London. Genteel poverty in Berlin. Near destitution in Paris. The footfalls of this or that tyrant and his murderous armies are always close behind. A boat waited at Saint-Nazaire, a desperate scramble for money to buy tickets; they made it by a whisker. Brian Boyd's second volume will begin with the already linguistically metamorphosing writer's arrival in America.

The assertion in *Lectures on Literature* – Nabokov never *suggested* anything – that 'great novels are great fairy tales' might be adapted to qualify its maker's life. Prince to pauper and back again; this is elemental, archetypal. There were the years when it seemed that he was condemned to wander eternally. There was his father's murder (by a rightist zealot who was to become second-in-command of

Hitler's department of émigré affairs). There was self-creation as a Russian writer, from material that was not half as promising as the old boy in his Montreux palace liked to claim. There was re-creation, in middle age, as an English-language writer, and there is, in Andrew Field's *VN: The Life and Art of Vladimir Nabokov*, a photograph showing Nabokov at his Montreux lectern with his pen in his left hand. By then, after the return to Europe, he had cast himself as the deposed prince of a lost land. And after 'the incomparable pangs of the mysterious mental manoeuvre needed to pass from one state of being to another', there is the bizarre posthumous fate. Not of his reputation, which is at present inviolable. It is the man himself who has been fought over by carrion-dons of the Nabokov industry, chief among them Bad Vulture Field and, in the shining coat, Good Vulture Boyd – both of them antipodean beards. Facial hair is fashion or disguise. Australasia (or America or, indeed, India) is of greater moment – for, although he wrote in English almost half his life, Nabokov never wrote English English.

Hence the antipathy to him of, inter alia, Evelyn Waugh and Kingsley Amis, though not of Auberon Waugh or, famously and onerously, Martin Amis: attitudes towards Nabokov are, partly, generationally determined. Retrospectively, it was his good fortune to have been shunned by English academe when he sought tenure here in the late thirties – what would have become of him had he obtained the post he coveted at Leeds University the summer before the war? The self-recreation would, necessarily, have been a very different one; the 'love affair with the English language' that made *Lolita* motor would have been lukewarm; the 'philistine vulgarity' that exhilarated him, which he fed on in America, would have passed him by. So – again, retrospectively – well played Leeds, and well done R. A. Butler (his Cambridge coeval, and 'a frightful bore', who refused to help the by then most distinguished Russian émigré writer). He was pushed to America, which was to be his

making on the big stage. One is idly forced to wonder what might have happened to two writers whom Nabokov admired and was friendly with had they, too, broken out of the parochial milieus they inhabited during the thirties: the francophone Belgian Franz Hellens and the French-Uruguayan Jules Supervielle, whose poetry Nabokov translated into Russian. (One of Supervielle's novels, *Le Voleur d'enfants*, was translated into English forty years ago; Hellens is unread outside Belgium.) I am not making a case for an anglophone tyranny, but Nabokov's example is potent ammunition in such a case. 'World Language': well, sort of. And fairy tales are universal, aren't they? Well, up to a point.

The first chunk of this fairy tale might have been better subtitled *The Russian Language Years*. It is easy to see why Boyd's book comes condoned by Vera Nabokov (widow) and Dmitri Nabokov (son), if not with their 'authorisation' – is there that much difference? Boyd is, basically, a discreet admirer. Field was (is?) an impassioned groupie. Boyd's tone is relentlessly, relentlessly sober. Field's was otherwise. Boyd apologises for his apostasies – and, heavens, some of them are heinous. The man actually considers *Laughter in the Dark* to be less than a masterpiece. And *Despair* . . . Dmitri Nabokov, Keeper of the Faith, the man who calls Mr Levin 'Critic Bernie', cannot have gone too much on that.

There is an unhappy congruence between the smooth surface of Nabokov's art (no 'marks', no slang, a dissembling polish) and the conception of himself he fostered: he sought to make books that were as perfectly shaped and self-contained as his beloved butterflies, and set himself up as a hands-on god, an intrusive puppet master. ('My characters are galley slaves,' he said somewhere, but not here.) He instructed his readers in how to read him; his disdain for manifestos ('dead with the Dadas', also not here) was a sham – he cunningly used interviews in their lieu. He made Boswells of his commentators. He bullied them into accepting him at his own

estimate – when in Nabokovia do as Nabokov does; more momentously, think as he thinks. Could he think or could he think? His mentation is astounding. Open any book on any page; the beauty of his brain clubs you, and its energy, and its polychromatic sensuality, which Leeds would have improbably fostered.

Boyd: born Belfast, brought up in New Zealand, PhD in Canada, teaches at Auckland Univ. A migrant – and the fact of that migrancy, that slight crossing, must help, a bit. He is interesting in a way that nobody, save Nabokov himself, has been on Russians in Berlin. *Speak, Memory* is unchallenged as an evocation of that society, but Boyd is double-best at detail. There are not that many witnesses left; but the description of Nabokov entering a room to tell two friends that his mother had died is hallucinatorily intense. They were going to play an unspecified practical joke on him; he told them of his orphanhood and put two fingers to his forehead, stroked it, said nothing more of that subject. (He was to make the same gesture a decade later when talking of his brother's death.)

Where Field was like a *Sun* writer with a thesaurus, Boyd is well-mannered – I refer to the matter of Nabokov's adulteries (Field) or adultery (Boyd). I tend to believe Field, though rather unwillingly. It is all too easy to believe in Anthony Burgess's protracted celibacy: what else can you expect of a man who swallowed a bottle of Gordon's per day? Nabokov did not drink. ('I've never been drunk in my life,' he lied with such affront that Geoffrey Wheatcroft, incapable of making that particular boast, set this as a question in the *Spectator* quiz in 1977.) Nabokov was mostly undrunk, because financially straitened. Poverty works wonders.

Boyd does as well as anyone could with Nabokov's lost and long weekend of sobriety. He is insistent about his subject's intermittent and opportunistic gregariousness, which his subject would subsequently deny (as part of the grandest reinvention). He does as well as anyone could with the parish-pump stuff of émigré literary politics.

He is also illuminating about the interfactional bickering that effectively prevented a united front mounting a concerted opposition to Bolshevism – the nightmare of the century was *not* inevitable.

Because few witnesses remain, and because, anyway, Nabokov was a writer who wrote rather than frequented bars or parties (he had no desire to shine socially), there is not an awful lot for a biographer to recount: non-joiners make art, not posthumous subjects; the real adventures in Nabokov's life were aesthetic ones.

Boyd is quite candid about the dearth of material: 'We have to lurch from recorded public events to the record of his published works, while the inner continuity of his life temporarily eludes us.' He compensates, or fills the blanks, with protracted critical analysis, tying the books to the outer events of the life in a manner which renders Nabokov a far more autobiographical writer than he has been hitherto considered – he used far more undigested, untransformed 'raw' material than he would ever have admitted.

Among those to whom he gave language lessons in Berlin was a German, mentioned in *Speak Memory*, who travelled the world to attend public executions, and whose observations on his specialised hobby Nabokov used, undiluted, in *The Gift* and *Invitation to a Beheading*. Was that latter book 'influenced' by Kafka?

Boyd is one of the faithful, and claims that Nabokov had not read the Czech at the time of the book's composition. Bad Vulture Field claims that Nabokov's reference to Gregor Samsa of *Metamorphosis* as Gregoire is evidence of his having read it in French translation in the *Nouvelle Revue Française*; Boyd sensibly dismisses the idea that Nabokov might have written *Novel with Cocaine*; Field is less emphatic, and at least leaves space for speculation. The squabble will continue, other beards will enter the lists. And though of course they will be autonomous human beings, they will dissemble that state, and behave for all the world as though they are articulated by the old puppet master they are claiming to stalk. (1990)

Only connect

Modern Times, Modern Places: Life and Art in the 20th Century
by Peter Conrad

There is a late-1960s photograph of Peter Conrad which the whole world, whether it knows it or not, has beheld, because it includes the future leader of the Free World, William Jefferson Clinton, a fellow Rhodes scholar. This new book, an extraordinary work marking Conrad's half-century and grappling with the world's entire century, begs the previously unthinkable question: which of these boys from Hicksville is the more ambitious?

When he wasn't posing for photographs with Clinton, Conrad was, I guess, doing twenty-four-hour shifts at the Scala in Headington or working his way through the entire Calder and Boyars list of those years: Beckett, Burroughs, etc. He's of a generation which believed, not without cause, that British writing was tired (he ignores Burgess, Ballard and B. S. Johnson) and he very likely only found a way into Wells through Borges's mediation.

Nonetheless, for all his enthusiasms and for all his pan-occidentalism, the Tasmanian Conrad is a de facto British critic, and one whose method relies on cumulative detail. *Modern Times, Modern Places* has nothing to do with modern criticism: Conrad doesn't give an emu's gonad for the opinions of the several schools of formalistic self-abuse which have turned his supposed discipline, Eng. Lit., into an hermetic farce. He is a man who belongs to no school other than the school of Conrad. He is actually quite old-fashioned in that he connects with 'art', however debased it may be, rather than with its former interpreters. He is a critic in the Wildean sense of an oblique autobiographer.

He writes here with a peerless energy, the sort of energy he couldn't summon a decade ago in his memoir of Tasmania. This one, though, is all speed and ecstasy, aesthetic rapture and cosmic

mockery. I have no idea what it *means*, still less what it's all about. I only know that by page – no, sentence by sentence – one is connecting with an astonishing brain whose own connections are way beyond the capacity of artificial retrieval. Conrad knows everything. Well, maybe he doesn't know that Lewis Carroll's first Russian translator was Nabokov but he does know that hatters were mad because they used mercury to make felt shine and that pre-Wasserman and pre-Fleming mercury was a 'cure' for syphilis.

There are thirty chapters here: they address, inter alia, Vienna, Chaplin, Nazism, modernism's debt to primitivism, the system of artifice called realism, Populuxe, Year Zero. But this is no mere series of conjoined essays. It is an oddball encyclopaedia which takes on anything which might be regarded as art with the same cool keenness which Perec brought to bear on the apartment block in *Life: A User's Manual*.

Conrad isn't faultless. The density of dropped names, congruent conceits and ludic unions is now and again excessive. But so what? It's seldom that we're offered something of such unremitting intensity. (1998)

Anthology of England

There was the cheerily camp Anglican; there was the gravest of light poets or the slightest of grave poets; there was the telly topographer who was actually a consummate music-hall turn – he was, in his way, quite the peer of Mick Jagger who, as a young man, tried unsuccessfully to snog his beautiful daughter; there was the ambulatory encyclopaedia of forgotten houses, ruinous chapels, overlooked architects and disgraced graffitists of the 1890s; there was the most improbable of committee men who doubled as a comedian; there was the jovial melancholic, the purposeful *flâneur*, the man who resolved to know everyone . . . John Betjeman was a host. He was Betjemen.

Yet — and this is seldom the case — the multiple roles, if that's what they were, are parts of a harmonious whole. They coalesce, they are consistent, they infect each other. He was proof of Buffon's dictum: *Le style, c'est l'homme même.* To separate the hymner of buildings and places from his fellows within the same skin is to somewhat diminish him, for Betjeman's haunting architectural prose and his memorable performances in front of camera are indissolubly linked to his poetry. This is not to say that the three are interchangeable. On the contrary, whatever he did was technically specific to the medium. Nonetheless, the astute eye, the heightened sensibility and the desperation to avoid boredom are constant.

The same goes for his subjects, which are, in a way, his inventions, so persuasive and transforming is his vision. He treats architects dead long before he was born with the proprietorial familiarity that certain late-Victorian novelists treat their characters. When he first wrote of, say, Cuthbert Brodrick or Harvey Lonsdale Elmes in the 1940s they could, for all anyone knew, have been his creations — much of his audience would never previously have heard of them, such was the mid-twentieth century's ignorant antipathy to the architecture of the mid-nineteenth century. No single person effected the dissipation of that antipathy more than Betjeman, who was for many years taken to be at best obstinately teasing, at worse perversely aberrant.

Much later, in 1973, in *Metro-Land*, Eddie Mirzoeff filmed him at Grimsdyke. His immersion in the period with which he was by then popularly identified lends him the air of a revenant from the milieu of the Royal Academician Reginald Goodall who commissioned it, Norman Shaw who designed it and W. S. Gilbert who drowned in its pond: rhododendrons, the Old English style, a proximity to Harrow, a wasteful death — did he not invent this too?

Just as he tirelessly opened our eyes to neglected architectural idioms, so did he persuasively broaden our appetite for places.

Places rather than mere architecture were his greatest forte: architecture, a component of places, was too limiting. Betjeman was excited by the humble, by the everyday, by the allegedly meretricious, by preposterous kitsch, by fortuitous juxtapositions, by collisions of the bathetic and the sumptuous. He brought an aesthete's sensibility to bear on found objects which better behaved or less professionally opportunistic aesthetes would shy away from, shrieking. He wrote in 1965 to Laura Waugh about Compton Acres at Parkstone: 'a series of gardens of such unexampled and elaborate hideousness that Evelyn will want to put pen to paper again, and that wonderful gift he has for bringing out the startling and alarming and funny in the trivial will be spurred into renewed activity'. He was, needless to say, describing his own gift. Compton Acres, a twee creation of the 1920s, happily still exists, still simpers. It belongs to the same gamut of taste as Limited Edition Porcelain Masterpiece Collection Nuptial Souvenir Figurines of Sir Elton John and Mr David Furnish.

But such no-holds-barred bereavements of taste in large-scale endeavours like landscape or architecture are rarer today than forty years ago when Betjeman discovered those gardens. He was of the same opinion as Vladimir Nabokov: 'There is nothing more exhilarating than philistine vulgarity.' But philistine vulgarity is not what it was in Betjeman's England. It is now 'quoted', 'ironically', in the mainstream – it has lost its innocence. We live in a more self-conscious and thus more self-curtailing age. The precepts of 'design' are relentlessly disseminated and ubiquitously adhered to because we are, thankfully, visually literate. Even retail parks, an epithet Betjeman would have relished, are infested by synthetic modernism. Our Man in Malmesbury snooping (there is no other word) as he once did in arched alleys and down hidden paths where back gardens give on to allotments would no doubt find a town Responsibly Attuned to Its Heritage, where lean-to roofs in corrugated iron (the material of the future in 1900) have been replaced by historically

appropriate tiles and where *Daily Mail* windows no longer illumine Jacobean cottages. Bricolage and extemporisation have been superseded by kits from B & Q: assemble it yourself is not the same as bodge it yourself, with scrounged materials intended for other purposes.

But then England is wealthier. What wealth brings, evidently, is the spread of tidiness. A derelict cottage or ivy-engulfed farmhouse is a rare sight. Buildings are saved, certainly, but at what cost? They are no more allowed to wither than are septuagenarian former starlets. It is improbable that Betjeman foresaw – or wished to foresee – the future absurdities of the conservation movement which he personified and popularised to the point where it is a cultural and social crime to support the demolition of, say, Georgian hackwork. He was, however, prescient about the fate of provincial town centres. In the introduction to his greatest book, *First and Last Loves*, he observes that: 'when the suburbanite leaves Wembley for Wells he finds that the High Street there is just like home'. That was over half a century ago. Half a century during which successive governments have failed to correct the retail corporatism which has scarred this country.

In general, though, the fabric which he recorded in that book and showed in his films is – astonishingly and hearteningly – extant. The society of Cheltenham, which he properly preferred to Bath, may have changed; the old India hands and the military widows have all gone now, the way of Adam Lindsay Gordon. (Did Betjeman know that Lindsay Anderson, to whom he wrote a fan letter after seeing *If . . .* , was a kinsman of that ill-starred poet?) But the terraces and caryatids have never looked better. The stucco gleams with new money. Tivoli blushes brightest pink towards summer dusk. Even the debased high street is, with the exception of the dire Cavendish House, recoverable beneath the fascias and face lifts. What is irrecoverable is an England that was not yet built over – I

mean, regenerated. An England which Betjeman had little cause to pay attention to, an often unremarkable, marginal England which is going or gone. And whose qualities may not be fully appreciated until it finds its peculiar rhapsodist. Let us think of it this way: Mr Prescott is merely supplying targets for a Betjeman of the future to drop his gentle bombs on. (2006)

The glass half empty

Everyday Drinking by Kingsley Amis

In his introduction to *The Compleat Imbiber No. 14*, Kingsley Amis observes of the anthology's editor, Cyril Ray, 'that those who may have gone to him for information stayed with him for pleasure'. Oddly, the contrary applies to this collection of Amis's three books on drink. He is, evidently, a writer one turns to for gruesome entertainment. But what is impressive here is the infinite cellar of knowledge.

Indeed in the third of the books, *How's Your Glass?*, the concentration of griff is such that his terse prose is merely at the service of facts: the writer is (mostly) subsumed by the buff, the supertoper. It comprises thirty quizzes of ten questions followed by their answers. Of course composing quizzes is an exercise in one-upmanship. But if you are a walking, occasionally staggering, encyclopaedia, why hide it when you can turn it to profit?

There is no such thing as useless knowledge. Etymologies, recipes, folklore, toponyms, eponyms, quotations, ritual, homophones, inventors, Hobson-Jobson arcana, distillation, *cépages* – these are all in themselves fascinating, without qualification. They are better still when annotated by an unexpectedly genial, witty pedagogue who suggests that literary invention is not merely connected to drink but largely dependent on it – an untenable proposition, but then Amis was *parti pris* and it must be admitted that, G. B. Shaw apart, one is hard-pressed to name writers who have stunk of Tizer.

Drink for Amis may have ultimately become a mere intoxicant which, as Christopher Hitchens notes in his introduction, 'robbed him of his wit and charm as well as of his health'. For many years, however, it did not get to him – witness his energy and versatility. It was much more than a psychotropic in a sleever or a snifter. His opinion that 'your true drink-man reads everything on the subject' might not be shared by the true drink-men of Kilburn or the Bowery, but it neatly suggests that in other circles a glass of, say, *baie de houx* is something to study and ponder as well as to imbibe. How many kilos of holly berries does it take to make a bottle? Why is it more expensive than *sorbier*? How old is the practice of distilling this particular crop, does it pre-date that of sloe and celeriac (which is peculiar, commercially, to the Belgian Ardennes)? One of the points of drink is to talk about it – but without resort to describing this Pinot Noir as bitumen, lavender and two-stroke fuel.

On Drink, though the earliest of the books, might as well be his drinking testament. There are rules, unexceptionable save for a recommendation for Diät Pils; hangover cures – watch out there, son, most of them just keep you pissed; how to lose weight without giving up drink (a likely story); cocktails and more cocktails; what to drink with what food, which is worth skipping; a beginner's guide to buying wine. The prose borrows from pub vernacular, specifically saloon bar when compared to Anthony Burgess's taproom locutions. He complains, though, that 'the pub is fast becoming uninhabitable', but has not yet become. This was written in 1971.

At a remove of almost forty years *On Drink* is, inescapably, what it wasn't intended to be, a snapshot of a particular milieu's and particular generation's bibulous mores. Amis writes about cocktails, spirits and, especially, sweet liqueurs with greater enthusiasm than he does about wine. But then the volume of wine consumed in Britain was a seventh of what it is today, and most of it was drunk by a small tranche of the middle class with food – not instead of beer, aperitifs and so on. The

only high street chain was Peter Dominic. Oddbins was a one-off on Shaftesbury Avenue. Supermarkets hadn't cottoned on to wine. That Britain would become the world's vinous warehouse was unthinkable – but then so was the predominance of English-language labels and hyper-flavoured, 14.5 per cent bevvies which at least partly prompted the exponential leap in its consumption.

The Amisian quality that these books lack is hatred. Drink might provoke the breathtaking despisal that drove so much of his work. That surely was a reason to adore the stuff itself. Any drink, even Suze, must be counted OK if it can give rise to the gleeful vivisection that Amis inflicted on Woody Allen. (2008)

Spices, salt and aromatics

Elizabeth David: Writing at the Kitchen Table by Artemis Cooper

The Elizabeth David whom I knew slightly towards the end of her life was a great hater – she was embittered, misanthropic, self-pitying, pretty graceless. Having once been paid a blurting though well-meant compliment by a friend of mine, she turned to me and sneered: 'What a remarkably stupid young woman – I suppose you know a lot of people like that.' One of her rare enthusiasms was Jeffrey Bernard, who made a career out of exhibiting the very characteristics that she could hardly reveal in her role as the grandest dame of British gastronomy. She enjoined me to arrange a meeting between the two of them and Jeff was keen at 11 a.m., but the consequences of bad behaviour conspired against it.

This Elizabeth David is unastonishingly absent from Artemis Cooper's terribly nice, terminally English biography – one gentlewoman's life of another. Cooper is understated, tactful, decent, restrained, polite: she lacks the wackiness and somewhat obsessional intensity of David's previous biographer, Lisa Chaney, but compensates with deft craft and respectful reasonableness. It goes without

saying that she doesn't address the question of whether such a figure demands two full-scale biographies: this, for what it's worth, is the authorised one – which means that David's literary executor Jill Norman was not obstructive towards Cooper as she was towards Chaney. This is manifest in the over-fulsome acknowledgement of 'the powerful espresso coffees and impromptu lunches' the lucky author was treated to by Norman and her husband.

Elizabeth Gwynne was born in 1913 into a minor aristocratic family to whom food was no more or less important than to any other of the same class at that date. As late as 1985 she would write that her family 'was impoverished' when her father Rupert Gwynne MP died: it all depends what you mean by impoverishment of course – but this does give some idea of David's worldview. For all her subsequent bohemianism, she remained in her attitudes and expectations a child of her natal milieu, one who was presented at court and who was 'finished' in France (where, inevitably, she seems to have suffered her first gastronomic epiphany). Through the 1930s she went on stage without much success, modelled for Worth, travelled enthusiastically, and led the prodigal life of a girl who may not have a trust fund but has a mother and an indulgent uncle to pick up the bills. She acquired a reputation for being difficult, and the first of a string of lovers deemed 'unsuitable', i.e. not PLU, an actor-writer called Charles Gibson Cowan.

Mid-century bohemia is indissolubly connected to boats (freedom, roving). It was with Cowan, on their vessel the *Evelyn Hope*, which they had navigated through French canals, that Elizabeth Gwynne found herself in Marseille when Germany invaded Poland. Cooper's imaginative suggestion that this occurred in 1938 might have been spotted by her 'wonderfully supportive' editor.

During that first winter of the war, in Antibes, Elizabeth Gwynne met the unsuitable septuagenarian Norman Douglas, author of the marvellous *South Wind*, sexual adventurer, scholar,

hedonist, a man who abhorred England's puritanical asceticism. While she owed her married name to a third unsuitable man, a kindly, thick, feckless soldier called Tony David, she owed her impetus for her self-invention to Douglas. She was his heir.

Or, if that is overstating it, she carried on the tradition he was part of, indeed a fomenter of – the tradition of northern longing for the warm south, of northern belief in the Mediterranean's cultural primacy. Douglas lauded 'the culture of the tomato' over that of the despised northern apple. He was not alone. Through the first half of this century the Mediterranean was a potently seductive magnet for anglophone writers: Lawrence, Hemingway, Fitzgerald, Connolly, Durrell, etc. The cults of Mediterranean man, of ancient paganism and immemorial wisdom, of honest bread and rough wine, of a willing proximity to the land, of blessed fecundity . . . they may all be crocks of sentimental Rousseauism – but given this country's national dread of colour, and given our eagerness to thrive on privation, it is not difficult to understand the south's appeal, even today. And when Elizabeth David started to write her first book, *Mediterranean Food*, in – wonderful touch this, a Trust House hotel at Ross-on-Wye during the dreadful winter of 1946–47 – she was trying, self-consciously, 'to work out an agonised craving for the sun'. She was, naturally, in the company of an unsuitable man.

That book may be her slightest, but it establishes the characteristic that makes her work unique – the coalescence of place, food, self. You might say her *oeuvre* consists of countless madeleines, that it's autobiography deflected through gastronomy. She is a great writer precisely because she is inutile as a recipe-monger. Her recipes often don't work. Well, *tant pis*, ducky – England abounds in provincial hairdressers like Delia who can help you get your wretched cake right: everything to do with cooking in this benighted country is supposed to be concerned with light-hearted practicality, frivolous didacticism, lovable nous.

But do we read Summerson or Nairn in order to learn how to build a house? No. Do we read Cooper's husband Anthony Beevor so that we know how to march on Russia when the time comes? No. (Well, maybe Toni does . . .)

Elizabeth David's legacy is manifold. There is her work, wrought in the face of the fantastic philistinism of moronic editors who would be entirely forgotten were it not for their animus towards her. Cooper exhumes these biddies – which is enough, she doesn't need to berate them. They score their own goals.

There is Peter Mayle, whom Elizabeth David loathed – god she hated him: he sleekly capitalised on reducing her lifetime's work to the Art of Living in France . . . the captivating aroma of ratatouille, the captivating yellow of the squash in the market at Valseuses, the captivating bicycle saddle of the onion merchant at Con-le-Con.

There is, thankfully, Claudia Roden, who writes as an inspired ethnographer and quotes in her magisterial *Book of Jewish Food* Edgar Morin's dictum that 'the kernel of every culture is gastronomic'. This is obviously not the case in England. Despite Elizabeth David, we still lack that kernel – it's as though Marguerite Duras or Monique Wittig devoted a life to writing in their native language about cricket, about a lost cause. No matter, the writing will always be there. (2012)

Tart, liar, great
Address to the Burgess Foundation at the National Portrait Gallery, London

When you exhume a Sicilian who has been in the grave for 2,000 years, he'll tell you *vafanculo*, and then he'll rather self-pityingly say: 'Why did you wake me? I haven't finished plotting my revenge yet.' I rather think if we dug up Anthony Burgess, we would get something similar.

He was colour-blind, which was very evident from the clothes he wore, but by the same token you would say that everyone in Munich is colour-blind. He smelled very pleasantly of cheap cheroots, Burma cheroots, which are about six inches long, quite thin, very very black tobacco, with a particular smell.

I met him initially because I went to interview him. It was like spending a few hours with an ambulatory encyclopaedia. There's nothing he didn't know. I didn't find this boring at all, I thought this was absolutely delightful, but it was clear he suffered from that all-too-English disease of being too clever by half. I think this is rather better than being moronic, but there is this English prejudice against cleverness.

He was very good company. He wasn't drinking an awful lot when I met him. That was at nine thirty in the morning. By ten he was complaining that he wanted a drink. Andrew Loog Oldham had thought that Burgess started writing Nadsat because he was taking drugs, but with the exception of a bottle and a half of gin a day, he wasn't taking anything.

I met him subsequently at a party where he told me that a book of stories I had written was a mistake because I should spread myself more thinly and I should not use an idea for a story that could actually be spread out into a novel. I didn't heed his advice and I actually regret not having heeded his advice.

I remember him with great fondness and huge admiration. I've never really wanted to meet famous writers, but he was the one I wanted to meet and he most certainly didn't disappoint. He was actually charming as well, which is not something that comes over all the time. I think in TV interviews and so on he put on a 'great writer' act, but he was not like that at all. He was modest. And physically very rangy, and lean. He didn't photograph well at all, but he looked very fit.

In person he was very genial, generous, and, among other things which you wouldn't expect from him, a very good listener. But in private, that's to say on the page (and one commits to the page things one would never say), he was rancorous and grudge-bearing and full of antipathies. One of these antipathies was to Vatican II, which dispensed with the Latin Mass and was in favour of ecumenicism, and turned churches into a kind of theatre of the round so that the congregation would be closer to the host (which seems over-literal).

Another of his antipathies was Stanley Kubrick, and a third was the way his reputation towards the end of his life rested on one novella, *A Clockwork Orange*. He really disliked being described as '*Clockwork Orange* author Anthony Burgess'. It's rather like '*Love's Labour's Lost* author William Shakespeare', or '*Grimus* author Salman Rushdie', or 'Go to Work on an Egg author Fay Weldon'.

A Clockwork Orange is also important in the Burgess canon, not just as a work but because the stuff around it is very fascinating. The film rights were bought for $500 by Mick Jagger, whom Burgess described as the very picture of delinquency and thought would be ideal as Alex, with the rest of the Rolling Stones as the droogs. Andrew Loog Oldham, their first manager, had put him up to this. On the sleeve notes of one of their early albums he did the notes in third-form Nadsat, which is the idiolect of Alex. Eventually, the film was made by Kubrick, this great genius as Burgess described him, who took all the credit for absolutely everything, even though the dialogue in the script was based word-for-word on the dialogue in the book.

The director Burgess would have liked to see work on this project was Ken Russell. This is revealing because it gives an indication of how Burgess viewed his own work: as comic, bawdy, excessive, coarse, vulgar, polychromatic, touched by bombast, touched also by Donald McGill, artist of seaside postcards, and by music hall. *A*

Clockwork Orange directed by Russell would have been vastly supe-
rior to the rather fastidious, frigid, over-stylised film that Kubrick
eventually came up with.

Burgess, unlike Kubrick, was not 'cool' in any sense of that grue-
some word. Burgess and Russell are kin in shunning understate-
ment. One of Burgess's favourite films was *The Life of Brian*. He
enjoyed anything that was remotely blasphemous. He was a fan of
vaudeville, and he was a friend of Benny Hill's – he gave the eulogy
at Benny Hill's funeral – and he was very fond of Lew Grade, who
called him 'Tone-boy' and commissioned him to write the life of
Jesus. Burgess said he was surprised that Jesus hadn't asked him to
write the life of Lew Grade.

What I value in Burgess's writing is the prose, which is wonder-
ful. I haven't read a book by him for quite a long time, but I pick up
things and just read a page. I find it absolutely beguiling that he
could do all of this with language. He would never say he was a
master of language, because saying you were a master of language
means that language is a finite thing and you can get to know it all.
It's changing the whole time, as he acknowledges. Every sentence is
about language, as well as what the alleged subject is.

It's a writer's job to be interesting in language. I hate the idea,
and he certainly loathed it, of impressionistic writing, which is gen-
erally done by the English upper classes with double-barrelled
names, like Patrick Leigh Fermor or James Lees-Milne and so on.
Ghastly writers.

Burgess wanted to describe absolutely everything, and you need to
know the word for it, you need to know the word for that bit of the
bottle, that bit of the bottle top and so on. And he did. He'd know
the word for the components of a bathroom tap. You can't know too
many words, because if you don't know them it becomes vague and
it becomes clichéd so you have to rely on someone else's construction
for the composition of a tap (should you be describing a tap).

All interesting people are self-created. Burgess created his own accent. He probably would have created a more dandiacal look if he hadn't suffered this colour blindness. He created a kind of prose style which had nothing to do with where he came from, and had nothing to do with contemporary kitchen-sink writers, proletariat writers who all lack humour. He may have thought he was not comic but he must have found out pretty soon that people considered him comic. He is a complete self-creation. I can't see what is particularly amiss about fabricating your past. All politicians do it.

I think he knew perfectly well that the stuff he was putting in the autobiography might be exaggerated or might not even have happened. I don't think it was due to false memory or faulty memory. It's much more important to be concerned with the shape of the book than it is with that slippery thing called the truth. The truth can be very awkward and impair the structure. His duty to himself was to write a good book rather than a truthful or revealing book.

Burgess came to think there was too much of him on the telly. He was on *Parkinson* every week, he was on *Russell Harty*, he was on *Wogan*. He'd be on anything. He was a tart. There is absolutely no doubt about that. And he was a liar and a charlatan, but all of those qualities are what make him great. There's nothing more tiresome in the world than purity. Chastity is grotesquely overrated. Burgess's work was deliberately impure. He'd pick up stuff from anywhere. There's a passage in *M/F* where he's describing a hotel foyer and he didn't want to use any of the normal words which would describe a foyer, so he got an English-Malay dictionary, opened it and used all of the words on those two pages to describe it. You get a completely fresh description through a kind of randomness. It's not really literary creation. It's more like some kind of Oulipian exercise. It's impure.

You don't copy Raymond Chandler. You copy Raymond Chandler and at the same time copy Gerard Manley Hopkins and Evelyn Waugh, so you get this meld of stuff, and I think that's what he did. It

comes out of huge reading, but a reading of polar opposites. He once said that all you need to write a novel is imagination and a children's encyclopaedia. I think you need more than that, but the chewiness of his prose, that muscularity, doesn't really have precedent.

The books I think will stand up are *M/F*, *Little Wilson and Big God*, *Earthly Powers*, *Tremor of Intent*, *The Malayan Trilogy*. *Tremor of Intent* is the best writing I've ever read about gluttony. It's also probably the best writing I've read about sex. It's extremely visceral. (2017)

From the cutting library

The Ink Trade: Selected Journalism 1961–1993 by Anthony Burgess, edited by Will Carr

In his introduction to this absorbing and scrupulously chosen collection of Burgess's literary journalism, Will Carr quotes a 1972 interview where the novelist talks about the benefits of book reviewing. For *Country Life*, 'I had to review books on stable management, embroidery, car engines – very useful solid stuff, the very stuff of novels.'

He might have qualified that as 'my novels'. For one of the many characteristics that set this giant of a writer apart from his contemporaries was his engagement with the everyday and his detachment from what passes for 'the literary life'. Quite how simulated that detachment was is moot. But it is undeniable that a formidable knowledge of just about everything is evinced in his fiction. He was too modest when he claimed that all a novelist needs is 'imagination and a children's encyclopaedia'. The encyclopaedia in his head was like the internet. To spend any time with him was to be dazzled by his sheer volume of knowledge and his (oddly humble) desire to keep adding to that volume, to be a specialist in all fields, trivial meadows included. Burgess would have agreed with Housman's dictum that 'knowledge is precious whether or not it serves the slightest human use'.

Most of his preoccupations manifest here will come as no

surprise to his devotees: Joyce, the perpetual futility of using high literature as the basis of films and the coarse chimera of synergy, slang and its lexicographers, the crassness of television in 1993 (when, by today's standards, it was at least watchable), the disgusting paltriness of censors, the brilliance of V. S. Naipaul and William Burroughs, the usefulness of pornography, the joy of blasphemy, the inadequacy of prose (and poetry) in comparison to music, where several lines can be played simultaneously.

Many of the pieces suggest that Burgess adhered to Wilde's paradox in *The Picture of Dorian Gray* that criticism is a form of autobiography, an ever-accreting *Bildungsroman* marked not by events but by thoughts, spiritual moods and imaginative passions. Criticism is, in Burgess's case, an autobiography of multiple contradictions. The most fundamental contradiction is the constantly implicit debate about the nature of fiction. Ought it to be opaque, like that of, say, Nabokov, where the style is, as Burgess has it, a 'character', or merely a narrative in the manner of Maugham or Priestley? Burgess lurched between the two, though there can be no doubt that, with the exception of *The Malayan Trilogy*, his best work belongs to the Nabokovian tradition – inventive, shocking, brutally poetic and proddingly boastful about the very words it is composed from.

Desiccated browning newsprint is seldom as entertaining as this dense and generous collection of enthusiasms, expressions of self-doubt and civilised muscularity. (2018)

Double daring

The Art of Invective: Selected Non-Fiction 1953–94 by Dennis Potter, edited by Ian Greaves, David Rolinson, John Williams; foreword by Peter Bowker

In his preface to *Visions Before Midnight*, Clive James recalls a conversation with the stage-door Johnny, Kenneth Tynan: 'When, he

asked, would I be turning my critical gaze away from television and towards its proper object, the theatre? Never, was my reply . . . Tynan was thunderstruck.'

On the back cover of this marvellously energetic collection Trevor Griffiths observes: 'It remains a scandal that because you worked in television, you are somehow downgraded. You don't belong in the category of high art. Well, Dennis does if anybody does.'

A priori this snobbism about television is all too easy to explain. The medium is irremediably contaminated by its *galère* of freaks, special-needs cases, kiddy-fiddlers and necrophiles: I guess that one advantage of being dead is that you don't know when Jimmy Savile is dating you. Anyone who essays originality or the non-generic or programmes that demand concentration and fail in their formulaic duty, offends against the laws of populism, which stipulate that everything, but everything, be comprehensible to a backward eight-year-old.

This is compounded by the people who control it owning an insidious sense of the medium's inadequacy, a cowed conviction that it is necessarily inferior to older forms. Witness the forelock-tugging, cap-doffing 'partnerships' that My Lord Hall has entered into with the Tate, the Globe, Sadler's Wells, etc.; these compromises are tantamount to an admission that television is not artistically autonomous, that it cannot create on its own terms and can only relay work which is not specific to it.

Dennis Potter's mordant, bracing tirades against the BBC are astonishing in their vituperative nerve. He gleefully bites the hand that feeds then chews off the rest of the arm just to be sure. And so effective was his self-publicity and so willing were quivering television executives to accept his confident opinion of his work that he was indulged, thus able to get away with it time and again. He was much more a figure of the broadcasting establishment and the

journalistic establishment than he liked to pretend, even though he very publicly had feet in both camps – as the television critic of the *New Statesman* and, later, the *Sunday Times* and, it says here, 'Britain's leading television dramatist', an epithet which is, even two decades after his death, seldom challenged. But what of Peter Nichols, Tom Stoppard, David Rudkin, David Mercer, David Hare? There was no real *nouvelle vague* in English cinema because the best people were working in television, which was, till the vandals seized it, one of this country's glories.

Potter was certainly very prolific, but as a dramatist he was thematically straitened and tirelessly self-plagiaristic. Chapel (and the Nonconformist, anti-Marxist socialism that derived from it), chippiness, the Forest of Dean, debilitating illness, the problem of prayer, virgins or whores: these are perpetually recurrent motifs. And surely one serial in which characters mime to pop songs would have been enough. He was at his best when least adhering to the mores and tics of the massively successful self-invention called Dennis Potter: the adaptation of *The Mayor of Casterbridge*; *Blue Remembered Hills*; *Brimstone and Treacle*; *Double Dare*.

Just as Martin Amis's distended, incident-light novels of the eighties and nineties derived from the largely forgotten and fiercely concentrated *Other People*, so did Potter's obscure *Double Dare* – his first script shot on film, much influenced by Robbe-Grillet and delicately played by Alan Dobie and Kika Markham – provide the template for the bloated anti-naturalistic mode that Potter would adopt and champion with dogmatic stubbornness. For a while he rather obtusely determined to judge work by the stylistic conventions it displayed rather than by the wiser Nabokovian criterion: 'There's only one school of writing, the school of talent.'

In the extraordinary – and the word is apt – loving interview Melvyn Bragg conducted with Potter three months before his death, he talked of the dramatist relinquishing technique, not

thinking about it, just getting on with writing. Potter the journalist, the polemicist, the preacher, had anticipated this. He had long since torn up the rule book. *The Art of Invective* might equally have been entitled *The Art of Castigation, of Lambast, of Mockery, of Vituperation, of Scorn, of Obloquy, of Feud*: his appetite for a bareknuckle scrap was insatiable. Clive James, David Hare, Humphrey Burton, Rupert Murdoch (Potter called his cancer 'Rupert'), Mary Whitehouse (of course) were all targets.

So too was the floundering, accident-prone Alasdair Milne, who when director of programmes at the BBC stupidly pulled *Brimstone and Treacle*. So too was the old fool Duke Hussey, whom Potter describes 'as my idea of a catastrophic manager'. This was the creature who would, a decade later, fire Milne from the post of director general and, on the advice of his fellow member of the Mendips Camorra, William Rees-Mogg, bring in the puppet Michael Checkland and Hussey's fellow 'croak-voiced dalek' John Birt, the latter having impressed Rees-Mogg with illiterate jargon-splattered articles in *The Times*.

This was when the rot really set in, with the advent of a cadre of grossly over-rewarded and underemployed managers whose numbers have swelled and swelled. Potter's attacks on these parasitical dunces were gleefully below the belt, ad hominem, ad scrotum. His candour is painful, his lack of self-pity is salutary, his wrath is mighty – the legacy of Sion, Bethel and Bethesda, of course, but also of a near obsession with Hazlitt.

His range was admirable. A review for the *New York Times* of Truffaut's posthumously published letters is followed by a fond introduction to *Breathe on 'um Berry!: 100 Years of Achievement* by Berry Hill Rugby Football Club. Lord Moran's no-wen-barred memoir of the valetudinarian Churchill, which prompts Potter to write of a 'Free World led by ancient carcasses with antique prejudices and the time-locked imaginations of Omdurman lancers', is

sandwiched between an enthusiastically reverent piece about H. G. Wells and a raw report from Aberfan on the morrow of the day in 1966 when a spoil tip buried the village school.

Every page of this book is constellated with sentences and phrases of, variously, humour, cleverness, warmth, indignation and savagery. It is one of the very finest collections of 'occasional' (but far from ephemeral) writing I have read: what counts is not the medium, not the genre, but the mind. The scholarship of the editors is impeccable. (2015)

Acknowledgements

I am grateful to all those who have taken a punt on this book.

My thanks are due to the publications in which various parts of this collection have appeared and to those organisations which have commissioned others: Architectural Association, *Architects' Journal*, *Architectural Review*, Barbican, *Blueprint*, *Country Life*, *The Critic*, *The Dabbler*, *Daily Mail*, *Daily Telegraph*, *The Economist*, Edinburgh Literary Festival, *Evening Standard*, *Guardian*, *Independent*, *Literary Review*, *London Review of Books*, *Mail on Sunday*, *Modern Painters*, *The Modernist*, *New Statesman*, *Observer*, *The Oldie*, *The Quietus*, RIBA, Royal Academy, *The Spectator*, *Standpoint*, *Sunday Correspondent*, *Sunday Telegraph*, *Sunday Times*, *The Times*, *Times Literary Supplement*, *Vice*, *Vogue*, *The White Review*.

My thanks too to John Mitchinson, Alex Eccles and most of all to my wife Colette Forder, who edited the book and, with endless tact, improved much of it.

A Note on the Author

Jonathan Meades is a writer, journalist, essayist and film-maker. His books include three works of fiction – *Filthy English*, *Pompey* and *The Fowler Family Business* – and several collections including *Museum Without Walls*, which received thirteen nominations as a book of the year in 2012. *An Encyclopaedia of Myself* was shortlisted for the 2014 PEN Ackerley Prize and longlisted for the Samuel Johnson Prize in 2015. His first and only cookbook, *The Plagiarist in the Kitchen*, was published in 2017.

Meades has written and performed in more than sixty highly acclaimed television films on predominantly topographical subjects such as shacks, garden cities, megastructures, buildings associated with vertigo, beer, pigs, and the architecture of Hitler, Stalin, Mussolini and Franco. He also creates artknacks and treyfs. *Treyf* means impure, not kosher: it sums up his approach to all writing, film and art.

Index

Aachen, University Hospital 775

Aalto, Alvar 570–1

abbreviations 461–71

Abercrombie, Patrick 503

accents 224, 443–5, 465, 466, 474, 480–1

accessibility 286, 384, 629, 760, 812

acronyms 461–71

Adam, Robert 702

Adams, Gerry 416–17

advertising 192, 205, 298

Ahnenerbe 576, 577, 578, 600–602

Aillagon, Jean-Jacques 357

Aire du Viaduc, Millau 296; see also Millau Viaduct

Albee, Edward 445

album covers 764–7

alcohol 69, 78, 230–2, 248, 324, 394, 534–5, 568–70, 928–30

Aldington, Peter 786

Algeria 291–2, 337, 341, 342–3, 345–7, 361, 364, 904

Allegro, John 331

Allen, Woody 451, 453, 930

Allsop, Bruce 86

Alsop, Will 485, 774, 786

Alton Towers 426

Alt Rehse 412–13, 575, 582–3

Amanita muscaria 22, 265, 331, 569

ambling 267, 276, 510, 520

Amery, Colin 636

Amess, David 724

Amis, Kingsley 148, 184, 252, 334, 453, 517, 919; *The Compleat Imbiber No. 14* 928; *Everyday Drinking* 928–30; *How's Your Glass?* 928; *On Drink* 929

Amis, Martin 265, 919, 941, 941

Amsterdam 143, 288, 504, 855

Amsterdam school 9, 184, 367, 637

Anderson, Lindsay 245, 430, 927

André, Carl, *Equivalent VIII* 50

Anglicanism 20, 265, 416, 417, 457

angulas 198

Anido, Severiano Martínez 441

animals 206, 489, 557–8, 724–8

Anthropocene era 83, 245, 397, 428, 886

anthropomorphism 26, 54, 80, 95, 134, 147, 398

anti-Semitism 252, 407, 416, 436, 576, 581, 596–7, 680, 698, 728, 909, 911, 912, 915

anti-urbanism 212, 214, 416, 431

Antonioni, Michelangelo 102, 103

Antwerp 371, 372, 374

appropriation 53, 61, 314

Aragon, Louis 71

ArcelorMittal *Orbit* 717

Archigram 767–75, 770–5, 833

architectural determinism 283, 683, 786, 810

architectural photography 121, 157, 805, 900–902

Architectural Press 636, 876

Architectural Review 108, 287, 636

architectural writing 103–104, 299–300, 524, 635, 689

architecture: ancient architecture 168; architectural press 803; Baltic 572–3; Belgium 373–4; British 9–10, 779; classical and Gothic architecture 536–7; critics 820–1; as cult 803–804; Estonia 566–8; failure 108–110; future 767–9, 777; Harris on 78–9; history 375; Nazism 381, 586–8; north 536, 544–5, 572–3; place 803–804, 805, 807; purpose of 567; Russia/Soviet Union 151–8, 381–5; sacred 421, 536, 700, 704; schools 278–87; and sex 842–4; and taste 253–5; Victorian 146, 159, 283–6; wit 99, 114

Arding and Hobbs 498–9

Argyle, Lord 751, 752

aristocracy 402, 403, 404, 420, 438, 700

Armstrong, William 27

Arnault, Bernard 351, 360

Arnold, Matthew 283

Arras 359, 530

Artaman League 581

art, and artists 9–84; accessibility 760; art aid 67; art history 33, 44, 65; and arts 57; art writing 45, 49, 50, 66; and craft 64, 65, 69, 202; cultural regeneration

Index

68; and danger 64;
establishment 51; fast and slow
art 59–60; northern art 535,
536; point of 549; and science
160, 176; and taste 253, 254
artknacks 53–4
art nouveau 125, 217, 366, 374,
378, 386, 394, 502–503, 504,
572, 816
arts 57, 67, 479, 761
Arts and Crafts movement 82, 121,
125, 142, 181–4, 366–7, 374,
403, 435, 503–504, 540, 580,
604, 914
Arts Council London 716
Ascherson, Neil 718
Ashbee, Charles Robert 183, 841
Ashbee, Henry Spence 840–1
Asplund, Hans 141, 163, 164
Asquith, H. H. 404, 435
Atelier Troost 605, 609
atheism 236, 238, 259
Atkinson, Ron 188, 719
Atlantic Wall 148, 165
Attenborough, David 859
Attlee, Clement 93, 115, 417, 695
Aubrac 336–8
Aurora statue, Krasnodar 156
Auschwitz 560, 581, 584
autobiography 271, 272, 310, 851,
939
avant-garde 44, 64, 390, 533
Azéma, Léon 421
Aztecs 325, 326

Bacon, Francis 18–20, 65, 77
bad taste 249, 250, 252, 255, 296
Bailey, David 249, 772
Bainbridge, Eric 28, 29
Baines, George 505
Bakema, Jaap 150
Ballard, J. G. 253, 685, 770
Balmedie 720, 721
Balmond, Cecil 717
Baltic 33, 143, 152, 415, 527–73,
692
Baltic Exchange 687
Banham, Reyner 141, 142, 164,
377, 634, 770

banlieue 347, 818, 905
Bara, Joseph 419
Barbara (Monique Serf) 38, 748,
846, 855, 856
Barbican, London 483, 826
Barcelona 178–9, 180
Barclay Bruntsfield church 79,
253
Barge, Jacques 421
Barka, Ben 361
Barnes, Julian 75, 180; Keeping an
Eye Open 75–8
Barnett, Dame Henrietta 93, 94,
96
baroque 98, 103, 158, 179, 366, 374,
389, 390, 435, 503,
689–90
Barrès, Maurice 910
Barry, Charles 426–7
Basque country 392, 393–4, 416,
422, 440, 789–90
Bastien-Thiry, Jean-Marie 736–7
Bata 222, 225, 679, 680
Bataille, Georges 838
Bath 89, 213, 805, 832–3
Battersea Power Station 524
Bauhaus 504
Bayonne chocolate 325–6
Bazin, André 430
BBC 134, 290, 365, 433, 643–4,
761, 857–9, 870, 873, 908, 940,
942
The Beatles 754–6, 762, 764
Beaton, Cecil 249, 250, 252, 255
Beaubourg, Pompidou Centre
712, 713, 774, 828, 831,
833–4
Beaucastle 698
beauty 132, 254, 536
Beauvoir, Simone de 162
Becchina, Gianfranco 46
Beck, Harry 500
Beckett, Samuel, Murphy 511
Beckmann, Max 34
Becontree 696
beer 370, 371, 491, 493, 495, 534,
540, 857
Beethoven, Ludwig van 317, 539,
552

Beevor, Anthony 933
Belgium 364–74, 503, 534,
856–7, 909
Bell, Mary 608
Bell, Steve 61, 62, 255, 642
Bellamont 702
Bellamy, Edward, Looking
Backward 403
Belli, G. G. 56–7
Belsize Park 110
Benalla, Alexandre (Maroine)
361–3
Benoît, Pierre, L'Atlantide 577
Bentley, Bill 507
Benton, Tim 890, 893
Berenson, Bernard 47
Berger, John 432
Bergmeier, Horst J. P., Hitler's
Airwaves 592–5
Berlin 89, 540, 587, 888
Bermondsey 100, 114
Bern, Stéphane 348
Bernard, Jeffrey 298, 303–304, 453,
508, 614, 623, 626, 930
Bernini, Gian Lorenzo 843
Bernstein, Levitt 773
Betjeman, Sir John 97, 146, 159,
197, 249, 703, 761; First and
Last Loves 105, 927
béton brut 142, 164
Bewdley 698, 880
Bezjak, Roman 391
Bible 237, 243, 244, 301, 375
Big Ben 427
Biggins, Christopher 255, 258,
489
Bilbao 68, 785, 788–9, 796, 810–12,
816–17, 822, 823–4, 825;
see also Guggenheim Museum,
Bilbao
Bilbao Airport 789–90
Bilbao effect 778–9, 796, 810, 811,
817, 824, 876
Bilbao library 822
Birchwood Mansions, Muswell
Hill 505
Birmingham 117, 123–6, 422, 529,
644, 776, 785–6, 789, 794–5
Bismarck, Otto von 531, 541

Index

Black Country 367, 898, 901

Black Tower wine 230–2

Blair, Tony 133, 265, 277, 353, 407–408, 417, 463, 525, 619, 706–709, 779–80, 811, 859, 876, 933

Blake, Peter 69, 764

Blanc, Raymond 248

Blenheim 26, 149–50, 158, 659

Blomfield, Reginald 368, 376, 423, 424, 638

Bluewater 652–5

Blythman, Joanna, *Bad Food Britain* 245–9

Bocuse, Paul 202

Bodson, Fernand 366, 374, 504

body 174–6, 179, 180, 552–3

Body-Gendrot, Sophie 889

Bofill, Ricardo 99, 113, 135, 712

Böhm, Dominikus 116, 584

Böhm, Gottfried 117, 143, 584

boiling 198

Böll, Heinrich 101

Bolshevism 234, 578, 922

Bonald, Louis de 420

Booker, Christopher 86, 618

Bordeaux 262, 544, 814, 875

Borel, France 18; 'The Face Flayed' 20

Boresse 339

Borges, Jorge Luis 311, 377, 569, 690, 882, 923

Bosch, Hieronymus 22, 34, 474, 536

Boumphrey, Geoffrey 376, 698

Bourdain, Anthony 241

Bournemouth 40, 228, 389

Bournville 92, 126, 215, 324

Bousquet, Joe 327, 328

Bové, José 288, 350

Bower, Stephen Dykes 633

Bower, Tom 716

Boxer, Mark, *The Stringalongs* 823

Boyd, Brian, *Vladimir Nabokov: The Russian Years* 918–22

Boyne, Colin 636

Bradlaugh, Charles 435

Bradley, Simon 686–7, 688, 697

Bragg, Melvyn 941

Brahms, Johannes 317

Branagh, Kenneth 73

Brandt, Bill 429, 500

Braque, Georges 160, 533

Bras, Michel 296

Brel, Jacques 748, 845, 855, 856, 857

Bremen 143, 150

Brentwood cathedral 223

Breton, André 628

Brexit 60, 371, 631, 729, 733, 736

Brezhnev, Leonid 151, 155, 390

Brighton 40, 126–32

Bristol 185, 802–803, 804, 809, 880, 896

Britain: art, sex and death 176; beer 534; Britishness 33; brutalism 145–6; cars 884; colonialism 903; cooking 207, 246, 247, 318, 371; food 197–208, 245–9, 318, 324, 371, 495–6; German language 539; have-nots 905; hotels 643–5; housing 189, 779–81; humour 708; immigration 903–904; inarticulacy 211; language 523; and London 185–90, 794–5, 820, 896; looking south 528–9; north-east England 22–9; pace of life 276; politics 706–709; regionalism 876–7; squeamishness 206, 248, 254; United Kingdom 371; wine 318, 320, 534, 929–30

British Empire 545, 903

British Library 632, 841

Brittain-Catlin, Timothy, *Bleak Houses* 110

Britten, Benjamin 31, 656

Brodrick, Cuthbert 386, 506, 796, 824, 925

Brooke, Rupert 739

Brooks, Alan, *The Buildings of England: Worcestershire* 696–8

Brophy, Brigid 453

Brothers Grimm 550, 551

Brown, Capability 669, 671

Brown, Craig 613, 626

Brown, Glenn 53

Brown, Gordon 133, 799

Brown, Richard 830, 831

Brown, Tina 728, 738, 739

brownfield sites 669, 897

Browning, Robert 133

Bruce, Lenny 452

Bruckner, Pascal 291, 356

Bruges 368, 555

Brunel University 144

Brussels 365–6, 374, 502, 504, 543, 566, 856

brutalism: A–Z of 141–51; churches 117, 118, 143; Le Corbusier 143, 147, 167, 894; legacy 111; Meades film 296–7; and modernism 112, 152, 168; and music 170; and nature 168–9; *nybrutalism* (new brutalism) 141, 163; origins 163–5; postcards 153–8; Soviet Union 152, 156; Ukraine 391; value of 171

brutophilia 297

Buchan, John 681; *Mr Standfast* 91, 582

Buckeridge, Anthony 753

bucolicism 188, 189, 191, 214, 215, 275, 660, 895

Buenos Aires 216, 569, 882

Buffon, Comte de 227, 367, 925

buildings 85–122, 182, 193, 277, 682–5, 844

Bulganin, Nikolai 382

Bullett, Gerald 653

bullfighting 393

bunkers 160, 161, 164, 165, 168

Bunning, James Bunstone 510–11

Buñuel, Luis, *El* 836

Burdett, Ricky 889; *The Endless City* 885–90

Burges, William 253, 358, 360, 386, 633

Burgess, Anthony 64, 65, 447, 453, 921, 929, 933–9

Burke, Thomas, *Limehouse Nights* 515

Index

Burleigh, Michael: *Earthly Powers* 417–20; *Sacred Causes* 414–17

Burne-Jones, Edward 78–82

Burra, Edward 31, 32, 65, 227, 376, 423, 669

Burroughs, William 19, 939

Burton, Richard 249, 445, 534

buses 496–7, 715, 879–82

bus stops/shelters 152–3

Butler, R. A. 919

Butterfield, William 79, 253, 280, 283, 284, 408, 637

Caborn, Richard 248

Cabot Circus 809, 810

Cachemaille-Day, N. F. 98, 696

Cadbury-Brown, Jim 150, 287, 294, 679

Calatrava, Santiago 179, 244, 351, 788, 789–90, 822

Caledonian Market 511

calendar 411–12, 753–4

Callaghan, James 798

Cambridge 135, 138

Cameron, David 60, 718, 730

Camp, Alan 484, 786

Camp, Sokari Douglas 487

Campbell, Alastair 735

Campden Hill 500, 501

Camus, Albert, *Les Justes* 346

canals 367, 667, 791, 792, 880

Candelis, George 150

Cantonese food 514, 516

Caradec, Madame Laure-Agnes 121, 122

caravanning 645–6, 647–8, 649–51

Carcassonne 327–8, 329, 556

care homes 270–1

Carr, Will, *The Ink Trade: Selected Journalism 1961–1993 by Anthony Burgess*, 938–9

Carroll, Lewis 133, 756, 766, 924

cars 46, 123, 124, 231–2, 881, 882–4

Carson, Edward 434–5, 437

Carson, Liam 624–7

cartoons 61–2, 63

Caselli, Eugène 347

Casson, Hugh 424, 634

Castello Mackenzie 378, 380

Castle Howard 26, 158

Catalonia 134–5, 441, 572, 631

cathedrals 30–1, 106, 117, 332, 356–8, 360, 394, 425, 532, 542

Catholicism 143, 174, 258–9, 282, 293, 331, 357, 416, 440, 503, 537, 584, 707, 754, 783, 816

Caulfield, Patrick 74

cave dwellers 147, 696, 808, 899

Celticism 133

Cenotaph 423

Centre Pompidou, Beaubourg 712, 713, 774, 828, 831, 833–4

Centrosoyuz, Moscow 911

Cerne Abbas Giant 642

Cézanne, Paul 77; *The Murder* 61

Chabrol, Claude 188

chalk 204, 640–3, 664, 799

Chalk, Warren, *Archigram: The Book* 767–75

Chamberlain, Houston Stewart 539, 576, 597

Chanel, Coco 73, 810

Chaney, Lisa 930, 931

Charing Cross station 114

Charles, Prince of Wales 85, 146, 150, 176, 193, 239, 376, 381, 444, 514, 525, 587, 609, 701, 829, 834, 891

Charney, Noah, *The Art of Forgery* 45–8

Chartwell 659–60

Chaubin, Frédéric 145, 152, 391

cheese 204, 337–8, 494–6, 544, 664

chefs 197, 202, 241, 246, 307, 621, 623

Cheltenham 895, 927

Cherry, Bridget 693, 696

Chilcott, Gareth 862, 870

childhood 305, 307, 308, 310–11, 656, 657

chilli 325–6

China 458, 473, 719, 723, 909

Chinese community 514–16

Chinese cooking 201, 802

Chirac, Jacques 296, 355, 357, 712

chocolate 129, 324–7

Christ, Jesus 202, 234, 301, 330, 420, 457, 459, 559, 576, 734

Christianity: Attlee on 417; and deserts 558; and faith 234, 236, 243, 252, 259, 265; France 330, 331; icons 457, 459; and Nazism 575–6, 585; the north 558, 559; post-war 415

Christmas cards 208, 209

Church 115–16, 186, 235, 238, 331, 632–3

churches: Baltic 559; brutalism 117, 118, 143; England 96–8, 285, 704; France 147–8, 420; Gothic 96, 98, 106–107; icons 458; medieval buildings 90; Nazism 584–5; new buildings 238; paganism 556; and religion 96–8, 117–18, 425; in the round 40, 143, 171, 935; Stamp on 632–3; Vatican II 115–18, 171, 783; Victorian architecture 285, 878; wealth 541–2, 544

Churchill, Lady (Clementine) 29, 30

Churchill, Winston 29, 434, 459, 659–60, 731, 942

CIAM (Congres Internationaux d'Architecture Moderne) 150

cinema 142, 285, 429–30, 941

The Circle, Bermondsey 114, 786

La Cité Radieuse (l'Unité d'Habitation), Marseille 120–2, 142, 166–8, 294, 316

cities 123–40; city of spectacle 822, 823; City of the Future 767–8, 769–71; civility 264; and country 188, 191, 819; criticism of 885; expansion 668, 793–4, 886; *flânerie* 267, 276; football 795; French historic cities 814; gentrification 898; health 552; homogeneity 816; north 545; planning 800–801; regeneration 68, 788; regionalism 877; and suburbs

Index

895; town halls 796, 824, 878; transport 883; urbanism 431, 886; Victorian writers 188; world cities 350, 501, 523, 794, 820, 887–8; *see also* garden cities; inner city

Citterio, Antonio 295

City Hall, London 786

City of London 520–1, 526, 686–8, 897

City of the Future 767–8, 769–71

Civilisation (TV series) 759–61

Clapham 496–8

Clark, Kenneth 73, 77, 759, 760

class clearance 684, 813–14, 898

classicism 98, 103, 193, 253, 424, 533, 536, 586, 638–9

Clayderman, Richard 331

Clayton, Robert 900; *Estate* 898–903

Clent, Wayne 198–9, 307, 496

Clermont-Tonnerre, Claire de 260, 261, 262

clichés 256, 257, 448–50, 454, 476–9

Cliff Road Studios 9

Clifton suspension bridge 651

Clifton-Taylor, Alec 197; *The Pattern of English Building* 104

climate change 83

Clintons Cards 209, 210, 211, 230, 463

Clinton, William Jefferson (Bill) 923

Cloisters, Letchworth 93, 423

Cobb, Richard 399, 856

Cocteau, Jean 73, 168, 392

Cohen, Jean-Louis, *Le Corbusier Le Grand* 890–4

Cole, Henry 208, 209

Coleman, John 220

collage 311–12

Collier, Jeremy 843

Collier, John 12

Collingwood, R. G. 71

Collins, Herbert 505

Collins, W. J. 505

colonialism 162, 292, 341, 342, 344–6, 363, 371, 903

colour 84, 427, 428, 430, 433, 484–5

Columbia Market, Bethnal Green 695

Combes, Emile 420

comic writing 450–3

Commission on the Built Environment 800–801

Commons Preservation Society 404

Commonwealth War Graves Commission 421

communism 156, 385, 387–91, 548, 555, 564, 565, 566, 911

Comper, Ninian 359, 411, 418, 756, 804

Comprehensive Redevelopment 771, 785, 787, 790, 808, 809, 810

Compton Acres, Parkstone 703, 926

Comte, Auguste 420

concentration camps 579, 584, 588, 607

Concorde Hotel, Quebec City 148

concrete 141–72, 297

Coney Island 905

congestion charging 883

Conlin, Jonathan 759

Conner, Piercy 874, 875, 876

Connolly, Cyril 16, 73, 612, 760

Conrad, Peter, *Modern Times, Modern Places: Life and Art in the 20th Century* 923–4

Conran, Terence 208, 318, 525

conservation movement 483, 927

Constable, John 33, 80, 672, 677

Constantine, David 277

construction industry 119–20, 461, 784, 800–801, 807, 821, 825, 886, 907–909

constructivism 146, 155, 382, 391, 563

Cook, Peter (Archigram member) 770, 774, 775

Cook, Peter (satirist) 293, 524

Cook, Robin (Derek Raymond) 718

Cooke, Rachel 296; *Her Brilliant Career* 150

cooking: Belgium 369, 370–1; Britain 207, 246, 247, 318, 371; Chinese 201, 802; as craft 201–202; France 319–20, 370, 392; gastroculture 239–42; Korean 508; south 533–4; Spain 392; television 621; *see also* food

cooling towers 145, 171, 285, 672

Cooper, Artemis, *Elizabeth David: Writing at the Kitchen Table* 930–3

Cooper, Diana 226, 227

Coop Himmelb(l)au 774

Coppedè, Gino 377, 378–80

copyism 79, 80, 179, 360, 366, 376, 480, 631, 891

Corbin, Chris 625

corruption 292–3, 369, 525, 908

Cosmic Ice theory 577–8, 602

Cotchford Farm 55–6

cottage *orné* 92, 275, 518

cottages 274–5, 503, 670, 671, 817, 886

council houses 683, 694

country houses 402–405, 659

Country Landowner journal 662–3

Country Life magazine 191–4, 610, 659, 660–1, 938

countryside 184–91, 651, 660–3, 670–1

Couture, Thomas 77

Coventry cathedral 30–1, 73

Coward, Noël 250

Cowlishaw, William Harrison 93, 423

Cow Parades 485–8

Cowper, William 135, 525, 788; *The Task* 62

craft 43, 64, 65, 69, 202, 327

Cragside 27

Craig, Patricia, *The Penguin Book of British Comic Writing* 450–3

953

Index

'creatives' 684, 917

credit 188, 219, 797

Creed 758, 759

cricket 318, 320, 710, 868, 872

critics, and criticism 524, 820–1, 923, 939

Critser, Greg, *Fat Land* 287–9

Crittall windows 222, 670, 680

Croce, Benedetto 158

Crompton, Dennis 767

Crompton-Batt, Alan 621–3

Crook, J. Mordaunt, *The Rise of the Nouveaux Riches* 104, 405–407

Crosland, Anthony 868

Crossland, W. H. 284

Crowley, Aleister 269, 579

Crutzen, Paul 886

cuckoldry 836

cults 65, 234, 235, 415, 417, 456, 537, 575

cultural regeneration 68, 834

culture 50, 68, 283, 812–13, 825, 834

Cunliffe, Lesley 612–14

Cunliffe, Marcus 613

curatocracy 43–5, 50, 69, 480

Cust, Edward 426

cycling 316–17, 882

Cyclopean 161–2

Dacre, Lord (Hugh Trevor-Roper) 596

Dadd, Richard 22

Dailey, David 762

Dainton, Sir Fred 632

Dalí, Salvador 257, 259, 459, 533

Dandy, Leslie 295

Danzig 554–5

Darbishire, H. A. 695

Darley, Gillian, *Excellent Essex* 222–5

Darré, Richard Walther 240, 467, 581, 582, 601; Race 605

Darwinism 20, 21

Davenport, John 840

Davey, Peter 182; *Arts and Crafts Architecture* 181–4

David, Elizabeth 16, 73, 204, 476, 533, 930–3

David, J.-L. 418, 419

Davies, Hunter, *The John Lennon Letters* 761–4

Davies, Maggie 57

death 109–110, 172, 173–80, 210, 234, 259, 269–72, 304, 316, 368, 447, 739

debt 188, 219, 220, 797

decadence 35, 82, 434–8, 678

Decadents 15, 34, 438, 678

Decathlon 866–7

Delafon, M. Laurent 758, 759

Delauney, Sonia 834

DeLillo, Don, *White Noise* 595

Delon, Alain 335, 361, 362

demolition industry 216, 800

dendrophilia 297

Dennis, Felix 752

Denver Sluice 83, 655, 667

department stores 215–17, 228, 497–9

Derbyshire, Andrew 112, 636

Desdemaines-Hugon, William 386–7

design 199, 926

Detmold 575, 576

Devey, George 183

Devil's Cathedral, Arnos Vale 800

Dewey, John 914

Diana, Princess of Wales 218, 408, 735

Dibden Purlieu 15, 17, 18

Dickens, Charles 188, 428–9, 430, 677, 731, 792

Dicks, Terry 860, 863

dictators 381, 385, 386, 387, 458, 721

Diderot, Denis 257, 269, 419

Dillon, Sheila 197

Dilworth, Steve, *Hanging Figure* 684

Dimakopoulos, Dimitri 148

Diptyque 758, 759

dirigisme 136, 220, 248, 321, 510, 568, 744, 790, 798

Dix, Otto 163, 293, 774, 826, 831

Dixon, Jeremy 114

dogs 389, 563, 722–6, 728

Dors, Diana 853, 854

Dorset 26, 677, 700–705

Douaumont ossuary 421

Douglas, Norman 16, 931–2

Douglas-Camp, Sokari 340

Doyle, Arthur Conan 22, 431

dreams 36, 270, 309

Drif, Zohra 345–6, 347

drink and drinking 69, 176, 230–2, 248, 394, 494, 534–5, 538, 928–30

drugs 22, 130, 132, 535, 724, 725

Dubuffet, Jean 164, 165

Ducasse, Alain 319, 320

Duchamp, Marcel 44, 50, 64, 69, 180, 262

Duff, Lady Juliet 250

Dumont, Jean 118

Durrell, Lawrence 31, 73, 533, 932

Duveen, Joseph 47

Dyckhoff, Tom, *The Age of Spectacle* 820–3

Dyke, Greg 691, 859

dystopia 142–3, 413

Eastbury 26, 703, 704

edgelands 669–70, 697

Edinburgh 89, 132–5, 805

Edman, Bengt 163

Edrei, Max 421

education 148, 211, 274, 278–87, 478, 517

Edwards, Osmund 310

Eigen Haard housing estate 504

Eisenstein, Sergei 546

electronic cottage 190, 817

Eliot, T. S. 26, 75, 79

elites 350, 353, 360, 466, 477, 717

Elizabeth, Queen 513, 642, 735

Ellis, Clough Williams, *England and the Octopus* 108

Ellwood, Craig 833

Elms, Robert 626

ELO 28, 125, 469, 749, 780

Elvetham Hall 79, 253, 659

Emin, Tracey 53

Engel, Carl Ludwig 569

Engels, Friedrich 188, 539

Index

engineering 27, 29, 79, 296, 817

England 181–225; Betjeman on 926–8; churches 96–8, 285, 704; Englishness 174–5, 176, 189, 253, 254; Eurich paintings 16, 18; Euroscepticism 342; food 197–208, 371; football team 863–4; and France 292–3; Gothic revival 329; housing 189, 779–81; humour 529; landscape 667–72; language 66, 106, 347–9, 443, 471–3, 477; Little England 196, 246, 711, 734, 779; and London 185–90; merry England 189, 192; middle England 89, 175, 191, 263, 267, 285, 707; non-English groupings 538; north and south 529–30; north-east 22–9; sex 839–40; urbanism 580; wealth 927; wine 502

England: *The Photographic Atlas* 195–6

English Heritage 146, 669, 671, 876

Enlightenment 97, 287, 408, 409, 415, 416, 551

Epstein, Jacob, *St Michael and Lucifer* 31

Erith, Raymond 502

Ernst, Max 55, 168

Eros Centre, Catford 145–6

eroticism 293, 837, 838

Escher, M. C. 380, 742

Esperanto 412, 472

Essex 222–5, 672–81, 693, 724–5

Essex University 148

Estonia 388, 546, 564, 565–8

ethnicity 199, 201, 401

Eton College 577, 718, 730

Eucharist 65, 66, 202, 234, 304, 783

eugenics 581, 601

euphemism 176–7, 445–8

Eurich, Richard 15, 16–18, 538

European Union (EU) 371, 494, 547, 567–8, 663

Euroscepticism 341–2

Evans, Matthew 746

Exeter cathedral 106

expressionism 64, 98, 103, 117, 143, 147, 150, 163, 374, 541, 588

Externsteine rocks, Detmold 575

exurbia 215, 818, 819, 879, 895

Eyck, Aldo van 150

The Faber Companion to 20th-Century Popular Music 746–50

Fabians 94, 436, 437, 680

Le Facteur Cheval 378, 830

the Factory, Manchester 825, 907

failure 108–110, 781, 790

Fairhurst, Angus 48, 53

fairies 20–2, 235

faith 232–9, 240, 243, 258, 282, 283, 304–305, 418, 733–4; fads and fashions 226–55

faith schools 282, 420

Falkland Islands 58

Falkner, J. Meade, *The Lost Stradivarius* 379

family 269–74, 303, 615, 640, 802

Farage, Nigel 60, 720

Farrell, Terry 114, 509, 510

Farson, Daniel 626

fascism 416, 584, 609, 909, 910, 911

Fashion and Textile Museum 484, 786

fast art 59, 60

fast food 200, 206–207, 247–8, 268, 288–9

Favreau, Lucien 340

Feldman, Marty 261, 329, 761

fellatio 244, 438, 448, 626

Fells, Joseph 680

feminism 247

Fens 25, 82–4, 184, 655, 667

Ferriss, Hugo 390

Fest, Joachim 599, 606, 608; Speer: *The Final Verdict* 598–600

Festival of Britain 141, 522, 571

fiction 273, 303, 310, 939

Field, Andrew 919, 920, 921, 922

Field, Horace 110

Fildes, Luke 10

Fillon, François 354

fine dining 72, 239, 241

Finland 569–72, 631, 822, 825

first person 256–317

First World War 40, 366, 368, 530, 539, 597

fish 204, 530–1, 553, 560

fish and chips 203–204, 247, 730

Fisher, Mark 459

Fitzgerald, John 'Fairy' 22

Fitzgerald, William (Ignatius Phayre) 610

Flanders 530, 533, 534, 555

flânerie 221, 267, 276, 387, 683, 889, 913

Flaubert, Gustave 77, 78

Fleming, Ian 579

Fletcher, Geoffrey 823

FLN (National Liberation Front) 292, 343, 344, 347

Florence 378, 379

Florida, Richard 917

fog 428, 430, 431, 499–500

folk art/music 92, 295, 562, 572, 656

food: animals as 722–6; A–Z of English food 197–208; Baltic 527, 530–1; Britain 197–208, 245–9, 318, 324, 371, 495–6; cheese 495–6; Chinese food 514–16; fast food 200, 206–207, 247–8, 268, 288–9; France 319–20, 324–7, 370, 392, 496; freshness 490; gastroculture 239–42; Germany 493, 538; industry 246; markets 221; north 529–31, 537–8, 542–3, 553–4, 559–60; regulation 201; religious practices 537–8; source of 205–206; south 533–4; Spain 392; television 197, 621; writing 200, 241, 312–14, 621–2, 930–3

The Food Programme (radio show) 197

football 54, 100, 138, 242, 247, 268, 306–307, 442, 468, 477, 480, 676, 795, 860–71, 873

Index

Forbes, Bryan 757, 850

Forderer, Walter 117, 143

Forest Hill 506

forests 549–51, 557–61, 570

forgery 45–8, 262

Forster, Joseph Wilson 10

Forth Bridge 27

Fortune, John, *A Melon for Ecstasy* 297

Foster, Norman 151, 351, 360, 687, 774, 788, 833, 834; City Hall 786; Millau Viaduct 821; Willis Faber building 100

Fourier, Charles 420

Fowler, John 27

Fox, Nick 102

Frame, Pete 592

France 318–63; and Algeria 342–3; anti-communitarianism 243; *banlieue* 347, 818, 905; beer 534; and Brel 857; brutalism 142; chocolate 324–7; churches 147–8, 420; class cleansing 813–14; colonialism 341, 342, 363, 371, 903; Comprehensive Redevelopment 808; defences against 719; and England 292–3; food 319–20, 324–7, 370, 392, 496; health care 315–16; historic cities 814; hypermarkets 321–4; immigration 341, 523, 903–904, 905; inner city 896; *Jonathan Meades on France* 289–93; language 347–8, 443, 471, 473; Le Corbusier 892, 893; living space 875; northernness 530; Notre Dame 356–8; and Paris 350; politics 361–2, 707; popular culture 308, 845–6; referendum 341, 342; religion 330–1; rural life 671; sport 468, 871; wine 231, 320–1

Francis, Sidney 249

Franco, Francisco 116, 439, 440, 442

free market 799

free speech 236

Freeze exhibition 51

French-bashing 349, 350

French Revolution 413–14, 418–19, 754, 848

Freud, Lucian 33, 77

Freud, Sigmund 20, 400

Frey, Roger 361

Friedman, Yona 808

Friedrich, Caspar David 23, 549, 551

Fritsch, Theodore 582

froissage 42, 56

Frost, Robert 450

Fryer, Paul, Transmission 717

Fry, Roger 76, 372, 533

les fuck-offs 348–9, 708, 709

Full English 199–200

Fuller, Martin 35–8

Fullerton, Elizabeth, *Artrage* 48–53

furniture 295–6

further abroad 364–98

Fuseli, Henry 22

Fussell, Paul 639

future architecture 767–9, 777

Future Systems 125, 774, 789

Gabo, Naum 9

Gage, Mark Foster 360

galleries 44, 49, 51, 53, 67–8, 826–7

garden bridge 62, 525–6, 715

garden cities 91–6, 212, 215, 374, 403, 435, 503, 504, 540, 582, 695, 914–15

gargoyles 542

gastroculture 239–42

gastronomic writing 200, 621–2, 930–3

gastronomy 246, 249, 621–2

gated communities 789, 897, 904, 917

Gate, Max 134

Gateshead 118, 742, 744, 745

Gaudí, Antoni 152, 179–80, 377, 378, 391, 504; Sagrada Familia 176, 179, 503

Gaulle, Charles de 166, 291, 292, 342–3, 361, 363, 736–7, 904

Gaulle, Yvonne de 737, 738

gavelkind 658

Gdansk 389, 554–5, 556

Géant 321–3

Gehry, Frank 351, 360, 394, 524, 785, 788, 816–17, 821–2; Guggenheim Museum, Bilbao 788, 810–11, 816, 821, 822, 824

Genet, Jean 19, 228, 447, 910

Genoa 377, 378, 379

gentrification 431, 684, 822, 878, 896, 898, 916

geology 104, 144

Georgia 144, 391

Germania 607, 609

Germany: anti-Semitism 597; brutalism 143, 144, 165; cars 231–2; emigrating artists 32–5, 161; food 493, 538; fortifications 160–1; garden cities 540; Gothic 540, 549, 550; Hamburg 540–1; Hanse cities 541, 548; language 539; music 539; naturism 552–3; neo-Nazis 565; non-English groupings in England 538–9; Northern Renaissance 533; *ostalgie* 491, 492, 565; public transport 796; resorts 551–2; romanticism 24; Rügen 549–51; totalitarianism 414–15; *Völkisch* tendency 580–1; war 33, 160–1, 165; wine 231, 232, 539; *see also* Nazism; NSDAP

Gestapo 361, 467

Geste Architectural 834

gestural engineering 817

Ghent 372, 555, 755

The Gherkin (Swiss Re tower) 526, 843

ghosts 21, 35

Gibson, Ian, *The Erotomaniac: The Secret Life of Henry Spencer Ashbee* 839–41

Gibson, James 498

Gide, André 166, 459

Index

Gidea Park 224, 695

Gifford, John 691, 692

Gilbert, Alfred 10–11

Gilbert, W. S. 925

Giles, C. E. 281

Gill, Michael 759

Gillick, Liam 49

Gilman, Harold 91

gin 534–5

Ginzburg, Carlo 416; *Myths, Emblems, Clues* 399–401

Girouard, Mark 193

Giscard d'Estaing, Valéry 712

Glancey, Jonathan 842

Glasgow 25, 133–4, 171, 571, 638, 692

Glass, Ruth 431, 822, 916

Globish 471–3

Gloucestershire 106, 213–14, 686, 880

Glover, Stephen 60, 738

Goacher, Alex 295

God, and gods 20, 21, 107–108, 143, 232, 233, 235, 243, 301, 415, 457, 458, 557, 558, 799

Godard, Jean-Luc 142, 419

Goebbels, Joseph 414–15, 447, 590, 593, 594, 603, 604, 608, 699

Goldfinger, Erno 696

Goldsmiths 48, 52

golf 650, 720

Gomme, Sir Bernard de 679

Gonzalez-Crussi, F., *On the Nature of Things Erotic* 836–9

good taste 89, 98, 249, 252–5, 403, 453

Goolden, Jilly 452

Gordon, Adam Lindsay 927

Gordon, Rodney 118, 145–6, 149, 171, 286, 808

Gore, Spencer 91

Göring, Hermann 603, 718

Gosport peninsula 719

Gothic: building system 358, 359; cathedrals 114, 117; churches 96, 98, 106–107; and classical architecture 536–7; Gaudí 179; Germany 540, 549, 550; and

Gothick 279, 329; and Hitler 106, 537; horror 142; literature 550; modern Gothic 79, 82, 158, 168, 253, 425; and the north 532, 535; origins 105–108; revival 281, 284, 329, 532, 778; Stamp on 631, 633

Gough, Piers 9, 87, 99, 114, 120–1, 294, 786

Gove, Michael 720, 727, 728

Goya, Francisco 257, 438–9; *Disasters of War* 60, 439

Graaf, Reinier de 912–13; *Four Walls and a Roof* 905–909

Grade, Lew 936

Grade, Michael 858

Graham, Peter Anderson 192

Grahame, Kenneth, *Dream Days* 181

Gravesend 678–9

Gray, A. Stuart 110

Gray, Eileen 32

Graz Kunsthaus 775

Great Packington church 96

Great Wall of China 719

Greaves, Derrick 74

Greco, Juliette 756

Green, Jonathon 447, 468, 479; *Days in the Life* 752; *Green's Dictionary of Slang* 98, 474–6, 676; *Oz magazine* 752

Greene, Grahame 454, 497, 633; *Brighton Rock* 429

Greenwich Peninsula 514

Gregorian calendar 412, 414, 753, 754

Gregory, David 246

Gregory, Richard, *Eye and Brain* 767

Gresley, Sir Nigel 743, 792

Griffiths, Trevor 940

Grigson, Geoffrey 699

Grimm Brothers 550, 551

Grimshaw, John Atkinson 637; *Iris* 21

grotesque 114, 535, 541

Groucho Club 624, 625, 626

Guédon, Christian 363

Guérini, Jean-Noël 350

Guernsey 588, 863

Guggenheim Foundation 825

Guggenheim Museum, Bilbao 68, 394, 778–9, 785, 788–9, 796, 810–12, 816, 817, 821–5, 876

guild socialism 221, 581

Gull, C. (Chris) 127, 128

Gunter, James 10

Guthrie, Woody 196

Gwynn, John 137

Gwynne, Patrick 507

Gwynne, Rupert 931

Gysin, Brion 91

H., J. Mayer (Jurgen Mayer Herman) 144

Habitat 67, Montreal 148

Hackney, Rod, *The Good, the Bad and the Ugly* 85–7

Hadleigh Farm 680

Haggard, Rider 577, 739

Hahn, Harry 47

Haig, Axel 403

Haight-Ashbury 129, 130

hallucinogens 22, 265, 331, 569

Hallyday, Johnny 356, 496, 856

Hamburg 150, 538, 540–1, 568, 588

Hamer, Robert: *Kind Hearts and Coronets* 430, 436; *Pink String and Sealing Wax* 429

Hamilton, Denis 853, 854

Hamilton, Hector 389

Hamilton, Richard 52

Hampson, Frank 773, 830

Hampstead Garden Suburb 91, 93–6, 384, 503

Hanley, Lynsey, *Estates* 683

Hanratty, James 488, 762

Hanseatic League 532, 541, 555

Hanse cities 541–2, 546–8, 549, 554, 555–6, 566, 816

Hardy, Bert 432

Hardy, Jacques 421

Hardy, Thomas 134, 300, 549, 665, 677, 739–40; 'A Man' 630; 'The Ruined Maid' 843; 'A Trampwoman's Tragedy' 118

Index

Hargraves, Orin, *It's Been Said Before: A Guide to the Use and Abuse of Clichés* 476–9
harkis 343, 344
Harries, Susie 48; *Nikolaus Pevsner: The Life* 698–700
Harris, José 403
Harris, Richard 684
Harris, Thomas 78
Harrison, George 356, 763
Harrods 216, 217, 218
Hartley, Dorothy, *Food in England* 198, 247
Hartley, Jesse 826
Harvey, Marcus 53
Hatherley, Owen, *Landscapes of Communism* 387–91
Hatton Garden 681, 915
Haussmann, Baron 510, 916
Healey, Denis 742
health 288–9, 314–17, 551–2
health and safety 248
Healthpolice 200–201
Heath, Michael 614
Heatherwick, Thomas 525, 715
Heathrow Terminal 5 831
Hebborn, Eric 47
Hedenkamp, Hans 583
Hedenkamp, Karl 583
hedges 667
Heffer, Simon: *The Age of Decadence* 434–8; *Staring at God* 739
Heidegger, Martin 914
Hellens, Franz 920
Hellerau 540
Helsinki 569–71, 822, 825, 907
Henry Moore Institute 180
Herkomer 11
Herman, Jurgen Mayer (J. Mayer H.) 144
herring 530–1, 534
Herron, Ron 770
Hertzberger, Herman 906
Herwig, Christopher, *Soviet Bus Stops* 151–3
Heseltine, Michael 787
Hess, Rudolf 579, 581
Heygate, John 594

high rises 86, 485, 696, 898
high street 209, 220, 222
High Victorian architecture 146, 168, 253, 286
High Victorians 104, 182, 183, 427, 539
Hill, Benny 197, 848–9, 936
Hill, Michael, *The Buildings of England: Dorset* 700–705
Hill, Oliver 634, 660, 679
Hill, Rosemary, *Architect: Pugin and the Building of Romantic Britain* 425–7
Hill of Crosses, Lithuania 562–3
Hillingdon Civic Centre 112, 636
Himmelfarb, Milton 597
Himmler, Heinrich 30, 176, 259, 574–5, 578–81, 590, 600–603, 607
Hipgnosis 764–7
hippies 750–1
Hirst, Damien 52–3, 175, 627
history 89, 374–5, 399–442
history of art 33, 44, 65
Hitchens, Christopher 929
Hitler, Adolf: Ahnenerbe 601; anti-Semitism 30, 588, 596–7; architecture 381, 586; Cook on 293; Enlightenment 409, 415; fortifications 161; gesture 587; Gothic 106, 537; Hanse cities 548; on Himmler 575; Hitler diaries 596; Hitler industry 595–8; home life 609–611; icons 458–9; media propaganda 609–611; *Mein Kampf* 585; neo-Nazis 565; NSDAP 576, 582; and Philip Johnson 149; religion 234, 259; and Riefenstahl 590; and Roselius 143; Rosenbaum on 595–8; and Speer 598–600, 602–611, 604, 606; and Stalin 365; theories 578
Hoare, Philip: *Serious Pleasures: The Life of Stephen Tennant* 226–30; *Spike Island: The Memory of a Military Hospital* 140, 409–411

Hoch Haus, Hamburg 588
Hodges, Mike 761
Hodgkin, Howard 61, 76
Hoetger, Bernhard 143
Hoffmann, Heinrich 610
Hoff, Rob van 't 9, 695
Hogg, Douglas 62
Holder, R. W., *The Faber Book of Euphemisms* 445–8
Holland 143, 371, 535, 537, 819
Hollande, François 349, 351, 352, 354, 355
Holloway, London 517–20
Holloway Prison 511
Holly Village, Highgate 695
Holm, Lennart 163
Holocaust 591, 597, 707
homogenisation 815, 816, 817
homosexuality 13–14, 19, 860
Honey, John, *Does Accent Matter?* 443–5
Hörbiger, Hanns 577, 602
Horniman, Roy, *Israel Rank* 436
horses 369, 641–2, 725–6
Horsley, J. C. 208
Hortefeux, Brice 340
hospitals 107, 112, 139–40, 170, 179, 314–15, 409–411, 775
Höss, Rudolf 581
hotels 157, 184–5, 302, 643–5
House for Essex 223
housing: England 189, 779–81; estates 88; failure 109; Hackney on 86–7; high density 896–7; international modernism 566; Lion Farm Estate 898–903; locations 791; London 694–6, 780–1, 876, 889; modernist 388; new construction 779, 784–5; Sinclair on 683, 684; *see also* social housing; volume builders
Housman, A. E. 63, 68, 549, 696, 740, 938
Howard de Walden estate 220
Howard, Ebenezer 87, 92, 96, 214, 695; *Tomorrow: A Peaceful Path to Real Reform* 91, 914

Index

Howerd, Frankie 854
HS2 743–4
Hubbard, Edward 699, 700
Hudson, Edward 192, 660
Hughes, Dusty 55
Hughes, Robert 57–8, 59, 752
Hughes, Thomas, *Tom Brown's Schooldays* 283
Hugo, Victor 166, 459
Hugo Boss 810
humanities 478
Hume, David 107, 134, 542
Hume, Mick 134
humour 99, 114, 125, 210, 450–3, 529, 541, 595–6, 708, 937
Hunstanton School 141, 287
Hunt, William Holman 79, 175
Hurst, Hal 10
Hussey, Duke 942
Hutchesontown flats, Glasgow 171
Hutton, Ronald 642
hypermarkets 321–4

iconic 453–61
iconoclasm 115, 542
identity 465, 481
immigration 263, 304–305, 341, 349, 388, 538, 729, 913
Imperial College London 118, 144–5, 171
Imperial War Museum North 68, 876
Impostures Intellectuelles 707
Impressionism 33, 77, 533
improvisation 869
Inca 151
Ince, Howard 11
incest 303
Indian restaurants 201
Industrial Revolution 10, 539
Inge, William 739, 740
Ingrams, Fred 83–4
initialisms 461–71
inner city 189–90, 431, 492, 526, 696, 813, 818, 895–6, 898
innovation, food 201–202
installations 69

international modernism 103, 162–3, 168, 504, 541, 566, 631
internet 471, 473, 779
invention 88, 89, 303, 309
Iofan, Boris 154, 381
Ireland 417, 444
irony 112, 401, 460
Irony Curtain 125, 529, 740
Irving, Clifford: *Fake!* 47–8; *Hoax!* 48
Isaacs, John 682
Islam 234, 236, 252–3, 330, 415–16, 489–90, 489, 556, 558, 677, 680
Isle of Grain 714, 715
Isle of Wight 184–5
Islington 89, 517, 916
Israel 149, 252, 346, 522, 537
Israeli Nuclear Research Plant, Soreq 149
Italy 24, 33, 102, 106, 374–80, 529, 532–3
IT magazine 751–2

Jacobsen, Arne 120, 637, 690, 806
Jacobs, Jane 915, 916
Jaggard, Anthony 702
Jagger, Mick 444, 458, 459, 935
James, Clive 752, 863, 942; *Visions Before Midnight* 939–40
James, Henry 303, 431
Japan 232, 508
les Jardins de Thalassa 904, 905
jargon 67, 446, 454, 466–7, 474–5, 479–82, 913
Jarman, Derek 12–14
Jasari, Nexhat 145
Jauffret, Régis 57
Jaywick 675, 680
Jehovah's Witnesses 579
Jencks, Charles 112
Jenkins, Simon 381, 891; *England's Best 1,000 Churches* 96–8
Jenks, Jorion 239–40
Jenner, Edward 97
Jerusalem 602
Jervois, William 719
Jews 325, 343, 416, 522–3, 560–1, 578, 584, 596–7, 601, 607, 912

Jezreel's Tower 681
John, Augustus 9, 67
Johns, Captain W. E. 91
Johnson, Boris 60, 371, 525, 681, 711–18, 728, 731–2, 738–9, 740–3
Johnson, Paul 92, 407
Johnson, Philip 57, 100, 149, 634
Johnson, Samuel 307, 745, 793
Johnson, Uwe 682
Johnstone, Keith 869
Jones, Barbara 72
Jones, Brian 56, 91, 749, 752
Jong, Erica 839
Jopling, Jay 53
journalese 454
journalism 193, 246, 454, 476, 477–8, 635, 874
Jowell, Tessa 248, 258
Joyce, James 71, 434, 939
Joy, Thomas Musgrave 14–15
Judaism 325, 416, 558
Julian calendar 412, 753
Junger, Ernst 160, 161
junk food 200, 206–207, 247–8, 268, 288–9
Juppé, Alain 262, 510, 814
Jurmala, Lenin monument 156
Juvenal 552, 885

Kafka, Franz 922; *Amerika* 885; *Metamorphosis* 922
Kalevala 571
Kapoor, Anish 717
Karaites 560–1
Kater, Michael 600
Kawczynski, Daniel 725
Keble College, Oxford 79, 253, 283
Kelleher, Paul 30
Keller, Thomas 241
Kelly, Anthony-Noel 174, 175, 176
Kelly, Mary 50, 175
Kempenaers, Jan 145, 152
Kent 658, 681–2
Kenyon, Nicholas 826
Khomeini, Ayatollah 238–9, 400

Index

Khrushchev, Nikita 151, 154, 155, 385, 388, 390, 563, 713

Kidderminster 698

Kiefer, Anselm 396

Kijno, Ladislas 42, 56

Kilmartin, Terry 618

Kipling, Rudyard 421–2, 436

Kipnis, Jeff 906

Kissinger, Henry 595, 837, 868

Kitchen, Martin, *Speer: Hitler's Architect* 607–608

kitsch 43, 134, 181, 218, 296, 327, 331, 446, 610, 653

Kivell, Rex Nan 74

Klenze, Leo von 359, 365, 380, 570

Klerk, Faf de 870–1

Klerk, Michel de 9, 143, 374, 504

Klotz, Clement 585

knives 337–9

Knox-Leet, Desmond 759

Knutsford 380, 502

Konstantinov, Janko 145

Koolhas, Rem 351, 774, 806, 822, 905, 906, 909

Koran 234, 375

Koreans 505, 507–508, 722

Korpinen, Pekka 822

Korth, Jens 583–4

Kréyol Factory 340

Krier, Leon 587, 609

Kubrick, Stanley 935, 936

Kuhne, Eric 652, 653, 654

Kundera, Milan 19

Kursaal, San Sebastián 789

Kuwait embassy, Tokyo 149

Labouchere, Henry 436

Labour party 89, 417, 706–709, 728

labskaus 202–203, 542–3

Ladenis, Nico 623

Lagardelle, Hubert 910, 911

Laguiole knife 30, 337–9

Laing, R. D. 411

Lambert, Gavin 430

Lancaster, Osbert 146, 159, 381, 522, 700, 701

land art 69, 196

land colonies 93, 213, 403, 698

land enclosure 188, 404

'landmark' buildings 125, 460, 717, 785, 786, 824

landscape 24, 25–6, 667–72, 784

Landseer, Sir Edwin, *Titania and Bottom* 21

Lane, Allen 691

The Lanes, Brighton 127, 128, 130

Langan, Peter 624, 625, 627

Langan's Brasserie 625, 626

language 443–82; accents 443–5; acronyms and initialisms 461–71; Belgium 372; Britain 523; clichés 448–50, 476–9; English 66, 106, 347–9, 443, 471–3, 477; euphemism 445–8; French 347–8, 443, 471, 473; German 539; Globish 471–3; humour 450–3; iconic 453–61; immigration 903; jargon 67, 479–82; learning 299–300; linguistic degradation 256–7; London 466; military 461–4, 465, 467; Normans 106; politics 480; regeneration 456, 460, 479; slang 67, 474–6; sports 480, 869–70; and television 460, 479, 480; and writing 936

lap dancing 260–1, 263, 564

Lapland 564, 569

Larkin, Philip 397

Larmer Tree Gardens 195, 403

Lasdun, Denys 148, 287, 696

late modernism 99, 112, 152

Latvia 546, 566

Lawrence, D. H. 16, 133, 372, 533, 932

Lawson, Nigel 188, 219, 220, 797

Leadenhall Market 521

Leadsom, Andrea 711, 728

Lean, David 430, 761

learning 274, 299–302, 305

Leavis, F. R. 80

Le Corbusier: affiliations 73; anti-Semitism 909–912; architectural wit 99; and brutalism 143, 147, 167, 894; and Buenos Aires 882; character 165–6; Cité Radieuse (l'Unité d'Habitation) 120–2, 142, 166–8, 294, 316; collaborators 150; influence 287; lawsuits 834; *Le Corbusier Le Grand* review 890–4; modernism 165–6, 566; Notre Dame du Haut, Ronchamp 116–17, 422, 893; painting 893; Petits Conforts 295; Plan Voisin 155, 771, 892; and postmodernism 113; sculpture 893; Unités d'Habitation 892; as writer 891–2

Ledoux, C.-N. 99, 842

Leeds 27, 180, 185, 506, 789

Leeds Town Hall 796, 824

Lees-Milne, James 71, 194, 224, 936

Léger, Fernand 142, 893

Legman, Gershon 841

Legoretta, Ricardo 484, 485, 786

Lemoine, Jean-François 806

Lenin, Vladimir 156, 234, 382, 383, 385, 390, 415, 458

Lennon, John 755, 756, 761–4

lentils 332

Leonardo da Vinci 47, 176, 525

Le Pen, Jean-Marie 342

Lequeu, Jean-Jacques 99, 257, 262, 773, 842, 891

Lesy, Michael, *The Forbidden Zone* 176–8

Letchworth Garden City 91–4, 212, 214, 215, 260, 423, 503, 540, 582, 695, 914

Le Tissier, Matt 306, 863, 864, 865

Letrosne, Charles 351

Levin, Bernard 264, 475, 595, 617, 920

Lévy, Bernard-Henry 345–6, 350

Levy, Paul, *Out to Lunch* 726

Lewis, Norman 224

Index

Lewis, Wyndham 72, 328; *Rotting Hill* 430–1
Ley, Robert 585, 590, 603, 718
ley lines 579
Leyton, John 488
Liaudet, David, *Architectures de Cartes Postales* 40
Liberty (shop) 378
Libeskind, Daniel 68, 517, 785, 821–2
libraries 148, 170, 437, 632, 786, 822, 841
Liddle, Rod 246
Lidl 492–4
Liège 368–9, 373
Lincoln 106, 425, 529
Lineker, Gary 247, 865
Lion Farm Estate, Oldbury 898–903
listed buildings 120, 121
Lithuania 152, 391, 546, 556, 557, 558–63, 566
Little England 196, 246, 711, 734, 779
Liverpool 202, 543, 771, 787, 788, 862
Livingstone, Ken 497, 510, 515, 709, 716, 881, 883, 884, 889
llama farming 663
Llanelli 438
Lloyd, David 410
Lloyd George, David 404, 435
Lloyd's Building 151, 828, 831, 833
Logis des Freres Michel 330
logos 459, 824, 825
loitering 267–8
Lombard School 702–703
London 483–526; accents 444; architectural wit 114; artists 917; and Boris Johnson 711–12, 713–14, 717; and Britain 185–90, 794–5, 820, 896; City of London 520–1, 686–8, 897; city of spectacle 823; Clapham 496–8; colour 484–5; concert halls 826; congestion charging 883; de

Graaf on 908; Dickens on 677; East End 694; and England 185–90; and Essex 223; fog 499–500; galleries 826–7; garden bridge 62, 525–6, 715; gentrification 822–3, 878, 916, 917; ghettos 263; growth 793–5; Harrods 216–17; Holloway 517–20; housing 694–6, 780–1, 876, 889; HS2 743–4; immigration 903; inner city 190; Islington 89; landmarks 786; languages 466; Lewis on 430–1; modern architecture 523; Muswell Hill 504–505; Nash Ramblas 508–510; New Malden 505, 506; Pevsner on 686–8, 693–6; planning 101; public space 510, 888–9; quality of life 820; regeneration 525, 780; religion 490–1, 492; restaurants 313, 318, 320; retail 220–1; slums 916; Southwark 786–7; tall buildings 483–4; tourism 217–18; transport 497, 715, 780, 793, 795–6, 881–2, 897; villages 220; W11 756–8; wine 232; World's End estate 150
London City Airport 714
London Metropolitan University (LMU) 517–18
London Underground 500, 791
Lönnrot, Elias 569, 571
Loos, Adolf 387
Lotz, Rainer E., *Hitler's Airwaves* 592–5
Lourdes 43, 116, 243, 562, 821
Lowell, Robert 310
The Lowry, Salford Quays 51, 68, 778, 779, 789, 876
Lubbock, Tom 312
Lübeck 542, 544, 545, 546, 548
Luder, Owen 118, 149, 286, 637
Ludlow 203
Lululaund, Bushey 11
Lumley, Joanna 525, 715

Lutyens, Edwin 94–5, 113, 183, 192, 377, 660, 661, 702; Marsh Court 95, 424, 641; Thiepval Memorial to the Missing of the Somme 104, 422–4, 638–9
luvviedom 618
Luzhkov, Yuri 389
Lyons, Eric 140, 150
Lyttelton, Alfred 94

Macfarlane, Robert, *Underland* 395–8
MacInnes, Colin 699; *Absolute Beginners* 757
Mackenzie, Evan 378
Mackintosh, Charles Rennie 571, 638
Mackmurdo, Arthur 75, 580
Macmillan, Harold 40, 147, 808, 899
Macron, Brigitte 356, 738
Macron, Emmanuel 316, 352–6, 357–63, 738
Maglev trains 743, 795, 796
magnetic north *see* north
Magritte, René 17, 75, 76, 367, 371, 766, 857
Maison de l'Iran, Paris 148
Major, John 642, 697, 709–710, 876
Malbork castle 556, 561
Mallard steam engine 743, 792
Malverns 696, 698, 723
Managerialism 464–5, 466
Manchester 68, 785, 789, 795, 796, 825, 826, 865, 896, 907
Manchester Liberalism 113, 159, 709, 715, 798–9
Mandelson, Peter 799
Mandler, Peter, *The Fall and Rise of the Stately Home* 401–405
Manet, Edouard 77, 78
manners 206, 253
Manning, Olivia 73, 74
Man on the Clapham Omnibus (MOCO). 496, 498
Manser, Jonathan 507
Manser, Michael 109, 507
Mansfield, Jayne 700

Index

maps 195
March, Juan 441–2
March, Werner 147
Marcus, Steven 841
Margaret, Princess 614
Marguerite of Navarre,
 Heptaméron 63
Marianne magazine 341, 344–5
Mariánské Lázne (Marienbad)
 563–4
Marienburg (Malbork) castle 556,
 561
Mariendom, Neviges 38, 117
Marienkirche, Lübeck 544
market forces 525, 799
markets 221, 511–12
Marković, Stevan 361–2
Marks, Howard 725
Marranos 325
Marseille 142, 166–7, 313, 315–17,
 904–905; Cité Radieuse
 (l'Unité d'Habitation) 120–1,
 142, 166–8, 294, 316
Marsh, Eddie 73
Marsh Court 95, 424, 641
Martin, Dean 494, 851
Marx, Karl 539
Marylebone 220–1
Massingham, H. J. 108
MasterChef 241
Match of the Day 868, 869
Matisse, Henri 162, 533
Maufe, Edward 98
Maugham, Somerset 199, 939
Maugham, Syrie 228
Maughan, Susan, 'Bobby's Girl'
 488–9
May, Ernst 384–5
May, Theresa 58–9, 61, 712, 728
Mayer, Emily 53, 173
Mayle, Peter 16, 933
Mayorcas, Elie 110
McCrum, Robert 746; *Globish:*
 How English Became the World's
 Language 471–3; *The Story of*
 English 471
McDonald's 59, 203, 288
McEwan, Ian 759
McGill, Donald 935

McLaren, Bill 861
McLaren, Malcolm 48
Meades, Jonathan
 books: *An Encyclopaedia of Myself*
 298–9, 302–303, 306, 308;
 The Fowler Family Business
 272–3; *Peter Knows What*
 Dick Likes 1; *The Plagiarist in*
 the Kitchen 312–14; *Pompey*
 270
 exhibitions: *Ape Forgets Medication*
 53–7
 films: *Belgium* 371–2, 857; *Ben*
 Building 56; *Full Metal*
 Carapace 643; *Heart Bypass* 123;
 Jargon: Matrix Hubbing
 Performative Pain Badgers 316,
 479; *Jonathan Meades on France*
 289–93; *L'Atlantide* 54;
 Meades Eats 197; *On the*
 Brandwagon 479, 824;
 tvSSFBM EHKL, or
 suRREAL FILM 256
 photography: *Pidgin Snaps* 41–3
Medawar, Peter 301
media 32, 59, 263–4, 427, 454, 460,
 480, 594–5, 622, 823
medical science 176, 314–16, 578
medieval buildings 89, 108
Mediterranean 16, 248, 533, 932
Medway estuary 681–2, 714
Mee, Arthur 196
Meek, Joe 518, 519
Méfret, Jean-Pax 347
Mélenchon, Jean-Luc 354
Melly, George 772
memorials 145, 156, 368, 421–3,
 562
Memorial to the Missing of the
 Somme, Thiepval 104, 422,
 423, 424, 638, 639
memory 35, 36, 70, 71, 308, 309,
 311, 512
Mencken, H. L. 236
Mendelssohn, Felix 317, 539
menhirs 171, 574, 575
Menin Gate, Ypres 368, 423–4,
 638
Mercury, Freddie 458

merry England 189, 192
metonymy 543
Metropolitan Cattle Market 511
Mexico 721
MI6 building, Lambeth 114
Michel-Chich, Danielle, *Letter to*
 Zohra D 346
Michelet, Jules 532
Michelson, Patricia 496
middle age 302, 303
middle England 89, 175, 191, 263,
 267, 285, 707
Middlesex Guildhall 498
Miles, Barry 752
military language 461–4, 465, 467
milk 494, 724
Millais, John Everett 79, 95
Millau Viaduct 296, 360, 821
Millennium Dome 88–9, 513–14
Miller, Henry, *Tropic of Cancer*
 453
Miller, Max 197, 854
Milligan, Spike 762
Milne, A. A. 55
Milne, Alasdair 858, 942
Milton Keynes 486, 879
Ministry of Defence (MoD) 102,
 103
Minster Court, London 687
Miralles, Enric 134
Mirbeau, Octave 736
mirrors 35
Mirzoeff, Eddie 925
Mitford, Nancy 446
Mittal, Lakshmi 716
Mitterand, François 113, 350
mobility 819, 820, 884
mobs 251, 371, 740, 872
mockney 445
modern Gothic 79, 82, 158, 168,
 253, 425
modernism: artists' houses 9, 10;
 Belgium 374; and brutalism
 112, 152, 168; and classicism
 424; constructivism 382;
 council planning 124; *Country*
 Life magazine 193–4;
 Coventry cathedral 31;
 curatocracy 45; Estonia 566;

Index

and expressionism 541; Hitler
and Stalin 381; international
modernism 103, 162–3, 168,
504, 541, 566, 631; Italy 375–8;
late modernism 99, 112, 152;
Le Corbusier 165–6, 566;
memorials 422; millennium
777–8; and modern
movement 160, 634, 635;
narrative 309; and Nazism
162, 163, 585; new housing
784–5; origins 502; painting
309; Pevsner 375, 689, 690,
697–8; and populism 286; and
postmodernism 100; post-war
hegemony 193; and progress
163; retrospection 277; Rogers
on 829; Russia/Soviet Union
381–2, 385; Stamp on 634; and
taste 254; Vatican II 115
Molière, *La Gloire du Val-du-Grâce*
105
monarchy 334, 335, 402, 439–40
Monbiot, George 728
Moneo, Rafael 394, 789, 822
Monkhouse, Bob, *Crying With
Laughter: An Autobiography*
851–4
Monro, Nicholas 175, 487
Monroe, Marilyn 488
monstrosity 98, 146, 160, 168, 253,
286
Montaigne, Michel de 815, 891
Montebourg, Arnaud 354
Monty Python 869; *The Life of
Brian* 936
monuments 152, 156, 157, 383,
384, 442, 554, 564, 638, 823
mood 427
Moody, Elizabeth 623
Moore, Henry 180, 408
Moore, Rowan, *Slow Burn City:
London in the Twenty-First
Century* 523–6
moose 485
morality 251, 261
Moran, Lord 942
Moreau, Gustave 78, 82
Morecambe and Wise 487, 853

Morgan, Piers 720
Morin, Edgar 248–9, 933
Morocco 362, 519
Morozov, Pavlik 419
Morris, Chris 724
Morris, Frances 50
Morris, Reverend Marcus 432
Morris, William 82, 87, 126, 183,
416, 428, 580, 697, 884
Mortimer, John 699
Mortimer, Raymond 73
Moscow 383–4, 385, 386, 388–91,
467, 555, 911
Moscow Academy of Sciences
391
Moses, Robert 915, 916
Mother Russia statue, Volgograd
38, 389
motoring 882–4
Muehl, Otto 175
Muhammad 57, 734
Mukhina, Vera, *Worker and
Woman from a Collective Farm*
381
multiculturalism 245, 340, 468,
481
Munnings, Alfred 53, 71, 225
Murdoch, Rupert 60, 942
Murphy, Douglas, *Nincompoopolis:
The Follies of Boris Johnson* 711–
18
Murray, Braham 773–4
Murray, Damon, *Brutal Bloc
Postcards* 153–8
Murray, Jenni 522
Muschamp, Herbert 821
Musée Picasso 350
museums 33, 44, 68, 826
music 36, 62, 170, 317, 539, 572,
592–5, 750, 764–7, 826
Muslims 116, 234, 264, 291, 341,
343, 345, 416, 537, 602, 898
Mussolini, Benito 381, 382
Muswell Hill, London 504–505
Muthesius, Hermann 184; *Das
Englische Haus* 539–40

Nabokov, Dmitri 920
Nabokov, Vera 920

Nabokov, Vladimir 86, 133, 634,
763–4, 918–22, 924, 926, 939;
Despair 920; *The Gift* 922;
Invitation to a Beheading 922;
Laughter in the Dark 920;
Lectures on Literature 918; *Lolita*
919; *Pnin* 257; *Speak, Memory*
921, 922
Naipaul, V. S. 939
Nairn, Ian: architectural writing
193, 635, 636, 779, 933; on
Belgium 367, 370; *The
Buildings of England: Surrey*
786; and failure 111; on
Gordon/Tricorn 146; *Nairn's
London* 105; and new
architects 109; 'Outrage' 108;
and Pevsner 686; and Scottish
Parliament 134–5; subtopia
411; television 761
Napoleon I 60, 336, 414, 459, 731,
740, 754
Napoleon III 334
narrative 309, 310
Nash, John 329, 366, 425, 426, 509,
510, 570, 715, 891
Nashi 564
Nash Ramblas 508–510
national dish 203–204, 247
National Gallery 30, 113
nationalism 419, 450, 547, 571–2,
631, 733, 734
National Socialism *see* Nazism;
NSDAP
national treasures 525–6
National Trust 196, 402, 404, 507,
660, 669, 671
naturalism 35, 36, 42, 70, 259, 572
nature 25–6, 42–3, 168–9, 190, 232,
277, 360, 557
naturism 552
Nazism: Ahnenerbe 600–602;
anti-Semitism 416, 560–2, 576;
architecture 381, 586–8; Arts
and Crafts movement 182;
arts and culture 68; brutalism
165; and H. S. Chamberlain
539; emigrating artists 34;
faith 234, 237; fortifications

Index

161–3; Hanse cities 548; and
light 549, 604; magic realists
15; and modernism 162, 163,
585; music broadcasting
592–5; myths 601–602; neo-
Nazis 565; and Pevsner 590,
698–9; and Riefenstahl
589–91; and Schad 293; Speer
as architect 598–600; *Völkisch*
rituals 580; *see also* NSDAP

Nead, Lynda, *The Tiger in the
Smoke: Art and Culture in Post-
War Britain* 427–34

Neeb, Dieter 41

neophilia 111, 115, 147, 156, 170–1,
216, 376

Nerrière, Jean-Paul 471, 472, 473

The Netherlands 503–504, 537

Netley Abbey 411

Neue Sachlichkeit 15, 18, 31, 77,
163, 431, 774

Neuschwanstein castle 333

Neville, Richard, *Hippie Hippie
Shake* 750–3

Nevinson, C. R. W. 50, 72, 390

New Ageism 92, 409

Newbolt, Henry 868; 'Vitai
Lampada' 873

new buildings 98, 147, 777

New Caledonian Market 511

New Forest 580, 655, 664–6, 670

New Labour 112, 216, 331,
706–709, 780, 798, 834, 859,
896, 902

New Malden 505, 506, 507,
722

Newman, John 704; *The Buildings
of England: Dorset* 700–705

newspapers 211, 263–4, 265, 408,
455, 463, 476–7, 594, 610–11

new towns 224, 805

New York 216, 289, 881, 905, 915–
16

NHS (National Health Service)
316, 742

Nichols, Peter 245, 941

Nicholson, Kit 9

Nicolaisen, Bjornar 398

Nietzsche, Friedrich 250, 553

Nightingale, Florence 410

Nijinksy, Vaslav 168

Nikolaikirche, Hamburg 540

nimbyism 98, 99, 121, 672

Nin, Anaïs 839

Nixon, Richard 741

noble savage 23, 188

noblesse oblige 709, 718, 798

Norman, Jill 931

north 527–73; adversity 553;
architecture 536, 544–5, 572–3;
broader north 33; drinking
538; expressionism 541; food
529–31, 537–8, 542–3, 553–4,
559–60; HS2 745; humour
541; as ideal 535; northern art
535; northernness 529–30,
534; northern spirit 535–6;
religion 536, 558, 559;
rustication 573; and Scotland
692; urban migration 879;
wealth and trade 543

north-east England 22–9

Northern Renaissance 371, 533

North Laine, Brighton 129–32

nostalgia 18, 188, 292, 391, 404,
791, 801–802, 809

Notre Dame cathedral, Paris
356–8, 360

Notre Dame du Haut, Ronchamp
116–17, 422, 893

Notting Hill 896, 916

nouveau riche 104, 405–407

nouvelle cuisine 320

nouvelle vague 761, 941

novels 309, 475

novelty 170–1

Nowak, Wolfgang 887

NSDAP (Nationalsozialistische
Deutsche Arbeiterpartei)
574–611; acronym 467;
Ahnenerbe 600–602; Hitler
and Speer 602–611;
Organisation Todt 147;
Riefenstahl 589–91;
Rosenbaum on Hitler 595–7;
Speer as architect 598–600;
unholy relics 574–88

nudity 552–3

nuns 244, 257–8, 274, 304, 842,
843

Nuremberg: rallies 143, 234, 459,
594, 604; ruins 586, 600, 608;
trials 579, 585, 598

nybrutalism (new brutalism) 141,
163

Oakeshott, Michael 409

OAS (Secret Army Organisation)
291, 344, 347, 361, 847

obesity 246, 288–9

obituaries 612–39; Liam Carson
624–7; Alan Crompton-Batt
621–3; Lesley Cunliffe 612–14;
Jennifer Paterson 614–21;
Alain Robbe-Grillet 627–30;
Gavin Stamp 630–9

O'Brien, Charles 693, 696

O'Brien, Connor Cruise 821

O'Brien, Flann 133, 450, 452–3;
The Third Policeman 453

Obrist, Hans Ulrich 717

Observatory Gardens, Kensington
499, 500, 501

O'Connor, Des 223, 225

offence 2, 57, 88, 249–55, 258,
452

O'Hear, Anthony, *After Progress:
Finding the Old Way Forward*
407–409

old age 305, 306, 308

Oldham, Andrew Loog 622, 934,
935

Old Kent Road, London 492

Oliver, Jamie 320

Olympics 147, 716–17, 889

OMA 826, 906, 907

omnibus 496, 497

Ono, Yoko 756, 762, 763

OPA (old pals' act) 636, 715

Opéra Bastille 113

optimism 740, 741

Ordensburgen 590, 604

Ordnance Survey (OS) 195, 196,
825

organicising 204

Organisation Todt (OT) 147, 160

ornament 385, 387, 542

Index

Ortiz, Ralph 175
Orton, Joe 114, 227, 252, 451, 518, 519–20, 843
Orwell, George 133, 159, 451, 711, 718
Osborne, George 907
ostalgie 491, 492, 565
out of town 640–85
outsider artists 81, 339, 377, 504, 562
Owen Luder Partnership 145–6, 171
Oxford 135–8, 445
Oz magazine 751, 752, 753

Pace, Shirley 114
Padworth College 617
paedophilia 30, 98
paganism 556–7
painting 14–18, 20–2, 35, 39, 46–7, 68–9, 75–8, 293–4, 309, 893
Palais de Chaillot 380
Palazzo di Montezza 379
Palazzo Vecchio, Florence 379
Palestine 252, 680
Palmerston, Lord 17, 410, 719
Palmerston's Follies 719
Parent, Claude 117, 118, 147–8, 808
Paris 33, 221, 261–2, 292, 350–1, 352, 416, 510, 756–8, 771, 881, 889, 892
Paris Exposition Internationale des Arts et Techniques 380–1
Paris, Franck 363
Parker, Barry 93
Parkes, Simon 197
Parkinson, Cecil 443–4, 798
Parkinson, Michael 444
parks 403, 487
parody 62
Parr, Martin, *Boring Postcards* 40
past 69, 87–8, 182, 211, 271, 329, 375
pastiche 113, 359, 801, 809, 833
Paterson, Jennifer 614–21
Le Pays Noir 367, 368
Pearson, Nicholas 299

Pears, Peter 656
Peckham library 786
Pedder, Sophie 352, 355, 356
Penguin 691
Penty, A. J. 94, 95
Peppiatt, Michael, *Francis Bacon: Anatomy of an Enigma* 18–19, 20
perambulation 663–4
Perec, Georges, *Life: A User's Manual* 924
Performance (film) 757
perfume 758
Perowne, Stuart 71
Perret, Auguste 912
Perry, Grayson 223
perspective 309–310
pessimism 740
Petticoat Lane 522
Pevsner, Nikolaus 686–705; and Archigram 771; baroque 689–90; on brutalism 143; *The Buildings of England* 104, 688, 690, 697, 699, 700; *The Buildings of England: Dorset* 700–705; *The Buildings of England: London 1: The City of London* 686–8; *The Buildings of England: London 5: East* 693–6; *The Buildings of England: Worcestershire* 696–8, 880; *The Buildings of Scotland: Stirling and Central Scotland* 691; humour 699; life 698–700; *London (Except the Cities of London and Westminster)* 694; modernism 375, 689, 690, 697–8; and Nairn 686; and Nazism 590, 698–9; revivalism 690; schools 284; Stamp on 636–7; on St Catherine's College 806; on Stourport 880; style 97; on Victorians 428; Watkin on 634; on Whitehall 103; writing style 104, 476, 688–9, 691, 699
Peyton-Jones, Julia 49, 717
Pharmacy 627

philanthropy 47, 222, 351, 694, 695
Philip, Duke of Edinburgh 108
Philippe, Édouard 357, 358
Phillips, Tom, *The Postcard Century* 40
photography: *Ape Forgets Medication* exhibition 54–5; architectural photography 121, 157, 805, 900–902; buildings 365; bunkers 168; *Country Life* magazine 193; desert island objects 294–5; *England: The Photographic Atlas* 195; monochrome 433, 434; *Picture Post* 434; *Pidgin Snaps* 41–3; postcards 40, 41–3, 157
photomontage 311
Piano, Renzo 100, 774, 833–4, 906
Picasso, Pablo 33, 142, 162, 180, 225, 257, 287, 471, 533, 566, 831
Picture Post 432, 434
picturesque 24–7, 29, 84, 94, 155, 213–15, 253, 275, 286, 410, 669, 671
Pierrepoint, Albert 32
piers 126
Piggott, Stuart 71
Pignight (film) 55
pigs 663
pike 204
Pilkington, F. T. 79, 253, 386, 572, 699
pimbyism 99
Pimlico School 171
Pinault family 357
Pink Floyd 766; *Ummagumma* 766
Pinter, Harold 265, 761
Piranesi, Giovanni Battista 380, 695, 773
Pitlochry 25
Pitt-Kethley, Fiona 453
Pitt-Rivers, Sir Augustus 403
place 276, 278, 401, 682–5, 802–805, 807, 925–6

Index

placeism 675–7

plagiarism 53, 314, 368, 390, 450, 631, 760, 817

planning 213, 781, 806

Plan Voisin, Paris 155, 771

plaques 262

Platini, Michel 443, 863, 864

Platonov, Yuri 775

Pleck 118, 119

plotland developments 225, 278, 648, 674–5, 680, 698, 905

Poelzig, Hans 598, 604

poetry 310, 756, 799

Poland 554–5, 558–9, 564, 729–30

policemen 174–5

political correctness 2, 344, 465, 468, 476

politics 480, 706–745, 909

Pompe, Antoine 366, 367, 374, 504

Pompidou, Claude 362

Pompidou Centre, Beaubourg 712, 713, 774, 828, 831, 833–4

Poole, Steven, *You Aren't What You Eat: Fed Up With Gastroculture* 239–42

pop art 51, 71

pop culture 308, 746–75

Pope, Alexander 667; *The Dunciad* 885

pop music 170, 488, 746–50, 765

population control 244

populism 60, 221, 252, 286, 360, 691, 940

pornography 21, 81, 191, 262, 288, 519, 840

portraits 29, 56

Portsdown Hill 237, 719

Portsmouth 118, 644, 676, 823

Port Sunlight 92, 215, 583, 656

poshness 481

postcards 38–43, 155, 157

postmodernism 99, 100, 111–13, 144, 387, 389, 391, 652, 778, 829

Potocki, Jan, *Manuscript Found in Saragossa* 60–1

Potter, Beatrix 728

Potter, Dennis 939–43

Poulson, John 774

Pound, Ezra 32, 75, 589

Poundbury 146, 254, 514, 701–702, 703, 806

poverty 668, 694, 813, 822

Powell, Anthony 501

Powell, Aubrey 765, 767; *Vinyl, Album, Cover, Art* 764–7

Powell, Enoch 59–60, 298

Powell, Kenneth 786

Power, Tyrone 854

PR (public relations) 621–3, 821, 874

prefabs 876

prejudice 675–6

Pre-Raphaelite Brotherhood (PRB) 79, 80

Prescott, John 668, 879, 928

presentism 211

Presley, Elvis 747, 754–5, 762

Preston, Paul, *A People Betrayed* 438–42

Preston, Peter, *The Stringalongs* 823

Preston bus station 881

Price, Cedric 774, 833–4

Priestley, J. B. 481, 939

primitivism 295, 573, 600

Primo de Rivera, Miguel 441

Primrose Hill 509

Prince of Wales *see* Charles, Prince of Wales

Pringle, Heather, *The Master Plan* 600–602

Prior, Edward 184

Private Eye magazine 638

privatisation 782

professionalism 871

professions 44, 219, 271, 801

propaganda 18, 156, 161, 589, 591, 592, 594, 606

property ownership 220, 663

Prora 549, 585, 586

proscenium arch 115

Protestantism 174, 259, 293, 537

Provence 534

psychedelia 22

public housing 899, 900; *see also* social housing

public space 510, 529, 875, 888

public transport 793, 879–81, 897

pubs 534, 929

Pudor, Heinrich, 'The Cult of the Nude' 552

Pugin, A. W. N. 97, 285, 329, 425–7

pundits 869–70

puppet theatre 72–3

Putin, Vladimir 251, 385, 564, 565, 713

Puttnam, David 850

Le Puy-en-Velay 330, 331, 332

Pyzik, Agnes 387–8; *Poor But Sexy* 387

Quakerism 324, 325

Quartiere Coppede, Rome 380

Quebec 148

queens 204

Quinn, Marc 180

Qutb, Sayyid 416

Raban, Jonathan 613–14

Rabeneck, Andrew 102

Rachman, Perec 'Peter' 878, 916

racism 199, 291, 361, 508

radio 592–5

Rafale, Reims 118, 808

Ragot, René 513

railways 403, 743–4, 792, 795, 796, 880

railway stations 108, 110

Raine, Craig 595, 746–7

Ramsay, Gordon 623

Ransome, Arthur, *Swallows and Amazons* 223

Raphael 34, 47

Rassemblement National (formerly FN) 361

rationalism 377, 409

Rattle, Simon 826

Raubal, Geli 609

Ravensbrück camp 584

Ray, Cyril 928

Reagan, Ronald 113, 415

real ale 495

realism 70, 573

reality TV 251, 307, 672, 677

Index

rebranding 781–4, 824, 826

received pronunciation (RP) 267, 268, 443–5, 465, 481–2

Redfern, Walter, *Clichés and Coinages* 448–50

Reed, E. T. 10

Rees, Peter 526

Rees-Mogg, Jacob 732

Rees-Mogg, William 942

refugees 343, 364

regeneration 776–827; awards ceremonies 788; beneficiaries 825; Comprehensive Redevelopment 771, 810; cultural regeneration 68, 834; fast track to the future 790–7; France 121; homogenisation 817; language 456, 460, 479; legacy 813; Moore on 525; *On the Brandwagon* 479, 824; onwards and upwards 776–81; rebranding 781–4; regionalism 877; retail 789

Regensburg 584

Regent's Park 487, 509

regionalism 204–205, 443, 450, 876–7

Reilly, C. H. 110

Reims 118, 530, 580, 808

relics 335, 574

religion: antipathy to 304–305; and churches 96–8, 117–18, 425; and cults 417; and death 304; expunging of 242–3; and faith 232–9, 734; France 330–1; and God 20; Gothic 106–108; Hanse wealth 541–2; icons 457–8, 490–1; London 490–1, 492; and Nazism 584; north 536, 558, 559; people in power 418; religious food practices 537–8; scholarship 259; souvenirs 282, 331; totalitarianism 415–16; Vatican II 115–16

Renaissance 106, 180, 371, 372, 532–3

restaurants 201, 204, 313, 318–19, 370, 514, 515, 621–2, 813

restoration 358

retail 136–7, 218–22, 497–9, 515, 652–5, 789, 808–810, 813, 926–7

retrophilia 87, 88, 181, 188, 402

retrospection 277, 403, 793

Revel, Jean-François 62, 377, 627, 628, 634

revivalism 79, 82, 103, 183, 376, 690

Rexroth, Kenneth 196

Reynolds, Joshua 79–80

Rhodes, Zandra 484, 485

RIBA (Royal Institute of British Architects) 85, 636, 637, 638

Richard Montgomery liberty ship 682, 715

Richards, Keith 444

Richardson, H. H. 11, 572

Riefenstahl, Leni 587, 589–91; *The Blue Light* 590; *Triumph of the Will* 591

Riga 389, 555, 816

right-on-ness 2, 255

right to buy 900, 903

Rinka (dog) 728

RMJM 287

roadhouses 124, 882

Robbe-Grillet, Alain 35, 286, 310, 627–30, 885, 941

Robbins, Lionel 148–9

Roberts, James 124

Robertson, George 'Lord' 265

Robinson, Geoffrey 641

Robinson, Tommy 724, 730

Rockaways peninsula 905

Rockwell, Norman 257

rococo 503

Roddam, Franc 241

Roden, Claudia 933

Rodez 321, 323, 337

Rogers, Ernesto 832

Rogers, Lady (Ruth) 831, 834

Rogers, Richard 828–35; *Architecture: A Modern View* 828–30; de Graaf on 906; and Foster 833; Lloyd's Building 151, 828, 831, 833; and London suburbs 881; Millennium

Dome 88–9, 513–14; other buildings 831; *A Place for All People: Life, Architecture and Social Responsibility* 830–5; Pompidou Centre 774, 828, 831, 833–4; and taste 254; variety 822

Roger Stevens building, Leeds 148

Rohe, Mies van der 141

Rolfe, Frederick (Baron Corvo) 98

The Rolling Stones 56, 622, 935

romanticism 23, 24, 25, 572, 631

Rome 115, 331, 375, 380, 885

Ronan Point 695

Ronay, Egon 247

Ronchamp 116–17, 422, 893

Roosevelt, F. D. 386, 737

Roselius, Ludwig 143

Rosenbaum, Ron, *Explaining Hitler* 595–8

Rosenberg, Alfred 546, 581, 590, 911

Rosenberg, Harold 19

Rosherville 679

Rosindell, Andrew 724

Ross, Alan 75

Rossetti, Dante Gabriel 79, 81, 681

Rossi, Aldo 103

Rotunda, Birmingham 124

Roussel, Raymond, *Impressions d'Afrique* 885

Rowson, Martin 61, 62, 255, 258, 355, 506, 643

Royal Academy of Arts 20, 22, 57, 69, 225

Royal Carpet Factory, Wilton 102

Royal College of Art 150, 171, 208, 225, 287

Royal Exchange theatre, Manchester 773

Royal Holloway College 284

Royal Hospital for Incurables, Putney 410

Index

Royal Mile, Edinburgh 132, 133, 134

Royal Victoria Hospital, Netley 139–40, 409–411

RP (received pronunciation) 267, 268, 443–5, 465, 481–2

Rudofsky, Bernard 890; *Architecture Without Architects* 889

Rudolph, Paul 150–1, 833

rugby 490, 832–3, 860, 870–1

Rugby school 283

Rügen 23, 549–51, 577, 585

ruins 586–7, 608

rural life 669, 670–1

RuSHA (Rasse und Siedlungshauptamt) 467

Rusiñol, Santiago 180

Ruskin, John 372, 437, 485, 688

Russell, Ken 761, 935, 936; *A British Picture: An Autobiography* 848–51

Russell, Seán 417

Russia 380–7, 388, 564, 713, 753–4

Russian Academy of Science 775

rustication 573

Rutland, Duke of 404

Rykiel, Sonia 339

Saarinen, Eero 631

Saarinen, Eric 613

Saatchi, Charles 53

Sachsenhain 574–5, 576

sacred architecture 421, 536, 700, 704

Sade, Marquis de 837

Saenredam, Pieter 115

Safdie, Moshe 148

Sagrada Familia 176, 179, 503

Sainte-Bernadette du Banlay, Nevers 117, 147–8

St Catherine's College, Oxford 120, 637, 690, 806

St Cyprian's, London 756

St Giles development 906

St John's Hospital, Lichfield 107

St Mary's Basilica, Gdansk 554

St Michael's College, nr Tenbury Wells 284, 310

St Pancras 359, 540

St Paul's Cathedral 89, 484, 688, 876

St Petersburg 383, 570

St Wolfgang, Regensburg 584–5

Saint-Exupéry, Antoine de 553

Saint-Ouen, Paris 130

saints 237, 332–3

Saki 436

Salisbury 101–102, 106, 138–9, 186, 209, 250–1, 641–2, 808

Salisbury cathedral 106, 139, 260, 265, 278–9, 332, 358, 425, 651

Salkeld, Audrey, *A Portrait of Leni Riefenstahl* 589–91

Salmond, Alex 720

Sams, Craig 240

Sandbanks 702

San Francisco 129

San Remo Towers, Bournemouth 389

Sansal, Boualem 346

San Sebastián 391–5, 789

Sardou, Michel 352, 421, 845–8, 856

Sarkozy, Nicolas 351, 352, 354, 355, 420, 814

Sarraute, Claude 627–8

Sarraute, Nathalie 627–8

Sartre, J.-P. 756

Sassoon, Siegfried 228, 423–4, 502, 638

satire 62, 63, 404, 409

sausages 58, 205, 288

Savina, Joseph 893

Schad, Christian 34, 39, 56, 163, 293–4, 826

Schellenberg, Walter 580

Schirach, Baldur von 581, 610

Schmidt, Helmut 744

Scholz, Georg 15, 62, 163, 311

schools 274, 278–87

Schubert, Franz 68, 317

Schubert, Karsten 53

Schultze-Naumburg, Paul 605

Schwarz, Rudolf 116

science 162–3, 176

Scirea, Gaetano 54

Scotland 132–5, 428, 691, 692–3, 720, 721, 844

Scott, Geoffrey 103–104

Scott, George Gilbert 359, 540

Scott, Richard Gilbert 117, 422

Scott, Sir Walter 839

Scottish Parliament 134–5

Scouse 543

Scruton, Roger 254

sculpture 29, 69, 143, 166, 294, 893

sea 16, 22–3, 83, 551, 555

Searle, Ronald 617, 757

Seaton Delavel 26, 27

Sebastian, John 613

Second Skin exhibition 180

Second Vatican Council *see* Vatican II

Second World War 145, 152

secularism 265

Seddon, J. P. 681

Segal, Walter 781, 876

self-build schemes 781, 876

self-invention 304–305

self-portraits 56, 293–4

Selfridge, Gordon 660

Selfridges, Birmingham 125, 785, 789

Seligman, Lincoln 9

Senger, Alexander von 911, 912

Sennett, Richard 887; *Building and Dwelling: Ethics for the City* 912–17

Sensation exhibition 22

Sereny, Gitta 599, 608, 912

Serf, Monique (Barbara) 38, 748, 846, 855, 856

Serota, Nicholas 50, 717

Serres, Michel 348, 349

Service, Alastair 110

Severn Valley 147, 648, 899

sex 836–44; addiction 261; comic writing 453; and death 174, 176; incest 303; morality 261, 564; in painting 294; population control 244; and pornography 288; shops 128, 519; tourism 520; Victorians 81

Index

Shadbolt, Blunden 181

Shakespeare, William 26, 33, 203, 408, 473, 537, 539, 637, 935; *Hamlet* 33, 250, 408, 530, 596, 797

The Shard 906

Sharp, Thomas 680

Sharpness 214, 880

Shaw, George Bernard 44, 75, 91, 212, 437, 480, 801, 803, 843, 928

Shaw, Norman 10, 27, 925

Shchusev, Alexey 390

Sheldrake, Merlin 397–8

Shepherd, Richard 625

Sheppard Robson 144, 171

Sheppey 682

Shizuoka press centre 149

shoes 214, 518–19, 653–4

shopping 157, 218–22, 652–5, 808–810

showbiz 845–59

Sibelius, Jean 572, 631

Sicily 106, 453

Sickert, Walter 57, 81

Siemens 584

sightbites 68, 460, 773, 811–12, 823–5

Sighthill, Edinburgh 806

Silver End, Essex 222, 673, 679, 680

Simenon, Georges 472

Simmons, Neil 30

Simond, Louis 731

Simpson, John 688, 859

Sinclair, Iain, *Living with Buildings and Walking with Ghosts: On Health and Architecture* 682–5

site-specific installations 31, 45

Sizewell nuclear power station 658

Skegness 40, 223

Skelton, Barbara 612–13

Skidmore, Owens and Merrill 831

Skinner, B. F. 810

Skopje, Macedonia 145

Skripal, Sergei 251

slang 67, 176–7, 348, 446, 447, 466, 474–6, 479

Slater, John 202

slave labour 584, 588

slow thought 58–9

slums 696, 785, 878, 896, 902, 916

Smallbrook Ringway 124

Smart, Elizabeth 298

Smethwick 185, 899

Smirke, Sir Robert 425

Smith, Dan 549

Smith, Delia 932

Smith, Edwin 224

Smith, Jack 74

Smith, Reggie 73

Smithson, Alison 102, 111, 113, 141, 150, 164, 287, 377

Smithson, Peter 102, 111, 113, 141, 150, 164, 287, 377

smog 428, 431, 500, 823

smoking 259, 287–8, 884

Snig's End 213, 214

social housing 86, 121, 147, 485, 503, 695, 781, 798, 876, 898–900

social realism 64, 155, 371, 390

social science 162–3

society 190–1

Society for French Aesthetics 167

Society for the Protection of Ancient Buildings 404

Soil Association 239–40

Solidarity 555

Solomon, Philippe Hababou 362, 363

Sonck, Lars 572, 631, 822

Soreq 149

source, of food 205–206

south 528–30, 533–4, 538, 692, 932

Southampton 138–40, 148, 410, 505, 676, 848–9, 848

South Bank, London 588

South Kensington Schools 208

Southwark 786–7

souvenirs 43, 116, 218, 335–6, 403, 815

Soviet Union: acronyms and initialisms 467; architecture 151–8, 381–5; bus stops/shelters 151–3; calendar 753–4; communism 387–91; and Estonia 564–6; Hanse cities 548; icons 458; Lithuania 561–3; postcards 153–8; post-war 415; spas 563; and Tallinn 564, 565

space 875

space travel 154, 389

Spain 137, 391–5, 416, 438–42, 809

Spark, Muriel 501, 615, 700

spas 539, 551, 563

Special K 202

The Spectator 618, 633, 921

speech 480–1

Speer, Albert 89, 147, 161, 381, 418, 459, 586–7, 590, 598–600, 602–611, 912

Spence, Basil 31, 148, 171, 287

Spinnaker Tower, Portsmouth 823

spomenik (memorials) 145

sport 860–73

sportsmanship 860–1, 862

sports pundits 480

Spring, Martin 103

Springfield, Dusty 502

SS (Schutzstaffel) 343, 560, 575, 578, 579, 580, 583, 602, 607, 810

Stalin, Joseph 153–5, 234, 365, 381–7, 389, 390, 419, 458, 563, 713

Stamp, Gavin 104, 630–9; *The Memorial to the Missing of the Somme* 104, 420–5, 638

standing stones 574, 575

Stanley, W. F. 285

Stanley Halls School 284–5

Starbucks 136

Starck, Philippe 185, 339

Stark, Freya 71

stately homes 401–405

statues 30, 156, 389

Stead, W. T. 436

Steadman, Ralph 61, 62

Index

steam engines 791–3
Stephen, Douglas 100, 502
Stevens, Alfred 78
Stevenson, Robert Louis 133
De Stijl 114, 367
Stirling, James III
Stirling University 287
Stockwell bus garage 880
Stone, Laurence 260, 261
Stonehenge 89
Stoppard, Tom 941; *Night and Day* 476
Stornoway 844
Stourport 792, 880
Stralsund 548
Strata, London 523
Stratigakos, Despina, *Hitler At Home* 605, 609
Strauss-Kahn, Dominique 352, 536
Straw, Jack 708
Street-Porter, Janet 444
Street-Porter, Tim 767
Stringfellow, Peter 261
Strong, Roy, *Country Life, 1897–1997: The English Arcadia* 191–4
structuralism 707
structure of feeling 427, 429, 430
studios 9, 10, 11
style 227, 366
sublime 23, 24, III, 783
subtopia 108, 410, 818
suburbanism 93, 371, 374
suburbs 95–6, 126, 183, 189, 190, 431, 659, 668, 813, 818, 878, 894–6
Sudjic, Deyan 888, 889; *The Edifice Complex* 888; *The Endless City* 885–90
Suffolk 655–8
suicide 177, 538, 645
Summerson, John 48, 330, 691, 933
Sumner, Heywood 665
Sundays 432
sunset homes 498
Sun Tzu 463

supermarkets 88, 220–2, 246, 248, 323, 492–4, 495, 508, 515–16, 726, 930
superstition 21, 107
Supervielle, Jules 920
surrealism 33, 235, 256–60, 262, 371, 373
Sussex University 148, 287
sustainability 171–2, 720, 907
Sutcliffe, Serena 46
Sutherland, Graham 30, 31, 32, 73
swastika 234, 459, 585
Swift, Jonathan 133, 158, 257, 452, 840
Swinburne, A. C. 63, 840
Swiss Re tower (The Gherkin) 526, 843
Switzerland 117
Sydney Opera 149
Sykes, Christopher 15
Sylvester, David 75–6
Symonds, Matthew 738

table manners 206
tables 295–6
Taine, Hippolyte 679
tall buildings 483–4, 875
Talleyrand, Charles-Maurice de 166, 417, 418
Tallinn 153, 388, 530, 555, 564–8
Tamms, Friedrich 142, 147, 160, 161, 163, 165, 168
Tange, Kenzo 145, 149
Tapiovaara, Ilmari 295
taste 89, 98, III, 159, 249–55, 258, 275, 296, 403, 453
Tate 50, 65, 69, 294, 766, 940
Tate Britain, London 78, 80
Tate Liverpool 826
Tate Modern, London 50, 786, 826–7
tattoos 132, 244
Taylor, A. J. P. 197
Taylor, Elizabeth 249, 445
Taylor, Graham 864
Taylor Woodrow 774
Tbilisi 383, 386
teaching 274
team spirit 872

Team X 150
Tebbit, Lord 224
technology 118, 777
television 197, 266–7, 460, 479–80, 621, 648–9, 759–61, 868–9, 940–2
Tennant, Stephen 226–30
Tennyson, Alfred 655
Teresa, Mother 239, 813
terraces 86, 89, 92, 107, 114, 274, 374, 502
terrorism 343, 904
Terry, Quinlan 518, 688
tertiary education 148, 517, 878
Tesco 220–1
Tessenow, Heinrich 598, 604
Teulon, S. S. 79, 253, 699
Teutonic Knights 556, 558, 561
thatch 274–5, 641, 670
Thatcher, Margaret 30, 113, 153, 158, 159, 211, 219, 494, 525, 632, 709, 715, 742, 876
Théas, Pierre-Marie 116
theatre 33, 68, 115, 171, 869
Theosophical Society 423
Theroux, Paul 447
Thiepval Memorial to the Missing of the Somme 104, 422, 423, 424, 638, 639
Third Reich 101, 182, 400, 458, 562, 578, 584–8, 590–2, 598, 605, 607–609
Thirties Society 635
This England magazine 196
This Is Tomorrow exhibition 51
Thomson, Alexander 638
Thorgerson, Storm 765, 765
Thorpeness 656–8
Tibet 577, 602
Tiebout, Joris 369
Tigbourne Court 95, 424
Tilbury Fort 678, 679
Tilden, Philip 660
Tiley, Mike 128
Tillett, Ben 435
Tirana School of Advanced Proxenitism 145
tithe barns 107
Titian, *The Virgin and Child* 30

Index

Tito (Josip Broz) 145, 361
Todt, Fritz 147, 606–607
Tokyo 149, 888
Tolworth Tower 507
Torre Velasca, Milan 832
totalitarianism 156, 381, 414, 707
tourism 43, 190, 815, 825
Tournier, Michel 587
Tournon, Paul 421
town halls 108, 542, 796, 824, 878
town planning 93, 886
townscape 520
Townshend, Pete 746, 747, 748
Toxteth riots 787
Toynbee Hall 93, 417, 695, 709
toys 208–209
trade 543–4, 547, 548, 555
tradition 88, 254, 567
traffic planning 124, 882
trains 743–4, 792–3, 795, 796–7
Trakai 528, 561
transport 791, 793, 879–81, 882–4
Trappists 420
travel 819, 884–5
trees 189, 297, 398, 551, 557, 570
Trelford, Donald 618
Trevor, Jack 594
Trevor-Roper, Hugh (Lord Dacre) 88, 596
Trevor-Roper, Patrick 328
Trewick, John 719
treyfs 53, 325
tribalism 341, 676
Tricorn Centre, Portsmouth 145–6, 171, 286, 808
Trident Centre, Gateshead 145–6, 171, 286
tripe 206
Tripode, Nantes 118
Trobridge, Ernest 524, 636–7
Trollope, Anthony, The Fixed Period 120
Troost, Gerdy 605, 609
Troost, Paul Ludwig 598, 600, 605
Trotsky, Leon 383
Troubridge, Ernest 181
Truffaut, François 942

Trump, Donald 61, 477, 715, 719–21, 741
Turnbull, David 857
Turner, J. M. W. 80, 328
Tuscany 277, 529
Tuymans, Luc, The Walk 602–603
tweeness 24, 94
Twentieth Century Society. 110, 111, 115, 630
twittens 127, 128
Tynan, Kenneth 14, 939–40

U and non-U 193, 446, 448, 462, 878
udder 206
UEA (University of East Anglia) 148, 287
Ukraine 391, 607
Unamuno, Miguel de 440, 441
unemployment 68, 93
UNESCO 121
Union Chapel, Holloway 517
l'Unité d'Habitation (La Cité Radieuse), Marseille 120–2, 142, 166–8, 294, 316
Unités d'Habitation 892
universities 112, 144, 148, 170, 282, 287, 478, 517–18, 878
University College London 282
Unwin, Raymond 93
Updike, John, 'Fellatio – A Poem' 843
Upper Lawn Pavilion 102
Urban Age Project, LSE 887
urbanism 93, 126, 139, 213, 254, 524, 580, 587, 874–917
urban regeneration 460, 525, 714, 784–5, 810, 812, 813, 886, 897
Urbel, Emil 567
Usherwood, Nicholas 14, 17
USSR see Soviet Union
utopianism 95, 238, 277, 341, 391, 409, 413, 508
Utzon, Jorn 149

Vago, Pierre 116
Vale of Evesham 697
Valle de los Caidos 442

Valls, Manuel 349–50, 354
Vanbrugh, John 26, 28, 149–50, 158, 286, 329, 634, 703, 843
vanity publishing 887
Vanverberghe, Francis 56
Vasari, Giorgio 105
Vatican 244, 414, 754
Vatican II 112, 115, 116, 117, 143, 171, 783, 935
Vauban, Marquis de 325, 719
VDNKh 467
vegetarianism 369
Venables, Terry 863–4
Venice 43, 549
Venturi, Robert 113, 359, 767
Verey, David 686
VerMeulen, Michael 626
vernacular revival 92, 182, 214, 777
Verrucci, Ernesto 379
Versailles 333–6
vertical streets 86
verveine 331–2
Vesey-Fitzgerald, Brian 108
Vespucci, Simonetta 80
Vichy regime 166, 910, 911, 912
Vickers, Hugo 229
Victoria, Queen 11, 410
Victoria and Albert Museum 208
Victorian architecture 146, 159, 283–6
Victorian Fairy Painting exhibition 20–2
Victorianism 429
Victorian Society 679
Victorian values 158–9, 840
Victuals Brotherhood 555
Vidal, Gore 43
Vienna 117, 143, 401, 597
villages 189, 213–15, 671, 815
Vilnius 558
Viollet-le-Duc 328, 329, 358, 359
Virilio, Paul 117, 148, 160
Virlogeux, Michel 296, 360
vision 237, 509, 829
vocabulary 474, 479
Vogue 610, 613
Voie Sacrée 421

Index

Völkisch buildings 182, 580, 581, 584, 604, 702

Völkischer Beobachter 539, 911

Vollard, Ambroise 77

Voltaire 158

volume builders 119, 525, 669, 744, 780, 784, 787, 834, 897, 907

Voysey, C. F. A. 10, 434, 702

Wadley, Veronica 716

Wagner, Martin 540

Wagner, Richard 539, 576

Waitrose 323, 726

Walden, George 350

Walentynowicz, Anna 554

Wales 534

Walesa, Lech 554–5

Walhalla 359, 365, 380, 570

Walker, Frank Arneil 691, 692

Walker, Raymond Myerscough 637

Walkley, Giles, *Artists' Houses in London* 9–12

Wallinger, Mark 53

walls 719–21

Walpole, Horace 411

war: 33, 152, 160–1, 165, 170, 462–3, 532, 539, 548, 750; *see also* memorials

War Artists' Advisory Committee 18

war criminals 598, 607

Ward, Seth 279

Ware, Sir Fabian 423

War Graves Commission 368

Warhol, Andy 47, 609, 764

Wark, Kirsty 134

Wasson, R. Gordon 331

water 82–4

Waterhouse, Alfred 796

Waterstone's 221, 655

Watkin, David 86, 408, 634; *Morality and Architecture* 633, 635

Watkins, Alan 463, 870

Watling, Giles 724

Watson, Frank, *Soundings from the Estuary* 682

Watt, Richard Harding 380, 502

Watts, G. F., *Minotaur* 436

Waugh, Auberon 452, 728, 797, 919

Waugh, Evelyn 14, 15, 18, 146, 159, 226–7, 250, 280, 404, 452, 594, 919, 926, 937

Waugh, Laura 926

Waxman, Harry, *The Long Memory* 682

Weale, Adrian, *Renegades: Hitler's Englishmen* 594

wealth 47, 543, 547, 702–703, 820, 927

weavers 327–8

Webb, Beatrice 436, 680

Webb, Mary 665; *Precious Bane* 61

Webster, Noah 473

Weight, Carel 872

Weimar Republic 34, 549, 590

Welch, Denton 451

welfare state 93, 694, 709

Wellcome Trust 682, 683, 684

Wells, H. G. 72, 133, 434, 923, 943; *The History of Mr Polly* 181; *The Passionate Friends* 404; *Tono-Bungay* 404, 407

Wells, John, *A Melon for Ecstasy* 297

Wells cathedral 106, 107, 332, 425

Welwyn Garden City 505, 805, 915

West, Mae 459

Westbourne Grove lavatory 114, 758

West Brom 367, 719, 776

West Mersea 674

Wewelsburg, Westphalia 579–80

Weyden, Rogier van der 34, 536

Weymouth 551

Whaddon 792

Wharton, Michael (Peter Simple) 538

Wheatcroft, Geoffrey 618–19, 744, 921

Wheeler, Frederick 10

Wheeler, Sir Mortimer 'Rick' 71

Wheldon, Huw 849

whisky 537

White, Marco Pierre 623

White, William 97

Whitechapel Gallery 51, 93

Whitehall 103

Whitehead, Jack 72

Whitehorn, Katharine 432

white horses 641–2

Whitehouse, Mary 767, 942

Wiggin, Bill 722, 723–4

Wilde, Oscar 75, 91, 434, 435, 438, 480, 771; *The Picture of Dorian Gray* 939

Wilder, Billy 161, 740

wilderness 25, 26, 195

Wilds, Amon, Junior 679

Wilkes, John 416

Wilkinson, Tom 842

Willerval, Jean 712

Williams, Emlyn 618

Williams, Raymond 427, 428

Williams, Shirley 211

Williamson, Henry 589, 594

Williamson, Nicol 452

Willink, Carel 15, 38, 39, 293

Willis Faber building 100

Wilmington Long Man 642

Wilsford Manor 228

Wilson, Harold 40, 112, 115, 148, 170, 418, 899

Wilson, Snoo 55

Wilton 102, 280

Wiltshire 102, 186, 213, 641, 641

Wimborne church 704

Winchester 11, 97

Windermere 25

wind farms 97, 651, 667, 669, 672, 720

wine 46, 230–2, 234, 318, 320–1, 370, 452, 502, 534, 539, 758–9, 929–30

Winner, Michael, *West 11* 757

Wismar 539, 546

wit 99, 114; *see also* humour

Witkin, Joel-Peter, *A Day in the Country, Poland* 294–5

wokeness 2

Index

Wolfe, Tom 891; *From Bauhaus to Our House* 635
Wolton, Georgie 9, 100
wood 398, 570
Wood, Anne 73
Wood, Christine 74–5
Wood, Keith Porteous 265
Wood, Kenneth 69–75
Wood, Roy 266
Woodcraft Folk 580
Woodhead, Chris 408
Woods, Shadrach 150
Woodyer, Henry 284
Woolf, Virginia 228, 434
Woolwich barracks 409
Worcestershire 696–8
work, and home 190–1
workplace 818, 819
world cities 350, 501, 523, 794, 820, 887–8
World Cup 54, 468, 868, 870, 871
World Heritage 122, 328
World Ice Theory 577–8, 602
World's End estate, London 150
Wotruba, Fritz 143
writers 918–43; Kingsley Amis 928–30; John Betjeman 924–8; Anthony Burgess 933–9; Peter Conrad 923–4; Elizabeth David 930–3; Vladimir Nabokov 918–22; Dennis Potter 939–43

writing: academic writing 478; architectural writing 103–104, 299–300, 524, 635, 689; art writing 45, 49, 50, 66; on bad writing 43, 48, 85–6, 194, 752, 936; books 43; characters 272, 273–4; comic writing 450–3; *Country Life* magazine 193; fashion writing 218; fiction 273, 303, 938, 939; food writing 200, 241, 312–14, 621–2, 930–3; impressionistic writing 936; journalism 477–8; and London 186; Nabokov on 941; narrative 309; novel writing 270–2; and offence 57; Pevsner 688–9, 691, 699; and planning 312; preservation of former self 650; right to offend 252, 253; sensitivity 227; Soviet Union 155; and thinking 299, 308; wine writing 452
Wyatt, James 425
Wyatt, T. H. 280, 281
Wyatt, Will, *The Fun Factory: A Life in the BBC* 857–9

xenophilia 207
xenophobia 182, 196, 346, 371–2, 419, 477, 565, 631, 711, 721, 729

Yale 150–1, 691–2, 693, 832–3
Yamanashi conference centre, Kofu 149
Yamoussoukro basilica 609
YBAs *see* Young British Artists
Yeats, W. B. 540
Yeldham, Peter, *The Comedy Man* 757
Yentob, Alan 620
York: city walls 140; York ham 208; York Station 110; York University 148, 287
Yorkshire 26, 444, 529
Young British Artists (YBAs) 48, 50, 51, 52, 53
Ypsilanti water tower 842
Yugoslavia 145, 152

Zanzibar, Covent Garden 624
Zapotec 151
Zemmour, Éric, *Le Suicide français* 349–50
Zeppelinfeld, Nuremberg 600
Zidane, Zinedine 468
Ziegler, Zog 208, 507, 750
Zola, Emile, *Thérèse Raquin* 61
zoomorphism 54, 111, 117, 131, 147, 255, 391

Unbound is the world's first crowdfunding publisher, established in 2011.

We believe that wonderful things can happen when you clear a path for people who share a passion. That's why we've built a platform that brings together readers and authors to crowdfund books they believe in – and give fresh ideas that don't fit the traditional mould the chance they deserve.

This book is in your hands because readers made it possible. Everyone who pledged their support is listed below. Join them by visiting unbound.com and supporting a book today.

Timothy Jan Adams

Peter Agbaba

David Aldworth

Michael Allen

Christopher Alner

Julia Anderson

Nathaniel C R Anderson

Oscar Andersson

Jane Angell

Stuart Ashen

Kenny Atkin

Adrian Atterbury

Roger Bagnall

Hans Willem Bakx

Mel Bale

Alex Balk

Stephen Ball

David Barker

Phil Barnard

Scott Barrett

Jack Barrie

Matthew Bate

Peter Baxter

Adam Baylis-West

Alison Bean

Jon Beech

Alan Beeson

Salma Begum

Alison Belshaw

Jon Bennett

Richard Bennett

Frances Bentley

Anne Berkeley

Sean Berry

Rachel Birrell

David Blake

Matthew Blake

Andy Blamey

Nick Bonny

David Book

Charles Boot

Richard Boulter

Jon Bounds

Alexander Bourne

Bruce Bowie

Roger Bowles

Michael Bownas

Alex Boyd

Phil Bramley

Jeremy Bray

Richard Breese

Tom Brereton

Lindsey Brodie

Jonathan Brooker

David Bruce

Lilian Bryce-Perkins

Ivor M Bundell

Alex Burghart

Hermione Burghart

Mike Burn

Keith Burns

Lazlo Burns

Mike Butcher

Jonathan Bygraves

John Byrne

Patrick Campbell

Peter Campbell

Stuart Canning

Xander Cansell

Paul Carlyle

Ana Cascon & William F
 Shadwick

Susan Chadwick

Imogen & Rodney Challis

Marnie Chesterton

John Cheston

Robert Chilton

Richard Clack

John Clark

Ross Clark

Paul Clarke

Keith Javier Claxton

Joe Clinton

Brian Clivaz

James Clive-Matthews

Felicity Cloake

Richard Clouston

Andrew Clubb

Ronnie Clyde

Malcolm Coghill

GMark Cole

Ewan Connick

Supporters

Harry Cooke

Mark E Cooper

Bernie Corbett

Mike and Rosie Corlett

Sarah Cornell

Andrew Correia

Joe Cotter

Jonathan Cox

Charles Crabtree

James Crane

Colin Crawford

John Crawford

Huw Crowley

Paul Cuff

Michael Cunningham

Max Cure-Freeman

Leon Curson

Catherine Curzon

James Darrall

Ricky Davies

Tony Davis

Jon Davison

Steve Day

Henry de Vroome

Gervase de Wilde

deadmanjones

Celia Deakin

Jamie Dean

Remy Dean

Morag Deyes

Howling Dick

Katrina Dickson

Martin John Diggins

Les Dodd

James Doeser

Rae Donaldson

Kevin Donnellon

J Doran

Peter Dorling

Matt Dowden

William Doyle

Peter Drabwell

Jonathan Dransfield

Sheila Dunn

Christian Dunnage

Paul Durkin

Daniel Durling

Glen Durrant

Thom Dyke

Alex Eccles

Lucy Elder

John Eley

Alistair Ellen

John Ellis

Jon Ellis

Tony & Chris Elphick

Louis Emmett

Gavin Erickson

David Evans

Mark Everett

Neil Ewen

Jon Ewing

Simon Faircliff

Brian Fearon

Jennie Finch	Gary Hall
Sally Fincher	Gretel Hallett
Robert Fitzgerald	Tibo Halsberghe
Alina Florea	Joshua Hanson
N W Ford	Leslie Hargreaves
Daniel Forth	Peter Hart
Julian Francis-Lawton	James Hartley
Justin Freeman	Richard Hartley
Deborah Friedell	Guy Haslam
Bridget Frost	Jonathan Haynes
Byron Fry	Rob Haynes
James Fry	Rebecca Haywood
Daniel Gardner	Anthony Heath
Antoinette Gavin	Zandy Hemsley
Amro Gebreel	Jude Henderson
Julie Giles	Nicholas C. Henry
Keren Gilfoyle	Deborah Herron
Stevie Gill	James Higgs
Mark Gillies	Graham High
Chris Gittner	Steve Hill
Tim Goodall	Mike Hine
Brian Goodwin	Paul Hodges
Jason Goodyer	Finn Holding
Gordo	Kevin Holmes
Sean Gordon	Chris Hough
Charlie Gould	Sam Houghton
Andrew Gregg	Antony Howard
Lucy Gregory	Paul Howard
Matthew Grice	William Howell
Mark Griffiths	Matt Huggins
Richard Grisdale	Graham Hughes
Adrian Haldane	Matthew J. Hughes

Supporters

Richard Hughes
Michael Hunt
Michael Imber
Jo Ireland
Ian Irvine
Allen Ives
Greg Ivings
Jack
David Jacklin
David Jackson
Martin Jackson
Mark Jeffery
Toby Jeffries
Dan Jenkins
Ric Jerrom
Mark Jewell
Billy Johnson
Ian Johnston
Sam Johnstone
Christopher Jones
Dulcie Jones
Glyn Jones
John Jones
Peter Jones
Philip Jones
Richard (Ricky) Jones
Sean Jones
Michael Jopling
John Kane
Stella Kane
John Kaye
Andrew Kelly

Tricia Kelly
Richard Kemmish
Aidan Kendrick
Jason Kennedy
Steven Kennedy
Seán Kenny
Peter Kettle
Malcolm Key
Dan Kieran
Patrick Kincaid
Alex King
Patrick King
George B Kinghorn
Simon Kingston
Adrian Kingwell
Grègoire Kretz
Brendan Lain
Martin Lam
Neal Lamont
Conrad Landin
John Lang
Miles Lanham
Per Larsson
Paul Lay
Robert D. Lee
Jonathan C. Leslie
Geoff Levett
Paul Levy
Roger Lewis
Robert Lipfriend
Bev Littlewood
Lowell Lloyd

Supporters

Stephen Longstaffe

Pat Lowe

Artem Lukianov

Mike Lynd

Andy Lyons

George MacBeth

Chris Macdonald

Ross MacFarlane

Donald Mackay

Donald Macleod

Clarrie Maguire

Kenneth Mann

Phil Manning

Elliott Mannis

Daryl Martin

Sara Masson

Jamie Maxwell

Richard Mayston

Malachy McAnenny

Robert McBride

Chris McCray

Ian McDonald

Polly Fiona McDonald

Kate McDonnell

NJ McGarrigle

John McKenzie

Frances McLaughlin

Martin McMahon

Ian McNally

Jim McNally

Fergus McVey

Christopher McWilliam

Rebecca Clare Mellor

James Mewis

Patricia Michelson

Ben Miller

Dominik Miller

Patrick Miller

David Millington

Alastair Mitchell

Clive Mitchell

Robert Mitchell

John Mitchinson

Gordon Moar

Rodney Moffitt

Diego Montoyer

James Morgan

Stephen Morris

Daniel Morrison

Michael Mosbacher

Ben Moshinsky

Andy (Pedro) Muggleton

Manjeev Muker

Mallord Mullvihill

Robin Mulvihill

Gina Murphy

Graham Murray

Paul Murray

Stephen Musgrave

Gareth Mytton

Craig Naples

Carlo Navato

Ian Newby

Andrew Nixon

Supporters

Stephen North
Conrad Nowikow
John O'Dea
Rory O'Gara
Michele O'Leary
Mark O'Neill
Niall Oakes
Roland Orchard
Andrew Ormsby
Kassia Oset
Stuart & Lesley
 Oxbrow-Trim
Neil Pace
Jack Page
Michael Paley
Sarah Palmer
Matthew Parden
Lev Parikian
Stephen Parker
Dylan Parrin
Graham Partridge
Richard Paterson
Mark Peachey
Bianca Pellet
Neil Perry
Dan Peters
Daniel Phillips
Greg Pickersgill
Alastair Pidgen
Kenny Pieper
Nigel Pike
Jack Pinnington

Stephen Pochin
Paul Pod
Shae Poffley
Justin Pollard
David Poole
John Porter
Niall Porter
Russell Porter
Daphne Preston-Kendal
Jonathan Pugh
Mark Pugh
Chris Purser
Jonny Rawlings
Nicholas Redding
Hugh Rees
Stephen Reizlein
Anthony Revollat
Alan Rew
Ben Richardson
Philip Richardson
Kyle Richmond
Stuart Riddle
Aidan Ridyard
Martin Riley
Jonathan Rishton
Ewen Roberts
Julian Roberts
Wyn Roberts
Brian Robertson
Graeme Robertson
Jim Robinson
David Roche

Jenny Rollo

Allan Ronald

Charles Rooney

Tom Roper

Andrew Rose

Adam Rosser

Andy Ruffell

Mark Samuelson

Mark Sanderson

Sukhdev Sandhu

Tim Sankey

Jerry Sargent

Keith Savage

Richard Scorer

Anne-Marie Scott

John Scott

Paul Scully

Andrew Seaman

Adrian Shaughnessy

Dale Shaw

Mick Sheahan

Andrew Shearer

Keith Sherratt

Andrew Shone

Paul Sills

Colin Simpson

Joe Skade

Greg Sloman

Lewis Smith

Nigel Smith

Paul C Smith

Simon Smith

Theresa Smith

Robert Smyth

Richard Soundy

Alice Spawls

Andrew Spencer

Owen Stagg

Laurence Staig

Andrew Stals

Martin Stals

Neil Stanley

Martina Stansbie

Luke Stapylton-Smith

Richard Stephens

Jack Steven

Neil Stevenson

Heather Stewart

Nina Stibbe

Tom Stiff

Gail Stoten

Philip Stout

Reuben Straker

Adrian Strangeway

Alan Stromberg

Andrew Stubbs

James Suttie

Graeme Swanson

Michael A Sweet

Alesandro Tate

Christopher Tate

Colin Dog Taylor

Matthew Taylor

Richard Thomas

Stephen Thomas

Ambrose Thompson

Arthur Thompson

Ben Thomson

Joanna Tindall

James Tobin

Giles Todd

Dave Tormey

James Turner

Luke Turner

Paul Turner

Ben Tye

Stephen Vaudrey

Gary Vernon

Greg Vincent

Jose Vizcaino

Mike Wade

Steve Walker

Dave Walsha

David JS Webber

Denis Welch

Ged Welch

Philip Weller

Peter Welsh

Carl West

Donald Whitaker

John White

Daniel Whitford

Michael Whitworth

Mark Wickenden

James Widden

Andrew Wiggins

Jennifer Wigzell

Victoria Wiksen

Gareth Wild

Andrew Wiles

Phil Wilkinson

Philip Wilkinson

David Williams

Gary Williams

Sean Williams

Derek Williamson

David Willis

Samantha Willis-Hall

Clarke Wilson

Don Wilson

Ellen Wilson

Stephen Wilson

Aidan Winterburn

Thom Winterburn

Walter Winterburn

Stephen Wise

Alexander Woolfson

Nick Wray

Stuart Wright

Tim Wright

Duncan Wu

Tom Yelland

Richard Young

Sam Young